# The Family Encyclopedia of Art

# The Family ENCYCLOPEDIA OF ART

General Editors:
Bernard L Myers
Trewin Copplestone

**Holt, Rinehart and Winston**
**New York**

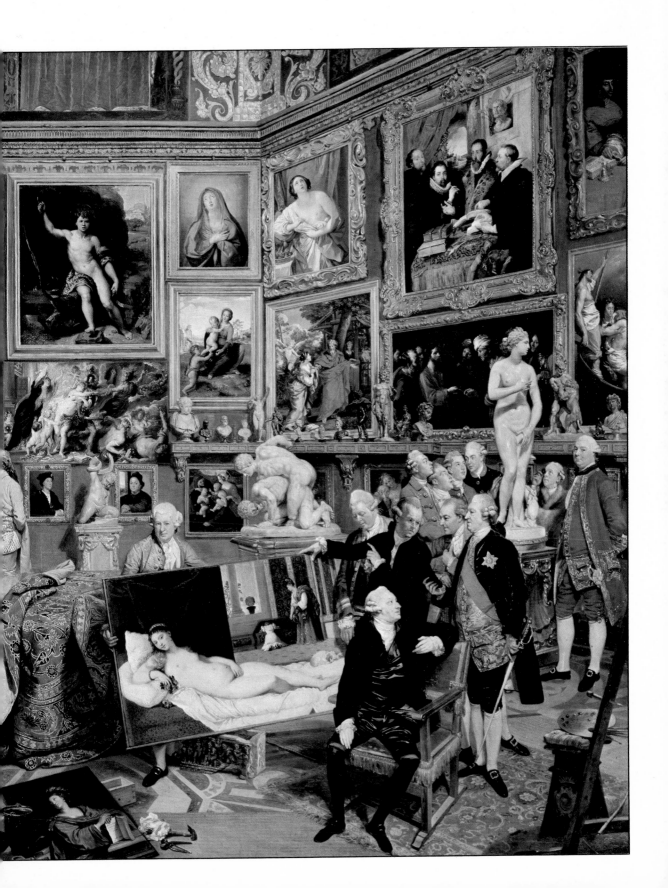

# Contributors

PALAEOLITHIC ART
**Emily Hays Moss,** Postgraduate Student, Institute of Archaeology, London University

CAVES TO CITIES
**Dominique Collon,** London University; Columbia University, New York

EGYPT
**Peter A. Clayton,** Managing Editor, British Museum Publications, London

CRETE; GREECE; ROME; CAVES TO CITIES (WESTERN EUROPE)
**Thomas F. C. Blagg,** Research Associate, Institute of Archaeology, London University

CHINA; AFRICA; OCEANIA; MEDIEVAL WORLD (ROMANESQUE ART)
**Dominic de Grunne,** Lecturer, Royal College of Art, London

INDIA; JAPAN
**Philip Rawson,** Curator of the Gulbenkian Museum of Oriental Art, Durham

EARLY CHRISTIAN AND BYZANTINE ART; THE ITALIAN RENAISSANCE; MEDIEVAL WORLD (PAINTING)
**Duncan Robinson,** Keeper of Paintings and Drawings, Fitzwilliam Museum, Cambridge

RUSSIA; MODERN WORLD (CONSTRUCTIVISM AND DE STIJL)
**Paul Overy,** Art Critic to *The Times*, London

ISLAM
**Ronald Lewcock,** Fellow of Clare Hall, Cambridge

DARK AGES
**Malcolm Jones,** Graduate of St John's College, Cambridge

MEDIEVAL WORLD
**Joanna Cannon,** Conway Library, Courtauld Institute of Art, London

15TH AND 16TH CENTURIES OUTSIDE ITALY
**Marguerite Kay,** Lecturer in Extra-Mural Studies, London University

17TH CENTURY IN EUROPE
**Michael Jacobs,** Courtauld Institute of Art, London
**Joy Law,** Publications Officer, Royal College of Art, London
**J. M. Nash,** Lecturer in the History of Art, Essex University

18TH CENTURY; MODERN WORLD
**Robert Cumming,** Director, Christie's Fine Arts Course, London

AMERICAN ART; NORTH AMERICAN INDIAN ART
**C. E. Brookeman,** Senior Lecturer in English and American Studies, Polytechnic of Central London

19TH CENTURY
**Clive Bridger,** Lecturer in Art History, North Staffordshire Polytechnic
**Robert Cumming,** Director, Christie's Fine Arts Course, London
**Leonée Ormond,** Lecturer in English, Kings College, London University
**Richard Ormond,** Deputy Keeper, National Portrait Gallery, London
**Keith Roberts,** Associate Editor of *The Burlington Magazine*, London
**Conal Shields,** Head of the Department of Art History and Allied Studies, Camberwell School of Arts and Crafts, London
**Michael Wilson,** Assistant Keeper, National Gallery, London

PRE-COLUMBIAN ART
**Elizabeth J. Carter,** Postgraduate Student, Institute of Archaeology, London University

Created, designed and produced by
Trewin Copplestone Publishing Ltd, London

First published in the United States in 1979 by Holt, Rinehart and Winston, 383 Madison Avenue, New York, New York 10017.

Published simultaneously in Canada by Holt, Rinehart and Winston of Canada, Limited

First published in Great Britain 1977

**Library of Congress Cataloging in Publication Data**

Main entry under title:
The Family encyclopedia of art.
   Bibliography: p.
   Includes index.
   1. Art — Dictionaries. I. Myers, Bernard L.
II. Copplestone, Trewin.
N31.F35      1979      703      79-833

ISBN 0-03-049046-4

First Holt Edition: 1979

Colour origination by Positive Plus
Printed in Italy by New Interlitho SPA, Milan

# Contents

# How to use this book

This book is intended to be practical and useful and has been carefully designed to that end.

The reader may browse with only the name of an artist or period as a starting point. The index will locate the page, and not only the subject but a number of other associations will become available. Thus moving backwards or forwards through the pages will take the reader through history.

**Charts.** The first features that the reader should consider are the special pictorial chart double pages which include an inset map, a time-scale and an introductory essay. Each chart identifies a particular period in the story of the visual arts which is dealt with in the following pages until the next chart introduces the next period. These sections are arranged in chronological order. The exceptions to strict chronology are the sections on Islamic Art, India, China, Japan, Russia, Oceania, Africa, Pre-Columbian America and the North American Indian. Although these peoples and their arts have a long history, the time-scales overlap and are often out of phase with the complex chronology of the arts of Western Europe and its influences. Each section varies in length according to the needs of its subject matter.

**Spreads.** Each double page or spread, is self-contained. The spread texts are of roughly one thousand words with an average of four or five pictures. The texts are subdivided into headed sections, three or four to a spread, for easy subject identification. The text can be read straight through as a story of art, or used to find basic information about a period or artist.

**Index.** The symbol $\nabla$ refers to the index. Names, places and works are listed for cross reference throughout the book. If you are reading about artist A, and artist B is mentioned in passing for comparison, then further references to B can be found by using the index.

**Glossary.** The glossary symbol is ☐. The glossary contains brief explanations of technical terms in the visual arts, referenced to the text, but also intended to be used in its own right and in conjunction with other reading.

# Introduction

A book with such wide coverage of the visual arts as this, may present to the beginner, a bewildering variety of styles. Each individual artist, and each scholar or critic too, must live and work as if one style – that to which he is personally dedicated – is the only style possible. It is this single-mindedness that gives the work of art its individual quality and authenticity.

For the art lover or the interested person a different approach is advisable. The expert (art historian or art critic) may research into or concentrate on one style or artist, but the layman's pleasure comes from the exploration of the way artists worked at all times of history. Artists had views which were both personal and related to the period in which they lived. They agreed with their contemporaries on most things including which art was good or bad. But in addition they thought and saw personally and had a private philosophy and faith which was theirs alone and expressed in their art. Thus, Caravaggio and Bernini, for example, are similar and different: similar because they lived at the same time and place, different in their view of life.

It is the job of the critic to sum up, to pinpoint the state of the arts at any time, and to help us form opinions. This book is not a work of criticism.

It is intended to have the first, not the last word, and must be regarded as such. Many will eagerly look for their own favourites here, only to find that a particular picture or artist has been omitted. This is bound to happen in a book of this size and scope. But the real way to use this book is not just to look for the art which we know about to see if we agree with the commentary, but to look at the art which we don't know about, and then to look at our favourite period again, to discover a new aspect of the familiar.

It is a guide and introduction about which, with or without the opinion of the professional critic, every reader can begin to form his own judgements, create his own critical view, and make his own personal feelings important. It is intended to create a confidence built on a basic understanding of periods, styles and artists throughout history.

The reader's approach may be casual (through a word for instance), constructive (using the book as a consecutive history), or emotional (by starting with the illustrations that attract and going on to information about them). Whichever it may be, this work is intended to interest and stimulate pleasure.

In a sense the idea that there is a history of art to be written can be misleading. We have to be constantly reminded that we are really dealing with the history of man, and arising out of that, the works of man, with the visual arts as one of those activities. There are those who would claim, and they put forward convincing arguments, that the visual arts are among man's greatest achievements, treasured and capable of arousing intense emotions long after the rulers and princes, the rich and powerful, have been forgotten.

But we must remember that the history of man – and we can see this clearly in his other works, in medicine, science and technology – is one slowly overcoming superstition and prejudice by reason. Science is not based on personal taste, likes or dislikes but on understanding. Unfortunately with the visual arts the reverse is often the case. After all, we are attracted to painting and sculpture in the first place by our emotions, just as the creative artist intended. The art that appeals to us may well have been produced as a counter or reaction to another art form. The stronger our enthusiasm for one particular artist or period, the more we may be blinded to other forms. So it is difficult as it is important to keep a balanced view of the visual arts.

This book is intended to be just such a balanced guide. Whatever our particular favourites may be, we find them here put in the context of the whole history of art from the earliest times to our own day. The text does not pass judgement but explains how and why the wide variety of arts and styles were created. It is not intended to reduce all work to the same level. A wider understanding of all visual arts often reinforces and enhances our own particular favourites, while introducing us to new experiences and delights.

# Time Chart

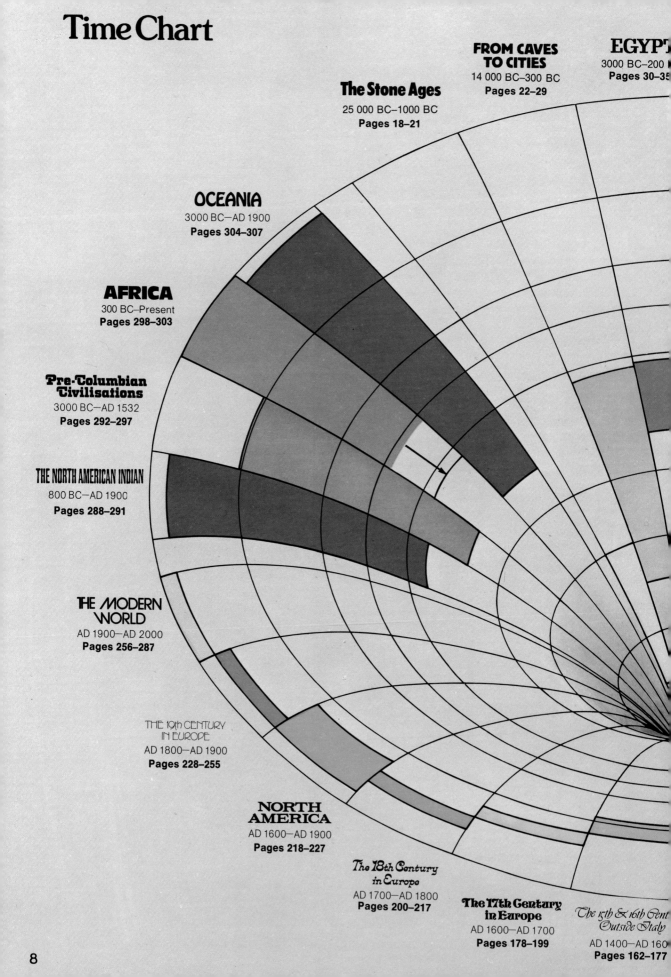

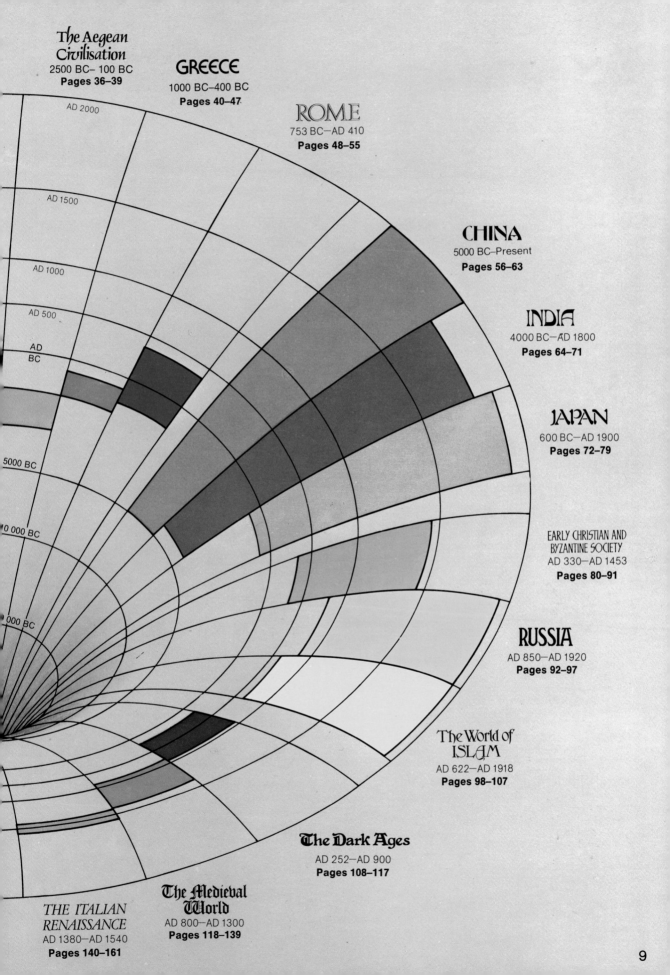

The Aegean
Civilisation
2500 BC– 100 BC
**Pages 36–39**

GREECE
1000 BC–400 BC
**Pages 40–47**

ROME
753 BC—AD 410
**Pages 48–55**

CHINA
5000 BC–Present
**Pages 56–63**

INDIA
4000 BC—AD 1800
**Pages 64–71**

JAPAN
600 BC—AD 1900
**Pages 72–79**

EARLY CHRISTIAN AND
BYZANTINE SOCIETY
AD 330—AD 1453
**Pages 80–91**

RUSSIA
AD 850—AD 1920
**Pages 92–97**

The World of
ISLAM
AD 622—AD 1918
**Pages 98–107**

The Dark Ages
AD 252—AD 900
**Pages 108–117**

The Medieval
World
AD 800—AD 1300
**Pages 118–139**

THE ITALIAN
RENAISSANCE
AD 1380—AD 1540
**Pages 140–161**

AD 2000

AD 1500

AD 1000

AD 500

AD
BC

5000 BC

10 000 BC

000 BC

# Index

This index has been prepared as the main preliminary information source. It should be used in conjunction with the glossary.

Certain terms, e.g. abstract, perspective, picture plane, engraving, etc. should be referred to in the glossary. Such words form some of the basic language of art and it could be useful to examine the glossary at an early stage in the use of this book. The index contains the words that are referred to in the text and can thus be used to locate any subject dealt with in its period and place.

# Index

# Index

# Index

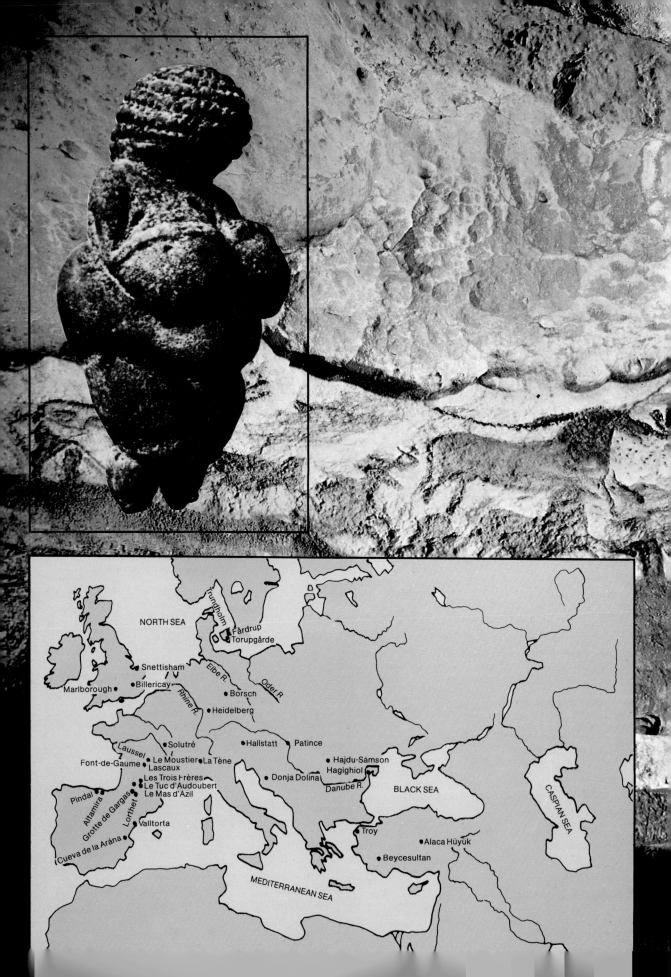

NORTH SEA

Trundholm
Fårdrup
Torupgårde

Snettisham
Elbe R.
Oder R.
Marlborough
Billericay
Borsch
Rhine R.
Heidelberg

Laussel
Solutré
Hallstatt
Patince
Font-de-Gaume
Le Moustier
La Tène
Hajdu-Sàmson
Lascaux
Hagighiol
Les Trois Frères
Le Tuc d'Audoubert
Donja Dolina
Pindal
Le Mas d'Azil
Danube R.
BLACK SEA
Altamira
Grotte de Gargas
Lorthet
Valltorta
Troy
CASPIAN SEA
Cueva de la Aràna
Alaca Hüyük

Beycesultan

MEDITERRANEAN SEA

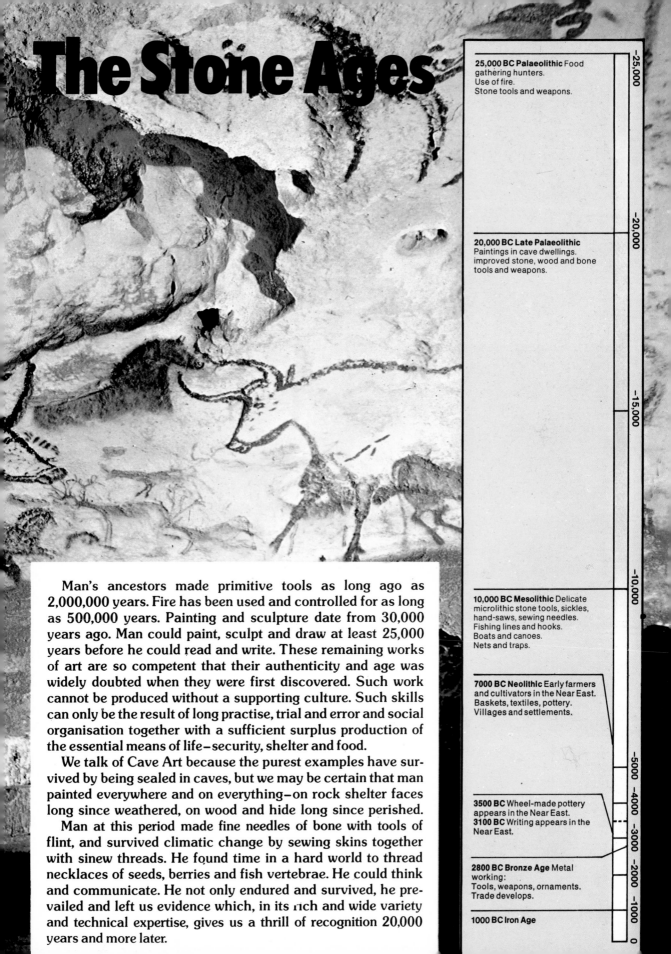

# The Stone Ages

**25,000 BC Palaeolithic** Food gathering hunters.
Use of fire.
Stone tools and weapons.

**20,000 BC Late Palaeolithic** Paintings in cave dwellings. improved stone, wood and bone tools and weapons.

**10,000 BC Mesolithic** Delicate microlithic stone tools, sickles, hand-saws, sewing needles. Fishing lines and hooks. Boats and canoes. Nets and traps.

**7000 BC Neolithic** Early farmers and cultivators in the Near East. Baskets, textiles, pottery. Villages and settlements.

**3500 BC** Wheel-made pottery appears in the Near East.
**3100 BC** Writing appears in the Near East.

**2800 BC Bronze Age** Metal working:
Tools, weapons, ornaments. Trade develops.

**1000 BC Iron Age**

-25,000
-20,000
-15,000
-10,000
-5000
-4000
-3000
-2000
-1000
0

Man's ancestors made primitive tools as long ago as 2,000,000 years. Fire has been used and controlled for as long as 500,000 years. Painting and sculpture date from 30,000 years ago. Man could paint, sculpt and draw at least 25,000 years before he could read and write. These remaining works of art are so competent that their authenticity and age was widely doubted when they were first discovered. Such work cannot be produced without a supporting culture. Such skills can only be the result of long practise, trial and error and social organisation together with a sufficient surplus production of the essential means of life—security, shelter and food.

We talk of Cave Art because the purest examples have survived by being sealed in caves, but we may be certain that man painted everywhere and on everything—on rock shelter faces long since weathered, on wood and hide long since perished.

Man at this period made fine needles of bone with tools of flint, and survived climatic change by sewing skins together with sinew threads. He found time in a hard world to thread necklaces of seeds, berries and fish vertebrae. He could think and communicate. He not only endured and survived, he prevailed and left us evidence which, in its rich and wide variety and technical expertise, gives us a thrill of recognition 20,000 years and more later.

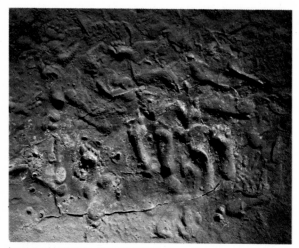

Impressed footprints. *About* 20,000 BC. Niaux, France

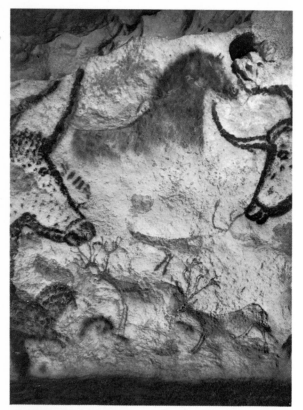

**Palaeolithic art** is remarkable both for its great antiquity and because it represents the beginning of visual expression. Art is virtually absent from the human record until the demise of Neanderthal man and the appearance of modern man in Europe, about 30,000 years ago. The new race combined its advanced technological skill with abundant resources to produce affluent and complex Upper Palaeolithic cultures. These people were highly successful hunters of big game until the end of the Ice Age at about 10,000 BC. In south-western France and northern Spain, limestone caves provided them not just with shelter in their entrances but with bare walls for painting, and private and mysterious places deep within their recesses. Palaeolithic art centres in the French–Spanish border area but extends to Portugal, Sicily and the Russian plains. More than a hundred caves bear paintings which must represent only a small proportion of the original works; any painting on organic material has long since perished. Like the art of any age, Palaeolithic art takes its form from the culture which created it. It is sometimes ritualistic, sometimes decorative, and it has an abstract element as well as a realistic one.

**Places.** Altamira (Cantabria) was discovered in 1879. It was the first prehistoric painted cave to receive world-wide attention, and it caused a sensation in the scientific world. It contained paintings which were the highest achievement of the hunters' art. The ceiling of the Hall of Bulls is a field of resting bison, engraved and painted in polychrome upon the natural rock features. Proportion, perspective and detail satisfy any modern criteria.

With the discovery of the cave at Lascaux (Dordogne) in 1940 came the recognition that it was the finest painted cave in France. Skill in draughtsmanship is greater here than concern for correct anatomy. A sense of energy comes not only from the animals themselves but from the spacing of the paintings along the walls and ceiling of the main chamber and into a passageway.

The yawning mouth of Niaux (Pyrenees) overlooks a valley where it could not have been unnoticed, yet its paintings were not discovered until 1906, for they are in a chamber half a mile from the entrance. The black, linear horses and bison of the Salon Noir are well drawn with great attention to detail.

Some of these caves are cramped, cold and even eerie, but others awaken the kind of awe and wonder that the finest Gothic architecture inspires.

**Cave Painting.** The most basic forms of human expression, hand prints and outlines, tracings and paintings with mud, are perhaps the earliest. Known examples form a basic chronology which shows stylistic change through time. Animals are by far the most frequently represented figures, and probably the act of painting an animal was itself important. Reindeer, mammoth, horse, and bison are common, as are less frequently hunted animals. The images vary from very small to almost life

*Above left: Animals of the hunt.* Cave painting. *About* 15,000–10,000 BC. Lascaux France
*Left: Horses. About* 15,000–10,000 BC. Height about 32 in (82 cm). Lascaux, France

size. Fierce animals such as bear, lion and woolly rhino are usually deep inside the cave, nearly inaccessible, and where artificial light is essential. Manganese oxide added black to the palette alongside various shades of ochre. Pigments mixed with animal fat or other organic vehicles were applied with fingers and brushes or hide pads.

Drawing skill increased through time, and with it the use made of paint to mould form and to render texture, but all through the Upper Palaeolithic a sure sense of design is frequently apparent. ☐Engraving is more common than painting, but techniques are often combined, and in many cases the paint may have faded beyond detection. Some figures are reworked several times, and others are superimposed without apparent regard for the form beneath. Australian aboriginal art, which has an ancient origin, suggests that some paintings are totem figures. The meaning of the paintings may be unclear, but they leave no doubt that the Upper Palaeolithic people developed the fine arts to an astonishing degree.

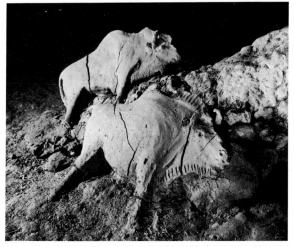

*Above: Clay relief of bisons. About 20,000–10,000 BC. Height of female 24 in (61 cm). Tuc d'Audoubert, Ariège, France*

**Sculpture.** Palaeolithic sculpture shows two sources, the engraving of stone slabs and three-dimensional shapes in stone, bone, ivory, wood and clay. From the latter come the finely carved female figures, 'Venus' figurines. The corpulent forms are faceless but the rare sculptures of heads suggest attempted portraits. Even the realistic figures are symmetrical, so that the later abstraction of the whole form is a natural development from the rounded shapes of the body. Low relief may have evolved from the first stone engravings. About 21,000 years ago the expression of animal forms in high relief eclipsed the human figures. The massive wall-reliefs of horses at Cap Blanc rock shelter are up to six feet long. Deep inside the cave of Tuc d'Audoubert four bison sculptures are modelled in clay, preserved by the nearly constant temperature and humidity. Here, the medium reached the height of its development.

**Tools and Weapons.** The decoration of objects is a hallmark of the last phase of the Upper Palaeolithic. Spear points, spear throwers, rods and *bâtons de commandement* (possibly shaft straighteners), were made of bone and antler. These, along with plaques and amulets, form the bulk of mobiliary art. At its simplest, the decoration consists of rows of dots and dashes or parallel lines along the edge of the object. More complicated carving was done on antler, because soaked in water it becomes more tractable and yet returns to its original hardness. The main shaft or handle of the implement is frequently carved with ornate swirls which are ornamental as well as functional. The larger end of the spear thrower is often a sculptured animal, and the position of the animal was dictated by the functional requirements of the tool.

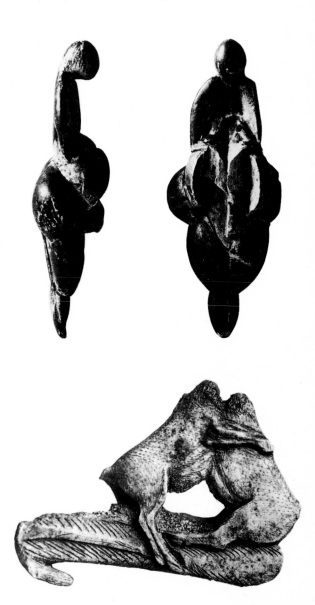

*Above right: Venus de Lespugue. About 20,000–18,000 BC. Grotte des Rideaux Haute-Garonne, France*
*Right: Spearthrower. Carved in form of fighting bison. About 15,000–10,000 BC. Les Trois Frères, France*

# FROM CAVES TO CITIES

Man the hunter was replaced by man the herdsman and cultivator. Man has been farming for more than 10,000 years. The change from living as a wanderer, hunting and trapping animals and gathering plants, brought about what has been called the Neolithic (New Stone Age) revolution.

Population increased, and man began to live in settlements. The agricultural way of life gave people more free time, and handicrafts, early technology and science developed. It became necessary to count, to tell the time by calendar. The king-warrior and the priest man-of-letters ruled together. Man developed his powers of abstraction. In his daily life and in his artefacts pattern became all important. He became an inventor and builder. During the whole period from the cave dwellings to the early city settlements a form of religious belief grew up becoming more complex and fixed as time passed. A system of Gods and rituals was created which formed one source of art inspiration. The growing king/dynasty-based systems provided another.

We here deal with a difficult time-scale. Most of the earliest settlements we know are found in the Middle East and West Asia. Many of these sites have always been inhabited. Cultures changed slowly. The art of building and the idea of the town spread outwards slowly, reaching the western edges of Europe only after towns had risen and perished and were rebuilt again and again on their original sites, until the great cities of Mesopotamia (land between the two rivers) are now mounds of perished brick, while great stone (lithic) structures, such as Stonehenge, (England), of earlier date, still stand.

During this time art changed radically: pattern and order became more important than 'snapshot' realism, and architecture became the dominant art.

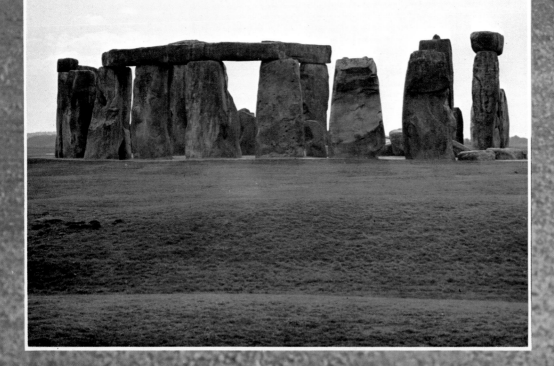

| | −15,000 | −10,000 | | −5000 −4000 −3000 −2000 −1000 | 0 |

**7000 BC** Earliest agricultural settlements in the Near East.

**3500 BC** Potter's wheel used in Mesopotamia.
Wheeled vehicles.
**3100 BC** Early cities in the Near East.
Cuneiform writing in Mesopotamia.
**2600 BC** The Royal Graves of Ur.

**2000 BC** Ziggurat builders.
Extensive trade ventures.
Lake-dwellers in Europe.
**1750 BC** Laws of Hammurabi.
Old Babylonian Empire.
Monoliths in Europe.
Stonehenge built in Britain.
**1595 BC** Hittites raid Babylon.
**1350 BC** Hittites and Egyptians seek supremacy in Syria.
Amarna Age.
**1285 BC** Battle of Qadesh.

**1000 BC** Iron-working in Europe.
**600 BC** Nebuchadnezzar's Babylon.
**586 BC** Jerusalem falls to Babylonians.
**539 BC** Babylon falls to Achaemenic Persians.
**331 BC** Alexander the Great captures Babylon.

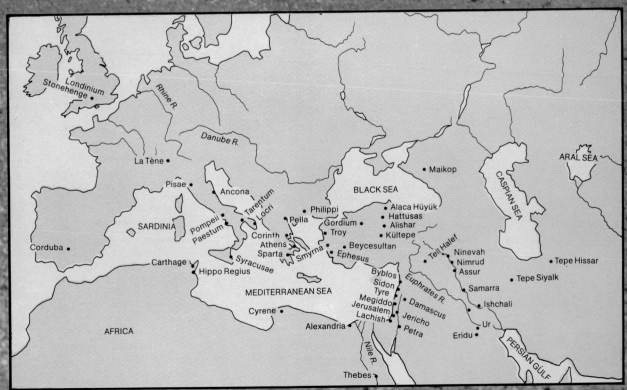

# FROM CAVES TO CITIES

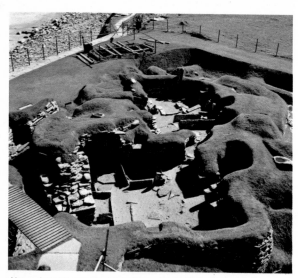

*Above:* Interior of a Stone Age house, Skara Brae, Orkney Isles

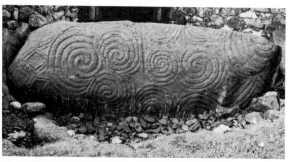

*Above:* Ornamented stone in front of passage entrance, Newgrange, Ireland
*Below:* La Téne pottery vessel

**Early Buildings.** The beginnings of agriculture in Europe led to permanent settlements. Their developing communal life was strengthened by the sharing of ceremonial centres and burial places, the first permanent European buildings. Many of these were of wood, since decayed, though archaeologists have identified their existence. Others were built of stone, and still survive. They include the unique temples of Malta, of 2700 BC onwards, with internal chambers, façades and outer walls constructed of enormous stones standing on end. Some of them, as at Tarxien, are decorated with carefully carved spiral designs. In Britain, many open-air 'henge' monuments of similar huge stones arranged in large circles were laid out with great precision. Stonehenge is one of the most complex, with several changes of design. The outer circle at Avebury has 98 stones averaging 12 feet high, and is approached by an avenue of stones, one and a half miles long. Similar multiple alignments survive at Carnac in Brittany. In countries bordering the Atlantic, megalithic tombs (from the Greek *megas* meaning 'great', *lithos* meaning 'stone') contained chambers entered through a passageway, with an earth mound over the top. Stones in the Breton and Irish tombs such as New Grange are carved with concentric and linear motifs. Construction of these monuments required thousands of hours' labour, and the task of transporting and then raising the huge blocks into position with ropes and scaffolding was formidable. All the shaping of the megaliths and the carving of the decoration was done without any metal tools. The planning and organisation of this work shows a highly developed society. Later, this organisation was applied to building fortifications. Sardinian bronze-age *nuraghi* consist of thick-walled stone towers with several storeys of □corbel-vaulted rooms, dominating villages of small round huts. In Celtic Europe hillforts were defended by ditches and ramparts of stone, earth and timber, and the later ones had complicated entrance designs.

**The Beginnings of Pottery.** The art of making pottery first came to Europe over 7,500 years ago, when farming was introduced from the Near East. Its spread westwards was a slow process, taking many centuries. In central and eastern Europe many of the wide variety of bowls, jars and tankards were decorated with painted patterns or graffiti. The pottery or early villages in the West was much simpler. Round-bottomed bowls and, later, flat-bottomed urns of coarse clay had impressed patterns made with twigs, bird-bones, finger-nails or cords. Paint was not used. At this time pottery was made on a small scale for the family or village, though the potter usually shared in a common tribal tradition. In the ▽Iron Age there was a great improvement. The potter's wheel was introduced, probably from the Greeks, whose ▽Black- and ▽Red-figured pottery was imported by wealthy chieftains, though native products could not rival its quality (*see* pages 46–7). The new technique helped potters to make more elegant shapes, such as vases, on finely turned pedestals, and skill and professionalism increased noticeably. Most pots were grey or black, and undecorated, but the flowing curvilinear patterns typical of ▽Celtic art are found, incised or occasionally painted.

**Sculpture** presents a rather varied picture in the art of Europe before Classical civilisation. Simple pottery figurines, usually female, from the early farming villages of south-eastern Europe, with incised lines to indicate their clothing and features, may represent goddesses or could be toys. Swedish ▽ Bronze-age rock carvings show stylised boats, plough-teams, ox-carts and sun symbols, designs which are also engraved on metal-work. Similar carvings have been found in the Italian Alps. In Spain, fine statues of seated women with elaborate dress and jewellery were carved in a naturalistic manner probably learned from ▽ Greek or ▽ Carthaginian examples. Apart from these, the only truly monumental sculpture is that of the ▽ Iron-age ▽ Celts, mostly religious in purpose. Stone and wooden human figures have the prominent eyes and simplified facial features found also in metalwork. Where the body is also represented, it is crude and pillar-like; all the emphasis is on the head, which Celtic religion considered to have supernatural powers. Figures in cast bronze are rare, but small stylised boars, cattle and other animals were made for decorating the rims of cauldrons or for religious offerings.

**Metalwork.** European metalworking seems to have been invented independently at several different places from about 4700 BC. The first products were beads, pins and small knives of hammered copper. The discovery that copper could be alloyed with tin to make bronze, and could be cast in a mould, meant that stronger implements and a much wider range of objects could be made. These included weapons (daggers, spears and swords), wood-working tools (axes and gouges) and jewellery. The honour paid to the warrior is shown by the magnificent equipment made for him: finely-tempered swords with engraved hilts and ornamented scabbards. Some of the finest achievements of this type of society were produced by the ▽ Celts. Their art was essentially one of personal display. They delighted in taking ideas from plant life and converting them into swirling formal curves and inter-laced lines, showing a love of pattern for its own sake and a mastery of balanced design. Human faces and animals were reduced to their simple essentials, so that although the result is stylised, the character is vividly conveyed. Helmets, the fronts of shields and the backs of bronze mirrors were decorated in this way. The technical mastery of □casting, □engraving, □embossing, enamelling and inlaying can be seen on the brooches, bracelets and torcs (neck-rings) of gold and bronze and on the harness-fittings of the chariot-teams, glorifying the warrior society in all its aspects. Sheet-bronze cups, wine-buckets and cast bronze flagons were used at their feasts. Additionally, the introduction of iron, though not suitable for this decorative display, provided the carpenters, wheelwrights, blacksmiths and farmers with most of the tools that were known before the Industrial Revolution.

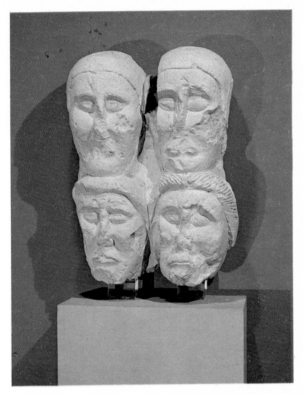

*Above:* Four-masks. Late Celtic La Téne II. Aix-en-Provence, France

*Below:* Desborough Mirror. Engraved bronze. Celtic. 1st century AD. Length 13¾ in (35 cm). BM, London

# FROM CAVES TO CITIES

Roughly equivalent to modern Iraq, Mesopotamia is watered by the Tigris and ▽Euphrates and their various tributaries. Northwards and eastwards it is bounded by mountains, westwards by deserts, while to the south the rivers run into vast marshes before reaching the Persian Gulf. The main trade-routes and cities lie along the waterways and throughout history tribes have moved in from the desert and down from the mountains. Though the cultivatable land is extended by means of irrigation, the country's natural and mineral resources are scant. There are a few rock outcrops in the north but stone has to be imported in the south; date-palm wood is fibrous with limited uses. Thus mud-brick, reed mats from the marshes and bitumen from Hit have always been the main building materials. The bricks are generally sun-dried so yearly replasterings are necessary. If a house is abandoned, the precious wooden beams and lintels are removed and it rapidly becomes a ruin into which the foundations of the next house are dug. Over a period of time the accumulated debris of a settlement can form a sizeable mound or □tel – a distinctive feature of Near Eastern archaeology resulting from the use of mud-brick rather than stone.

Goat in a Thicket. From Ur, *about* 2600 BC. Gold and lapis lazuli. BM, London

**The Beginnings of Writing.** In the 6th millennium BC, cultivators moved into Mesopotamia from caves and villages in the surrounding hills and settled in primitive farming communities along the edge of the rainfall belt. A series of cultures grew up, distinguished by their painted pottery. Figurines of clay and veined alabaster, amulets and stamp seals became increasingly sophisticated and there are round structures at Arpachiyah, T-shaped houses at Tel as-Sawwan, while at Eridu, archaeologists excavated a sequence of shrines from an early mud-brick hut to an elaborate raised building with buttressed walls. These □buttresses were both decorative and structural and became a feature of Mesopotamian architecture. Towards the end of the 4th millennium there was a series of innovations: wheel-made pottery appears as does monumental architecture characterised, at Uruk, by huge shrines with complex plans and elaborately niched walls or with engaged or free-standing columns studded with a mosaic of coloured clay cones in geometric patterns. At Uqair the whole temple was adorned with □murals. Cylinder seals were carved with designs and these are our main source for the □iconography of the different periods. With the invention of □▽cuneiform writing, Mesopotamia emerges into history.

**The Age of the Ziggurat.** As a result of these innovations we find extensive urban development and the creation of Sumerian city-states. Sequences of shrines, excavated in the Diyala valley, contained examples of sculpture in the round and evidence of advanced copper and bronze casting techniques, some objects being made by the complicated □cire-perdue process. The copper high □relief decoration of the temple façade at Al 'Ubaid also survives. At Ur, many rich burials, some of them in vaulted tombs, contained beautiful gold, silver, lapis lazuli, coloured limestone and shell objects, jewellery, gaming-boards, harps, weapons and cylinder seals. After this rich early dynastic period, Mesopotamia was united under the Semitic kings of the dynasty of Akkad (*about* 2370–*about* 2230 BC) whose art is illustrated by some interesting reliefs, very fine fragmentary life-size figures in stone and copper, and some of the most beautiful cylinder seals ever cut. After a period of chaos, there was a Neo-Sumerian revival. Innumerable statues of Gudea of Lagash survive but few of the temples he built. Many of the buildings set up by the rulers of the 3rd dynasty of Ur have been excavated, however, and the first true ziggurat or stepped temple pyramid dates from this period.

*Below left:* Cylinder seal and impression. King Darius of Persia hunting lions. *About* 500 BC. BM, London

*Below:* The ziggurat of Ur. End of the third millenium BC

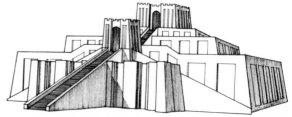

**The Empire of Hammurabi.** The 3rd dynasty of Ur fell in 2003 BC before the Amorites who moved in from the desert and set up a series of Semitic dynasties, but under Hammurabi of Babylon, in the 18th century BC, Mesopotamia was united and a fine □*stele* records his laws. In the North, Assur had become rich as a centre of trade with Central ▽ Anatolia. The Kassites from Iran gradually gained power in the south but maintained the traditional architectural forms though some paintings at Aqar Quf and a brick façade decorated with life-size figures at Uruk show some originality. Northern Syria and Mesopotamia became part of the kingdom of Mitanni and fine painted goblets, known as Nuzi Ware, occur on many sites. The great innovation of the 15th century was the use of glass and glazing: there are several examples of multicoloured, opaque glass from Tell el-Rimah and Middle Assyrian examples of glazed bricks. This was the period during which the □Assyrians consolidated their kingdom.

**The Hanging Gardens of Babylon.** The ▽ Assyrians emerged in the 10th century BC as the dominant force in the Near East. They built huge palaces, temples and ziggurats at Nineveh, Nimrud, Khorsabad, which were guarded by stone portal lions, winged bulls or genii. They recorded their campaigns and exploits in long inscriptions, in detailed low □reliefs on limestone slabs, in □repoussé on bronze gates, in glazed brick panels and on wall-paintings. The booty they brought back contained numerous bronze bowls, furniture fittings and ivory plaques, carved in varying styles, which are technically superb and often very beautiful; these objects are, however, mostly of foreign workmanship. It was some time before Babylon's fortunes revived but under the Chaldaean kings of the late 7th and 6th centuries BC the city was adorned with temples and palaces including Nebuchadnezzar's famous Hanging Gardens, which excavations have revealed to have been built over a series of vaulted chambers of different heights. The Ishtar Gate and a processional way leading from it were decorated with bulls, dragons and lions in low relief on brightly glazed bricks. The Persians, under Cyrus the Great, put an end to this Babylonian dynasty in 539 BC and thereafter Mesopotamia was ruled by a series of foreign dynasties – Achaemenids, Seleucids, ▽ Parthians and ▽ Sassanians – who, from the Seleucids onwards, however, established their capital in the neighbourhood of Babylon.

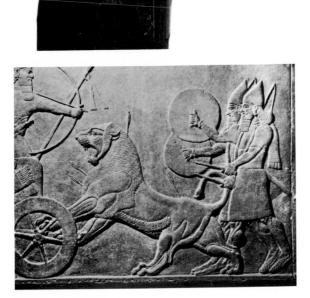

*Top:* The stele of Hammurabi. *About* 1750 BC. Hammurabi and the Sun God are above, the laws below. Louvre, Paris

*Centre:* Gudea, ruler of Lagash. *About* 2130 BC

*Bottom:* Royal lion hunt on the walls of the throneroom of Ashurnasirpal II of Assyria. 883–859 BC. BM, London

# FROM CAVES TO CITIES

**Anatolia, Syria-Palestine, Iran.**
Trade and migration routes linking Europe and Asia across the land bridge of Anatolia (modern Turkey), run up river valleys from the coast, on to the central plateau and thence, through mountain passes, into the Caucasus and southern Russia, into Iran with its mountainous fringe surrounding an uninhabitable desert, or down into Syria-Palestine where mountain ranges run parallel to a coastal strip with good harbours and a road striking inland to Mesopotamia. Mud-brick, wood and stone are available as building materials and there are sources of copper, gold and silver.

**Anatolia.** In caves in southern Turkey around 10,000 BC, rock engravings and designs on bones are the first intimations of art. Settlements grew up round obsidian deposits in central and eastern Turkey and later round copper mines near Diyarbekir. From the late 7th millennium BC onwards, we have a succession of villages at Çatal Hüyük. Access to the houses was from the roof and shrines were distinguished by varied painted and □relief decoration. Remarkable pottery and figurines were found here and at Hacilar. A 5th-millennium fortress was excavated at Mersin in Cilicia. In the ▽ Bronze Age, the ▽ megaron appears as an architectural unit and rich treasures were found at Troy and in graves at Alaca Hüyük. Kültepe became a centre for trade with Assyria in the early 2nd millennium until the ▽Hittites gained control and established an empire with the stone-built, walled city of Boghazköy as their capital. The migrations of the Sea Peoples in about 1200 BC brought chaos; in their wake the Phrygians, Lydians and Lycians settled in western Anatolia, driving the Hittites south. The so-called Tomb of Midas (*about* 690 BC), at Gordium in Phrygia, contained wooden furniture, bronze bowls and fibulae. In eastern Turkey, the Urartians built rich mountain citadels against ▽Assyrian expansion. Anatolia became part of the Persian empire in the 6th century BC but ▽Hellenistic and Roman influences increased (*see* pages 54–5) and the monumental complex on Nemrut Dagh (*about* 60 BC) is a synthesis of Eastern and Western art.

**Syria-Palestine.** The Natufian culture of Palestine (10th millennium) produced some early decorated artefacts. In the 8th millennium, the pre-pottery people of Jericho built a stone tower with an internal staircase, and imported Anatolian obsidian. Farming communities evolved different house types – some round, some with internal □buttresses, some painted. Pottery appears in the 6th millennium BC and a fine 4th-millennium metal hoard was found at Nahal Mishmar. By then, Syria had developed an urban civilisation: there is a huge walled city at Habuba Kebira on the ▽Euphrates. A palace and shrines containing sculpture at Mari, and □cuneiform tablets at Ebla (Tell Mardikh) show links with 3rd-millennium ▽Mesopotamia. A later palace at Mari was decorated with fine murals and housed an important archive. Byblos and Ugarit grew rich through sea trade with Egypt. By the middle of the 2nd millennium, the introduction of the horse and chariot had revolutionised warfare techniques and huge ramparts were built around

cities throughout the area, including Ebla and Canaanite cities such as Hazor, Jericho and Lachish. Egyptians, Anatolian ▽Hittites and North Syrian Mitannians vied for control of Syria-Palestine and this is reflected in art. Soon after the arrival of the Israelites, the catastrophic migrations of the Sea Peoples brought in the Philistines (?Pelasgians) (*about* 1200 BC) and led to the founding of the Syro-Hittite kingdoms with citadels decorated with □reliefs and with palaces of the *bît hilani* type – a columned portico entrance to a reception room, which had evolved as an architectural unit in Syria during the 2nd millennium and was now extensively used. The ▽Assyrians adopted it; they also carried off bronze bowls and beautifully carved ivories during their raids along the rich seaboard where the Phoenicians were founding a commercial empire and establishing colonies as far afield as ▽Carthage. In 586 BC Nebuchadnezzar carried the Jews into exile whence they returned in 538 BC after the fall of Babylon. Increasing East-West trade led to the establishment of rich caravan cities such as Nabataean Petra (Red Sea route) and Palmyra, ▽Dura Europos and Hatra (Syrian desert route) whose art and architecture reflect these cultural cross-currents.

**Iran.** Prehistoric cultures grew up in the highland valleys of Iran, with pottery and figurines appearing at Ganjdareh before 7000 BC. Susa, always important as a gateway to Mesopotamia, had beautiful early pottery. Writing appears there at the end of the 4th millennium and also at Tepe Yahya, near Kerman, which handled trade with the East and manufactured chlorite vessels for export to Mesopotamia and Syria. Tepe Sialk, on a more northerly route, also developed writing early but is better known for late-2nd-millennium, distinctive spouted vessels. The 13th-century Elamite city of Choga Zambil has a huge ziggurat with vaulted stairways; glass and glazes were used to decorate it. Early in the 1st millennium, the Mannaeans, Medes and Persians moved into Iran and came into conflict with the Assyrians. Hasanlu was sacked in about 800 BC and fine objects have been recovered from the debris, including a gold bowl decorated with mythological scenes. A gold treasure from Ziwiye and the Luristan bronzes also demonstrate the craftsmen's skill. The Achaemenid Persians gradually gained predominance and founded an empire under Cyrus the Great (559–529 BC), stretching from Anatolia to Bactria and Egypt. They used foreign craftsmen and adorned their palaces and huge columned halls at Pasargadae, Persepolis and Susa with fine □relief sculpture and glazed brick panels. The Oxus Treasure shows ▽Scythian influences in their metalwork. ▽Alexander the Great burnt Persepolis in 330 BC but the Seleucid Greeks were overthrown by the ▽Parthians who re-established the empire in the 2nd century BC and opened the silk route to China. Their art is best seen at Hatra in Mesopotamia, with its □iwan temples and palaces decorated with statues. Finally, from AD 224 until the Islamic Conquest in AD 651, the ▽Sassanians dominated the East with their capital at Ctesiphon where a huge brick □iwan survives. Domed palaces decorated with □stucco and □murals, □relief sculpture, inlaid metal dishes and beautiful textiles influenced their successors.

# Anatolia, Syria-Palestine, Iran

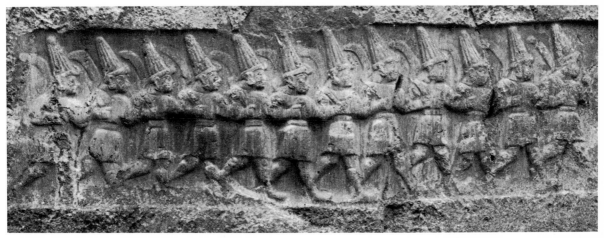

*Above:* Yazilikaya, near Boghazköy. Procession of the twelve gods. Hittite. *About* 1350–1250 BC. h. of figure 30–34 in (about 80 cm)

*Right:* Persepolis. Detail of bull capital
*Left:* Philistine pot. *About* 1150 BC. Institute of Archeology, London
*Below right:* Alaca Hüyük. Gold utensils and bronze disc. *About* 2400 BC. Archeological Museum, Ankara

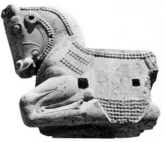

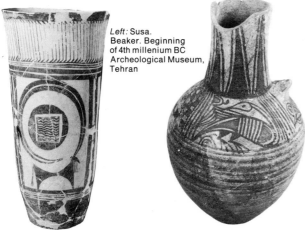

*Left:* Susa. Beaker. Beginning of 4th millenium BC Archeological Museum, Tehran

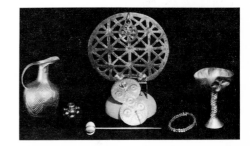

*Below:* Persepolis Grand Stairway. Gate of All Nations. 518–6 BC

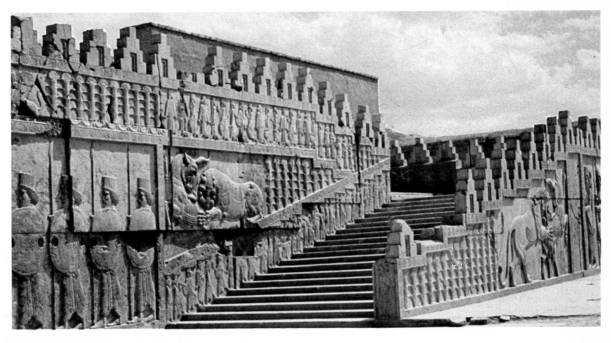

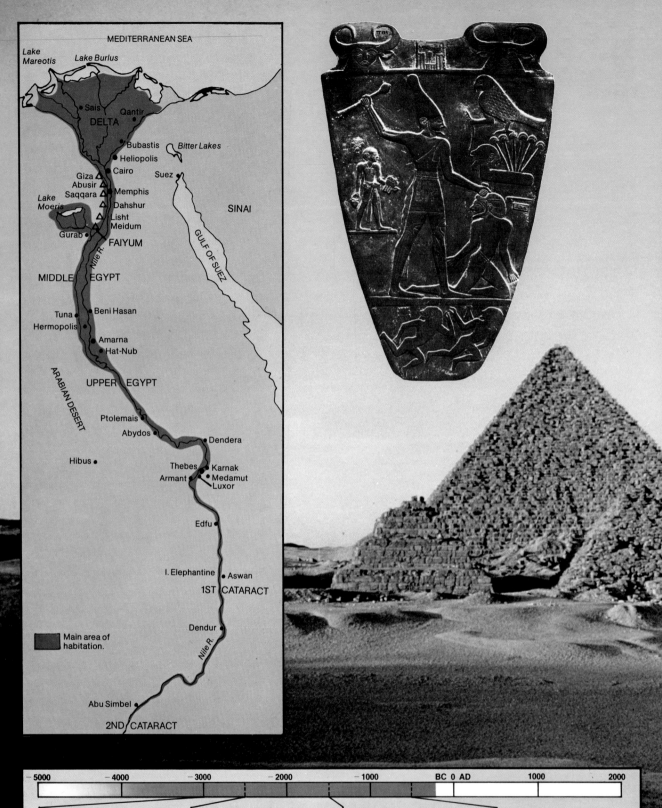

## Map labels

MEDITERRANEAN SEA

Lake Mareotis
Lake Burlus
Sais
Qantir
DELTA
Bubastis
Heliopolis
Giza
Cairo
Abusir
Memphis
Saqqara
Lake Moeris
Dahshur
Lisht
Meidum
Gurab
FAIYUM
MIDDLE EGYPT
Bitter Lakes
Suez
SINAI
GULF OF SUEZ
Nile R.
ARABIAN DESERT
Tuna
Beni Hasan
Hermopolis
Amarna
Hat-Nub
UPPER EGYPT
Ptolemais
Abydos
Dendera
Hibus
Thebes
Karnak
Armant
Medamut
Luxor
Edfu
I. Elephantine
Aswan
1ST CATARACT
Dendur
Nile R.
Abu Simbel
2ND CATARACT

Main area of habitation.

## Timeline

| −5000 | −4000 | −3000 | −2000 | −1000 | BC 0 AD | 1000 | 2000 |
|---|---|---|---|---|---|---|---|

**3000 BC** Two kingdoms of Upper and Lower Egypt united.
Bronze and copper tools in use.
Hieroglyphics developed.
Numerals used.
**2750 BC** Egyptians use 365-day calendar.
King Zoser: stepped pyramid built at Saqqara.
First Egyptian mummies.

**2500 BC** King Cheops: Great Pyramid built at Giza.
Great Sphinx at Giza.
Papyrus books.
First Egyptian libraries.
**2250 BC** Middle Kingdom.
Irrigation dams and canals built.
Horse-drawn chariots used in warfare, hunting.
Sea-going ships built.
Egyptians dominate Eastern Mediterranean.

**1500 BC** Great Hall built at Karnak.
Giant monolithic obelisks erected.
Akhnaten attempts reforms of state and religion.
Tutankhamun restores old religion; given exceptional burial, tomb found almost intact.
**1000 BC** Age of Rameses: temple built at Abu Simbel.
Giant statues: colossi.
**750 BC** Assyrians conquer Egypt.

**500 BC** Persians conquer Assyrians and rule Egypt.
**300 BC** Alexander the Great conquers Persians and rules Egypt.
Alexander's general Ptolemy initiates Ptolemaic dynasty of rulers.
Great age of Alexandria.
**30 BC** Egypt becomes a Roman province.

# EGYPT

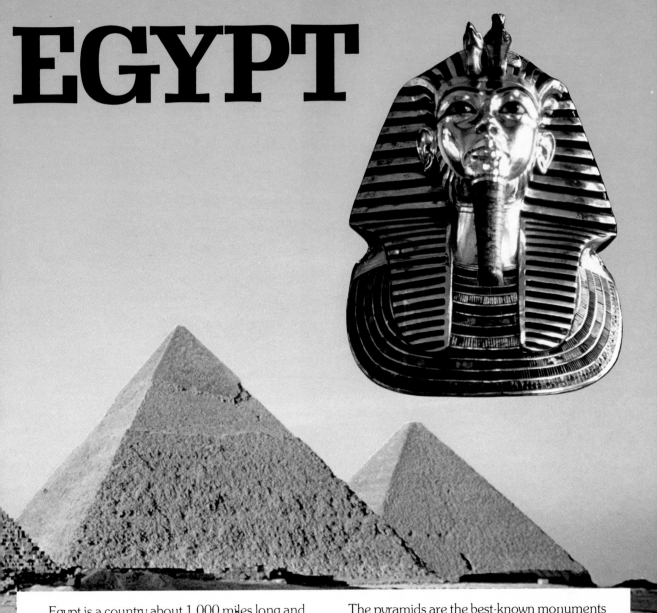

Egypt is a country about 1,000 miles long and only a few miles wide. It is the country of the River Nile, a thin ribbon of rich green agricultural land surrounded by desert. The river was both the source of life and the main route of communication. The annual flooding of the Nile from melting snow in the uplands of Abyssinia replaced all the rich top soil. Two crops a year could be harvested, giving an agricultural surplus in return for minimal labour. Together with natural easily defended frontiers this gave ancient Egypt a security and stability that lasted for three thousand years. Moreover, the large part of the working population was available for public works schemes for a large part of the year. It is usual to think of the great temples and pyramids as having been built by slave labour, but experience shows that such labour does not produce highly skilled work to the standards that were achieved. It may be better to think of the work force as an equivalent to modern conscription or a form of national service, an idea revived in the 20th century.

The pyramids are the best-known monuments of ancient Egypt, and their shape reflects the structure of ancient Egyptian society. At the apex was the god-king, the pharaoh. Below him was a powerful priesthood that controlled the civil service and a large bureaucracy. The army officers also occupied a high stratum in the pyramid, followed by freeholders, merchants and craftsmen, with at the very bottom an enormous foundation of labourers of all kinds.

The Egyptians wore clothes woven from vegetable fibres, thin, light, gauzey and easily pleated. They made paper from papyrus reeds. They built in stone, quarried in the south and floated on barges down the Nile.

The relationship between the pharaoh and the priest system provided a balance of power which remained practically unchallenged for over 3,000 years.

This unchanging nature of Egyptian society is reflected in their stable massive ordered architecture and formal art.

# EGYPT

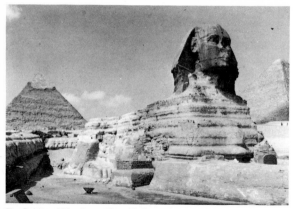

The Sphinx of Chephren, Giza. 4th dynasty

**Egyptian architecture** has two main characteristics: massiveness and a conservatism that existed for over 3,000 years. Massiveness is best seen in the pyramids and temples, conservatism in motifs such as the pharaoh smiting his enemies that first appears about 3000 BC, and is still a standard representation for Roman emperors in the guise of pharaohs in the 2nd century AD. The main factors governing Egyptian art and architecture were a state religion and the geographical confines of the Nile Valley. The continuity of religious practice, maintained by a powerful priesthood, gave rise to a conservatism that verges on the mechanical.

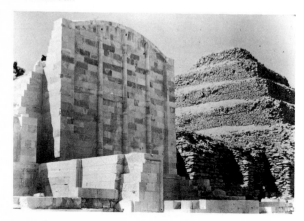

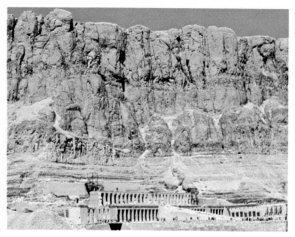

**Pyramids and Tombs.** The first known stone building in the world was the Step Pyramid at Saqqara, rising to a height of 204 feet in six steps. It was built for the pharaoh Zoser in the 3rd dynasty, about 2680 BC, by his chief architect, Imhotep. Previously, buildings were of mud-brick and wood (with the rare use of stone blocks as a door threshold). At Saqqara Imhotep translated the traditional building styles and materials into a new medium, stone, using small blocks but retaining all the earlier building characteristics. The Step Pyramid stood within a sacred enclosure with various ritual buildings nearby. These were all dummy buildings, merely façades backed by rubble with shallow doorways entering only a foot or two. None of their columns was free-standing; they were keyed into adjacent walls; the builders were unsure of the new building material's stability. Fluted columns used there precede their Greek counterparts by about 2,000 years (*See* pages 32–4). From this first beginning of a stepped pyramid it was a natural development to fill in the steps and obtain a proper pyramid shape. The pyramid, the burial place of the pharaoh, also represents the sun's rays as they strike the earth, an important symbol of the sun-cult of Heliopolis. The great age of pyramid building was in the ▽Old Kingdom (3rd–6th dynasties, about 2613–2181 BC), and especially between 2600 and 2500 BC during the 4th dynasty. The three famous pyramids at Giza were built then: the Great Pyramid of Cheops (one of the traditional Seven Wonders of the World), *about* 2560 BC; the pyramid of Chephren, *about* 2530 BC, and the smaller pyramid of Mykerinus, *about* 2530 BC.

Their bulk could only have been raised in so short a time by workers with strong religious convictions that their involvement contributed to the immortality of the pharaoh and therefore the benefit of the State. The pyramids were probably constructed by using a series of ramps encircling and rising with the pyramid, up which the building stone could be dragged on rollers. The stones were fitted to the highest standard of accuracy. Later pyramids of the 5th and 6th dynasties (some with their burial chambers inscribed with the Pyramid Texts) built at Saqqara and Abusir are now meagre heaps of rubble, often less than 100 feet high compared to the 481 feet of Cheops' mighty structure. In the ▽Middle Kingdom (11th and 12th dynasties, *about* 2133–1786 BC) more emphasis was laid on great public works such as drainage schemes and the pyramids were not so massive as in the Old Kingdom. They were built of mud-brick and rubble, often with only internal support walls and their outer casing being of stone. These pyramids are to the south of the Old Kingdom ones, at Dahshur, Hawara and Lahun.

When the seat of religious power moved to Thebes with the ascendency of the god Amun at the beginning of the ▽New Kingdom (18th dynasty, *about* 1567 BC) the pharaohs, starting with Tuthmosis 1 (*about* 1525–*about* 1515 BC), were buried in rock-cut tombs in a remote valley on the west bank of the Nile, the Valley of the Kings.

*Above left:* Step Pyramid and detail of Zoser Complex. *About* 2680 BC (3rd dynasty)
*Left:* Temple of Queen Hatshepsut, Deir-el-Bahari nr. Thebes. 1504–1483 BC (18th dynasty)

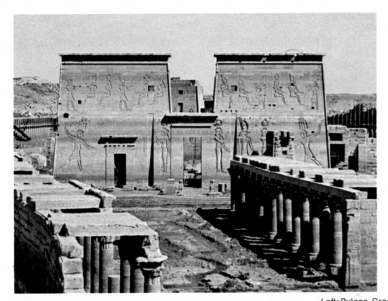

*Right:* Capital types
*Top:* Temple of Gourna
*Centre:* Temple of Edfu
*Bottom:* Temple of Dendera

*Left:* Pylons, Great temple Complex, Philae (Ptolemaic period).
*About* 300 BC

*Above:* Plan, Temple of Horus, Edfu. 140–124 BC (Ptolemaic period)

*Below:* Early Egyptian House

**Temples and Monuments.** The earliest temples were simple structures of mud, reeds and palm leaves, no traces of which remain. Stone temples first appear in the 4th dynasty associated with the pharaoh's pyramid, one against its east face at the head of a long causeway leading down to the cultivated land, where another temple was placed. These were mortuary temples connected with the funerary cult of the dead pharaoh. In the ▽New Kingdom the large Egyptian temples began to be built. There are two types, a mortuary temple on the west bank and a temple to the living god on the east bank of the Nile. The largest group of temples is at modern Luxor (ancient Thebes). The basic temple plan was an approach avenue, often lined by sphinxes, leading to two great entrance pylons (usually with two obelisks, emblems of the sun, before them); next an open court, a hypostyle (columned) hall and last, the sanctuaries. This plan could be elaborated by the addition of further courts, halls or colonnades. Only high officials were allowed beyond the great outer court. Two of the best preserved Egyptian temples, both of the ▽Ptolemaic period (304–30 BC), at Dendera and Edfu, are dedicated to the goddess Hat-hor and the god Horus respectively.

**Towns and Houses.** There is little evidence for town planning, except for workmen's towns at Kahun and Deir el-Medineh – both instances of living quarters for people employed on the pharaoh's tomb. At ▽Akhenaten's short-lived capital of ▽Amarna (*about* 1374–1362 BC) the town houses were like suburban villas. The essence of an Egyptian house was its setting within a garden. This is borne out by tomb wall-paintings and drawings on some □papyri. Models of houses exist; two superb wooden examples were found in the tomb of the noble Meket-re, *about* 2050 BC, at Thebes. Egyptian houses were built of mud-brick and timber with occasional stone rests for column bases or thresholds. An Egyptian house was built for a lifetime, a tomb for eternity.

Even then they did not completely abandon the pyramid and its significance, for a natural pyramid, the 'Lady of the Peak', rises directly above the Valley and the tombs are in its shadow. High officials still had a small pyramid above the entrance to their tombs, represented in □papyrus copies of the Book of the Dead.

# EGYPT

**Egyptian art,** like the architecture, was basically motivated by a deep religious belief. Everything that happened was by the will of the gods and within an essential framework of stability and continuity called *ma'at*. Egyptian painting and sculpture tends, regardless of its scale, to have a look of sameness to the uninitiated. This is because the representation of men, women and gods was governed by a rigid 'canon of proportion', a code of rules of proportion for depicting the human form which hardly changed in three thousand years.

**Painting.** Although governed by the rules of representation for official purposes, painting at times gives brief glimpses of the unofficial side of life, as in the sketches and caricatures drawn on limestone flakes (*ostraka*) when workmen merely doodled for their own amusement. Here, and in some of the humorous □papyri, animals and humans change places, mice attack fortresses held by cats and lions play draughts. Often, especially in the tomb-painting, the colours used are as bright today as when they were painted. This is because the Egyptians used naturally occurring materials for their primary colours: red ochre for red, powdered malachite for green, and other earth and mineral pigments. Convention dictated that a man's flesh was always shown reddish-brown, burnt by the sun, but a woman's skin, never exposed to the sun, was always yellow; the face of a deity such as Osiris, god of the dead and the underworld, was invariably painted black or green. A draughtsman would first mark out a wall to be decorated in a grid pattern within which the major parts of the scene and the people would be drawn. If the wall was to be carved the sculptor would proceed, followed by the painter decorating the □reliefs. □Hieroglyphic inscriptions were often deliberately composed to form a decorative element in themselves. The owner of the tomb would be solidly depicted on a much larger scale than anyone else featured, but remarkable little vignettes occur: two girls fighting in a cornfield, in the tomb of Menna, or a cat enjoying a fish under its master's chair, a popular motif in several tombs. It is from the painted reliefs in ▽Old Kingdom tombs of officials and especially wall-paintings in the tombs of ▽New Kingdom nobles that we learn most about Egyptian daily life. There is a good-natured humour in much of this painting and a freedom and accuracy of line, especially when drawing animals, that is lacking in official art.

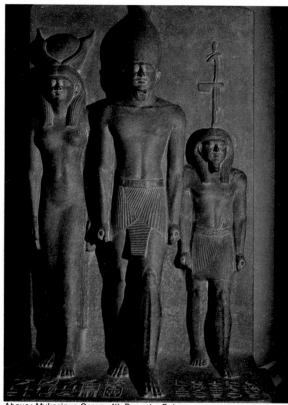

*Above:* Mykerinus Group, 4th Dynasty. Cairo.
*Left:* Akhenaten, Nefertiti, and three daughters, Amarna period. *About* 1360 BC. h. 17 in (43·5 cm). Staatliche Museen, Berlin

**Sculpture.** From a very early period the Egyptians were skilled in working stone, wood, ivory and, a little later, metal. Fragments of ivory sculpture from royal tombs of about 3000 BC are exquisite, and the polished hard-stone bowls and dishes are superb. Most sculpture was produced for a religious, usually funerary, purpose: three-dimensional statues to go in the tomb chapel where offerings could be laid before them, or sculptured scenes of everyday life for the walls of the chapels. These were intended to be brightly coloured. In many tombs □reliefs left unfinished because of the death of the owner make it possible to follow the techniques of the sculptors. A curious aspect of relief sculpture, also to be seen in wall-paintings, is the 'twisted' projection – the chest of the person depicted is seen frontally but the head, legs and arms are in profile. Full frontal representation of a person in a relief or painting is very rare in Egypt, and a knowledge of proper perspective does not appear until very late. Official sculpture, governed by strict rules of representation and heavily influenced by religious requirements, had to show the pharaoh and also the noble in an idealised form. This is particularly evident in the ▽Old Kingdom but the ▽Middle Kingdom produced some outstanding portraits of world-weary god-kings on earth. During the so-called ▽Amarna Age (*about* 1379–1362 BC) more naturalism appears in official art, although it had always been present earlier in scenes of animals and daily life. Particularly noticeable are the strange, brooding and deformed representations of the pharaoh ▽Akhenaten, and the head of his beautiful queen Nefertiti. Although later pharaohs proscribed the 'heretic'

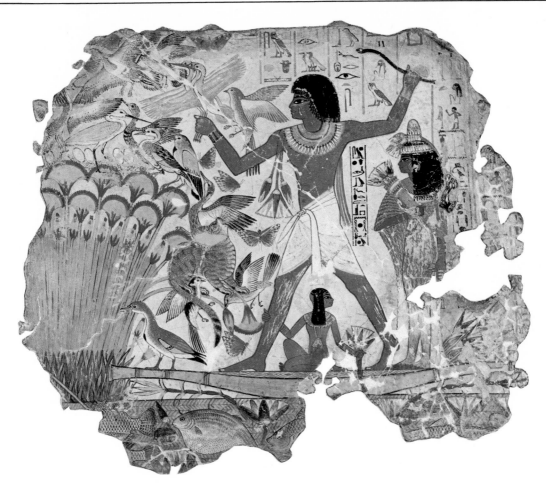

Marsh scene from the tomb of Nebamun at Thebes. BM, London

pharaoh, elements of Amarna art can be traced thereafter throughout the remainder of the ▽New Kingdom. When foreign invaders struck Egypt changes came about in sculpture and painting, especially during the □Ptolemaic period when Greek influence softens and fills out much of the line of sculpture and reliefs.

**Arts and Crafts.** Egyptian craftsmen excelled in the minor arts, especially in woodworking and jewellery. The natural shortage of wood in Egypt meant that high quality joinery became an art form in itself. A passion for colourful decoration (not uncommon in bright sunlit countries) and for ornament inspired much Egyptian jewellery. Most of it is securely based on a bead structure, great wide collars, necklaces and bracelets, as well as a ready use of gold, which was plentiful. Brightly coloured stones, mainly of the semi-precious varieties such as blue lapis lazuli or red carnelian, were used as inlays on gold with great effect. Silver was rarer than gold in ancient Egypt, and consequently very precious. Many small objects were made of □faience, a sand-based glazed □frit, generally blue but sometimes green; especially numerous are many varieties of amulets and funerary figures called *ushabtis.*

The dry climate of Egypt, coupled with the religious belief that it was necessary to bury objects with the dead for their use in the next world, has preserved large numbers of objects, especially those of organic materials such as wood, cloth and □papyrus. It is thus possible to admire the bright colours and □calligraphy of a funerary papyrus, wall-painting, jewellery and even children's toys such as a wooden dog with a movable jaw – all had their place and use in Egyptian art and society.

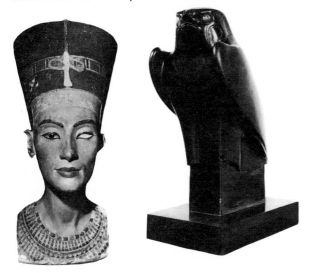

*Left:* Head of Nefertiti. 18th Dynasty. Berlin.
*Right:* Hawk. 30th dynasty. Black basalt. h. 18¾ in (47·5 cm). Louvre, Paris

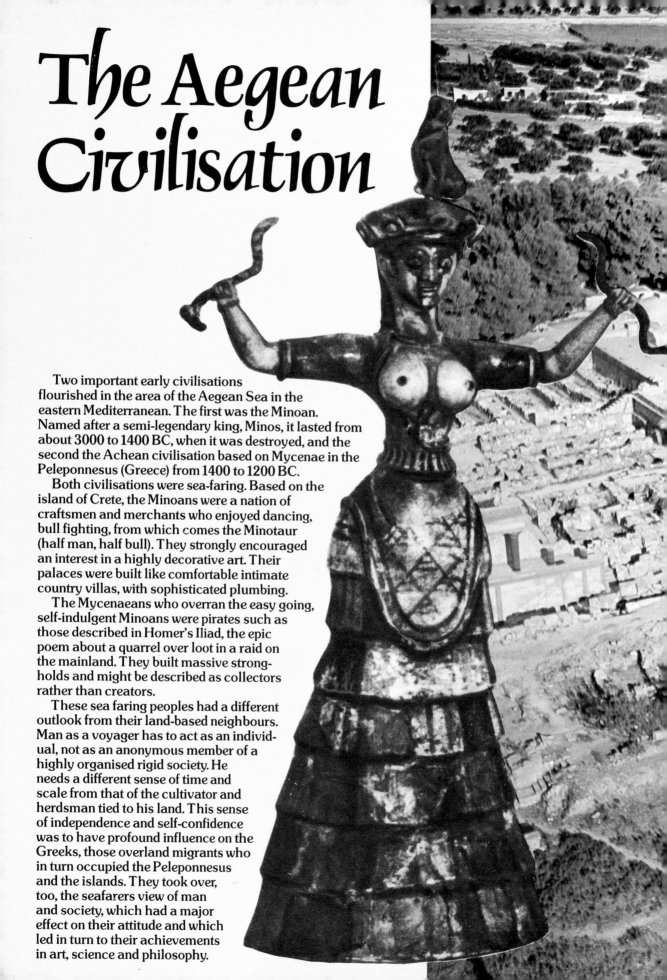

# The Aegean Civilisation

Two important early civilisations
flourished in the area of the Aegean Sea in the
eastern Mediterranean. The first was the Minoan.
Named after a semi-legendary king, Minos, it lasted from
about 3000 to 1400 BC, when it was destroyed, and the
second the Achean civilisation based on Mycenae in the
Peleponnesus (Greece) from 1400 to 1200 BC.

Both civilisations were sea-faring. Based on the
island of Crete, the Minoans were a nation of
craftsmen and merchants who enjoyed dancing,
bull fighting, from which comes the Minotaur
(half man, half bull). They strongly encouraged
an interest in a highly decorative art. Their
palaces were built like comfortable intimate
country villas, with sophisticated plumbing.

The Mycenaeans who overran the easy going,
self-indulgent Minoans were pirates such as
those described in Homer's Iliad, the epic
poem about a quarrel over loot in a raid on
the mainland. They built massive strong-
holds and might be described as collectors
rather than creators.

These sea faring peoples had a different
outlook from their land-based neighbours.
Man as a voyager has to act as an individ-
ual, not as an anonymous member of a
highly organised rigid society. He
needs a different sense of time and
scale from that of the cultivator and
herdsman tied to his land. This sense
of independence and self-confidence
was to have profound influence on the
Greeks, those overland migrants who
in turn occupied the Peleponnesus
and the islands. They took over,
too, the seafarers view of man
and society, which had a major
effect on their attitude and which
led in turn to their achievements
in art, science and philosophy.

| −5000 | −4000 | −3000 | −2000 | −1000 | BC 0 AD | 1000 | 2000 |

**6000 BC** Neolithic settlements in Crete.
**2800 BC** Early Minoan period.

**2000-1500 BC** Oldest palace at Mycenae.
Palace of Minos at Knossos.
Palace at Phaestos.
Minoan palaces built with ventilation and plumbing systems.
**1750 BC** Knossos at its peak.
Bull fighting and dancing cult.
Linear scripts developed.

**1450 BC** Knossos destroyed.
**1400 BC** Mycenaean culture supersedes Minoan.
Beehive tomb at Mycenae.
Acheans invade Greece.

**1000 BC** Iron Age in Asia Minor.
Greek colonial expansion in Eastern Mediterranean.

PELEPONNESUS

Tiryns

Mycenae

AEGEAN SEA

IONIAN SEA

SEA OF CRETE

Knossos
Mallia
Gournia

Phaestos

MEDITERRANEAN SEA

# THE AEGEAN CIVILISATION

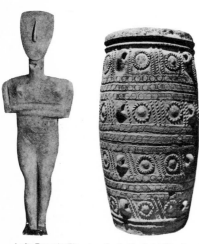

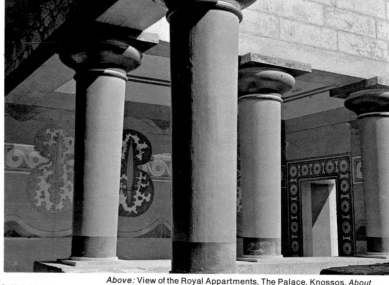

*Left:* Female Figurine Cycladic, 3rd Millenium BC.
*Centre:* Storage jar, Knossos, Crete. *About* 1500 BC. Height approx. 4 ft (120 cm)

*Above:* View of the Royal Appartments, The Palace, Knossos. *About* 1700 BC.

**Knossos and Minos.** In 1899 Sir Arthur Evans began uncovering at Knossos a civilisation which until then was completely unknown. This he called the Minoan, after Minos, the legendary king of Crete. The first palace was destroyed by earthquake in about 1700 BC, together with other smaller palaces. The great building which replaced it was constructed round a large central courtyard, reached by the winding passages recalled in the story of the maze through which the Greek hero Theseus had to thread his way. West of the courtyard were the State rooms, including the audience hall and the main shrines. Behind them lay store rooms with huge clay jars for oil and corn and recesses in the floor for chests of cloth and treasure. A form of writing now known as Linear A was evolved, probably for the palace records, but is still undeciphered. On the opposite side of the courtyard were the private apartments, the upper floor reached by a grand staircase. The plastered ceilings were supported on wooden columns, tapering downwards and brightly painted. The rooms were arranged round small courtyards for light and air, giving the impression of gradual growth rather than regular planning. There was a piped water supply, drains and a form of water closet.

**Mycenae.** In contrast with the peace-loving Cretan civilisation, that of the Myceneans was based on the power of a warlike aristocracy. Their cities were protected by thick walls of massive irregular blocks of stone, which still survive impressively at Tiryns, and at Mycenae itself, where they were entered through the Lion Gate. The earliest remains at Mycenae are the Shaft Graves, surrounded by rings of upright stone slabs. They date from about 1550 BC, when Mycenean civilisation was still emerging. Among the wealth of weapons and treasure they contained were many objects showing Cretan artistic influence. Soon the sea-faring

Myceneans were to dominate the Cretan palaces and beyond. A later royal tomb, the so-called Treasury of Atreus, consisted of a circular stone-walled chamber with a □corbel-vaulted roof nearly fifty feet high. It was reached by a passage ending in a doorway with finely carved green marble pillars and a stone lintel weighing over a hundred tons. The Mycenean cities also had their palaces, whose main feature was a *megaron*, a rectangular hall with an entrance porch supported on columns, entered from a courtyard. The four columns carrying the hall roof stood round a large central hearth, the focus of the feasts of the heroic society celebrated in Homer's poems. Mycenean script (Linear B) has been identified as an early form of Greek.

The Lion Gate, Mycenae. *About* 1330 BC

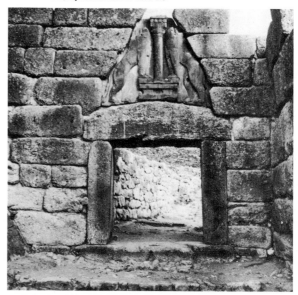

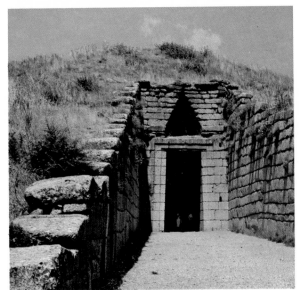

The Treasury of Atreus, Mycenae. *About* 1330 BC

**Painting and Sculpture.** The walls of the Cretan palaces were colourfully adorned with □frescoes. Many of them show the Minoan love of nature which also inspired their pottery decoration, with delicate plants, birds and leaping fish and dolphins. This naturalistic style is the first truly historical European art, and it also included scenes from palace life, with processions, bull-leaping acrobats and other human figures. Something of that freshness is missing from paintings which decorated the palaces of the Mycenean rulers, whose different interests were illustrated in rather rigid and formal hunting expeditions and chariot processions. The representation of human figures goes back a long way in the Aegean, where from about 2800 BC the Cyclades islands produced small idols shaped in marble by grinding with emery. The features of the body are greatly simplified, with an elegance which has a particularly modern appeal. Minoan sculpture was much more naturalistic, and included figurines of snake-goddesses and female attendants in the flounced skirts and bodices seen also

The Dolphin Fresco, The Palace, Knossos. *About* 1450 BC

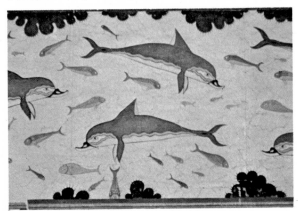

on wall-paintings. These are found in ivory, gaily coloured □faience and cast bronze, in which male worshippers and vigorous figures from the bull sports were also made. (*See* Index for further references to Crete and Mycenae.)

**Jewellery and Decoration.** The Minoans excelled in the intricate work of the jeweller. Rings and pendants of gold were decorated with embossed designs, filigree and granulation (the attachment of minute grains of gold), as on the pendant of two hornets, from Aegina. This miniaturist skill is seen at its finest on the engraved seals made from semi-precious stones, where lions, deer, fish or scenes from the famous bull-leaping sports were carefully adapted to the round or oval shape of the seal. Much of the Cretan artist's ability later served Mycenean patrons: the Vaphio cups, embossed with scenes showing the capture of wild bulls, were found in one of the Shaft Graves at Mycenae. Such objects as the gold so-called 'Mask of Agamemnon', also from a Shaft Grave, show the stiffer and more reserved Mycenean taste. Other cups and bronze daggers were inlaid with gold, silver and □niello, and the Myceneans appear to have discovered the art of enamelling metal with coloured glass. There was a long tradition, learned originally from Egypt (*see* pages 34–5), of carving cups and bowls from marble and other coloured stones. The interior was hollowed out with a tubular drill fed with sand and water, and the finishing was by laborious grinding with sand or emery.

Shaft Grave, Dagger (reconstruction), Mycenae. *About* 1500 BC

**Pottery.** Much of the elegance of Cretan civilisation can be seen in the painted decoration and shapes of its pottery. At the time of the first palaces this was decorated in red, yellow and white on a black background, using mainly abstract designs with gracefully curved patterns. Selected fine clays produced a smooth, shiny surface. Jars, cups with handles and jugs with spouts rather like teapots were made on the potter's wheel, introduced from Asia Minor. At the time of the later palaces much more elaborate decoration in dark colours on a light background was preferred. This included spiral and other pattered designs, but the greatest inspiration came from sea creatures – octopuses, squids and shellfish – and delicately painted flowers and grasses. Some of these also decorated Mycenean pottery, though often without the Minoan liveliness and elegance. The Myceneans also favoured pictorial scenes of riders in chariots and hunting, and later on, birds and animals drawn in outline, the bodies filled in with fine patterns possibly inspired by embroidery or weaving. These appeared on bowls, jars, drinking goblets and flasks with a double handle on top in the form of a stirrup.

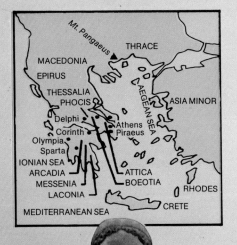

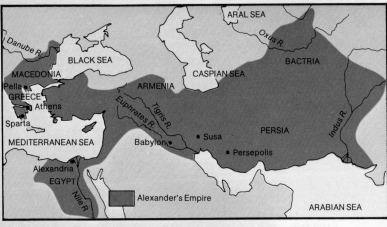

Alexander's Empire

# GREECE

The Greeks were newcomers to the Mediterranean. They came overland out of Central Asia and settled in the Peleponnese, that curious land formation stretching down like a hand reaching into the Mediterranean, in the islands of the Aegean, along the coast of the eastern Mediterranean and into Sicily and Italy.

They adopted the gods of the people that they displaced, and combined technology borrowed from the Egyptians with the adventurous free thinking of the island dwellers. They lived by trading and piracy, as much as by agriculture and they quickly dominated the 'Middle Earth' (Mediterranean) Sea.

The Egyptians had used the right-angled triangle with sides in the proportion of 3, 4 and 5 for three thousand years of building and surveying, but it was the Greeks who developed the general theory of geometry through Euclid and Pythagoras in three hundred years. The Chaldeans had a calendar and told the time by the stars, but it was the Greeks who

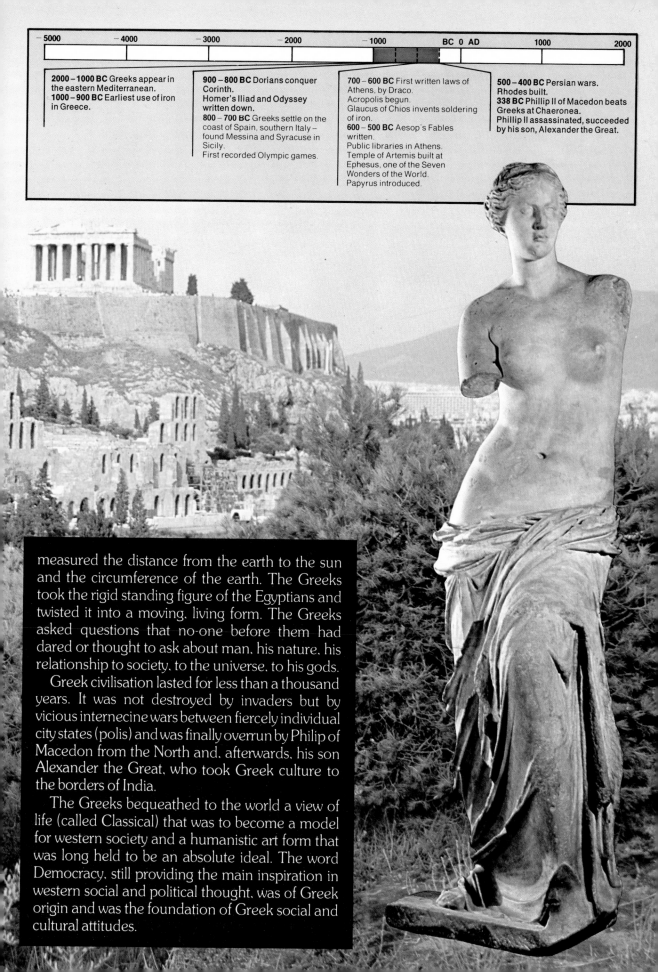

| −5000 | −4000 | −3000 | −2000 | −1000 | BC 0 AD | 1000 | 2000 |
|---|---|---|---|---|---|---|---|

**2000–1000 BC** Greeks appear in the eastern Mediterranean.
**1000–900 BC** Earliest use of iron in Greece.

**900–800 BC** Dorians conquer Corinth.
Homer's Iliad and Odyssey written down.
**800–700 BC** Greeks settle on the coast of Spain, southern Italy – found Messina and Syracuse in Sicily.
First recorded Olympic games.

**700–600 BC** First written laws of Athens, by Draco.
Acropolis begun.
Glaucus of Chios invents soldering of iron.
**600–500 BC** Aesop's Fables written.
Public libraries in Athens.
Temple of Artemis built at Ephesus, one of the Seven Wonders of the World.
Papyrus introduced.

**500–400 BC** Persian wars.
Rhodes built.
**338 BC** Phillip II of Macedon beats Greeks at Chaeronea.
Phillip II assassinated, succeeded by his son, Alexander the Great.

measured the distance from the earth to the sun and the circumference of the earth. The Greeks took the rigid standing figure of the Egyptians and twisted it into a moving, living form. The Greeks asked questions that no-one before them had dared or thought to ask about man, his nature, his relationship to society, to the universe, to his gods.

Greek civilisation lasted for less than a thousand years. It was not destroyed by invaders but by vicious internecine wars between fiercely individual city states (polis) and was finally overrun by Philip of Macedon from the North and, afterwards, his son Alexander the Great, who took Greek culture to the borders of India.

The Greeks bequeathed to the world a view of life (called Classical) that was to become a model for western society and a humanistic art form that was long held to be an absolute ideal. The word Democracy, still providing the main inspiration in western social and political thought, was of Greek origin and was the foundation of Greek social and cultural attitudes.

# GREECE

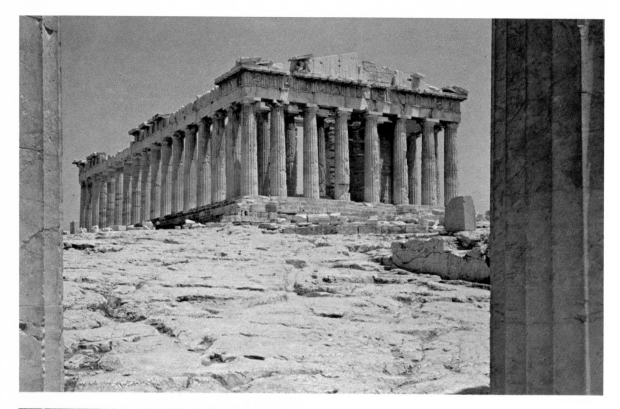

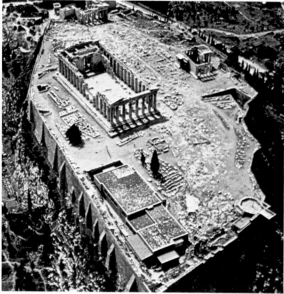

*Above:* The Parthenon on the Acropolis, Athens. 447–432 BC. View from Propylaea
*Left:* The Acropolis, Athens from the air
*Below:* Plate illustrating the Three Orders: centre, Doric, left, Ionic, right, Corinthian

**Building: The Greek Orders** (*See* glossary). Much of Greek life – the activities of the market-place, politics, athletics and drama – was passed in the open air, and Greek architecture concentrated on the external appearance of buildings. It was based on the column and lintel, a form of construction developed from building in wood (*see* pages 24–5). Using decorative features first seen in ▽Egypt and ▽Assyria, Greek architects produced something essentially their own, the formal and regular schemes for columns and superstructure now known as the Orders. The main two were the ▽Doric, of the main-

land, and ▽Ionic, evolved in Ionia, now the west coast of Turkey. Both had fluted columns, the Ionic being more slender with a decorated base. The columns were topped by capitals, with a square block above a round profile in Doric, and projecting spirals in Ionic. A third type, the ▽Corinthian, was decorated with rows of leaves. Above these, the superstructure was divided into three horizontal sections: architrave, frieze and cornice. These imitated in stone features of the original timber construction. Grooved panels (*triglyphs*) on the Doric frieze represented boards covering the beam-ends, with series of small fastening-pegs carved above and below them. The Ionic cornice had a row of square blocks imitating the ends of the rafters. Limestone, usually □stuccoed and painted, and marble were the main

materials used in monumental building, with ☐terracotta, and later marble, roof tiles. Tile ☐reliefs were made to protect wooden superstructures and as ornaments for the eaves and roof-ridges.

## Public Buildings.

Reflecting religion's importance in early Greek life, it was in the temple that Greek architectural ideas first developed. It consisted of a rectangular central room to house the god's image, with a columned porch in front (the ▽Mycenean ▽*megaron* plan), and often also at the back. It stood on a foundation of steps and was normally surrounded by columns. The ▽Parthenon on the Acropolis (High City) at Athens, built by Kallikrates and Iktinos between 447 and 438 BC at the time of the city's greatest glory, is perhaps the finest ▽Doric temple. The nearby Erechtheum has six columns in the form of maidens (☐*caryatids*)' Religious festivals provided the focus for the common culture of which the disunited Greeks were supremely conscious. The sanctuary of Apollo at ▽Delphi included treasuries built by individual communities to house their offerings and to emphasise their prestige. The theatre there is a reminder that Greek drama originated at religious festivals. A circular area, the orchestra, for the chorus, was surrounded by semicircular tiers of seating cut back into the hillside. Behind the orchestra the stage (*skene*) became increasingly important as the roles of individual actors developed, with a columned building to provide a permanent stage set. Many of these theatres, such as that at Epidaurus, have magnificent acoustics. Men from all over the Greek world competed at the athletic games at sanctuaries such as ▽ Olympia, where the oldest surviving stadium was built.

## Towns and Town Planning.

The Greeks credited Hippodamus of Miletus (5th century BC) with the invention of the city plan based on a grid of streets intersecting at right angles. We know now that the idea was taking shape two centuries earlier, when Smyrna was rebuilt after a great fire, and new colonies such as Megara Hyblaea were laid out in Sicily. To Near-Eastern ideas of orderly layout, the Greeks added their feeling for symmetry and harmony, and their concept of the city and civic life as fundamental for man's self-expression. Blocks of housing, areas reserved for temples, theatres and commerce, water supply and drainage, thus provided for man's social needs. The *agora* (market-place), the centre of town life, was adorned with *stoai* (colonnades), giving shelter from sun and rain, and meeting halls. Monumental architecture ceased to be focused wholly on religious life. The concern for symmetry and regularity was such that street grids were laid out over hilly sites like ▽ Miletus and ▽ Priene despite their steep slopes.

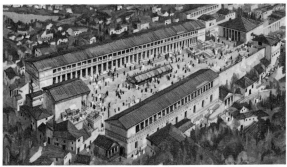

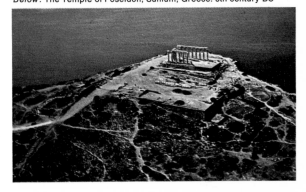

*Above:* The Agora. Assos, Greece (reconstruction drawing). *About* 5th century BC
*Below:* The Temple of Poseidon, Sunium, Greece. 5th century BC

## The Colonies.

The Greeks' strong sense of their shared language and culture was combined with an equally strong individualism, reflected in the rivalries of their small independent city-states. Expanding populations and shortage of land, political exile or the quest for trade, led to the foundation of new cities in Ionia, and later, colonies in Sicily and southern Italy, and the Black Sea. These colonies were independent settlements; some, like ▽ Syracuse, became great cities themselves. The theatre at Syracuse and the fine temples of Paestum and Agrigentum place these cities firmly within the mainstream of Greek art and culture. The impressive squared stone and mud-brick walls of Gela illustrate their need, nevertheless, to defend themselves against their rivals, both Greek and non-Greek. ▽Alexander the Great's (died 323 BC) empire extended Greek culture as far as India. Among many new cities founded was ▽Alexandria in Egypt, where the lighthouse ranked as one of the ▽Seven Wonders of the World – a dignity shared by earlier buildings in the great Ionian cities, like the Temple of Artemis at Ephesus and the tomb of Mausollos (the ☐Mausoleum) at Halicarnassus.

*Below:* The Theatre. Ephesus, Turkey. 4th century BC

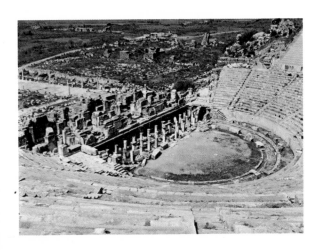

# GREECE

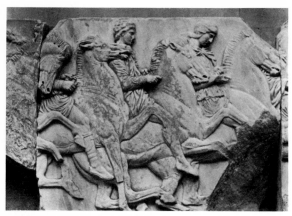

*Horsemen*. From a frieze on the Parthenon, Athens. 5th century BC. BM, London

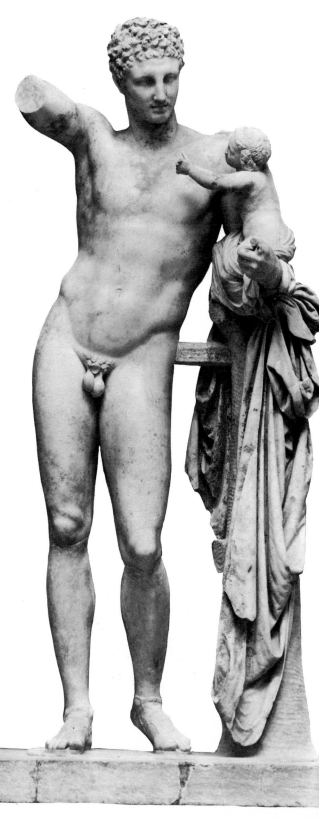

PRAXITELES. *Hermes*. Marble. h. 84 in (215 cm). Olympia Museum, Greece

**Archaic to Free Movement.** From the 7th century BC the Greeks learned from ▽ Egypt and ▽ Mesopotamia the techniques of carving monumental human figures in wood and stone. Their sculptors soon began to adapt the formal conventions of the East. The earliest free-standing figures were of young men (*kouroi*) and standing or seated women (*korai*), made for temple dedications. The features, hair and the women's clothes were simplified and stylised. During the 6th century the sculptor developed his understanding of the human body. By 480 BC it is as if life had been breathed into the stone, though the same limited range of types and poses was maintained. The same development can be seen in the □ relief sculpture which decorated temples and private funerary monuments. In earlier examples, such as those from the Siphnian Treasury at ▽ Delphi, some parts of the body were shown from the front, others in profile, as if they were disconnected; the attitudes were rigid. The sculpture of the following Classical period achieved the naturalistic portrayal of the human body, but as an ideal: faces do not express emotion, bodies have a serene poise. Action and flexibility of the body came to be represented with increasing success, as in the ▽ *Diskobolos* by ▽ Myron, or on the pediment and friezes of the ▽ Parthenon. A wider variety of figures was being carved by the early 4th century, with artists showing off the brilliance of their technique in carving drapery that seemed virtually transparent. Idealised representations of individuals, like Pericles, Socrates or Demosthenes, were carved and modelled some years before observed portraiture from life was attempted. The later ▽ Hellenistic sculptors became interested in the realistic portrayal of violent action and emotion, as in the *Dying Gaul*, *Laocoön*, and the agitated wind-blown drapery of the *Winged Victory of Samothrace*.

# Sculpture

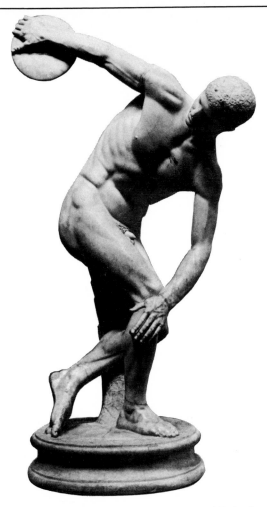

MYRON *Discobolos*. Roman copy of Greek bronze original. National Museum, Rome

**Sculptors** occasionally carved their names on their works. We also know much from ancient authors who discussed them, and from Roman copies. It is characteristic of Greek individualism that theirs should be the first civilisation in which the artist emerges from anonymous obscurity. ▽ Myron's ▽ *Diskobolos* and his *Marsyas* (460–50 BC) make him perhaps the best-known of the earliest Classical sculptors. Pheidias supervised the decoration of the ▽ Parthenon in Athens. His famous statue of Athena in ivory and gold which stood inside it survives only in marble copies. These show the majestic style for which his Zeus at ▽ Olympia was also famous. His contemporary, Polykleitos, produced in his *Doryphoros* (a young man carrying a spear) a work of outstanding harmony and poise which was regarded as providing the pattern for beautiful proportions. In the mid-4th century Praxiteles was most celebrated for his nude *Aphrodite of Knidos*. His original *Hermes and the infant Dionysus* has survived. Praxiteles' sculpture shows the greater warmth, feeling and delicacy of this period, and superb technical mastery. Lysippos, ▽ Alexander the Great's favourite sculptor, developed a new system of proportions, reducing the size of the head relative to the body, to increase the impression of height, and giving a restless twist to the stance suggesting imminent movement.

**Bronzes and Terracottas.** The same development towards naturalism and free movement can be seen in bronze and □ terracotta sculpture, though much less of this has survived. Many bronzes, however, are known from later Roman marble copies, as are many Greek marbles. Most large-scale bronze sculpture was hollow-cast by the lost wax method (□ *cire perdue*), and the wax model made for the casting was a most suitable medium for sensitive detail, as shown by the folds of the robe of the *Delphic Charioteer*. The idea of the *Poseidon* from Cape Artemision, with his outstretched, unsupported arms and legs, was far easier to accomplish in bronze than in marble. Eyes of bronze statues were often inlaid in glass. Large terracottas were either built up in coils, or, later, moulded. They have been discovered at ▽ Olympia and at ▽ Corinth, and the technique proved popular in Sicily and South Italy. The terracottas were used mainly as decorations on temple roofs.

**Small-scale Sculpture.** Statuettes and small reliefs reflect many of the artistic tendencies of larger sculptures but on an intimate scale. Solid-cast bronze statuettes of human figures dating from the 9th century BC onwards were made for dedication in sanctuaries, and human and animal figures were attached to tripods and cauldrons. A few wooden and ivory figures also survive. Classical bronze figurines are rarer, but large numbers of ▽ Hellenistic bronzes apply the artistic realism of the period to intimate portrayals of people in daily life – dancers, slaves, philosophers and actors – as well as deities and mythological subjects. In □ terracotta, early hand-modelled groups such as chariots and plough-teams were followed in the 6th century by a more restricted repertoire of moulded statuettes, particularly of women, many made for temple gifts. These were coated in a white clay □ slip, and brightly painted after baking. Hellenistic terracottas, like the bronzes, concentrated on individual people in everyday activities. Many have been found in tombs; Tanagra in Boeotia has produced them in quantity. Moulded □ reliefs were also made, probably for decorating private houses.

Figures from Tanagra, Boeotia. The mistress of Theocritus and her attendant

45

# GREECE

**Ceramic Technology.** The potter's art was the first to re-emerge from the 'dark age' which followed the destruction of the ▽Mycenean palaces. In 10th-century BC Attica, vases were decorated with bands and concentric circles drawn with the compasses and multiple brush. From this the Geometric style developed, with patterns filling the whole surface, and warriors, funeral scenes and animals in silhouette. About 700 BC ▽Corinthian potters invented the ▽Black-Figure technique. Friezes of animals, strongly influenced by Near-Eastern patterns, appeared in black, with detail incised so that the pale background clay showed through. When the kiln was opened to admit air in the last stage of firing, the more porous clay of the body of the vessel absorbed oxygen and turned back to red, while the denser refined clay used for the decoration remained black. White clay, lacking the iron oxides which produced these colour changes, was also used for added detail. About 530 BC Athenian potters began to produce ▽Red-Figure pottery by reversal of the painting technique. The figures were drawn in outline and the background was filled in to appear black. Detail was added in paint instead of being incised. This produced the flowing composition and vivid elegance of line which gave Athenian vase-painting a quality never equalled in □unglazed ceramics.

**Greek Pottery: Form and Use.** Greek pots were a product of a well organised industry of a high standard of technology with a large export market.

Greek potters produced a standard range of forms designed for particular uses. They combined elegant shapes with functional efficiency. Among drinking vessels was the *kylix*, a broad, shallow cup with two horizontal handles and a pedestal. The *skyphos* was deeper and narrower and had no stem. The *kantharos* was a deep, stemmed cup with looped vertical handles rising above the rim. The Greeks mixed their wine with water in a deep broad-mouthed urn, the *krater*. The *calyx-krater* had a flaring mouth, with horizontal carrying handles curving upwards. The *amphora,* the *pelike* and the *stamnos* were containers for wine and other liquids, and the *hydria*, with two horizontal handles and one vertical pouring handle, was for fetching water from the public fountains. The bulging trefoil-mouthed *oenochoe* and the slim narrow-necked *lekythos* were jugs for wine and oil respectively. The *aryballos* and the *alabastron* held ointments and perfumes and the *pyxis* was a box with a knobbed lid, for toilet articles.

**Vase-Paintings and Painters.** By the later 6th century Athenian potters far surpassed all others in the inspiration of their designs and their technical skill. Their wares were traded from Spain to the Black Sea. Potter and painter were equally honoured. Some vessels were signed with the names of those who had made or painted them; sometimes the same man did both. Other artists can be identified from their styles. Fine ornamental motifs – palmettes, lotuses, rays and meanders – framed figure compositions. The François Vase, a ▽*krater* found in an ▽Etruscan tomb, was made by Ergotimos and painted by Kleitias with the gods, mythological scenes and battles which were the favourite repertoire of the early ▽Black-Figure painter. The figures are in profile with the stylised drapery and stiff attitudes seen also in the sculpture of the period. Exekias, who was both potter and painter, illustrates the noble elegance that could be produced within these conventions. His work carried vase-painting from the realm of decoration into that of true art. The new ▽Red-Figure technique coincided with the increasing naturalism of contemporary sculpture. Painters like Euthymides and Euphronios, in about 510 to 500 BC, show more lively attitudes and successful attempts at foreshortening. A greater interest in subjects from daily life, with ceremonies, sports, women's activities and drinking scenes, reflected the self-confidence of society in the early years of Athenian democracy. The Brygos Painter depicted energetic battle and revelry scenes, full of vitality, with dramatically painted drapery. Vase-painters of the mature Classical period were inspired by the artist Polygnotus in spatial composition and portrayal of character. Black-Figure vases were still made, especially for prizes in the Panathenaic Games, with pictures of the contests for which they were awarded. White ▽*lekythoi* were delicately painted in □tempera colours by such artists as the Achilles Painter. In the late 5th century the end of the best period of vase-painting is marked by a quieter and mannered refinement.

**Other Greek Arts.** Greek artists also excelled in miniature work. Seals were made for aristocratic owners, with human and mythological figures engraved on coloured stones such as carnelian and chalcedony. The masterpieces signed by Dexamenos included herons and a portrait head. In the ▽Hellenistic period □cameos began to be carved from stones banded in contrasting colours, like sardonyx. Coins were essentially a Greek invention, appearing first in Lydia about 650 BC. Those of the Sicilian Greek cities of ▽Syracuse and Naxos are among the finest early examples, and those of later Hellenistic rulers carried their portraits. Taste in jewellery favoured the intricate and elaborate, with earrings decorated in filigree and granulation, necklaces of multiple pendants on chains, and spiral bracelets ending in animal heads. ▽*Kraters*, ▽*hydriae* and mirrors were cast in bronze and decorated with human and animal figures as handles. Many of these were traded: the Vix Krater was found in the tomb of a Gaulish princess. Ornamental motifs from Greek metalwork inspired the curvilinear patterns of ▽Celtic art. Cups and bowls of silver and gold with □repoussé and □chased decoration became increasingly ornate in the Hellenistic period. Nothing survives of the large-scale paintings for which Apelles, ▽Polygnotus and others were famous in their own day. Their work is palely reflected in vase- and tomb-painting, and in □mosaic, which was invented in Greece, at first using coloured pebbles set in mortar and later specially cut cubes of stone. Some mosaics made by Greek craftsmen for the Romans reproduced well-known paintings. That of ▽Alexander at the Battle of Issus, from ▽Pompeii, probably copies a painting by Philoxenos, and gives us some idea of these lost masterpieces.

# Pottery and Other Arts

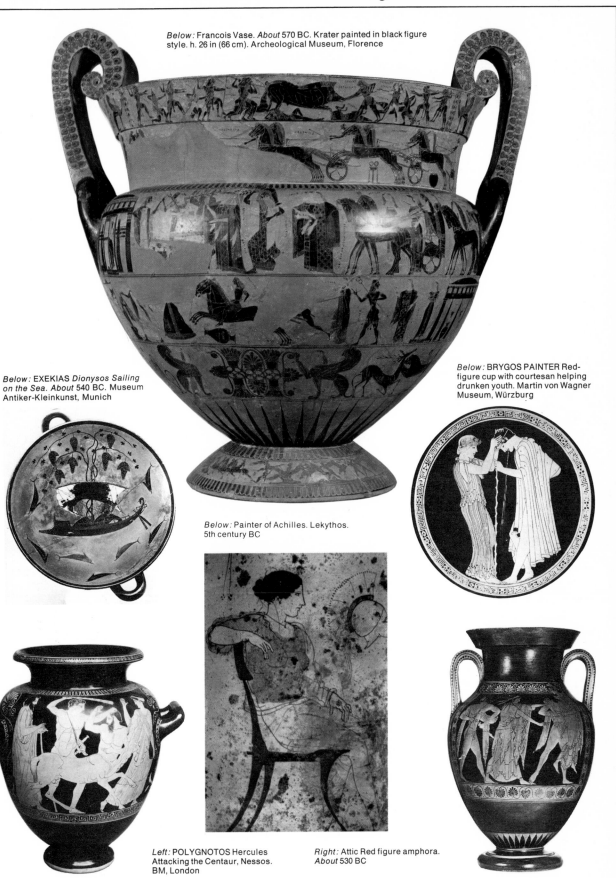

*Below:* Francois Vase. *About* 570 BC. Krater painted in black figure style. h. 26 in (66 cm). Archeological Museum, Florence

*Below:* EXEKIAS *Dionysos Sailing on the Sea. About* 540 BC. Museum Antiker-Kleinkunst, Munich

*Below:* BRYGOS PAINTER Red-figure cup with courtesan helping drunken youth. Martin von Wagner Museum, Würzburg

*Below:* Painter of Achilles. Lekythos. 5th century BC

*Left:* POLYGNOTOS Hercules Attacking the Centaur, Nessos. BM, London

*Right:* Attic Red figure amphora. *About* 530 BC

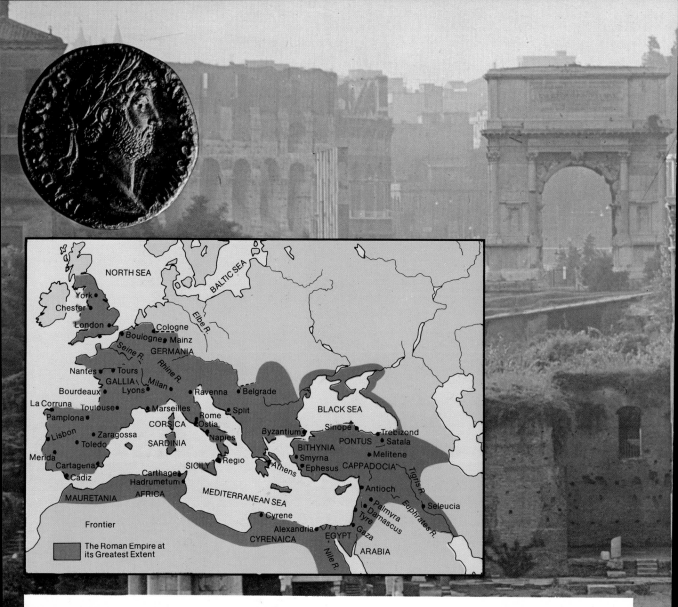

The Roman Empire at its Greatest Extent

The Romans inherited from the Greeks an Empire and an art form. The conquests of Alexander the Great died with the man himself, but his idea and ideal of a unified world-civilisation persisted and was put into practice by Rome.

Rome was a city as well as an Empire. Traditionally founded in 753 BC, by the third century BC Rome dominated the Italian peninsula.

The Republic annexed Sicily and conquered Greece, and by the time of Julius Caesar (101-44 BC) Rome dominated the Mediterranean and Western Europe. After a disastrous civil war Caesar declared himself dictator, and under his successor Augustus, who took the title of victor or imperator, the Empire was established. Augustus (27 BC-AD 14) claimed to have found Rome built of brick and timber and transformed it into a city of marble. Certainly it was under the succession of emperors that all the great monuments that recall Classical Rome today, were built.

The Romans introduced aesthetics into politics, using art and architecture to give the varied nations of an Empire stretching from Asia Minor to Scotland and from Africa to the Rhine a sense of uniformity and of belonging to a coherent, desirable and admirable social organisation.

'All roads lead to Rome' is a common phrase that was almost literally true. The Roman road network centred upon Rome, enabling the fast transport of troops to any part of the Empire, had great effect in unifying and controlling the Western World.

During the second century AD the Empire, decayed and broke up from within, split into two parts, and was eroded at all its boundaries. But it bequeathed a lasting system of overland communication, an international language of scholarship and administration, Latin, and a near international language of art to the future Christian society of Europe.

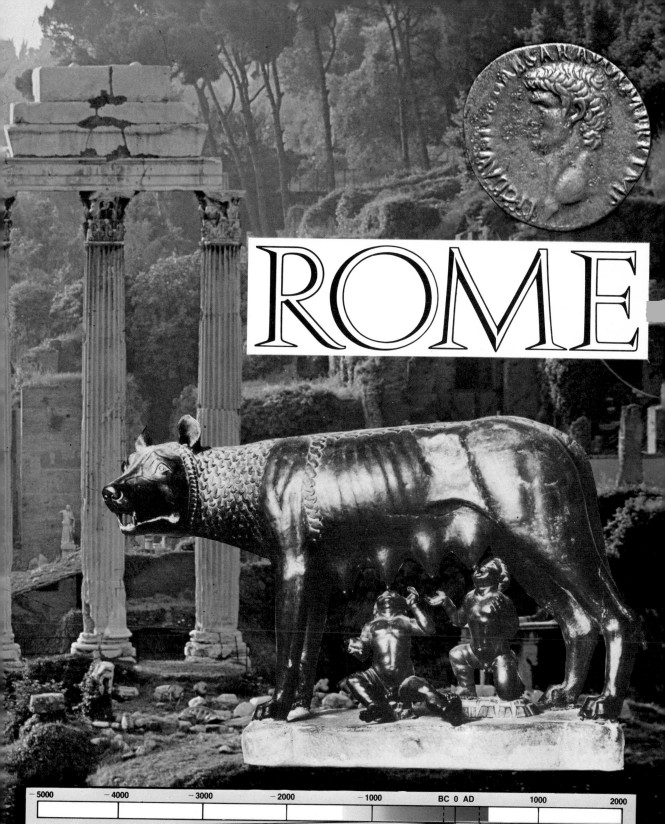

# ROME

| −5000 | −4000 | −3000 | −2000 | −1000 | BC 0 AD | 1000 | 2000 |

**753 BC** Legendary date of founding of Rome.
**750 BC** Etruscans in Italy.
**510 BC** Rome declared a republic.
**300 BC** Romans vanquish Etruscans.
Appian aqueduct, Appian Way built.

**147 BC** Romans destroy Corinth.
**146 BC** Romans destroy Carthage.
**58-50 BC** Caesar conquers Gaul.
**31 BC** Augustus becomes 1st Roman Emperor.
Egypt a Roman province.

**AD 1** Birth of Jesus Christ in Roman province of Judea.
**AD 43** Conquest of Britain.
**AD 100** Building of Hadrian's wall. Building of Pantheon.
**AD 200** Building of Baths of Caracalla.
Bishop of Rome takes title of Pope.
**AD 280** Diocletian reorganises the Empire and administration moves capital East.

**AD 303** Constantine becomes Christian.
**AD 313** Christianity becomes accepted religion of Empire.
**AD 330** Byzantium (Greek City) becomes Constantinople.
**AD 470** Empire ends in the West.
**AD 410** Rome sacked.

# ROME

Banqueting Scene, Tomb of the Leopards, Tarquinia. 5th century BC

**The Etruscans** emerged as the first native Italian civilisation in the area north and west of the River Tiber during the 8th century BC. Their art was influenced by the Near East and the Greeks, many of whose products were imported, notably metalwork and Corinthian and Athenian pottery (*see* pages 46–7). They laid out their temples in accordance with elaborate religious ritual, building them of wood, with broader proportions than Greek temples. They decorated them with □terracotta plaques and statues, such as the Apollo from Veii, ideas learned from the Greek cities of South Italy. The Etruscans lived in independent cities. Outside these, large cemeteries contained the rock-cut tombs of aristocratic families. Tombs were regarded as the houses of the dead, and imitated those of the living. At Caere, their interiors were carved with doorways, windows and rafters, features of timber construction copied in stone, and had several connecting rooms. At Tarquinia and elsewhere, the ceilings and walls were painted. Exuberant scenes of banquets, dances, war and hunting surrounded the dead with what they had enjoyed in life, and show the overflowing vitality with which the Etruscans adapted Greek art to their own society. Their great skill in metalwork is shown by the many weapons, armour, bronze statues, bowls and flagons from such places as Caere and Arezzo. Goldsmiths' work was highly accomplished, particularly in filigree and granulation, and often extremely ornate.

**The Origins of Roman Art.** Rome developed from a small collection of villages, and its earliest recorded history is as a small town under the domination of Etruscan kings. The first great temple, that of Jupiter on the Capitol hill, was on the Etruscan plan, and decorated by Etruscan artists. The Etruscans were also pioneers in road building and water supply and drainage, in which the Romans were to follow them with enormous success. The great days of the Etruscans' power in central Italy were over before the Classical period of Greece had time to influence them strongly. Greek art (*see* pages 42–7) came to the Romans as they expanded during the 3rd century in southern Italy, and later in the east Mediterranean. The rich spoils of cities like Tarentum and ▽Corinth included vast quantities of marbles and bronzes carried back to Italy. Hitherto frugal Roman society was revolutionised by ▽Hellenistic luxury. Its enthusiasm for Greek art was satisfied by Greek craftsmen who came to work for Roman patrons and slave owners. Their ideas were assimilated by the Romans' native genius and adapted widely to the needs of their new empire.

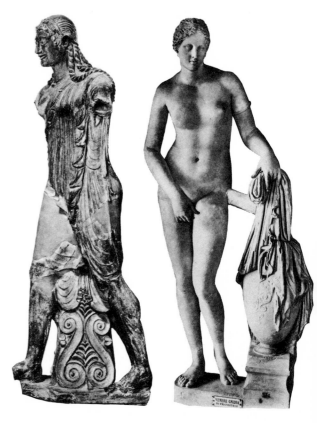

*Above left: Apollo of Veii.* About 490 BC. h. 69 in (175 cm). Villa Guilia, Rome
*Above right: Aphrodite of Knidos.* Roman copy of mid-4th century Greek original. Vatican, Rome
*Left:* Memorial to a Republican Roman family. 1st century BC. Vatican, Rome

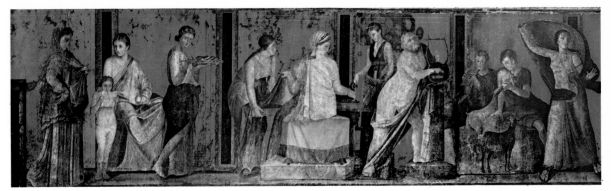

*Above*: Detail of wall in the Hall of Mysteries. Pompeii. 70–50 BC. Naples Museum

**Wall-painting.** The best examples of Roman wall-painting come from Rome itself and from the wealthier houses of ▽ Pompeii and ▽ Herculaneum. It was based essentially on architectural schemes. In the first style, the wall was divided into three zones, with marble panelling and coursed stonework represented in paint. In the second, this architectural framework was elaborated, with columns and cornices, and the illusion of space given by vistas of gardens and receding buildings, as if the wall were partly a window open to the world outside. Another favourite motif was the panel painting, showing mythological scenes or landscapes. These reflected wholly Roman interests: the love of nature and the collection of works of art. The wall decoration is essentially a picture gallery, with subjects selected to suit the purpose of the room and the particular interests of the owner. In later styles the architectural elements became more fantastic, some designs strongly influenced by theatrical scenery. Colours were rich and varied. Great interest was shown in three-dimensional illusion often with considerable success. The swift work demanded by □fresco painting could produce scenes with a delicacy of tough and a refined economy of effect which have an almost impressionist quality.

**Sculpture.** The taste for Greek art was reflected in the copies of Greek sculpture (*see* pages 44–5), both marble and bronze, made for private collectors and public display. Many originals would be totally unknown were it not for these later copies. Portrait sculpture, however, was developed with great originality. The custom in noble families of placing images of their ancestors in their halls and parading these busts at their funerals provided the incentive. Under the late ▽ Republic (2nd and 1st centuries BC) a taste for great realism developed, in strong contrast to the idealised versions of Greek art. Every detail of the face – wrinkles, warts and all – conveys the forthright character of the men and women of the time. It was felt that a portrait should also reflect appropriately a man's position in society. Dignified bronze and marble statues of magistrates in their togas, generals and emperors were erected in public places, conveying the majesty of their office and the pride of their achievements as well as their character. The taste for portraiture extended throughout society. Figures of ordinary soldiers, craftsmen and traders were carved on their tombstones, dressed in their uniforms or surrounded by the tools of their trade.

*Below*: Roman mosaic of a pastoral scene. Corinth Museum

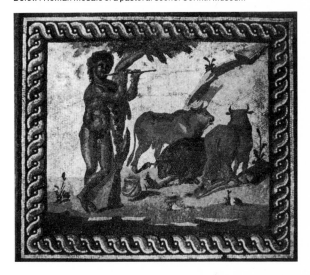

**Mosaic** work was introduced to Rome from Greece, and many of the earliest floors were made by Greek craftsmen. They consist of small cubes, *tesserae*, of stone or tile, set in fine mortar over a solid foundation. Repetition of similar designs in different places, far apart, suggest that patterns books were used. Mosaic also decorated walls and vaults, and sometimes glass *tesserae*, occasionally backed by gold leaf, were employed to give a greater brilliance. A mosaic floor was only part of a scheme of interior decoration. Though stones of many colours were used from the first, the richly coloured wall-paintings of earlier Roman buildings were offset by floors with geometrical or figured designs in black and white. These, however, might have coloured panels with scenes of daily life or animals, rather in the manner of rugs. Occasionally □*trompe l'oeil* effects suggest nuts, shells or bones lying on an unswept floor, or geometrical perspectives. Later multicoloured mosaics, particularly in the Empire, were divided into variously shaped compartments, and illustrated a wide range of subjects from almost every aspect of Roman life – chariot-racing, gladiators, farming, hunting – though gods and mythological subjects remained the most popular. (*See* Index and Glossary for further references to mosaic.)

# ROME

*Above: Augustus Caesar* (63 BC–AD 14)
*Right:* Trajan's Market, Rome. *About* AD 100–12

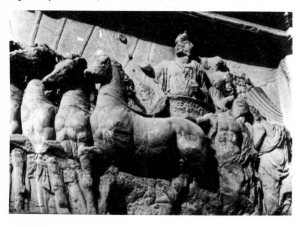

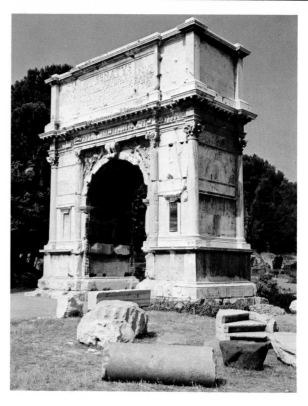

*Above:* Arch of Titus, at the top of the Sacred Way, Rome. AD 81
*Left:* Titus in triumph. Detail from the Arch of Titus

**The Imperial Message.** The erection of buildings for public use was traditionally regarded as a responsibility of high social position and as a matter of prestige. This public aspect of Roman art was also illustrated in other forms. Greek □reliefs on buildings which commemorated particular achievements alluded to them in an allegorical way, through battles of gods and giants, or Greeks and Amazons (*see* pages 44–5). The Romans represented the historical events themselves, and this became a powerful element of Imperial propaganda. The deeds of Roman history, emperors' victories and their benefactions were carved on public monuments for all to see. Augustus' Altar of Peace commemorated his return from the western provinces and symbolised his achievement in putting an end to the long years of civil war. The Arch of ▽Titus has reliefs showing the triumphal parade of spoils from the Temple at Jerusalem after the successful quelling of the Jewish Revolt. ▽Trajan's Column was carved with a continuous spiral relief showing scenes from the ▽Dacian War in the greatest detail. Designs on the coinage, which ▽Republican moneyers had used to remind the electorate of the distinguished state service of their ancestors, were adapted to similar ends. The emperors followed the practice begun by ▽Caesar and Pompey of putting their own portraits and titles on coins. Special issues and inscriptions on the reverse commemorated notable events of their reigns, and brought the Imperial message into the purse of every inhabitant of the Empire.

**The Architects.** The training of Roman architects was essentially that of apprenticeship and practical experience. In certain cases this was acquired in carrying out construction work for the army. Apollodorus of Damascus, the architect of ▽Trajan's Forum and his Baths, had served with the Emperor in the ▽Dacian campaign, where he constructed a bridge over the Danube. Romans made no distinction between architects and engineers. The designers of Nero's Golden House, Metellus and Celer, described as both, produced that splendid building a country villa set in landscaped parkland in the heart of Rome, containing among other marvels a dining-room with a revolving ceiling; they also designed a 160 mile long canal from Lake Avernus to the Tiber. ▽Vitruvius obtained his experience in the same way. His ten volumes on architecture, *De Architectura*, are our main source for the building practice of the late 1st century BC, but extend also to water engineering, astronomy, clocks, artillery and other machines, all part of the architect's trade. Though conservative by the standards of his time, his writing shows the essential combination of theory and practical application which was the hallmark of the Roman architect. Rabirius, who designed the palace of the Emperor Domitian on the Palatine Hill, was one of the first to realise the potential of concrete construction for interior design. In subsequent buildings – Hadrian's Villa at Tivoli and the various Imperial baths – vistas from one room to the next, soaring vaults and domes, and the interplay of shapes and surfaces, show the awareness of interior spaces which was one of the Romans' great contributions to the history of European architecture.

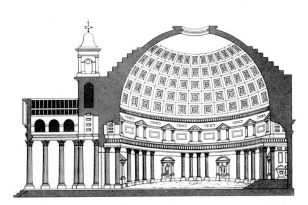

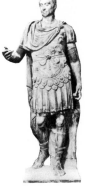

*Above and right:* Elevation and plan of the Pantheon, Rome. AD 120–4
*Below:* Amphitheatre at Arles. 1st century AD

*Right: Julius Caesar* (100–44 BC)
*Below:* Basilica of Maxentius, Rome. AD 307–12. Completed by Constantine after AD 312

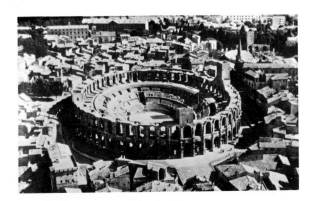

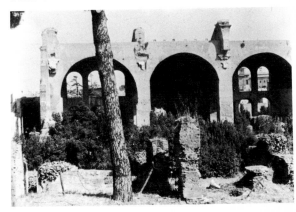

**Public Building.** During the ▽ Republic and for the first two centuries of the Empire, Rome was the show-place for official building schemes. Since the old market-place of the Romans, the Forum, had become too small, Julius ▽ Caesar began the first of a series of Imperial fora, each surrounded by colonnades housing some of the finest sculpture, and with temples at the end. That of Trajan had a great hall, the Basilica Ulpia, and two libraries which stood on each side of his Column, erected to commemorate his conquest of Dacia. Other military successes were marked by triumphal arches; those of ▽ Titus, Septimius Severus and ▽ Constantine survive. Amphitheatres like the Colosseum, built for gladiatorial games, depended essentially on concrete to carry the system of radiating vaults and concentric galleries which supported the tiers of seating and permitted the huge crowds to get in and out without difficulty. Public baths, like those of the Emperors Caracalla and Diocletian, were erected on an equally large scale; attendance at the baths was an essential feature of everyday Roman life. As well as the usual range of cold, warm and hot rooms, they included swimming baths, exercise courtyards, libraries and meeting rooms, and their magnificent decoration provided, as in modern hotels, surroundings far beyond the usual reach of their users.

**Building Technology.** The most revolutionary achievement by Roman builders was in the discovery and development of □ concrete construction. Roman concrete consisted of mortar made from lime mixed with volcanic sand with an □ aggregate of stone rubble. Its great advantage as a building material was that, once it had set, it formed a solid mass through which the thrusts and stresses in a building were balanced. Vaults, domes and arches of concrete could thus be used to span wide spaces held up by massive walls and piers. This had an enormously liberating effect on architectural design, freeing it from the limitations of column and lintel construction (*see* Greeks). Arches and vaults had been used before the Romans, but it was they who developed the full possibilities. They used concrete for vaulted foundations for villas and temples, enabling advantage to be taken of an imposing site on irregular terrain. Concrete needed facing to protect it from the weather, with either stone or brick. Brickfaced concrete became the standard form of construction for large buildings. Stone and marble continued to face major buildings, and traditional columns and entablatures were long retained, for decorative rather than structural reasons. The Pantheon, Rome, illustrates these new principles. The vast dome, 142 feet in diameter internally and of equal height, was supported on eight great piers, with built-in relieving arches to transmit the weight over the narrower walls between the piers. The arches and dome were constructed over a framework of timber shuttering, and the weight of the aggregate in the dome was carefully graded, with light pumice used in the middle, where the stress was greatest.

**Civil and Military Engineering.** The roads for which the Romans are justly famous were essential for the control and administration of an empire which extended from Britain to Iraq. Many new routes in the provinces were surveyed by the army, and they were maintained for the courier service which linked the provincial administration with Rome. Road metalling consisted of a rough foundation of large stones, with graded layers of gravel above. In Italy blocks of basalt were used for the surfacing. A steep camber ensured the run-off of rainwater, for which ditches were dug on each side. Timber piling was used underneath on boggy ground, and also for the piers of bridges. Bridges were often of wood, but impressive stone arched constructions may be seen at Salamanca, Merida and Trier. Aqueducts were constructed on the same principle. The water supply was a vital need of Roman town life, and adequate sources were often far away. Where possible an underground channel was used, lined with waterproof cement, as this was cheaper to maintain. Where the ground level changed abruptly, as in steep river valleys, the aqueduct was carried on arches, still standing at the Pont du Gard, Segovia and Tarragona. Julius Frontinus' book on aqueducts, written after he had been curator of Rome's water system, gives us valuable information. He had been a provincial governor and commander of armies, and also wrote a book on tactics. Many military works, such as the defensive walls, gates and ditches of forts and towns, are impressive. In Britain, Hadrian's Wall, 76 miles long, served as a fortified base line for the control of the northernmost frontier of the Empire.

**Towns and Buildings.** The most obvious way in which the Romans revolutionised men's lives, particularly in the west, was by spreading the idea of the town and civilised town life. The Roman town plan consisted of two main paved streets, the *cardo* and *decumanus*, round which a grid of subsidiary streets was laid out, often lined by colonnades. In a new foundation, the territory of the town was divided into rectangular plots in a similar grid system (*centuriation*), accurately surveyed with a sighting instrument. The centre of the town and of its life was the Forum and Basilica. The latter was a rectangular hall, its roof supported on lines of columns, often with an □apsidal end. A Roman invention, it was an adaptable type of building, used as law courts, public offices, meeting places for merchants, military assembly halls and later, the first Christian churches (*see* pages 82–91). Provision was also made for public amenities: markets, shopping arcades, baths, lavatories, drains and recreation buildings. These last included amphitheatres, theatres and circuses. The gladiatorial displays and the wild beast hunts of the amphitheatre were popular. So too was chariot-racing in the circus, a long course running up and down a central strip with turning posts at each end, and tiered seating. The Roman theatre shows developments from that of the Greeks. The stage building is now predominant, with very elaborate architectural detail, well seen in Sabratha. The orchestra is reduced to a semicircle, and the stage-building is joined on to the tiers of seating.

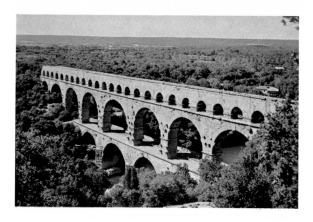

*Above:* Pont du Gard, Nîmes. *c.* AD 14
*Right:* Maison Carrée. Nîmes. AD 117–38

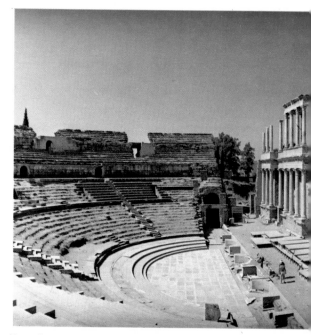

*Above:* Roman theatre, Merida, Spain
*Right:* The Lycurgus Cup. 4th century AD. BM, London
*Below:* View along a street, Pompeii, before AD 79

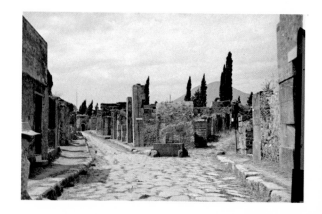

# The Roman Provinces and Private Life

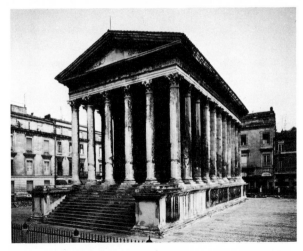

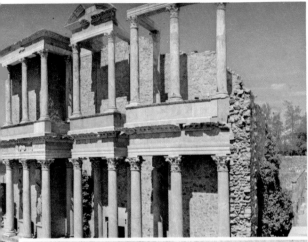

**Temples and Houses.** The Roman temple reflected ritual practices shared with the ▽Etruscans. It was placed at the end of its precinct, and intended to be approached from the front, where steps led up to the podium on which the temple stood. Sacrifices were made at an altar placed in front of the steps. Although it came to be built according to Greek rather than Etruscan proportions, the Roman temple retained these essential ritual differences. The Maison Carrée at Nîmes is one of the best-preserved examples. The traditional house of the Romans was built round a central hall, the *atrium*, with a roof opening to provide light and air. This was the main reception room, and was flanked by bedrooms, with a dining-room at the end opposite the street entrance Later it became fashionable to add a ☐peristyle, a columned formal garden, beyond the atrium, and this became the predominant feature in the plan. Elsewhere, pressure on spade led to higher buildings. The houses of Ostia, the congested port of Rome, were built as blocks of apartments, three or four storeys high, with a central courtyard and a street frontage with shops on the ground floor and balconies above. The country villa ranged from the simple farm to the luxurious houses of the rich. Most sing-storey buildings, free from space restrictions, showed the Roman's love of nature in being sited to take advantage of the views and to harmonise with the landscape. ▽Pompeiian wall-paintings illustrate the columned façades of Campanian sea-side villas, and mosaics from Tabarka depict the farms of North Africa in their olive-groves and vineyards.

**Metalwork, Glass and Pottery.** Gold and silver plate closely followed the ▽Hellenistic tradition, with ☐repoussé scenes of mythology and ☐chased and ☐engraved designs. Bronze was used for decoration, handles and bindings of boxes, furniture fittings, pins, bracelets and toilet articles, as well as for lamps and household objects like saucepans and jugs. Many figures of deities were cast in bronze for domestic shrines and for dedication in temples, and for ornamental purposes. Glass-blowing was an important new discovery of the 1st century BC. Free-blown bowls, jugs and ointment flasks were common, as well as square flagons, blown into a ☐mould. Syria and ▽Alexandria were great glass-production centres, and Syrian craftsmen settled at Cologne to establish a fine industry specialising in elaborately cut glass. The secret of producing completely clear glass was also discovered. The many varieties of pottery were mostly for local use. One industry centred in France produced ▽Samian, a red ware with a glossy surface, made in moulds in standard forms, either plain or with figure decoration produced from stamps. Very large quantities were traded widely by potters who came as near as the ancient world ever did to mass production.

# CHINA

Cut off by mountains, deserts and oceans from other centres of developing civilisation, China had a self-contained history with its own special time-scale.

The original centre of Chinese culture was along the great Yellow River which crosses the North China Plain, where stable settlements date from at least 4000 BC. From about 2500 BC the people here cultivated silk worms, made pottery, had beautifully finished tools and lived in comfortable thatched huts. China has its own history of technology as well as art. Ceramic and metal-working crafts were developed from 2000 BC quite independently of the West, and may indeed have spread westwards from the East. A system of writing which is still the foundation of modern Chinese script was established by 1800 BC.

China is dated by its Dynasties, a word which

has been coined by western historians from the Greek root for 'power, force or domination.' Successive waves of invaders came out of the Central Asian land mass, from the Steppes and the Turcu River, conquered, ruled and were in turn assimilated and overrun. The names of these Dynasties have been used as convenient labels for the art and artefacts produced by them, and the reader has to be patient with an unfamiliar roll-call of names and dates, the latter identifying a high degree of technical achievement astonishingly early in civilised history.

| | | | |
|---|---|---|---|
| **5000 BC** Neolithic settlements on banks of Yellow River. Black pottery made on wheel. **2500 BC** Beginnings of systematic astronomy, etc. Calendar of 360 days. **1700 BC** Shang Dynasty. Bronze vessels and weapons. Wheeled vehicles. Walled cities. Silk textiles. | **1050 BC** Tcheou dynasty. Chinese script fully developed. Brush and ink painting. Chinese dictionary. Chinese mathematical tables. **770 BC** Western Tcheou dynasty ends, Eastern Tcheou begins. **600 BC** Lao Tzu, founder of Taoism, born. **551 BC** Confucius born. **550 BC** Buddha born. Age of Jewish prophets. Greek poets. | **500 BC** Tcheou Dynasty splits up into warring states. Iron Age in China. **220 BC** Ch'n dynasty. **215 BC** Great Wall of China 1400 miles long. **200 BC** Western Han dynasty. Chinese troops in Central Asia. Chinese ships reach India. **AD 220** Han dynasty ends. Buddhism in China. | **AD 221** Period of Six Dynasties. **AD 589** Sui Dynasty. **AD 618** Tang Dynasty. Block printing. Chinese science. **AD 906** Five Dynasties. **AD 960** Sung Dynasty. **AD 1279** Yuan Dynasty. Mongol incursions and conquest. **AD 1368** Ming Dynasty. Europeans arrive in China. **AD 1644-1921** Ching Dynasty – Manchus. |

-5000  -4000  -3000  -2000  -1000  BC 0 AD  1000  2000

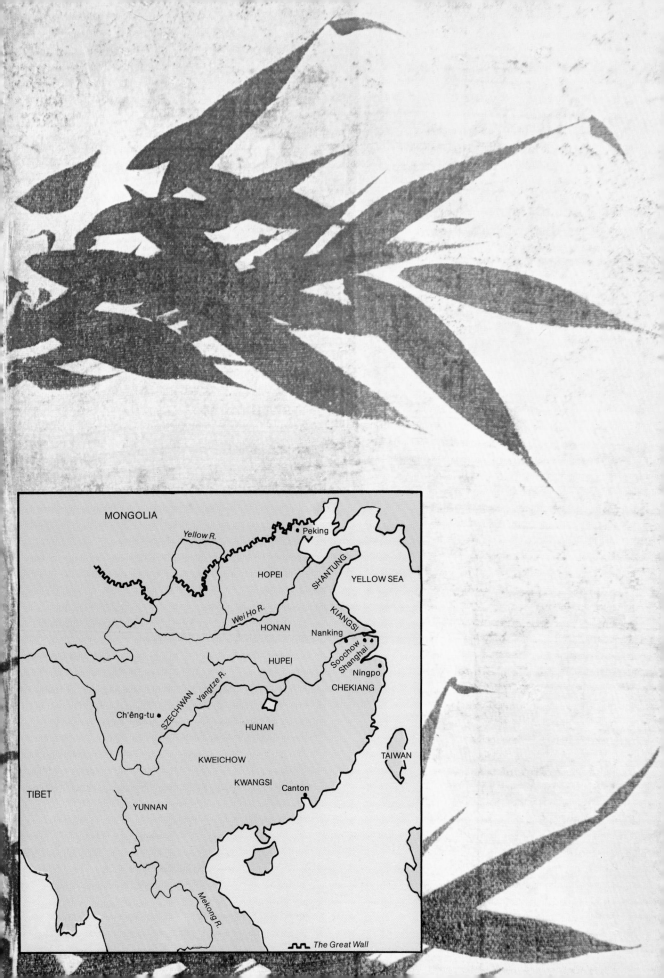

MONGOLIA

Yellow R.

Peking

HOPEI

SHANTUNG

YELLOW SEA

Wei Ho R.

HONAN

KIANGSI

Nanking

HUPEI

Soochow

Shanghai

Ningpo

Yangtze R.

SZECHWAN

CHEKIANG

Ch'êng-tu

HUNAN

TAIWAN

KWEICHOW

TIBET

KWANGSI

Canton

YUNNAN

Mekong R.

The Great Wall

# CHINA

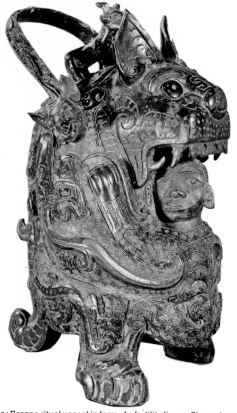

*Above:* Bronze ritual vessel in form of a fertility figure. Shang dynasty

**The Bronze Age.** The ▽ Shang dynasty (*about* 1500–1028 BC) was assumed to be mythical until the discovery in north-west China, in 1898, of a hoard of oxen's shoulder-blades bearing inscriptions. In the same region, near An-yang, quantities of bronze vessels were unearthed bearing also inscriptions in ancient Chinese script. When deciphered and compared they enabled scholars to piece together the history of Shang society with the names and dates of kings. It was a loose federation of city-states whose bronze weapons enabled them to dominate the valley of the Hoang-ho (Yellow River) and its tributary, the Wei. In many ways the Shang resembled the ▽ Mycenean princes celebrated by ▽ Homer. Their bronze vases were made by the method of direct casting as well as by the □*cire-perdue* (lost-wax) process. They were used by kings and their retainers for ritual and sacrificial ceremonies. The inscriptions they bear give the name of the owner and the maker with the purpose of the ceremony. The vessels were buried with their owners and they acquired a green, blue or red patina according to the nature of the soil. They fall into three main categories: vessels for cooking or containing ritual food, vessels for heating or pouring millet wine, and vessels for ritual washing. They were utilitarian, functional objects, but this did not prevent them from being superb works of art. Their ritual purpose and magical connotations explain the symbolic nature of the early decoration. Motifs from the animal world were mainly used – the dragon and the cicada (life and fertility) or the fabulous *tao-tieh* – which resembles a cross between an ox and a tiger.

**Shang and the Iron Age.** The state of ▽ Shang came to be dominated by the Tcheou (or Chou) highlanders from the west who captured the capital, An-yang, in 1027 BC. They belonged to or adopted the Shang culture and produced the same kind of vessels but with a few differences. The stylistic evolution was gradual and a marked change appeared only after the Tcheou had moved eastwards to a new capital, Lo-yang, in 722 BC. The high □relief of the Shang motifs gave way to low relief and registers. Ornament became increasingly geometric until it was reduced to wing-and-spiral and hook-and-□volute patterns. With the tools of the ▽ Iron Age it became possible to introduce inlaying of gold and silver. This was the period of the Warring States (*about* 481–222 BC), when the Tcheou state had disintegrated into contending feudal territories. ▽ Confucius, who died at the beginning of this period, was a high-minded moralist and the unsuccessful adviser, for a time, of one of the Tcheou's rulers. He was a travelling teacher, and lectured on political ethics, non-violence and filial piety. His doctrine was collected, much later, in the *Analects* which became the gospel of the all-powerful class of scholarly civil servants, remaining so till modern times, and which deeply marked the Chinese code of manners.

**Taoism.** Among the 'Hundred Schools of Philosophy' which addressed themselves to the Chinese ruling classes in this period of argument, the most remarkable perhaps was that of the Taoists. *Tao* means the Way or the Universal Principle. Taoism is an attitude to life not a system. It implies being in harmony with nature and shuns all dogmas and restrictive moral codes. Its most famous theoreticians were Lao-tzu, an enigmatic author expressing himself in paradoxical apophthegm, and Chuang-tzu (*about* 350–275 BC) who wrote in parables pervaded with a subtle irony and showing a deep insight into man's motivations. To some people they seem to combine the best in Christianity, Zen Buddhism and Yoga. Taoism was destined to have a profound influence on Chinese painting.

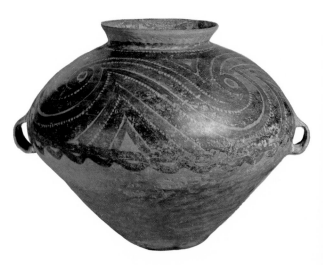

*Above:* Neolithic pottery vessel Pan Shan. 2nd millennium BC

# The Foundations of Culture

**The centralised Empire.** Political confusion was ended by the dictatorship (221–206 BC) of Shih-huang-ti, the ▽ 'Peter the Great' of China, who came from the state of Ch'in (hence the name China). He smashed feudalism and replaced the war lords by civil servants or commissars. His advisers belonged to the legalist schools who asserted the authority of the State. Traditions were to be forgotten and all books destroyed, particularly the writings of ▽ Confucius. It was a cultural revolution, with many martyrs. Shih-huang-ti gave China a unified administration and a road system; he built canals and extended the frontiers of China.

After the death of Shih-huang-ti and a period of civil war, a powerful bandit, Liu Pang, rose to the throne and inaugurated the long-lived ▽ Han dynasty (206 BC–AD 220), which rehabilitated Confucius but retained Shih-huang-ti's administrative reforms and ruled China with the help of a centralised administration.

Under the Han a new, naturalistic outlook prevailed in figurative art. This is particularly evident in bronzes and in the pottery figures called *ming-chi* which people had buried with them in their graves. The Chinese believed in an afterlife and they liked to surround themselves with representations of familiar sights, particularly of those things which had given them pleasure on earth, such as dogs and horses, dancers and concubines. These figures enable us to know precisely how the subjects of the Han dynasty were dressed, what they ate, what tools they used, what games they played, the domestic animals they reared and the appearance of the houses in which they lived. Many of the figures were coated in a lead glaze; others were painted. All are interesting and their stylised elegance is often of arresting beauty. Bronze vases were made in quantity; so were bronze figures of men and horses, and these show the same stylised naturalism as the pottery figures. This was also a great age for lacquer work, jade and silk fabrics.

**Painting and Printing.** The mulberry tree had been cultivated for some time in China and silk became a Chinese monopoly. It was the chief article of export to Persia and the Near East via the caravan routes through central Asia, known as the 'Silk Road'. ▽ Han painting and drawing, either on silk, on lacquer or on stone and tile, shows a most lively hand and great lightness of touch. Towards the end of the reign a technique for making paper was discovered. When block printing was later invented the Chinese possessed the means of diffusing laws and literature throughout the Empire. The languages were many and varied, but the □ ideographic script was the same all over the country. This made the task of the administrators easier and it provided the Chinese people with a unified culture. In its calligraphic form writing became an art in its own right, the form of art which stood highest in the Chinese intellectual's esteem. It became a way of life, the preserve of the few, among whom were the painters, poets and scholars, those whose art was founded on □ calligraphy.

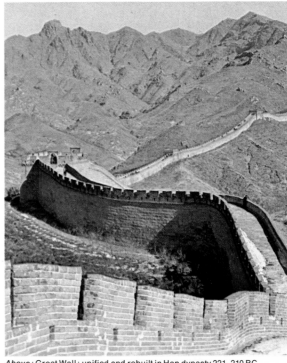

*Above:* Great Wall: unified and rebuilt in Han dynasty 221–210 BC

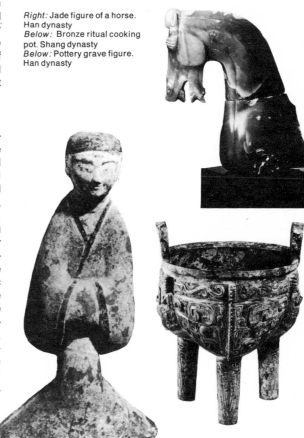

*Right:* Jade figure of a horse. Han dynasty
*Below:* Bronze ritual cooking pot. Shang dynasty
*Below:* Pottery grave figure. Han dynasty

# CHINA

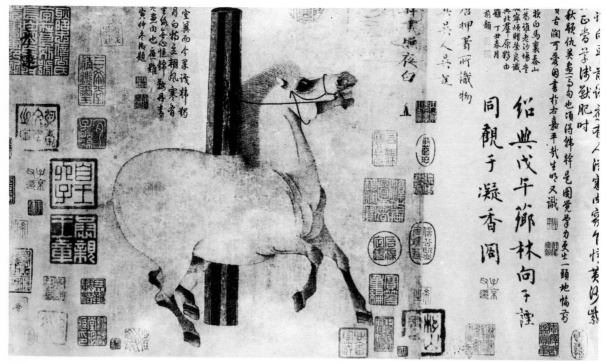

HAN KAN *The Night-Shining White Steed.* c. 750. 13½ × 12 in
(34·3 × 30·5 cm). Handscroll. Mrs John D Riddell Coll

**Buddhism and Anarchy.** After the demise of the ▽ Han dynasty in AD 220 China was to know nearly four centuries of fragmentation. This state of chaos was aggravated by invasions from northern and central Asia. The hungry horsemen from the steppes were attracted irresistibly by an agricultural society with big cities. They adopted the superior Chinese culture, became assimilated and sedentary and the process was repeated. Among the 6th-century invaders were a Central Asian people called the To'pa, who founded the Wei dynasty and ruled the northern half of China from AD 386 to 554. Their most memorable contribution was the official adoption of ▽ Buddhism, a religion born in India, which had been infiltrating China for some time. Its founder, the living Buddha, dwelt on the border of Nepal shortly before ▽ Confucius (*see* pages 68–9). Buddhism had spread via ▽ Gandhara all along the Silk Road eastwards. Eventually it reached the border of China where the vast sanctuaries of Tun-Huang and Yun-Kang revealed wall-paintings and banners and a multitude of statues carved in serried ranks out of the walls of cliff and cave. Being of non-Chinese stock the Wei adopted Buddhism as a way of asserting themselves. It was always considered by the Confucian elite an outlandish, superstitious doctrine (*see* pages 58–9).

**Buddhist Sculpture.** Without Buddhism there would be very little Chinese sculpture in stone. The Mahayana and Amitabha schools of Buddhism which prevailed in China required the representation of Buddha in his past, present and future form, and also of the Bodhisattvas (aspiring Buddhas), and attendants. Following the expansion of Buddhist monasticism, these were to pro-

liferate all over the country either in stone or in bronze. Wei sculpture, particularly in the Lung-men caves, has a transdendent beauty: idealised, elongated figures, with oblong heads and enigmatic smiles, sitting cross-legged, in long robes cascading down in rhythmical folds, the very image of mystical bliss. The stance, gestures and symbols were stereotypes derived from Indian origins. The Chinese seemed to find in Buddhism an answer to the problem of human suffering, the answer of love and prayer, and hope of ▽ Nirvana.

**The T'ang Dynasty.** China was reunited in AD 589 by a powerful general, who founded the Sui dunasty. This was succeeded by the T'ang dynasty (AD 618–906) whose greatest emperor, T'ai-tsung, extended the empire deep into central Asia and Korea and allowed all religions and races to flourish in an atmosphere of tolerance and intellectual curiosity. The capital, Chang-an, became a great cosmopolitan centre, as did Canton and other southern ports. ▽ Muslims, ▽ Christians (Nestorians) and Manichaeans lived and worshipped side by side with ▽ Buddhists, ▽ Taoists and ▽ Confucianists. T'ai-tsung was succeeded by his son and an able but ferocious concubine, Empress Wu, who favoured Buddhism and even fell under the spell of a Rasputin-like monk. Her successor, the Confucianist emperor, Hsuan-tsung, presided over a most brilliant court and founded the Academy of Letters; he loved music, painting and poetry, as well as horses. T'ang society was bursting with vitality and optimism. T'ang dynamism is felt in all the arts. The sculpture in stone, influenced by the ▽ Gupta style from India, displays round, swelling forms, combining Indian fleshiness with Chinese linear rhythm.

# The Three Kingdoms and the Six Dynasties

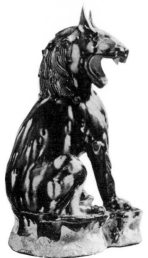

Lion tomb figure. T'ang dynasty.
Glazed pottery

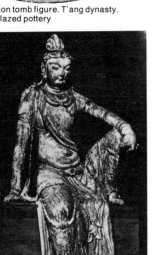

*Above:* The Boddhisattva Kuan-yin. T'ang dynasty. Wood

*Below:* Horse and groom. T'ang dynasty. Horse h. 11¼ in (28·5 cm).
Glazed earthenware

Boddhisattva Lung-men.
Northern Wei dynasty

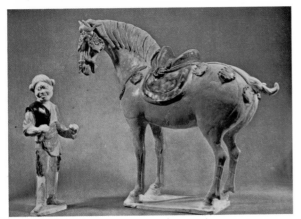

**The T'ang frescoes** of Tun-huang show a dynamic brush-line and the same fullness of form in garish colours. The secular tomb-paintings are even more lively; they depict powerful men and opulent women in ample robes and theatrical attitudes, displaying a keen enjoyment of life. Little painting on silk or paper has survived – enough to testify the same love of vivid colour and an interest in landscape painting which was to bear fruit under succeeding dynasties. This was the age when the art of poetry, intimately connected with painting and □calligraphy, produced its first masterpieces with Po-chu-I, Ling-po, and the painter Wang-wei. As for metal-work, particularly silver, it reveals Persian influence. A number of Iranian artists, fleeing the Arab conquerors, settled in China, but as with all other foreign influences, the Persian was absorbed and became unmistakably Chinese, in spirit and in form. Some of the finest examples of the T'ang decorative arts are to be seen in the Shoso-in treasure at the temple of □Nara in Japan. For the Japanese were already looking to China for their inspiration.

**Pottery and Porcelain.** Contemporary pottery, and particularly the tomb figures (*ming-chi*) provides us with a vivid insight into ▽T'ang society: the horses, of which the T'ang were so fond, the camels, the musicians, jugglers, itinerant merchants, many with strongly emphasised foreign features, the dancing-girls, the dignitaries and generals, the tomb-guardians and earth-spirits; all these witnesses to the period are brightly coloured in rich, polychrome, freely-flowing glazes – a recent Chinese invention made with the oxides of copper, iron and cobalt, as were the vases and other vessels in stoneware or earthenware. These are round, beautifully made and always superbly balanced.

By then the Chinese had rediscovered and brought to perfection another of their inventions, the art of making □▽porcelain, (a hard translucent ware fused at high temperatures with the aid of 'Chinese stone' (*petuntse*) and feldspar). This art had been lost since the days of the ▽Shang. White porcelain of the finest quality was produced under the T'ang and it soon found its way to Japan, Persia and the Near East. China never opened her frontiers so widely to foreign trade and to foreign ideas as during the T'ang period, when the merchant navy was flourishing and when Chinese armies penetrated into western Turkestan. Along the Silk Road a string of Chinese-influenced oasis-kingdoms assured a two-way traffic in objects and in ideas between East and West. China sold its porcelain, its silk rolls and garments and in return it imported Persian cobalt, techniques of metal-work and stylistic ideas. All this ceased in 751 when the Chinese army suffered a crushing defeat at Tallas in Turkestan by the hands of the Muslim invaders, who had conquered Persia and were overrunning central Asia. One link remained with the outer world: the ports of southern China with their large colonies of foreign merchants; but these were wiped out by a wave of nationalism at the end of the dynasty and China inaugurated a policy of isolation which still continued.

# CHINA

**The Sung dynasty.** After a period of disorder known as the Five Dynasties, a vigorous general reunited China again by founding the Sung dynasty. In spite of a constant threat of invasion Kaifeng, the new capital, became one of the most refined centres of civilisation ever known, particularly under the reign of the emperor-painter Hui-tsung who was surrounded by artists and acquired a fabulous collection of their work. He devoted too much time to the arts at the expense of his army, for in a lightning raid Tungus barbarians called the Jurchen captured the court and destroyed Kaifeng and the entire art collection. The whole of northern China fell to the Jurchen; the survivors from the Sung settled in Hangchow on the Yang-tse-kiang river in the south where they continued in their pursuit of culture and beauty until they were submerged for good under the Mongol onslaught which had already reduced Asia and was threatening Europe. The dominant ideology in the days of the Sung was Neo-Confucianism, a blend of the ideas of ▽Confucius and those of ▽Taoism with some ▽Buddhist asceticism as well. This went with a renewed interest in the earlier traditions of China, the writings of the classical authors and a strong antiquarian bias, leading to the copying of ▽Shang and ▽Tcheou bronzes. Buddhism of the Amitabha persuasion was on the wane and degenerating into superstition.

**Dhan Buddhism.** But a new spiritual outlook appeared on the scene with *dhan* (Japanese Zen) in which man comes to terms with himself and nature through a momentary flash of intuition. *Dhan* was to influence painting, calligraphy and pottery. Mu-ch'i was one of its most famous exponents. Sung sculpture continued the T'ang tradition, but with greater elegance and a masterful rhythm of flowing lines as can be seen in the representations of the Bodhisattva Kuan-yin, the spirit of mercy who became to the Chinese what the Madonna had become to many Europeans.

It is in the realms of painting and pottery that the civilisation of Sung reached its summit. Before the fall of Kaifeng there were two distinct schools of painting: that of the court artists, virtuosi who, displayed supreme but soulless competence whether in colour or ink, on silk or paper, their subjects being flowers and animals, bamboo shoots and landscapes; and that of the amateurs and individualists. These civil servants, scholars and poets painted as a form of personal expression, intellectual as well as spiritual, a way for the individual to come to terms with himself through communion with nature, in the rendering of the essence of a landscape, a bamboo sprig or a dragonfly. The experience was so personal that there were a hundred styles, a hundred ways of outlining a leaf, a rock, a cloud, just as there are a hundred ways of depicting a character, for the stroke of the brush on silk or paper does not allow for hesitation or correction; it proceeds straight from the mind and this can not be done spontaneously without deep contemplation beforehand. The Chinese invented the art of landscape painting as a genre, but it was never purely descriptive, however close to reality. It was a spiritual exercise that went to the heart of things.

These painters and poets were also great lovers of pottery, for a beautiful vase, like a piece of jade, was at the same time a poem and a painting. Ceramics were designed both for use and for contemplation. Their quality resided in the balance between their form, reduced to essentials, and their glaze, through which they appealed to visual and tactile senses. The wealth of craftsmanship underlying their elegant reticence was satisfying to the Confucian mind. There were kilns all over China working with different clays and glazes. Among the most famous were those producing the 'crackled' *kuan* ware and the rare *ju*. Porcelain like the creamy white *t'ing* or the pale blue *chin-pai* with their incised decoration come close to perfection.

**The Ming dynasty.** The Mongols who overran China in 1280 quickly adopted the Chinese culture. We have a description of the court of Kublai Khan written by the Venetian merchant, Marco Polo, the first European to visit China (1275). The Mongols took the name of Yüan for their dynasty. They employed Chinese artists and continued the Sung tradition. The period was notable for its painters, particularly the 'Four Great Masters' who stayed aloof from the Mongol court. The Mongols were overthrown by a popular insurrection led by a shepherd and guerrilla leader who founded the Ming dynasty, with its capital in Nanking, which was transferred later to Peking. The Ming court was as glamorous as that of the T'ang but ridden with corruption and paralysed by internal conflicts. Painting continued as before becoming over refined at the end of the dynasty. But the Ming are particularly famous for their blue and white ☐porcelain, where cobalt blue is applied on the paste under a transparent glaze. Later ceramicists took to using bright enamels in three or five colours. The pieces were decorated with allegories, ▽Taoist and ▽Buddhist symbols and a variety of bird, flower and dragon motifs. Much of Chinese architecture that has survived dates from this period, but it lacks the imagination of the Sung buildings with their ☐cantilevered eaves and brackets.

**The Manchus.** In 1644 the Manchus in the north took advantage of economic and social unrest. They were a military race with great admiration for the Chinese. Their emperors were powerful men who administered the country with a strong hand until the end of the 19th century, but the Chinese elite did not mix with the Manchus for a long time. This was detrimental to the progress of Chinese civilisation, at the moment when the Europeans were becoming important in Asia.

The names of the Emperors Kang-hsi and Chien-lung will always be associated with types of porcelain known as *famille-verte* and *famille-rose*, more appreciated by Europeans than by the Chinese who preferred subtle monochromes.

Between the abdication of Chien-lung in 1795 and the 20th century China continued to produce objects of quality but the inspiration failed and forms became cluttered with decorative details.

Peking. The Forbidden City

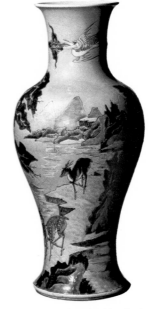

Vase made during the reign of K'ang-hsi. Manchu dynasty. h. 16¾ in (43 cm)

Summer Palace in Peking. A P'ai-lon on K'un-ming Lake

Bowl made in the Sung dynasty. Height 5 in (13 cm). V & A, London

*Breaking the Balustrade.* Sung dynasty. Ink on silk

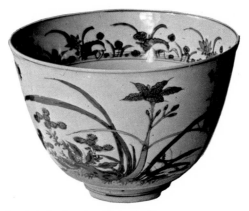

Bowl made during the reign of Hsüan Te. Ming dynasty. V & A, London

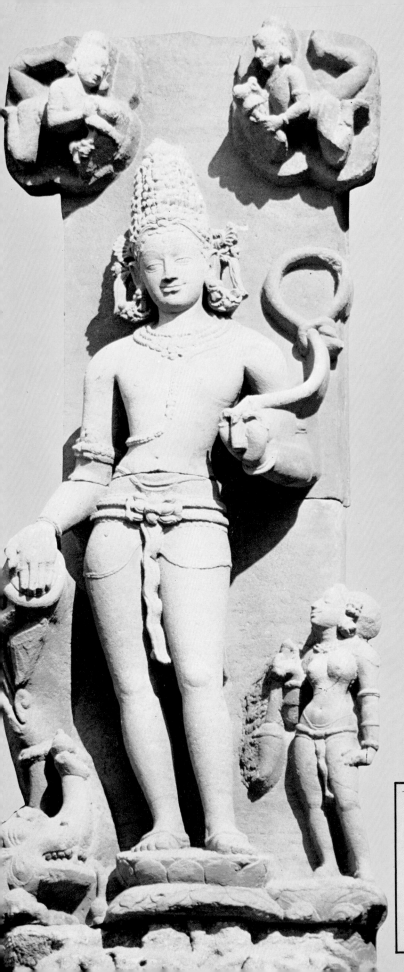

The Indian sub-continent has a history of civilisation dating back to at least 4000 BC, linked to that of Mesopotamia. But the civilisations from which Indian art, as we understand it, survive have a much shorter history dating from about the second century BC to the eighteenth century AD.

Between 1500 and 800 BC, an Aryan invasion almost completely conquered the peninsula, bringing with it the Sanskrit language and the basic texts of the Indian religion. These texts so dominate Indian thought, art, literature and music that they have survived to this day, quite unaffected by Muslim conquest and European colonialism.

Indian art is as complex as the Indian theology that generated it. All the arts are derived from and controlled by Vedic texts. The word is all important: its meaning is expanded by poetry; poetry dictates song. Song dominates music, words and

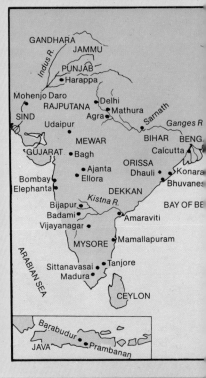

GANDHARA
JAMMU
Indus R.
PUNJAB
Harappa
Mohenjo Daro
Delhi
RAJPUTANA
Mathura
Sarnath
SIND
Agra
Ganges R
Udaipur
BIHAR
BENG.
MEWAR
Calcutta
GUJARAT
Bagh
ORISSA
Ajanta
Dhauli
Konara
Bombay
Ellora
Bhuvanes
Elephanta
DEKKAN
Kistna R.
Bijapur
BAY OF BE
Badami
Amaraviti
Vijayanagar
MYSORE
Mamallapuram
ARABIAN SEA
Sittanavasal
Tanjore
Madura
CEYLON
Barabudur
JAVA
Prambanan

| − 5000 | − 4000 | − 3000 | − 20 |
|---|---|---|---|

4000 BC Mohenjo-dara, Harappa.
2000 BC Indus valley civilisations.
1500 BC Aryan invasions.

560 BC Birth of Buddha.
300 BC Mauryan period
Ashoka.
AD 100 Greco-Buddhist
AD 300 Mathura-pre-Gu
period of art.

# INDIA

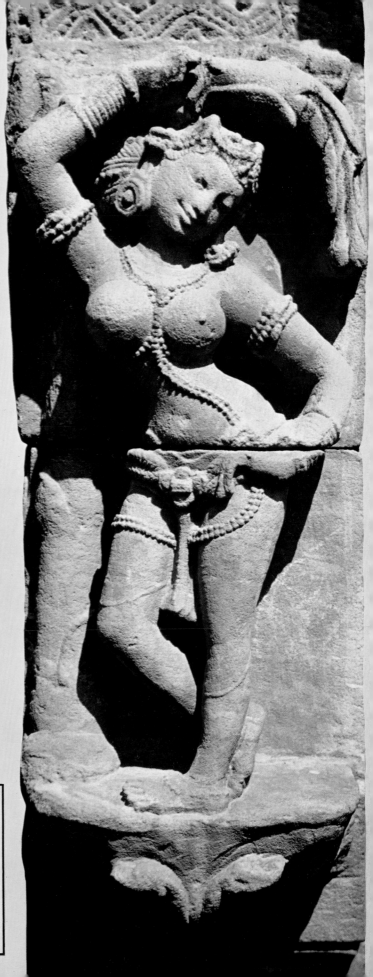

music together dictate the dance. Dance gesture in turn dictates pose and posture and therefore meaning in painting and sculpture. Classical Indian sculpture is entirely based on dance language or 'Mudra,' and even quite recent secular miniature paintings are based on a visual language through which season, colour, time of day and human incident are all related to poetry through an elaborate code.

This pattern of meaning has prevailed to the present day. The contemporary Indian artist is now faced with the problem of rediscovering and maintaining his historical identity in the modern world.

CHINA

Chieng Mai

angkok

angoon • Angkor
Takeo

− 1000    BC 0 AD    1000    2000

**AD 400** Gupta art.
**AD 700** Post-Gupta period.
**AD 700** Medieval Brahminic art.
Classic temples Khajuraho.
Buvaneswar, etc.

**1520** Mughal Empire.
Forts at Delhi Agra.
Building of Fatehpur Sikri.
Taj Mahal.
Miniature painting.
**1800** End of Mughal Empire.

# INDIA

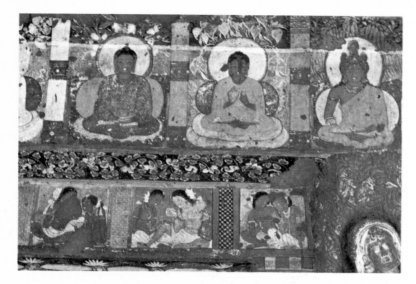

**Indus Valley Civilisation.** A civilisation flourished here between about 2800 BC and 1350 BC. It represented the culmination of a ▽ Bronze-Age culture, whose sites are scattered throughout the hills to the West. Two major cities have been excavated; Harappa and Mohenjo-daro, some six hundred miles apart, with many other towns and vilages, including a port, Lothal, whose harbour has a tide-sill. The cities were planned on a rectangular grid, which remained virtually unchanged. The houses faced inwards on to courts, and the larger had at least two storeys. There was an elaborate drainage system. The existence of large cities, the use of timber for floor and roofs and of burnt brick for facing, suggest the area was then very fertile. Each city had a raised citadel, on which was a 'collegiate' building with a large bath; in its shelter lay granaries with underfloor air-flues. It is believed that the cities were ruled by a caste of priest-kings. Apart from painted pottery, the art found is all very small, including a few miniature sculptures in bronze, stone and □terracotta, connected in some way with religion. But most important are the stone stamp-seals and the relief clay sealings struck from them. These represent animals, especially humped bulls, and complex scenes of ritual. They also bear a script, as yet undeciphered. There are many terracotta toys – monkeys, carts and animals with moving parts. The tools and weapons are of relatively conservative Bronze-Age types.

**The Hindu Caves.** It is probable that natural caves were revered by the early animist-▽ Hindu population of India as dwellings of the divine; they still are today, The major Hindu caves which are known are in fact rock-cut temples of many different dates. Their architecture parallels contemporary structural styles. The most important Hindu cave groups are in the ▽ Deccan at ▽ Badami (6th century AD) and ▽ Ellora (7th–9th century AD). At Badami, in one cave dedicated to the god Vishnu, a set of the finest iconographic sculpture in India is preserved. There are also fragments of early wall-painting. At Ellora the whole series of great cave-shrines centres on a vast monolith, the Kailashanatha, carved inside and out from the hillside (8th–9th century AD). At this site, too, the magnificent sculpture conveys the characteristic Hindu intuition of the immensity of the universe and its gods. At Elephanta (8th century AD), an island near Bombay, a small cave dedicated to the god ▽ Shiva contains some of the most famous sculptures in India, including a colossal bust, whose three faces represent his aspects as creator, preserver and destroyer of the cosmos.

**The Buddhist Caves.** Much Indian architecture survives in rock-cut form. Caves are excellent refuges from the fierce sun of India, and many early shrines were cut into the relatively soft volcanic rocks, especially the Western Ghats of the ▽ Deccan. Natural caves were not unmodified. The early sequences (*about* 200 BC–AD 200) at Bhaja, Pitalkhora, Karle, and Kondane for example, are cut virtually as sculptures of vast timber buildings which once existed, but are now all destroyed by India's extreme climate. They are ▽ Buddhist preaching halls, each containing a rock-cut □▽ *stupa*, with small celled living-caves nearby for monks. The halls are vaulted and □apsidal, with aisles and ambulatory, the long axis at right angles to the rock-face. The façade is pierced by doors, above them a huge lattice-window shaped as a pointed horseshoe arch. This latter became a Buddhist architectural motif. Some earlier caves (3rd century BC) are known at Udayagiri, in Bihar. These are much smaller, and on far simpler plans. The most famous of the sets of caves is ▽ Ajanta. This was a Buddhist monastery, with twenty-seven caves, cut between about 220 BC and AD 600 into the curved rock-face above a bend in a river. Some of the living-caves are large, opening on to courts with two or three storeys. They are notable for the wall-paintings on plaster which survive, from the 1st century BC to the 6th century AD. These paintings, when copies were published in the West in 1896, were the first works to attract attention to the achievement of early Indian art. (*see* also Buddha and Buddhism pages 68–9.)

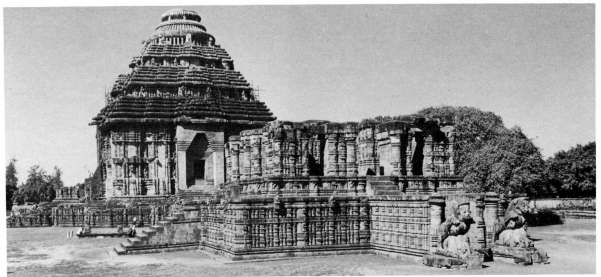

*Above:* The Black Pagoda, Temple of Surya, 13th century. Konorak, Orissa. Dancing pavilion in foreground
*Far left: Gandhara Buddha.* 2nd or 3rd century AD. h. 31½ in (80 cm). Private Coll, Switzerland
*Near left: Gandhara Buddha,* Hadda, Afghanistan. *About* 5th century. h. 11 in (29 cm). V & A, London
*Below:* Shore temple, Mamallapuram. 8th century

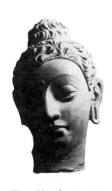

**Hindu Temples of the North.** The Northern type of
▽ Hindu temple evolved from a single stone cell with
pillared portico, the earliest examples of which belong to
the early 5th century AD, into splendid and elaborate
oramental stone buildings, the best of which date from
about AD 1000, the latest being the Black Pagoda at
Konarak, ▽ Orissa, left unfinished in about AD 1240. The
invasions of ▽ Islam interrupted development in the
North. The temple retained its fundamental pattern
throughout, which was determined by the ritual it housed.
The cell contained the central sacred object, perhaps
the image of a god, often a lingam (phallic emblem) of the
god ▽ Shiva. Visitors to the shrine would bring offerings
of food and flowers, which would be dedicated to the
god by the officiating priest, usually a Brahmin, and then
distributed to all those waiting outside as sanctified
'gifts'. The image would be cared for by the priest as if it
were a royal guest. Temples were usually dedicated by
members of ruling dynasties, so old capital cities often
have many shrines; Khajuraho, in Bandelkhand, a
famous centre, had over eighty, built between about AD
950 and 1050. An important temple might have added and
aligned with the cell up to three large halls, one for im-
portant visitors, one for other visitors and one for danc-
ing. The interiors might be elaborately sculptured. The
whole building would be raised on a plinth and crowned
by a curvilinear pyramidal tower. Around the exterior
would be sculptured figures of the gods and other in-
habitants of the heavens.

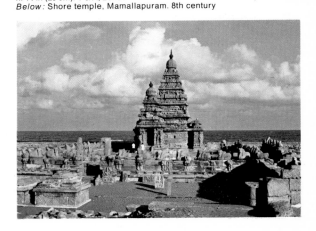

**Hindu Temples of the South.** Whereas in the north the
temple was treated as a single mass of masonry, and its
evolution was completed during the middle ages, the
evolution of the southern temple continued virtually into
modern times. The temple evolved through stages of
being a single masonry structure, into a combination of
main cell-hall block crowned by a pyramidal tower. By
the 10th century under the Cholas, this pyramid had be-
come enormous. But later evolution took place chiefly in
the ever larger enclosures which were built over the
centuries around already existing sacred shrines. These
were often lined with sculptured piers, with, in the centres
of their walls, progressively larger towered entrance-
gates (*gopurams*). The earlier, inner courts were then
often roofed, to provide halls and corridors used, for
example, as bazaars. Chidambaram and Madurai are
two famous instances. Superb bronze sculptures were
made for these temples from about AD 950 onwards.

# INDIA

**Buddha and Buddhism.** The living Buddha was a teacher who died as an old man about 485 BC in Central India. The religion he founded, Buddhism, spread to many countries of the East. The Buddha was not a deity, although he was looked on as the incarnation of Truth. His ideal image was therefore revered; and it was widely believed that the supernatural effectiveness of any newly made Buddha image depended upon its being close in type and measurement to ancient patterns. Hence Buddha images, derived from Indian prototypes at widely different places, resemble each other; though, naturally, stylistic differences did appear. The ealiest image known was probably cut at Mathura, early in the 1st century AD. Before that the Buddha's person was not represented in art, probably because it was felt impious to represent physically a being who had passed into ▽Nirvana. By the 5th century AD Buddha images were being made at shrines and monasteries all over India, ▽South-East Asia and elsewhere. Regional traditions were developed in Ceylon, Burma, Thailand, Tibet, Java and Cambodia, producing images in stone, bronze, even brick and plaster, many extremely large. The Buddha image is always characterised by an expression of deep tranquillity, a plumpness of body which expresses well-being and denies extreme asceticism, a posture of total relaxation, and by a set of thirty-two physical marks derived from ancient Indian astrological tradition. The most obvious of these are a protuberance on the top of the skull, hair-curls like snail shells, a tuft of hair between the eyes, webbed fingers, lotus marks on palms and footsoles, long arms, and genitals covered with a membrane. The main types of posture are: the Buddha either standing or seated with legs crossed, his hands making gestures of protection or giving; seated, teaching, or with one hand touching the earth; lying on his right side passing into Nirvana at the moment of his death.

Carved figure of Shiva, in the Elephanta Caves, near Bombay. 8th century. h. 18 ft (5·49 m).

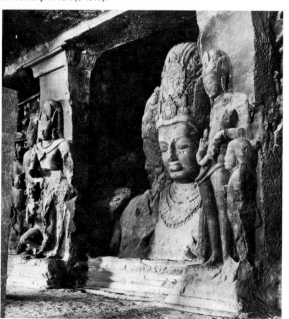

**The Gupta Dynasty** ruled northern India and the ▽Deccan between AD 320 and the mid-6th century AD. Under their rule a united Indian style achieved a high classical phase in all the arts, including music and drama.

No temples survive intact, but much sculpture which once formed part of temples, both ▽Hindu and ▽Buddhist, does. Hindu images of deities and heavenly beings are marked by a courtly elegance; their wigs, jewels and postures tend to over-elaboration.

Buddhist images are characterised by a smooth, sweetly suave surface of undulant, rounded modelling, with haloes decorated with lightly incised floral patterns.

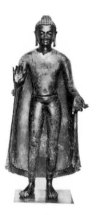
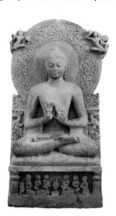

*Above left: Buddha.* Gupta dynasty. From Sultanganj. 5th–6th century. Copper. h. 88½ in (225 cm). Birmingham
*Above right: Buddha initiating the Buddhist doctrine.* Gupta dynasty. From Sarnath. h. 66 in (157 cm). Sarnath Museum
*Below: Enlightenment of the Buddha.* Gandhara style. *About* 2nd century. Freer Gallery of Art, Washington DC

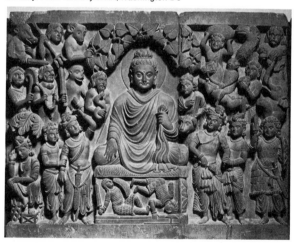

**The Gandhara Tradition.** In the 3rd century BC this north-western frontier area of India was dominated by Greek and other influences from Asia Minor. After the 2nd century AD it became an important Buddhist centre under the Kushans from central Asia.

Buddhist sculpture shows a marked late ▽Hellenistic influence. Figures wear classic toga-like garments. There are classical ☐putti, swagged garlands, classical nude torsoes and even scenes from Greek mythology among Indian iconography.

Gandhara art became the basis for the whole tradition of Far Eastern ▽Buddhist art.

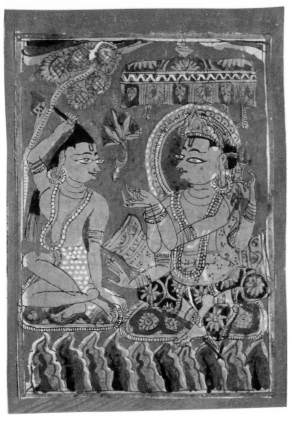

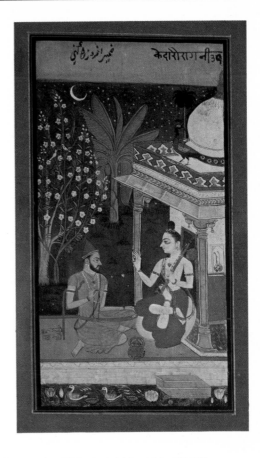

**Painting** as an art was very widespread in India. From literary sources we know that a high proportion of the millions of ancient public buildings and private houses, mostly made of wood and which have totally vanished, were lavishly decorated with secular painting and painted wood-sculpture. During the early city-civilisations of India (*about* 600 BC to AD 400) painting must have flourished, no less than in later times. The earliest painted house which survives is probably from the 16th century AD. But precious fragments of religious wall-painting on plaster are known from the ▽Ajanta caves (2nd century BC to 6th century AD), Bagh caves (*about* AD 500), ▽Badami caves (6th century), ▽Ellora (9th century) and Tanjore ▽Shiva temple (*about* 1000). They are, despite their religious subject matter, in sweet, sensuously rounded styles matching the contemporary styles of sculpture. Small-scale painting must also have been common. The earliest illuminated manuscripts on palm leaf, of ▽Buddhist texts, survive from north east India of the 11th century AD. They, too, match the styles of sculpture on contemporary Buddhist architecture, such as that at the great excavated University of Nalanda. A ▽Hindu style of painting on palm leaf survives in ▽Orissa from the middle ages; and from some unknown date in western India a manuscript style, first on palm leaf, then after about AD 1400 on paper, was used chiefly for texts of the ▽Jain religion. In ▽Rajasthan and central India a native style also existed, which combined in the 16th century with imported ▽Persian styles to generate the ▽Mughal and other Muslim styles, and the ▽Rajput miniature styles.

*Left: The Consecration of Mahavira* (miniature) Jaina MS. 1404. 3 × 4 in (7 × 10 cm). BM, London
*Above: Kedara Ragini. About* 1640. 9 × 5½ in (23 × 14 cm), V & A, London

**Rajput Miniatures.** These were produced at princely courts in ▽Rajasthan and the Panjab between the 17th and early 20th centuries. They are painted in body-colour, on paper, in bright colours and usually have a border of colour, most often a strong red. Some of them were designed as series, to illustrate a poetical text; others were made as individual works of art. They were small enough – rarely more than twelve inches in their largest dimension – to be kept in albums, and enjoyed by members of the court. The idea of the album miniature seems to have been imported into India from ▽Persia, where it had become popular during the 15th and 16th centuries, and combined with older traditions of native Indian manuscript illumination. The skills needed were disseminated in northern India under the ▽Mughal emperors, especially ▽Akbar (1556–1605), who maintained workshops of painters, and from Muslim courts in the ▽Deccan. Artists trained there found employment at the courts of Rajput nobles who sought to emulate imperial Muslim splendour. The commonest subjects were portraits of the rulers and their families, the legend of the Hindu god Krishna, aspects of love, and courtly pleasures, such as hunting. The chief centres for their production in Rajasthan were Mewar, Malwa, Jaipur, Jodhpur, Kishangarh, Bikaner, Bundi, Kotah, and in the Panjab, Guler, Kangra, Basohli, Kulu, Bilaspur, Jammu, Garhwal.

The *Jambudoipa Tantra*. Diagram of the universe with Mount Meru in the centre. Rajasthan. *About* 1800

**Tantric Art:** This is the generic name for a group of related cults of unknown age but considerable antiquity, which use art as a means of expressing metaphysical ideas in diagram form. These cults are common to the ▽Hindu, ▽Buddhist and ▽Jain religions. They flourished in India, Tibet and South-East Asia at different times. They are characterised by their use both of yogic techniques and of sex as a constituent symbol. Hindu Tantra, traces of which appear in literature of the 1st millennium BC and which still survives, pays particular attention to various forms of the goddess, as female generative agent of the indwelling principle of reality which is thought of as male. Buddhist tantra, whose earliest text is dated 6th century AD, symbolises its wisdoms and initiations in female forms whom the male initiate 'marries'. Tantra conceives the universe as generated for each individual by successive tiers or circuits of energies, which may be personalised as goddesses. These may also be condensed into potent syllables, called *mantras*. The individual may harness these energies by uttering the *mantras*, consolidating them by meditation within the forms of diagrams called *yantras*, as a means of returning his consciousness through a subtle system of channels within his body to its divine point of origin. *Yantras* may range from drawings on paper, diagrams on the ground, through to entire architectural complexes adorned with sculptured images of metaphysical principles.

**Pagoda and Stupa.** The *stupa*, also called *pagoda* in Burma, *dagoba* in Ceylon, *ceddi* in Thailand, still provides the focus of the Buddhist faith in any Buddhist establishment anywhere in the world. It can be of any size, ranging from a huge architectural structure at the centre of a Buddhist shrine to a miniature for personal contemplation. Its fundamental shape is a base, usually square, on which is set a drum surmounted by a dome. This in turn is crowned by a pointed, tiered finial, some-

times carried on a cubical die. The *stupa* symbolises the state of enlightenment and ▽Nirvana, the ultimate condition into which the ▽Buddha entered at his final passing away. In its earliest form, in northern India, soon after the Buddha's death, from the 5th century BC to the 2nd century BC, *stupas* were little more than domed ▽tumuli sheltering relics of the incinerated bodies of the Buddha and Buddhist saints. Reverence was paid to them by the Buddhist laity, who walked round each *stupa* clockwise. As time went on *stupas* were given plinths, stone cladding, raised railed pathways, high domes, a small railed enclosure at the summit and tiers of honorific umbrellas of wood or stone raised over the whole. The dome remains the essential feature even when the shape is condensed into, say, a high, pointed bell, as in Burma. Sculpture was often added, especially images of the Buddha facing one or more of the cardinal directions, and relief carving or painting illustrating scenes from his life and Buddhist legend.

**The Temple of Borobudur.** In Central Java stands this huge ▽Buddhist ▽stupa constructed as an artificial mountain in about AD 800 by an unknown king. It represents the culmination of a developing artistic tradition in Central Java, whose other chief monuments are Mendut, Kalasan and Sewu. Comparable ▽Hindu shrines are on the Djieng plateau and at Lara Jonggrang (*about* AD 900). Borobudur represents perhaps the most complete synthesis of Buddhist doctrine ever attempted in architecture. On a high plinth are ranged six square, walled terraces, each stepped out at the centre of all four faces, with a staircase running up it. The walls of each terrace are lined with continuous relief sculpture expounding the doctrine of the ▽Bodhisattva's (compassionate enlightened being) route to enlightenment. This route culminates on the three circular unwalled terraces at the summit, bearing 72 open stone lattice-work *stupas* each containing a Buddha figure, and a central larger *stupa* that contains a 'supreme Buddha'. The ascending levels, as they are experienced by the visitor, represent the transition from ordinary human spheres of existence at the base, up through a series of progressively higher levels of psychological insight, to the three realms of all-embracing truth on the topmost terraces, at the centre of which is found total enlightenment.

Temple of Borobudur, central Java. 8th century

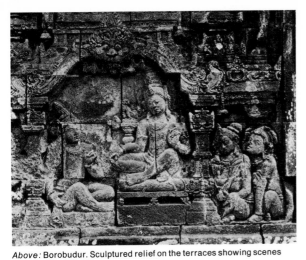

*Above:* Borobudur. Sculptured relief on the terraces showing scenes from the life of Buddha
*Below:* Pagan, Burma. Thon-Pyn culture. Complex of buildings. 11–12th centuries

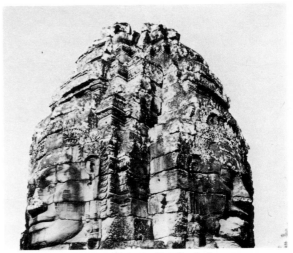

Detail of a 'temple-mountain', Angkor Wat, Cambodia

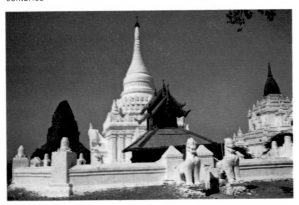

**The City of Pagan.** This old city contains the most complete set of medieval brick buildings still standing in Asia. It lies to the southwest of Mandalay, in Burma, on the Irrawaddy river, which has probably eroded part of the site. First constructed in about AD 849, from the 11th century to 1287, when it was overrun by invading Mongols, it was the capital of a region roughly the size of modern Burma, which was enriched by trade. About 1056 Pagan was chosen as new royal capital of the ▽ Buddhist kingdom, and thousands of craftsmen – mostly slaves – were gathered to build it. The hundreds of surviving buildings probably constituted a royal-religious complex, the population living outside. For the site comprises large bell-shaped Buddhist *stupas*, and shrines based upon modified *stupas*, which are surrounded by lesser buildings that were probably once royal palaces and pavilions later dedicated to monastic use as, for example, libraries and preaching halls. Some of the shrines and buildings are still in use. The materials were brick, faced with □stucco plaster, the latter being worked into decorative designs, and used as sculptural medium. Sculptured □terracotta panels, some simply □glazed, were applied, representing Buddhist legends, and many of the buildings contain remains of original wall-paintings. Pagan is thus a museum of medieval art-styles, especially those strongly influenced by contemporary northeast India, whose own comparable buildings have long vanished.

**The Angkor Complex.** The most colossal monument ever made by man, Angkor was a sacred city composed of artificial temple-mountains, reservoirs and canals built between about AD 880 and 1220 as the capital of the Khmer kingdom in modern Cambodia. The Khmer inherited from earlier kingdoms a superb native style of sculpture, but they developed their own stone architecture from Indian patterns. Angkor was the centre of a vast irrigation system under the control of the kings, each of whom built his own ▽ Hindu temple mountain, full of symbolic and decorative sculpture. The extensive Khmer empire was founded on this secure economic base. The temple-mountains were girdled with sculptured enclosures rising in tiers, and crowned by one large image-shrine, or a set of five, and were built of material excavated to make the reservoirs. Earlier mountains were demolished to make room for later. The most famous is Angkor Wat, the culmination of Khmer art (early 12th century), one of whose open colonnaded galleries contains over a mile of continuous superb relief sculpture. Angkor Thom, a new city enclosure of about AD 1200, is encircled by a moat ten miles long and has as its central shrine the vast ▽ Buddhist Bayon, with several miles of □relief sculpture. The many images in both stone and bronze of Hindu deities and Buddhas are in a distinctive evolving style of the highest aesthetic quality.

*Above:* Temple and Mausoleum of King Suryavaram 11, Angkor Wat, Cambodia. 1113–1150

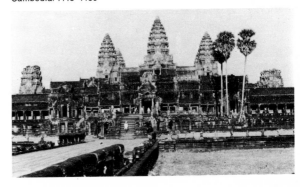

# JAPAN

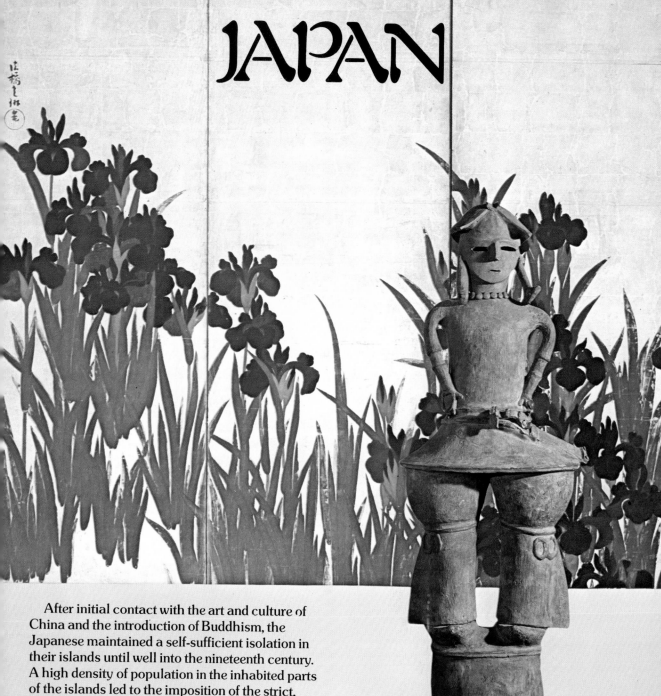

After initial contact with the art and culture of
China and the introduction of Buddhism, the
Japanese maintained a self-sufficient isolation in
their islands until well into the nineteenth century.
A high density of population in the inhabited parts
of the islands led to the imposition of the strict,
formal and ritually dominated social system and
code of behaviour.

This formality dominated the arts and crafts.
Every artefact was made with great care and
attention to detail, whether in weaving and
thatching, weapon-making and the practice of
fencing and archery, in calligraphy or flower
arranging. Not only the forms, but the act of doing
or making has a sharpness and clarity which, in
the code of the 'samurai,' the medieval warrior,
manifested itself as an unsparing ruthlessness
which anachronistically survived into the mid-
twentieth century.

It was this clear-cut formal aspect of Japanese
art which had such an appeal to those artists of

the late nineteenth century who were looking for
an alternative to both played-out academic art and
the apparent lack of definition in impressionism.

Japanese culture was wrenched overnight from
a medieval society into the industrial age, and the
long tradition in the visual arts was shattered. It
survives only in Japanese crafts, and has been
translated in the most extraordinary way into
Japanese film-making, and, most unlikely of all,
into engineering and manufacture, where a true
Japanese renaissance may be taking place.

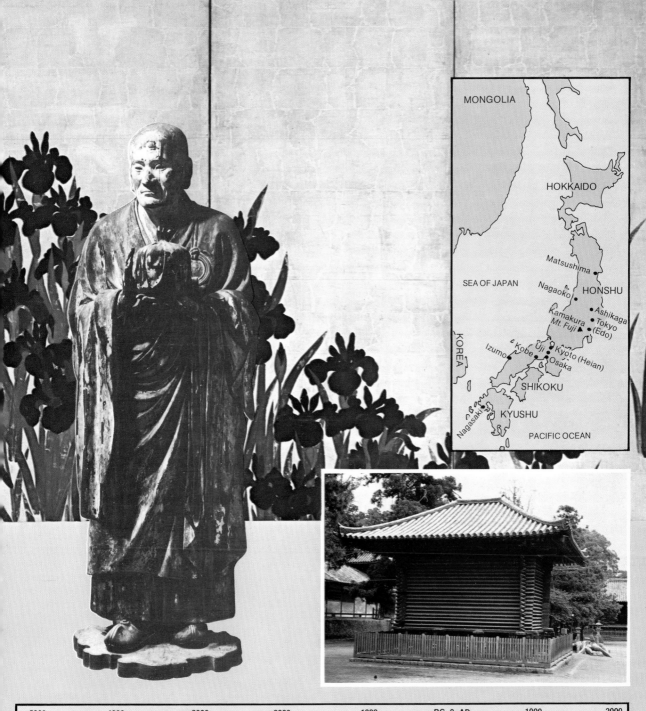

MONGOLIA

HOKKAIDO

Matsushima

SEA OF JAPAN

Nagaoko

HONSHU

Ashikaga
Kamakura · Tokyo
Mt. Fuji ▲ (Edo)

KOREA

Izumo Kobe Uji · Kyoto (Heian)
· Osaka

SHIKOKU

Nagasaki KYUSHU

PACIFIC OCEAN

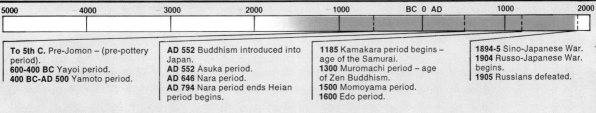

| 5000 | 4000 | 3000 | 2000 | 1000 | BC 0 AD | 1000 | 2000 |
|------|------|------|------|------|---------|------|------|

**To 5th C.** Pre-Jomon – (pre-pottery period).
**600-400 BC** Yayoi period.
**400 BC-AD 500** Yamoto period.

**AD 552** Buddhism introduced into Japan.
**AD 552** Asuka period.
**AD 646** Nara period.
**AD 794** Nara period ends Heian period begins.

**1185** Kamakara period begins – age of the Samurai.
**1300** Muromachi period – age of Zen Buddhism.
**1500** Momoyama period.
**1600** Edo period.

**1894-5** Sino-Japanese War.
**1904** Russo-Japanese War. begins.
**1905** Russians defeated.

# JAPAN

**Pre-Buddhist Art.** Before ▽Buddhism entered in AD 552, Japanese art had passed through two major productive phases. The earliest, the neolithic ▽Jomon, produced vessels and intensely expressive hieratic figures of coarse grey pottery. They have standing flanges, features are incised on faces, surfaces are mat-impressed and have raised and incised spirals. It is thought that the figures were associated with fertility cults. About 200 BC the Yayoi people began to push the Jomon people north. Then, after AD 200, the Kofun, or ▽tumulus period began. The tumuli were the graves of the aristocracy of united Japan. The major works of art produced then are called *haniwa*. These are red-buff fired clay figures, swiftly modelled hollow on pipe-like shafts, to be set around the tumuli of the important dead in place of the actual people and animals who had earlier been slaughtered to accompany their masters into the next world. The figures often convey a vivid expression of life and even individuality with their abbreviated modelling and hasty incisions in the clay.

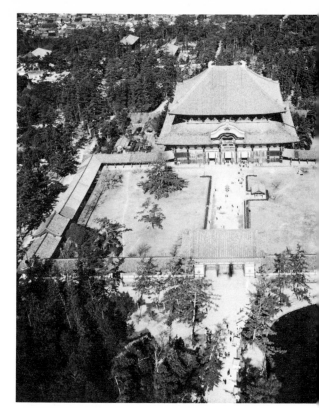

*Above:* Temple of the Great Buddha. Temple of Todai-Ji, Nara, Japan. 756–60

*Above left:* Jomon figurine from Saitama. h. 8 in (20·4 cm). Tokyo National Museum
*Above right:* Jomon figurine from Gumma. h. 12 in (31 cm). Private Coll. Japan
*Below:* The Phoenix Hall, Uji near Kyoto. Heian period. erected 1053

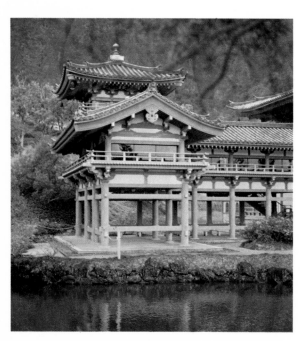

**Architecture.** Japanese architecture is of wooden post and lintel construction. Walls are relatively simple, and the chief visual focus is the complex gable roofing, together with its often elaborate cantilever wooden capitals. The earliest pre-▽Buddhist Shinto shrine-types, such as the Ise and Naiku, are raised on piles and have thatched roofs, showing affinity with South-East Asian examples. But, with the coming of Buddhism (AD 552) Chinese patterns became dominant, and many early buildings survive whose Chinese originals have vanished. Fine roofs have a characteristic delicate upward inflection at their corners and often concave gable-slopes, usually shingle or tile-hung. A type of 'log cabin' walling seems to have been used in the early Buddhist period, as certain major buildings survive with it, notably the Shoso-in at Nara, an 8th-century royal treasury. Buddhist monasteries contain the greater part of early architecture. The basic unit is a hall contained under a single roof-span, usually at balcony floor level, which may be very large, and is always beautifully proportioned. A monastery or palace consists of several such units, linked or enclosed by roofed walkways. In the 16th and 17th centuries the feudal nobility built huge castles, which were many-storeyed wooden towers raised on high stone plinths, often with five roof-levels, enclosing huge halls. Domestic buildings might run the roof units together, and subdivide the inner space with light wood and paper partitions as at the Katsura Imperial villa of the 17th century.

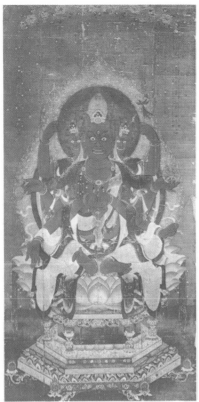

*Above:* Bato Kannon. Heian Period. 11th century. h. 65⅜ in (166 cm). Museum of Fine Arts, Boston
*Right:* Ban Dainajon scroll. 12th century

**Buddhist Sculpture.** Japan was the home, between the 6th and 16th centuries AD, of one of the world's greatest sculptural traditions. The forms of ▽ Buddhism first imported from Korea and China called for many large-scale icons of ▽ Buddhas and ▽ Bodhisattvas (compassionate enlightened beings) which were arranged according to a symbolic system in major shrines, especially at ▽ Nara and ▽ Kyoto. Korean and Chinese artists came to Japan, and it is probable that some of the finest earlier images were made by them; but many great Japanese masters are known. The materials used were bronze, which was very expensive and relatively rare, wood, either in the piece or made up of blocks fitted together, clay, and dry-lacquer. The last technique, using lacquer-stiffened fabric over a wooden frame and lacquer paste to model, produced light figures which could easily be carried out of a shrine to escape fire or earthquake. All the figures were often either gilded or coloured, and set into brilliantly cast, carved or carpentered frames, so that their effect matched the descriptions of supernatural cosmic groups of beings in the standard Buddhist texts. Among the most important works are the black bronze triad in the Yakushi-ji temple, Nara (7th century), a Kannon Bodhisattva with other figures in the halls of the Toshodai-ji temple, Nara (8th century) and many icons in the Tachibana-dera, the Byogo-in, the Kyoogoku-ji and Karyu-ji at Kyoto (9th–12th centuries). The most famous individual masters are Unkei and Kaikei, of early 13th-century Nara.

**Yamato-e Painting.** This means 'Japanese style', and was applied to painting derived actually from ▽ T'ang dynasty Chinese work, but long naturalised in Japan, to distinguish it from the imported austere black monochrome ink painting which was being adopted officially by the new military dictatorship of the Shoguns of ▽ Kamakura after 1192 (*see page 76: Zen painting*). The *Yamato-e* had been very much a court style, using large quantities of gold and brilliant colour. It emphasised figures, rather than landscape. One of its chief manifestations had been in the lavish representation on hanging scrolls and screens of ▽ Buddhist deities and scenes for the great monasteries patronised by the Heian dynasty of ▽ Kyoto. They paralleled the superb large-scale symbolic Buddhist sculptures housed in the major shrines of these monasteries (*see* Buddhist Sculpture). Another major type of *Yamato-e* was the illustration of ▽ story scrolls containing literary classics such as the world-famous *Tall of Genji*; but it was also applied to decorate palace walls and screens, musical instruments, furniture and lacquer wares, which again were modelled on original Chinese T'ang pieces. After the Kamakura regime began its dictatorship, *Yamato-e* survived as the court style of the retired emperors, carried out especially by the ▽ Tosa family of artists.

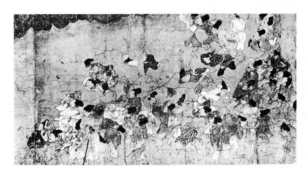

**Story Scrolls: Emakimono.** This is perhaps the most characteristic and interesting type of Japanese painting, a product primarily of the ▽ *Yamato-e*. Painted book-scrolls originated in China; and ▽ Buddhist texts with separate illustrations were imported and then copied in Japan. The earliest surviving are from 8th-century ▽ Nara. As time went on the illustrations became, first, a linked series, pinctuated by text; then a continuous fluid design which was read, like Japanese script, from right to left. Individual scrolls may be up to 60 feet long, calling for sustained invention of a high order. Many *emakimono* were produced for the imperial or provincial courts, and illustrated courtly stories with a compartmented sequence of scenes; the figures epitomise contemporary chic, are coloured mainly in pale blue, green, black and gold, and are set in architecture with the roof removed, shown in isometric projection. In the great Buddhist monasteries, many were also made in vivid narrative styles free from the burdens of courtly convention. Buddhist legends, even satires on Buddhism, were filled with hundreds of lively figures in vigorous action. A great series of historical scrolls, the Ban Dainagon series, represents the epitome of the type (12th century). Good *emakimono* continued to be painted by ▽ Tosa artists well into the 16th century.

# JAPAN

**Zen Painting.** The technique of monochrome ink painting, along with the ▽ Zen (Ch'an) form of reformed Buddhism, was adopted as the official style by the strict military dictators of the ▽ Kamukura regime at the end of the 12th century. This artistic austerity was seen as a counterpoise to the luxury and moral licence associated with the ▽ *Yamato-e* which had led to appalling civil wars. Major works by Chinese Zen painters, notably ▽ Mu-ch'i, and ▽ Liang-K'ai were imported, and are still treasured. Monochrome ink (*suiboku*) had been known in the 10th century, but its implications had not been realised. By the 14th century its impact was fully felt in Japan. The exponents of Zen were hardy monks, and the Samurai military aristocracy adapted Zen teaching to their military skills. *Suiboku* painting had been developed by the scholars of ▽ Sung China, then adopted as the abbreviated expression of instantaneous Zen insight. The immediacy of its bare brushstroke and rough ink-wash on plain paper well reflected the new Samurai ethic, and many of the greatest Japanese exponents were of Samurai caste. The greatest names are Shubun (1423–48), ▽ Sesshu (1420–1506), Soami (1472–1525), Tohaku (1539–1630) and the swordsman Niten (1584–1645). The work of the ▽ Kano school owed much to Zen *suiboku*; and the practice of abrupt minimal ink painting survived in Zen monasteries, as Zen-ga, into the 20th century.

**The garden art of Japan** is infused with a love of nature that grew out of ancient reverence for the spirits of the countryside, and pre-Buddhist worship of sacred places among the mountains and forests, and on the seashore. Already in the ▽ Tumulus period (*about* AD 250–452) literary and archaeological records suggest that gardens were appreciated. By the 8th century palaces and monasteries had carefully cultivated symbolic gardens. The art was profoundly influenced by Chinese ▽ Taoist religious ideas, which saw landscape, either painted or constructed, as an emblem of the hidden working of the principles of nature. It was, however, under the influence of ▽ Zen Buddhism (*see* Zen painting) that garden art reached its peak. Careful arrangements of rocks, shrubs, trees, watercourses either actual or of gravel, bridges and pavilions were meant to induce profound spiritual experience, and were derived, like the painting, from Chinese prototypes. No early gardens survive in China, whereas many do in Japan, notably in Zen monasteries, dating from the 14th and 15th centuries. Famous examples are in the Saiho-ji and Tenryu-ji, ▽ Kyoto; and the greatest of all, perhaps, are in the Daitoku-ji and Ryoan-ji, also in Kyoto. Some of the finest compositions are attributed to major painters of the time. The Sento and Katsura Imperial palaces also contain gardens of the 16th and 17th centuries.

**The Kano School.** Kano Masanobu (1434–1530) was the first of a family of painters who served the Muromachi military dictators and aristocrats of Japan as official court artists. The disturbed times caused the nobility to build castles – huge timber structures towering on high stone plinths. Their vast halls and corridors were filled by the Kano painters with painted panels and screens, some up to 150 feet long. The artists developed

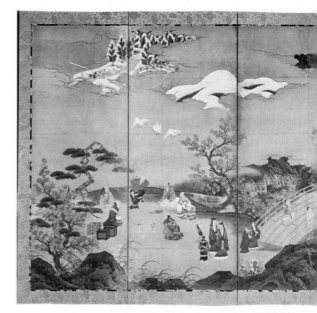

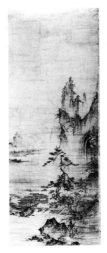

*Above:* The Zen Garden at the Temple of Rioanji, Kyoto
*Left:* SHUBUN *Landscape.* Mid-15th century. Hanging scroll. Ink on paper. 35 × 13 in (89 × 33 cm). Seattle Art Museum
*Below left:* NITEN *Shrike on a Barren Tree.* Hanging scroll. Ink on paper. 49½ × 12½ in (125 × 31 cm). Tokyo National Museum

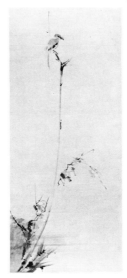

KANO HIDEYORI *Maples at Takao*. Tokyo National Museum

a swift and flamboyant style, derived from and combining the monochrome ▽Zen painting of ▽Sesshu and elements from the ▽*Yamato-e*. The subject matter embraced all the themes which had been absorbed into the Japanese tradition – trees, flowers, birds, rocky landscapes, legendary Chinese emperors, and the sages of Chinese tradition, including ▽Buddhist saints. Kano Eitoku (1543–90), perhaps the greatest and most prolific of the school, was the great grandson of Kano Masanobu. He trained and employed scores of assistants, including his own sons. A branch of the school settled in ▽Kyoto; and others went to work in ▽Edo, and helped to found the ▽*Ukiyo-e* tradition.

**Sesshu** (1420–1506) is generally regarded as Japan's greatest painter and exercised a potent influence on all later artists, especially the ▽Kano school. He was a ▽Zen monk, and went to China in 1467 for over two years; he records that he gained great honour there for his superiority over native painters in the Zen style of landscape, and decorated an official building in Peking. He assimilated and developed all the Chinese monochrome ink techniques, and evolved an angular and vigorous personal brush-style in which he was able to carry out extended designs, full of magnificent □formal inventions. Returning in 1469 Sesshu settled at Oita in Northern Kyushu, in a beautiful studio with expansive views, being patronised by nobles and commoners alike. As a monk he executed ▽Buddhist paintings, as well as both elaborate and abbreviated "splashed' landscapes. From 1481–4 he travelled in Japan, making some of the earliest Japanese topographical pictures, then settled again at Yamaguchi. He had many direct pupils, the most interesting being Sesson (1504–?1589), a lonely eccentric who painted harsh, dark pictures.

*Opposite bottom right:* SESSHU *Ama-no-hashidate*. Early 16th century. $66\frac{1}{2} \times 35\frac{1}{2}$ in (163 × 90·2 cm). Kyoto National Museum

HIROSHIGE *The Inside of a Teahouse with a view of the Sea*. Early 19th century

**The Tea-Ceremony** (*Cha-no-yu*) was developed in Japan as a social-religious and aesthetic custom first of all by the ruling military aristocracy probably during the 14th century, later being adopted by the merchant classes of ▽Edo (modern Tokyo), especially the women (*see* page 78: *Ukiyo-e*). It derived originally from the normal ceremony in the Chinese ▽Buddhist monastery when a visitor was welcomed into the tranquil environment with a bowl of tea, and absorbed the atmosphere of transcendent peace communicated by the simple wooden tea-hut, the modest black ▽Fukien peasant pottery and the disciplined gestures of the monks. All these aspects were transplanted to Japan, formalised and made into the object of an aesthetic appreciation. Tea-houses were built in gardens, containing an alcove (*tokonoma*) where one special painting might be hung and a symbolic flower-arrangement set out with superb art. The serving itself was a high art, with its master executants. The invited guests had to remove all marks of rank, and were supposed to be transported spiritually away from the claims of status-conscious Japanese society. Painting, flower-arranging and ceramics were made to accord with this spirit. The tea-bowls and dishes especially became the object of intense artistic effort, their forms being rough, subtly coloured, and grateful to the hands. Kenzan (early 18th century) was the greatest master.

# JAPAN

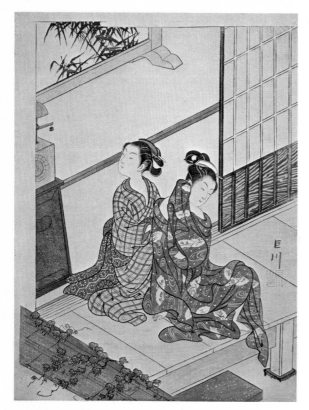

HARUNOBU *The Evening Bell of the Clock. About* 1766. Art Institute of Chicago

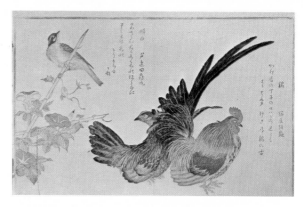

UTAMARO Cock and hen on a bamboo shoot from *Birds Compared in Humorous Ditties. About* 1791. BM, London

**The Floating World: Ukiyo-e.** This was a type of art produced primarily for the population of the new mercantile capital ▽Edo (Tokyo) from the 17th century to the mid-19th century. Edo was made capital in 1603 by the new military dictator Ieyasu, founder of the Tokugawa regime. At this time a great growth of popular arts took place, including romantic and picaresque novels, poetry and Kabuki theatre, and a whole quarter of the city – the Yoshiwara – was devoted to pleasure. A galaxy of visual artists grew up working outside the strict conventions of earlier art. Their subject matter dealt primarily with this world and its pleasures, rather than the ▽Buddhist themes of earlier art; hence in accordance with Buddhist teaching of 'emptiness' it is called 'floating world' art. Splendid kimonos were woven; panels, screens and scrolls were painted for the aristocracy and merchants in outline and bright colours; and the famous □woodblock prints were made for the less wealthy. Among the great painters of the period were Korin (1658–1743) and Sotatsu (first half 17th century), who both painted screens and fans, using much gold. Marugama Okyo (1733–95) introduced a new so-called 'realist' style into screen-painting, perhaps influenced by European art. Among the great names of the woodblock print are Kaigetsudo Ando (17th century), Marunobu (?1618–94), Harunobu (1725–1770) who developed the multi-colour print, Koryusai (18th century), ▽Utamaro (1753–1806), Kiyonaga (1752–1815), ▽Hokusai (1760–1849) and Hiroshige (1797–1858). All worked for publishers of books, as well as designing the better-known single prints, many of which are erotic.

**Utamaro** (1753–1806) is generally regarded as the doyen of ▽Ukiyo-e print masters. He produced only a few paintings, devoting himself to the multi-block colour print and illustrations. He studied with Sekien, alias Toyofusa, as a young man in ▽Edo (Tokyo), and was taken into the household of the publisher Tsutaya Juzaburo, a wit, poet and helper of promising artists, who published his early work. He began by specialising in beautiful women in the manner of Shigemasa and Kiyonaga; then drew and painted nature – albums of birds, insects and fish. After a great personal loss in 1790 his art took a new turn; he developed his personal type of female beauty, large-bodied, soft and strong, executed in circling sensuous lines. He projected this type into the illustrations of many Japanese legends, pictures of courtesans, fisher-girls and erotic scenes. After 1793, with his reputation at its peak, he worked for many publishers. Much of his best work was done in the 1790s, though he is often said to have overworked his talent. Technically his prints are always superbly conceived, incorporating such devices as transparent gauzes and subtly cut-away figures.

**Hokusai** (1760–1849) is the ▽Ukiyo-e artist perhaps best known in the West. He signed himself 'the old man mad about painting'. His production was continuous and immense, and he is said to have executed over thirty thousand designs. At one time or another he worked in all modes of *Ukiyo-e*. Early on he produced conventional prints of girls, legends and animals, and his slender, wistful women had a vogue in the 1790s. He illustrated a vast number of books, including novels and travel guides, his illustrations being valued more highly than the texts. Hokusai's unique achievement came from the extraordinary life and freedom of brushwork. This was epitomised in his *Mangwa* series of volumes begun in 1814, which were virtually block-printed sketch books, without text, filled with pages of figures, animals, scraps of landscape and visual jokes, that convey his deep appreciation of humanity in all its aspects. His famous *Thirty-Six Views of Mount Fuji* (1820s) and three volumes of *The Hundred Views* are the work by which he is best known in the West; the latter was issued in 1880 in London, and greatly influenced European artists. The majestic sweep of these landscape designs are all punctuated by glimpses of struggling humanity.

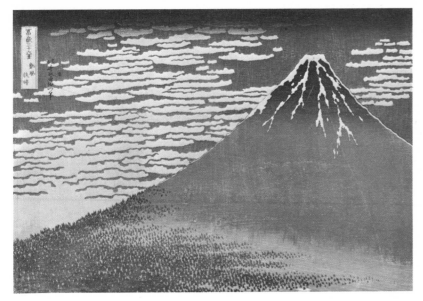

*Above:* HOKUSAI *Red Fuji.* Early 19th century. *About* 10 × 14 in (25·4 × 35·6 cm). BM, London

*Above:* Porcelain ewer with dragons. Ko-Kutani ware. Late 18th to early 19th century. V & A, London

**Netsuke** are toggles made usually of wood, bone, ivory or metal and less than 2½ inches across, which were fastened to the ends of the cords upon which various objects worn by Japanese men were hung. The toggle was tucked up through the sash to stop the cord pulling out. The objects carried on the cords might be tobacco pouches, or *inro* – small partitioned boxes for herbs and snuff, often very finely lacquered and inlaid. *Netsuke* were made chiefly between the later 18th century and the 20th century although earlier examples are known, among them Chinese ▽ Ming dynasty miniature ivories. There were several types, all carved into an extraordinary variety of subjects from Japanese and Chinese legend – humans, demons, animals, birds, figure groups, landscapes, for example. They were treated as items of personal jewellery, and embody a whole tradition of lively miniature sculpture. Carved by professionals, many of them are signed; some of the artists were also distinguished sculptors, painters or swordsmiths. At first they were not highly valued in Japan and a great many were allowed to leave the country. But since they have been widely collected and valued in the West, Japanese interest has grown. The design has to be compact, without protuberances to be damaged, and high art is needed to produce such a vivid sense of life. Conflict of scale is often used, as for example when a mussel-shell *netsuke* contains a tiny house with inhabitants.

**Ceramics.** The earliest pots belong to the ▽ Jomon period. By the 8th century, however, glazed ceramics based on Chinese ▽ T'ang dynasty wares seem to have been begun. At Seto ash-glaze and green glaze wares were made of modest form, for lacquer ware was then highly esteemed. After about AD 1100 Seto's industry increased, and in the 13th century a series of Zen monks

*Above left:* Ivory netsuke of Jo and Uba. BM, London
*Above right:* Olimono showing five samurai. BM, London

aided the assimilation of Chinese ▽ Sung techniques, especially celadon, and black and brown ▽ Fukien wares. Seto became famous for the latter. Until the 16th century Chinese wares were preferred for the ▽ tea ceremony; but then the aristocracy began to patronise Seto tea-potters extensively. Korean wares also made a great impact on Japanese ceramics, and immigrant potters settled, notably in Hizen province, where Karatsu wares flourished especially in the 17th century, and in Satsuma in the South. Japanese wares evolved a great variety, some of them analogous to Chinese types of under- and overglaze enamels, for example Arita Kakiemon versions of Chinese ▽ Famille Verte, 17th century. Others developed idiosyncratic types such as Satsuma cream crackle-glaze with brilliant flower and figure enamels, Imari blue and red on white (18th–19th centuries), polychrome Kutani and Nabeshima (18th century) with splendid blazon designs.

# EARLY CHRISTIAN AND BYZANTINE SOCIETY

Christianity was accepted as a recognised religion (not *the* only recognised religion) within the Roman Empire just as the divided Empire was on the verge of breaking up. The result was that early Christianity developed two churches, one Greek, based on Constantinople/Byzantium, and the other Latin, centred on Rome.

The influence of the Judeao-Christian tradition is so strong today in Western civilisation, in spite of growing secularisation, that its social origins are entirely taken for granted. Nevertheless it was the Roman civic and imperial organisation that gave Christianity a ready-made system of communication to enable its phenomenal growth and spread in three generations from a handful of Jewish heretics to a socio-religious system that has come to dominate the Western world and provide one of the great faiths of mankind.

In the West, the peoples of the broken Roman Empire still continued to regard themselves as heirs of a great power, even though reduced to a single walled city (Rome), and later the barbarians (Goths, Vandals etc.) continued to be crowned Emperors of Rome.

In the East the Byzantine Empire was more of a reality. In spite of constant war, internal and external, under constant pressure and invasion both from Europe and from Islam, the Empire remained the richest and most powerful single entity, outside Asia, for five hundred years, maintaining the resources for patronage of art and architecture on a large scale.

# EARLY CHRISTIAN AND BYZANTINE

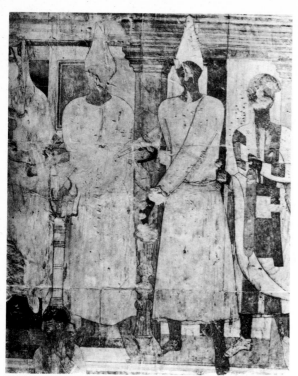

Old testament Cycle. Fresco. Dura-Europos, Syria. *c.* AD 256

**The Catacombs.** The spread of Christianity from its birthplace in the eastern Mediterranean took place under the domination of Europe and Asia Minor by the ▽Roman Empire. Christianity was a minority religion, which did not conform to the standards of emperor-worship promoted by the officially recognised pagan cults. As a result, Christians had to be unobtrusive, using ordinary houses for their meetings and services, and developing an art which symbolised rather than described their faith. One of the best surviving examples of an early Christian church was discovered earlier this century at Dura-Europos on the River Euphrates. Now in Syria, Dura-Europos housed a Roman garrison which was beseiged by ▽Sassanians in AD 256. Within an ordinary town house, the Christian community built a baptistery, with a large bath in which converts could be immersed. The walls were decorated with scenes from the Old and New Testaments, in a style which drew from both Roman and Jewish sources.

In Rome itself, evidence of early Christianity survives in the catacombs, abandoned quarries used as underground burial chambers. These have become associated with the persecution of Christians, as places of refuge, although they were built and maintained as cemeteries in which the system of subterranean corridors with their rows of *loculi* was an effective way of making the best use of restricted space. In the more ambitious catacombs, crypts or small chapels were constructed and decorated with appropriate symbols and scenes. The figure of the Good Shepherd, a beardless figure derived from the Classical figures of Pan and Orpheus, was a favourite subject, together with scenes of the Old Testament such as Noah in the Ark or the three Hebrews in the Fiery Furnace which prefigure Salvation through Christ.

**The Age of Constantine.** In 313, the Emperor Constantine issued the so-called Edict of Milan, which established Christianity as one of the official religions of the Roman State. Recognition led to the building and decoration of churches on an unprecedented scale. In Rome itself, Constantine began the erection of ▽St Peter's basilica and granted land to the Bishop of Rome for the building of the basilica of St John Lateran. In Jerusalem as a result of excavations to find the tomb of Christ, the church of the Holy Sepulchre was built, and in Bethlehem a sanctuary was constructed over the supposed site of the Nativity. Above all, in his new capital of ▽Constantinople the Emperor identified the Roman Empire with Christianity.

**Early Christian building.** The newly reorganised church adapted existing architectural forms, and sometimes actual buildings, to its own needs. The sanctuary, built to enshrine a relic or the tomb of a martyr, followed the centralised plan often found in Classical architecture (*see* Pantheon). The 4th-century Church of ▽Santa Costanza in Rome, for instance, was built originally not as a church, but as a □mausoleum for one of the daughters of ▽Constantine. The most important architectural source was the civil □basilica, a rectangular pillared hall with three aisles, capable of enclosing a large, unobstructed space. As a church the entrance was placed in the short, west wall. The central aisle, or nave, was usually broader and higher than the flanking aisles, allowing clerestory windows above the colonnades, and there was a raised apse at the east end. The 5th-century basilica of Santa Sabina in Rome admirably demonstrates these essential features, and contains fine examples of Classical columns and capitals, salvaged from an earlier building. It was from this simple pattern that ecclesiastical architecture in the West developed over a period of a thousand years.

The Throne of Maximian. 6th century. Metropolitan Church, Ravenna

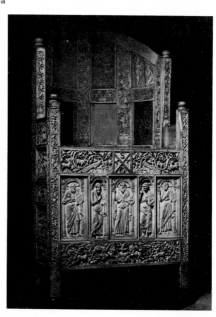

# The Beginnings of Christian Art

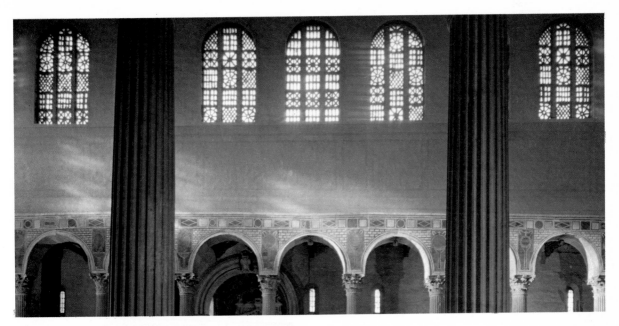

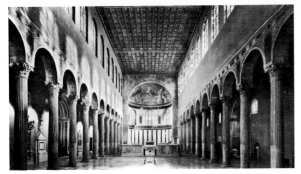

*Above:* Sta Sabina, Rome. AD 425. Interior view of the nave
*Left:* Sta Sabina. View along nave

*Below:* The Annunciation and Visitation. Coptic textile roundel. 6th century. V & A, London

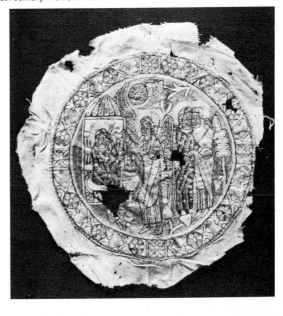

**Early Christian Carving.** It is important to remember that when Christianity joined the pagan religions as their equal it was dependent upon the same craftsmen, the same tools and the same techniques for its works of art. It is hardly surprising that there are so many examples of Classical survival in the early Christian period. Like pagans, Christians often placed their dead in marble coffins or *sarcophagi*. Traditionally, the Roman *sarcophagus* was decorated with tritons, nereids and other appropriate symbols of eternity, many of which could be adapted for use on Christian *sarcophagi*. On the 4th-century Sarcophagus of Adelphia from Syracuse, the deceased are shown in a shell-patterned roundel common to pagan monuments, but surrounded by a complex arrangement of Biblical scenes. In the 5th century the realistic modelling of the Classical tradition was to give way to a flatter and more linear treatment of form. The 6th-century Throne of Maximian at Ravenna demonstrates these two tendencies in Christian art. St John the Baptist and the Four Apostles are, in contrast with the remaining panels of carved ivory, deeply cut to achieve three-dimensional form. The 6th-century figure of the Archangel Michael from the eastern Mediterranean, with its freedom of pose and flowing draperies, shows that in provincial centres the old Classicism lingered in spite of the more abstract style which was spreading outwards from Rome.

**Art of the Coptic Church.** In the 5th century Egyptian Christians, known as the Copts, formed an independent Church. Their art was similarly local and distinctive. Its concern with surface decoration led, in stone-carving, to the elimination of natural forms in favour of intricate stylised patterns. It was in textiles however that these tendencies found their fullest expression. The scenes of the Annunciation and Visitation are combined in a 6th-century embroidery in a single roundel with decorated borders. It contains no suggestion of depth; the figures are arranged on the flat surface of the textile, boldly outlined and brightly coloured to create a striking two-dimensional design.

# EARLY CHRISTIAN AND BYZANTINE

**Byzantium: The Golden City.** The ancient fortified city of ▽Byzantium was chosen by the Emperor ▽Constantine for his new capital by virtue of its important strategic position, bridging the two worlds of East and West. Known as both the 'new Rome' and ▽Constantinople, City of Constantine, it was inaugurated in AD 330, and survived as a Christian capital until it fell to the Turks in 1453. Before the end of the century, however, Constantine's empire had been divided between his successors into East and West, a split which Christianity reflected in the divergence between the Orthodox and the Roman Churches. The art and architecture of the eastern Church is generally referred to as Byzantine to distinguish it from other Christian art. This distinction, which is of use in later periods, hardly applies to Early Christian art in which an overall unity prevails. Also Byzantine art, which by comparison with Western art from the ▽Renaissance onwards appears stylised and conservative, has been identified with those characteristics in retrospect. Actually the reverse is often the case in the Early Christian period; ▽Hellenistic elements survived in the art of Greece and Asia Minor rather than in Italy where Classical traditions were not always to the tastes of barbarian settlers from the north. When the Emperor ▽Justinian ordered the reconquest of Italy, he did so in an attempt to reunite Christendom and to reconstruct a single Roman Empire.

**The Early Eastern Church.** The dome is the most prominent architectural feature of the Eastern church. From the 5th century onwards, the centralised plan derived from Classical ▢mausolea was favoured in the East, and thus provided, with its crossing where the four short naves intersect, the opportunity for a dome. The most spectacular example of this type of building is ▽Santa Sophia, or the Church of Holy Wisdom, in ▽Constantinople, where a further refinement was added to the central dome in the form of two half-domes of the same diameter to extend the square of the plan into a rectangle. The church was designed by Anthemius of Tralles and Isidorus of Miletus for the Emperor ▽Justinian, who built it (532–37) to replace an earlier church erected by ▽Constantine and destroyed in the civil war of 532. The main dome is 108 feet in diameter and rises 182 feet from floor to crown. It rests upon four arches and is pierced by forty windows. The overall impression is of a vast, uninterrupted space filled with light, enclosed by soaring architecture above which the massive dome appears to float. When Justinian entered the completed church he is supposed to have said, 'Solomon, I have triumphed over you'. Indeed Santa Sophia must rank as one of the greatest architectural achievements of all time; it recalls on the one hand the buildings of ancient Rome, and anticipates on the other the domes which adorn some of the principal monuments of the ▽Italian Renaissance.

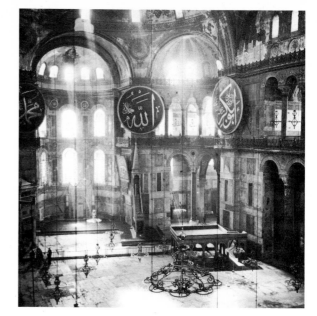

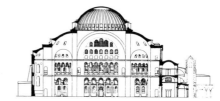

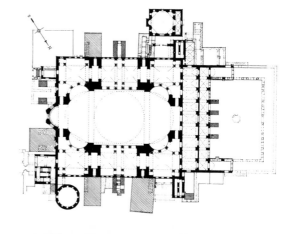

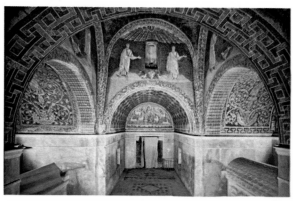

*Top and centre:* Santa Sophia, Istanbul. 532–6. Interior, elevation, and plan
*Bottom:* Mausoleum of the Empress Galla Placidia, interior mosaics, ; second quarter 5th century

**The Flowering of Ravenna.** At the beginning of the 5th century, Honorius Flavius, Emperor of the West, established ▽Ravenna as his capital. During the ▽Justinian conquest, it became the capital of the exarchate, or ▽Byzantine State in the West. As a result of its sustained importance as a civil and religious centre, the buildings of Ravenna offer a unique opportunity to study the development of Christian architecture of the 5th and 6th centuries under successive waves of Eastern and Western influence. The so-called □Mausoleum of the Empress Galla Placidia, who built it as a Chapel of St Lawrence in about 425, after the deaths of her husband Constantius III and her brother, Honorius, represents the simplest form of the centralised plan, in contrast with ▽San Vitale, a more sophisticated exercise in the same form begun soon after 525 by Archbishop Ecclesius who, like Galla Placidia a century earlier, had returned to Ravenna from Constantinople. The 5th- and 6-th century Churches of ▽Sant' Apollinare Nuovo and ▽Sant' Apollinare in Classe follow the familiar Roman pattern of the □basilica, with two aisles divided from the nave by columns and a semicircular □apse.

**Decoration and Worship.** The capitals of ▽Sant' Apollinare Nuovo in Ravenna bear, in spite of a certain stylisation, a familiar resemblance to ▽Corinthian capitals like those in Santa Sabina, Rome. If we compare them with capitals in ▽San Vitale, Ravenna, however, we are confronted by a far more radical change. The high-relief carving of the Classical capital has been superseded by a simple profile and flat sides ornamented with lace-like patterns. The blocks inserted between the arches and the capitals exaggerate the geometrical severity of the outlines. Structurally they concentrate the weight of the arches on to the column shafts, but visually they lighten the upper wall by dramatically cutting away its mass. The effect, like many of the details, may be compared with the ▽Justinian churches of ▽Constantinople, in particular with Saints Sergius and Bacchus (AD 525). A concern for the decoration of the surface informs the whole of the interior of San Vitale. Marble inlay, mosaic and shallow carving all emphasise the importance for its designers of two-dimensional patterning.

**Religion without Art.** In 726, the Emperor Leo III removed the figure of Christ from the gates of the Imperial Palace and replaced it with a cross as a protest against the literal worship of images. This act began the image-breaking (iconoclastic) controversy which for more than a century and with varying force, prohibited the making and worship of images. It was opposed in Italy by the Pope, whose links with ▽Charlemagne, together with Lombard aggression, served to weaken Imperial authority in the province. In the East, however, iconoclasm led to the destruction of numerous works of art and church decorations in which divine figures were represented. □Apsidal □mosaics depicting □Christ Pantocrator ('Ruler of All') were especially vulnerable; many were demolished and replaced, as in the Church of Santa Irene, Constantinople, by simple crosses. It has been argued that a decline had set in to artistic produc-

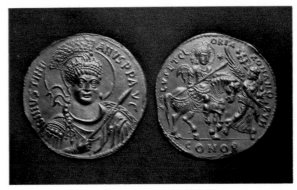

*Above:* Gold coin, from the reign of Justinian. 527–65

*Below:* S. Vitale, Ravenna. View of the apse. second quarter 6th century

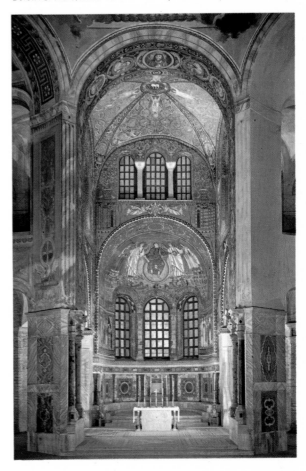

tion in the 7th and 8th centuries which iconoclasm merely accelerated. However, the success of the image-breakers has left little enough evidence on which to base a reliable assessment. In 843, the Empress ▽Theodora, acting on behalf of her son ▽Michael III, brought the controversy to an end. Appropriately the image of Christ was restored to the gates of the Imperial Palace.

# EARLY CHRISTIAN AND BYZANTINE

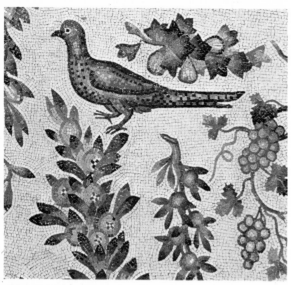

*Above:* Detail from the mosaic on the vault of the Ambulatory, Santa Costanza, Rome. Mid 4th century

**Method and materials.** Mosaic decoration consists of small pieces of stone, glass, tile, or enamel, called *tesserae*, arranged to form patterns or pictures and cemented together into a flat surface. The Romans composed elaborate pavements in this way, but there is little evidence of wall mosaics before the 4th century. The process was a laborious one: teams of craftsmen worked over considerable periods of time to assemble decorations which were often vast in scale. As a result, many of the great mosaics are timeless and impersonal; qualities ideally suited to the sacred subjects of which they are powerfully expressive. The earliest Christian mosaics are directly comparable with contemporary pagan examples. In the Church of ▽Santa Costanza in Rome, the vaults are decorated with Bacchic scenes, with birds, foliage and fruit. Conveniently the peacock, whose form was undeniably decorative and whose flesh was thought to be incorruptible, could be justified as a Christian symbol.

*Below: Justinian and his Court.* San Vitale, Ravenna. 6th century

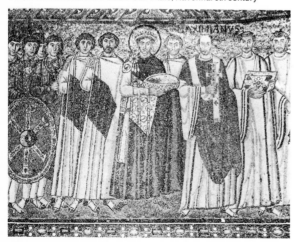

**Towards a Sacred Art.** The 5th-century mosaics in the nave of Santa Maria Maggiore, Rome afford comparison with Roman wall-painting. The modelling of the draperies in the narrative scene of Abraham and Lot is reminiscent of brushwork in the way in which it gives three-dimensional weight to the figures. Like the painters of ▽Pompeii, the artist responsible was interested in the creation of pictorial space. His figures stand upon firm ground, while behind them a recession is implied by the architecture and the distant view of buildings. At ▽Ravenna, the 5th-century mosaics in the ▽Mausoleum of Galla Placidia show similar affinities with Classical models. The figure of the Good Shepherd is somewhat stiffened and has lost the freedom of movement of Abraham and Lot, but he sits well back in a realistic space, divided from the spectator by a common illusionistic device, a broken rocky ledge in the foreground. The sheep are well modelled and shadows are implied by the shading.

A century later, in the presbyterium of ▽San Vitale, Ravenna, the famous mosaic portraits of ▽Justinian and his suite were installed, together with those, on the opposite wall, of the Empress ▽Theodora. To the right of the Emperor, identified by an inscription and holding a cross, stands the Archbishop Maximian. His head, like that of the Emperor and of the figure between them, is individually characterised. The life-size figures are placed on the wall so that they acquire a strong sense of reality. There is no implied recession of space to distance them from the spectator, just as no incidental detail is allowed to distract or compete with their fixed stare outwards. In a near-contemporary mosaic of the Transfiguration in the Church of the Virgin in the monastery of St Catherine on Mount Sinai, the figures of Christ and his Apostles are similarly flattened on to the curved surface of the ☐apse. Christ appears static and motionless in a central ☐mandorla, an icon with a fixed expression directed outwards towards the observer.

To return to Ravenna, the tendency of mosaic decoration towards the creation of powerful religious images can be seen in the presbyterium of ▽Sant' Apollinare in Classe. The saint stands in adoration of the cross, as a symbolic representation of Christ. The landscape around him is flat and schematised, with the sheep alternating with flowering shrubs in a symmetrical frieze at his feet. Beneath, the saints stand frozen into their shallow niches, designed with an eye for linear pattern and ornamental detail. The highly decorative effect of such a scheme should not obscure its meaning, however. It represents not the real world but a world of spiritual values in which every form has symbolic meaning. Above the cross of Sant' Apollinare, and on its axis are the hand of God and the dove, combining to symbolise the Trinity. To right and left, busts of Moses and Elias serve as reminders of the Transfiguration. The sheep symbolise the faithful; twelve of them, the number of the disciples, climb from the cities of Jerusalem and Bethlehem towards the uppermost representation of ☐Christ Pantocrator. On the side-walls left and right, nearest the spectator, are two full-length figures of the archangels, Gabriel and Michael, respective heralds of the first and second comings of Christ.

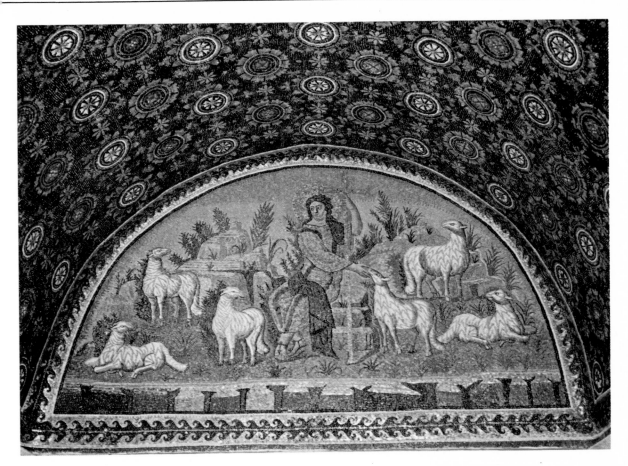

**The Great Revival.** Freed from the threat of iconoclasm, ▽Constantinople once again assumed the importance of a capital under the Macedonian dynasty. In the ▽Santa Sophia, a mosaic of the Emperor Constantine IX Monomachus and the Empress Zoë celebrates the bond which existed between the Eastern Church and the state. Originally Romanus III was shown, but his head was replaced and the inscription changed when Constantine IX succeeded him both to the throne and to the hand of Zoë. What is important is the relationship between the Emperor, whoever he may be, and the Divinity. He is shown bearing gifts to the left, the Empress to the right, of the seated figure of Christ, whose hand is raised in general benediction. Some of the finest mosaics of this period are to be found in the 11th-century monastery church of the ▽Dormition of the Virgin at Daphni. The roundel of □Christ Pantocrator there has long been recognised as a consummate work in which authority and omnipotence prevail. The mosaic of the Crucifixion in the same church is a masterpiece of restrained emotion. The face of the suffering Christ is impassive while the two witnesses, the Virgin and St John, maintain a quiet dignity in their sorrow. The 12th-century mosaics in the church of St Mark, Venice, are direct descendants of these earlier works. For several centuries, Eastern craftsmen were at work there, establishing Venice as the centre in Italy for the *maniera greca* (Greek style), as the ▽Byzantine style was called. The standing Virgin and Child in the apse of Torcello Cathedral is a work of the 12th century in which the

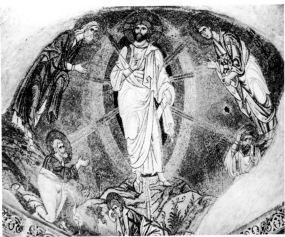

*Top: The Good Shepherd.* The Mausoleum of Galla Placidia, Ravenna. 5th century
*Above: The Transfiguration.* The Daphnian Monastery, Greece. 11th century

isolation of the figure is accentuated by the curving, reflective surface of the gilded □apse. Beneath her, the flat and rigid figures of the twelve Apostles with their sharp-edged draperies may be slightly earlier in date. They, too, reflect the art of Constantinople as it spread westwards during the 12th century. (*See* Index for further references to Mosaic.)

# EARLY CHRISTIAN AND BYZANTINE

**Byzantium: The Golden Age.** Basil of Macedonia became Emperor in 867, having procured the murder of ▽Michael III, and thus founded the Macedonian dynasty which survived for two centuries. Under his skilful rule, the fortunes of the empire revived and art and architecture, together with other cultural activities, benefited from the patronage of the Imperial court. Buildings were restored, the art of mosaic flourished (*see page 87*), as did those of ivory-carving and enamelling, while in the monasteries of the scholarly Emperor Constantine VII Porphyrogenitus (913–59) manuscripts were copied and illuminated. In its achievements, this period had been called the second golden age of ▽Byzantine art; second, that is, only to the time of ▽Justinian. Once again, we encounter one of those recurrent phases of Classicism in Byzantine art as artists looked to the past to provide a basis for the new Imperial style.

**Late Byzantine Painting.** Late derivatives from Russia and the eastern Mediterranean have encouraged the view that by the end of the Middle Ages, ▽Byzantine art had become dry and conventional. However, under the Palaeologue Emperors, who ruled until the final fall of ▽Constantinople in 1453, a late flowering took place in an artistic tradition which was already nearly a thousand years old. At the beginning of the 14th century, the results in mosaic and wall-painting in the small church of ▽Kariye Cami in Constantinople were remarkable. The iconography of Christ's Descent into Limbo is conventional but the sweeping composition and the dramatic movement with which Christ seizes Adam and Eve from their tombs is quite exceptional. To the left, David and Solomon are portrayed as individuals. The way in which they turn to one another and at the same time incline towards the centre of the composition finds parallels in Italian art of the 14th and 15th centuries. Among the panel paintings of the same period, the icon of the Annunciation from Ochrid in Yugoslavia is outstanding. The agitated draperies of the angel, who is set at an angle in the composition, are perfectly balanced by the stillness of the Virgin as she faces serenely outwards from the recess of her throne. Here too a comparison may be made with contemporary developments in Italy, where similar achievements were made in panel painting by the Sienese artist ▽Duccio di Buoninsegna.

**The Decorative Arts.** ▽Byzantine sculpture is nearly all carved in relief, much of it on the small scale dictated by the use of ivory. The ivory Nativity shows something of the craftsman's skill in rendering in miniature a variety of form and detail. Stylistically, 10th-century ivories range from the stiffly formal representation of Christ crowning the Emperor Romanus II and Eudocia to the abandoned Classicism of the Veroli Casket, on which appears the mythological subject of Europa and the Bull. The rituals of Church and court alike were served by the finest metalwork. The Treasury of St Mark's in Venice contains no fewer than thirty-two chalices, many of them looted from Constantinople during the Crusades. Like the example illustrated, they are finely wrought from a variety of precious metals, stones, tortoiseshell and ☐cloisonné enamel. Similar materials were used to make book-covers, and reliquaries like the Beresford Hope Cross, an Italo-Byzantine work of the 9th century. The finest surviving example of this kind of ornamental metalwork must however be the Pala d'Oro, the great altarpiece in St Mark's. The present setting dates from 1345, but the enamels themselves were imported from ▽Constantinople in the 10th and 13th centuries. They combine with the gems and gold settings to produce a dazzling vision of Christian faith, as rich in symbolism as the Book of Revelation.

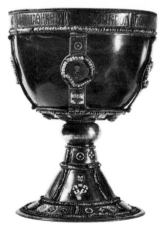

*Above:* Chalice. St Mark's, Venice

*Below: The Anastasis. About* 1305. Kariye Cami, Constantinople

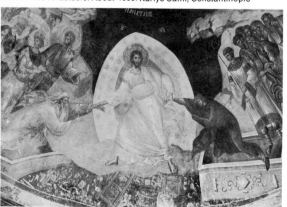

*Below:* The Katholicon, Hosias Lukas, Greece. Founded 942

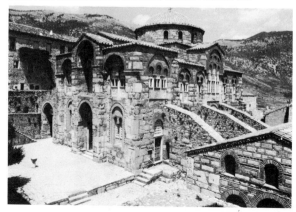

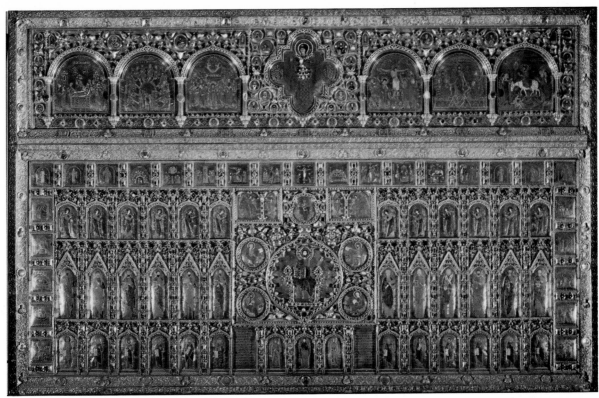

*Above:* The Pala d'Oro. St Mark's, Venice. 10th–14th centuries

*Below:* View into Apse. St Mark's. Venice. End 11th century

**The Late Eastern Church.** During the 10th century, a number of new churches were built in ▽ Constantinople. One of the most important was the Nea, built by the Emperor Basil II (*about* 958–1025), but later destroyed. The Church of San Theodore does survive; its plan is the familiar cross within a square, with a central dome. The same pattern is followed in the monastery church of the Dormition of the Virgin at Daphni, built in the second half of the 11th century, one of the best-known examples of this type of architecture. Another slightly earlier Greek church in the monastery of St Luke, at Phocis, has a central dome supported by means of an octagon on ☐squinches, curved arches which distribute the weight on to the piers. This modification to the conventional structure of the dome appears to have been popular in Greece during the Macedonian period. Elsewhere in the empire, local variations appeared. In Russia, lanterns tended to be extended into cylindrical towers, often arranged in clusters and capped by onion-shaped domes, as in the 11th-century cathedral of Santa Sophia in ▽ Novgorod. In Italy, the most important product of the architectural revival was the cathedral of St Mark in Venice. Though independent, common interests forged close links between Venice and the Byzantine Empire. St Mark's, begun towards the end of the 11th century, is a cross-shaped church with five main domes, and an exterior portico around the western arm, covered by a series of smaller domes. The design was based upon ▽ Justinian's Church of the Holy Apostles in Constantinople. It remains, with its mosaics, the most impressive tribute to ▽ Byzantine architecture in the West.

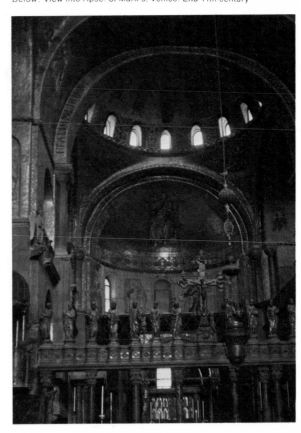

# EARLY CHRISTIAN AND BYZANTINE

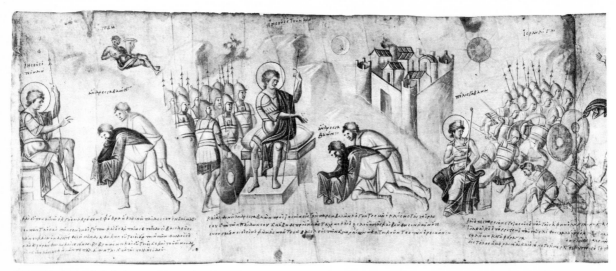

*Above:* The Joshua Roll. *Joshua receiving emissaries.* 10th century. Vatican, Rome
*Right:* The Vienna Genesis. *Rebecca at the Well.* 6th century

**Codex and Scroll.** In the ancient world, texts were written and sometimes illustrated on rolls of □papyrus, a brittle, paper-like substance named after the reed plant from which it was made. □Vellum, a far more durable material consisting of thin sheets of bleached animal hide, was introduced as an alternative around 150 BC. At first the skins were simply sewn and rolled in a continuous scroll, but improvements in their preparation enabled both sides to be used, and led to the development of the □codex, as a bound manuscript is properly called. For Christianity, the innovation was a fortunate coincidence. 'In the beginning was the Word'; a religion which relies so heavily on the written word soon recognised the potential of the new form. The copying of Old and New Testaments, and of commentaries and sermons, became a priority of the Church. In monasteries and in the Imperial courts, *scriptoria* were established where monks trained in and practised the skills of book production, from the curing of the hides to the lettering and illustration of the texts. Styles changed, but methods remained essentially the same until the invention of printing. Veneration for the contents of the book led to a respect for its appearance. In addition to ink, coloured dyes, expensive mineral pigments and gold and silver leaf were used to illuminate the page. The book became an object of great beauty.

**Early Christian Illumination.** Few early Christian illuminated manuscripts survive, and those which do are fragmentary. The Joshua Roll is a work of the 10th or 11th century, but it reflects or is copied from a 5th- or 6th-century original. It serves to show how illustrations were serialised to suit the horizontal format of the roll. The figures are drawn and shaded quite simply, but with an illusionism which recalls late Roman painting (*see* page 51). The same may be said of the damaged figures decipherable in the fragments of the Cotton Genesis of

around 400. This suggests a comparison with contemporary pagan □codices, and indeed it has been established that the 5th-century *scriptorium* which was responsible for the Vatican Virgil also produced Christian manuscripts.

The 6th-century ▽Vienna Genesis is a far more elaborate production. It is a □codex, but the use of horizontal compositions continues to recall the arrangement of the roll. Its illuminations are brightly coloured against a purple background. The only existing comparison is with the purple parchment in the Cathedral Treasury at Rossano. The 6th-century Gospels of St Augustine are Italian in origin, although the manuscript was brought to England in ▽Anglo-Saxon times. By the 10th century, it was at St Augustine's Abbey, Canterbury, and Bede tells of how Pope Gregory sent such manuscripts to Augustine, missionary to the English. The classically draped figure of St Luke is placed in a convincingly recessed space between the two centre columns, in contrast with the flat little scenes from the life of Christ on either side. Several similar canon tables survive, including one in a 7th-century Gospel Book from Asia Minor in the British Museum. They offer a kind of visual pun in which the page becomes an ornamental façade, with painted columns to divide the surface into columns for the tables it contains.

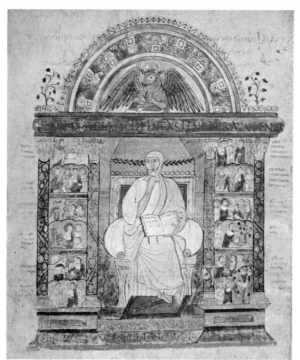

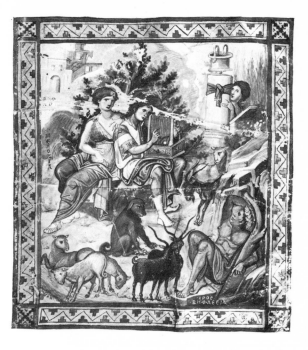

*Above:* Augustine Gospel. *St Mark.* 6th century. Corpus Christi
*Above right: David Composing the Psalms.* Paris Psalter. 10th century
$14\frac{1}{8} \times 10\frac{1}{4}$ in (36 × 26 cm). Bib Nat. Paris
*Right: The Temptation and Fall of Adam and Eve,* from the Homilies of
of Kokkinobaphos. 12th century. 9 × 6 in (23 × 16·5 cm). Bib Nat. Paris

**Byzantine Illumination.** In ▽Byzantine illumination, the horizontal narrative style of the ▽Vienna Genesis survived to reappear after the iconoclastic period in 10th- and 11th-century Gospels executed in ▽Constantinople. The sponsorship of the court also ensured that miniature versions appeared of the symbolic imperial portraits in mosaic, already mentioned (*see* pages 86–7). In an 11th-century manuscript of the Homilies of St John Chrysostom the Emperor Nicephorus III is shown between the Saints John and Michael, and on the following page, together with his Empress, being crowned by Christ. The composition and formal style of the figures is directly comparable with the mosaic of Constantine IX in the ▽Santa Sophia. In contrast is the Paris Psalter of the 10th century, perhaps the finest manuscript to survive from the Macedonian period. Nothing illustrates more clearly the revived Classicism then favoured in the Imperial workshops. The composition of *David Composing the Psalms* recalls a 5th-century prototype, with its steep recession and naturalistic detail. The figure of David is accompanied by a personification of Melody, one of a number of roundly modelled, draped female figures in the manuscript. They, together with the Classical character of the river-god in the lower right, help to explain why the manuscript was, until quite recently, mistaken for a late Roman production.

Decoration played an important part in later manuscript illumination as it did in other branches of Byzantine art. The size and complexity of initials and borders increased and ornament tended to dominate the forms it embellished. The architectural setting, familiar from the canon tables, has been extended and elaborated in the representation of the Ascension in the 12th-century Homilies of John of Kokkinobaphos until it resembles in outline the domed façade of an Eastern church. The decoration is strictly two-dimensional however; any architectural conviction which the columns might have carried is contradicted by ornamental distortions. One of the most impressive manuscripts to survive from the Palaeologue period is the Works of the Emperor John VI Cantacuzene, illuminated 1370–75. Like the painters of ▽Kariye Cami, the artist of the Transfiguration has succeeded in giving expression and dramatic form to his subject. He does so in a characteristically Byzantine manner; all six figures are arranged on the surface at the front of the □picture plane. Symbolic peaks support the feet of Christ and the two disciples who flank him, but the overall impression is one of vision rather than of representation. The nimbus explodes into dynamic rays of symbolic light, which seem to anticipate, together with the elongated figures and vertical composition, the art of ▽El Greco in the 16th century. (*See* Index for further references to Manuscript Illumination.)

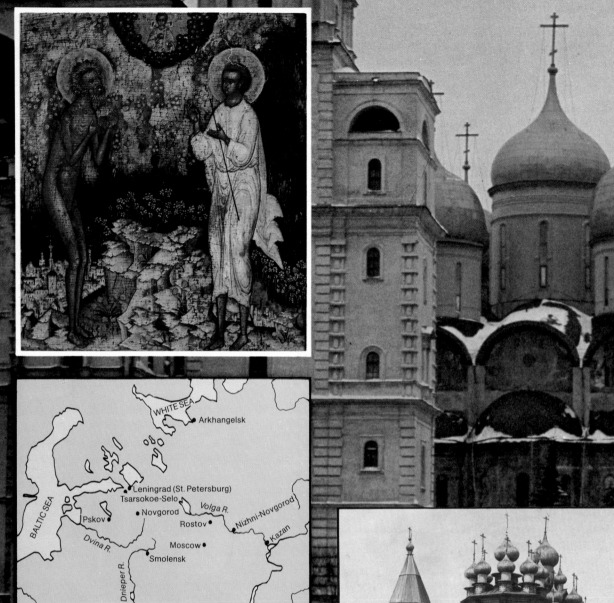

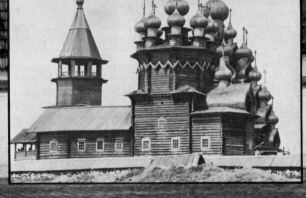

| | | | | |
|---|---|---|---|---|
| −4000 | −3000 | −2000 | −1000 | BC 0 AD | 1000 | 2000 |

**AD 850** Norse kingdom of Kiev.
**AD 862** Founding of Novgorod.
St. Cyril and St. Methodius'
mission to Slavs.
Invention of cyrillic form of
Byzantine alphabet.
**AD 988** Christianity official religion
of Slavs.
**AD 1100** First mention of Moscow.

**1547** Ivan the Terrible crowned
Czar.
Unification of Russia and
expansion eastward begins.
**1689** Peter the Great Czar of
Russia.
Westernisation begins.
Founding of St. Petersburg.
**1762** Catherine the Great Empress.
Completion of St. Petersburg.

**1812** French invade.
Burning of Moscow.
**1853** Crimean War.
**1860** Empire reaches Pacific
coast.
**1861** Emancipation of serfs.
**1898** Trans-Siberian railway begun.

**1904** Russo-Japanese war.
**1905** First revolution.
Massacre in St. Petersburg.
Potemkin mutiny.
Russian parliament created.
**1917** February revolution:
abdication of Nicholas II.
October revolution: execution of
Nicholas II.
Lenin First Commissar.
**1920** Civil War Ends.
**1922** USSR founded.

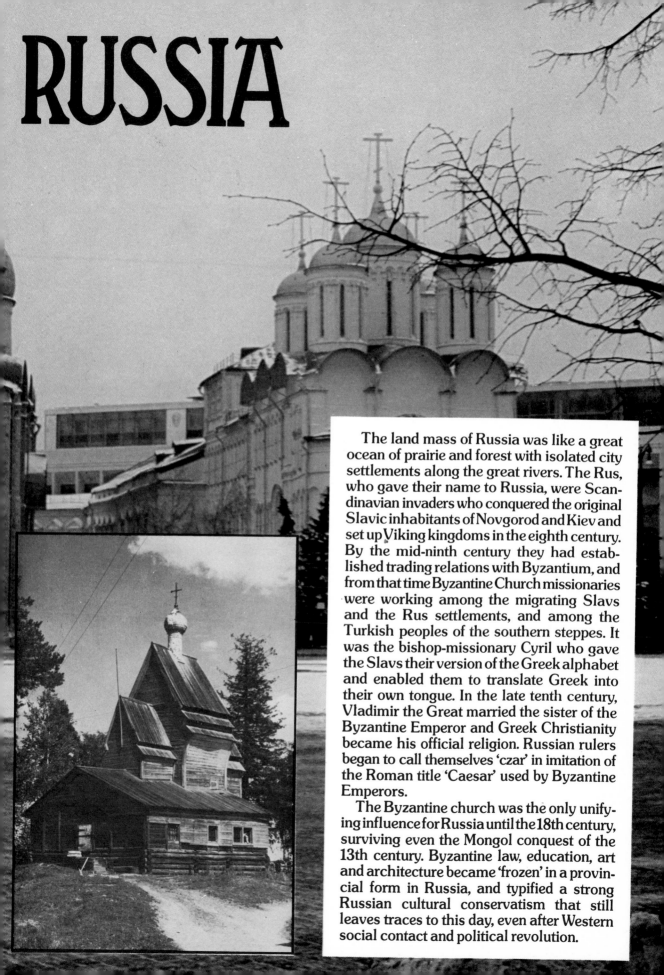

# RUSSIA

The land mass of Russia was like a great ocean of prairie and forest with isolated city settlements along the great rivers. The Rus, who gave their name to Russia, were Scandinavian invaders who conquered the original Slavic inhabitants of Novgorod and Kiev and set up Viking kingdoms in the eighth century. By the mid-ninth century they had established trading relations with Byzantium, and from that time Byzantine Church missionaries were working among the migrating Slavs and the Rus settlements, and among the Turkish peoples of the southern steppes. It was the bishop-missionary Cyril who gave the Slavs their version of the Greek alphabet and enabled them to translate Greek into their own tongue. In the late tenth century, Vladimir the Great married the sister of the Byzantine Emperor and Greek Christianity became his official religion. Russian rulers began to call themselves 'czar' in imitation of the Roman title 'Caesar' used by Byzantine Emperors.

The Byzantine church was the only unifying influence for Russia until the 18th century, surviving even the Mongol conquest of the 13th century. Byzantine law, education, art and architecture became 'frozen' in a provincial form in Russia, and typified a strong Russian cultural conservatism that still leaves traces to this day, even after Western social contact and political revolution.

# RUSSIA

**The Kiev Empire.** Although the ▽ Scythians, the nomadic tribes of southern Russia, produced a vigorous decorative art in Classical times, Russian art really begins with the adoption of Orthodox Christianity in AD 988–9 by Vladimir, Prince of Kiev and ruler of Russia from 978 to 1015. The first churches were built in Kiev and Novgorod. Kiev's Santa Sophia was of brick and the architect and master mason were from ▽ Byzantium, although Russian labourers were employed. ▽ Novgorod's first Santa Sophia was of wood. Both closely followed the Byzantine plan, cruciform with several aisles and domes. But Kiev was much more elaborate, with a large central dome symbolising Christ, rising from amid twelve smaller domes representing the twelve Apostles. This was to be the model for later Russian churches and was unique to Russia; the Byzantines never used as many domes. These expressed the spiritual aspirations of Russia and transformed the skyline, focal points of the isolated communities rising above the flat landscape. Small village churches had only one dome, larger ones had three of equal size. Larger town churches had five domes, with the central dome bigger than the other four.

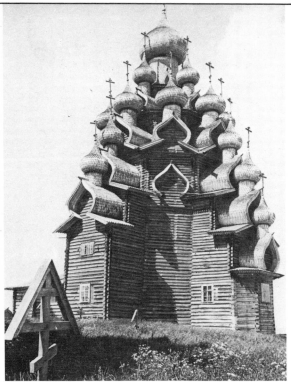

*Above:* Preobrazhenskaya Church. 1714
*Right:* ANDREI RUBLEV *The Virgin Mary of Vladimir.* 12th century. Tretyakov
*Below:* Santa Sophia, Novgorod. 1045–62

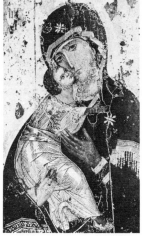

**Icon Painting.** In spite of the many churches in Kiev and other parts of Russia decorated with murals and mosaics, Russians showed a greater fondness for □▽ icons than for ▽ wall-painting, because of their more human scale. The first icons in Russia were by Greek artists, but – as with architecture – from the beginning these were less hieratic than ▽ Byzantine examples, influenced by the human and spiritual qualities typical of Russian art. Icons were painted on seasoned wood primed with white or gold leaf with □tempera colours made from pigments mixed with egg yolk and diluted with *kvass*, a kind of beer. The main subjects were Christ, his Mother, saints and martyrs.

Andrei Rublev (*about* 1365–1430) was a monk at the Andryonikov monastery, Moscow. He was the pupil of the Greek icon painter Theophanes and became the best known of all Russian icon painters. His work is marked by a quality of serenity and devoutness.

Dionysius, who, despite his name, was Russian, lived a century after Rublev. He was the first layman to paint icons and hence was able to devote all his time to it. His work is more sophisticated than that of Rublev.

**The Decorative Arts.** The high standards of ▽ Scythian metalwork and jewellery were maintained in the ▽ Early Christian period in Kiev with the production of fine gold □cloisonné enamels and enamel on copper decorated with stylised birds and geometric patterns. In the post-Mongol period craftsmen in Moscow surpassed the earlier Kiev work with delicate filigree and gold plate for the many new churches and the houses of the wealthy *boyars*.

As Western influence brought about the decline of wood as a material for great palaces and cathedrals, craftsmen turned their attention to the decorative arts, making wooden tableware, household utensils, ornate window surrounds, balconies and elaborate crosses for cemeteries.

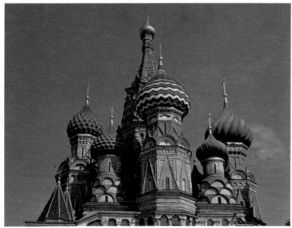

Cathedral of St Basil the Blessed, Red Square, Moscow 1552

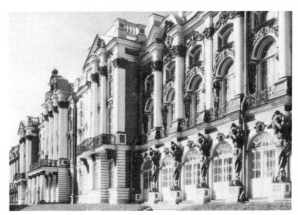

Ekaterinensky Palace (The Grand Palace of Catherine the Great), (Tsarskoe Selo, Pushkin); near Leningrad. Late 18th century

**Moscow and the Kremlin.** In 1328 under Ivan I (1325–41) the Metropolitan see was transferred from Vladimir to Moscow, which became the new capital. Moscow with its ancient fortress, or Kremlin, is the most typical of all Russian cities, in architecture as well as in spirit, combining Asiatic and Western influences in a unique and vigorous synthesis. Inside the ancient walls of the Kremlin are the former Grand Palace of the Tsars and the Cathedral of the Assumption rebuilt by the Venetian architect Aristotle Fioravanti (completed 1479).

The Cathedral of the Annunciation was designed under Ivan II by Russian architects from Pskov. This was the first attempt to reproduce some of the features of traditional Russian wooden architecture in masonry. Pskov architects also designed the exquisite little Cathedral of the Ordination begun in 1485. The Church of the Archangel Michael was designed by the Milanese architect Alevisio Novi (1505–1509) who introduced ▽Italian Renaissance features hitherto unknown in Russia such as cornices, capitals and pediments. The tall bell-tower of Ivan Veliki was built by another Italian, Marco Bono, between 1532 and 1542. This introduced a new Western influence. From then on the steeple began to displace the dome in churches in the Moscow area.

The Cathedral of St Basil the Blessed (1555–60) was built in Red Square by Ivan the Terrible to commemorate the capture of Kazan in 1552. Designed by the Russian architects Postnik and Barma it combines the two traditional church styles of Russia: the ▽Byzantine domed church and the Russian tent-shaped church. St Basil's is a central church encircled by eight domed chapels lavishly ornamented inside and out in the Russian style which characterised the 16th century.

**St Petersburg: City and Palaces.** ▽Peter the Great (1682–1725) loved both Holland and ▽Versailles and tried to combine the qualities of both in his new capital, ▽St Petersburg. What in fact he did was to create a unique city, more westernised than Moscow, but an extraordinary synthesis of light, stone and water.

Peter first employed the Italian architect Domenico Tressini (1670–1734) who came to Russia in 1703 and built the Fortress of St Peter and St Paul with the help of the Russian architect Ustinov. Its gateway was the first example of the ▽Palladian style in Russia. Tressini also began the Summer Palace which was completed by the German architect Andreas Schlütter. Another German architect Mattarnovi built the Kunstcamera (Cabinet of Curios) between 1718 and 1725 on the opposite bank of the river Neva.

The Winter Palace was built and rebuilt several times, but owes its form as it is today largely to another Italian architect, Rastrelli (1700–71), who redesigned it after Peter the Great's death in 1725 and created the fully developed Russian ▽Baroque style in St Petersburg. He gave the palaces immense frontages which took advantage of the position on the Neva and emphasised their horizontally with a regular and beautifully proportioned pattern of windows.

At ▽Catherine the Great's palace at Tsarskoe Selo, Rastrelli was succeeded by the Scottish architect Charles Cameron who worked in the style of ▽Robert Adam. Catherine (1767–96) preferred the formality of ▽Roman architecture, inspired by the rediscovery of ▽Pompeii, to the exuberance of Baroque.

RASTRELLI Winter Palace, Leningrad. Built 1754–64. View from the River Neva

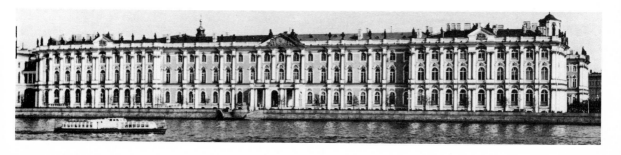

# RUSSIA

**Icon to Portrait Painting.** Russian painters found it more difficult to adjust to Western ideas than architects and craftsmen. The gap they had to cross was much greater, from stylised ▽icons to naturalistic Western painting with its vast range of subject matter. At first they found portrait painting easier. Icon painters had begun to paint portraits as early as the beginning of the 16th century, perhaps encouraged by the exchange of 'likenesses' between Ivan the Terrible and Elizabeth I of England. But at first the Church, particularly under the dictatorial patriarch Nikon, was strongly opposed to this.

To improve the standards of Russian art, ▽Peter the Great founded a school of drawing and sent young artists to study abroad. By the time of ▽Catherine the Great there was a group of more sophisticated portraitists like Vladimir Borovikovski (1757–1825) and Dmitri Levitski (1735–1822). Sometimes called 'the ▽Gainsborough of Russian art', Levitski painted portraits in the grand manner which nonetheless convey the character of their sitters with technical skill and vitality.

**The Early 19th Century.** Karl Brüllov (1799–1852) was the first Russian artist to gain international renown. His monumental *The Last Day of Pompeii* (1830–3) was widely exhibited in Western Europe and inspired Bulwer Lytton's novel *The Last Days of Pompeii* (1834) Brüllov was also an excellent portraitist. Alexander Ivanov (1806–58) was a painter of religious subjects who also painted some of the earliest nudes in Russia and produced remarkably modern portraits.

Alexey Venetsianov (1779–1847) was the first important Russian □genre artist. The son of a Greek merchant who had settled in Russia, he painted scenes from peasant life with great sensitivity but without sentimentality. He was the first to convey in painting the sweeping beauty of the immense, flat Russian landscape. His most interesting pupil, Grigory Soroka (1823–64) was born a serf and worked as a gardener until the emancipation in 1861. He was a painter of remarkable poetic imagination.

**The Wanderers.** The so-called ▽Wanderers (peripatetics) were a group of thirteen artists who set themselves in opposition to the academic standards of the ▽St Petersburg academy. They wished to bring art to the people by showing realistic paintings in travelling exhibitions and believed that art should have the purpose of encouraging social reforms. They were inspired by the Slavophile movement which, in reaction against those who wished Russia to develop along Western European lines, believed passionately in a return to essentially Russian values and subjects for art. They found more support in Moscow than St Petersburg and were encouraged by the Moscow patron and collector Tretyakov (1832–98). The leader of the Wanderers was Ivan Kranskoy /1837–87), a vigorous if unsubtle painter.

Far more accomplished than the Wanderers was Ilya ▽Repin (1844–1930) the best known of 19th-century Russian artists. Although not a member of the group he was inspired by similar ideals. A skilful realist, he painted portraits of his famous contemporaries such as the writer Leo Tolstoy and pictures with a strong social message like *They Did Not Expect Him* (the return of a political exile from Siberia) and *The Volga Boatmen* (1870).

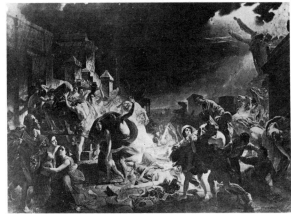

*Above:* KARL BRULLOV *The Last Day of Pompeii.* 1833. 172 × 262 in (454 × 654 cm)

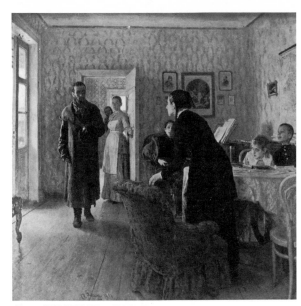

*Above:* ILYA REPIN *They Did Not Expect Him.* 1884. Tretyakov

*Below:* ISAAC LEVITAN *Over an Eternal Resting Place.* 1894

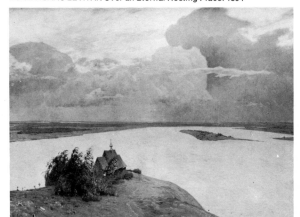

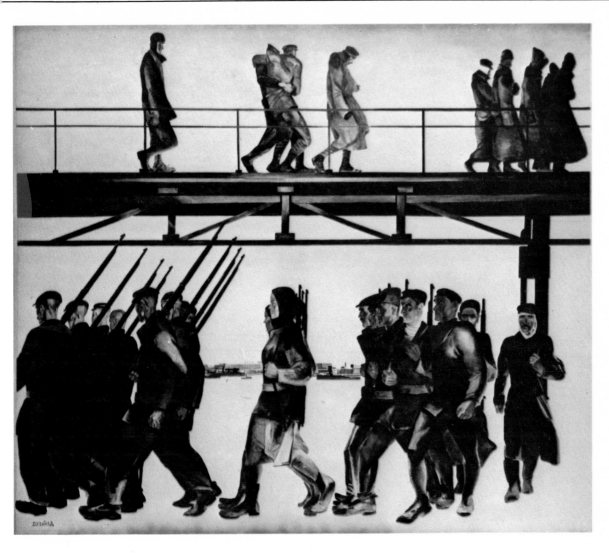

A. DEINEKA *Defence of Petrograd*. 1927. 87 × 142 in (218 × 354 cm). USSR Forces Central Museum

**'The World of Art'.** In 1870 a Moscow railway tycoon Savva Marmantov set up an artists' colony, on the lines of William ▽Morris's teaching, at Abramtzevo near Moscow with workshops for pottery and facilities for the decorative arts. A frequent visitor was Mikhail Vrubel (1856–1910) whose work is the opposite of that of ▽Repin, decorative and colourful, with strong hints of ▽Art Nouveau, its subject matter often drawn from Slavonic mythology. Valentin Serov (1865–1911) was a remarkable portraitist of great psychological insight.

The *World of Art* group was devoted to art for art's sake in contrast with the ▽Wanderers' social aims. The members were often close to the theatre, like the painter and stage-designer Alexander Benois. In 1904 Diaghilev founded a magazine called *The World of Art* to enable the group to have a platform. The group's most famous member was Léon Bakst whose brilliant, barbaric designs for Diaghilev's Russian Ballet in the years before the First World War alerted the West to the vitality of Russian art.

Isaac Levitan (1860–1900) was a friend of the dramatist Chekhov. Levitan's paintings of the enormous flat landscape of the Volga had a melancholy spirit similar to that of the writer and fittingly close the century.

**Revolution and After.** The first two decades of the 20th century saw an explosion of artistic talent. These were the years just before the First World War when Russian artists suddenly and dramatically 'caught up' with the West. The most important painter was Wassily ▽Kandinsky (1866–1944) a pioneer of ▽abstract art, who spent most of his working life in Germany and France. An extraordinary burst of avant-garde activity took place in Russia just before and just after the October Revolution of 1917 (*see* ▽Constructivism). But this did not last for long and after Stalin succeeded Lenin official Soviet Art returned to pick up the threads of social realism from painters like ▽Repin and the ▽Wanderers. Some of the early works of Socialist Realism like Pimenov's *For Industrialisation* (1927) and Deineka's *Defence of Petrograd* (1928) still show the influence of constructivist stage design.

# The World of ISLAM

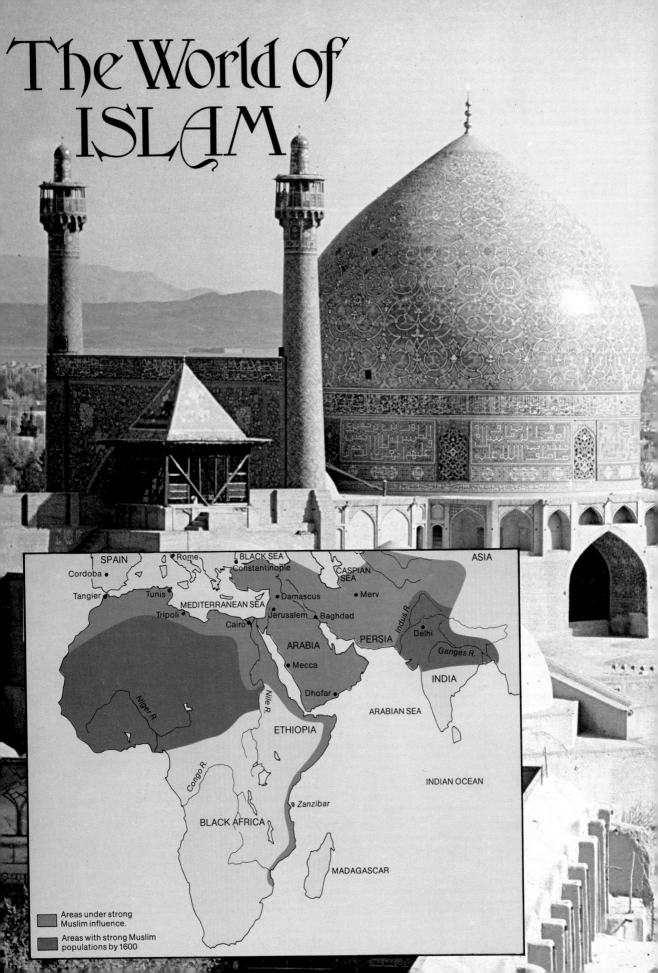

SPAIN
Cordoba
Tangier
Tunis
Rome
BLACK SEA
Constantinople
CASPIAN SEA
ASIA
MEDITERRANEAN SEA
Tripoli
Cairo
Jerusalem
Damascus
Baghdad
Merv
Indus R.
Delhi
PERSIA
ARABIA
Mecca
Ganges R.
INDIA
Niger R.
Nile R.
Dhofar
ARABIAN SEA
ETHIOPIA
Congo R.
Zanzibar
INDIAN OCEAN
BLACK AFRICA
MADAGASCAR

Areas under strong Muslim influence.

Areas with strong Muslim populations by 1600

The ancient empires of the Middle East had only reached the fringe of the Arabian peninsula, whose inhabitants had remained nomadic pastoralists and pagans. The city of Mecca was the oasis site of a pagan shrine to tribal gods, and an annual pilgrimage had made Mecca the commercial centre of Arabia. Merchants from Byzantium trading for imports from Africa and the Far East brought with them Jewish and Christian theology philosophy and religious customs. In this world of freedom and argument Muhammed experienced his first revelations in about AD 610. He began to preach a mixture of religion and politics, and was surprised to receive a hostile reaction. Seeing that his religious beliefs could only take root in a new society, Muhammed fled Mecca, won over pagan tribes, and embarked upon a war of religious conquest that was to continue in his name until a unified Arab-Muslim Empire was established by the 8th century in the Middle East. Conquest and conversion continued until the Empire reached from Spain to Central Asia.

Although Muslim theology was rigid and exclusive, the cultural attitude to the physical sciences was tolerant, and modern mathematics and sciences still draw heavily upon an Arabic vocabulary – al-gebra, al-chemy, even al-cohol. It was through Islam that much of Byzantine Greek culture was carried into Europe via Spain – music, gardening and cultivation and architectural construction. The Arabs also introduced inventions from Asia into Europe – the magnetic compass, the mechanical clock, paper making and the horse collar, enabling the horse to replace the ox in pulling the plough and the cart.

Islamic Art has always had a special character as the result of the teaching of Muhammed through the Koran. During much of its history it has been doctrinally opposed to portraiture and pictorial representation whilst the strong sense of decoration inherent in the Arab peoples has led to quite magnificent architectural decorative forms.

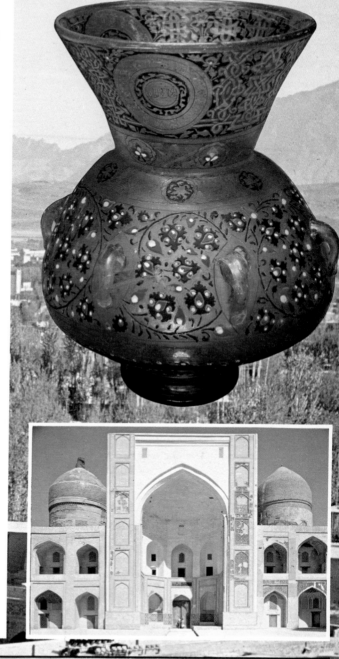

# THE WORLD OF ISLAM

**Islamic Art** is essentially a religious art which derives from the teaching of Muhammad, the prophet who lived in Arabia at the beginning of the 7th century AD. It contains elements taken from the creative traditions of many conquered countries. One of the outstanding achievements of Islam was the success with which the cultures of people of the most diverse origins were fused into a new whole, which eventually maintained its universality throughout the Islamic world, and this was especially true in art.

Very little is known of the earliest phases of Islamic art based on ancient Arabian traditions. The first surviving monuments are those of the Omayyad dynasty of caliphs, who transferred the capital out of Arabia to Damascus in Syria in AD 661. With this move the Romano-Byzantine character of Omayyad art was firmly established. The Great Mosque in Damascus was built within the walled precinct of a Roman temple, and its Roman corner towers were used as platforms for the call to prayer. Both it and the octagonal shrine known as the Dome of the Rock, erected a few years earlier in Jerusalem, used a late Roman structural system with □mosaic decoration of Byzantine type (*see* pages 86–7). Other decoration included window grilles in geometrical patterns derived from late Roman floor and ceiling patterns, and marble panelling in □veneers cut from ancient slabs and columns, a ▽Byzantine technique which survived in Islamic architecture, especially in Egypt, down to modern times.

**The Omayyad Dynasty in Spain**. In the mid-8th century the Omayyad dynasty was replaced by the Abbasids, with their capital in Baghdad instead of Damascus. From then on Persian and Asiatic influences began to figure strongly in Islamic architecture; brick was used more often as a building material, and ornament of oriental type appeared over the interior and exterior surfaces.

In Spain, where the last survivor of the Omayyad dynasty ruled, after fleeing from Syria, the Syrian tradition continued to flourish and develop. In the late 8th century the Great Mosque of Cordoba contained many features in plan and decoration which derived from the East, but it also contained inspired local innovations. One of these was the introduction of two rows of superimposed arches above the columns to increase the height of the volume without weakening the structure. The result was an effect of complicated spatial geometry, with striped horseshoe arcades stretching upwards and outwards in every direction – an effect which inspired architects in the next two centuries to add complicated superimposed □scalloped arches which interpenetrated each other, in the richly decorated □mihrab areas of the mosque.

**The Fatimid Dynasty**. The 10th century saw the rise of the Fatimid dynasty in North Africa, their capture of Egypt, and the founding of Cairo. North Africa and Egypt were predominantly interested in stone building, also a characteristic of the contemporary Turkish Seljuk kingdoms of Syria. The rise of the Turkish tribes to positions of power in the Islamic world introduced new architectural forms and types of expression. One of these was the □domed mausoleum, such as the Mausoleum of Isma'il the Samarid at Bukhara, of about 940. Here the ancient flat brick of the ▽Sassanians is used to create architectural features and a wide variety of decorative patterns over the interior and exterior surfaces.

The extent of Turkish power was steadily increased until by 1100 it included almost all of Asia Minor, which from then on remained thoroughly Turkish. The earlier prohibition against the building of monumental mausolea by Muslims was to a large extent broken, although the presence of a tomb for a secular ruler was often excused by its inclusion in a teaching building, a □madrasah, or a foundation for a religious order, a *khanqah*.

**Calligraphy and the Book**. Islamic writing was formed in all periods in a number of different styles. Kufic, named after the early Iraqi Arab colony, Kufa, tended to dominate from the 8th until the 14th century. Its elegance is well illustrated in a Koran executed in the 9th or 10th century in Syria or Iraq, in black ink on □parchment. The gold-leaf heading of the chapter following is placed at the bottom of the page.

Calligraphy is considered the noblest of the arts in Islam because it is the medium through which the word of God is revealed in the Koran. Fine handwriting is a skill honoured among kings and princes, and appreciated by Muslims of all walks of life, for literacy has always been high. It has been said that calligraphy epitomises the Islamic aesthetic sense, combining composition according to strictly laid down rules with a sense of lyrical, rhythmic freedom.

Arabic is a phonetic script, so that its characters do not have the visual associations of that other great calligraphic script, Chinese, which is □pictographic. To this extent each of the great variety of calligraphic styles developed in Arabic writing constitutes an abstract art, and in its subsequent use in architecture imparts its own aesthetic quality.

**Pottery.** One result of the establishment of the Abbasid caliphate at Baghdad, and the new capital of Samarra in the 9th century, was the growth of the influence of Eastern techniques and tastes, not merely those of Persia, but of countries further east as well. Inspired by the fragility and beauty of white Chinese porcelains (*see* pages 60–1), which fetched high prices because of their rarity, the Islamic potters set out to imitate them, in appearance, and soon succeeded to a surprising degree. But their wares retained an Islamic character, being decorated with Arabic inscriptions or fine palmette motifs. Perhaps as a result of a traditional Islamic injunction against the use of gold in metalwork, potters attempted to imitate the effect of gold, burnished metal or mother of pearl from the 8th century onwards. Lustreware, as it is called, was probably developed in direct competition with Chinese white porcelain. By the middle of the 9th century the technique had been applied to the manufacture of wall tiles as well. It soon spread west to Egypt. In the 12th century the finest lustreware was made in Persia, although the lustreware of Spain almost equalled it in quality.

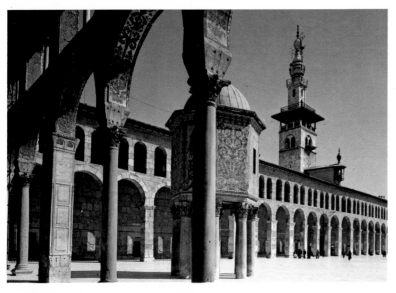

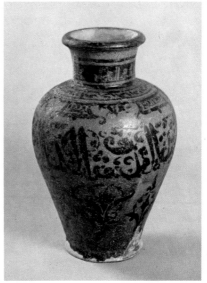

*Top left:* The Great Mosque, Damascus. Started 715. Courtyard looking west
*Top right:* Syrian Raqqa vase. Earthenware. Late 12th–13th century

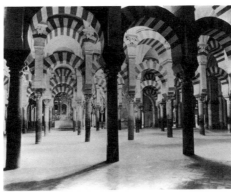

*Centre left:* Persian calligraphic bowl
*Centre right:* The Great Mosque, Cordoba. Started 786

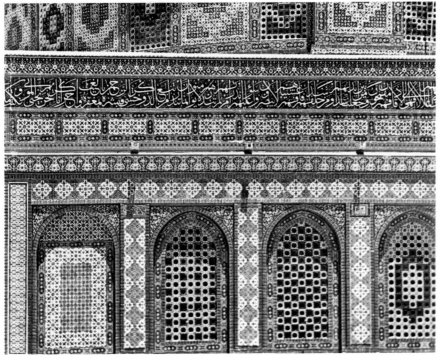

*Bottom:* Haram, Jerusalem. Exterior view showing details of tiles

# THE WORLD OF ISLAM

**Architecture and the Mosque.** When, in the 13th century, Egypt and Syria were united under the Mamluks, a slave dynasty of northern origin, the newly found prosperity which resulted gave rise to an extraordinary flowering of stone architecture in Damascus, Jerusalem and Cairo. Not only was the architecture exquisitely refined, but these qualities appeared in the minor arts as well, in woodwork inlaid with mother of pearl and ivory, in brass-work inlaid with silver and gold and in superb glass lamps. A major function of the leading mosque in each city was, besides congregational prayer, its use for the delivery of the Friday sermon by the caliph or his representative. The mosque plan was early crystallised to include a columned or arcaded prayer hall, an open-air courtyard and a high surrounding wall. The wall on the side nearest Mecca, the □*qibla*, indicated the direction of prayer, and sometimes included a niche or □*mihrab*. The sermon was delivered from a flight of steps, the *minbar*. Sometimes one or more minarets were built on the entrance side of the mosque from which the call to prayer was made.

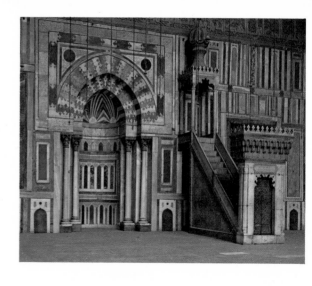

*Above:* The Mosque and Madrasah of Sultan Hassan, Cairo. Built 1356–63

**Art and Ornament.** The minor arts of Islam, painting, textiles, metalwork, glass, and ceramics, tended to follow the same pattern of development as architecture, flourishing and moving as the major centres flourished and shifted. Islamic ornament was characterised by the facility with which it could be universally applied, and many forms of pattern are found repeated on works of art in widely differing materials.

It was generally believed in Islam that the presentation of the human figure had been expressly forbidden. This affected especially the arts of painting and □bas-relief ornament. In fact, the prohibition is nowhere mentioned in the Koran, but occurs only in collections of the Hadith, the 'sayings of the Prophet Muhammad', which do not carry the same authority. Indeed, the Omayyad caliphs in the early period of Islam had decorated their palaces and baths with paintings and painted bas-reliefs of human figures. But subsequently there were long periods when the content of wall-paintings seems to have excluded human figures. Eventually, however, human figures were introduced into the decoration of metalwork and pottery, especially in the 12th and 13th centuries. Nevertheless, the essential nature of Islamic decoration is formal patterning using geometry and repetitive floral □arabesques.

**Courtyards and Gardens.** Many parts of the Islamic world were arid, dusty and hot. A concept which developed early was that or architecture providing a man-made oasis, surrounded by a high wall and focusing on a fertile garden in a courtyard, replete with pools, fountains, fruit trees, and flowers. This was conceived as an earthly reflection of the Islamic image of paradise. The widespread distribution of this type of oasis courtyard throughout Islam is one example of the universality of Islamic art.

Sometimes the richness of the planting in the courtyard seems to have inspired the architect to create around it a matching fantasy of delicate construction. A masterpiece of this type is the 14th-century Court of the

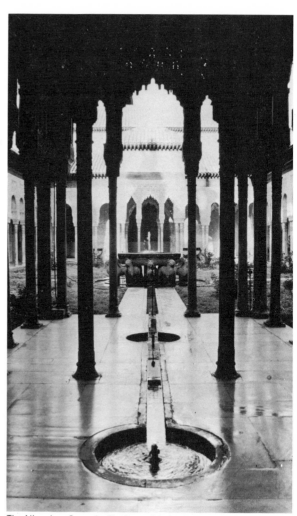

The Alhambra, Granada. The Court of the Lions showing fountains and water course. *About* 700

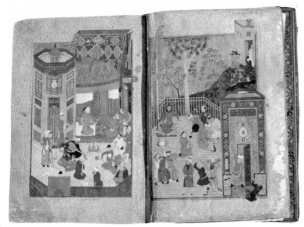

*Above:* SADI *Al Bustan.* 1488. Bibliothèque Nationale, Cairo

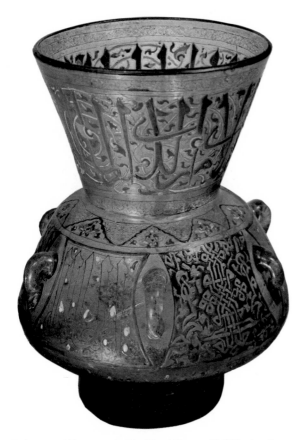

Syrian vase. 14th century. h. 11 in (28 cm). Museum für Völkerkunst, Vienna

Lions, one of a number of such courtyards in the Palace of the Alhambra at Granada in Spain. Pierced ☐stucco screens rise from the slenderest of columns and are framed in panels of an endless variety of decoration. Water sprays up in shallow fountains in the shadows of the arcade and runs out along channels to converge from four directions on the central lion fountains. The cult of the garden affected the decorative arts. Not merely in painting, but in carpet patterns and ☐arabesques, the representation of the paradise garden and its flowers and leaves became one of the characteristic Islamic ideals.

**Illumination and Painting.** The Islamic artist possessed a profound love of colour. This is one of the qualities which predominates in the great manuscript illustrations of the Persian school of painting of the 15th to the 17th century. Another is a new sense of space. The field of action is clearly spread out before the viewer, who can take delight in the precise qualities of design and association in the setting and its details. Bihzad (fl. 1475–d(c.) 1525) is generally acknowledged to be the greatest of all Persian painters. In 1522 Shah Ismail appointed him director of the Royal Library, in which post he was responsible for all book production. His work had a wide influence, through his personal followers, especially on Moghul miniature painting of the 16th century.

Signing himself as a 'slave', he illustrated Sadi's *Bustan* (in translation 'Fruit garden'), a highly popular work republished over and over again in manuscript form since 1257. This didactic poem of moral and ethical principles was plentifully illustrated with tales and anecdotes, a fruitful source of subject matter for the illuminator.

The scene set in a richly decorated mosque is painted with immense skill in great detail. The architecture really provides the compositional element that pulls the picture together, the little groups of figures distributed in an apparently random fashion. This is typical of Bihzad and his school.

**Glass.** There already existed a long tradition of glass working in Egypt, Syria, Persia and Mesopotamia before conquest by the Arabs in the 7th century. Glass blowing, moulding and the art of colouring glass originated here.

From Syria came the highest achievements of Islamic glass. Of the gilt and enamelled glass produced, the mosque lamps are the most spectacular. They were hung as mosque and sanctuary lamps by chains and cords from six looped handles. The traditional text, enamelled in colours on a gold ground on the neck of such lamps, is taken from the chapter in the Koran on Light, and discusses the divine light of Islam.

The peak period of the production of these elaborate glasses was the 13th and 14th centuries. Beakers and lamps were treasured in the West both in churches and as family heirlooms.

Syria was overrun and Damascus was sacked by Tartar invaders in 1400. The richly decorated Islamic glasses suffered a decline, and eventually the princes of Islam were forced to look to Venice for their glass.

# THE WORLD OF ISLAM

**Persian Tiles.** In the dusty towns of the semi-deserts which made up much of the Islamic territory, the monotony of the vast, featureless landscape was cheerfully relieved by the use of pattern and colour on major monuments. In the 12th and 13th centuries 'faience mosaics' were developed in Iran by cutting brilliantly coloured glazed tiles into designed shapes which were then assembled into complex patterns. Into this formal patterning, the introduction of bands of quotation from the Koran in decorative script lent a highly spiritual quality. The letters of the alphabet were shaped and ordered to take a special place in the design, whether in stonework, brickwork, metalwork, or ceramics. The high regard in which □calligraphy was held by the Arabs, and their feeling for the shape of words, was used throughout the history of Islamic art to intensify its meaning. Eventually, the development of a variety of patterns and scripts enabled the designer to vary the effect of a surface through a wide repertoire of textures and characters, which could then be juxtaposed to contrast or harmonise with one another. A final step was the development of patterned surfaces which at first seemed totally abstract but were then seen to contain the cyphers of a script word or phrase.

**Persian Carpets.** Few early carpets survive, and knowledge of carpets before the 15th century derives mainly from Persian and Western paintings. An essential item in the life of nomadic peoples, the carpet was also a focal element in the furnishing of all buildings from a Muslim urban household to a royal sanctuary, and for these purposes carpets of sophisticated design were specially woven. That shown here, the Ardebil carpet in the Victoria and Albert Museum, besides being exceptionally large, is generally acknowledged to be one of the finest carpets remaining from the great period of Persian carpet design in the early 16th century. Its workmanship is of almost miraculous quality. This is a royal carpet with a central medallion, corner medallions, a framed border and a wealth of endlessly varied subordinated detail, made for a mosque tomb. It contains these words as part of an inscription: 'I have no refuge in the world other than thy threshold; there is no place of protection for my head other than this door . . .'.

Later carpets were woven specially for a European market, and became influenced by Western tastes, especially after patterns had been sent for them prepared by European designers. Nomadic carpets remained unaffected, but nearly all those sought out by collectors today date from after the beginning of the 19th century.

**Turkish architecture** was characterised by its extensive use of domes, a tendency which was reinforced by its contact with the architecture of its great enemy, Byzantium. In particular, a type of mosque was evolved with a large central dome over what had before been the courtyard; a development which doubtless resulted from the vicissitudes of the northern climate. After the conquest of ▽ Constantinople in 1453, and the conversion of the ▽ Santa Sophia to the role of a □Friday mosque, Turkish architects became preoccupied with the attempt to sur-

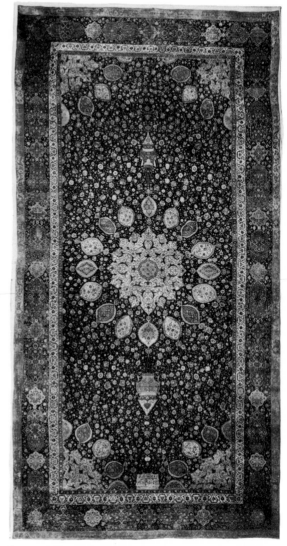

*Above:* Ardebil carpet. 16th century

*Below:* The Selimiye Mosque, Edirne, Turkey. 16th century

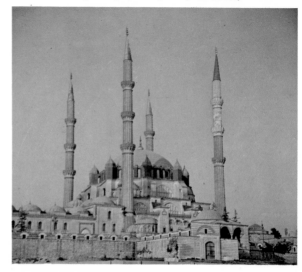

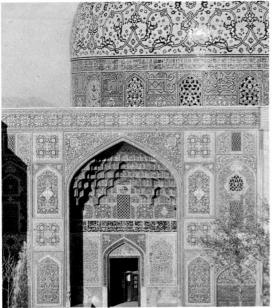

*Top:* Mosque pendant vault, Isfahan, Iran
*Above:* The Masjid-i-Shaykh Luft Allah, Isfahan
*Below:* The Royal Mosque, Isfahan. 1612–30

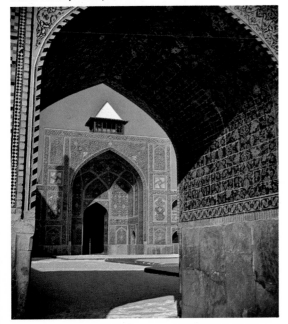

pass this masterpiece of ▽ Byzantine design. Eventually the great architect Sinan did so, in the Sultan Selim Mosque at Edirne, which not only had a slightly larger dome (102 feet in diameter), but avoided the multitude of supports in the earlier building, supporting the dome on only eight tall columns. The latter are placed close to the walls, and the opening of the interior through a multitude of large windows created the effect of one vast airy, unencumbered space.

**Persian architecture.** Here the traditional royal audience hall, the open ☐*iwan* of the kind preserved from ▽ Sassanian times at Ctesiphon, was incorporated into the mosque. Like the royal audience hall, it had behind it on the side nearest Mecca a domed chamber, which became in the mosque the domed space in front of the ☐*mihrab*. The earliest mosques of this kind had probably only one *iwan* on the ☐*qibla* side. But by the time of the rebuilding of the Great Mosque at Isfahan in the 12th century a large *iwan* faced into the court on all four sides, the additional ones apparently serving as ☐*madrasah* platforms for the teaching and study of the Koran. From then on this Persian type of mosque became increasingly influential; not only was it copied in mosques from Cairo to India, but it was the model for *madrasahs*, ☐*caravanserais* and many other Islamic buildings. The type reached its culmination in the Royal Mosque built by Shah Abbas at the southern end of his great Maidan in Isfahan from 1612 to 1630. This building carried brightly coloured decoration in tiles to its greatest heights of achievement, ☐'faience mosaic' here being largely replaced by painted decorations on square tiles. The whole structure of the building is clothed in a shimmering surface of carpet patterns of exquisite design and richness.

**Minarets and Vaults.** The entrance to many medieval mosques was accentuated by placing a pair of flanking ☐minarets over the gateway. In the Royal Mosque at Isfahan another similar pair flank the great ☐*iwan* on the ☐*qibla* side. But the chief glory of the Royal Mosque gateway is its ☐'stalactite' vault. This epitomises a particular Islamic tendency to transmute and proliferate structural features for decorative effect. For the stalactite vault began as a series of superimposed ☐squinch arches bridging the corner between a dome and the square plan below it. Quite early it was realised that the squinch arches could be interlocked by placing the second row so that it rose from the points of the first row, and so on. By also projecting the centre of each arch outwards, the upper row ☐cantilevered over the first, to create a sloping surface bridging the corner. Arab experiments with geometry revealed that such vaults could be evolved to fit perfect geometrical patterns in plan; by varying these, wonderfully complex and diverse effects could be produced in the vault. The final step was to achieve the quality of ☐pendants, like stalactites, which seemed to drop down to provide a magical support for each tiny vault. The exquisite examples of these vaults built in the time of Shah Abbas are, like all important surfaces in his buildings, entirely clothed in tiles of a breathtaking beauty of design and execution.

# THE WORLD OF ISLAM

**The Mughals** invaded India from Persia – their name is Persian for Mongol – and founded an empire in northern India under Babur in 1526. The Mughal dynasty had much in common by way of absolutism and patronage with many of the great princely houses of Europe, and, like many of them also, declined and fell at the end of the 18th century. They brought with them a centralised system of administration and taxation which gave political stability to their empire and made their princes the richest men in the world in personal fortunes, which they spent freely on patronage of all the arts: painting, architecture, music and literature. Their patronage achieved a fusion of cultures which led to a true □renaissance. They employed and encouraged Indian artists and craftsmen. In architecture this meant that Indian form and construction was stripped of all figurative decoration and given a new purity of its own. As Muslims, however, they were neither as puritanical nor as iconoclastic as their Arabian neighbours. They encouraged secular painting and gave new life to the Indian miniature.

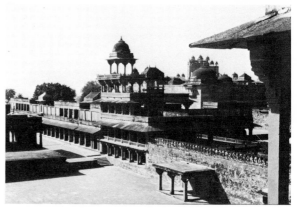

*Above:* Fatehpur Sikri, late 16th Century

**Palace, City and Mosque.** The Emperor Akbar (1556–1605), son of Baber, had some claim to be considered a universal man. His court was liberal and cosmopolitan. He enjoyed religious and philosophical debate, and was a generous host to scholars and theologians of all schools – Hindu, Christian, Jewish and Muslim. He laid out new town plans for Delhi and Agra, but these were overshadowed by his attempt to found a completely new capital city, fit for a philosopher king, at Fatehpur Sikri. Unfortunately the site survey was at fault and the water supply failed. The city was abandoned, leaving its mosque, shrines, palaces and administrative buildings intact, isolated within a widespread town wall built to protect a town which was never inhabited. Unlike Delhi and Agra, there was nothing of value to loot at Fatehpur Sikri, and its stone buildings survive in a remarkably good state of preservation.

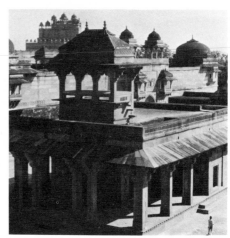

*Above:* Fatehpur Sikri

As at Delhi and Agra, pavilion-type buildings are arranged among flower-beds and pools of water. The plans of all these are rectilinear, but not formally axial. The buildings of bracketed stone columns and beams seem curiously incomplete. These buildings have ring bolts for ropes, and the pavements have sockets for poles. The areas between buildings were tented in. Hangings separated chambers, formed corridors, and roofed in courtyards. In winter they kept in the warmth; in summer their fringed edges trailed in channels of running water. By absorption and evaporation they provided a form of cool 'air-conditioning'. The effect of light and colour can only be imagined.

*Below:* Sidi Saiyad's Mosque, Ahmedabad. *About* 1500

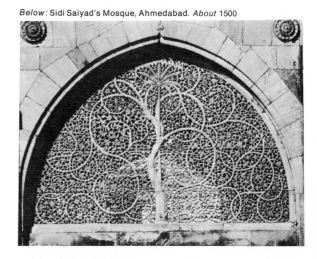

**The Mosque.** The traditional Indian temple is essentially a shrine: the mosque is an assembly hall for prayer and teaching. As long as Indian builders and craftsmen followed the building ritual function prescribed by religious and court officials they were allowed complete freedom in their craft. The Mughals thus saw nothing either incongruous or heretical in having their mosque domes crowned by the sacred lotus. As stated, all animal representation was barred, but the craftsmen were given full rein in plant and geometric forms in pierced screens, and in window lattices of great virtuosity in pierced and fretted marble. The Mughals brought with them the glazed tile which was also used in both geometric and floral patterns, and much use was made of barred and striped marble. But the crowning beauty of such buildings lies in the unique geometry of their domes of every size.

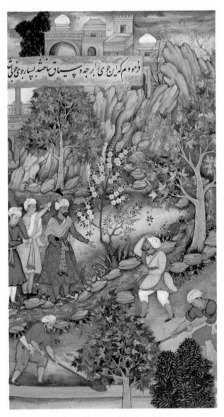

*Babur inspecting a Garden.* Mughal School
miniature. BM, London

The Taj Mahal, Agra, India, 1635

**Mughal Painting.** The Persians had a long figurative tradition in the secular arts unusual in Islam. Indian painting too had always been figurative, but religious in content. Mughal painting was courtly and secular; its themes were imperial and official portraits, hunting and battle scenes celebrating the courage of the Mughal conquerors, and scenes from Persian literature, which also enjoyed both a revival and development under the Mughals which was to outlast the emperors themselves.

The court artists brought with them masterly technical skill in drawing. A fine fluid line combines freedom with accuracy. Artists had their own specialisations: as draughtsmen or colourists, figure or background, in plants, animals, calligraphic script or geometrical pattern. A masterpiece may be the result of teamwork. At first the paintings are highly idealised. Realistic figures throw no shadows, and the form is shaded only to show solidity. Trees and plants are stylised, and 'perspective' is really a form of projection without the single viewpoint. Under European influence – not only of Jesuits at court, but from the large and flourishing Portuguese colony of Goa, Mughal painters attempted both □chiaroscuro and □aerial perspective, and imitated European miniatures. This hybrid painting loses the best qualities of both, but another interbreeding of Mughal skill with Hindu subject matter and its tradition of mood expressed through colour and gesture, related to music and the dance, was to revitalise the painting of north India.

**The Shrine.** All conquerors in all ages have built personal monuments in order to help establish legitimacy and continuity of government. The Mughal regal mausolea were of this nature, and the shrine which the Emperor Shah Jehan (1628–58) built to the memory of his wife Mumtaz – she died in childbirth in 1631 – is one of the best-known buildings in the world, which still, despite familiarity, retains its essential magic. Set in a formal garden and sited axially at the end of an avenue lined with glittering sheets of water, and on a platform overlooking a great river, the Taj Mahal consists of a single dome-capped chamber – the done is 65 feet in diameter – surrounded by four smaller compartments. Under the dome, the tomb of Mumtaz, inlaid with cut semi-precious stones in floral patterns, is enclosed within a pierced and fretted stone screen of great beauty.

Shah Jehan was a pious conservative who instinctively avoided the florid complexity of other Mughal building. All decoration is subordinated to the clear form of the whole structure. The lotus banding of the dome is inlaid, not carved. The building is enbellished with chastely carved and inlaid stone panels in which the Persian love of plants and gardens comes to the fore. Plants are displayed symmetrically, combining architectural formality with absolute botanical accuracy. The ignorant prejudice of Europeans of a later age led them to suppose that this building must have been designed by an Italian architect for Shah Jehan, but it is absolutely Mughal in conception and building skill.

# The Dark Ages

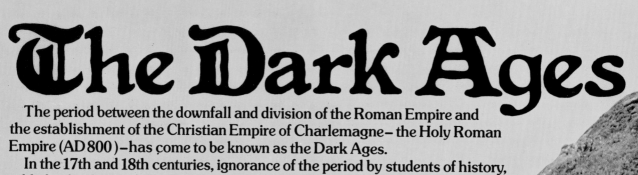

The period between the downfall and division of the Roman Empire and the establishment of the Christian Empire of Charlemagne– the Holy Roman Empire (AD 800)–has come to be known as the Dark Ages.

In the 17th and 18th centuries, ignorance of the period by students of history, added to by the confusing and separated histories of the different and changing states during the five hundred years between AD 300 and 800, led to the choice of a name which has no more appropriateness than other labels commonly used such as Gothic (barbaric) or Baroque (imperfect, ill-formed).

In fact, modern research has revealed that not only is the period one of great energy and creativity but the art (from Sassanian to Viking and Celt) is of the highest interest and quality.

Europe was then a melting pot in which scholars, scribes and crafts-men as well as rulers, statesmen and soldiers, travelled widely so that, for instance, Irish churchmen founded monasteries in Italy and Charlemagne's chief minister came from England.

It was also, nevertheless, an age of war, tyrannicide and great destruction. The great invasions of the Huns, Goths and Visigoths, Vikings and Saxons swirled around Europe and the turmoil of the period both made study difficult and the interchange of art inevitable; treasures from Scythia are found in Britain, and ornaments of similar form from Spain to Russia.

But, through this period, the Christian Church was gaining strength, losing ground in some places (Spain) expanding rapidly in others (Russia). The crowning of Charlemagne at Aachen founding the Holy Roman Empire is a symbol of the victory of the Church and its unity with the power of the state.

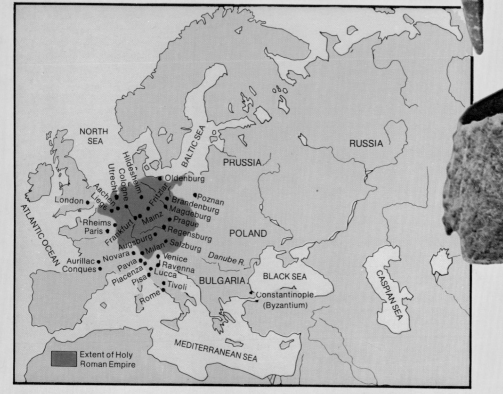

Extent of Holy Roman Empire

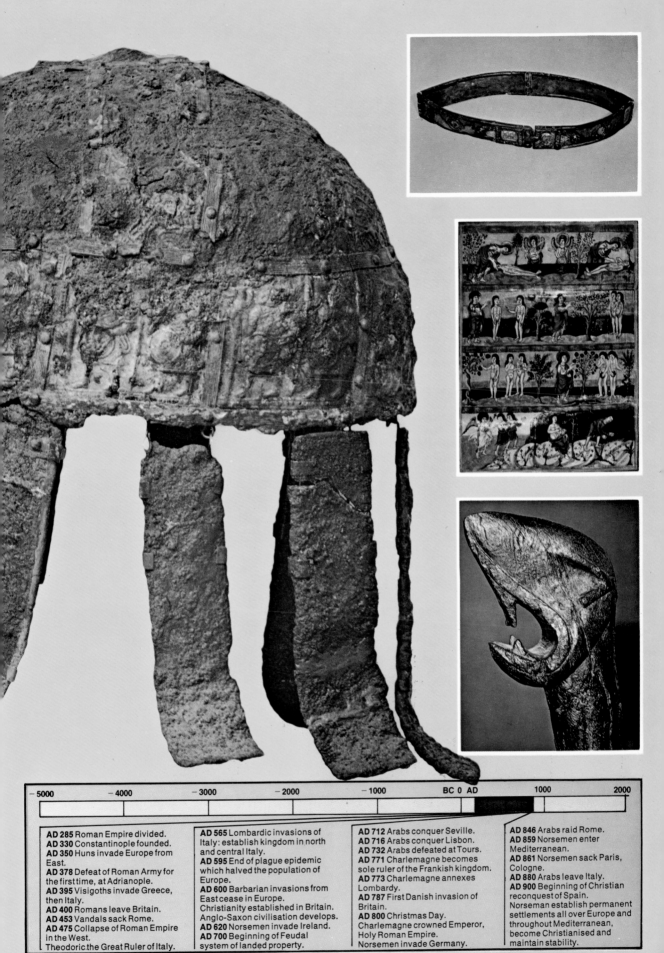

# THE DARK AGES

**The Invaders.** In the 4th century, the eastern ▽ Goths, a Germanic people living in the Black Sea hinterland, came into contact with the neighbouring steppe nomads of southern Russia, the Sarmatians and the fearsome ▽ Huns. About AD 370, the Huns attacked and drove the Goths before them as they surged westward. They, in their turn, drove other Germanic tribes further west to batter down the Frontier and pour into the rich Mediterranean lands of the ▽ Roman Empire. Pressure from such movements of peoples also initiated the sea-borne migrations of the Germanic tribes living on the North Sea coasts to the south and east shores of Britain. Throughout the 5th century they arrived in expertly built ships whose frighteningly carved prows ably serve to remind us of the many works in wood from this period which have not survived.

Before coming into contact with the ▽ Roman world, in the frontier provinces of the Empire, the Germanic peoples seem to have had very little original art of their own, apart from the most rudimentary stamped and incised geometric motifs, with which they decorated their pottery burial urns. Though of early 7th-century date, the urn illustrated here is from one of the earliest ▽ Anglo-Saxon cemeteries in England, established in the mid-4th century. This urn is exceptional in that, along with typically Saxon stamped decoration, it bears an incised scene of figures in a boat facing a large wolf-like creature. This has been plausibly interpreted as representing the evil wolf Fenrir, jaws agape, as the boat Naglfar, with its giant crew, sails free on the Day of Doom, a story preserved in Old Norse mythological sources.

Some of the very first pieces of Germanic jewellery are gold pendants known as *bracteates*, which are simply barbarised copies of Imperial coins with a suspension loop. However, further devolution soon followed, and to the imitation portrait head, the goldsmith added animals and borders of encircling stamped geometric ornament, the richest examples even bearing inset human masks and filigree designs, or magical inscriptions in runes; but by the 6th and 7th centuries, the *bracteates* had become simply small discs decorated in the prevailing animal style.

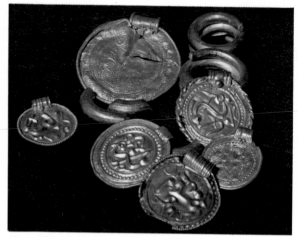

*Above:* Viking gold bracteates. *About* AD 500

Caistor-Urn, from Caistor by Norwich. 4th century. Norwich Castle Museum

*Below:* Eagle brooch. Gold and garnets. 6th century. German National Museum, Nuremburg

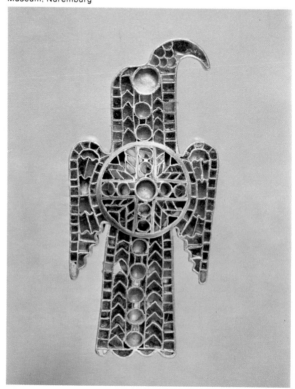

**The Influence of Rome.** In the first centuries of our era, however, through trade, plunder, and diplomatic gifts, quantities of Roman luxury goods (*see* page 55) reached the Germans beyond the Frontier; highly decorated '▽ Samian ware' pottery, and silver and bronze tableware with small, naturalistic animals occupying the borders (especially on provincial items emanating from Roman Gaul), initiated the first Germanic animal styles, with highly stylised animals similarly inhabiting the borders of native metalwork. Tacitus, the Roman author of an early work on the Germans, *Germania*, also records the important influence of Roman coins (*see* page 53), which are found widely distributed throughout Germania, thus ensuring that the barbarians became accustomed to portrait heads and chariot scenes and that a demand for decorated metalwork was created.

**Animals as Ornament.** In the late 4th century, more and more Germans entered the Rhine frontier army as mercenaries, and were equipped with the contemporary military buckles and belt-fittings decorated in the provincial Gallo-Roman technique of 'chip-carving', worked in sharply ridged relief so that the faced metal glitters with reflected light. These were often embellished with inlays of silver or black silver sulphide (*niello*). The newly established taste of this sort of decoration then gave rise to its use on the characteristic square-headed brooch with stylised horse-head foot common to all the Germanic peoples. The form of these bow brooches ultimately derives from the ▽ Iron Age, but the technique and decoration are provincial Roman in origin – small panels of chip-carved geometric ornament, curls and step-patterns, bordered by schematised animals.

The development of a second Germanic animal style in the 6th century is probably connected with the migration of one particular tribe, the Lombards, from their homeland on the Baltic coast in the late 5th century. In the early 6th century they crossed the Danube frontier, and then began to add the interlace motif which they found on late ▽ Roman mosaics to their existing animal style. The resultant style was quickly disseminated throughout the other Germanic tribes, appearing about 550 on royal Frankish jewellery.

The principal artistic masterpieces for which the early Germans are remembered, however, are the sumptuous pieces of gold and garnet jewellery which were transmitted westward by the ▽ Goths in the 4th century, who learnt the techniques (which ultimately derive from ancient ▽ Persia) from the steppe nomads. The practice of ornamenting gold brooches with precious stones (mostly red garnets) set in tiny gold-walled cells of different shapes is wholly independent of the Roman tradition. It is interesting to note that an early 5th-century Imperial document refers to this art of □ cloisonné jewellery as '*barbaricus*'. Such brooches in the form of eagles are found throughout the Germanic lands, and must have had a symbolic as well as a practical, dress-fastening function. Indeed, the eagle, as king of the birds of prey, whose shape Woden, the god of war, himself sometimes borrowed, is clearly a fitting badge for the aristocratic war-leaders of the □ Migration period.

**Germanic Art.** In marked contrast to the tradition of Greco-Roman humanism, whole human figures rarely appear in Germanic Art. Early German artists were interested not in naturalistic or representational art, but in the possibilities of pure ornament. By the end of the 7th century, however, only the north of Germanic Europe still resisted conversion to Christianity. With the acceptance of the faith and more intimate contact with the late Classical traditions of the Empire, the human figure reappears, especially in funerary art, in the 7th century in the south, and slightly later north of the Alps, together with the introduction of scrolled plant motifs, so characteristic of ▽ Byzantine art. Contact with the Byzantine workshops of the Mediterranean is clearly seen in the magnificent series of 7th-century crowns from Visigothic Spain; some of these seem to be of pure Byzantine workmanship, while others, such as that illustrated here, appear to be local German imitations in plainer decorative techniques.

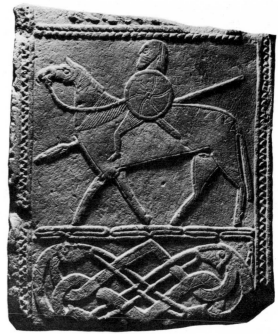

*Above:* Horseman stele. 6th century. Saxon

*Below:* Visigothic gold votive crown. 7th century. Cluny Museum, Paris

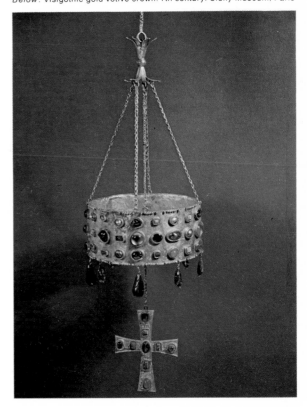

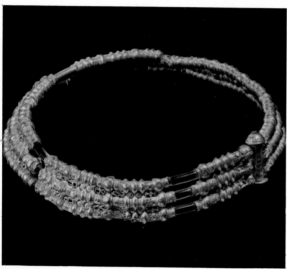

The Alleberg gold collar. Stockholm

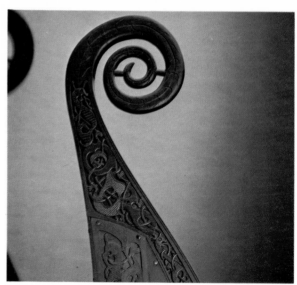

The Oseberg Ship. 8th–9th century AD. Part of the stern. Viking Ships Museum, Bygdoy, Oslo

**Coins and Collars.** The richest of the early graves of southern Scandinavia contain imported luxury goods in glass, pottery and silver from the Roman world. Yet, while adopting some provincial Roman techniques such as □chip-carving, the influence of Classical decoration on the later artistic repertoire of the North is surprisingly meagre. While central Europe was undergoing the violent disturbances of the migrations, Scandinavia remained comparatively isolated. Despite internal troubles, these earliest centuries were a wealthy period for this relatively independent area, and its richness is nowhere better illustrated than in the first exceptional works of native art, the sumptuous gold collars from the Västergötland region of Sweden.

The massive weight of these neck-rings is brilliantly offset by the delicacy of the gold filigree spirals and beading, applied even to the minute animals and human masks which nestle and creep between the contours of the circlets, seemingly animated by the play of light. Items of personal adornment which have their origins in the ▽ Iron Age, these collars, though of purely indigenous form and decoration, were wrought from Roman gold in the form of melted down coins. Coins were also used whole at first, as the centres of *bracteate* pendants, but soon suffered an equal dissolution into highly stylised imitations. Diminutive animals such as those on the bracteates probably derive from the animals seen in relief on imported Roman tableware. They were made from gold beads and wire, or pressed out from foil, and were then applied to the larger metalwork.

**The Ship Burials.** The feeling for representation, as against stylisation, was occasionally allowed to resurface in later times, but never to stand alone, as is illustrated on the helmets of the immediately pre-▽ Viking period found in royal ship burials of the 7th century from Uppland, Sweden. These helmets from Vendel prove that the ▽ Sutton Hoo example must also be of Swedish manufacture – like it, they are of mask form, with winged, dragonesque eyebrow-ridges and nose-pieces, and ridged tubular crests. The cap area is divided into square or oblong panels filled by impressed bronze sheets depicting naturalistic warriors fighting or carrying weapons, offset by bands of plain interlace derived from the second animal style, so that, for a brief while, naturalism and stylisation co-exist.

A century later, at the next important mid-9th-century ship burial, from Oseberg in southern Norway, we are well into the Viking period, whose art is dominated by its own fleshy, gripping-beast version of the inherited interlace pattern; this third animal style is seen on the ship's elegant prow, which terminates in a coiled snake's head. Within the bounds of the style, however, individual interpretation is possible, as indicated by the names given to the different carvers represented at Oseberg, 'the conservative Academician', 'the careful Eclectic', and 'the baroque Impressionist'. A beautifully carved ceremonial wagon – and the Oseberg treasures remind us of the many pieces of carving, in this medium most natural to the Northmen, which have perished – is ornamented with a few heads modelled in the round, and occasionally, in the saga scenes which decorate the sides of the vehicle, with identifiable human figures which emerge from the seas of surrounding interlaced beasts.

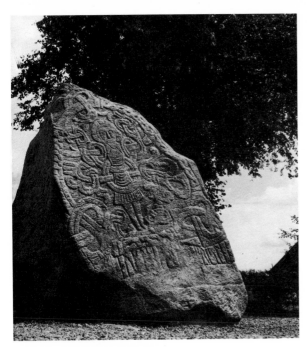

*Above:* The Jelling Stone, Denmark
*Above right:* Stele from Gelgarda, Lärbro, Gottland, Sweden. *c.* 700. Museum of National Antiquities, Stockholm

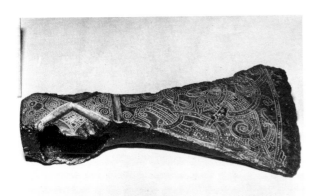

*Above:* Silver inlaid axe from Mammer, near Viborg. 10th century. National Museum, Copenhagen

*Below:* Ceremonial wagon from Oseberg ship

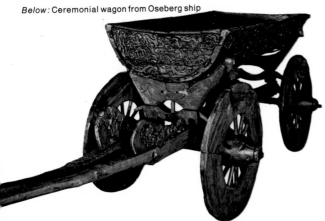

**The Survival of Pagan Art.** Such representational tendencies are, however, rare at any period in the art of the pagan North, as the five succeeding animal-interlace styles emphasise, pervading the art of the next three centuries, and shading imperceptibly into each other. This iron axehead in the so-called Mammen style of the late 10th century depicts an interlacing deer executed in inlaid silver wire.

In the other Germanic lands of Europe, Christianity had been established throughout the 7th and 8th centuries. The Church, along with the necessary liturgical artefacts decorated in Classical and ▽Byzantine styles, had brought with it the attendant art of church-building in stone, and more especially, the arts of writing and painting, which flourished in the gospel copies produced in the ▽Celto-Saxon and ▽Carolingian periods. The Scandinavian North could not benefit artistically from this tradition until the very end of our period; only exceptionally, as on the island of Gotland, is there any evidence of early contact with the linear style of painting, in the unique erection of pictorial memorial stones illustrating pagan mythological and saga stories framed by purely abstract interlace.

**The Arrival of Christianity.** Without the illuminated manuscript tradition of Christianity, however, such linear naturalism was never more than very localised or fleeting. Indeed the strength of the inherited tradition of native animal-interlace styles may be judged from the fact that, despite the high quality of looted treasures from Christian lands from the late 8th century onwards, ▽Viking artists would rather melt such vessels down, and refashion and decorate them in accordance with Scandinavian taste; and further, that despite the most astonishingly widespread trading contacts (extending throughout Russia and the Mediterranean to include ▽Byzantium and the Near East), the scroll foliage of the vine, which so pervaded the rest of European art, makes a later appearance in Scandinavia. In the first representation of the Crucifixion known from the Christianised north, on the runic stone set up by Harold Blue-tooth of Denmark at Jelling in about 985, Christ is crucified by bands of thick animal-headed interlace.

# THE DARK AGES

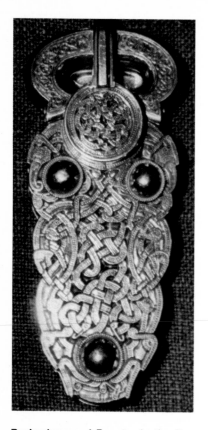

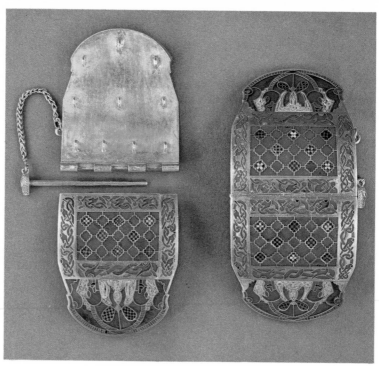

*Above:* Pair of hinged shoulder clasps. 7th century AD. Gold inset with garnets, mosaic glass and filigree. Sutton Hoo treasure. BM, London

*Left:* Buckle from Sutton Hoo Treasure

**Barbarians and Beasts.** As the Romans withdrew from Britain in order to bolster up the crumbling Empire, Germanic invaders were already settling in East Anglia, and throughout the 5th century they continued to arrive in shiploads from the North Sea coasts; by the end of the succeeding century, they had conquered all but the westernmost ▽ Celtic areas. They buried their dead in pottery urns, or in graves accompanied by bronze brooches of cruciform shape, or with radiate or square head-plates, often gilt and covered with relief patterns of highly stylised beasts literally dis-jointed into their constituent limbs, and terminating in an equally stylised animal head. By the 7th century, earlier 'saucer' and disc-type brooches could become dazzling displays of colour and craftsmanship, like those from the rich kingdom of Kent, which had strong contacts with the ▽ Franks. They were set with garnets, shells and glass pastes in tiny gold-walled cells on a gold background, with minutely detailed gold filigree in the new animal style of ribbon-like interlacing bodies whose beast-heads often bend back to bite themselves. In the early ▽ Migration Period, these are international Germanic brooch forms.

**Missionaries and Kings.** The conversion of the English to Christianity took place throughout the 7th century, carried out by missionaries from both Rome and the ▽ Celtic Church, who furnished their monasteries with books and artefacts decorated in their separate artistic traditions. Ambivalent attitudes to the new religion, in the first stages of the Conversion, are suggested by the mixed nature of the sumptuous 'grave-goods' from the royal ship burial at ▽ Sutton Hoo of about 625: looted

baptismal spoons and silver bowls bearing cruciform designs from the Christian Mediterranean accompany a battle-helmet bearing pagan Scandinavian scenes of a ritual war-dance in honour of the god Woden, by 'beserkers' wearing horned helmets. But more important is the juxtaposition of art styles: the restrained Classicism of the ▽ Byzantine silverware; the exuberantly ▽ Celtic spirals of the 6th-century hanging-bowl mounts (in direct line of succession to the abstract curvilinear ornament of pre-Roman British art); and the interlacing ▽ Anglo-Saxon beasts of the great gold buckle, and the astonishingly worked shoulder-clasps. Obviously in the Germanic tradition, yet enriched by the Celtic technique of ☐ mille-fiori glass chequers, the clasp symbolises one of the first meetings of the two art styles which, combined, were ultimately to give birth to the great illuminated manuscripts of the next two hundred years. With its panels of geometric ornament surrounded by a border of interlaced biting beasts, it prophetically suggests the 'carpet' pages of the beautiful ▽ Lindisfarne Gospel, produced about 700 in Northumbria.

**Christian and Pagan Carving.** Christian building during and following the 7th century encouraged the development of a sculptural tradition through the demand for decoration on columns and capitals in the churches and on the free-standing stone crosses. This sculpture ranges from figures and scenes illustrating the Bible teaching to scrolled vine-foliage ☐ reliefs in which birds and animals are found. These high crosses, particularly the Irish ones, frequently depict animal scenes with great simplicity and vigour and suggest the influence of the

enigmatic Picts, whose pagan symbol stones and later Christian cross-slabs are incised or carved with masterly depictions of animals.

Pictish influence has also been seen in the whalebone Franks Casket (*about* 700) from Northumbria in northern Britain.

**Manuscripts and Metalwork.** The few illuminated books which survive the ▽Viking raids of the 7th century, when many monastic libraries, such as that at York, were burnt, lead the way towards the great examples of illumination of the 8th century. These luxury □codices take elements from both ▽Celtic and ▽Anglo-Saxon sources so that the years around 700 saw the full expression of the joint Celto-Saxon style in some of the most gloriously decorative and elaborate illuminations still existing. The forms found in illuminations, combining scrolled, spiral and geometric forms with interlacing animals, are repeated in the metalwork of the period, as for example in the early 8th-century Irish belt-reliquary.

**The art of the Vikings.** In 793 and the two years following, the ▽Vikings successively sacked the Christian settlements of ▽Lindisfarne, Jarrow and Iona. At first they simply plundered the astonishing wealth that the monasteries had accumulated during the century (the Golden Age), but by the middle of the 9th century the invaders were beginning to settle in the Isles of Scotland, Ireland, the Isles of Man and England, so that by 900 several thousands had come to stay.

This period of conquest and settlement, and continual violence and upheaval, did not encourage the making of works of art of a high standard during the 9th and early 10th centuries, but by the middle of the 10th century Anglo-Viking art, inspired by a monastic revival and by ▽Carolingian art of the previous century, achieved new heights. One of the best preserved ▽Anglo-Saxon churches at Bradford on Avon contained a stiffly draped angel figure from a rood, an example of the 'Winchester' style more familiar in illuminated manuscripts.

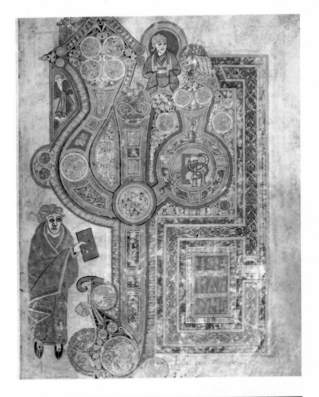

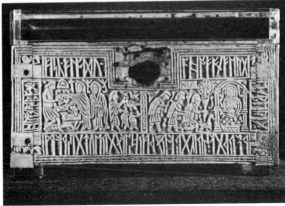

*Top:* Book of Kells. Folio. AD 760–820. 13 × 9½ in (33 × 24 cm). Trinity College Library, Dublin
*Above:* Franks Casket. Whalebone with carving showing Christian and Germanic legend. *About* AD 700. BM, London
*Below:* Angel from a rood. St Lawrence Church, Bradford-on-Avon. *About* 700

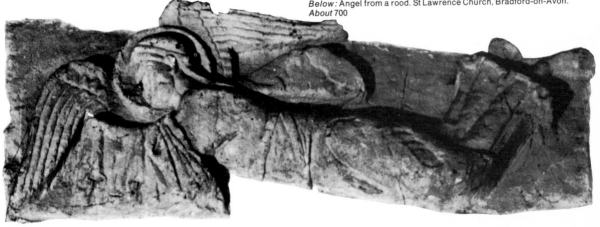

# THE DARK AGES

**Charlemagne's Christian Empire.** On Christmas Day 800, Charlemagne, warrior-king of the Frankish domains, was crowned by Pope Leo III in ▽St Peter's, Rome, and acclaimed as 'Emperor and Augustus'. Coins struck after this coronation bear the legend 'Restoration of the Empire', and the new political ideal of a Christian Empire modelled on that of ancient Rome also entailed a cultural renaissance which drew its inspiration from the late Classical artistic traditions of the ▽Early Christians. Charlemagne saw himself as the 'new ▽Constantine', with Aachen, his capital, a 'second Rome', and his palace-chapel built octagonally like Justinian's Hall of State at Constantinople. His early churches owed their plans to late Roman basilican types; similarly the gatehouse to Lorsch Abbey was based on that outside St Peter's, as well as on the Classical triumphal arch (*see* pages 52–3), with details such as the pilaster arcade and half-columns with Classical capitals.

**The Book and the Church.** The first generation of manuscripts illuminated at the court in Aachen divide into two groups, reflecting the separate traditions of both early ▽Roman, and contemporary ▽Byzantine Christianity. The hybrid Franco-Saxon style of the later 9th century combines the vibrant, impressionistic adaptation of the Byzantine manner (found in manuscripts from Reims), with full-page initials built up from panels of abstract and animal-headed interlace in the ▽Celto-Saxon manner deriving from manuscripts produced in continental Irish monasteries. Charlemagne imported scholars from abroad, like the Anglo-Saxon Alcuin of York, whom he placed in charge of the production of corrected religious manuscripts, and created Abbot of Tours (796–804). Alcuin undoubtedly supplied his monastery with books from the famous library of his native York; these must have included a 5th-century Roman illustrated Bible, for on such a book depend the pictures in the new, one-volume ▽Tours Bibles of the next generation. Now, for the first time in medieval Europe, the true art of continuous narrative is rediscovered, the story divided into zones like a strip-cartoon, two figure scenes to a line, split into frames by trees of a naturalism that can only derive clearly from late Classical art. (*See* Index for further references to Manuscript Illumination.)

**Carolingian Collapse.** The initial political and hence artistic dependence on the traditions of Christian Antiquity, introduced naturalistic art, especially representation of the human figure, to the Germans, whose art during the previous ▽Migration Period had consisted mainly of highly stylised, animal-based, interlace patterns. As well as in the flat plane of book illustration, the human figure now made its first appearance in the semisculptural dimension of carved ivory covers for those books. The panel illustrated depicts three New Testament scenes in descending zones, and below them, Abundance and a river-god of patently Classical origin, as is the luxurious acanthus border. The carving is finely executed, being deeply undercut, and the lively figure-style, found also in Reims manuscripts, suggests manufacture there about 870. The much later jewelled gold frame (*about* 1012) which surrounds the ivory, is set with ▽Byzantine enamel portraits, and Evangelist symbols in ▽Ottonian enamel, so that in its final state the cover ably summarises the sources of influences operative in the succeeding period. The first half of the 10th century, however, is something of a black artistically, for, as in Britain, the rich monasteries of a now fragmenting Empire were easy prey to barbarian invaders, who were not checked until the middle of the century by the new Ottonian dynasty.

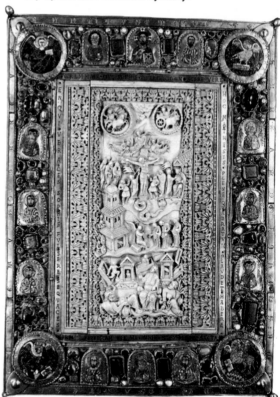

*Above:* Book Cover (Crucifixion). About 820–30. Frame. 11th century. Bayerische Staatsbib., Munich

*Left:* Gatehouse to Lorsch Abbey, Germany. 810

**The Ottonian Revival.** The Ottos were concerned to maintain their ▽Carolingian heritage both artistically and politically, through the closest links with Rome and the Papacy. Otto I was crowned Emperor by the Pope at Rome in 962, and Otto III's seal again proclaimed the 'Renewal of the Roman Empire'. He was active in importing artists like the painter, Johannes Italicus, from Rome, just as his mother, a ▽Byzantine princess, had introduced artists from ▽Constantinople. Consequently manuscripts of the late 10th century may be illuminated in various styles, like the ▽Codex Egberti, whose extensive cycle of scenes from the life of Christ is certainly based on a late Roman Bible, and includes miniatures by an artist with knowledge of contemporary Byzantine painting, as well as the master represented here, whose work shows a profound understanding of late antiquity's naturalistic draped forms and illusion of space.

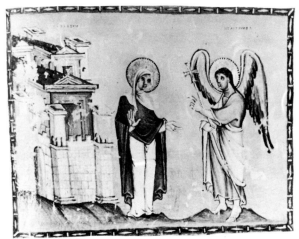

*Above: The Annunciation.* Codex Egberti. Late 10th century
*Below left: Altar Cross of Abbess Matilda and Duke Otto.* 973/82. Essen, Germany
*Below right:* Hildesheim Cathedral. Bronze doors commissioned by Bishop Bernward 1015

**Metalwork and Sculpture.** The heights of ▽Ottonian plastic art are represented by the jewel-encrusted processional crosses of the late 10th century. The example illustrated also incorporates a plaque portraying the donors, executed in gold-walled cells of enamel, a technique practised by Germanic goldsmiths of the ▽Migration Period; but it is the figure of Christ (with jewelled and filigree halo) nailed to the cross, that is the real masterpiece, for it marks the beginning in northern art of a feeling for representation in the round, and for the sensitive depiction of the human, suffering Christ, with gaunt body and pitifully expressive face.

Towards the end of the period, in 1015, Archbishop Bernward had figured bronze doors cast for his church at Hildesheim. The idea, though not the figure-style, probably derives from the late Classical wooden doors he would have seen on one of his journeys to Rome. The original sculptor undoubtedly used as his models, figure cycles both from recent, Ottonian Bibles like the ▽Codex Egberti, for the Life of Christ scenes on the righthand door and from older, ▽Carolingian pictures like those in ▽Tours Bibles, for the Genesis scenes on the lefthand door. They show the same vertical arrangement of zones, and similar division of each frame by trees, whose stylisation, however, proclaims their Ottonian date. The heads of the figures are modelled completely in the round, while their bodies recede into the further plane occupied by the buildings and trees, emerging, in turn, from the background of the doors themselves, which, in this articulation of form and space, herald the succeeding ▽Romanesque style.

*Below: The Fall.* Detail from one of the panels on the doors of Hildesheim Cathedral

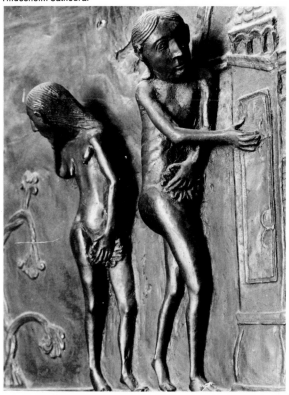

# The Medieval World

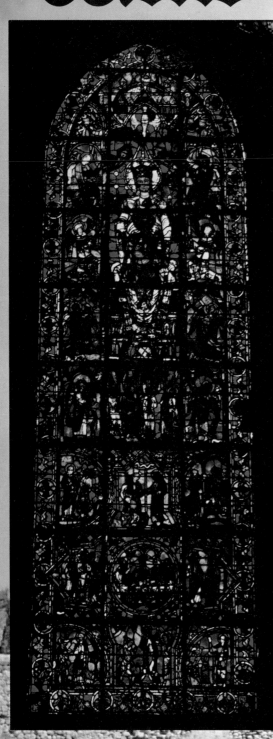

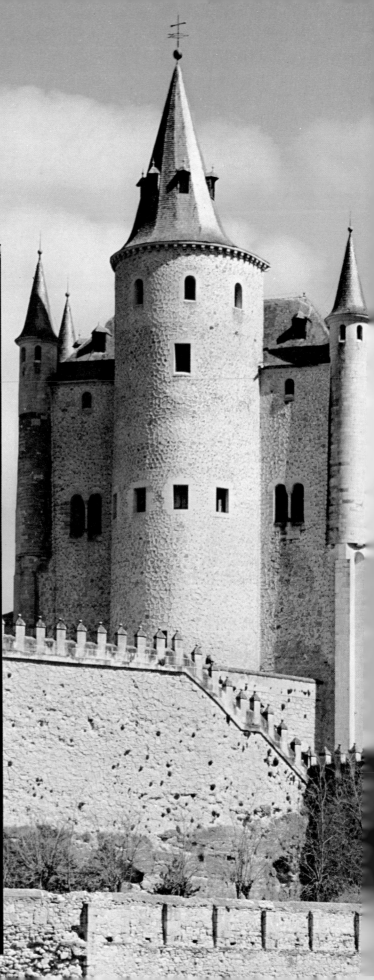

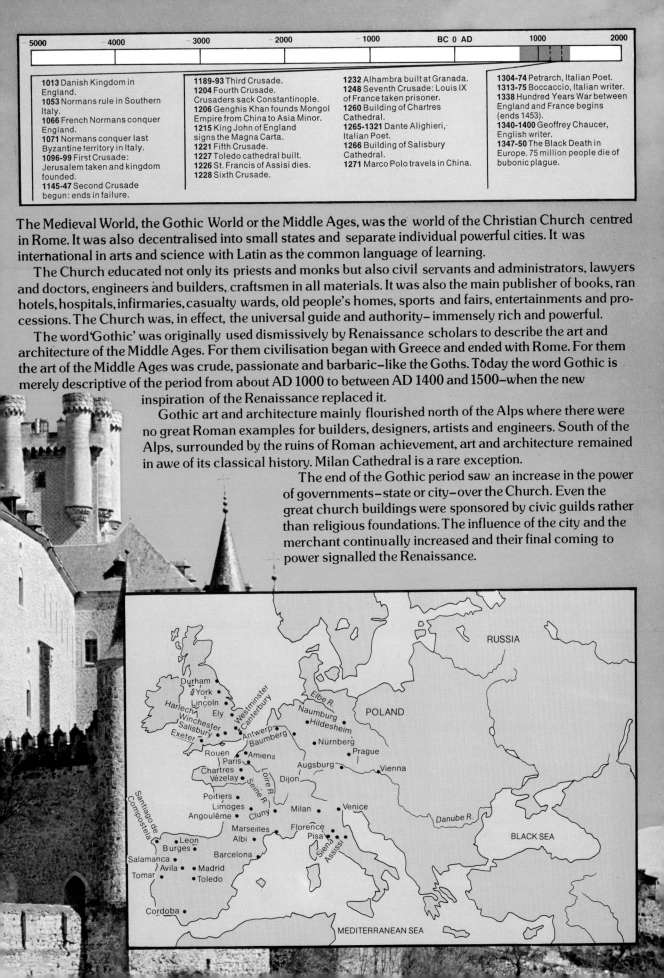

**1013** Danish Kingdom in England.
**1053** Normans rule in Southern Italy.
**1066** French Normans conquer England.
**1071** Normans conquer last Byzantine territory in Italy.
**1096-99** First Crusade: Jerusalem taken and kingdom founded.
**1145-47** Second Crusade begun: ends in failure.

**1189-93** Third Crusade.
**1204** Fourth Crusade. Crusaders sack Constantinople.
**1206** Genghis Khan founds Mongol Empire from China to Asia Minor.
**1215** King John of England signs the Magna Carta.
**1221** Fifth Crusade.
**1227** Toledo cathedral built.
**1226** St. Francis of Assisi dies.
**1228** Sixth Crusade.

**1232** Alhambra built at Granada.
**1248** Seventh Crusade: Louis IX of France taken prisoner.
**1260** Building of Chartres Cathedral.
**1265-1321** Dante Alighieri, Italian Poet.
**1266** Building of Salisbury Cathedral.
**1271** Marco Polo travels in China.

**1304-74** Petrarch, Italian Poet.
**1313-75** Boccaccio, Italian writer.
**1338** Hundred Years War between England and France begins (ends 1453).
**1340-1400** Geoffrey Chaucer, English writer.
**1347-50** The Black Death in Europe. 75 million people die of bubonic plague.

The Medieval World, the Gothic World or the Middle Ages, was the world of the Christian Church centred in Rome. It was also decentralised into small states and separate individual powerful cities. It was international in arts and science with Latin as the common language of learning.

The Church educated not only its priests and monks but also civil servants and administrators, lawyers and doctors, engineers and builders, craftsmen in all materials. It was also the main publisher of books, ran hotels, hospitals, infirmaries, casualty wards, old people's homes, sports and fairs, entertainments and processions. The Church was, in effect, the universal guide and authority– immensely rich and powerful.

The word 'Gothic' was originally used dismissively by Renaissance scholars to describe the art and architecture of the Middle Ages. For them civilisation began with Greece and ended with Rome. For them the art of the Middle Ages was crude, passionate and barbaric–like the Goths. Today the word Gothic is merely descriptive of the period from about AD 1000 to between AD 1400 and 1500–when the new inspiration of the Renaissance replaced it.

Gothic art and architecture mainly flourished north of the Alps where there were no great Roman examples for builders, designers, artists and engineers. South of the Alps, surrounded by the ruins of Roman achievement, art and architecture remained in awe of its classical history. Milan Cathedral is a rare exception.

The end of the Gothic period saw an increase in the power of governments–state or city–over the Church. Even the great church buildings were sponsored by civic guilds rather than religious foundations. The influence of the city and the merchant continually increased and their final coming to power signalled the Renaissance.

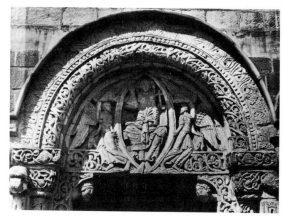

*Above: Christ in Majesty* from the Prior's Door, Ely Cathedral.
12th century

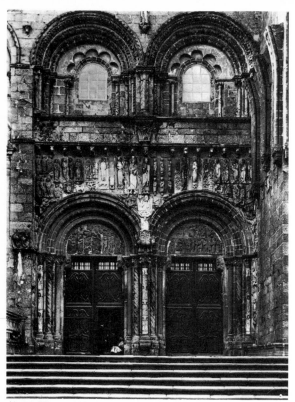

*Above:* Silversmith's Portal, Santiago de Compostela, Spain.
12th century

**The Classical Heritage.** Europe was left in chaos by the invasions which succeeded each other from the 5th to the 10th centuries. Every invader – German, Slav, Arab, Norseman, Magyar – left his mark on the residue of Greco-Roman culture bequeathed by the ▽ Roman Empire. After the last invasions died away, the work of reconstruction began in earnest under the guidance of the only unifying force, the Latin Church. A new civilisation took shape between the 10th and 12th centuries and it gave birth to a specific style, called Romanesque, which was a synthesis of the Classical heritage, the ▽ Celtic and Germanic traditions and Oriental influences. The Classical heritage was still visible in the monuments and the statuary scattered all over Europe, from Naples and Sicily to Bath in England and Trier on the Rhine. It was kept alive by the Latin tongue and Church literature. It continued in its Greek form at ▽ Constantinople and in the ▽ Byzantine empire. It constituted one of the two main streams that went into the making of Romanesque art. The other had its origins in the tribal past of the ▽ Celts, ▽ Goths and ▽ Germans; it showed itself in the ☐ runic stones, the Irish crosses and illuminated ☐ manuscripts, the Scandinavian woodwork, the ▽ Visigothic and ▽ Merovingian jewellery, the Lombardic ☐ reliefs. The Classical strain was humanistic and tended to revert to Greco-Roman naturalism; the tribal outlook was abstract, fantastic, poetical, full of dreams and metamorphoses, fond of monsters and ☐ interlacings. The former asserted itself more strongly around the Mediterranean shores; the latter predominated in Northern Europe. Wherever the two co-existed and blended we have the Romanesque style.

**Carving and Decoration.** Romanesque sculpture was mostly located in monastic churches or cathedrals. Here the Benedictine order of monks set the tone, being the intellectual and artistic elite of the time. This sculpture was the translation into stone of the illuminations to be seen in the holy books: the stylised, dancing figures, the monsters and ☐ interlacings of the insular and barbaric tradition or the Biblical allegories of the Greek Fathers. The abstract and imaginary themes were particularly well suited to a sculpture which was subordinate to the architecture it decorated. Romanesque sculpture was incorporated in the architectural element on which, or out of which, it was carved, whether the ☐ tympanum, ☐ lintel or ☐ jamb of a ☐ portal, or a ☐ capital, or a ☐ corbel under the roof. It not only underlined the function of those elements; it brought them to life pictorially (since sculpture was painted) and turned them into vivid representations of the holy mysteries, such as Pentecost (Vézelay), God's Revelation (Moissac), the Last Judgement (Autun, Conques), or the perennial struggle between the forces of Good and the forces of Evil (Chauvigny, Saulieu, Plaimpied). Another characteristic of Romanesque sculpture is the geometrical nature of its composition; every scene or section, whether figurative or not, is organised around an abstract pattern of circles and triangles. Classical proportions were not taken into account, but it was an 'art of geometry'.

The sculptors remained anonymous. They were recruited from both monks and laymen and moved from one building-site to another in the monastic network. Much of their work has been destroyed by fire, decay or iconoclasm. Only a few examples survive in Protestant countries. Among the finest carvings in England are those of Kilpeck (Hereford) and Chichester. In what is now France one of the main survival areas is Burgundy with Vézelay, Autun and the Cluniac churches which were one of the great sources of artistic inspiration; next to it comes the south-west, from Poitiers to Toulouse, extending down into Spain along the pilgrimage routes to Santiago de Compostela. In the territories of the Germanic empire the sculptural genius expressed itself not so much in architectural decoration as in metalwork, especially in reliquaries, crucifixes and bronze statues. Mention must also be made of bronze doors such as those of San Zeno in Verona.

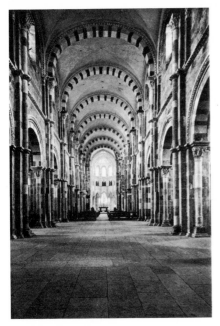

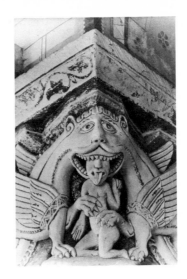

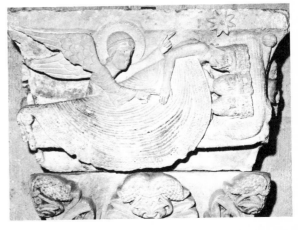

*Above:* The Nave. Ste Madeleine, Vezelay. Begun 1104
*Top centre:* Capital (A dragon devouring a woman). St-Pierre, Chauvigny. *About* 1100
*Top right:* Porch. San Zeno, Verona. 1070
*Right:* The Dream of the Maji. Autun Cathedral. 1090–1130

**Architecture in France and England.** Romanesque architecture, in its religious form, was essentially Romano-Byzantine in conception. The church was a cross between the Roman bath with its stone □vaults and the Roman □basilica with its timbered ceilings to which was often added a □cupola or domed vault above the crossing. Many churches, particularly on the pilgrimage routes of the continent, built an □ambulatory around the apse, opening on to chapels containing relics, and allowing the crowds to circulate more easily; some had galleries above the aisles for the same purpose. Romanesque architecture was functional and logical and the interior disposition could be read from the outside. It developed along its own lines, displaying a typically Western sense of dynamics.

This is particularly noticeable at the east end of the greater churches in Burgundy and south of the Loire where small chapels support the apse, which itself props up the chancel, which acts as a springboard to the soaring tower above the transept; this is the case at La Charité-sur-Loire, at Paray-le-Monial and Brioude. Interiors tend to grow ever higher and let in more and more light. The round arch was replaced by the pointed, borrowed from ▽Islam; the timbered ceiling prevalent in Italy, Germany and the Anglo-Norman territories was replaced gradually by stone vaults (of the □barrel or □groin types), until Durham cathedral, followed by Caen in Normandy, devised the solution of the □ribbed vault which was to lead, in the hands of the French, to the articulated and aerial ▽Gothic system.

**Architecture in Germany and Italy.** Romanesque architecture is remarkable for its variations between one region and another. It was □dome-vaulted in the southwest of France (Perigueux, Souillac), but retained timber ceilings in many Anglo–Norman churches (Norwich, Winchester, Southwell) and also in Italy (San Miniato in Florence, San Zeno in Verona). The materials employed were generally local. Romanesque mural-painting was inspired by ▽Byzantine models. Enough remains to point to the existence of at least two schools of painting. One is Greek in origin and is found in Burgundy and the Germanic empire. It uses several layers of grounding and colour, fixed with wax. It is thick and brilliant (Berzé-la-Ville, Le Puy). The other prevails in the Loire valley and consists of □distemper, with the colours diluted in a mixture of water and liquid glue applied on the dry plaster; the colours are light and matt (St Savin, Tavant).

Artists travelled all over Europe, like the English painter of Sigena in Spain or the Greek who worked at Canterbury. Southern Italy and Sicily remained faithful to the Byzantine art of the mosaic (Rome, Palermo, Monreale). The subjects of the murals and mosaics were scenes of the Old and New Testaments on the walls of the nave, lives of saints and of the Mother of God and, usually, in the hemicycle of the apse a gigantic figure of Christ in Majesty with the □tetramorph.

# THE MEDIEVAL WORLD

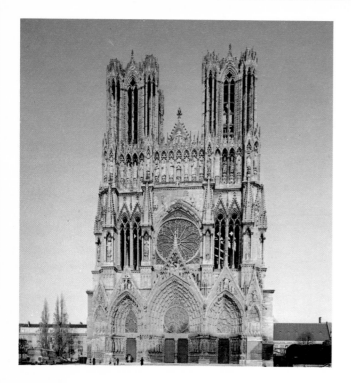

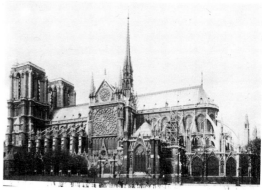

*Above:* Notre Dame, Paris. South transept façade, begun 1258
*Left:* Reims Cathedral. Second quarter 13th century. West front

**The Origins of Gothic.** During the late 12th and early 13th centuries a building style grew up in the north-east of France (the Ile de France) which was to influence cathedral and church builders throughout Europe for over two hundred years. Later generations called this style ▽ Gothic to distinguish it (in its supposed barbarity) from the rational, civilised style of Classical architecture. But the term has long since lost its pejorative tone and is now used simply as a label for the fine and often sophisticated constructions of the later middle ages and for the painting, sculpture and decorative arts which followed that architecture's stylistic lead.

**Gothic Vaulting.** The new constructional techniques of the ▽ Gothic style differentiate it sharply from ▽ Romanesque architecture. The emphasis on the strength and solidity of the wall necessary to Romanesque builders, was replaced by the desire to create a type of skeleton or frame with which to achieve ever-increasing effects of light, lightness and height. Light and lightness were obtained by paring down the size of architectural members, making architectural decoration delicately linear and opening increasingly large windows in the wall space between the supporting parts of the structure.

The height of succeeding buildings grew: the vault of ▽ Chartres is 121 feet high, ▽ Amiens 140 feet and ▽ Beauvais – before the structural collapse it suffered which called a halt to this competition in dimensions – measured 157 feet to the top of the choir □ vault. The impression of soaring height was enhanced by the carving of delicate, elongated shafts on the surfaces of □ piers and walls, often running uninterrupted from the floor of the church up to the starting point ('springing') of the □ rib vaults above. In the vaults the ribs continued the line made by the shafts below so that visually each bay of the church formed a complete and unified structure.

The development of the pointed arch and the rib vault allowed the stone mason to span rectangular □ bays or compartments. The round-headed arch could only span square bays since the semicircular arches had to be all the same height. By using a broken or pointed arch the builder could make rib arches of the same height but different spans. Other structural advantages followed: there was far less side thrust from a pointed arch and structures could be lighter with larger window openings.

It was this technological development that was the heart of Gothic architecture.

**The West Front and Transept Façades** of ▽ Gothic cathedrals provided scope for exterior decoration. ▽ Reims shows the full development of the High Gothic west front. The three large portals are encrusted with sculpture on the □ jambs and arches (□ voussoirs). Above this storey comes the rose window, filled with □ bar tracery, next the gallery of kings containing giant statues and finally the two towers, originally intended to be surmounted with □ spires.

While the exterior of Reims achieves its effect through massive sculptural richness, the south transept façade of ▽ Notre Dame, Paris, creates an impression akin to thin metalwork. The sharply pointed gable of the □ portal, punched through with a tracery motif, is repeated in the gables which flank it, while above almost the entire composition consists of traceried windows, with the small intervening areas of masonry also covered with □ tracery ('blind tracery'). This use of geometric forms to build up a composition meant that this style of decoration could easily be adapted for use all over Europe.

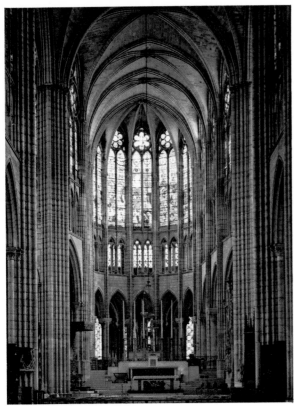

*Above*: St. Denis, nr Paris. View of the choir and high altar. After 1231

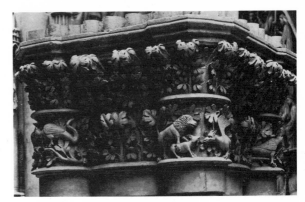

Reims Cathedral. The sculptured decoration of a capital

**Naturalistic Capitals.** The sculptured decoration of □capitals became standardised in the ▽Gothic period and a stiff formalised leaf pattern – the □crocket capital – was generally used. However there were some exceptions, notably an interest in producing very naturalistic and finely carved representations of real plants, which manifested itself in different parts of Europe: in France at ▽Reims, in Germany at ▽Naumburg and in England at Southwell.

**Tracery Patterns.** The introduction of bar tracery – delicate cut stone decoration based on geometrical patterns – created even greater effects of light and lightness than before. The interior of St Denis shows the lacy effect of the bar tracery patterns against what is virtually an upper wall of glass. The back wall of the □triforium is now glazed and the shafts of its diminutive □arcade link with the shafts of the window above, so that the triforium is visually joined with the □clerestory, producing the impression of a two-storey elevation in contrast with the three-storey elevation of ▽Chartres.

Amiens Cathedral 1220–88. East end

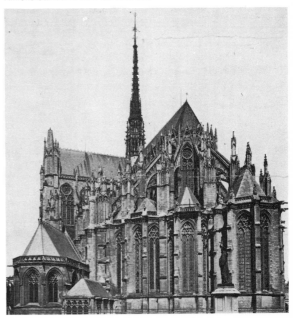

**Buttresses and Piers.** Large buildings had previously been □buttressed by means of solid piers abutting the masonry or brickwork, and the upper parts of the structure had sometimes been supported by arches (concealed beneath the aisle roofs) designed to transmit the outward thrust exerted by the vaults and main roof to the buttresses of the aisle walls. ▽Gothic masons considered the skeletal internal appearance of a church so important that they made these external arched supports – 'flying buttresses' – visible and gave them a greater role in the engineering of a large church. Thus the characteristic exterior of a French cathedral, with flying buttresses decorated with spiky □pinnacles and □finials, is really an elaborate permanent scaffolding system of elegantly carved stone.

The elevation and ground plan of the typical French High Gothic cathedral followed a fixed pattern adapted from the ▽Romanesque. The elevation of ▽Chartres, the earliest High Gothic cathedral, consists of a tall arcade with pointed arches, a gallery which has shrunk to a decorative band (□triforium) and a large window area (□clerestory) composed of two □lancet windows and an □oculus with plate □tracery. The typical High Gothic ground plan was formed by a □nave flanked by two aisles crossed, before the □choir, by a transept which also had two aisles. The curved east end had a ring of polygonal chapels, visible from the exterior.

# THE MEDIEVAL WORLD

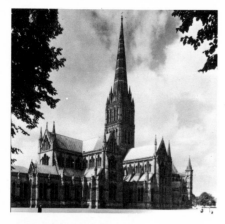
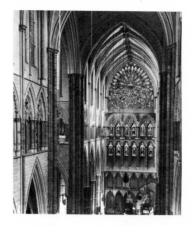
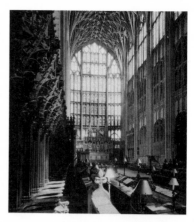
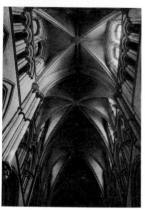
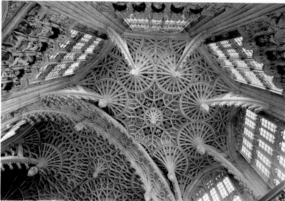
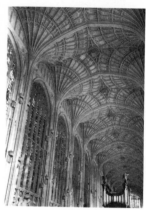

*Top left:* Salisbury Cathedral. 1220–58. From the north-east
*Top centre:* Westminster Abbey. 1245–69. The south transept seen from the north transept
*Top right:* Gloucester Cathedral. After 1330. The choir

*Above left:* Lincoln Cathedral. 13th century. Small south transept vault of St. Hugh's choir
*Above centre:* Westminster Abbey. *About* 1512. Pendant vault in Henry VII Chapel
*Above right:* King's College Chapel, Cambridge. 1446–1515. The vaulting in the nave

**English Gothic architecture** developed along rather different lines from ▽Gothic architecture on the continent, although of common origins. In the case of the choir of ▽Canterbury Cathedral, a Frenchman directed the English masons. However the English often adopted foreign ideas long after they were out of fashion in their country of origin, and changed the elements which they borrowed almost beyond recognition, and many of the finest achievements of English Gothic architecture are separate from developments elsewhere.

**Salisbury and Westminster.** The view of the east end and north transept of ▽Salisbury Cathedral, begun in the same year as ▽Amiens, shows some of the main differences between English and French High ▽Gothic cathedrals. There are no □flying buttresses, no □tracery and the east end chapels are all rectangular. There is an emphasis on the horizontal rather than the vertical, even more marked in the interior of the church than the exterior, which is underlined by the insistent use of horizontal □mouldings ('string-course'). A single spire over the crossing tower crowns the composition.

In contrast with Salisbury the designers of ▽Westminster Abbey were closer to developments in the Ile de France. The new Abbey Church, built by Henry III as a

shrine for Edward the Confessor and as a setting for the elaborate tombs of members of Henry's own family, has various French-influenced features: the ground plan with polygonal east chapels and two aisled transept, □flying buttresses, the elevation, and the use of □bar tracery, especially the patterns used in the transept □rose windows, reminiscent of ▽St Denis. However other features are English: the polished marble shafts attached to the piers, the use of a proper □gallery rather than a □triforium and the ridge rib traversing the axis of the □vault.

**English vaults** were often decorated with more ribs than were structurally necessary. The vault of St Hugh's Choir, Lincoln, shows a variation on the theme of the basic four-rib (□quadripartite') vault. Shorter ribs, connecting the two major vault ribs (□'liernes') could be added as in the choir vault of Gloucester Cathedral. □Tracery patterns could also be applied to vaults and were especially effective when used in conjunction with cone-shaped vaulting compartments to create □fan vaulting, as in King's College Chapel, Cambridge. In King Henry VII's Chapel, Westminster Abbey, an even richer impression was created by making these cones hang free to form a □pendant vault.

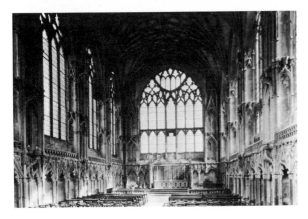

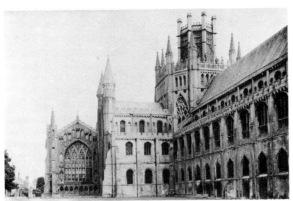

Top: Wells Cathedral. After 1285. The chapter house
Centre: Ely Cathedral. 1321–49. Lady Chapel
Bottom: Ely Cathedral. Exterior showing Lady Chapel, begun 1321.

**Chapter Houses.** Some of the most inventive English ▽ Gothic architecture was created for the small chapels and other buildings which clustered around the main body of a Cathedral or Abbey Church. Chapter Houses, in which the canons or monks met to discuss their daily business, were often fine structures.

Wells Chapter House is centrally planned (octagonal) so that each member of the chapter could be given a seat against the wall and be able to see and hear his fellows. The many-ribbed vault forms a cone of clustered ribs supported on a single pier at the centre of the room, so the view is as open as possible. Most of the upper wall space is given over to large windows which light the room clearly and are filled with robust □ tracery patterns. Each member's place is marked by one section of the decorative arcade which runs along the lower wall. The Chapter House thus links form, function and ornament.

**Decorated architecture.** While French Gothic architects distinguished themselves by their engineering skills the most striking accomplishment of their English counterparts was their ability to devise rich decorative effects with which to animate the plain surfaces of a building. These talents are shown to best advantage in English 'Decorated' architecture, the name given to buildings produced between about 1285 and 1335.

The Lady Chapel at Ely is a basically rectangular structure. The lower walls are decorated with an arcade of complexity. Plain gables, divided by slender □ crockets and decorated with lively leaf forms, frame a second layer of arches with nodding □ ogee heads – shapes which undulate in three dimensions. Miniature rib vaults are placed beneath these arches and miniature □ buttresses with ogee-headed □ niches scooped out of them, divide the windows above. Graceful sculptured figures, many now severely damaged, were set in any available space. The □ tracery patterns, □ lierne vault and treatment of the exterior show a corresponding variety of imagination and the effect must have been even more decorative in the original painted state.

**Perpendicular architecture.** The stunning effects of the Decorated style could only be achieved when highly skilled masons were available. For more widespread use a simpler method of creating dense ornamentation was necessary. During the 14th century the 'Perpendicular' style of architecture grew up to fill this need. The earliest surviving major monument of the style is the choir of Gloucester Cathedral, reconstructed within the shell of the ▽ Norman choir, to house the tomb of the murdered King Edward II.

In England this device was applied with special thoroughness, and is seen in the distinctively shaped narrow rectangles of tracery, with □ cusped arches at the head, which were applied to every available surface (or space), the use of patterned vaults which harmonised so well with the walls below, and the creation of great east windows – huge screens of tracery and ▽ stained glass. It was a relatively simple matter for a local mason to copy and apply the tracery panel, and the style soon made its appearance in churches of all sizes and types throughout Britain.

The ▽ Gothic architecture developed in the Ile de France had an impact all over Europe. In some cases faithful copies of French High Gothic buildings were obtained by following French architectural drawings or importing French masons. At other times a few structural ideas or decorative motifs were used by local masons who continued to work largely within their own traditions and produced interesting hybrid designs. Some talented architects used High Gothic only as a starting point for their own very original and successful ideas.

**The Master Mason.** High ▽ Gothic ground plans, elevations and details of mouldings and other sculptured architectural decoration could be transmitted by sketch books – either those belonging to French architects summoned to work in another part of the country or abroad, or those made by foreign architects travelling to France as part of their training, who recorded the new ideas they saw there. Villard de Honnecourt, a French architect who worked at Cambrai and visited Hungary, compiled an album in about 1225 which includes, among other things, technical instructions for masons, ground plans of several churches, drawings of executed and unexecuted designs for ▽ Reims, □ tracery patterns, ideas for □ piers, □ capitals and □ mouldings and the plan and elevation of the towers of Laon Cathedral, of which variants appear at Bamberg, ▽ Naumburg and Palermo, possibly based on Villard's transmission of the design.

**Germany.** Foreign architects might follow French techniques very closely. This is the case in the huge cathedral of ▽ Cologne, whose German architect, Gerhard, clearly knew ▽ Amiens, ▽ Beauvais and ▽ St Denis well and had at his disposal masons who were skilled in the most up-to-date French methods. The ground plan, with its two-aisled transept and ring of polygonal chapels, derives from Amiens, but the elevation has been pulled upwards to the startling height of almost 160 feet so that the □ arcade and □ clerestory are exceptionally tall and narrow. The □ triforium, its back wall glazed, has been linked with the clerestory as at St Denis, and the parade of graceful figure sculpture attached to the choir piers was adapted from the Sainte Chapelle, Louis IX's palace chapel in Paris. The vast but visually delicate structure is supported on the outside by a system of □ flying buttresses. Although few buildings of this magnificence were attempted, the Cologne workshop acted as a training ground for German masons who could carry their new skills to other parts of the country.

The implications of making the arcade of a High ▽ Gothic cathedral exceptionally tall were taken even further in Germany, where a type of church called the 'hall church' was developed and became so popular that examples can be found throughout present-day Germany, Austria and Czechoslovakia. The Wiesenkirche, Soest, shows how the arcades were made so tall that the □ triforium and □ clerestory were dispensed with entirely and the vault sprang directly from the arcade piers.

The aisles were made the same height as the □ nave, but distinguished from it by being much narrower.

The open vista which the hall church provided allowed the maximum amount of light to enter from the tall windows – here reminiscent of the clerestory of ▽ Cologne Cathedral – which occupied almost the entire wall space. The decoration of the arcade piers at Soest is very restrained. The shafts on the piers are hardly articulated at all and the capitals, which would have interrupted the transition from pier to vault, have been omitted altogether.

**Spain.** The cathedral of León in northern Spain also shows a knowledge of French architecture, especially of ▽ Reims and ▽ Amiens, but it is not certain whether the architect, Master Henry, was French or Spanish. Structurally the building was faulty – extensive repairs were necessary in the 19th century – so the Spanish masons may not have understood the French models they were following, in the way that Gerhard did in ▽ Cologne.

Despite shortcomings, León Cathedral is a most attractive building; the broad □ clerestory windows are still filled with their original light-toned stained glass and the proportions of the elevation, much squatter than Cologne, produced a calm, measured effect. Only the addition of half □ lancets to the sides of the clerestory and □ triforium openings in every bay hints at the waywardness present in other Spanish Gothic cathedrals such as Toledo, where arcades of clearly Moorish inspiration are used in the triforium. High Gothic never really took root in Spain. It remained a foreign import, used only rarely.

In contrast, architects working in Catalonia, southwest France and Majorca produced some daring and original buildings, whose hall-marks were an interest in structure rather than decoration and a lack of interest in admitting light into buildings. Barcelona Cathedral is a good example: the arcades are made so tall that they seem to push the triforium right up to the vaults. The clerestory, lit by small circular windows, almost disappears entirely. The broad nave is flanked by numerous small side chapels, squeezed in between the buttresses. Little interest is shown here in the use of □ tracery or other carved stone decoration – instead the emphasis is on the massiveness of the cathedral nave.

Gerona Cathedral went even further in this direction: the broad, aisleless nave of the church is covered by a single giant □ rib vault which, at a span of over 75 feet, is probably the widest rib vault ever constructed.

**Italy.** If the Catalonians and Germans were interested in structure at the expense of decoration, the Italians went almost to the opposite extreme. They kept to their traditional methods of construction but occasionally made exuberant use of the Ile de France decorative vocabulary. Milan Cathedral, an isolated example, was planned on such a massive scale that construction experts from France and Germany had to be called in to help, but the Italians had no problems in dealing with the exterior, which, covered in a profusion of spiky motifs, is one of the most striking ▽ Gothic exteriors ever created.

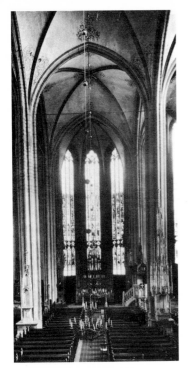

*Above:* The Wiesenkirche, Soest, Westphalia, begun 1331 View along nave towards altar

*Above:* Barcelona Cathedral, begun 1298

*Above:* Cologne Cathedral, begun 1248 View along the nave looking east

Milan Cathedral. 1385–1485. West front

Leon Cathedral, begun 1225. The choir from the south transept

**Tracery and Decoration.** In ▽ Gothic cathedrals, windows were so large as to be virtually glass walls and played an important part in the decoration of the building. Whenever possible the windows were filled with ▽ stained glass, which formed patterns, represented figures, or illustrated scenes from the Bible or other holy stories. The technique of colouring glass and then setting it in metal frames to form decorative windows had probably been in use since ▽ Carolingian times and surviving 12th-century windows show that by that date the art was already well advanced. But the great majority of existing glass dates from the late 12th and the 13th centuries and it was at this time that the popularity of stained glass clearly had an influence on architectural style.

The introduction of flying buttresses and the increase in window size which this made possible, have already been mentioned in the section on the French church (*see* pages 122–3). As the size of windows grew, metal bars were no longer sufficient to support the weight of glass the windows contained. Stone supports, at first □ plate tracery (pierced slabs of stone) and later □ bar tracery (delicate strips of cut stone) were employed to carry the glass. This tracery quickly assumed elaborate decorative shapes and eventually dominated the stained glass itself.

**Illumination and Atmosphere.** The interior of ▽ Chartres Cathedral shows the stunning effect produced when an entire set of stained glass windows is preserved. It is not possible for photographs to convey the varied effects of illumination and atmosphere created by the changing light shining through the dark-toned, many-coloured glass to cast pools of coloured light on the stonework inside. The work of the anonymous architect of the cathedral is almost forgotten as the spectator's attention is constantly drawn to the glowing windows, filled with scenes, figures and patterns, set into the aisles and □ clerestory.

The western □ 'rose' (large circular window) of Chartres shows a perfect balance between exterior and interior decoration. On the exterior the stone □ tracery patterns provide a satisfactory decoration which fits well within the composition of the west front as a whole. Inside the cathedral the pattern is reversed. Here it is not the areas of stone tracery, but the spaces between them which form decorative patterns. As in all early 13th-century glass, deep tones of red and blue predominate. The subject of the glass is the Last Judgement; at the centre of the rose sits God in Judgement, around Him are the Apostles, and the outermost ring is inhabited by the blessed and the damned.

**La Belle Verrière.** One piece of stained glass in Chartres, representing the enthroned Virgin and Child, was so prized that it was preserved from the former building and placed in a surround of 13th-century glass in the new cathedral. There it formed the object of much devoted veneration – respect similar to that accorded to the large panel-paintings of the Virgin and Child by Italian masters such as ▽ Giotto and ▽ Duccio. The window came to be known as *La Belle Verrière*. The illustration shows clearly how the glass was fitted together before the introduction of □ bar tracery divisions. A sturdy metal grid divided the window into rectangles and within this, strips of lead divided the window into irregular shapes based mostly, but not entirely, on the shapes of the forms to be represented (see illustration, page 118).

Glass of single colours, which had previously been fired in large sheets, was cut up and fitted into the metal frames. The details of the design – features, hair, drapery folds and so on – were painted in, normally in black. Sometimes further colours, especially some which could not be successfully fired in with the glass, were also added to the surface. Obviously the specialised technique had the effect of influencing and limiting stylistic developments, but the finest glass painters were able to manipulate the medium to good effect, and many different styles of glass painting can be distinguished.

**History Scenes.** The programme of figures and stories contained in a series of stained glass windows was carefully planned; it may well be that the entire stained glass and sculptural decoration of ▽ Chartres was intended to form one complex extended programme. Stained glass should be thought of as the equivalent of the extensive □ fresco cycles which sometimes appear on the walls of Italian churches. Numerous scenes from the Bible, stories of saints and everyday contemporary life were chosen to give an encyclopedic view of the Christian history of the world. This was a parallel to the encyclopedia-like texts being compiled at that time by medieval scholars.

To accommodate these numerous scenes the windows were often divided into smaller areas so that, for example, a single window, taking as its subject the Good Samaritan, would tell the story in sequential scenes, (and possibly also contain scenes suitable to the donor of the window). Different shapes enclosed these scenes and the intervening spaces were filled with patterns. In this way the window provided instruction when looked at close to, and made a decorative effect when viewed from a distance.

**Roundel Windows.** One of the most popular shapes for enclosing scenes was the □ roundel. This example, which shows the Parable of the Sower, comes from ▽ Canterbury Cathedral and reminds us that much fine English stained glass still exists, for example at Canterbury and ▽ York. The techniques used here are similar to manuscript decoration, both in the way the composition of the scene is made to fit and to complement the circular frame, and in the way a wealth of small details produce a very decorative effect. Comparison with the illustration of the ▽ St Louis Psalter makes clear the stylistic links between the two media. In both cases form is described by means of a delicate line superimposed on the pale faces of the figures and on the flat areas of colour of the drapery and settings.

*Top left:* Exterior view of the western rose of Chartres Cathedral. *About 1196–1216*
*Top right:* Interior view of the same
*Bottom left:* Canterbury Cathedral, *The Sower*, 13th century panel from the Poor Man's Bible Window
*Bottom right:* Chartres Cathedral. The Rose of France in the north transept

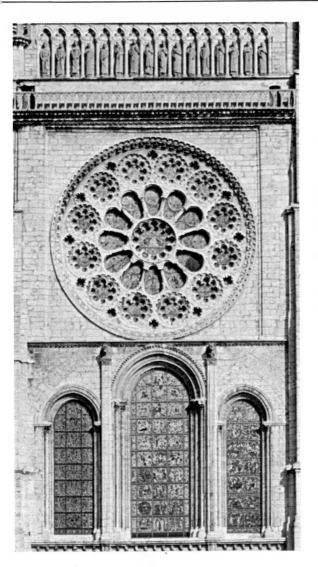

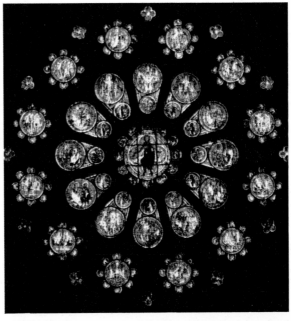

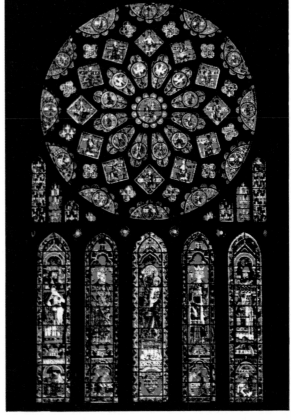

# THE MEDIEVAL WORLD

Early tribal wars were largely piratic raids by land or sea. It was profitable to wait until your enemy had gathered his harvest or accumulated wealth, then to raid his settlement and reap the fruit of his labours. Consequently, the ideal site for a settlement had at its centre an easily defended hill top, with a village round its base, with fields, orchards and grazing beyond that. In time of danger, everything could be drawn into the fortified perimeter. Water was important, and a hill top with a fresh water supply was invested with the qualities of a near miracle and held to be sacred – as in the cases of the ▽ Acropolis, the Citadel of ▽ Jerusalem, and Mount Abu in ▽ India.

A concentric ring of earth works, ditches and wooden palisades on a hill was the prototypical castle. These fortifications were by no means primitive. As settlements grew larger, richer, more stable and socially developed, so the fortified citadel became a permanent structure of stone. The sophisticated castle was no longer limited to an isolated hill top. It could be sited to dominate a safe harbour, to secure a river crossing, to guard a road, to police a city.

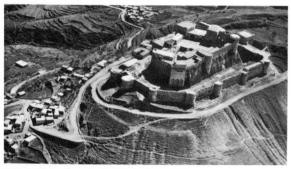

Krak des Chevaliers, Syria. 12th Century.

**Crusader Castles.** The fortifications of ▽ Byzantium were a model for the whole medieval world. As the city grew, and methods of warfare developed, Byzantium became a proving ground for all innovations in defence and attack. Byzantine examples were taken up and improved by both sides in the Crusader Wars. The Saracens built the great citadel of Cairo. The Crusaders built their chain of forts from the Syrian coast, along the eastern ridge of the great rift valley of the Jordan and Dead Sea, and down to the southern tip of the Moab uplands, commanding the ancient road from Arabia to the great cities of Damascus and Byzantium.

The 12th-century Crusader castles are the finest examples of the military architecture of their day. Built to withstand long sieges, isolated in desolate country, they had to be self-contained settlements with large water reservoirs, food warehouses and all the necessities for a garrison upwards of 1,000 strong. They all took advantage of strong sites. The castle at Saone, guarding the road to Antioch, is built on the tongue of a high, rocky promontory with a deep gorge on either side. A remarkable feature is a defensive cutting 426 feet long, 63 feet wide and 92 feet deep, cut by hand-tools through solid rock. All the castles have comparable engineering works, carried out by hired labour guarded by a handful of knights in a hostile country.

The best preserved of the Crusader castles is the Krak des Chevaliers in Syria. Perched on top of a great rock-hill, it is the most powerful and imposing work of its kind. Continually rebuilt and adapted over two centuries, its complex maze of concentric fortifications proved unconquerable by siege. On the upper stone platform of the castle originally stood windmills for pumping water and grinding corn, and other wooden buildings and defensive 'hoardings'.

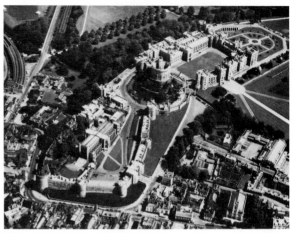

Windsor Castle. 11th century onwards

**The Castle in Europe** From the end of the ▽ Roman Empire until the 11th century there was little respite from local wars to allow for the building of permanent fortifications. It was after the Norman Conquest of France and Britain that the earthwork and palisade forts – not to be underestimated for their organisation, engineering and efficiency – were replaced by stone keeps and curtain walls, often following the plan of the old fortifications. The keep might be a round tower, as at Windsor, or a square tower, as in the citadel fortress of London. Where castles took advantage of a natural feature their plan would follow the site with all its irregularities, as on a pinnacle, a peninsula or other rocky outcrop. A castle sited in flat country, guarding a river crossing or a road, would be symmetrical in plan, surrounded by carefully cut regular ditches.

Experience gained in the Crusades led to elaboration and development in the Crusaders' homelands. Square towers, vulnerable to mining at the corners and to battering by powerful artillery machines, were replaced by round towers. The archers' loophole was developed to combine protection with a wide field of fire. Concentric systems of walls with maze-like defensible openings replaced simple walls. The keep, or main tower, became more civilised as living quarters. The castle became a status symbol of power and wealth and was no longer merely functional, as also did the armour that the knights wore. The castle became an elaborate home for the nobility, a military barracks, and a prison building. Cannon finally rendered the great castle obsolete. Elaborate earth works once more became the best means of defence with artillery forts embedded well within them. The old castle walls were pierced with windows and converted into impressive country houses.

# Castles and Fortifications

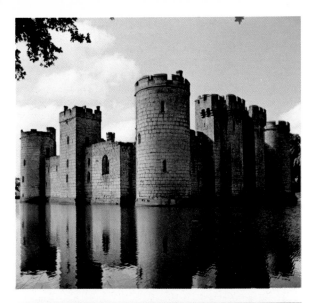

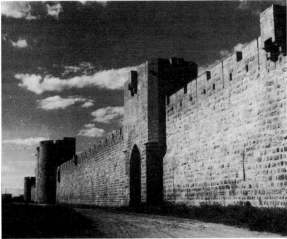

*Top:* Bodiam Castle, Sussex. 1386
*Above:* Ramparts, Aigues Mortes, Provence, France. *After* 1272
*Below:* Albi Cathedral, France. 1282–1390

**Walled cities** have existed from the earliest times and everywhere that man has built towns. The traditional pattern is of a widespread defensive wall with towers and gates and a single city strongpoint: a citadel or fortified area: a Tower of ▽London; an ▽Acropolis in ▽Greece, a Kremlin in ▽Russia, a Forbidden City in ▽China, a Zimbabwe in ▽Africa. Sometimes the walls were extended across country. Hadrian's Wall, built during the Roman occupation of Britain during AD 122–5, is 73 miles long. The Long Wall of Byzantium from Marmora to the Black Sea (AD 500), was about 50 miles in length. The Great Wall of China, probably in existence by 250 BC, is some 1,600 miles long.

These great walls, like city walls, were manned very thinly. Each tower contained a guard room for a handful of men who would patrol their section of wall. The wall was thus an effective way of controlling a frontier. The main value of the walled city was for the protection of merchants, travellers and warehouses. Revenues from caravans or convoys using walled cities a day's march apart were an important source of revenue, and explains the existence of perimeter walls which a town garrison could not possibly defend and which were not meant to withstand a long siege. Such cities were built in Asia in quite recent times.

During the middle ages, many new towns were built from scratch, complete with walls and a rectilinear grid plan. When the site permitted the walls were symmetrical. The town of Aigues Mortes in Provence is a well-preserved example. Once a main port of embarkation for the Crusades, it has now become an inland town.

**Fortified Bridges and Churches.** The men who built the great castles and cathedrals were also the engineers for bridges, mills – both wind and water – for irrigation and navigation canals and the great barns and houses of the middle ages. The carpenter played a major role in building construction. Naturally enough as castles were abandoned, degraded or adapted, the wooden parts of the structure, often considerable, were the first to decay, or be burnt, or salvaged for other buildings. The great castles were surmounted by elaborate wooden shelters, roofs and galleries, with windmills, cranes and other machines.

The fortified bridge was an important factor in control and customs as well as in defence. Old London Bridge existed until the end of the 18th century with its elaborate towers. Those of Paris were demolished at the same time. Fortified bridges still exist at Toledo in Spain, Verona in Italy, and Orthez in the Pyrenees. The bridge over the Monnow at Monmouth in Britain is still complete, with its tower, guardrooms, door and portcullis..

Fortified churches are found where their isolation makes them tempting prey to looters, sanctioned or otherwise. The cathedral at Albi, the churches of St Michael's Mount, Cornwall, and Mont Saint Michel, Brittany, the Sainte Maries near Aigues Mortes, and at Royat and Puy-de-Dôme in France are all fine examples of fortress churches. Such churches were not only treasure-houses, but places of sanctuary for the local population.

# THE MEDIEVAL WORLD

At the beginning of the Gothic period large-scale stone sculpture was confined to being architectural decoration. Sculpture was mainly intended to embellish the architect's cathedral designs, and position, subject matter, type and even the shape of the sculpture were dictated by the architecture in which it was set. During the course of the period sculptors were allowed to create individual pieces worthy of being considered as works of art in their own right. As with architecture, so too with sculpture, the ▽Ile de France was the cradle of new ideas, which then spread across Europe to be reinterpreted in many different ways.

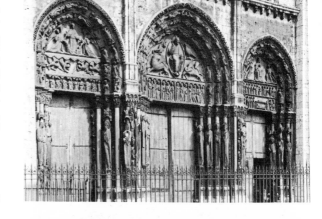

*Above right:* The *Royal Portal.* Chartres. *About* 1150

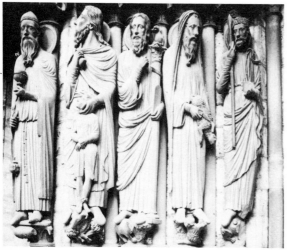

*Above: Melchizedek, Abraham, Moses and Samuel.* North Portal, Chartres
*Right: The Annunciation and Visitation.* Central Portal, Reims. *About* 1220

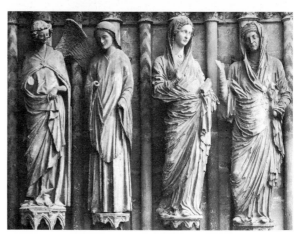

**The Static Figure.** The west porch of ▽Chartres, the *Portail Royal*, illustrates the ▽Romanesque and early ▽Gothic use of sculpture in the service of architecture. The □lintel is filled with a row of figures squeezed under an arcade, the arches above the entrance (□voussoirs) are packed with three ranks of seated figures, and the space between lintel and voussoirs (□tympanum) is filled with large-scale figures of the Redeemer and Evangelist symbols, carefully designed to fit into the available semi-circular space.

The columns which flank the entrance have capitals densely inhabited with figures from Biblical scenes, and growing in the place of the shafts of the columns themselves are large-scale figures which take on the elongated proportions of the architectural members they replace. These column figures are specifically designed not to upset the architectural balance of the □portal. They stand upright, their heads erect, gazing straight ahead of them, with all their gestures restricted to the narrow space which would have been occupied by a column shaft. Most of the carving on them takes the form of surface patterning whose horizontal and vertical lines further emphasise the shaft shape.

**Free Movement.** At Reims, about 70 years later, sculptors created less stylised figures in carved stone. The programme of sculptural decoration at Reims was so extensive that several different schools of sculptors worked there, in distinctive styles, within a short space of time. The Visitation and Annunciation figures show three of the most important successive stages. The pair of figures on the right, representing the Visitation, were carved by a man known as the 'Master of the Antique Figures' because of the similarity between his treatment of drapery and that used in some antique sculptures. His figures are no longer statically bound by the confines of the column, but move freely in space, creating a zig-zag profile. The facial type and expression of each woman is carefully differentiated and the two are conceived as a pair who relate to one another – a situation which would have been unthinkable in the rigid formula at Chartres.

On the left is the Annunciation. The Annunciate Virgin is carved in a restrained style with broad, smooth drapery folds. The Angel Gabriel, probably the latest of the four figures, is in a style connected with a sculptor known as the 'Joseph Master'. Here the plain drapery of the ▽Amiens style has been animated to produce lively cross-rhythms, as complex as the Visitation figures, but more graceful. Gabriel's head turns towards the spectators in direct communication, and the smiling face which we see is strikingly naturalistic.

**Gothic Realism.** Sculptors from abroad came to study and work at ▽ Reims and transmitted what they saw there to their native countries. The most talented of all these foreigners was a man now known as the 'Master of Naumburg' because of his sculpture for that east German cathedral. A series of figures placed between the windows of the choir represent the founders of the cathedral. Although these people had been dead for hundreds of years the sculptured figures have the realism of contemporary portraits. The illustration shows Ekkehard, Margrave of Meissen, and his wife Uta, a Polish princess, engaged in everyday activities and apparently communicating with the other figures in the choir.

**Gothic Classicism.** In Italy the Tuscan-based sculptor Nicola Pisano and his son Giovanni produced a series of richly decorated pulpits as complicated as a cathedral portal. The pulpit shown was made by Giovanni in 1301 for the church of Sant' Andrea, Pistoia. The realistic handling of the pulpit columns suggests that Giovanni had made a detailed study of natural forms and the emotionally charged crucifixion scene, in which the Virgin swoons backwards into the arms of her companions, indicates that he was also aware of developments in German and French sculpture. Giovanni's talent in representing figures and emotions, and in making new compositions, made him an important influence on painters such as ▽ Giotto and ▽ Michelangelo.

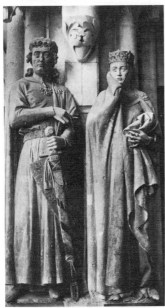

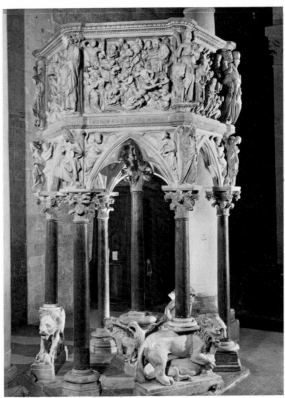

*Above:* GIOVANNI PISANO Pulpit. Completed 1301. S. Andrea, Pistoia
*Above left: Ekkehardt and Uta.* Choir, Naumberg. After 1249
*Below left: Virgin and Child.* Notre-Dame, Paris. 14th century

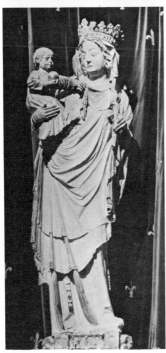

**Late Gothic.** The figures on the ▽ Pisano pulpit adopt an elegant pose, the weight thrown over one knee and the hip jutting outwards, which is sometimes called the 'gothic sway'. It appears in an early form in the Vistation group and the Angel Gabriel at ▽ Reims. The most common use of the pose was in the type of French Virgin and Child in which the Virgin, crowned as the queen of an elegant heavenly court, sways to one side and holds the child up at shoulder level. Adapted for use in portable objects such as ivories, the design was influential throughout Europe.

**The Art of Book Illumination.** Before the invention of printing every book was an individual production; handwritten, generally on □parchment, (dried sheep-skin) and often decorated in coloured inks or □tempera paints. Embellishment varied from simple patterns on capital letters to full-page scenes forming a complete picture cycle preceding the text of the book. In the middle ages book illumination was considered a major form of art much as □easel-painting was in subsequent periods. The loss of so much medieval wall and □panel painting makes manuscript decoration the best source of information concerning painting in the middle ages.

**The Scribes.** During the middle ages the monasteries and nunneries of Europe were important centres of learning. The books which this study necessitated were generally produced by the monks and nuns themselves, and some of these scribes were skilled in the decoration of books, so that certain monastic houses became important artistic centres. Sometimes in book illumination the relation between text and illustration is clear and no further elements are introduced (as in books today) but at other times purely decorative elements play an important part in the scheme and the historiated illumination (figures and scenes) and text are partly or entirely subordinated to them. The medieval artist had many ways of arranging these elements on the page.

In the page from the gospel book of Uota, abbess of Niedermünster, the text was specially composed (by a theologian called Hartwic) to fit into the design. Text (running along the borders), scene (St Ehrhard and an acolyte celebrating Mass) and decoration (mainly shapes derived from plant forms) all blend into a satisfactory whole. The artist is not interested in creating three-dimensional and other 'realistic' effects, provided the event he depicts is absolutely clear, so he is able to break up the clothing of the two figures into fairly even areas, or patterns, of line and colour and use the same hues for both decorative elements and scene, thus achieving an even distribution of 'weight' throughout the page. The lavish use of burnished gold-leaf emphasises the coherence of the design and the flat surface of the page, creating an effect similar to contemporary metalwork.

**The Decorated Initial.** Different approaches were necessary when decorating a full text. Generally the scribe left a large space at the start of a new section, which the artist filled with an illuminated initial which might be purely decorative or, if pictorial, might or might not relate to the text it accompanied. This frontispiece to a work of religious commentary, St Gregory's *Moralia in Job*, was written and decorated in the mother house of the Cistercian order at Cîteaux in France (possibly by an Englishman) and completed on 24 December 1111. The artist has succeeded in uniting action and decoration by distorting the schematised figures into the shape of the initial Q. The monk bending over his labours forms one side of the initial, while the sheaves beneath his feet complete the body and tail of the letter. The choice of scene seems to have no direct connection with the text.

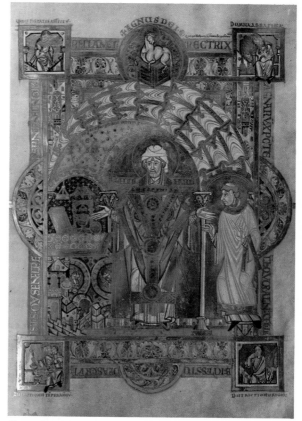

*Above: The Gospel Book of Uota*, Abbess of Niedermünster. 1002–25. 15 × 11⅖ in (38 × 29 cm). Bayerische Staatsbibliothek, Munich

St Gregory, *Moralia in Job: Harvesting*. Finished 1111. Bibliothèque de la Ville, Dijon

**Psalters and Breviaries.** In the 13th century, book production began to change as universities, especially Paris, became major centres of study and a book trade run by independent laymen developed in the university towns. Illuminated Psalters, Breviaries and Books of Hours (prayer books used by the laity) were more in demand than the large Bibles produced for monastic patrons. Some of the finest books of the period were commissioned by the laity: the ▽St Louis Psalter, probably made for the French King after his return from the crusades in 1254, typifies the new Paris style. In the cycle of scenes preceding the psalter text the area which the figures occupy is reduced by filling much of the small page with foliate motifs and architectural designs based on ▽Gothic architecture, only leaving room for tiny figures arranged in elegant poses.

**The Miniaturists.** The miniaturist technique of the St Louis Psalter was particularly suitable for text decoration. The Belleville Breviary, made for a nobleman by the 14th-century French artist Jean Pucelle and his workshop, shows the use of this technique to decorate not only the initial, but also the 'bar' borders surrounding the text, the *bas-de-page* area beneath the text and even the line-ends, where the text stops short of the border. The three scenes all show subjects related to the book, but the borders are populated with miscellaneous creatures and vegetation (*drôleries*) chosen only to amuse and to display the artist's skill in naturalistic and humorous depiction, on a scale so small that a magnifying-glass was probably used when decorating the manuscript.

**Court Patronage.** The mastery of ☐perspective developed in ▽Renaissance Italy made greater demands on the skill of the book illuminator. Text and decorative elements had to be joined with realistic scenes which disrupted the flat surface of the page; moreover the book illumination could not achieve the monumental effects which the patrons of ☐fresco and panel paintings had come to value so highly. With the invention of printing and the use of reproducible woodcuts the independent status and qualities of illumination suffered a further blow. Fine work was still produced but it tended to imitate other forms of art rather than to produce its own innovations.

But there was a final independent flowering of illumination, connected with the patronage of certain European courts and higher nobility. An example is the *Très Riches Heures du Duc de Berry*, executed by the Flemish ▽Limbourg brothers in about 1415.

The heirs to this style, for example the ▽Van Eycks, are to be found working on paintings in their own right rather than in books.

LIMBOURG BROTHERS *June* from the *Très Riches Heures du Duc de Berry*. About 1415. $11\frac{1}{2} \times 8\frac{1}{4}$ in (29 × 21 cm)

*Left*: JEAN PUCELLE *The Belleville Breviary*. 14th century. $9\frac{2}{5} \times 6\frac{7}{10}$ in (24 × 17 cm)

During the ▽ Gothic period numerous items were produced in precious metals, enamel, ivory, wood and textiles. Many of these objects were destroyed, either through long use, or because the need for them had ended, or because they were made of intrinsically precious materials, such as gold, and were melted down so that the materials could be reused. Although only a few of these objects have survived it is important to remember that they were at one time numerous and formed an essential part of religious services and of the decoration of the churches mentioned in the preceding sections.

Much church furniture has disappeared, leaving us with starker cathedral interiors than their designers intended. Pulpits, screens, thrones and choir stalls often matched the style of the architecture which contained them. Wooden choir stalls, for example, employ exactly the same type of □finials, □pinnacles, panels and □canopies as are visible in large-scale cut stone decoration on church exteriors or on tomb canopies.

**Reliquary and Image.** The same patterns could be repeated on a much smaller scale, as the Three Towers Reliquary from Aachen demonstrates. Metalwork, especially the glittering silver-gilt of which this piece is made, is probably the most fitting medium of all for the use of the spiky, skeletal, architectural type of decoration so favoured by ▽ Gothic designers. In this case no structural considerations impede the free range of the artist's invention. One of the most notable features of Gothic Art is this free exchange of decorative forms which took place between the different media – particularly of forms inspired by architectural decoration. This decorative relationship must have made the fully furnished interior of a Gothic church into a unified visual experience.

Large-scale sculptural design was also translated into other media. The silver-gilt statuette of the Virgin and Child presented to the Abbey of St Denis by Jeanne d'Evreux, wife of Charles le Bel of France, shows how successfully a large-scale stone Virgin and Child from Notre Dame, Paris, could be reduced. The statuette represents a perfect mixture of courtly elegance and tender human affection. The meaning of the work is enriched by the addition of scenes from the passion to the base on which the figure stands. These designs are picked out in red and blue enamel. Enamel work, produced by melting at a high temperature powdered coloured glass set in metal beds, was a popular form of decoration for metalwork, during the middle ages. The most prolific production was centred in the Limoges region of western France.

**Ivory and Tapestry.** France was also the site of a large-scale production of ivories during the ▽ Gothic period. Many of these were portable □triptychs or □diptychs – panels with hinged wings, which could be closed for protection when not in use or during a journey. These were for private devotional use, but many ivory ornaments, book covers, clasps, mirror backs and brooches were often decorated with secular scenes, such as figures engaged in the hunt or in games of chess. French Gothic ideas – the composition of the scenes, the gestures and elegant poses of the figures, the architectural framing of the scenes and the shape of the triptych as a whole – could easily spread to other parts of Europe by way of the export of these small, sought-after objects.

The Gothic artist also had a contribution to make in embellishing the homes of the rich. One of the most beautiful surviving pieces of secular decoration is the late Gothic set of □tapestries, probably made for Anne of Brittany in celebration of her marriage to Louis XII of France, which depict the hunt of the unicorn. The tapestry shows the unicorn resting at a fountain during the course of the hunt. The courtly, chivalrous world which this marvellously detailed work conjures up is akin to that represented in the works of the ▽ Limbourg brothers in the *Très Riches Heures du Duc de Berry*. It is the world of late nothern Gothic – 'the waning of the middle ages' – not yet transformed by the developments taking place in ▽ Renaissance Italy.

*Right: The Three Towers Reliquary. About* 1370. Silver gilt with enamel panels. h. 37 in (94 cm). Aachen Cathedral Treasury

**Chalice and Vestments.** The chalice made for Suger, Abbot of St Denis, out of an antique sardonyx cup, represents both the beauty which essential liturgical vessels such as the chalice, paten, pyx and altar cross could achieve, and the luxurious patronage that a rich and powerful individual was prepared to exercise. Suger himself decided that the cup should be given its gold filigree, gemmed and pearled mounting to transform it from a pagan object to a Christian chalice.

Once the altar of the church had been dressed with cloths, cross and candles and the vessels necessary for the performance of the Mass had been prepared, the priest and his assistants clothed themselves in suitable garments. Sometimes these vestments were very elaborately embroidered, covered with coloured silks, gold thread and pearls, in patterns and pictorial scenes from holy stories which harmonised with the sculpture, ▽stained glass and illuminated service books of the Church. English workshops produced such fine and elaborate vestments that they were prized all over the world, and often numbered among a Pope's cherished possessions. This work was known as *Opus Anglicanum*.

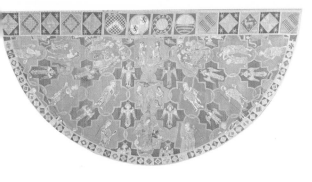

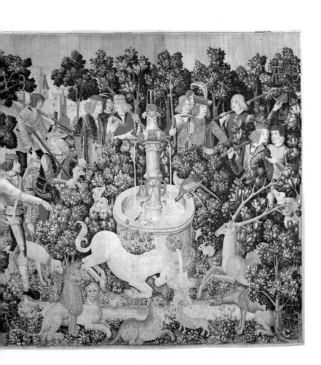

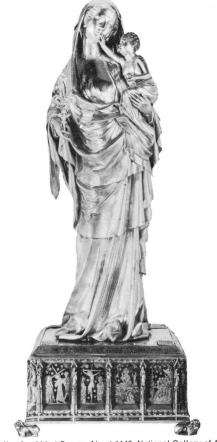

*Top:* Chalice for Abbot Suger. *About* 1140. National Gallery of Art, Washington DC
*Above: The 'Madonna of Jeanne d'Evreux' reliquary.* 1339. Silver gilt and enamel h. 27⅛ in (69 cm). Louvre, Paris
*Above left: The Syon Cope* (Opus Anglicanum). English 14th century. Embroidered in coloured silks and silver and gold thread
*Left: The Hunt for the Unicorn* tapestry. *About* 1500. 145 × 149 in (366 × 378·5 cm). MM, New York

# THE MEDIEVAL WORLD

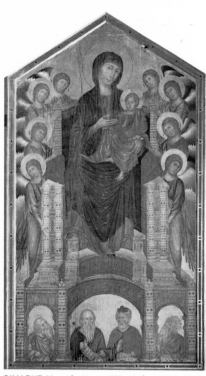

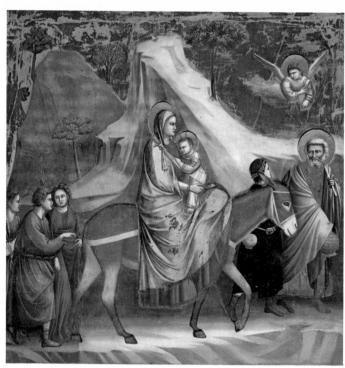

CIMABUE *Maestà. About* 1280. 151⅜ × 87⅛ in (385 × 223 cm). Uffizi, Florence

GIOTTO *The Flight into Egypt.* Scrovegni Chapel, Padua

**The Growth of the Fresco.** During the 13th century, strong, local schools of painting emerged in Italy. Artists working in ☐mosaic and on panel continued to look towards ▽Byzantine models, but mural painting, or ☐fresco, rapidly gained ground as a faster, cheaper and more flexible alternative through which the great Italian artists of the 14th century were to develop both indigenous and personal styles.

The Church, enlarged by the formation and growth of the mendicant orders, remained the leading patron of the arts. When, towards the end of the 13th century, the Franciscans began the decoration of the great shrine they had raised for their founder at ▽Assisi, it became a centre of artistic activity to which painters were drawn from neighbouring cities. The authorship of the *Legend of St Francis* remains fiercely controversial, but what the frescoes do reveal is the importance of Assisi as a meeting-place of styles.

**Cimabue** (*about* 1240 – *after* 1302). Benevieni di Pepo, or 'Oxhead' as his nickname, Cimabue, means literally, is referred to in a document of 1272 as '*Pictore de Florencia*'. His best-known work is at ▽Assisi where he decorated the choir and transepts of the Upper Church, about 1280. Of his Florentine productions two important panel paintings survive; the *Crucifix* in Santa Croce and the *Maestà*, (Madonna Enthroned), which he painted slightly earlier, before 1285, for the church of Santa Trinità in Florence. Both works illustrate Cimabue's revolutionary attitude towards ▽Byzantine models. The Madonna's monumental throne recedes backwards from its outer edges, which are flush with the edge of the frame, and rises upwards to create enough space to contain her, the

Child and the attendant angels, without any sense of crowding. The soft modelling of the Virgin's features combines with the expression on her face to give her a greater humanity than her pictorial predecessors. For ▽Vasari, Cimabue's achievement amounted to 'hardly less than the resurrection of painting from the dead'.

**Giotto di Bondone** (1266/7–1337). If ▽Cimabue began the process, Giotto was 'the true restorer of the art of painting' as far as ▽Vasari was concerned. His first certain works are the ☐frescoes in the Arena Chapel at Padua, decorated soon after 1300 for the banker, Enrico Scrovegni. The cycle covers all the available wall space inside the small chapel with scenes from the lives of the Virgin and Christ, and a Last Judgement. It is undoubtedly one of the greatest masterpieces of early Italian painting. The detail of the *Flight into Egypt* shows how carefully Giotto arranged his figures across the foreground of the scene, so that the eye is drawn by the composition along the path from left to right. Behind the Virgin and Child, the shape of the hillside reflects that of the travellers, its strongly lit slope reinforcing the movement to the right.

At about the same time, Giotto painted the *Ognissanti Madonna*, now in the Uffizi, his answer to the challenge of Cimabue's Santa Trinità Madonna. As Dante attested in the *Divine Comedy*, Giotto superseded the older artist to establish his own reputation as the leading Florentine painter of the day. In Santa Croce, his frescoes in the Bardi and Peruzzi Chapels survive. In 1334 he became *Capomaestro* or Supervisor of Works at the cathedral in Florence, a post which gave rise to the notion that he was an architect, responsible for the design of the bell-tower popularly known as 'Giotto's tower'.

*Above:* SIMONE MARTINI *Guidoriccio Fogliani on horseback.* 1321.
Town Hall, Siena
*Left:* DUCCIO DI BUONINSEGNA *Entry into Jerusalem.* 1308–11.
Siena Cathedral Museum

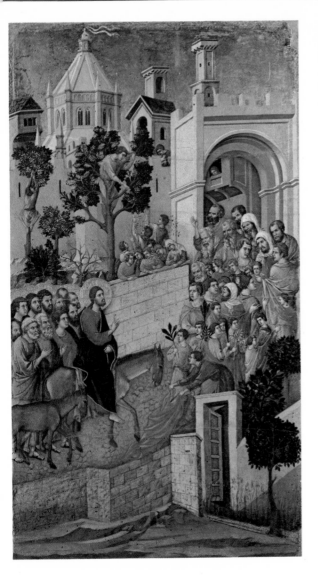

**Simone Martini** (*about* 1284–1344) almost certainly received his training in ▽Duccio's Sienese workshop. This debt is visible in his *Maestà* □fresco of 1315 in the Palazzo Pubblico, or city hall, of Siena. Apparent also is the younger artist's ability to work on the monumental scale dictated by the size of the wall, a talent which he had the opportunity to exploit a few years later in the St Martin Chapel in the Church of San Francesco, Assisi.

In 1328 Simone was once again working for the authorities of his native city. His fresco of Guidoriccio da Fogliano commemorates the victories of the mercenary captain enlisted by the Sienese to suppress revolts in the dependent towns of Montemassi and Sassoforte. The fresco is remarkable as one of the first civic commissions of the Middle Ages to depict a secular subject.

Simone's equestrian portrait marks, with its landscape setting, a high point of naturalism in his career. His later preoccupation with linear refinement is indicated by the famous *Annunciation* of 1333, now in the Uffizi. Simone died at Avignon in 1344, a seminal influence upon the International Gothic style of the fifteenth century.

**Pietro and Ambrogio Lorenzetti** (active *about* 1320 – *about* 1348). Like ▽Simone Martini, the Lorenzetti brothers may have received their early training from ▽Duccio. ▽Pietro Lorenzetti is first known in Assisi in 1320. Then Ambrogio, perhaps slightly younger, matriculated in Florence in 1327.

In 1335 the two brothers collaborated on □frescoes, now lost, on the façade of the Ospedale della Scala in Siena, and two years later Ambrogio received the commission to paint the frescoes of *Good and Bad Government* in the Palazzo Pubblico there. Less than a decade after Simone's *Guidoricco da Fogliano*, he embarked upon the most ambitious cycle of civic decorations to survive. Good and Bad Government are represented allegorically in a scheme which owes as much to Aristotle's *Ethics* as it does to the Bible, while the effects of the two regimes are vividly illustrated in contemporary terms. The view of the well-governed city is a mirror of the age, with its wealth of descriptive detail which includes building and commerce, and its unmistakable use of symbolism epitomised by the circle of dancing figures in the foreground. Among the later works of the Lorenzetti brothers, a number of panels are remarkable for their advanced experiments in □perspective. Both brothers are assumed to have fallen victims to the Black Death of 1348.

**Duccio di Buoninsegna** (*about* 1255 – *about* 1318) was the great Sienese contemporary of ▽Giotto. His Ruccellai Madonna, commissioned in 1285 for the Church of Santa Maria Novella in Florence, hangs in the Uffizi alongside the two comparable panels by ▽Cimabue and Giotto. The masterpiece of Duccio's career is another panel painting, the *Maestà*, which he painted for the High Altar of the cathedral in Siena between 1308 and 1311. On the front, the Madonna and Child enthroned are surrounded by a vast array of saints and angels. The back of the altarpiece originally comprised a large number of small panels, 26 of them illustrating scenes of the Passion. The *Entry into Jerusalem*, with its lively detail and steep perspective, shows Duccio's narrative ability and his unmistakable loyalty to earlier ▽Byzantine models. Like Giotto, he invested his figures with humanity, but in contrast with the burgeoning naturalism of the Florentine artist, Duccio concentrated upon the expressive power of line and colour. The result was a style of exquisite refinement which remains, for many, synonymous with Sienese painting.

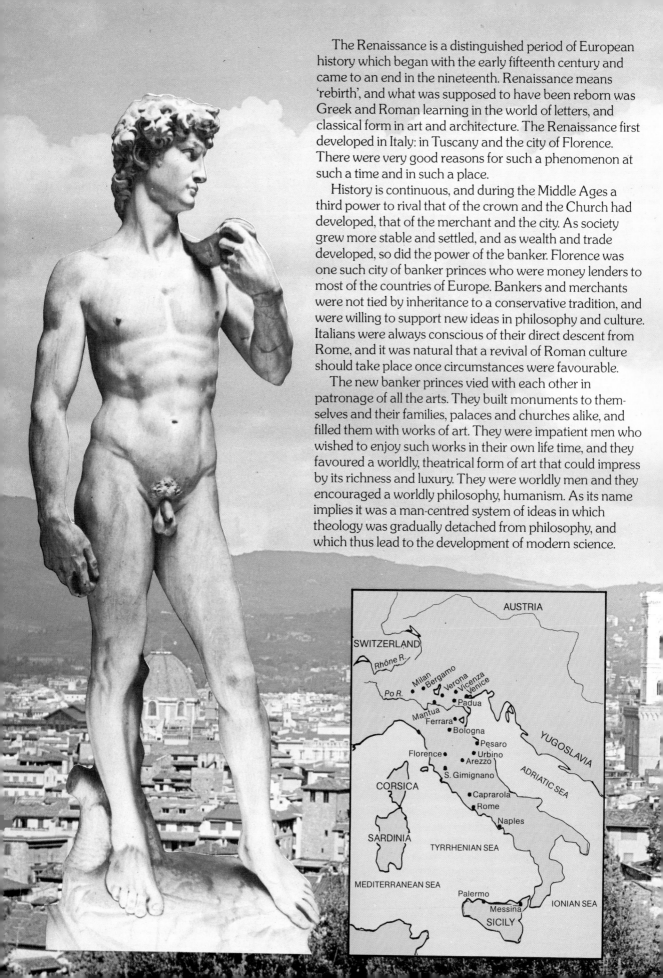

The Renaissance is a distinguished period of European history which began with the early fifteenth century and came to an end in the nineteenth. Renaissance means 'rebirth', and what was supposed to have been reborn was Greek and Roman learning in the world of letters, and classical form in art and architecture. The Renaissance first developed in Italy: in Tuscany and the city of Florence. There were very good reasons for such a phenomenon at such a time and in such a place.

History is continuous, and during the Middle Ages a third power to rival that of the crown and the Church had developed, that of the merchant and the city. As society grew more stable and settled, and as wealth and trade developed, so did the power of the banker. Florence was one such city of banker princes who were money lenders to most of the countries of Europe. Bankers and merchants were not tied by inheritance to a conservative tradition, and were willing to support new ideas in philosophy and culture. Italians were always conscious of their direct descent from Rome, and it was natural that a revival of Roman culture should take place once circumstances were favourable.

The new banker princes vied with each other in patronage of all the arts. They built monuments to themselves and their families, palaces and churches alike, and filled them with works of art. They were impatient men who wished to enjoy such works in their own life time, and they favoured a worldly, theatrical form of art that could impress by its richness and luxury. They were worldly men and they encouraged a worldly philosophy, humanism. As its name implies it was a man-centred system of ideas in which theology was gradually detached from philosophy, and which thus lead to the development of modern science.

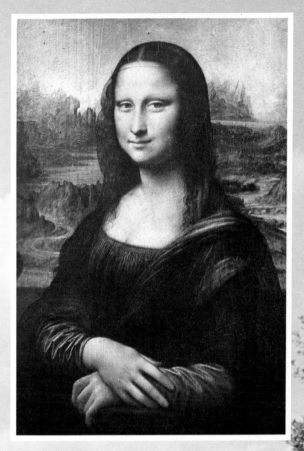

# THE
# ITALIAN
# RENAISSANCE

| −5000 | −4000 | −3000 | −2000 | −1000 | BC 0 AD | 1000 | 2000 |
|---|---|---|---|---|---|---|---|

**1381** Venice wins war against Genoa.
Commerce, arts and sciences flourish.
**1406** Venice acquires Padua. Florence subdues Pisa.
**1412** Filippo Brunneleschi publishes Rules of Perspective in Florence.
**1428** Venice conquers Brescia and Bergamo.
**1431** Joan of Arc burnt at the stake by the English at Rouen.

**1434** Cosimo de Medici ruler of Florence.
Florence cathedral (Duomo) completed.
**1450** Printing by movable type in Germany.
**1453** End of Hundred Years War.
**1469** Lorenzo de'Medici (the Magnificent) ruler of Florence until 1492.
Machiavelli, Renaissance political thinker, born (died 1527).

**1492** Catholics take Granada. Columbus discovers American continent.
**1494** Charles VIII of France invades Italy, enters Florence and Rome.
**1495** Charles VIII crowned King of Naples.
**1503** Pope Julius II.
**1506** Machiavelli forms Florentine militia.
First national army in Italy.

**1508-12** Sistine Chapel painted in Vatican by Michelangelo.
**1516** Publication of 'The Prince' by Machiavelli.
**1519-22** First circumnavigation of the globe by Magellan.
**1524** French driven out of Italy.
**1527** Sack of Rome by troops of Emperor Charles V.
**1539** Founding of Society of Jesus (Jesuits) by Ignatius Loyola (1491-1556).

# THE ITALIAN RENAISSANCE

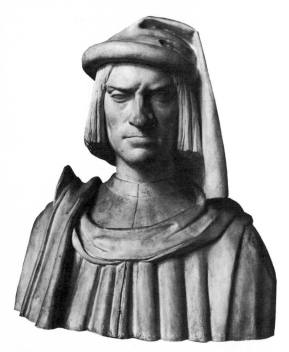

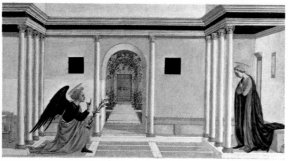

*Top:* ANDREA VERROCCHIO *Lorenzo de Medici.* Palazzo Medici Riccardi, Florence
*Above:* DOMENICO VENEZIANO *The Annunciation, c.* 1450. 10⅝ × 21¼ in (25 × 53 cm). Fitzwilliam Museum, Cambridge

*Below:* GENTILE DA FABRIANO *Adoration of the Magi.* 1423. 111⅛ × 128⅛ in (282 × 300 cm). Uffizi, Florence

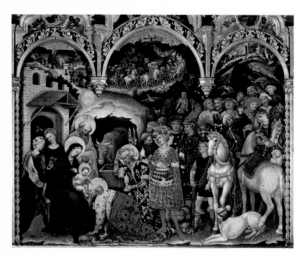

**Florence.** Writing shortly after 1300, the historian Giovanni Villani predicted a bright future for his native city. He had grounds for optimism; in the 13th century Florence had risen to a position of dominance in central Italy. Her merchants and bankers had extended their activity and their credit abroad, and the city's coinage, the gold 'florin' first struck in 1252, established itself as an international currency. During the 14th century, Florence began to assume the shape that she still has today. The cornerstone of the new cathedral, renamed Santa Maria del Fiore, was laid in 1294, and within a year or so, work had begun upon the Franciscan Church of Santa Croce and upon the city hall, the Palazzo Vecchio. The city's cultural prestige was advertised by her poets, Dante Alighieri (1265–1321) and Boccaccio (1313–75) while ▽ Giotto became, in the fine arts, a legend during his own lifetime. In common with the rest of Italy, Florence was to suffer in the middle of the 14th century social and economic disasters following the Black Death, but she was to recover from them to achieve a pre-eminence in the arts unmatched in Europe during the 15th century.

The honours of the High ☐▽ Renaissance were to be shared between Rome and Venice, but during the early Renaissance Florence has no rival. Nothing illustrates better the union of arts and science in the Florentine culture of the 15th century than the Annunciation from the ☐ predella of ▽ Domenico Veneziano's *St Lucy* altarpiece (*about* 1445). The ☐ perspective is drawn with the mathematical precision which ☐ Alberti (1404–72), the humanist and scholar, advocated, while the lighting is rationalised to conform to natural laws. Above all, in the relationship of parts to the whole, there is that symmetry and harmony towards which, in its philology and philosophy, contemporary ▽ humanism strove.

**Florentine Patrons.** Civic pride was inextricably linked with the building and decoration of the city's principal monuments. The new cathedral and the Church of Santa Croce were both founded by the Commune, and financed by a combination of taxation and private endowment. Rich patrons were encouraged by the clergy to sponsor chapels and burial sites within the churches. For the patron, in addition to religious virtue acquired by such acts of generosity, it meant public acknowledgement of his wealth, his culture and his charity. The richest Florentine of his day was Palla Strozzi. He commissioned Gentile da Fabriano (*about* 1370–1427) to paint his famous altarpiece, the *Adoration of the Magi,* in 1423. Now in the Uffizi, it was originally in the Church of Santa Trinità, where it stood on the altar of the sacristy-chapel as a memorial to Onofrio Strozzi. In 1434, ▽ Cosimo de' Medici seized control of the city and Strozzi, a political opponent, was exiled. The Medici had already distinguished themselves as patrons of the Church of San Lorenzo. In 1442, Cosimo de' Medici sealed the connection when he provided capital, the interest from which was to pay for the nave. For the same church he commissioned pulpits from ▽ Donatello (*about* 1386–1466), and for the Dominican order, bore the financial burden of the reconstruction of the convent of San Marco.

By contemporary standards, Cosimo's own palace was a modest affair. In 1559–60, its small family chapel was decorated under the supervision of his son and

heir, Piero, with ☐frescoes by ▽ Benozzo Gozzoli (1420–97). Like Gentile's Strozzi altarpiece, the subject is the Adoration of the Magi, in which members of the family are portrayed as participants in the procession. From Vespasiano di Bisticci, Strozzi and Medici alike acquired books and manuscripts. As patrons, they identified themselves with the new learning of their time, ▽ humanism. ▽Lorenzo de' Medici, or Lorenzo the Magnificent, was Cosimo's grandson. He ruled Florence from 1469 until his death in 1492. In spite of his reputation. Lorenzo was less of a patron of the arts than either his father or his grandfather. Instead he supported scholarship and letters, and financed a Neo-Platonic academy. His taste, like his learning, was Classical. Lorenzo collected antique vases and gems. He continued his grandfather's interest in architecture by offering advice to his fellow citizens on their plans for buildings and by designing a number of schemes himself, among them a façade for the cathedral.

*Above:* Cup formerly in the collection of Lorenzo de' Medici, Sicilian jasper with silver gilt base. Museo degli Argenti, Florence

**Palaces (Palazzi).** Medieval Florence was, like any other central Italian city, a collection of houses, towers and semi-fortresses. By the 14th century, however, the blood feuds which had disrupted earlier civic life were succeeded by commercial rivalries between native families, and although fortune could still turn sharply, there was a growing tendency for domestic architecture to reflect a more peaceful way of life. The Palazzo Davanzati, built in about 1330, was typical, incorporating a number of features which are common to the great Renaissance palaces of the 15th century. Of these, the Palazzo Medici, designed by ▽ Michelozzo (1396–1472), was begun in 1444. The façade is divided into three storeys, decreasing in height and less heavily ☐rusticated towards the roof. The arches on the ground floor were originally open, to provide cover for trading and other business transactions. Inside the palace, suites of rooms are arranged round a central courtyard which once boasted a fountain by ▽ Donatello. In contrast with the forbidding exterior, still very much a stronghold, the emphasis is upon light, accessibility and space. In 1446, Giovanni Ruccellai built his palace, designed by ▽ Leon-Battista Alberti (1404–72), to be 'easy of access, beautifully adorned, and rather delicate and polite than proud and stately'. Characteristically, the horizontal bands of rustication on the façade are broken by Classical ☐pilasters. In complete contrast is the palace built for Filippo Strozzi. Strozzi cleverly avoided the accusation of competition or ostentation and in 1489 laid the foundation stone of the most imposing palace of the century. It was completed after his death by the architect Cronaca, whose courtyard heralds the massive grandeur of the ▽ High Renaissance. The Palazzo Pitti, built in the mid-15th century, was bought by Eleonora of Toledo, the wife of Duke Cosimo I, in 1549. It too was enlarged and remodelled by a 16th-century architect, Bartolommeo Ammanati, to provide a magnificent setting for the Medici court.

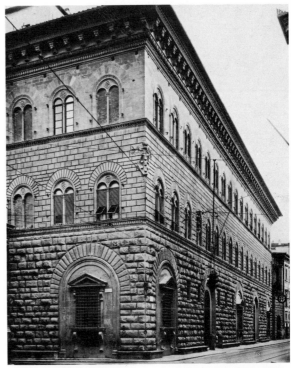

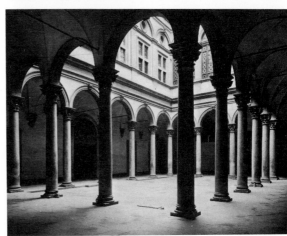

*Above right:* MICHELOZZO The Palazzo Riccardi Medici, Florence. Started 1444
*Right:* CRONACA The courtyard of the Palazzo Strozzi, Florence. The building started by Filippo Strozzi in 1489

# THE ITALIAN RENAISSANCE

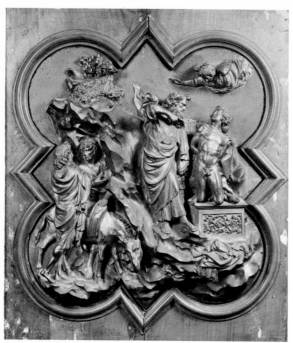

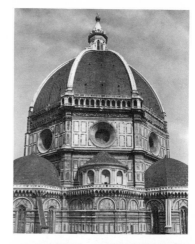

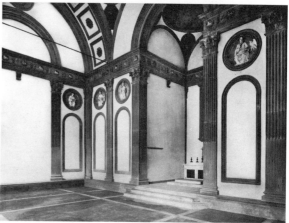

*Above:* LORENZO GHIBERTI *The Sacrifice of Isaac.* Competition reliefs for the Baptistery doors. 1402. 20⅛ × 17¾ in (52 × 45 cm). Museo Nazionale (Bargello), Florence

*Above right:* FILIPPO BRUNELLESCHI The dome of Florence Cathedral. Cathedral started 1296, finished 1461
*Right:* FILIPPO BRUNELLESCHI The Pazzi Chapel, in the cloister of S. Croce, Florence. Started 1429

**Lorenzo Ghiberti** (1378–1455). In 1402, Ghiberti won the competition to execute in bronze a set of doors for the Baptistery in Florence. His submission, *The Sacrifice of Isaac*, is remarkable as a technical achievement, being cast in one piece. The figure of Isaac must have seemed no less revolutionary at the beginning of the 15th century. It is one of the earliest male nudes of the Renaissance, its anatomical accuracy derived from study of antique sculpture. It is typical of Ghiberti however that the *ignudo* (nude) is an isolated feature, occurring in combination with more linear, ▽Gothic forms. Ghiberti and his assistants worked for 20 years on the doors, which were installed in 1424. Their immediate success led, a year later, to the commission for a second pair (1425–52). Partly as a result of these two major commissions which spanned consecutively half a century, Ghiberti became the leading Florentine artistic entrepreneur of his day. Many of the principal artists of the next generation trained in his workshop, among them ▽Donatello, ▽Uccello and ▽Gozzoli. For the façade of Or San Michele, Ghiberti executed three statues. His St John the Baptist (1412–16) is in contrast with Donatello's St Mark of the same years. It is boldly modelled, with sweeping linear curves which form the drapery. Such works demonstrate both Ghiberti's innate medieval conservatism and his technical resourcefulness. In the second set of doors for the Baptistery, called the 'Gates of Paradise' by ▽Michelangelo, he succeeded in blending the linear grace of the ▽International Gothic style with the new science of □perspective.

**Filippo Brunelleschi** (1377–1446). One of ▽Ghiberti's closest rivals in the competition for the doors of the Florentine Baptistery was Brunelleschi, whose trial □relief is also preserved in the Bargello, Florence. The two men first worked together on the problem of constructing a dome to cover the crossing of the cathedral (*duomo*), but it was Brunelleschi's own design, using his knowledge of Roman building methods (*see* pages 52–3), that was successful. In 1419 the building of his Loggia degli Innocenti (Foundling Hospital) began, its elegant colonnade being an early example of Brunelleschi's Classicism. This can be seen in its full extent in the Old Sacristy of San Lorenzo and in the Pazzi Chapel of Santa Croce. These are the first fully Classical Florentine Renaissance buildings, and establish Brunelleschi as a founder of Renaissance architecture. Both have a central plan and in both the architect used a wide range of Classical details in window and door frames, □cornices, □cofferings and mouldings, carved in contrast to the plain white walls in dark, fine-grained □*pietra serena*. Brunelleschi's last work, begun in 1436, was the Church of Santa Spirito. Its plan is based, like San Lorenzo, upon multiples of the square as a unit of measurement and its elevation is controlled and articulated by a mathematical system of proportions. The curve of the dome is extended to the surface of the sidewalls to produce a unique architectural effect of lightness and clarity.

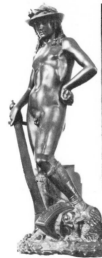
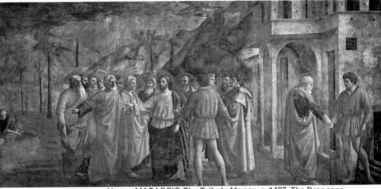

*Above:* MASACCIO *The Tribute Money.* c. 1427. The Brancacci Chapel, Santa Maria del Carmine, Florence

*Above left:* DONATELLO *St George.* 1416–20. h. 82¼ in (208 cm). Or San Michele, Florence
*Above right:* DONATELLO *David.* 1430–2. h. 62¼ in (158 cm). Museo Nazionale, Florence

**Donatello** (*about* 1386–1466). Donatello came from the workshops of ▽Ghiberti and Nanni di Banco (*about* 1384–1421) to be the most important Florentine and European sculptor of the 15th century. All three sculptors worked in competition on the façade of Or San Michele, the Guild Church of Florence for which Donatello carved a St Mark in 1411–12, a St George in about 1417, and for which he cast in bronze a St Louis, between 1422–5. For sheer realism, the St George is unmatched. The young warrior, whose idealised features bear a slight frown, stands, legs apart, almost on tiptoe, relaxed but ready for action. In the □relief beneath the niche he is shown again on horseback, fighting the dragon, in a landscape setting modelled in shallow relief, or □*rilievo schiacciato.* Donatello was also involved with Ghiberti in the decoration of the Siena Baptistery font, for which he completed a relief of the Dance of Salome in 1427, a work in which his individual figure style with its strongly Classical flavour and his profound interest in □linear perspective are abundantly clear. From 1425, Donatello worked in partnership with the architect ▽Michelozzo (1396–1472) on a number of commissions, among them the tomb of the Antipope John in the Florentine Baptistery.

The bronze *David*, commissioned by the Medici, dates from the 1430s. It is a sensuous study of nude youth □*all'antica*, the first free-standing life-size statue of a nude to appear in the Renaissance. In 1443, Donatello went to Padua, where he produced his equestrian statue of the Condottiere Gattamelata, a conscious copy of the Classical bronze statue of ▽Marcus Aurelius on the Capitol in Rome. Donatello's late style is characterised by a tendency to distort the figure in search of greater expressiveness. His statue of Mary Magdalene (*about* 1455) is carved in wood, painted and, on the highlights, gilded. This dramatic work can be seen as a fulfilment of the promise shown by the statues of Jeremiah and Habakkuk carved some 20 years earlier for the façade of the cathedral in Florence. It may be compared also with the reliefs on the pulpits in San Lorenzo, commissioned by ▽Cosimo de' Medici.

DONATELLO *Gattamelata.* 1445–50. 132 × 156 in (335 × 396 cm). Piazza del Santo, Padua

**Masaccio** (1401–28) entered the Florentine Guild as a painter in 1422. Before his early death in Rome six years later, he painted in a new and monumental style some of the outstanding masterpieces of the 15th century. For the Carmelite church at Pisa he painted a □polyptych which is now dismembered, the central Madonna and Child being in the National Gallery, London. At about the same time, Masaccio executed his □fresco of the Trinity for Don Lorenzo Cardoni in the Church of Santa Maria Novella, Florence. The strict □perspective of the painted architectural setting reflects both the principles and the style of Masaccio's older contemporary, ▽Brunelleschi. Even so, pictorial rules are subordinate to those of theology; the setting and the two donor figures are subjected to the human perspective of the observer while the sacred figures of the Trinity do not conform to it. The *Virgin and Child with St Anne* in the Uffizi gives early evidence of Masaccio's collaboration with Masolino da Panicale (1383–*after* 1435), the artist with whom he worked about 1427–8 on the ▽Brancacci Chapel frescoes in the Church of Santa Maria del Carmine, Florence. Exactly which artist was responsible for what part of the decorations remains conjectural, but it is agreed that Masaccio's share includes the *Expulsion* and the *Tribute Money*, a work in which the stern figures, their psychological force and the realistic space they occupy are equalled among Masaccio's contemporaries only by ▽Donatello.

# THE ITALIAN RENAISSANCE

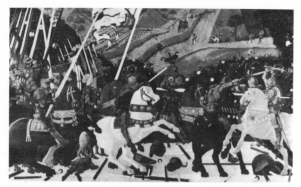

PAOLO UCCELLO *The Battle of San Romano.* c. 1456. 72 × 125¾ in (183 × 319·5 cm). NG, London

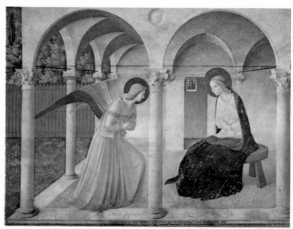

*Above:* FRA ANGELICO *The Annuciation.* c. 1437. Museum of San Marco, Florence
*Below:* FRA FILIPPO LIPPI *Madonna and Child.* Galleria Palatina, Florence

**Paolo Uccello** (Paolo di Dono) (1397–1475) was an assistant in Ghiberti's workshop in 1407 and again in 1412. Subsequently he went to Venice and worked as a mosaicist in St Mark's, 1425–30. He returned to Florence where he painted the memorial to Sir John Hawkwood in the cathedral, after 1436. This □fresco, which depicts the English soldier of fortune as an equestrian statue, is one of the most ambitious attempts at □*trompe l'oeil* in the 15th century. Its daring □perspective anticipates his greatest work, the fresco of the Deluge painted about 1445 in the Chiostro Verde of Santa Maria Novella, Florence. It demonstrates his almost obsessive interest in mathematical perspective. ▽Vasari was to criticise Uccello for indulging his interest in perspective at the expense of his figures which, in the 1440s, show something of the powerful simplicity of ▽Masaccio and ▽Donatello. Between 1454 and 1457, Uccello painted the three battle scenes which are now in London, Paris and Florence. With their deep recession and dramatic □foreshortening the effect is far from naturalistic. The paintings have a static, decorative quality akin to tapestry and indicative of the artist's late, 're-gothicising' style.

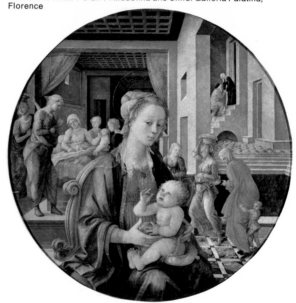

**Fra Angelico** (Guido di Pietro) (*about* 1400–55). Born around 1400, Guido di Pietro entered the Dominican convent at Fiesole in about 1421. Throughout his career, his art reflected his deeply held religious views. □The polyptych he painted for the Church of San Domenico about 1428, one of his earliest surviving works, is still in late ▽Gothic style. In 1433, Fra Angelico was commissioned to paint the Linaiuoli □triptych now in the Museum of San Marco in Florence, for which ▽Ghiberti designed the frame. The figure of the Madonna reveals his knowledge of ▽Masaccio's art, while the saints on the outside are strongly reminiscent of Ghiberti's St John the Baptist at Or San Michele. In 1436, the Dominicans took over the convent of San Marco and during the following decade, Fra Angelico, helped by numerous assistants, carried out the decoration of its common rooms and cells. These paintings display a profound simplicity. In them Fra Angelico conveys his deep religious feeling, which is so strongly sympathetic that it has moved generations of non-religious admirers. His innate gentleness shows even in his scenes of great anguish and passion. His typical combination of conservative medieval and pro-

gressive elements can be seen in his panel paintings of the period, for instance in the *Coronation of the Virgin*, now in the Louvre. Fra Angelico's late works are in Rome, where he was commissioned to decorate the chapel of Pope Nicholas V in the Vatican.

**Fra Filippo Lippi** (*about* 1406–69) was a young Carmelite monk who presumably met ▽Masaccio when the painter was working on the ▽Brancacci chapel □frescoes in the Florentine church of the order. Lippi's earliest surviving works are fragments of fresco depicting the *Relaxation of the Carmelite Rule* in the same church, painted soon after 1430, and strongly reminiscent of Masaccio. In 1437 Lippi began his Barbadori altarpiece now in the Louvre, Paris, one of the earliest □*sacra conversazione* of the 15th century, in which the traditional divisions of the centre and side panels are replaced by a single, continuous space in which the figures represented are allowed to move freely. Between 1452 and 1464 Lippi was at work on frescoes in the cathedral at Prato; stormy years during which he stood trial for fraud and was

released from his vows in order to marry the nun whom he had abducted, and by whom he had a son, Filippino, who also became a painter.

In Lippi's work, the influence of Masaccio gradually gave way to that of ▽ Donatello to whom the *Pitti Tondo* of 1452 is in certain respects a tribute.

**Andrea del Castagno** (1423–57). At the early age of 17, Castagno was supposed to have painted on the walls of the Bargello in Florence the corpses of men hanged as traitors. In 1442, he worked with Francesco da Faenza on □ frescoes in the Venetian church of S. Zaccaria, but had returned to Florence by 1444 when, like ▽ Uccello, he designed stained glass for the cathedral. His affinities with Uccello as well as their common respect for ▽ Donatello are most obvious in the equestrian portrait he painted in the cathedral in 1456 of Niccolo da Tolentino, for which rivalry with Uccello's ▽ Hawkwood provided both the prototype and the challenge. Castagno's frescoes in the convent of Sant' Apollonia were probably painted before 1450. The *Last Supper* is depicted with vivid realism, created by the dramatic lighting of the figures and the illusion of their spatial setting which appears as a bay extension of the refectory itself. Towards the end of his short career, Castagno moved closer to the style of Donatello. *The Famous Men and Women*, which he painted in the Medici Villa at Legnaia, are truly sculptural in concept. The figures were designed to look like free-standing statues, each one in a niche of painted 'architecture'.

**Piero della Francesca** (*about* 1420–92) was a Tuscan, not a Florentine; he was born in Borgo San Sepolcro and carried out his most important cycle of □ frescoes, *The Legend of the Finding of the True Cross*, in the Church of San Francesco at Arezzo (*after* 1452–*before* 1466). However, in 1439, he worked with another non-Florentine artist, ▽ Domenico Veneziano, on the lost frescoes in the Church of San Egidio, Florence. Apart from the style of his master, with its clear light and precise form, Piero was thus exposed to the influence of ▽ Masaccio, ▽ Uccello and ▽ Andrea del Castagno. From them, as his *Baptism* shows, he derived a personal and monumental

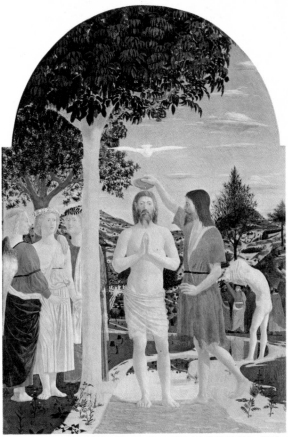

PIERO DELLA FRANCESCA *The Baptism of Christ.* 1448–50. 65½ × 45½ in (166 × 115 cm). NG, London

style of his own. The static, statuesque gravity of his figures remained one of his outstanding features. The Arezzo frescoes show his interest in geometry and □ perspective, as in the enigmatic panel of the *Flagellation of Christ*, one of the works painted by Piero at the Ducal Court of Urbino. Perhaps because of failing eyesight he abandoned painting to devote the last years of his life to the study of mathematics and perspective, on which he wrote two treatises.

*Below:* ANDREA DEL CASTAGNO *Last Supper. c.* 1444–9. Fresco. 162 × 378 in (410 × 995 cm). Sant' Apollonio, Florence

# THE ITALIAN RENAISSANCE

**Andrea del Verrocchio** (*about* 1435–88). A goldsmith by training, Verrocchio became, after the death of ▽Donatello, the leading sculptor in Florence. His bronze group of the *Doubting Thomas* was executed, (commissioned in 1463) for the niche on the façade of Or San Michele which originally contained Donatello's statue of St Louis. Verrocchio's replacement lacks the drama and emotion of Donatello. It is a work of extreme refinement; all the artist's care has been lavished upon the folds of the drapery and upon the detailed modelling of hair, hands, and sandalled feet. No less exquisite is the bronze *David* now in the Bargello. Made for the Medici, it is an example of Verrocchio's reworking a subject treated by Donatello for the same patrons. In this case, Verrocchio exploited the sensuous appeal of the polished surface to create a highly decorative statue. His equestrian monument to Bartolommeo Colleone in Venice completes the list of artistic challenges, with its unmistakable reference to ▽Donatello's *Gattamelata*. Verrocchio received the commission in 1479, but the statue was completed after his death. He was also active in Florence as a painter. His most important work is the *Baptism of Christ* (*about* 1470), in which ▽Leonardo da Vinci is supposed to have painted the kneeling angel on the left. Certainly, the young Leonardo trained with Verrocchio, who gave up painting, according to ▽Vasari, when he was confronted by the prodigious talent of his assistant.

**Sandro Botticelli** (*about* 1445–1510). In all probability a pupil of ▽Filippo Lippi, Botticelli's first documented work is the figure of *Fortitude*, of 1470, his contribution towards the set of Virtues painted by the ▽Pollaiuoli. The *Adoration of the Magi* was executed some five years later. It is a more characteristic work, freed from the obligation to conform to another artist's style. It displays crisp line, clear colour and decorative elegance, hallmarks of Botticelli. Among the spectators are recognisable portraits of the Medici family for whom a number of his most important pictures were painted. The *Primavera* (*about* 1477–8) and the *Birth of Venus* (*about* 1486) belonged originally to a young Medici, Lorenzo di Pierfrancesco, and hung in his villa at Castello. For this young man who enjoyed the best Classical education available these ravishing images served as allegorical illustrations of his humanist studies. The popularity of Botticelli's Madonnas is proved by the large number which survive from these years, many of them worked by his assistants. In 1500, he painted the *Mystic Nativity*, a work in which the elegance of his earlier style is replaced by a more restless treatment of figures and draperies. This more emotional, less rational approach which characterises his late works has often been attributed to the influence upon Botticelli of the religious reformer Savonarola. At the beginning of the sixteenth century it did not prove popular and Botticelli spent his last years in obscurity.

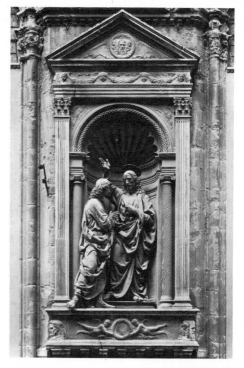

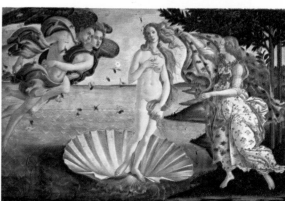

*Top:* ANDREA DEL VERROCCHIO *The Incredulity of St Thomas.* 1465–83. h. 90⅜ in (230 cm). Or S. Michele, Florence
*Above:* SANDRO BOTTICELLI *The Birth of Venus.* c. 1485–6. Tempera. 68 × 109½ in (172·5 × 278·5 cm). Uffizi, Florence

*Below:* DOMENICO GHIRLANDAIO *Confirmation of the Franciscan Rule.* 1485. Fresco. S. Trinita, Florence

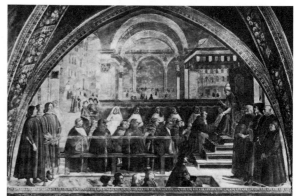

# The High Renaissance in Florence

**Leonardo da Vinci** (1452–1519). By 1476, Leonardo was living in the house of his master ▽Verrocchio and had already painted the portrait which anticipates his famous *Mona Lisa* by 25 years, the *Ginevra di Benci*, now in Washington. In 1481 he was commissioned to paint the *Adoration of the Magi.* The unfinished picture in the Uffizi reveals the extent of his originality. The central group is a tightly composed pyramid of figures from which the landscape recedes into distant atmospheric depth. It prefigures his later studies of the *Virgin and Child with St Anne* with its densely unified composition. The complicated poses could only be achieved after many preliminary studies of drapery and anatomy. Leonardo was a compulsive draughtsman whose thousands of drawings, together with notebooks, record his artistic experiments and scientific explorations.

In 1483, Leonardo offered his services to Lodovico Sforza, Duke of Milan, as painter, sculptor, military engineer and architect. He remained at the Milanese court until it fell to the French in 1499. For a projected equestrian monument to Francesco Sforza he made a huge clay model of a riderless horse, and in Santa Maria della Grazie, Milan, he painted in oil his famous *Last Supper* (*about* 1497) a work of psychological subtlety unprecedented at that date. His painting of the *Madonna of the Rocks*, of which two versions survive in London and Paris, shows a growing mastery of □*sfumato*, of atmospheric blending and blurring of light and shade by which he achieved in oil painting a new and subtle range of □tonal values. In 1517, Leonardo removed to France to the Château of Cloux, where he continued until his death to investigate the nature of the world around him, respected both for his intellectual integrity and for his artistic genius.

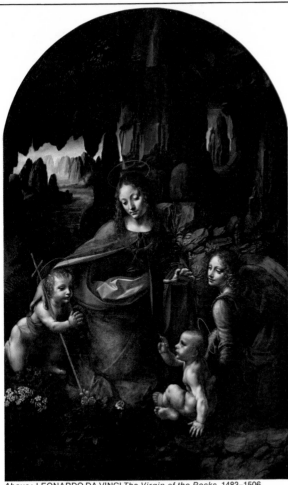

*Above:* LEONARDO DA VINCI *The Virgin of the Rocks.* 1483–1506. $72\frac{1}{2} \times 45\frac{1}{2}$ in (184 × 115 cm). NG, London

*Below:* LEORNARDO DA VINCI *Last Supper.* 1495–8. 173 × 339 in (439 × 859 cm). Convent of Sta Maria delle Grazie, Milan

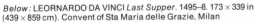

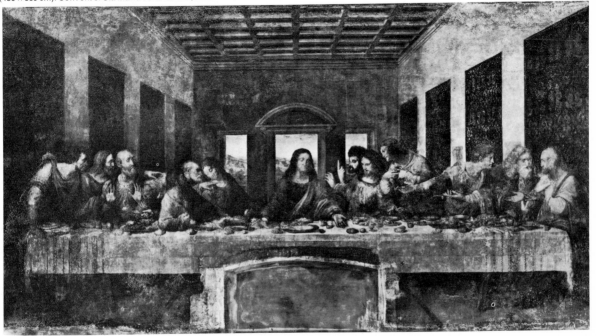

# THE ITALIAN RENAISSANCE

**Michelangelo Buonarroti** (1475–1564). In 1488, the young Michelangelo entered the Florentine workshop of the ▽Ghirlandaio family. Within a year, however, he had transferred his allegiance to the sculptor ▽Bertoldo and the informal school set up under the patronage of ▽Lorenzo de' Medici in a garden near San Marco. His earliest work shows a combined respect for antiquity and for those contemporary sculptors, such as Bertoldo, whose work is imbued with it.

**Sculpture.** The figure of *Bacchus* which Michelangelo carved in Rome in 1497 belongs to the same tradition as the David figures of ▽Donatello and ▽Verrocchio, Medici commissions in which the antique source is successfully combined with a refined sensuality. Significantly, the *Bacchus* was designed to harmonise with existing Classical statues in a sculpture garden. During his first visit to Rome, Michelangelo also carved the *Pietà*, the work which established his reputation as a mature artist. In it he solved, in the most moving way, the considerable problem of supporting the full-length figure of the dead Christ on the Virgin's lap, an equivalent in sculptural terms of ▽Leonardo's famous composition of the *Virgin and Child with St Anne*. In 1501, Michelangelo was commissioned by the new Republic of Florence to carve a statue of David from a huge block of marble which had been reserved for the purpose since 1462. In contrast to the treatments of the same subject by Donatello and Verrocchio, this was to be over life-size, and was identified from the outset with the struggle of the new administration for its independence. Artistically, the statue, which was unveiled outside the Palazzo Vecchio in 1504, rivalled the □*colossi* of antiquity and, with its perfection of the human form, set the seal upon the Renaissance as a complete Classical revival.

In 1516, Michelangelo was sent to Florence by the Medici Pope, Leo X, to complete the façade of San Lorenzo. The project was abandoned four years later in favour of the Medici Chapel, or New Sacristy, of the church. Michelangelo's starting point was ▽Brunelleschi's Old Sacristy, in which the founders of the house of Medici lay buried. From it he took the colour scheme of white walls contrasted with grey □*pietra serena* decorations. In place of Brunelleschi's placid Classicism, however, Michelangelo treated his architecture as sculpture, exploring the dramatic effect of the dome and heavily moulded windows, which lack any obvious means of support, to provide a visual equivalent to the theme of Resurrection. The figure sculpture contributes to the same end, its symbolism that of time and mortality, with statues of Giuliano and ▽Lorenzo de' Medici set over the tombs, above personifications of Day and Night, and Dawn and Dusk.

**Architecture.** In works such as the Medici tombs, Michelangelo's architecture is inseparable from his sculpture. When Cardinal Giulio de' Medici became Pope Clement VII in 1523, work on the tombs intensified, and to Michelangelo's other Florentine commitments, the Laurentian Library was added in 1524. His approach to the articulation of the building was no less dramatic; the Vestibule is regarded by many as the first, irresistible essay into

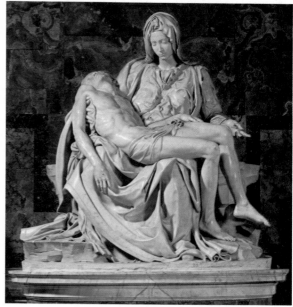

*Above: Pietà.* 1498–9. Marble. h. 69 in (175 cm). St. Peter's, Rome

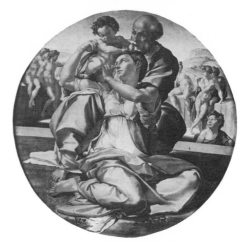

*Above: Holy Family* (Doni Tondo). *About* 1503. Uffizi, Florence

*Below:* The Medici Chapel, San Lorenzo, Florence. 1520–34

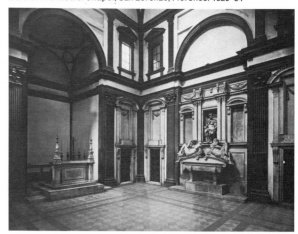

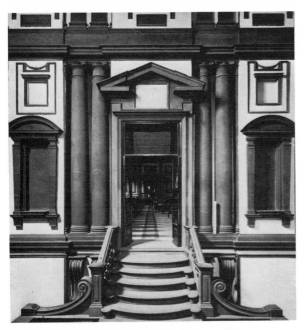

*Above:* The Laurentian Library, Vestibule, Florence, 1524

*Below:* Part of the Sistine Chapel, Vatican. 1508–12

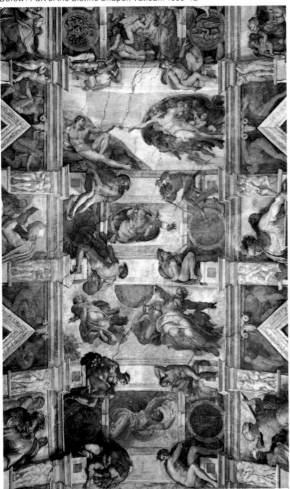

architectural ▽ Mannerism. The weight of the walls and of their mouldings is apparently supported by inadequate forms in contradiction of the laws of gravity. For the central flight of stairs which flow with a deliberate sense of movement downwards from the □*piano nobile*, Michelangelo made a clay model from which the actual staircase was carved (1533–4).

In 1556 the papal architect, Antonio da Sangallo, died. Paul III immediately called upon Michelangelo to complete the Palazzo Farnese, to replan the Capitol and to supervise work on St Peter's. When Michelangelo took over in 1547 as Chief Architect of St Peter's, an office for which he refused any salary, the central crossing had been constructed according to ▽ Bramante's plan. Michelangelo promptly re-designed it to concentrate the building around and beneath his triumphant dome.

Michelangelo became a legend in his own lifetime. Two years after his death, the second edition of ▽ Vasari's biography appeared and established him as the Renaissance artist *par excellence*. Whether in sculpture, painting or architecture, Vasari saw his achievement as superlative, an estimate of his genius which few have challenged since.

**Painting.** In 1504, the Republic of Florence commissioned from Michelangelo a □fresco to commemorate the Battle of Cascina. He was allotted a wall in the Great Hall of the Palazzo Vecchio, adjacent to the one on which ▽ Leonardo was employed to paint a complementary scene, the *Battle of Anghiari*. Had the two projects been realised, they would have offered a unique opportunity to study the divergent talents of the two titans of Renaissance art. From surviving copies it is possible to see that Leonardo, the master draughtsman of men and horses, used the subject of combat to introduce extremes of violent expression and movement. Michelangelo by contrast shows his knowledge of Signorelli, ▽ Bertoldo and the antique. There is a three-dimensional clarity about his group of nude bathers, victims of surprise attack. The figures are arranged to demonstrate his command of the human form on a monumental scale.

In the □*tondo* of the *Holy Family* painted for the Doni family in about 1503, Michelangelo shows his mastery of the kind of tight and complex figure composition with which Leonardo had been preoccupied. Once again, however, the clarity and weight of the figures betray his sculptural interests. In 1508, ▽ Julius II commissioned Michelangelo to decorate the ceiling of the ▽ Sistine Chapel. Four years later he had painted, virtually without assistance, every inch of the shallow barrel vault over the chapel. Its relatively simple articulations were deliberately complicated by the introduction of painted architectural ribs, used to divide up the space into frames out of which Michelangelo's massive figures could burst with colossal energy and force. The *Creation of Adam* is justly famous: in the Sistine Chapel, Michelangelo rose to creative heights which earned for him, from his contemporaries, the epithet 'divine'. More than 20 years later, Michelangelo returned to the chapel to paint for the Farnese Pope, Paul III, the *Last Judgement* on the altar wall. Unveiled in 1541, it presents in contrast with the ceiling frescoes, a turbulent and pessimistic vision of the Judgement.

# THE ITALIAN RENAISSANCE

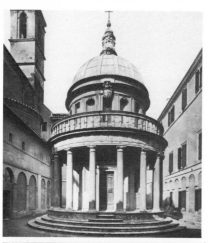

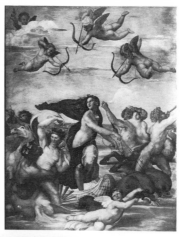

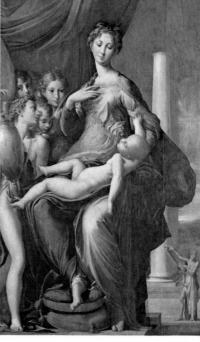

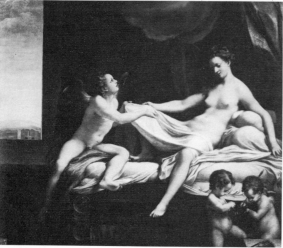

*Top left:* DONATO BRAMANTE *Tempietto: San Pietro in Montorio,* Rome 1502
*Top centre:* RAPHAEL *The Triumph of Galatea.* 1511. 118 × 90 in (295 × 225 cm), Villa Farnesina, Rome
*Left:* ANTONIO CORREGGIO *Danae. c.* 1531. 63½ × 76 in 161 × 193 cm (161 × 193 cm) Borghese Gallery, Rome
*Above:* IL PARMIGIANINO *Madonna of the Long Neck.* 1534. 85 × 52 in (216 × 132 cm), Uffizi, Florence

**The Papacy.** In 1471, Francesco della Rovere ascended the papal throne as Sixtus IV. His long pontificate was marked by strenuous political activity on behalf of the papacy, and by at least one major act of patronage. Bewteen 1475 and 1480, the ▽Sistine Chapel was built in the Vatican, and a group of artists were assembled to decorate the side walls with ☐frescoes. ▽Botticelli, ▽Ghirlandaio and Perugino (*about* 1445–1523) were among the contributors to the first stage in the decoration of what was to become a focal point for the patronage of the Renaissance papacy. ▽Julius II (1503–13) was another determined and resourceful politician of the Church. It was his distinction to employ simultaneously in the Vatican ▽Bramante, ▽Michelangelo and ▽Raphael. From his accession until the Sack in 1527, Rome enjoyed something of a golden age as far as the arts were concerned. Her rise in importance as a centre of patronage corresponded to a decline in the role of Florence after the expulsion of the Medici in 1494. Julius II was succeeded by two Medici popes, Leo X (1513–20) and Clement VII (1523–34). They continued and extended papal patronage, although family interests occasionally intervened; Michelangelo worked on the Medici tombs in Florence under orders from the Pontiff. Paul II (1532–49) on the other hand was a member of a prominent Roman family, the Farnese. When Michelangelo took over as papal architect from Antonio da Sangallo in 1547, he assumed responsibility not only for the building of St Peter's, but for the completion of the Palazzo Farnese and the replanning of the Capitol.

**Donato Bramante** (*about* 1444–1514). Born near Urbino, Bramante grew up under the influence of one of the most cultured courts in 15th-century Italy. He may have trained as a painter with ▽Piero della Francesca, who enjoyed the patronage of the Duke, Federico da Montefeltro. As a young architect, Bramante cannot have failed to appreciate the graceful Classical harmonies of the Ducal Palace, built 1470–5. Some time before 1480, he went to Milan where his Church of Santa Maria presso San Satiro shows the influence of ▽Alberti. In 1499 Bramante went to Rome. There, his own brand of severe Classicism emerged in the Tempietto of San Pietro in Montorio, built to mark the spot of St Peter's crucifixion. Both the centralised plan and the strict use of Classical orders reflect Bramante's use of antiquity. The style appealed to his papal patrons, for whom he carried out a number of commissions in the Vatican. The triumph of strict Classicism came in 1506, when ▽Julius II instructed Bramante to rebuild St Peter's. He planned to replace the early Christian ☐basilica with a centralised church, and before his death the four great piers and arches of the crossing were completed. Bramante's original design was subsequently modified, chiefly by ▽Michelangelo, but it remains his distinction to have begun the rebuilding of St Peter's as a monument to Renaissance humanist ideals.

# The High Renaissance in Rome

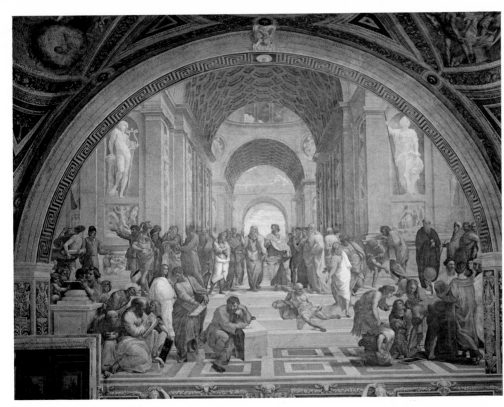

RAPHAEL *The School of Athens*. 1508–11. Fresco from the Stanza della Segnatura, Vatican

**Raphael Santi** (1483–1520). Raphael's mercurial career began in provincial obscurity, as an assistant of ▽ Perugino (*about* 1445–1523). In the early 16th century he went to Florence where he quickly assimilated the influences of ▽ Leonardo da Vinci and ▽ Michelangelo. The *Holy Family* (*about* 1507) shows how Leonardo's intricate figure compositions directed the younger artist towards a compact, pyramidal grouping of his subjects. By 1509, Raphael was in Rome and had secured the patronage of Pope Julius II, for whom he painted the □frescoes in the □*Stanza della Segnatura* which represent Philosophy and Theology, the *School of Athens* and the *Disputà*, as they became known. Here Raphael, at the age of 28, established himself as a serious rival of his great contemporaries. Around the central figures of Plato and Aristotle, an array of ancient philosophers are assembled in every variety of pose and attitude. The stage they occupy is a vast imaginary hall, a Classical fantasy of a huge, centrally planned building.

Raphael continued with the *Stanza d'Eliodoro*, decorated between 1511 and 1514. It reveals in its greater sense of drama and the importance given to the human figure the impact of Michelangelo's ▽ Sistine ceiling, unveiled in 1512. Unlike Michelangelo, who preferred to work in isolation, Raphael was highly successful in training numerous assistants to whom he entrusted large sections of the later *stanze*. With their help, he was also able to undertake commissions like the decoration of the Villa Farnesina whose walls and ceilings are covered with apparently effortless and undeniably decorative frescoes. The *Triumph of Galatea* is a superb example of the refined elegance of such painting, which illustrate Classical myths susceptible of humanist interpretation.

**The School of Raphael**. When Raphael died prematurely, he was survived by assistants who were able to complete outstanding commissions. ▽ Giulio Romano (*about* 1492–1546) was his principal follower who had assumed major responsibility during Raphael's lifetime for work on the Vatican *stanze*. He finished the decoration of the *Sala di Constantino* before leaving for Mantua in 1524. There his own exaggerated version of Raphael's style reached heights of its own in the *Fall of the Giants* and other □frescoes painted 1526–34. Francesco Parmigianino (1503–40) arrived in Rome three years after Raphael's death, to develop a peculiarly attenuated elegance of which the *Madonna of the Long Neck* is typical. In its contrived treatment of a Raphael-esque composition, the picture demonstrates how the later followers devised idiosyncratic variations of his style which are, in different ways, expressions of ▽ Mannerism in 16th-century painting.

**Correggio** (Antonio Allegri) (*about* 1499–1534). Originating from Parma and traditionally a pupil of ▽ Mantegna, Correggio lies, strictly speaking, outside the Roman school. Nonetheless, the references to ▽ Michelangelo and to ▽ Raphael in his painting imply that he must have visited Rome before 1520. The debt is apparent in the □cupola he painted in San Giovanni Evangelista, Parma, 1520–3, which is a forerunner for the larger cupola of Parma Cathedral, executed 1526–30. Both cupolas demonstrate an extremely virtuoso illusionism. His greatest achievement however was in the soft and sensuous modelling which he developed, with a touch of ▽ Leonardo's □*sfumato*, for his intimate mythologies. Of these, the *Danae* is justly celebrated.

# THE ITALIAN RENAISSANCE

**Mannerism.** The term Mannerism is derived from the Italian *maniera*, a word meaning style, or stylishness. It was coined by ▽ Giorgio Vasari, a participant himself, to identify a distinguishing feature of 16th-century art. The generation of artists who succeeded ▽ Michelangelo and ▽ Raphael were understandably overawed by their achievements. They naturally sought to invent as well as to emulate, and the result was the self-conscious pursuit of refinement or special effect. To some extent, Michelangelo and Raphael provided the cues; in architectural terms, the staircase of the Laurentian library is Mannerist in its wilful disruption of Classical severity. Raphael's later *stanze* sacrifice the balanced harmonies of the *School of Athens* to dramatic effect and virtuoso composition. The ingenious use of sources became an important ingredient in Mannerist art, which flattered patrons by appealing to their knowledge and taste. As a court art, it had to entertain and amuse; the greatest architects and sculptors of the period, men like Bernardo Buontalenti, were employed to design elaborate spectacles and other ephemera, in addition to planning gardens full of contrivances for squirting water and other practical jokes. In painting, the emphasis was upon exaggeration of form, colour and expression. Mannerism has been called a neurotic or decadent art, a view which overlooks the range and diversity of what is better regarded as an historical period than as a movement.

JACOPO PONTORMO *Deposition*. 1526–8. 123¼ × 75½ in (313 × 192 cm). Santa Felicita, Florence

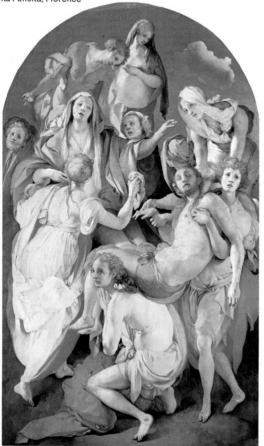

**Andrea del Sarto** (1486–1531) was one of the leading Florentine painters at the beginning of the 16th century. Both ▽ Leonardo da Vinci and ▽ Michelangelo inevitably influenced his early style. Around 1510, Sarto began the ☐fresco decoration of the Chiostro allo Scalzo in Florence, which was less than half completed when he visited France in 1518–19, at the invitation of Francis I. In the previous year, Andrea del Sarto painted the *Madonna delle Harpie*. Its dramatic lighting, the angular gestures of the saints and the athletic pose of the child are characteristic of his mature style. His use of colour rather than line to give shape and definition to his figures provided an important lesson for his immediate followers, Jacopo Pontormo (1494–1556) and Rosso Fiorentino (1494–1540).

Pontormo's altarpiece of 1518 in the Church of San Michele Visdomini, Florence, shows both his debt to Sarto and the restless agitation of his own Mannerist style. The fresco of Vertumnus and Pomona, painted in 1521 in the Medici villa at Poggio a Caiano, is decorative and gay, in contrast with the *Deposition* of about 1526, in the Church of Santa Felicità, Florence. This is his finest work, in which the elaborate figure composition, executed in sharp, bright colours, is infused with religious fervour.

ANDREA DEL SARTO *Madonna of the Harpies* (*Madonna delle Harpie*). 1517. 81½ × 70½ in (207 × 178 cm). Uffizi

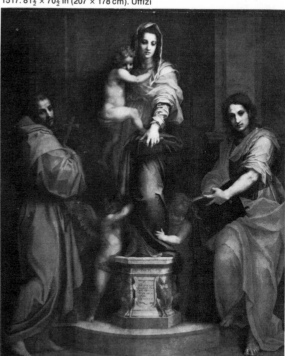

**Giorgio Vasari** (1511–74) was born in Arezzo. Thanks to the friendly interest of Cardinal Passerini, tutor to Ippolito and Alessandro de'Medici, he received the best ▽ humanist education available in Florence. As a painter, he trained in the circle of ▽ Andrea del Sarto, but ▽ Michelangelo was by far the greatest influence upon him. After the Sack of Rome (1527), Vasari went there where he decorated the *Sala Regia* in the Vatican. His ☐frescoes are exemplars of Mannerism, with their exaggeration of Michelangelo's figure style. They are

comparable with the work of his contemporaries, Jacopino del Conte (1510–98) and Francesco Salviati (1510–63), both of whom worked in the Church of San Giovanni Decollato, Rome from about 1535. Throughout his career, Vasari was adroit at the business of art, in spite of his patrons' changing fortunes in the unsettled political climates of both Florence and Rome. His greatest success was after 1554, when he returned to Florence as an architectural adviser to the restored ▽Duke Cosimo de'Medici. For the Duke, Vasari remodelled and redecorated the Palazzo Vecchio and designed the Uffizi Palace. The publication in 1550 and 1568 of his *Lives of the Most Excellent Architects, Painters and Sculptors* made Vasari's reputation as a man of letters and it is by this book that he is chiefly remembered.

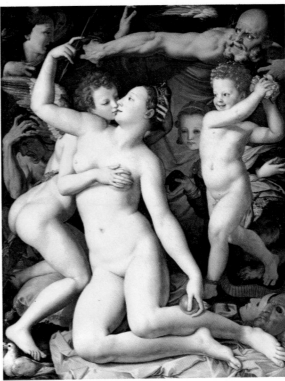

AGNOLO BRONZINO *Venus, Cupid, Folly and Time.* c. 1545. 57 × 45½ in (144 × 155 cm). NG, London

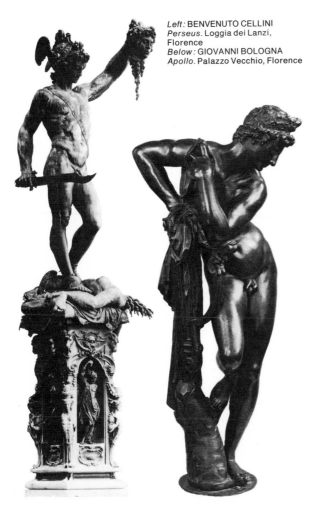

*Left:* BENVENUTO CELLINI
*Perseus.* Loggia dei Lanzi, Florence
*Below:* GIOVANNI BOLOGNA
*Apollo.* Palazzo Vecchio, Florence

**The Art of the Granducal Court.** As Vasari discovered to his advantage, ▽Duke Cosimo I de'Medici was anxious to establish his Florentine court as a centre of artistic activity. The leading sculptor in Florence after the departure of ▽Michelangelo was Baccio Bandinelli (1493–1560), whose *Hercules and Cacus* was unveiled in the Piazza della Signoria in 1534. Its attempt to emulate Michelangelo's *David* is a sorry one, but the debt is there.

The sculptor Benvenuto Cellini (1500–71) described Hercules' anatomy as a 'sack of melons'. Cellini's autobiography offers a racy alternative to Vasari's more dignified account of the status of the artist. He had already worked at the French court before going back to his native city in 1545. His figure of *Perseus*, cast in bronze for the Duke, shows a profound respect for both ▽Donatello and Michelangelo, and yet in its elegant treatment of a violent subject, it is unmistakably Mannerist.

Agnolo Bronzino (1503–72) a pupil of ▽Pontormo, touched like most of his contemporaries by the inescapable influce of Michelangelo, was Court Painter. His portraits of the Medici are the cold and impersonal images favoured by an absolute dynasty. The painting of *Venus, Cupid, Folly and Time* (1545) displays his characteristic bright colours and high degree of finish. The improbable poses of the figures, their extended limbs and frozen gestures illustrate further the aims and achievements of Mannerist art.

Some time before 1560, a young Flemish sculptor, Giovanni da Bologna, (1529–1608) settled in Florence. His small bronzes are the apogee of Mannerist sculpture. The *Apollo* of 1573–5 is typical; it was designed above all to please the connoisseur; it was made for the *Studiolo* of the Duke Ferdinando de'Medici. The pose of the figure is arranged to create the maximum of elegant curves viewed from every conceivable angle, while the surface is carefully polished to that high degree of finish which was fashionable at the Medici court. Not that the taste was confined to Florence; the mass-production of his statuettes guaranteed the spread of Giambologna's work throughout Europe.

# THE ITALIAN RENAISSANCE

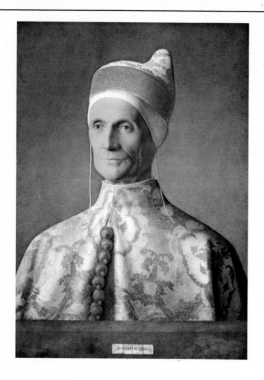

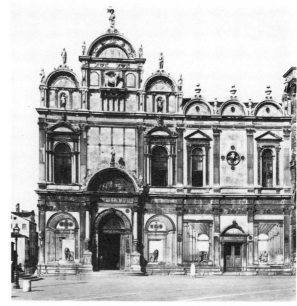

*Left:* GIOVANNI BELLINI *Portrait of Doge Loredano. About* 1501. 24¼ × 17¾ in (61 × 45 cm). NG, London
*Above:* PIETRO LOMBARDO Scuolo di San Marco. *About* 1490

**The Venetian State.** 'Your nation . . . traces back its fame to the most remote antiquity,' the 14th-century poet Petrarch wrote to his Venetian friend, Doge Andrea Dandolo. Like Florence, Venice aspired to the title and status of a new Rome. The cult of St Mark lent weight to the claim, as did the strong ties which existed between Venice and Constantinople, the original 'new Rome' which fell to the Turks in 1453. Geographically Venice stood between East and West, in contact with both □Byzantine and Roman civilisations. Her position accounts for her growth during the middle ages. At the head of the Adriatic, with access overland to the north, Venice was the natural gateway to the Near and Far East. Her relative isolation from the rest of Italy gave her a measure of independence from mainland politics, while seapower protected the shores of the lagoon and gave the Venetians an international role.

Scenes like those which appear in ▽Carpaccio's paintings show that Venice was, at the end of the 15th century, a bustling commercial centre. Her network of canals brought merchant shipping to the heart of the city, where wharves and warehouses together with public buildings and private houses lined the principal waterways. In common with a number of medieval Italian city-states, Venice was a Republic. The Great Council represented predominantly mercantile interests and the Doge, or chief magistrate, was an official elected from the inner cabinet, with carefully circumscribed powers to deter dynastic ambitions. Once elected, he was surrounded by an aura of sacred majesty as the standard bearer of St Mark, and was venerated as the head of State. Although he was an accountable official, in all other respects the Doge of Venice was the equal of any Renaissance prince. ▽Bellini's portrait of Leonardo Loredan (1501–21) is a study of the cool authority and astute management which the more able incumbents brought to the office.

**Venetian architecture.** Venice is built upon alluvial mud. Her buildings are supported by piles, their outer walls bounded by the canals which interlace the city. As the map attributed to Jacopo de'Barbari shows, by 1500 land was at a premium; Venice was already crowded within her strictly limited boundaries. In domestic architecture, the Venetian Gothic style extolled by John Ruskin in *The Stones of Venice* survived well into the 15th century. The façades of the Doge's Palace, built 1309–1424, are visually striking with their ornate □tracery and coloured marble. In private buildings, site restrictions often led owners to concentrate their efforts upon frontages; Contarini's house of 1422–40 is called the Ca'd'Oro from the profusion of gold used on its façade.

Change reached Venice in the second half of the 15th century via Padua. The sculptor and architect ▽Pietro Lombardo was there in 1464, before settling in Venice, where he and his two sons Antonio and Tullio were responsible for the first works of the Venetian Renaissance. They rebuilt the Scuola di San Marco about 1490, and decorated the façade with an illusionistic □perspective reminiscent of ▽Mantegna, carved in □relief. At about the same time, Tullio Lombardo was responsible for the tomb of Doge Andrea Vendramin, a monument based upon the Roman triumphal arch and decorated with relief and free-standing sculpture which recall precise Classical prototypes. The Lombardi were exceptional, however. In general, local traditions gave way to the advance of the Classical revival more slowly in Venice than in central Italy. Many of the patrician palaces which line the Grand Canal date from the end of the 15th century. Like the Palazzo Dario and the Palazzo Cornaro-Spinelli, they combine Classical features with the more traditional architectural vocabulary of Venetian Gothic.

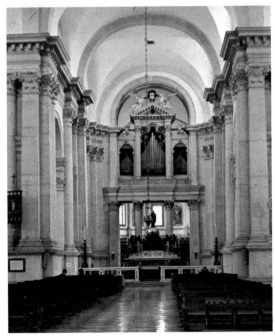

*Above:* ANDREA PALLADIO San Giorgio Maggiore. 1565

*Below:* JACOPO SANSOVINO Library of St Mark's Venice with the Loggetta on right. 1532–54

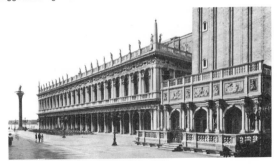

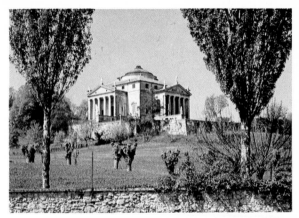

*Above:* ANDREA PALLADIO Villa Capra, near Vicenza, begun 1567
*Below:* ANDREA PALLADIO Palazzo Chiericati, Vicenza. 1550

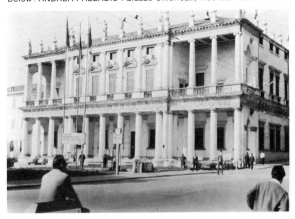

**Jacopo Sansovino** (1486–1570). It was not until the arrival of Sansovino, who fled to Venice from the Sack of Rome in 1527, that a purely Classical style of architecture appeared in the Republic. Sansovino took his name from his master, the Florentine sculptor Andrea Sansovino (*about* 1460–1529). He went to Rome with Giuliano da Sangallo in 1503. There he became known as a student of the antique who restored damaged statues for Pope ▽Julius II. He knew ▽Bramante and ▽Raphael, and was responsible for the design of the Church of San Giovanni dei Fiorentini. In Venice, Sansovino took charge of the public buildings around the square of St Mark's. His Library of 1537 was the first example of uncompromising Classicism in Venetian architecture, with its rows of columns and □balustrades. Like all of his buildings. it is sculptural in its treatment of masonry and is decorated with elegant statues. Sansovino's most important sculptures in Venice are the colossal figures of Neptune and Mars which stand at the head of the staircase of the Doge's Palace. His Loggetta at the base of the campanile of St Mark's is the best example of his skill at combining sculpture with architecture. Four nearly life-size bronzes of extreme refinement are set across the façade within

**Andrea Palladio** (1518–80). A native of Vicenza, Palladio is arguably the greatest domestic architect of the 16th century. He is certainly one of the most influential; the publication of his *I Quarttro Libri dell' Architettura* in Venice (1570) ensured that his designs for town and country houses in the Veneto were known throughout Europe. In England his influence resulted in some of the finest houses of the 18th century.

In 1541, Palladio was taken to Rome to study architecture by his patron, the humanist Count Trissino. As a result his mature style displays a full acqaintance with the work of ▽Bramante and the slightly younger Roman architects, who, like ▽Giulio Romano, came from the circle of ▽Raphael. However, Palladio's was also a personal style. He took liberties of a particular and elegant kind with the Classical vocabulary for which ▽Vitruvius had been regarded as the ultimate authority since the 15th century. In the Palazzo Chiericati at Vicenza for instance, begun in 1551, the façade is opened up to provide a continuous colonnade along the ground floor and three bays to left and right of the central solid section above. The Villa Capra (Rotunda) of the same years is an exercise in perfect symmetry, with its central dome and, on each side, pedimented ▽Ionic porticos. At Maser, the Villa Barbaro is another Palladian house, distinguished by the collaboration of ▽Paolo Veronese in the decoration of the interiors with extremely delicate and often witty □*trompe l'oeil* frescoes dating from 1561–2. Palladio also designed churches; in Venice he was responsible for San Giorgio Maggiore, 1565, and the Redentore, 1577.

# THE ITALIAN RENAISSANCE

**Venetian Painting.** In painting no less than in architecture, the links between Venice and the eastern Mediterranean played an important part. The □mosaic decoration of St Mark's, like the building itself, followed ▽Byzantine traditions and was executed, to begin with at least, by Byzantine craftsmen. Panel painting showed a similar conservatism towards Eastern influences. The altarpieces of Carlo Crivelli (*active* 1457–93), painted at the end of the 15th century, show a deep concern for surface pattern of a heavily decorated kind. Peacocks and oriental carpets appear as favourite adornments of the intricate, □linear perspectives in which the figures are placed. Nothing remains of the 15th-century □frescoes in the Doge's Palace, on which ▽Gentile da Fabriano was working in 1409. When he went to Florence work was continued by ▽Antonio Pisanello (*about* 1395 – *about* 1455), who completed by 1422 what must have been the major expression of the ▽International Gothic style in Venice. In Sant' Anastasia, Verona, Pisanello's fresco of *St George and the Princess* (*about* 1437) survives. In spite of its poor condition, it is possible to see the emphasis upon observation of detail, a high degree of finish and beautiful drawing; characteristics for which Pisanello was admired by his contemporaries.

**Antonello da Messina** (*about* 1430–79). An account of Venetian painting must include Antonello, a south Italian painter who was in Venice in 1475–6. He was one of the first Italians to use oil paint, a Flemish innovation associated with the ▽Van Eycks, and to develop the advanced technique it allowed. His work was admired among others by ▽Giovanni Bellini who adopted the method and, in his portraits, something of Antonello's style. Both artists painted, at about the same time as ▽Piero della Francesca's Brera altarpiece, □*sacre conversazioni* in which the picture space is treated, with the help of illusionist architecture, as an extension of the actual space of the church.

**The Bellini.** Jacopo Bellini (*about* 1400–70) was, like his contemporary ▽Pisanello, a pupil of ▽Gentile da Fabriano. He was working in Florence with Gentile in 1423 and competed successfully against Pisanello with a portrait of Lionello d'Este in 1441. Very few surviving works can be certainly attributed to him, but two sketchbooks are preserved, in the British Museum and the Louvre, which reveal his powers as an imaginative draughtsman. They contain drawings for compositions, architectural and landscape □perspectives, several of which occur in the painting of his two sons.

Jacopo's elder son, Gentile (1429/30–1507), trained as a painter under his father, and specialised in views of processions and ceremonies in the city of Venice. His pictures present a colourful account of contemporary life. Gentile's principal follower in this popular art form was Vittore Carpaccio (*active* 1490–1523/6). In 1479–81, Gentile went to ▽Constantinople where he painted portraits for the Sultan Mahomet II; one example of the links which continued between Venice and the Bosphorous under Turkish occupation.

Giovanni Bellini (*about* 1430–1516) took over from his brother the painting of a cycle of histories in the Doge's Palace when Gentile left for Constantinople. Like those of Gentile da Fabriano and Pisanello, they were destroyed by fire in 1577, a major loss to our knowledge of Venetian painting of the period. Another important work of the 1470s, the altarpiece Giovanni painted for the Church of SS. Giovanni e Paolo was also burnt, in 1467. It was clearly the prototype for his San Giobbe altarpiece of 1483–5. In this, the painted architecture creates a massive □niche for the figures of the □*sacra conversazione* and, in its original relationship to the real architecture of the church, connected them not only with one another but with the spectator as well. Through his brother-in-law ▽Mantegna. Giovanni may well have known the work of ▽Piero della Francesca, and in particular his *Madonna with the Duke of Urbino as Donor* of 1472. His relationship with Mantegna is best seen in the paintings by each artist in about 1460 of the *Agony in the Garden*, both in the National Gallery, London. Giovanni's landscape, derived from a drawing in his father's sketchbook, is more continuous, whereas his figures lack the clarity and weight of Mantegna's.

No such deficiency exists in the *St Francis* panel of the late 1470s. The figure of the saint has a physical and psychological presence as he confronts the sunlight outside his cell in anticipation of his stigmatisation, in a landscape which sacrifices none of its naturalism to the symbolic meaning it also sustains. Giovanni Bellini was recognised officially in Venice as the leading painter of his day. His workshop specialised in the production of highly popular, devotional pictures of the Madonna, and his assistants included most of the leading painters of the next generation, ▽Giorgione and ▽Titian among them. In 1506 when ▽Dürer visited Venice he reported that Giovanni was 'very old, but still the best in painting'. Indeed, his late works show him adapting to the taste of the new century.

**Andrea Mantegna** (*about* 1431–1506), not a Venetian-born painter, married the daughter of one and had two others, whom he influenced, as his brothers-in-law. Moreover his activity was concentrated in the north of Italy. Like the ▽Lombardi, he had strong connections with nearby Padua and settled for many years as Court Painter to the Gonzaga family at Mantua. Mantegna's most important early work was the □fresco decoration of the Ovetari Chapel in the Church of the Eremitani at Padua, destroyed in 1944. Photographs of the *Martyrdom of St James* survive to show the virtuoso □foreshortening and the intensely Classical style of the figures and architecture of the scenes. Many of his paintings emulate the effect of □relief carving; evidence of Mantegna's profound admiration for ▽Donatello. In the Ducal Palace at Mantua, he painted the *Camera degli Sposi* (1472–4) with portraits of the Gonzaga set into □illusionistic landscapes. They are revealed by drawn curtains painted as hanging from poles attached to pilasters. On the ceiling, a parapet opening to the sky completes the playful illusionism of the room. Mantegna's archaeological devotion to antiquity is illustrated by the *Triumph of Caesar* he painted at Mantua (1486–94), now at Hampton Court.

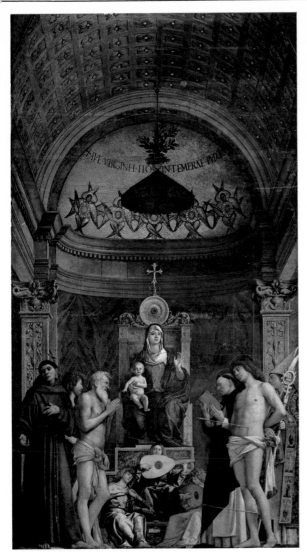

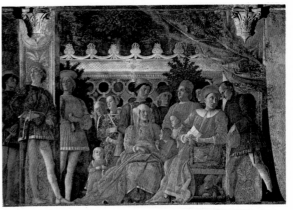

*Above:* ANDREA MANTEGNA *Ludovico Gonzaga receiving the Messenger announcing the return of Federigo Gonzaga from exile.* 1473–4. Mantua
*Below:* ANTONELLO DA MESSINA *St Jerome in his Study.* 1474. 18 × 14¼ in (46 × 36·5 cm). NG, London

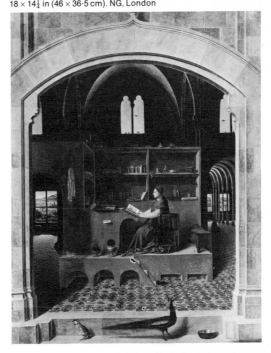

*Above:* GIOVANNI BELLINI *San Giobbe Altarpiece.* 1483–5. 188 × 103 in (471 × 258 cm). Accademia, Venice

*Below:* VITTORE CARPACCIO *Miracle of the True Cross.* 1494–5. 143¾ × 153 in (365 × 389 cm). Accademia, Venice

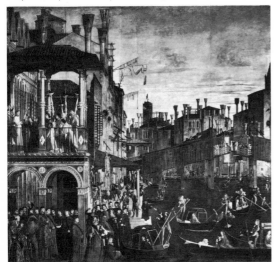

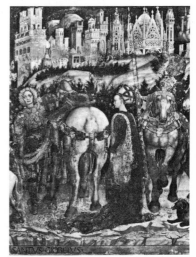

*Right:* PISANELLO *St George and the Princess of Trebizond.* (Detail). Fresco. Verona

# THE ITALIAN RENAISSANCE

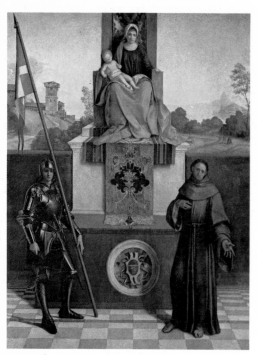

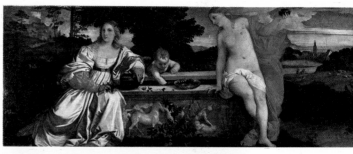

*Above:* GIORGIONE *Madonna and Child with SS Francis and Liberale.* 78¾ × 60 in (200 × 152 cm). San Liberale, Castelfranco

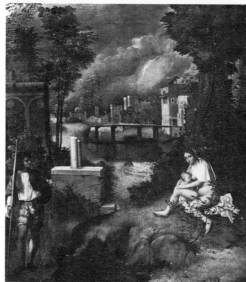

*Above:* TITIAN *Sacred and Profane Love.* About 1515. 47½ × 112 in (118 × 279 cm). Borghese Gallery, Rome
*Left:* GIORGIONE *Tempestà* 32⅜ × 28½ in (83 × 73 cm). Accademia, Venice

*Below:* TINTORETTO *The Ascension.* About 1581. 17 ft 8 in × 10 ft 8 in (537 × 324 cm)

*Below:* VERONESE *Hermes, Herse and Aglauros.* About 1580. 92 × 69½ in (232 × 173 cm) Fitzwilliam Museum, Cambridge

**Giorgione** (*about* 1476–1510). The details of Giorgione's short career remain as obscure as the meaning of certain of his pictures. His early debt to ▽ Giovanni Bellini can be seen in the *Castelfranco Madonna*, painted soon after 1500. In 1508, Giorgione was working with ▽ Titian's assistance on exterior □frescoes on the Fondaco dei Tedeschi, a collaboration of which all too little survives. On the other hand, the small oil-painting known as the *Tempestà* is universally accepted as his work. The riddle of the subject continues to exercise iconographers, and was complicated further by the discovery, through X-ray photography, that the male figure on the left replaces an earlier seated female nude. What is unmistakable is the picture's power of evocation, its representation of nature in a particular mood, in this case under the threat of impending storm. Of the unproven attributions, the *Adoration of the Shepherds* in Washington incorporates a landscape of great sensitivity and softness of handling. The *Venus* in Dresden was unfinished when Giorgione died of the plague; according to a reliable contemporary source, Titian completed the landscape and the figure of Cupid which has since been painted out. Of the precise nature of his debt to Giorgione we shall never be sure, but of the general dependence upon the Dresden picture of his *Venus of Urbino* painted 30 years later, there can be little doubt.

**Titian** (Tiziano Vecellio) (*about* 1487/90–1576). With the work of Titian, the Venetian Renaissance reached its zenith. The decisive influence upon him appears to have been his contact with ▽ Giorgione, rather than the formal training they both received in the ▽ Bellini workshop. Tradition links Titian with the perished □frescoes on the Fondaco dei Tedeschi for which Giorgione was paid, and with the Dresden *Venus* left unfinished at the time of his premature death. Giorgione's later influence can be detected in the *Three Ages of Man*, a beautifully idyllic composition. It lingers also in *Sacred and Profane Love*, Titian's depiction of the Twin Venuses commissioned by Niccolo Aurelio after 1516. In 1516, Titian succeeded Giovanni Bellini as Painter to the Republic and in 1518 completed the *Assumption of the Virgin* for the high altar of Santa Maria dei Frari. The picture's immediate success established his reputation and led, in 1519, to another commission for the same church, the *Pesaro Altarpiece*, completed in 1526. Between 1518 and 1523, Titian painted three mythologies for Alfonso d'Este. In the last to be executed, the *Bacchus and Ariadne*, there are references to ▽ Michelangelo's *Bathers*.

In 1545–6, he visited Rome, where he painted the incisive and unflattering portrait, now in Naples, of his host Pope Paul III with his two grandsons. For one of them, Cardinal Alessandro Farnese, he executed the *Danae*, also now in Naples. Titian attended the Imperial Court at Augsburg in 1548–9 and 1550–1 as Court Painter to Charles V, a position he held, on friendly terms with the Emperor, from 1533. For the Emperor's son, Philip II of Spain, he painted his famous, late *poesie*, a series of nude mythological studies. Among them is *Diana and Callisto* (1559). A remarkably open and spacious composition, its coherence is derived from the subtle interrelationship of the figures. The actual paint surface is grainy, looking forward to the extremely

free handling of paint which is characteristic of the last decade. The *Death of Actaeon* demonstrates Titian's disregard for □linear definition and the dependence of his late works upon brushwork to suggest form. In his last religious paintings, Titian achieved a rare synthesis between form and content; his use of paint achieves a sublimity of expression rarely matched in Western art.

**Paolo Veronese** (*about* 1528–88). Veronese's principal artistic debt was to ▽ Titian. He began to paint ceilings in the Doge's Palace in 1553. In 1560, he went to Rome, as a result of which his frescoes in the Villa Barbaro, Maser, of 1561–2 indicate a knowledge of the Palazzo Farnese, one of the prime examples of 16th-century pictorial □illusionism. In Venice, Veronese became established as one of the most prolific decorators of his time. The sumptuous interiors in which he set his historical and Biblical subjects are indicative of contemporary Venetian taste. In 1573 however, he was accused by the Inquisition of secular profanity in his treatment of sacred subjects. The painting of *Hermes, Herse and Aglauros* is a perfect demonstration of Veronese's ideas and ideals. The narrative is of little consequence; there is no sense of drama in the picture. Instead it is distinguished by the artist's concern for colour and texture. He has taken elaborate care to differentiate between the softer surfaces of flesh and drapery and the polished, light-reflective areas of stone or metal. The predominant blues and pinks are light, decorative colours, chosen to appeal, seductively, to the eye.

**Jacopo Tintoretto** (1518–94). The outset of Tintoretto's career is obscure. A general debt to Titian emerges from his early work, but it is transformed, just as Raphael's art was in the hands of his followers. In 1548, Tintoretto painted the large canvas of *St Mark Rescuing a Slave* which is in the Accademia, Venice. It is a theatrical, brilliantly coloured work which established his reputation as a master of □foreshortening. In 1564, he became involved with the Scuola di San Rocco. From 1566 to 1588 he received a regular stipend from the Confraternity to decorate the entire building, which he did with a series of vast canvases (those in the upper hall are over 16 feet high). They treat their subjects, the Lives of Christ and the Virgin, with characteristic drama and spectacular lighting effects. *The Ascension* of about 1576–81 belongs to the scheme. The swirling composition with its mastery of the figure in a wide variety of poses is highly characteristic. After the fire of 1577 which destroyed the earlier frescoes in the Doge's Palace, Tintoretto and ▽ Veronese were employed by the Republic to provide new decorations. Tintoretto's contribution includes the scene of *Paradise* painted for the main hall, planned and executed on the gigantic scale which was his *forte*. In view of the size and number of his commissions, he maintained a large workshop, in which his two sons, Domenico and Marco, and his daughter Marietta were active.

# The 15th & 16th Centuries Outside Italy

Renaissance philosophy was universal and spread quickly through western Europe. Outside Italy, however, it produced rather different results both in art and society.

The rest of medieval Europe had enjoyed a very different culture from that of Italy. Dominated by the new monuments of the Gothic world rather than by Roman ruins, the revival of classical art and architecture was slow to get under way. In Italy the highpoint of the Renaissance was to be the building of the new Rome, and the Popes in close alliance with the banker princes tried to establish their absolute authority.

By contrast, in Northern Europe the new ideas of humanism encouraged independent thought in religion and in politics, which bore fruit in the Reformation. The monument to the Renaissance here was the printing press, not a classical art. Printing spread fast, and ideas spread with it. England, most backward of all in art and architecture, became foremost in literature and science, her great Renaissance men being Shakespeare, Milton and Newton.

The Reformation was to have a marked effect on the arts. The Latin states of Europe, faithful to Rome, were to follow to the full the new classical language of painting and building, with France soon rivalling Italy.

In the Protestant states of Europe both art and architecture were practised on a smaller, more domestic scale. Churches were plainer and religious art was not encouraged, and palaces became more like large country houses.

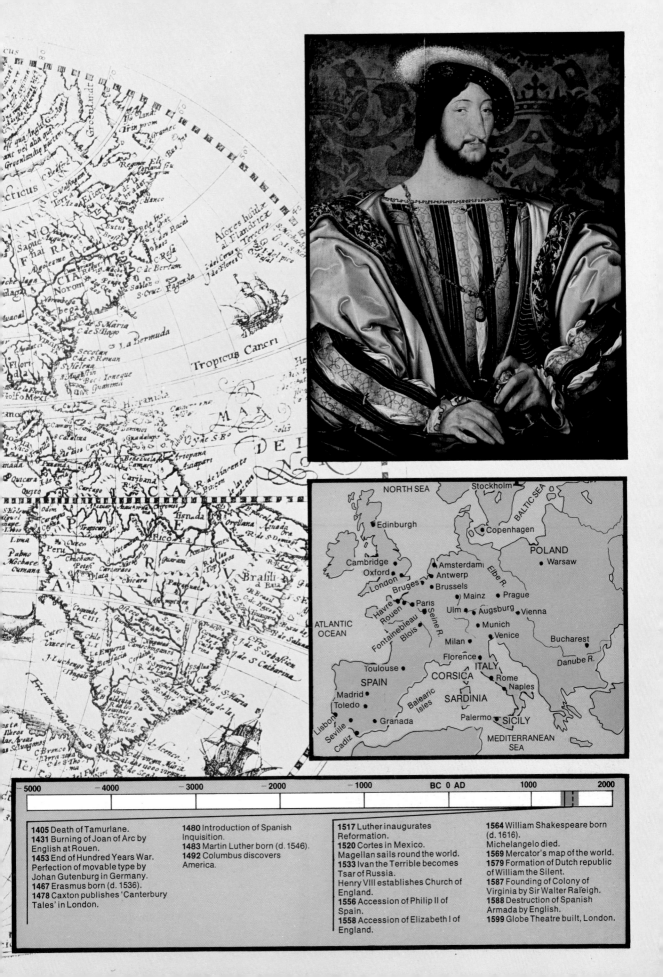

| -5000 | -4000 | -3000 | -2000 | -1000 | BC 0 AD | 1000 | 2000 |
|---|---|---|---|---|---|---|---|

**1405** Death of Tamurlane.
**1431** Burning of Joan of Arc by English at Rouen.
**1453** End of Hundred Years War. Perfection of movable type by Johan Gutenburg in Germany.
**1467** Erasmus born (d. 1536).
**1478** Caxton publishes 'Canterbury Tales' in London.

**1480** Introduction of Spanish Inquisition.
**1483** Martin Luther born (d. 1546).
**1492** Columbus discovers America.

**1517** Luther inaugurates Reformation.
**1520** Cortes in Mexico. Magellan sails round the world.
**1533** Ivan the Terrible becomes Tsar of Russia. Henry VIII establishes Church of England.
**1556** Accession of Philip II of Spain.
**1558** Accession of Elizabeth I of England.

**1564** William Shakespeare born (d. 1616). Michelangelo died.
**1569** Mercator's map of the world.
**1579** Formation of Dutch republic of William the Silent.
**1587** Founding of Colony of Virginia by Sir Walter Raleigh.
**1588** Destruction of Spanish Armada by English.
**1599** Globe Theatre built, London.

**Claus Sluter** (died 1406) was born at Haarlem and became a member of the Brussels Stone Carvers' Guild around 1379. In 1385 he joined the workshop of Jean de Marville, court sculptor to Philip the Bold, Duke of Burgundy, at Dijon. The Duke, one of three brothers of the French king, all notable patrons of art, was especially interested in his new foundation, the Chartreuse, at Champnol. After Marville's death in 1389 Sluter took over the workshop. For the decoration of the church portal he introduced a new style with vividly portrayed kneeling figures of the Duke and Duchess presented by their patron saints to the Madonna and Child in the centre. His best known work, also for the Chartreuse, is the *Well of Moses*. The well head with its six monumental Old Testament prophets survives, but of the Calvary which originally crowned it only fragments remain. The dramatic realism of the figures, at a time when the ▽ International Gothic style was in full swing, places Sluter as a pioneer of a new era.

**Robert Campin** (1378–1444). The increasing prosperity of the Flemish towns in the southern Netherlands at the beginning of the 15th century led to a great upsurge in the arts. Flemish artists now found ample patronage among the wealthy merchants in Flanders. The new patrons favoured a realistic style and painters of genius were at hand to create it. No signed or documented works by Robert Campin are known but he is generally identified with the Master of Flémalle to whom a number of important altarpieces are attributed. In them the biblical scenes are no longer depicted as remote or transcendental but set in an everyday environment and enacted by real people. Interiors, landscape and portraiture play an important part in his work. The *Merode Altarpiece* shows on the central panel an Annunciation in a middle-class Flemish interior while on the left panel the donors kneel outside the room behind an open door and a street scene is visible in the distance. St Joseph on the right panel is shown as a working carpenter and outside the window at the back are the buildings of a Flemish town.

**Rogier van der Weyden** (1399–1462) was a pupil of ▽ Robert Campin at Tournai (1426–32). From 1435 on he lived in Brussels where he was highly regarded both for his art and for his good works. For Chancellor Rolin of the Burgundian Court he painted a most impressive *Last Judgement* in the Hôtel Dieu, Beaune (*about* 1445). In 1450 he visited Rome, but he never changed his personal style with its deeply religious content. His intention to make the greatest possible impact on the spectator is already apparent in early works, notably the *Deposition* (Prado), a masterly rendering of the mourning figures round Christ, set in a shallow shrine against a gold background almost in the nature of a sculptured relief. He also made a great contribution to portraiture, introducing a complex psychological interpretation that goes beyond mere physical likeness. In the second half of the 15th century Rogier's influence was stronger even than that of ▽ Jan van Eyck.

**Jan van Eyck** (died 1441) was the founder of the Bruges school and the greatest painter of the early Flemish school. He became Court Painter to Philip the Good, Duke of Burgundy, for whom he also undertook diplomatic missions. He settled at Bruges in 1431. His greatest strength lay in his appreciation of the beauty of the world around him. He combined detailed observation with a feeling for the whole and was able to retain overall unity whilst concentrating on the details. Light and air encompass his figures whether set in interiors or out of doors. He created a new type of portraiture in his marriage portrait of the Arnolfini, showing the couple full-length in a spacious interior. Many of his works are signed and dated and bears his motto *als ich kan*.

A personal recipe for oil painting enabled him to develop his great sense of colour. His formula is not known but his colours have retained their freshness down to the present day.

**Hugo van der Goes** (died 1481). Of the many artists working in the second half of the 15th century in the Netherlands, Hugo van der Goes was the most outstanding. In 1467 he joined the Painters' Guild at Ghent and was twice elected its Dean. In later years he suffered from manic depression, and, obsessed by religious fears, he left Ghent and entered an Augustinian monastery near Brussels. He continued to paint and was allowed visitors and to travel. On his way back from a visit to Cologne he succumbed to a fit of suicidal mania.

Hugo's chief work, the *Portinari Altarpiece*, commissioned by the Italian merchant Tommaso Portinari, dates from around 1475. On its completion it was immediately sent to Florence where it had a considerable effect on Italian artists. The centre panel depicts the Adoration of the Shepherds. Here the handling of light, space and colour gradations subtly unify the scene of the Adoration with the landscape beyond. Of particular interest are the three shepherds adoring the recumbent Christ Child, a mixture of awe and wonder on their faces. Highly expressive but capable of great tenderness, Hugo's art marks the highlight of Flemish painting in the second half of the 15th century.

**Hans Memlinc** (died 1494). The art of Memlinc seems to sum up the achievement of Netherlandish painting. A German by birth, his style owes little to German art. He was probably trained and certainly worked in ▽ Rogier van der Weyden's workshop at Brussels and Rogier's influence on his art is strong. He did, however, tone down the expressive tension so characteristic of that artist and whilst borrowing many of his compositional ideas, he created a personal, serene and harmonious style that ensured him wide and lasting popularity. He settled at Bruges in 1465 and from then on never lacked commissions, covering a wide range of subjects including portraiture, for which he was especially talented, large-scale religious subjects such as the Last Judgement, now in Danzig, and narrative cycles of which the St Ursula Shrine (1489, Bruges) is the most famous.

*Above:* ROGIER VAN DER WEYDEN *Deposition. About* 1438.
86½ × 103 in (220 × 262 cm). Prado, Madrid

*Above:* HUGO VAN DER GOES *Adoration of the Shepherds.*
*About* 1475. Central panel of the Portinari Altarpiece. Uffizi

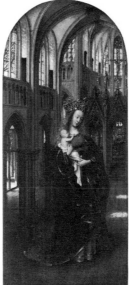

*Above left:* JAN VAN EYCK *John Arnolfini and his Wife.* 1434.
33 × 22½ in (83 × 62 cm). NG, London
*Above centre:* JAN VAN EYCK *Madonna in a Church.* 1425.
12⅝ × 5½ in (32 × 14 cm). Staatliche Museum, Berlin
*Above right:* JAN VAN EYCK *Cardinal Albergati.* 1431.
8¼ × 7⅛ in (21·2 × 18 cm). Kupferstich Kabinett, Dresden
*Left:* ROBERT CAMPIN *Annunciation. About* 1425. 25½ × 25½ in
(64·5 × 64·5 cm). MM, New York
*Below:* HANS MEMLINC *The Donne Triptych. About* 1485. Central panel
28 × 27½ in (71 × 69 cm). NG, London

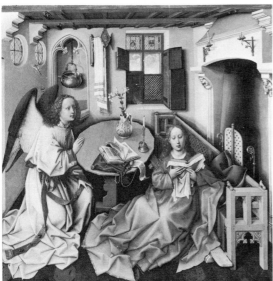

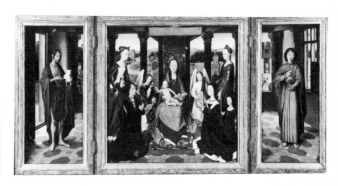

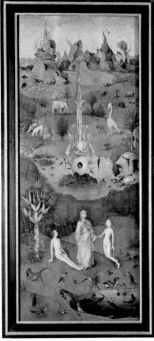
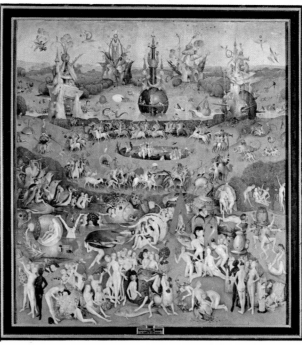
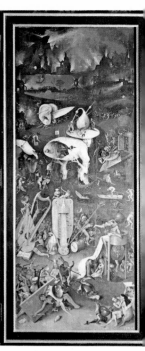

HEIRONYMUS BOSCH *Garden of Earthly Delights.* 86⅝ × 144¼ in (220 × 367·6 cm). Prado, Madrid

HEIRONYMUS BOSCH *The Temptations of St Anthony.* About 1510. 28 × 20 in (70 × 51 cm). Prado, Madrid

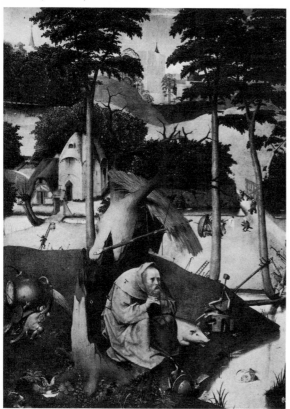

**Hieronymus Bosch** (*about* 1450–1516) was the most original and interesting of Flemish artists. His early life is obscure; he may have been born at Hertogenbosch in the northern Netherlands and certainly spent his working life there. Some of his pictures are clearly satirical comments on the folly of men or interpretations of Flemish proverbs but the majority are of religious subjects. These include the Adoration of the Magi, the Passion of Christ, saints and hermits and scenes of Creation and Hell. They fall into two categories, the first of which is more traditional in treatment with large-scale figures full-length or half-length and a clearly legible rendering of the subject matter.

**The Painter of Nightmares.** The second category, in which Bosch's macabre medieval vision appears, shows the full measure of his originality. They are filled with horrific ill-shapen monsters, small human figures engaged in largely incomprehensible pastimes, sometimes with animal-like heads whilst strange almost prehistoric marine creatures grow as architectural structures out of water and support demonic half-human shapes and plants. They have been compared to ▽ surrealist visions but their symbolic meaning, now lost, was perhaps inspired by contemporary writings. Philip II of Spain owned, among other paintings by Bosch, the most famous of all, the large □triptych known as the *Garden of Earthly Delights.* As a painter Bosch's originality and virtuosity are equally marked. He used subtle colours applied directly on to the canvas, which gives a sparkling brilliance to the whole.

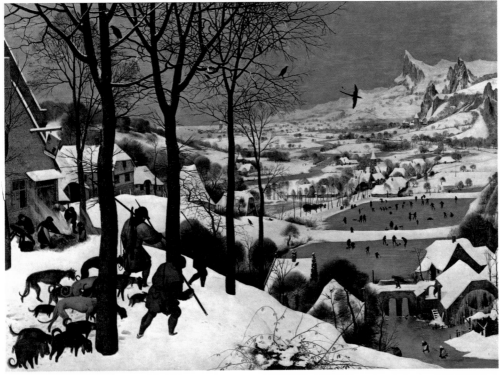

*Above:* PIETER BRUEGEL THE ELDER *Hunters in the Snow.* 1565.
47 × 65 in (117 × 162 cm). KH, Vienna
*Left:* PIETER BRUEGEL THE ELDER *Children's Games.* 1559–60.
46½ × 63⅜ in (118 × 161 cm). KH, Vienna

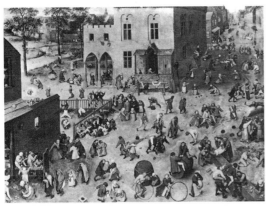

**Pieter Bruegel the Elder** (1525/30–69) was the greatest Netherlandish artist of the 16th century. In his own day, however, he ranked below painters who worked in the Italian manner and his pictures were bought or commissioned by only a small number of enlightened friends, scholars and connoisseurs. The place and date of his birth are uncertain. He may have had some initial training with a watercolour artist and is said to have been a pupil of Pieter Coecke van Aelst at Antwerp whose daughter he later married. In 1551 he became a Master in the Antwerp Guild of Painters. Like many artists of his day he then visited Italy travelling via France to Rome and Sicily. By 1555 he was again established at Antwerp working for the publishers Jerome Cock whom he supplied with drawings for □engravings, including landscapes and figure compositions. These latter were satirical, didactic and moralising, directed against folly and vice, and were often peopled with fantastic monsters in the manner of ▽Bosch. He also did many single drawings direct from nature, marked at the back as *Naer het leven* (from life).

**The Painter of Man.** Bruegel cared nothing for the Classical world, for history or mythology, and treated his Biblical subjects as contemporary events. His well-known panel paintings begin in 1559 and continue without interruption until his death. The earlier ones are linked in style to the engravings, crowded with figures and depicting individual incidents, such as *Netherlandish Proverbs* (1559), and *Children's Games* (1560). Slightly later in scenes of witchcraft, death and devils his mind seems obsessed with ▽Bosch-like fantasies and clouded with visions of doom and disaster.

In 1563 Bruegel moved to Brussels where he spent the last six years of his life. Some of his most impressive paintings date from this period. They include most of the peasant scenes, the series of landscapes known as *The Seasons* and his last works *The Parable of the Blind* and *The Cripples.* The compelling vitality of *The Peasant Kermess* represents a new theme in □genre painting. In his series of landscapes, *The Seasons*, five of which survive, he created a new kind of composite landscape in which he blended vast panoramic views, craggy rocks and mountains, partly based on his early experience of Alpine scenery and partly on tradition, with real views of the Flemish village and countryside to form a complete unity. Of the Winter picture (*Hunters in the Snow*) the geographer Abraham Ortelius, Bruegel's lifelong friend, said that he had painted the unpaintable, the actual feel of winter cold.

# THE 15th & 16th CENTURIES

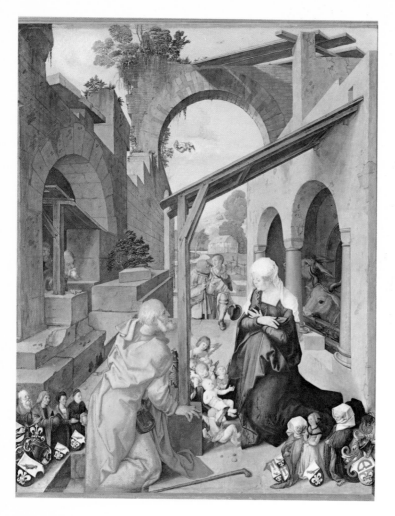

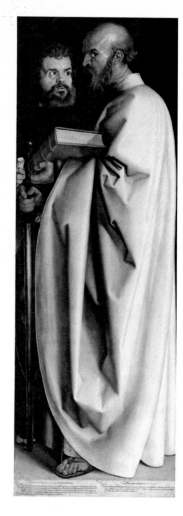

**Albrecht Dürer** (1471–1528). The real understanding of
▽ Italian Renaissance art was largely due to the genius
of one man, Albrecht Dürer of Nuremberg. He was
a painter and graphic artist by profession and he was
endowed with intellectual powers that put him in line
with the great Italian masters. He was profoundly con-
cerned with the theory of art and wrote treatises on
various subjects including proportion and artistic theory.
He was the son of a goldsmith and first trained in his
father's shop but later transferred to painting. He was
apprenticed to Michael Wolgemut, a competent but un-
inspired painter who ran the largest workshop in Nurem-
berg. Wolgemut had close links with the publishers in-
cluding Anton Koburger, Dürer's godfather, whom he
supplied with woodcut illustrations for his books, an
advantage for Dürer who was above all gifted as a
draughtsman and graphic artist. Despite the limitations
of a rigid workshop training, Dürer was not content to
confine himself to his own artisan class. He set about
widening his education by studying mathematics, Latin
and the Humanities, thus broadening his horizons
intellectually and artistically.

The influx of Italian engravings, mainly by the ▽ Pol-
laiuoli and ▽ Mantegna, whose works Dürer copied,
opened his eyes to the new feeling for solidity of the
human form, even before his first visit to Italy (1494/5).

On his return he married, and opened a workshop which
was soon highly successful. Patrons included patrician
families and members of the aristocracy and later he
became Court Painter to Maximilian I. His powers of
observation were acute and his drawings and water-
colours of plants and animals and charming and highly
realistic landscape studies surpassed anything so far
attempted in Germany. He was also an innovator in the
field of portraiture. His early self-portrait of 1498 shows a
sense of status and a new elegance of style. From the
beginning he set new standards as a graphic artist.
His early woodcut series of the Apocalypse, while
showing some Italian influence, is basically late Gothic in
its highly charged emotionalism. He also pioneered the
nude figure in German art, not very successfully to begin
with, but after a second visit to Italy which lasted from
1505 to early 1507, he improved considerably adapting
this very Italian art form to his own northern tempera-
ment. His engravings of Adam and Eve established his
reputation outside Germany, especially in the Nether-
lands where, too, his ever inventive compositions,
notably in his woodcuts and engravings, were eagerly
exploited. His last important painting, the *Four Apostles*,
shows his final achievement in blending German expres-
siveness with Italian monumentality.

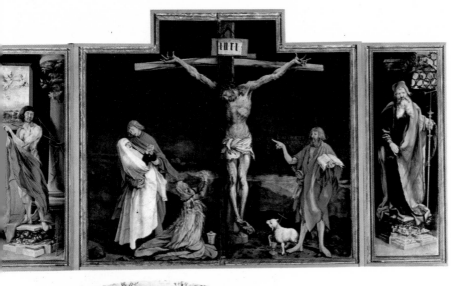

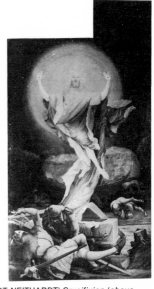

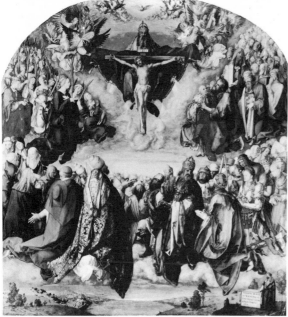

GRUNEWALD (MATHIS GOTHARDT-NEITHARDT) *Crucifixion* (*above left*) and *Resurrection* (*above right*) from the Isenheim Altarpiece. 1515. h. 8 ft 10 in (269 cm). Musée d'Unterlinden, Colmar
*Left:* ALBRECHT DURER *Adoration of the Trinity.* 1511 56⅛ × 51⅛ in (144 × 131 cm). KH, Vienna

**Mathis Gothardt-Neithardt** (*about* 1470/80–1528). Better known as Mathis Grünewald, his art is very different from that of Dürer. Where Dürer was learned, didactic and intellectual, Grünewald was a visionary mystic imbued with medieval spirituality. Almost nothing is known of his life but documentary evidence suggests that he was born in Würzburg. He was probably a near contemporary of Dürer and died in 1528. Around 1500 he settled at Seligenstadt and was Court Painter and engineering architect to two successive archbishops of Mainz. Like Dürer he had Protestant sympathies and seems to have supported the Lutheran cause.

A small number of paintings and a handful of exquisite silverpoint drawings have survived. His most celebrated work, and one of the great masterpieces of painting, is the High Altarpiece of St Anthony's Monastery at Isenheim. The Anthonite order had been founded by a French nobleman in the early middle ages in gratitude for his son's almost miraculous recovery from the dreaded disease of ergot poisoning, and a hospital for skin diseases was invariably part of the monasteries of the order. Grünewald's work was dedicated to St Anthony, patron saint against the disease popularly known as St Anthony's fire. On admittance to the hospital, patients were invariably brought first to the altar, hoping for a cure or for comfort at the sight of the figure of Christ, covered with festering wounds, sharing their suffering. During the week the altarpiece was closed and the picture showed Christ on the Cross set against a desolate, stormy landscape and sky. On Sundays and feast days the wings were unfolded to reveal in the centre panel the Virgin and Child. The wings depict the Annunciation and the marvellous Resurrection. The closed □predella shows the Entombment of Christ, the heavy body covered with sores. The fully opened altarpiece reveals a carved shrine with St Anthony and other saints, and on the predella Christ and the Apostles. Grünewald's painted wings show on the one side the Visit of St Paul the hermit to St Anthony, on the other the fantastic Temptation.

*Opposite left:* ALBRECHT DURER *The Nativity* (*Baumgarten Altarpiece*). 1504. 62 × 50 in (155 × 126 cm). AP, Munich

*Opposite right:* ALBRECHT DURER *St Paul and St Mark.* 1526. 86 × 30½ in (214·5 × 76 cm). AP, Munich

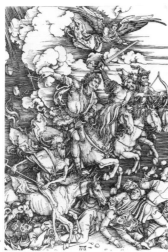

ALBRECHT DURER *The Four Horsemen of the Apocalypse.* 1498. BM, London

**The Age of Printing.** Germany's real contribution to 15th-century art lay not in the fields of architecture, sculpture or painting but in the graphic arts. From the beginning of the century the *Einblattholzschnitt*, a simple form of □woodblock line engraving, was widely used. It was the forerunner of printing and by the middle of the 15th century Johann Gutenburg set up the first printing press at Mainz where his famous Bible was published in 1455. Printed books soon became the means of a rapid spread of ideas. Woodcuts and copper-plate □engravings were much in demand for book illustrations and this also provided a valuable opportunity for the fruitful exchange of artistic ideas.

**German Banker Patrons.** The last decades of the 15th and the first half of the 16th centuries witnessed the flowering of German Renaissance art, especially painting. There was, however, no unity of artistic style. Nominally ruled by the emperor, the country was in fact split into a number of more or less powerful electorates, petty principalities and flourishing towns, many of them free imperial cities. Of these, Augsburg, the home of the merchant family the Fuggers, enjoyed the special protection of Emperor Maximilian I. The workshops of the ▽Holbein and Burgmair families were the most influential and Hans Burgmair the elder (1473–1531) was Maximilian's favourite artist. The *St John on Patmos* (1519) shows Burgmair's talent also for landscape and animal painting and his rich feeling for colour.

In addition to its importance for the graphic arts Augsburg was also a leading centre of Renaissance sculpture. This was largely due to the Fugger family who rivalled the ▽Medici in Florence as Europe's leading international bankers. The Fugger chapel in the Church of St Anne is, on a minor scale, a German version of an Italian Renaissance building and is conceived as an architectural and sculptural unity. Many sculptors were employed and Dürer contributed designs for two large marble □reliefs, but the chief artist was Sebastian Loscher of Augsburg (1482/3–1551). His journeyman years took him to northern Italy and he was able to infuse a new fullness and solidity of form to his figure sculpture, notably the busts and □putti figures that originally decorated the choir stalls but are now to be seen in various German museums.

HANS BURGMAIR THE ELDER *St John on Patmos*. 1518. 60¼ × 49⅛ in (153 × 124·7 cm). AP, Munich

LUCAS CRANACH THE ELDER *Rest on the Flight into Egypt*. 1504. 27⅛ × 20⅛ in (67·5 × 51 cm). Staatliche Museen Preussischer Kulturbesitz, Berlin

**Lucas Cranach the Elder** (1473–1553). To begin wit the □Reformation had little effect on artistic production and many artists with Lutheran sympathies continued to work for non-Lutheran patrons. There was, however, one artist, Lucas Cranach the elder, who can rank as the greatest painter of the German Reformation. He changed his style radically after he had settled at Wittenberg as Court Painter to Frederick the Wise, Elector of Saxony. At Wittenberg he met Martin ▽Luther, then teaching at the newly founded university there, and became his great personal friend. Cranach's earliest known work dates from 1502. It was painted in Vienna, where he lived until 1505, mixing with University and ▽Humanist circles. His small scale pictures of that time are very much in the old German tradition, brutally realistic or lyrical, but they already show a personal and original style and a deep love of landscape. His panel painting *Rest on the Flight into Egypt* renders the scene almost like a fairy tale with jubilant baby angels with whom a charming little Christ Child is fully involved. The scene is set in a romantic landscape which contrasts in colour with the reds, blues and golds of the figures. At Wittenberg many new influences, including a visit to Antwerp and knowledge of Italian art, crowded in on the artist. He continued to paint religious altar panels and throughout his life remained an outstanding portrait painter; he was the first German painter to paint full-length figures. He also painted portraits of Martin Luther and his family. He is best known for his original adaptations of Italian Classical and mythological themes and Renaissance figures, especially the female nude in which he transformed the sculptural forms into elegant linear rhythms painted in very pale colours with an enamel-like finish.

**Albrecht Altdorfer** (*about* 1489–1538). Landscape painting had been a popular subject in Germany since the 15th century and despite influence from the Netherlands showed great originality. The so-called 'Danube School' which developed around 1500 is the nearest approach to a universal style, linking, at least for a time, artists from many different centres. The chief master was Albrecht Altdorfer. In 1503 and again in 1511 he travelled down the Danube to Vienna and Mondsee and the Alpine scenery made a lasting impact on his art. His early works are small, often almost like miniatures, and his tiny figures are barely visible in the vast forest and mountainous settings. He loved larch trees with overhanging branches and jagged rocks, romantic in mood. Light plays a spectacular part in all his painting, for example the eerie effects in the many Nativities such as the one in Berlin (*about* 1515). In later life he painted larger altarpieces such as that for St Florian's Monastery. In 1529 for William IV of Bavaria he painted the famous *Battle of Alexander at Issus* in which the massed crowds of little fighting figures and the exquisite land- and seascape in the background are spanned by a vast cosmic sky giving epic grandeur to the scene.

**The German Carver.** During the first half of the 15th century sculpture and painting were of little more than local interest and artists were content to follow the lead of the more advanced art of the southern Netherlands. Knowledge of the ▽Italian Renaissance came slowly, first via the Netherlands and later through direct contact with Italy. Sculptors led the way and individual sculptors established important workshops in many of the towns: Ulm, Nuremberg, Augsburg, Wurzburg and many more. Veit Stoss (*about* 1447–1535) after working for nearly twenty years at Cracow settled in Nuremberg in 1496. He was a great, original artist and though he remained late ▽Gothic in spirit infused a new monumentality and a heightened sense of reality into his work. The carved altarpiece, sometimes with painted wings, had long been a characteristic German art form but Stoss whilst retaining its medieval spirituality gave it a new sense of religious urgency. A good example of his monumental style in Nuremberg is the *Annunciation* of 1517–18 made for the late Gothic choir of the Church of St Lawrence, Nuremberg, where it once formed part of an iron candelabra. The angel and the Virgin Mary stand upright in an open oval frame composed of roses and inset with medallions showing the seven joys of Mary. They stand on the drapery folds of an ecstatic little angel whose upward glance directs the eye to the venerable figure of God the Father crowning the scene. Angels seen from various angles float round the figures and, together with the rich gilding and painting, lend a festive air to this extraordinary conception, half visionary, half earthbound.

*Top:* ALBRECHT ALTDORFER *Battle of Alexander.* 1529. 62 × 47 in (155 × 115·5 cm). AP, Munich
*Left:* VEIT STOSS *Annunciation.* 1518. Painted wood. S. Lorenz, Nuremberg

# THE 15th & 16th CENTURIES

**Portraiture in Spain.** When Charles V abdicated and gave his Netherlandish provinces to his son Philip II, King of Spain, Spanish power and prosperity became firmly established. Philip, like all the ▽Hapsburgs, patronised the arts and was especially interested in portraiture. His three favoured portrait painters were ▽Titian, Antonio Moro and Alonso Sanchez Coello. Antonio Moro (1517/20–1576/7) was born at Utrecht, trained under Jan Scorel and joined the Painters' Guild at Antwerp in 1547. He travelled to Italy, where he absorbed the influence of Titian and the Italian ▽Mannerists. In 1552–3 he was in Madrid and in 1554 on the occasion of the marriage to Mary Tudor to Philip II he went to London to paint her portrait. It well represents the elegant aloofness and rather over-refined quality favoured in aristocratic circles. Although Moro had to leave Madrid under suspicion of heresy he continued to work for Philip II and his popularity never declined.

Alonso Sánchez Coello (1531/2–1588) was born in Spain but spent his childhood in Portugal. He was sent by the Portuguese king to Flanders for training under Antonio Moro. He returned to Portugal for a short time and then moved to Spain where he became Court Painter to Philip II. He was a prolific painter but much of his work was lost in various fires that destroyed the royal palaces. His portrait of Don Diego, fourth son of Philip II and his fourth wife Anne of Austria shows his sensitive interpretation of children as well as the elegance of his composition.

**El Greco** (1541–1614) was the painter who really established Spain as an artistic centre. Born in Crete, where he received his early training, his real name was Domenikos Theotokopoulos. He went to Venice as a pupil of the aged ▽Titian and visited Rome. He was influenced by the Venetian painters, especially ▽Tintoretto, and was interested in the new style of ▽Mannerism. In Rome he studied the work of ▽Michelangelo and ▽Raphael. By 1577 he was in Spain at Toledo where he developed his own original and visionary style which was exactly suited to the spiritual and intellectual life of the city. Though neither Philip II nor the members of the Madrid court were sympathetic to his art he found ready customers among the intelligentsia and ecclesiastical circles in Toledo, where he settled. His earlier Spanish paintings still show strong Italian influence but by the mid-1580s he had developed his mature personal style. The key painting which best illustrates this, and one of his most famous works, is the *Burial of Count Orgaz* (1586), which depicts a 14th-century legend. The lower part shows St Augustine and St Stephen burying the body of Gonzalo Ruiz, a benefactor of the Church, while the ceremony is attended by living ecclesiastics and important civic personalities. Above is a visionary scene, in which the body is received into Heaven by Christ, the Virgin Mary and the whole heavenly host. El Greco's ability to blend mystic vision and reality is here fully realised. Glowing, brilliant colours and flame-like shapes increase the emotional tension of his later religious pictures. He established a new expressive type of portrait that influenced his successors, including ▽Velasquez.

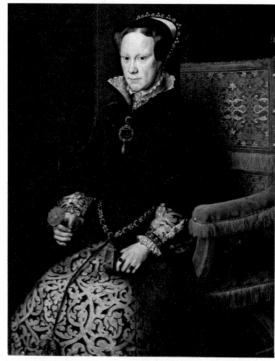

*Above:* ANTONIO MORO *Mary Tudor.* 1554. 45 × 33 in (114 × 84 cm). Castle Ashby

*Below:* EL GRECO *'Espolio'* (Disrobing of Christ). 1577–9. 112 × 68 in (285 × 173 cm). Toledo Cathedral

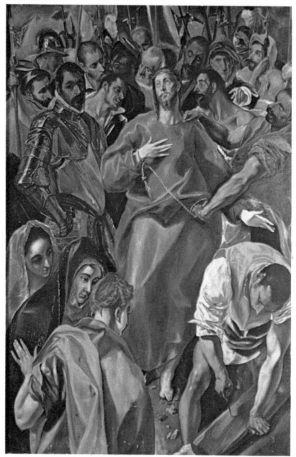

*Above:* EL GRECO *Burial of Count Orgaz.* 1586. 189 × 141¾ in (480 × 360 cm). S. Tomé, Toledo

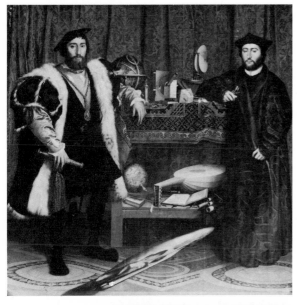

**Portraiture in England.** English art was slow to emerge from the Medieval tradition and it was not until the reign of Henry VIII that ▽Renaissance ideas began to penetrate. There were few native artists capable of supplying the growing demand and foreign artists, mainly of inferior talent, came to fill the gap. But the arrival of Hans Holbein the younger gave a new status to English art. Hans Holbein (1497/8–1543) was born at Augsburg and trained by his father Hans Holbein the elder, then the ened thinkers. The ▽Humanist philosopher Erasmus of Rotterdam favoured the town above all others and most of his books were published there by the printer Froben, for whom Holbein also worked. Very early in his career the artist established his reputation as a draughtsman with his illustrations for Erasmus's book *In Praise of Folly* and he gained the friendship of the then middle-aged scholar who commissioned portraits from him. His successful career in Basle was cut short by religious fanaticism, resulting in hostility to the arts.

Probably at Erasmus's suggestion, and with a letter of introduction from him to Sir Thomas More, Henry VIII's adviser, Holbein went to London in 1526 and remained for nearly two years. During this period he painted portraits of More and his friends, and the famous group portrait of More and his family for which only the full-scale drawing and later copies survive. After a further four years in Basle Holbein returned to England in 1532 and remained until his death. During his absence the political climate in England under the tyranny of Henry VIII had changed completely. More was out of favour and life was dangerous for opponents of the King. Soon after his return Holbein painted the double portrait known as *The Ambassadors*, which represents the French Ambassador Jean de Dinteville and his friend Georges de Selve, Bishop of Lavour. The many objects on the table have symbolic and religious allusions and the strange form lying diagonally in the foreground is a skull (German *Holbein*: skull) drawn in distorted perspective. By 1536 Holbein had been appointed Court Painter to Henry VIII. He painted portraits of the King and his wives, and continued with his graphic work, designing jewellery, metalwork for all kinds and architectural schemes. His portrait drawings at Windsor Castle give a superb pictorial record of the men and women of the Tudor court.

The most interesting native artist in the reign of Queen Elizabeth I was the limner (painter in miniature) and goldsmith Nicholas Hilliard (*about* 1547–1619). He was born at Exeter, the son of a goldsmith and was himself a member of the Goldsmiths' Company. He is best known for his miniature portraits of Queen Elizabeth and of members of the British aristocracy which show a delicacy, refinement and technique unparalleled in English art at the time. He visited Paris and certainly knew and admired Italian art. In his *Treatise on the Art of Limning* he upholds the Italian concept of the status of an artist. His poetic style and exquisite sense of line may be seen in the portrait of a *Young Man amid Roses* (about 1590), a picture that has excited much literary speculation.

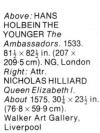

*Above:* HANS HOLBEIN THE YOUNGER *The Ambassadors.* 1533. 81½ × 82½ in. (207 × 209·5 cm). NG, London
*Right:* Attr. NICHOLAS HILLIARD *Queen Elizabeth I.* *About* 1575. 30¼ × 23½ in. (76·8 × 59·9 cm). Walker Art Gallery, Liverpool

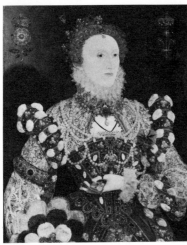

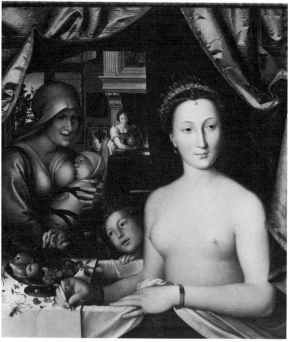

**Jean Fouquet** (*about* 1420–*about* 1481). During the 15th
century there was little influence in France by the new
art developing in Italy. Even a visit to Italy by Jean
Fouquet did not change his style, though he did acquire
knowledge of □linear perspective and was greatly im-
pressed by the art of ▽Piero della Francesca. Jean
Fouquet was born at Tours and probably trained in Paris.
His visit to Italy took place sometime between 1443 and
1447. By 1448 he was back at Tours where he had a suc-
cessful career working first for Charles VII and his court
and then for Charles' successor Louis XI. He was gifted
in many fields but is best known for his book illuminations
and panel paintings, mainly portraits. He painted the
so-called *Melun Diptych* for Etienne Chevalier, repre-
senting him being presented by his patron saint, St
Stephen, on the left panel, to the Birgin surrounded by
angels on the right panel. Traditionally the model for the
Virgin was Agnes Sorel, the mistress of Charles VII.
For the same patron Fouquet illuminated a Book of
Hours. The page showing St Margaret as a shepherdess
is an idyllic scene with figures and sheep in the fore-
ground and a charming landscape background. Behind
the saint on the right is a typical French château.

**Jean Clouet** (died 1541). During the 16th century French
portraiture was dominated by two painters, father and
son. Jean Clouet was probably of Netherlandish origin
and was never a nationalised Frenchman. By 1509 he
was well known in France and by 1516 was working for
the court. Poems of the day compare him to the greatest
Italian artists including ▽Michelangelo. Today only a
handful of portraits can be attributed to him, one of which,
a splendid likeness of Francis I, clearly shows his links
with the Flemish school. His son François (died 1572)
succeeded his father as Court Painter. He, too, is best
known as a portrait painter but unlike his father shows
strong links with Italian and German ▽Mannerism. Very
different from his life-size full-length portrait of Charles
IX is the so-called *Lady in her Bath,* generally identified
as a portrait of ▽Diane de Poitiers. Here the half-length
nude figure in ▽Leonardoesque in origin. It was a
popular work and was frequently copied.

**Fontainebleau.** The invasion and conquest of Milan by
the French in 1499, under Louis XII, had far-reaching
repercussions on French art. ▽Leonardo da Vinci was in
Milan at the time and every effort was made to attract
him to France, efforts that were later successful under
Francis I. The French King had advanced tastes and hoped
to bring the ▽Italian Renaissance to France. At first only
second-rate artists accepted his invitations. It was not
until he was engaged in rebuilding the royal hunting
lodge at Fontainebleau that he successfully attracted
leading Italian artists for its decoration. Most of the
palace was remodelled under ▽Napoleon and the
interior decoration very heavily restored. It is, however,

# Fontainebleau and French Painting

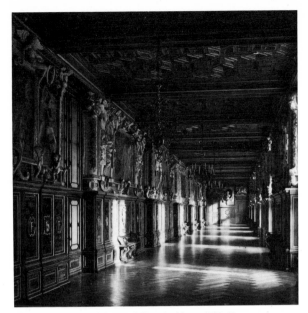

*Above:* The gallery of Francis I, Fontainebleau. 1533–40

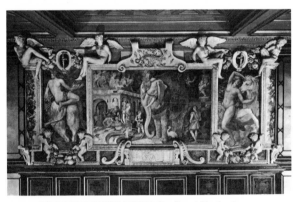

*Above:* GIOVANNI BATTISTA ROSSO *The Royal Elephant.* Fontainebleau

*Below:* PHILIBERT DE L'ORME Entrance: Chateau d'Anet. 1548–55

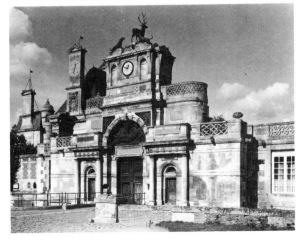

this decoration that constitutes the real originality and importance of the 'School of Fontainebleau'. Two Italian artists were responsible for the work, first the Italian ▽ Mannerist painter Giovanni Battista Rosso (1494–1540) in 1530 and two years later Francesco Primaticcio (1504–1570). They were mainly responsible for the unique blending of ☐stucco framework and painted panels. The pictures are of allegorical and mythological subjects, the stucco work is partly figures in high ☐relief and partly decorative; with ☐swags, ☐cartouches and above all ☐strap-work, in which the stucco is cut into leather-like strips, rolled at the ends and then intertwined to form fantastic shapes. Stucco ornament was to be copied all over Europe. This decoration occupied the upper walls, the lower part being covered with decorative wooden panels, largely restored in the 19th century. Rosso was responsible for the Gallery of Francis I, Primaticcio, who outlived Rosso by many years, went on to decorate the Queen's Room, where part of the very elaborate mantelpiece survives. Primaticcio in later life also took part in the architectural and garden designs. Other Italian artists who worked for the King at Fontainebleau included ▽ Benvenuto Cellini and Niccolo del Abbate. The Fontainebleau style, was widely copied at European courts and established France as an important artistic centre.

**The Architects.** By the end of the 15th century, especially after the French invasions of Italy, ▽ Renaissance influence was beginning to have some effect on French building. Attracted by the more luxurious way of living in Italy, French noblemen re-modelled and enlarged their châteaux. The builders were still master masons with craftsman status. When in the 16th century Italian architects, notably Sebastiano Serlio in 1540, came to France, the French Renaissance began in earnest. Serlio, who actually built very little, was influential mainly through his richly illustrated treatise on architecture, *L'Architettura* (1537–51). By the middle of the century professional architects, men of culture who understood the new ideas, began to replace the master masons. The two leaders were Pierre Lescot (1500/15–78), best known for his work on the Louvre in Paris, and Philibert de l'Orme (*about* 1510/15–70). De l'Orme was the leading artistic personality of his day and shared the universality of the Italian great masters. Born at Lyons he spent three years in Rome. There he met the Cardinal du Bellay, who later introduced him to the circle of the Dauphin and ▽ Diane de Poitiers, who became his most distinguished and influential patrons. When the Dauphin became Henry II, he made de l'Orme Superintendent of Buildings. After a brief fall from favour following Henry's death, during which time he wrote two works on architecture, he was reinstated and continued working for Catherine de Medici, the Queen Mother. His best known work is the Château of Anet which he built for Diane de Poitiers. Most of the building has been destroyed but the entrance survives. It is a simple structure crowned by a clock with a bronze stag flanked by dogs that move when the clock strikes. Apart from the ▽ Doric columns on either side of the entrance, the building is entirely French in its massive simplicity, enlivened by the pierced ☐balustrade at the top. Cellini's bronze nymph, now replaced by a plaster copy, adorns the ☐tympanum.

**The Houses of England.** The dissolution of the mona-steries by ▽Henry VIII made big tracts of land available to his subjects. During the latter part of his reign, a new phenomenon appeared in England, a passion for building private houses on an ever increasing scale, gathering momentum and reaching a peak in Elizabethan times. Various craftsmen were involved in the designs, and the man who drew the plan was generally not further involved in the execution. The patron was liable to change his mind and order sweeping alterations or even an entirely new design. Decorations were taken from the many pattern books available, usually fantastic adaptations of Italian motifs by Flemish artists, who had received them via ▽Fontainebleau, in which □strap-work, □cartouches, scrolls and □grotesques pre-dominated. Many patrons had travelled to Italy, France, the Netherlands or Germany, were impressed by the buildings and the cleanliness of the towns, and sought to emulate them. Brick began to supersede timber and plasterwork and finally, as wealth and the desire for ostentation increased, stone. In areas where timber was plentiful, however, the medieval craftsman-built house persisted. Moreton Old Hall in Cheshire bears on the bay-windows the signature of the carpenter Richard Dale and the date 1559. With its steep gables and use of timber and decorative plasterwork in black and white it is a good example of the craftsman's skill.

One of the best-known examples of early Tudor brick building can still be seen at Hampton Court in the sur-viving parts of the house originally built by Cardinal Wolsey, then Archbishop of York. The alterations and en-largements that took place when Henry VIII seized it for himself, and the later extensions added by ▽Sir Christo-pher Wren Wren for William and Mary, left large parts of Wolsey's great house unchanged. Built on a gigantic scale originally round four courts, in typical Tudor style, it housed Wolsey and his retinue of some four hundred retainers and also had individual suites to house visitors of distinction. It contained a long hall and a great chamber, permanent features of such great houses. Though basically late ▽Gothic in structure there were some Italian features in the decoration such as the □terra-cotta busts of Roman emperors and Wolsey's coat of arms surmounted by a cardinal's hat, the work of Italian artists in England. The tall chimneys, now mostly copies of the originals, were a new feature inspired by French examples. The brickwork is striking, consisting of light and dark bricks arranged to form □diaper patterns. The old entrance still stands, originally a straight front with a strongly emphasised gatehouse in the centre.

Queen Elizabeth commissioned little building herself but did much to encourage her subjects to do so by her 'Progresses', undertaken during the summer months when she descended on selected subjects expecting grand accommodation in their newly built houses. Not all great houses were built to entertain the Queen and the building passion was not confined to men. Hardwick Hall was built for Bess of Hardwick, widow of the 6th Earl of Shrewsbury. An important part in its design was played by Robert Smythson, one of the earliest English craftsmen who was something of a real architect. He had previously been involved with the building of Long-leat, the first of the Elizabethan houses, which heralded a new style. Hardwick Hall is symmetrical in plan and

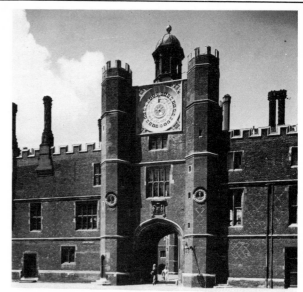

*Above:* Clock Court, Hampton Court Palace. *After* 1515

*Below:* Hardwick Hall, Derby. 1590–7.

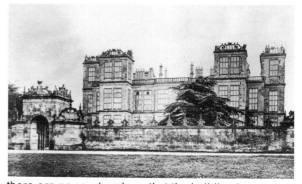

there are no courtyards so that the building becomes a single, massive block. The entrance is through a long, plain, pillared porch leading directly to the great hall. The walls are entirely broken up by vast windows, prompt-ing the old saying, 'Hardwick Hall, more glass than wall'. Tall towers at the four corners emphasise the height. The rooms on the first floor are low but on the floor above reached by a stone staircase is the great chamber with coloured plaster walls, on which are depicted a stag and boar hunt and mythological scenes.

Burghley House, Stamford, is one of the great houses built by William Cecil, Lord Burghley, an obsessive builder who admitted to spending more than he could afford on houses he did not need. The house, begun in about the middle of the 16th century, was not completed until about 1587. It is more conservative in style than Theo-balds in Hertfordshire, the largest of all Lord Burghley's buildings, which was extravagently enlarged to entertain Queen Elizabeth but which no longer stands today. Burghley has a traditional entrance façade, along the lines of Wolsey's Hampton Court, with a three-storeyed, turreted gatehouse flanked by very high towers. The whole building is massive and over-ornate and reveals many different influences. The courtyard is striking with projecting pavilions and a heavy □loggia at the hall end interrupted by a huge three-storeyed tower surmounted by a clock and crowned with a great obelisk.

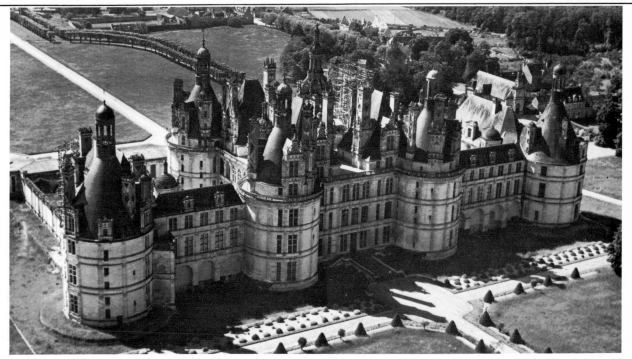

*Above:* Chambord, France, *begun* 1519

**The Châteaux of France.** Although most of the medieval French châteaux have partially or wholly disappeared beneath later rebuildings they once formed picturesque landmarks all over the country. Some idea of their appearance can be obtained from the illustrations of the *Très Riches Heures*, the exquisite ▢Book of Hours painted by the ▽Limbourg brothers for the Duc de Berry. It was not until the French campaigns in Italy, especially of Francis I, when Milan and Genoa were occupied by the French, that Italian influence really began to make itself felt in French architecture. Francis himself was a great and ambitious patron of the arts and spent vast sums on his building projects. His first efforts were concentrated on the château of Blois. This was originally built in the 13th century and the Salle des États and gateway to the court, round which the later extensions were built, formed its nucleus. The wing of Francis I on the east side of the court was erected over the old foundations. The famous spiral staircase built in an open tower has a heraldic decoration consisting of the letter F and the salamander, the emblem of Francis I.

Chambord, one of the most famous châteaux and the largest of those along the banks of the Loire river, was built by Francis I as a hunting lodge, although it was not completed until after his death. Designed by an Italian architect, Domenico da Cortona, the original plans were much altered by the French masons who were probably responsible for the medieval aspect of the whole with the elaborate roofline and round towers set on all the corners. It is unusual in plan consisting basically of a great rectangular court with a much smaller rectangular block inside, adjoining the central part of one side of the court. The living rooms are in this smaller block; its great feature is the central tower in which is built the famous spiral staircase in a stone cage.

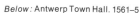

*Below:* Antwerp Town Hall. 1561–5

**Public Buildings of the Netherlands.** Among the great public buildings erected in Antwerp in the 16th century is the Town Hall, designed by the Antwerp architect and sculptor Cornelis Floris (1514–75), the chief artist of the Netherlandish ▽Renaissance. Built in 1561–4, the Town Hall stands at one end of a vast square. It is of great width with a high, dominating centrepiece. The edifice rises in four storeys, consisting of a ▢rusticated ground floor with a massive pillared arcade, above this the two main floors, quite plain except for the two different orders flanking the rectangular windows, ▽Tuscan on the first, ▽Ionic on the second, and beneath the roof a low ▢loggia enclosed by a ▢balustrade. The centrepiece is heavily ornate with its Flemish-style adaptation of Italian motifs and curving gable top giving it a rather ▽Baroque effect.

# The 17th Century in Europe

The 17th century was an age of conflict: of religious wars between Protestantism and the Church of Rome, as well as wars of colonial expansion.

Art and architecture were used by warring factions as propaganda weapons. Protestants preached an austere and rationalist religious faith with an emphasis on the moral nature of religion. The Roman Church attacked with a heightened appeal to the emotions, building churches in which architecture, painting, sculpture and music were combined in a theatrical performance involving all the senses. It was therefore the Latin countries that kept the ascendancy in the visual arts, first in Rome, and then in France. Here, under Louis XIV (1638-1715) the state itself almost became a religion, and the full force of Baroque art and architecture were used to glorify and maintain the absolute power of the King over a centralised state.

Later, even Protestant rulers copied Louis, and his court and palace at Versailles became models for all the princes of Europe. French became the international language of the educated man. French art would remain dominant for two hundred years. Nationalism became the new political force, and gave impetus to world exploration and the spread of European culture overseas in colonies.

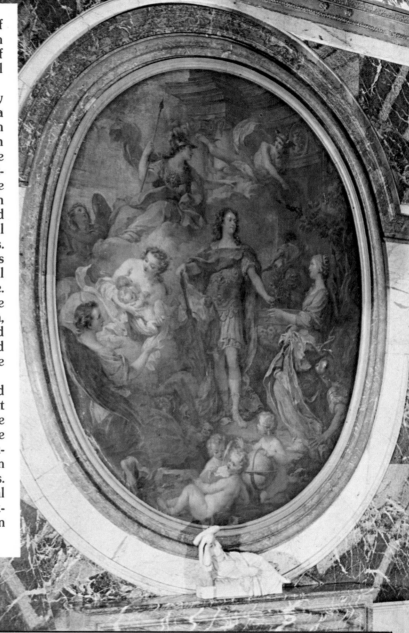

| −5000 | −4000 | −3000 | −2000 | 1000 | BC 0 AD | 1000 | 2000 |
|---|---|---|---|---|---|---|---|

**1601** Gobelin manufacturing started in France.
**1608** John Milton poet born England (d. 1674).
**1610** Galileo builds telescope, Italy.
**1611** King James' Bible, England.
**1618** Thirty Years' war (ends 1648).
**1619** Johannes Kepler (astronomer) publishes 'Harmonia Mundi'.

**1623** St. Peter's Rome, finished.
**1636** Harvard University founded, Cambridge, Massachusetts.
**1637** Rene Descartes publishes 'Discourse on Method', France.
**1649** Execution of Charles I, England.

**1649** The Commonwealth established, England under Oliver Cromwell.
**1651** Thomas Hobbes publishes 'Leviathan', England.
**1658** Blaises Pascal's 'Pensees', France.
**1661** Louis XIV takes power in France.
**1666** Fire of London.

**1675** St Paul's Cathedral, London.
**1679** Habeas Corpus Act, England.
**1682** Accession of Peter the Great, Russia.
Newton establishes Laws of Gravity and Motion.
**1683** Leeuwenhoeks microscope, Holland.
**1692** Leibnitz Differential Calculus.

NORTH SEA

BALTIC SEA

ATLANTIC
OCEAN

Oxford
Bath
London
The Hague
Haarlem
Amsterdam
Utrecht
Antwerp
Brussels
Cologne
Berlin
Warsaw
Oder R.
Elbe R.
Versailles
Blois
Paris
Fontainebleau
Rhein R.
Munich
Vienna
Milan
Danube R.
Turin
Madrid
Toledo
Rome
Naples
Seville
Palermo

MEDITERRANEAN
SEA

# THE 17th CENTURY IN EUROPE

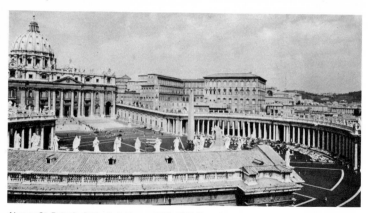

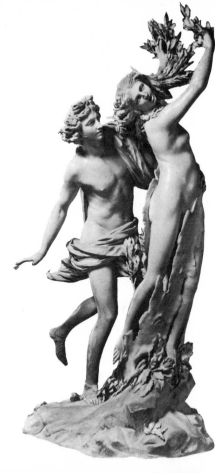

*Above:* St. Peter's Cathedral, Rome. 1506–1626. Seen from the piazza
*Top right:* GIANLORENZO BERNINI *Apollo and Daphne*. 1622–5. Marble. Life-size. Villa Borghese, Rome
*Bottom left:* PIETRO CORTONA *Allegory of divine Providence*. 1633-9. Fresco. Palazzo Barberini, Rome
*Botton right:* GIANLORENZO BERNINI *Ecstasy of St Teresa*. 1645–52. Life-size, Cornaro Chapel, Santa Maria della Vittoria, Rome

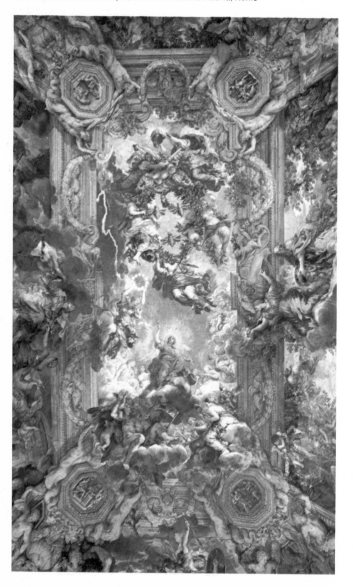

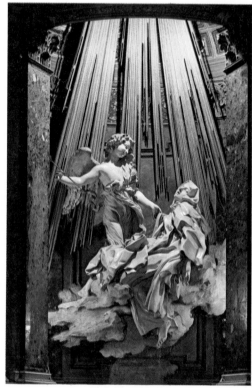

# Baroque Art in Rome

**The Idea of Baroque.** The word Baroque was originally used as a term of abuse in the 18th and 19th centuries, and described art and architecture of the 17th century that was thought to be bizarre or exaggerated. These are, however, only subsidiary characteristics of a style that was essentially a reaction against the mannered creations of late 16th-century Italy (*see* Mannerism, pages 154–5) in favour of more immediate emotional appeal. The sensational naturalism of ▽ Caravaggio and the dramatic illusionism of ▽ Bernini are thus part and parcel of the same phenomenon. It was a sensual rather than an intellectual style, but underlying all its shock tactics and visual tricks, its love of movement, richness of colour and materials, is a desire for unity and order. At a later date it was thought that Baroque art contradicted all conventional canons of taste, but this is far from being the case. Along with its innovations, came a revival of Classical ideas and forms which had been severely violated in the second half of the 16th century. Many great Baroque works derive their inspiration from ancient Roman art, and it is thus no coincidence that the most important centre for the development of the style was Rome itself.

**Gianlorenzo Bernini** (1598–1680) was without doubt the most important exponent of the Baroque style in Rome. He was principally a sculptor, but he also earned considerable recognition as an architect, painter and stage-designer. All his works are dominated by an overwhelming sense of drama, accompanied by great technical virtuosity and illusionistic wizardry. As a sculptor he almost denies the material limitations of stone. In the *Apollo and Daphne* for instance the nymph Daphne's sudden transformation into a tree is graphically depicted, a sculptural feat of extreme daring. Never before had sculpture been so effectively used to convey a sense of movement. Even when sculpturing a portrait bust, such as that of Louis XIV, he transcends the traditional approach in the creation of vivid, lifelike figures who seem interrupted in the midst of great activity.

With Bernini the arts of architecture, painting and sculpture merge, a fusion seen particularly in the Cornaro Chapel of Santa Maria della Vittoria, Rome, in which the sculptured figures of the *Ectasy of St Teresa* (1645–52) are only part of an elaborate whole. Gilt rays descend from a hidden source of light, painted angels on stucco clouds seem to have broken into the chapel, and gesticulating figures witness the events from a balcony. The Ecstasy itself, rendered in embarrasingly physical terms, is a fitting climax to a work of art that makes the divine world seem so uncannily real.

Throughout his life Bernini worked on official commissions for St Peter's. He not only transformed radically the interior with spectacular creations like the massive *baldacchino* (a canopy-like construction covering the tomb of St Peter), and the gilt-bronze throne of St Peter, but he also designed a suitably grandiose approach to the cathedral in the form of an oval piazza contained by two free-standing colonnades. His self-declared intention was to suggest the outstretched arms of the Church welcoming the faithful, a truly sculptural conception of architecture.

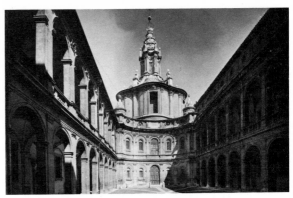

FRANCESCO BORROMINI Sant' Ivo della Sapienza. 1642–50.

**Francesco Borromini** (1599–1667) began his career working as a stone carver at St Peter's under ▽ Bernini but went on to become the latter's most powerful rival in architecture. A difficult and neurotic man who later committed suicide, his architecture is the most outstandingly individual in 17th-century Rome. Most of his buildings are the result of ingenious play with geometrical forms, resulting in the most unconventional plans. The plan of Sant' Ivo della Sapienza (1642–60) is based on a star-hexagon, a form that symbolises Trinity and Wisdom (*sapienza*). His architecture displays considerable restlessness, convex and concave forms being frequently played against each other, and in the case of the exterior of Sant' Ivo, this leading up to a fantastic climax in the unique stepped spiral feature on top of the dome.

**Architecture in Painting.** All the major developments in large scale □illusionistic □fresco painting in the first half of the 17th century took place in Rome. In 1595 the Bolognese artist Annibale Carracci (1560–1609) was called to Rome to paint a ceiling in the Palazzo Farnese. This fresco is a complex work, incorporating several layers of meaning. In spite of its complexity, however, its different elements are brought together by an energetic, unifying vision that paves the way for some of the more spectacular creations of the Baroque, such as the ceiling of the Palazzo Barberini (*finished in* 1639) by Pietro da Cortona (1596–1669), a prolific and versatile figure and one of Rome's leading architects. Here we find hundreds of struggling figures who are drawn together as if in a centrifuge, leading the eye right into the centre of the ceiling where the emblems of the family, the Barberini Bees, fly triumphantly. Two other famous illusionistic ceilings in Rome belong to the second half of the century. On the ceiling of the Church of Sant' Ignazio, Andrea Pozzo (1642–1709), by an ingenious use of perspective, apparently expanded the interior by hundreds of feet. Totally different is the illusionism in the ceiling of the Gesù (1668–85). Although painted by Baciccia (1639–1709), it was probably planed by ▽ Bernini and is indeed a very Bernini-like creation in its fusion of □stucco, architecture and painting, the whole drawn together, not by a complex architectural structure, but by a brilliant and all-pervading light.

# THE 17th CENTURY IN EUROPE

**The Classicists.** Annibale Carracci and Caravaggio were the two most influential Italian artists at the beginning of the 17th century. Both were recognised in their time as artists who, reacting against the ▽ Mannerism prevalent in the second half of the 16th century, had brought back naturalism to painting. They did so, however, in completely different ways. Annibale Carracci combined naturalism with a respect for Classical models, and though he could depict everyday scenes with remarkable truth, his world is an idealised one, based on the Classical concepts of harmony and balance. His followers, mainly from Bologna, likewise developed a calm, Classical style strongly opposed to the vividly realistic, dark and dramatic style of Caravaggio. One of the more famous of these followers, Guido Reni (1575–1642), started his artistic career in Rome in a Caravaggesque manner but soon changed, painting in 1611 his famous *Aurora* fresco for the Palazzo Rospigliosi, Rome, a masterpiece of harmonious, Classical composition painted in cool, clear colours. By far the most Classicising of Annibale Carracci's followers, however, was Domenichino (1581–1641). His frescoes in San Luigi dei Francesi, Rome, have a simplicity and austerity that is lacking in the more sensual and sentimental works of Reni. This less appealing style was greatly admired by the highly intellectual French painter, ▽ Nicolas Poussin.

One of the most important categories of painting developed by the Classicising painters of the 17th century was landscape painting. In Annibale Carracci's *Flight into Egypt* (1604) the figures have been totally overwhelmed by a landscape which, though containing much naturalistic detail, is a highly ordered and tidied-up vision of nature. This work was crucial for the development of the ideal landscape, a type of painting particularly associated with the French artists Poussin and ▽ Claude, and which became the most accepted form of landscape painting, lasting well into the 19th century.

**Michelangelo Merisi da Caravaggio** (1573–1619), known as Caravaggio, from his birthplace near Bergamo, Italy, was in his lifetime an immensely controversial figure. A violent, irresponsible, anarchic man, he was nevertheless an energetic, productive and extraordinarily influential painter. His numerous followers are known as ▽ Caravaggisti, and those he influenced include, directly or indirectly, such masters as ▽ Rembrandt and ▽ Velasquez. For most of his working life he was a fugitive from the law or other authority he had offended and, in the last year of his short life, he was left for dead in a back alley in Naples where one of his enemies had caught up with him. He rarely stayed more than a few months in one place – fortunately he was a quick and fluent painter.

Despite this fiery life, his work from the first was original and revolutionary; his uncompromising ways were reflected in uncompromising art. He started by painting ☐ genre scenes of card players or drinkers and in his first major work, the decoration of the Chapel of St Matthew in the Church of San Luigi dei Francesi, Rome, he daringly treated the religious theme as an everyday subject. In *The Calling of St Matthew* (about 1600) he depicts Christ appearing to the saint in a tavern where

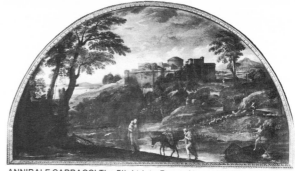

ANNIBALE CARRACCI *The Flight into Egypt. About* 1603. 48 × 90½ in (122 × 230 cm). Doria-Pamphili Gallery, Rome.

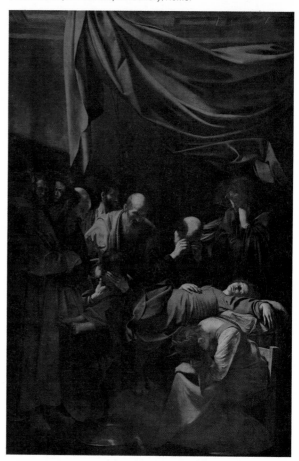

*Above:* MICHELANGELO DA CARAVAGGIO *Death of the Virgin.* 1605–6. 154¼ × 96½ in (369 × 245 cm). Louvre, Paris
*Below:* GEORGES DE LA TOUR *St Peter Denying Christ.* 1650. 47½ × 63 in (127 × 160 cm). B-A, Nantes

# Painting in Italy and the Caravaggisti

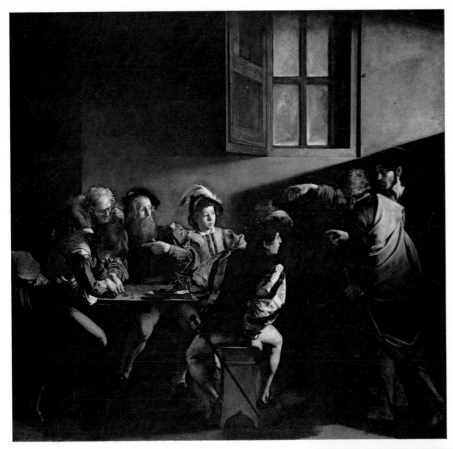

*Above:* MICHELANGELO DA CARAVAGGIO *The Calling of St Matthew.*
San Luigi dei Francesi, Rome
*Right:* MICHELANGELO DA CARAVAGGIO *The Beheading of John
the Baptist.* 1608. 11 ft 10 in × 17 ft 2 in (355 × 545 cm). Malta

the latter is playing cards with friends. The scene is
presented with bold and dramatic lighting – the central
figures highlighted but the rest in murky darkness. The
vivid actuality of the treatment which he developed in
later paintings was quite contrary to the accepted
artistic treatment of Christ as an idealised, remote
figure. The power of his work was however recognised
and the realism was much in sympathy with the Protest-
ant view. In his last religious works, such as *The Raising
of Lazarus* (1609) or *The Beheading of John the Baptist*
(1608), there is deep pathos and human sympathy
unexpected from this aggressive man.

**Georges de la Tour** (1593–1652) was one of the most
original interpreters of the Caravaggesque idiom.
Instead of exploiting the more gruesomely realistic
features of Caravaggio's art, he favoured instead a more
detached interpretation, creating in his paintings a
haunting mood of stillness and tranquillity. An element
of mystery permeates his work more than that of almost
any other of the Caravaggisti. A candle shaded by a
hand, for instance, is not just used to display' technical
virtuosity, but it also, as in *The Denial of St Peter* (1650),
helps to create a very introverted mood through the
centralised source of soft and obscured light – that
flows outward from the painting except directly to the
viewer who feels excluded.

**The Followers** (Caravaggisti). ▽ Caravaggio's art was so
revolutionary that it had an immediate impact. Even
before his early death he had a considerable following
in Rome. Quickly his influence became international,
spreading to Spain, France and Holland. The Caravag-
gisti are a mixed bunch, some merely aping the dramatic
lighting effects in ▢genre paintings of tavern scenes,
some using them for religious emphasis through the
depiction of details with minute care. On the other hand
some found in Caravaggio's work the source of new
inspiration – of a new view of the world, uncompromising
and direct. ▽ Rembrandt's soft and subtle darkness owes
something to him, as does the delicate light of ▽ Velas-
quez.

# THE 17th CENTURY IN EUROPE

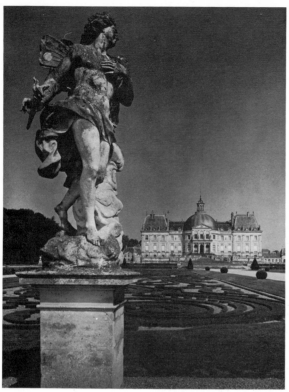

Vaux-Le-Vicomte. 1655–61

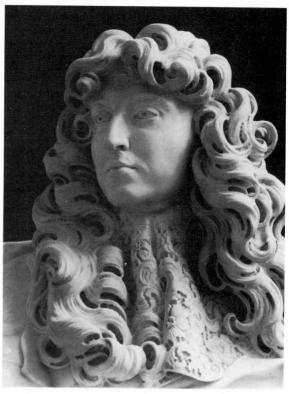

GIANLORENZO BERNINI detail *Louis XIV*. 1665. Marble. Life-size.
Versailles

**Vaux-le-Vicomte.** Louis XIV, who gave his name to a whole era, was born in 1638, ascended the throne aged five, and died in 1715. His long reign was marked in the arts by a remarkable vitality and variety despite a characteristic and pervasive emphasis on Classical antiquity. He himself did not care for pictures of peasant life like those painted by the Le Nain brothers ('remove these horrors'); his taste for grandeur was whetted by the example of his father, Louis XIII, and of ▽ Cardinal Richelieu.

Nicolas Fouquet, Louis's Superintendent of Finance, with an arrogance born of his newly-made riches and a miscalculation as to his master's character, invited the King to an entertainment of incredible lavishness at his château, Vaux-le-Vicomte, in August 1661. Nineteen days later he was in prison – for the rest of his life.

Vaux-le-Vicomte, built in five years, was the seed of the great French Classical tradition. The peak of its style, was a purely artificial creation intended for a life of display and pleasure. The architect was Louis Le Vau (1612–70), assisted by Charles Le Brun, and, in the gardens, by André Le Nôtre. Their success led to their employment by Louis for his own projects.

**Art and the State.** Louis was fortunate in his choice of replacement for Fouquet, Jean-Baptiste Colbert, who proved to be a genius at organising the country's economy and finances. It was through Colbert's centralised control of trade and commerce that Louis could afford to build his new château at Versailles on so huge a scale.

Charles Le Brun (1619–90) was employed for this task. A pupil of Vouet, he had studied in Rome under ▽ Poussin and returned to Paris in 1646 where he was commissioned to decorate the Hôtel Lambert, and Vaux-le-Vicomte. He undertook the Galerie d'Apollon at the Louvre for the King, who appointed him First Painter in 1662. He also became the first Director of the Academy and the Gobelins Manufactory, which employed an army of artists and craftsmen to create the paintings, sculpture, furniture, tapestry and furnishings for the new palace. He instituted as rigid a control over artistic policy as Colbert did over hours of work and scales of payment. Le Brun himself was a typical exponent of the decorative style of his time exemplified in his masterpiece, the *Galerie des Glaces* at Versailles, where the grandeur of his conception and its allegorical treatment is matched by his technical mastery.

**Versailles** was originally a small brick and stone hunting-lodge used by Louis XIII. Louis XIV had felt insecure in Paris and in his determination to centralise power in his own hands and immobilise a restless nobility he was anxious for political as well as aesthetic reasons to create a court which would contain the entire machinery of government under one roof.

The first stages of the alteration were undertaken by Le Vau, who added to the original building. He was succeeded in 1677 by a Parisian, Jules Hardouin Mansart (1646–78) who had designed the château at Clagny for one of Louis' mistresses. Mansart was the great-nephew of ▽ François Mansart, still remembered today

Versailles. View from the gardens

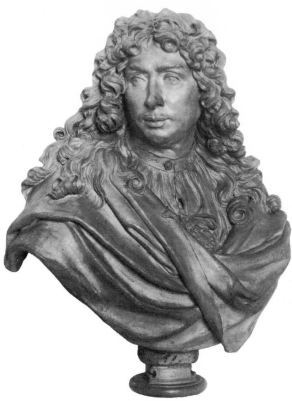

ANTOINE COYSEVOX *Charles Le Brun.* 1676. Terracotta. h. 26 in (66 cm). Wallace

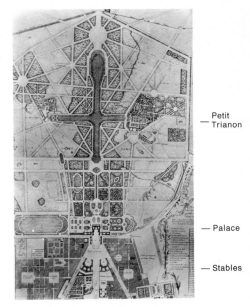

Petit
— Trianon

— Palace

— Stables

Plan of the palace and gardens of Versailles

for the roof-design that bears his name. Jules Hardouin Mansart transformed Versailles; he modified Le Vau's garden façade and added two immense wings to contain the Galerie des Glaces, the Salon de la Guerre and the Salon de la Paix in which France's victories were celebrated by the work of the Gobelins and Le Brun. He also built other additional wings, the 'office blocks', the stables, the Orangery, the Trianon in the park and planned the chapel. Virtually the whole ensemble which we see there today is his.

**The Sun King.** Louis and his court moved into Versailles in 1682; France and her Sun King (*Le Roi Soleil*) had reached their joint zenith. Louis held a mystical belief in his quasi-divinity (like England's Charles I) and he had been at pains, in his own writings as well as in the forms of art he permitted, to achieve his own deification. He and his family were painted in 1670 by Jean Nocret (1616–71), a standard Academician, as an assembly of gods and goddesses in which he appears as Apollo, his mother as Cybele, his wife as Juno and his brother and sister-in-law (Charles I's daughter) as Pluto and Flora.

Nocret's allegory exemplifies the rules governing art that Le Brun and the Academy had formulated. The theories of social structure and a pyramidical heirarchy were reflected in the choice of subject; man was placed in the centre of the world by God with the King at the top; the platonic ideal of submitting the real to the ideal was paramount. Art, though it might imitate nature, must accord with the laws of reason – a doctrine which in fact resulted in mere competence rather than brilliance.

**Nature and Art.** Nature, though it might be imitated, must also be controlled. The overall grandiosity of the concept of totality in art embraced the countryside itself and it had to be tamed and barbered to fit. André Le Nôtre (1613–1700) was the man to do it. The son of generations of gardeners, he was trained as an architect, studied painting under ▽Vouet and was a noted horticulturalist. He created the gardens at the Tuileries and the Luxembourg in Paris before working at Vaux-le-Vicomte.

His master work is undoubtedly the park and gardens of Versailles. Vistas and alleys, drawn with a precision based on the new laws of optics, could be viewed with equal pleasure from the windows of the château or by the casual stroller. Water, brought and harnessed by the new technological devices of hydraulics, tumbled in cascades to be caught in still pools reflecting the infinite or to be shot back into the air from elaborate fountains. In a scheme where reason predominated and symmetry was all, fantasy was restricted to unexpected arbours and niches where statues and vases were artfully placed to surprise. Here, as everywhere else, man was the measure of all things.

# THE 17th CENTURY IN EUROPE

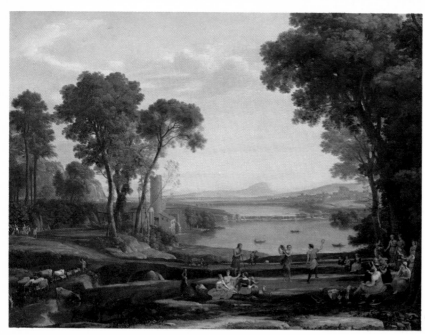

CLAUDE *The Marriage of Isaac and Rebekah, 'The Mill*. NG, London

**Claude Lorraine** (1600–82) was named after that province of France in which he was born. He went to Rome as a youth to work for a fashionable landscape artist and he had an early success which lasted for the rest of a life wholly spent there. He was the first painter to devote himself entirely to landscape painting and is known to have painted one interior only. Indeed his figures were frequently painted by his assistants.

His work consists of views of Rome, the Roman *campagna* (countryside), seaports on the Neapolitan coast and idealised views with Biblical, mythological or pastoral themes. His concept of space and his composition were on strictly Classical lines but his love and observation of nature prevented his pictures from becoming conventional. His pictures are laid out in accordance with the dictates of an overall scheme in which he employed simple devices for dealing with ☐perspective.

It is above all in his sense of poetry that Claude's greatness lies. A delicate luminosity invades his paintings; all his castles are enchanted, all his people are illuminated by a perpetually radiant sun. His gentle vision was to influence all subsequent landscape painting, particularly in England.

**Nicolas Poussin** (1594–1665) was born in Normandy and apprenticed locally before going to Paris. He went to Rome in 1624 and, apart from two years in Paris (1640–2) working for ▽Richelieu on the Louvre, he spent the rest of his life there. His paintings encompass a wider range of subjects than those of Claude, for in addition to the mythological and bacchanalian scenes he painted before he was 45, he moved on to architectural, religious and historical subjects; indeed he may be said to have invented the ☐'history-picture'. Not until he was 54 did he paint a pure landscape.

All Poussin's works are rigorously intellectual. His subjects are nobly, indeed heroically, idealised and Roman gravity is wedded to French logic. Everything that he does is the result of considered thought where reason reigns above sentiment. He formulated for himself a set of rules (which became the basis of those of the French Academy) whereby every item and gesture had precise meaning. There are no elements of fantasy, chance or nostalgia. His landscapes embody acts of heroism; the events portrayed encapsulate a moment of eternal truth; the attitudes of his figures relate strictly to the point he wishes to make.

His vision recalls a Virgilian Arcadia where a golden age of innocence takes sober account of the presence here too of death; but his severity is tempered by an insidious sensuality that, like his colours, he derives from ▽Titian, whom he greatly admired.

At the end of his life he combined architectural and historical subjects in canvases such as the *Four Seasons* (1660–4), which were painted for the Duc de Richelieu (whose son lost them to ▽Louis XIV in a wager at tennis). Despite changing tastes at the end of the century, when he was displaced in popularity by ▽Rubens, his influence on French 19th-century painting cannot be overestimated.

**Rigaud and Largillière.** When the State requires its art so remorselessly to glorify its rulers there must be portraiture on a grand scale. In the age of ▽Louis XIV this task fortunately fell to artists of fair quality. The two outstanding portraitists of the latter half of the reign were Rigaud and Largillière.

Hyacinthe Rigaud (1659–1743) was born in Montpellier and trained in Perpignan. He was one of the few artists of his time who did not go to Italy but was influenced by Flemish painters whose merits became apparent to the French nobility forced for so long to campaign in the Low Countries. He is reputed to have averaged 35 pictures a year for 62 years (with the help of an army of assistants), and in their ▽Baroque flamboyance, his portraits combined the grandiose

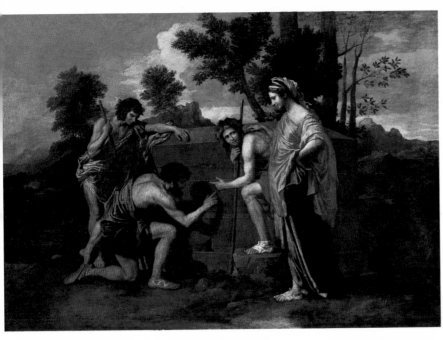

*Left:* NICHOLAS POUSSIN *The Arcadian Shepherds.* 1638–9. 33½ × 47⅝ in (85 × 121 cm). Louvre, Paris

formality of the State record with a real understanding of the character of his sitter. As the Sun King grew old and fashionable society gradually forsook Versailles for Paris, the men who had made money out of both the court and the wars sat for him, as they did his contemporary and rival Largillière.

Nicolas de Largillière (1656–1746) was born and died in Paris but he had been apprenticed in Antwerp and worked for some years in England as an assistant to ▽ Lely. His slightly unorthodox background may explain his looser style and his adaptability, and his Flemish training the rich brushwork which gave his paintings such brilliance. He was influenced by both ▽ Rubens and ▽ Rembrandt. Although his family portrait is still in the formal tradition, his later paintings anticipate the ▽ Rococo delicacy of the 18th century.

**The End of an Age.** Towards the end of the century as wars impoverished France and death decimated both the population and ▽ Louis XIV's immediate family, the glitter of the court dimmed to a religious stuffiness and there was a reaction against formal splendour. Painters such as Pierre Mignard (1612–93), who had quarrelled with ▽ Le Brun and the establishment, came into their own; the influence of the Low Countries became stronger and still-life and rustic scenes became fashionable subjects for painting.

Alexandre-François Desportes (1661–1743), the son of a peasant, was born in Paris. He studied under Nicasius Bernaerts, a Fleming, and at the Academy before going as a portrait painter to the court of Poland from 1695–6. On his return to France, Louis XIV employed him to paint hunting scenes, and to record his favourite dogs and the rare animals in the Ménagerie at Versailles, and at Marly.

*Above:* NICHOLAS POUSSIN *Summer.* 1662. One of the *Four Seasons.* Louvre, Paris

*Below:* NICHOLAS DE LARGILLIERE *Portrait of the Painter, His Wife and Daughter.* Louvre, Paris

# THE 17th CENTURY IN EUROPE

**Diego Rodríguez de Silva y Velasquez** (1599–1660) is the giant of Spanish painting. Born and trained in Seville, his early □genre paintings are remarkable assimilations of the Caravaggesque idiom and are painted with great technical accomplishment and no hint of sentimentality or coarse exaggeration. His reputation soon spread outside Seville and by 1623 he was established as Court Painter to Philip IV in Madrid. Influenced by the King's extensive collection of 16th-century Venetian paintings, he gradually abandoned his precise and sombre early style in favour of a much freer technique. The freedom of technique he developed in his maturity, which could evoke form and texture in a few bold brushstrokes, was something remarkable for his time. Equally outstanding was his use of colour which sometimes explodes like fireworks on the canvas in a manner which transforms even greys and whites into a magical, silvery sheen.

Throughout his life Velasquez painted the members of the Spanish court in a series of startlingly lifelike portraits that transcend the conventions of such painting. More than almost any other artist before him, Velasquez could depict children in a natural, unsentimental way, their vitality retained even underneath the heavy trappings of court dress. Velasquez's only group portrait, the enormous *Las Meninas* (The Ladies-in-Waiting) of 1655, is both a brilliant depiction of children and a compositional *tour de force*, the artist including in the painting not only himself at the easel, but also the King and Queen who are reflected in a mirror at the back of the picture. The subtlety and complexity of the composition creates an atmosphere of mystery which underlies all the greatest of Velasquez's works.

Velasquez is exceptional among Spanish artists in that he frequently painted mythological subjects. One of the greatest of these paintings, *Las Hilanderas* (The Weavers), depicts a scene from Ovid's *Metamorphoses* (the legend of Arachne). It is painted with such freshness and originality that, in spite of the ▽Michelangelo prototype for the two foreground figures, it is unlike any other mythological painting of the 17th century, both rendering the world of deities in human terms and transforming the ordinary, human world into something magical.

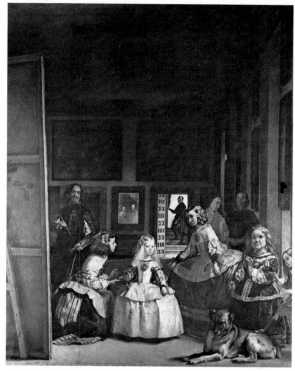

*Above left:* DIEGO VELASQUEZ *Woman Frying Eggs.* 1618. 39 × 46 in (99 × 116·8 cm). NG Scotland, Edinburgh
*Above:* DIEGO VELASQUEZ *Las Meninas.* 1655. 125 × 118½ in (318 × 276 cm). Prado, Madrid

DIEGO VELASQUEZ *The Infanta Margarita in Blue.* 1659. 50 × 42 in (127 × 107 cm). KH, Vienna.

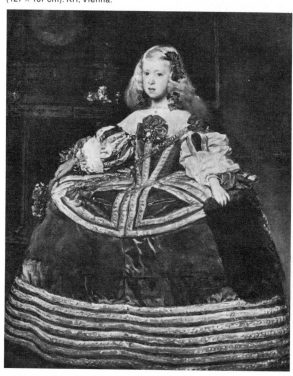

# Art in Spain

**José Ribera** (1591–1652). Although born in Spain, Ribera spent almost all his life in the Spanish dominion of Naples. In his works the realistic, □tenebrist manner of ▽Caravaggio is carried to its ultimate extreme. A prolific artist, who specialised very largely in half, or less frequently, full-length portraits of saints, his paintings lack the subtle structuring of Caravaggio's and seek more to shock. The transitions in his works between light and dark areas are much more brutal than in those of Caravaggio and likewise there is much greater concentration on realistic detail, which may be exaggerated out of all proportion. When commissioned to paint a bearded woman with her child at her breast, Ribera was obviously in his element. This shock element in his art still retains its power today, and two of his later paintings, the *Flaying of Marsyas* and the *Drunken Silenus* (1626) are possibly two of the most brutal paintings of the 17th century. In the former, the agony of Marsyas' death is depicted as graphically as possible, and in the latter, the swollen sunburnt figure of the sprawling Silenus is so revolting that the drunken nudes of ▽Rubens seem almost gentle in contrast. Ribera's style becomes much quieter in his later years, possibly under the influence of ▽Velasquez who visited Naples in 1630.

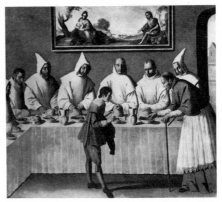

FRANCISCO DE ZURBARAN *St Hugo's visit to the Carthusians.* *About* 1633. Seville Museum

**Francisco de Zurbarán** (1598–1664). Like ▽Velasquez and ▽Murillo, Zurbarán was trained in Seville. Many of his religious paintings have an almost unprecedented austerity, but, unlike ▽Ribera, he did not contort his figures or dwell on disagreable details. In contrast his figures are solemn and monumental, painted in sombre colours. His kneeling monks are abstract compositions in brown, a single prop, like a skull or a cross, emphasising the intensity of the subject's meditations. His backgrounds are made as simple as possible, and he often abandons perspective in favour of a □relief-like presentation, as in *St Hugo's Visit to the Carthusians* in which white-robed monks are starkly set against a plain background. The painting's absence of shading and perspective, coupled with the simplicity of its colours, gives it a remarkable modernity.

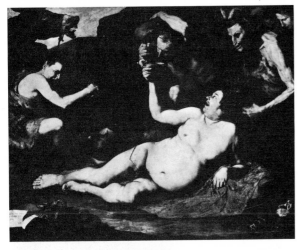

*Above:* JOSÉ RIBERA *Drunken Silenus* 1626. Museo Nationale, Naples

**Bartolomé Esteban Murillo** (1617–82) was the most prolific and successful artist working in southern Spain. His art forms a complete contrast to that of the earlier Seville painter ▽Zurbarán in that it is fluently painted, cheerful and exuberant. Although he was mainly a religious painter, he also painted a few □genre scenes of children. Some of these, like *Peasant Boys*, are often touching in their simplicity, but their realism is sometimes marred by moralising and romantic overtpnes. Murillo is perhaps best known for his innumerable depictions of the Immaculate Conception and the Virgin and Child. These rather sentimental works met with considerable enthusiasm in the 19th century. In spite of the cloying sentimentality of much of his work, his technical virtuosity is undeniable and his infinite variations on delicate, pale colours make him one of the more subtle Spanish colourists of the 17th century.

*Left:* BARTOLOME MURILLO *Peasant Boys* 63¼ × 41¼ in (160·7 × 104·8 cm). Dulwich College Picture Gallery, London

**Spanish architecture** of the 17th century is characterised by profuse and extravagant decoration. This decoration was however applied to relatively straightforward structures, the revolutionary spatial concepts of ▽Roman ▽Baroque architecture being largely unexplored by Spanish architects. Perhaps the only truly Baroque creation in Spain is Narciso Tomé's (*about* 1690–1742) *Transparente* in Toledo Cathedral, a daring fusion of painting, stucco and architecture that recalls the work of Bernini.

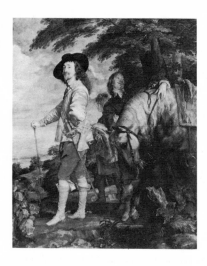

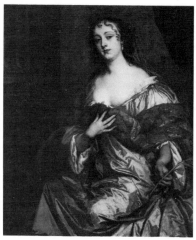

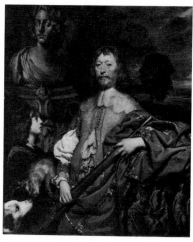

*Above left:* ANTONY VAN DYCK *Charles I of England. About* 1635.
107 × 83½ in (271 × 212 cm). Louvre, Paris
*Above centre:* PETER LELY *Countess of Gramont. About* 1665.
50 × 40 in (127 × 101·6 cm). Hampton Court Palace
*Above right:* WILLIAM DOBSON *Endymion Porter. About* 1643–5.
59 × 50 in (149·9 × 127 cm). Tate Gallery, London

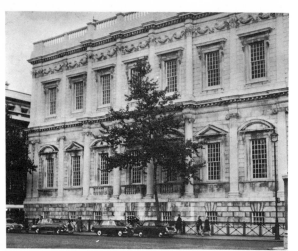

*Left:* INIGO JONES Banqueting Hall, Whitehall. 1619–22.

The most important British contribution to the European ▽Renaissance lay not in the visual arts but in science and literature. ▽Shakespeare and Milton, Bacon and Newton were outstanding among many men of letters, poets and philosophers. The visual arts, indeed, were regarded with some suspicion, particularly by the increasingly powerful middle classes. This was not only due to Puritan dislike of Church imagery, but there was also a popular association of European art with the Roman Catholic Church on one hand, and political absolution and royal prerogative on the other. This neatly bracketed Italy and France, the two leaders in art and architecture, together as undesirable foreign examples. Consequently British painting, sculpture and architecture continued in a provincial isolationism which was not to be entirely broken until the 18th century. Charles I tried to establish his court upon European lines. He patronised ▽Peter Paul Rubens and ▽Van Dyck and built up a major collection of European paintings and drawings, and had ambitious plans drawn up for Whitehall palace in modern monumental style befitting a major European capital. But his political assumptions led directly to civil war, defeat and execution, and his unfortunate example served only to harden popular opinion.

**The Court.** Two Flemish painters imported by Charles I were to influence British portrait painting until the end of the 18th century. They were Anthony Van Dyck (1599–1641) and Peter Lely (1618–80). Van Dyck was Ruben's successor in Charles I's plan to end English isolationism in politics and culture, and he, in turn, was succeeded by Lely. Together their work gave rise to a popular fancy dress mythology of life at the Cavalier and Restoration courts that has lasted ever since.

Van Dyck's cavaliers are generally dressed in satin and lace, men and women alike beribboned and long haired. But amid the supposed gaiety and gallantry of his court the King had the appearance of rather a plainly dressed English gentleman, and was painted as such. It is hard to see in Van Dyck's portraits the quintessence of an autocracy which clung with such stubborn refusal to the concept of the Divine Right of Kings, particularly by comparison with the State portraits of Louis XIV.

Lely's courtiers have heavy-lidded, dark-shadowed eyes in imitation of their King, Charles II. There is a general air of languid dissipation in Charles II's court portraits. An intelligent man, Charles II's chief ambition was to avoid the fate of his father. He used frivolity as a social mask and political camouflage, and Lely was his unconscious propagandist. Both painters were personal friends of their royal patrons and were generously rewarded with titles, houses and pensions.

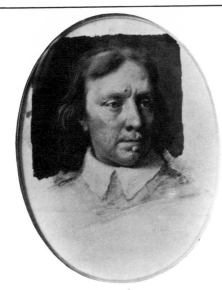

*Above:* SAMUEL COOPER *Oliver Cromwell. c.* 1657. $3\frac{1}{2} \times 2\frac{1}{2}$ in (8·9 × 6·4 cm). Duke of Bucclench Coll

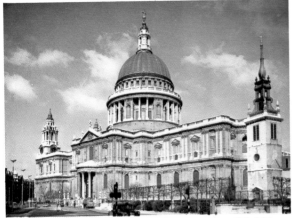

SIR CHRISTOPHER WREN St Paul's Cathedral. London. 1675–1709.

**King and Parliament.** The 17th century in England is dominated by the Civil War – by the events which led to it, by the Commonwealth experiment and by the Restoration that succeeded it. The war itself took place almost in mid-century. Writers and artists, dependent upon patronage, were forced to take sides, dragged willy-nilly into the conflict by the allegiances of their patrons.

William Dobson (1610–46) followed Charles I to Oxford. The leading English-born painter of his day, he was inundated with commissions from the King's followers. Among them was Endymion Porter, writer, diplomat and royal favourite, who was instrumental in building the King's collection of paintings and drawings. Dobson was improvident and extravagant. Ruined by the King's defeat and heavily in debt, he was imprisoned in 1645, rescued by his friends and died soon after.

Samuel Cooper (1609–72) raised the status of miniature painting to that accorded to oil painting. Painter to the Parliamentarians, he is best known for his series of portraits of Oliver Cromwell. Cooper's popularity lasted through the Restoration and into the reign of James II.

**Inigo Jones** (1573–1652). An essential item in Charles I's programme to wrench England out of isolationism and into line with European culture was an ambitious building programme. This was entrusted to Inigo Jones, London-born painter, stage designer and architect. Jones travelled in Italy under patronage in 1613 and returned full of enthusiasm for the work of ▽ Palladio and bearing copies of his books on architecture. In his day Jones stood alone in his contact with and knowledge of Italian architecture, both antique and contemporary.

Palladio's buildings are severe, elegant and chaste, and Jones followed suit. As a stage designer he had been free and fanciful, but there is nothing theatrical or extravagant about his architecture. Three buildings survive, the Queen's House at Greenwich (1616–35), the Banqueting Hall, Whitehall (1619) and the Chapel Royal, St James, the first Classical church in London. The Queen's House is typically Palladian in form and proportion, but sensibly adapted to English weather and climate. Its decoration, in shallow engraving rather than sculpture itself, is well suited to the soft grey light. In its unity of design it is deceptively small, looking as if it could be picked up and held in the hand. Jones' plans for a fine palace in Whitehall reveal his inability to plan a large-scale complex of buildings, but interrupted by the Civil War, his plans were never realised. Jones' influence was to be out of all proportion to the number of his buildings with the Palladian revival of the 18th century in both England and America.

**Sir Christopher Wren** (1632–1723) was a true ▽ Renaissance universal man. Mathematician, experimental scientist, a professor of astronomy and founder member of the Royal Society, he also sat as Member of Parliament. Well into his thirties before he became involved in architecture, he was appointed Surveyor under the Rebuilding Act of 1667 following the Great Fire of London. He drew up an inspiring and imaginative overall plan for the City with great axial thoroughfares meeting in squares and roundabouts and a stepped and colonnaded river front which would have made London the new Classical capital city of Europe, but which through opposition was never realised.

Nevertheless Wren set about designing and rebuilding the City's churches on their old medieval sites. Under pressure of work – for he was engaged on 30 churches simultaneously in the year 1677 – his efforts to make every church different from every other on oddly shaped sites led to an extraordinary variety in plan and detail quite outside any accepted rules for classicism. Wren's bizarre fancy still goes unnoticed due to long custom and familiarity.

His great masterpiece was St Paul's Cathedral (1675–1709) the only real survivor from his great City plan. Here Wren was allowed to give the skyline of London a great dome comparable to that of St Peter's in Rome and the Invalides in Paris. A difficult, marshy site taxed all Wren's knowledge of mathematics and structure but he saw St Paul's completed. In the meantime he had designed and built the two veterans' hospitals at Chelsea and Greenwich, ▽ Baroque and Classical in plan, but domestically English in scale.

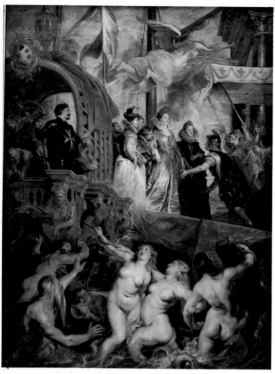

*Above:* PETER PAUL RUBENS *The Arrival of Marie de' Medici.*
1622–5. 155 × 116¼ in (394 × 295 cm). Louvre, Paris

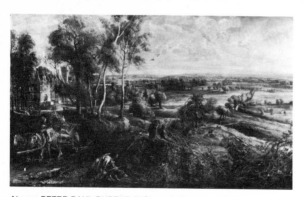

*Above:* PETER PAUL RUBENS *Château de Steen. c.* 1635.
51¾ × 90½ in (131·8 × 229·9 cm). NG, London
*Below:* FRANS HALS *Banquet of Officers of the Civic Guard of St
George at Haarlem.* 1627. 70½ × 101 in (179 × 257·5 cm). Frans
Halsmuseum, Haarlem

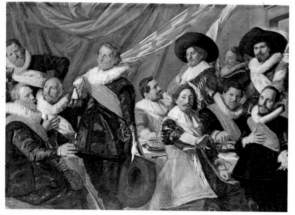

**The Birth of Dutch Art.** The 17th century saw the growth of a new nation, the Dutch Republic, and a new, Dutch school of painting. For two centuries previously the visual arts, especially painting, had flourished in the Low Countries. In the 15th century Bruges and Ghent had produced such masters as the van Eycks and Hugo van der Goes, and in the 16th century Pieter Bruegel was only one of a generation of artists who flourished in Antwerp. But in all this time the Low Countries, prosperous though they were, were ruled by foreigners. In the 15th century they had been part of the Duchy of Burgundy and in 1477, by a dynastic marriage, had become a small corner of the great Habsburg Empire. But it was only after the Emperor Charles V had abdicated in 1555 and his son, Philip II of Spain, became their new ruler that the peoples of the Netherlands rebelled. In 1579, at the Union of Utrecht, the northern provinces declared their independence of Spain. There were many desperate struggles both before and after that date, but from that time, while the Spanish Netherlands and the erstwhile mighty city of Antwerp fell into decline, the new republic grew in power and wealth. While a few artists, such as Rubens, remained faithful to the Spanish crown, many more found a new freedom in the north.

**Peter Paul Rubens** (1577–1640) was a many sided genius. One of the greatest painters of European civilisation, he was also an antiquarian and scholar, a skilful diplomat, a devout Catholic, sincere monarchist and a patriot of the Spanish Netherlands. He won the friendship of ▽ Philip IV of Spain and of ▽ Charles I of England and secured a peace treaty between them. As a young man he was Court Painter to the Duke of Mantua where he studied the art of Classical antiquity and the ▽ Italian Renaissance. He never abandoned the ideals of Classical art. A traditionalist in art as in religion and politics, he was the perfect painter of the Counter Reformation.

Yet his pictorial imagination was powerful and original. Ideas flowed from his brush, giving employment to an army of assistants (who included ▽ Anthony Van Dyck, Jacob Jordaens and Frans Snyders) in his Antwerp studio. His works adorn the churches and palaces of Catholic Europe, for as Rubens himself said: 'my talent is such that no undertaking however vast in size . . . has ever surpassed my courage.' His secular commissions included the ceiling of the Whitehall Banqueting House, London, and 21 enormous canvases illustrating the life of Marie de Medici, Queen of France, for whom Rubens conceived grandiose, allegorical fantasies. In the depiction of her coronation, which was otherwise a realistic reconstruction of the actual event, angels descend, spilling fruit and gold from a cornucopia. And when they first meet, Marie and her husband, Henry VI, are themselves transformed into Jupiter and Juno floating on clouds.

Yet Rubens could also produce work of a highly personal nature and on an intimate scale. In 1630, after being a widower for four years, he married sixteen-year-old Hélène Fourment and retired to the country. His work from then on becomes quieter and more spiritual. Landscape played an increasingly important part, and was to have great influence on his successors.

**Frans Hals** (*about* 1581/5–1666) whose parents emigrated to Haarlem from Antwerp during the war-torn years of the 1580s, was the first great painter of the new Dutch Republic. He himself refused to leave his home town even to go to Amsterdam to complete an important commission for a group portrait.

Hals was a superlative portrait painter and painted little else at a time when portraits were in great demand but were very little valued as objects of art. With a daringly free brushstroke and a very few colours, Hals could capture the living presence of his sitters. Yet he was capable of great exactitude and delicacy when the occasion demanded, as is demonstrated in the embroidered sleeve of his most famous work, the so-called *Laughing Cavalier* (1624).

Hals' greatest works were five group portraits of the Haarlem militia companies in which he showed himself a master of composition worthy of comparison with the great □history painters of Italy. His bold new realistic style influenced an entire generation of Haarlem painters and did much to mould the character of Dutch painting.

**Adriaen Brouwer** (?1606–38). Among the young Haarlem painters who reacted against the articiality of International ▽Mannerism and the Catholic pomp of ▽Rubens' ▽Baroque was Adriaen Brouwer. He was probably a pupil of ▽Hals and, with Buytewech, Molenaer, Dirck Hals and Esaias van de Velde, turned to painting scenes of contemporary life. His pictures are comic and often vulgar, in the tradition of the great 16th-century Flemish painter, ▽Pieter Bruegel, and often have a sharp satirical and moral point. He was admired by ▽Rembrandt, and by ▽Rubens who owned 17 of his works. His followers in the Spanish Netherlands included David Teniers.

**Adriaen van Ostade** (1610–85), lived and died in Haarlem. He specialised in peasant scenes, producing many etchings, watercolours and drawings, in addition to oil paintings. Although all his work is comic, some follows Brouwer into satire, while other works appear to commend the simple virtues of rustic life.

**Jan Steen** (1626–79) was a pupil of ▽Ostade, and he too painted scenes of family life. His art has proved so popular that the boisterous, chaotic, slovenly 'Steen household' has remained proverbial, even in the modern Netherlands. He painted many scenes of traditional Netherlandish festivals and customs, including *The Feast of St Nicolas, The Twelfth Night, The Egg Dance, The Christening Feast* and *The Wedding Feast*. His characters are often well-dressed and prosperous and always jolly and warm-hearted, but they are typically shown in moments of indulgence in the sensual pleasures of drink, gluttony and wantonness.

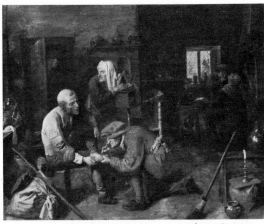

*Above:* ADRIAEN BROUWER *The Operation.* $12\frac{1}{4} \times 15\frac{3}{4}$ in (31 × 40 cm). Bayerische Staatsgemaldesammlungen, Munich

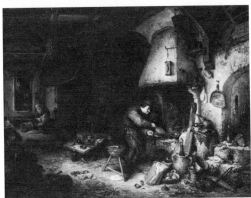

*Above:* ADRIAEN VAN OSTADE *An Alchemist.* 1661. $13\frac{1}{2} \times 17\frac{1}{4}$ in (34 × 45 cm). NG, London.

*Below:* JAN STEEN *Skittle Players Outside an Inn.* c. 1660–3. $13\frac{3}{16} \times 10\frac{5}{8}$ in (33·5 × 27 cm). NG, London

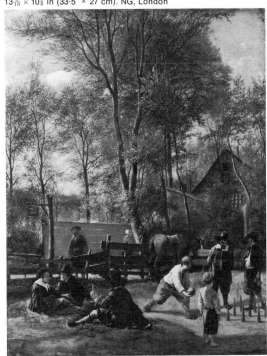

# THE 17th CENTURY IN EUROPE

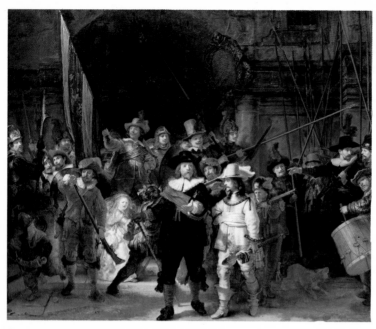

*The Night Watch.* 1642. 141⅜ × 172½ in (359·1 × 438·1 cm). Rijksmuseum, Amsterdam

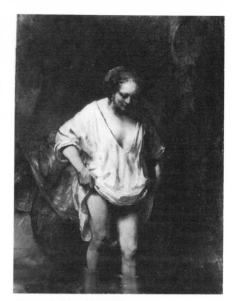

*Woman Bathing.* 1654. 24⁵⁄₁₆ × 18½ in (61·8 × 47 cm) NG, London

In 1609, when Spain reluctantly signed the Twelve Years Truce with its rebel Northern Provinces, Rembrandt van Rijn (1606–69) was three years old. As he grew up so the new Dutch Republic became one of the most powerful and rich trading nations the world has known. He was the son of a wealthy Leyden miller and after seven years at Latin School was enrolled at Leyden University when he was 14. But he soon turned to painting and went in 1624 to Amsterdam, the new nation's capital, to the studio of Pieter Lastman, who had worked in Italy and was able to introduce Rembrandt to the practices and the ideals of ▽ Italian Renaissance art. Rembrandt, who claimed he was too busy ever to travel to Italy himself, was soon recognised by his fellow-countrymen as a native genius who could rival the great masters of the past. It was a reputation he never lost, despite changes in taste and the folly of his own extravagance that eventually led to his bankruptcy in 1656.

ADAM ELSHEIMER *Flight into Egypt.* 1609. 12¼ × 16¾ in (31·1 × 42·5 cm). Louvre, Paris

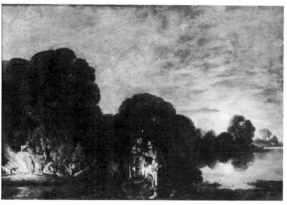

**History Painting.** In Rembrandt's day, the painters with the highest reputations were the ▽ Renaissance masters of 'history' painting (the 'histories' being episodes taken only from the Bible or Classical literature). But in the Protestant, bourgeois society of the Dutch Republic there was little patronage for a tradition of art associated with Catholic Empire. Yet Rembrandt painted a considerable number of history subjects, both from the Bible, and such pagan subjects as the *Abduction of Europa* and *Diana and Actaeon.* He was often inspired by prints and engravings after the Italian masterpieces he never saw in the original. His pictorial technique was inspired by ▽ Lastman and by the German ▽ Elsheimer, from whom he learned the secrets of ▽ Caravaggio's use of dramatic light and shade. But Rembrandt also developed the earthy realism that was so strong an element in the Northern tradition of painting.

The essential qualities of Rembrandt's art lie in the combination of dramatic realism, and subtly controlled light and shade, realised with consummate delicacy. For his pictures were not intended to decorate an altar or a grand apartment. They were □cabinet pictures, intended for a collector, a connoisseur, to pore over, meditate on, and to live with.

**Portraits.** Whatever may have been Rembrandt's ambitions for fame as a history painter, he was employed principally to paint portraits. His first success was a group portrait of Amsterdam surgeons known as *The Anatomy Lesson of Dr Nicolaes Tulp* (1632). Other commissions to portray merchants, pastors and other professional men and their wives followed. Although in later years commissions became fewer as Rembrandt became less willing to flatter his subjects, he painted memorable likenesses throughout his life, notably those of his friend the burgomaster Jan Six in 1654, and of the arms manufacturer Jacob Trip and his wife, Margaretha de Geer (*about* 1660).

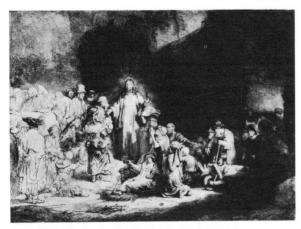

*Above: Christ Healing the Sick* (the Hundred Guilder Print).
*About* 1642–5. 11 × 15½ in (28 × 39 cm). BM, London

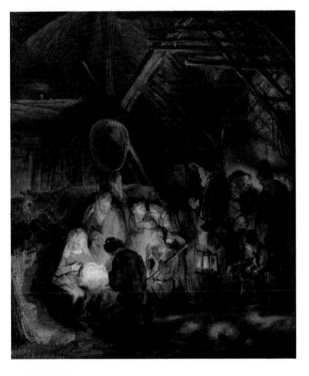

**Imaginary Portraits.** Rembrandt also painted many uncommissioned portraits. These included many self-portraits, from the time he was an industrious, ambitious student until he was old and already enfeebled. In others, that represent the same few models, Rembrandt was for long believed to have repeatedly used his own family, but it is generally accepted now that many of these half-length figures are 'imaginary portraits' of famous men and women of antiquity. Between 1652 and 1663, for a rich art collector in Sicily, Don Antonio Ruffo, Rembrandt painted the now famous portrait *Aristotle Contemplating the Bust of Homer*, followed by another of Aristotle's pupil, ▽ *Alexander the Great*, and a third of *Homer Dictating to a Scribe.*

**Etchings and Drawings.** Rembrandt was also a prolific print-maker, rivalling such earlier masters as ▽ Dürer and his fellow citizen, Lucas van Leyden. Until then, □ etching had simply been a quicker, easier alternative to copper □ engraving and largely used to make prints after paintings, but Rembrandt transformed it into a rich and subtle original medium, as eloquent as his own paintings. By this time, prints were collector's items, and Rembrandt was accused of deliberately creating different versions (or 'states') of the same design in order to increase his sales. In addition to Biblical illustrations, portraits and landscapes, he also treated many of the scenes of daily life that were in vogue, including picturesque beggars, rat-catchers and other street figures.

When he was neither painting nor etching, Rembrandt was drawing, and well over a thousand of these drawings survive. A few are careful studies in chalk, but the majority are rapid pen sketches. Many are compositional ideas of history subjects, but there are also many hundreds of incidents from daily life. Some of the most poignant drawings record the decline of his beloved wife Saskia to her early grave.

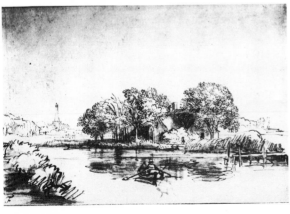

*Above: The Adoration of the Shepherds.* 1646. 25¾ × 21⅝ in (65·5 × 55 cm). NG, London

*Left: View on the Bullowijk looking towards the Ouderkirk with a Rowing Boat.* 5¼ × 7⅞ in (13·3 × 20 cm). Devonshire Coll, Chatsworth

# THE 17th CENTURY IN EUROPE

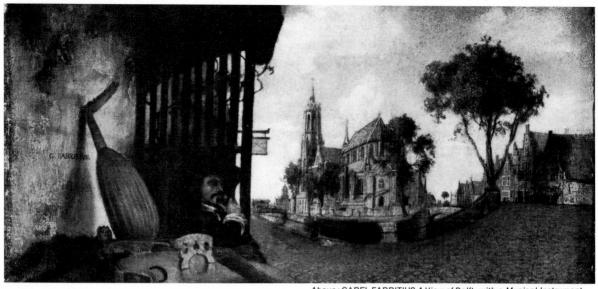

*Above:* CAREL FABRITIUS *A View of Delft, with a Musical Instrument Seller's Stall.* 1652. $6\frac{1}{16} \times 12\frac{7}{16}$ in (15·5 × 31·6 cm). NG, London
*Left:* GERARD TERBORCH *The Dancing Couple.* 30 × $26\frac{3}{4}$ in (76·2 × 69 cm). Polesden Lacey, Surrey National Trust

**Gerard Terborch** (1617–81). Some time during the 1650s, the paintings of barrack-rooms, inns and peasant households, so popular in the early years of the Dutch Republic, gave way to a new taste for tranquil, orderly, prosperous, domestic scenes. Nicolas Maes, ▽ Carel Fabritius and ▽ Pieter de Hooch were all associated with this new development, but among the older generation who turned to this new form was Gerard Terborch, who in his early career had specialised in barrack-room scenes and small-scale portraits of outstanding quality. Terborch excelled in the representation of silks and other fine fabrics, and his sumptuously dressed young women and elegant cavaliers in richly furnished interiors appear to reflect the increasing wealth of the Republic and the growth of luxurious tastes. But, perhaps for this very

reason, Terborch largely confined himself to a narrow range of subjects which were the images of the old moralising tradition in a new guise. He represents the pleasures available to the senses, but also warns of the folly of succumbing to them. In *Interior with a Dancing Couple*, the dance may lead to less innocent pleasures. But between the couple an open watch on the table measures the fleeting moments of sin against the Judgement of Eternity.

**Carel Fabritius** (1622–54) was another pupil of ▽ Rembrandt and one of the most talented. Though few of his works survive, his reputation was high before his early death in the explosion of the municipal arsenal of Delft. The influence of Rembrandt is most evident in his portraits, though they have their own distinctive technique. He painted in a variety of modes, but perhaps the most significant aspect of his vision is revealed in his *View of Delft*. This is a strange little panel: the violin in the foreground is large and very foreshortened, apparently out of scale with the lute and man in the middle distance, and in surprising contrast with the miniature view of Delft's New Church and Town Hall in the far distance. These unusual ☐perspectives are precisely calculated, however, and it is probable that the panel was designed to be viewed in a peepshow, similar to one by yet another of Rembrandt's pupils, ▽ Samuel van Hoogstraten. This concern for accurate perspectives of contemporary scenes prepared the way for other painters in Delft.

**Pieter de Hooch** (1629–84). In 1654, the year Fabritius was killed, Pieter de Hooch of Rotterdam was married in Delft, where he continued to work for several years. It was there that he became one of the first masters of the new style of domestic interior. He specialised in scenes of domestic virtue; the opposite, in many ways, of the pictures of ▽ Steen. In a quiet, well-ordered household, in which a succession of swept, neat, sunlit rooms may

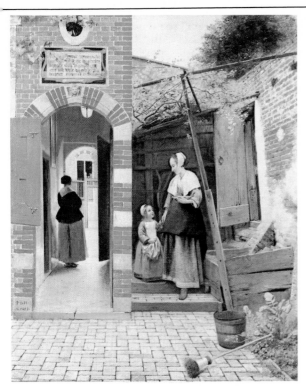

PIETER DE HOOCH *The Courtyard of a House in Delft.* $28\frac{5}{6} \times 23\frac{5}{8}$ in (73·5 × 60 cm). NG, London

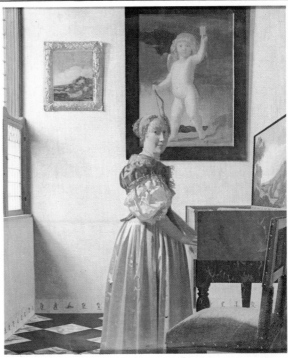

JAN VERMEER *Lady Standing at the Virginals. About* 1670. $20\frac{1}{2} \times 17\frac{3}{4}$ in (51·5 × 45 cm). NG, London

be glimpsed through open doors, a mother and child live in happy harmony. The woman offers milk from a jug, peels an apple or combs her daughter's hair.

De Hooch's paintings are remarkable for their □perspective. Like ▽ Fabritius and ▽ Hoogstraten, he was a master of pictorial geometry. Through the laws of perspective, Nature was at his command. Doors, shutters, corridors, and certainly movable furniture, are exactly where he wants them. Light falls where he wills. He was a wonderful inventor of spatial effects, and it is one of the chief delights of his art that the stubborn materials of the real world are ordered effortlessly into clear, abstract harmonies. His paintings have a pictorial order to match the domestic order of the households they depict – all in all, they are a celebration of spiritual and moral order.

**Jan Vermeer** (1632–75). Like ▽ de Hooch, Vermeer specialised in domestic interiors represented in careful □perspective. But Vermeer's technique was unique. Unlike any other painter before the 19th century, he rendered light with something akind to photographic objectivity. His drawing was reduced to the essential elements of patches of tone and colour, and those tones were graded in a regular, simple scale. Unlike his contemporaries, he did not vary his technique according to what he was representing: fabrics, woods, porcelain, metals, even flesh, all were treated in the same impersonal way. Such a highly objective, almost mechanical procedure suggests that he used a □*camera obscura*, a small cabinet with a lens in one side, in which he could sit and trace the image of the subject cast on his canvas

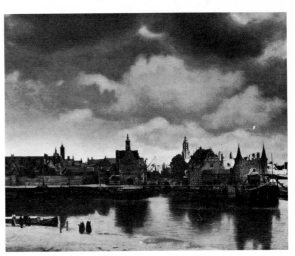

JAN VERMEER *View of Delft. About* 1658. $38\frac{7}{8} \times 46\frac{3}{8}$ in (98·5 × 117·5 cm). Mauritshuis, The Hague

by the lens. Such an apparatus was familiar by the 17th century, and Leeuwenhoek, the lens-grinder, was one of Vermeer's friends.

In another way, too, Vermeer's art is problematic. His preferred subject was a prosperously clothed young woman alone in a well-furnished room. Everything appears tranquil, harmonious, but it is impossible to be certain that, like de Hooch, Vermeer intends to reflect a harmonious existence, because he treats all the old traditional subjects, and in particular *The Love Letter* and *Music Making*, subjects that in the past had had strong erotic overtones. But in Vermeer's reticent, almost abstract compositions, it is impossible to guess what significance may lie hidden.

*Above:* JAN PORCELLIS *Dutch Ships in Storm.* National Maritime Museum

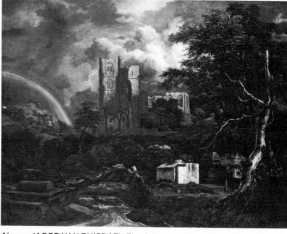

*Above:* JACOB VAN RUISDAEL *The Cemetery.* 56 × 74½ in (142 × 189 cm). Detroit Institute of Arts.

*Below:* AELBERT CUYP *Distant View of Dordrecht.* 62 × 77½ in (157·5 × 197 cm). NG, London

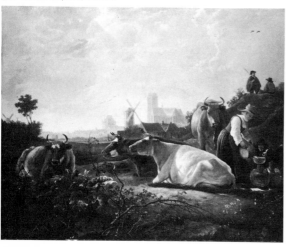

*Below:* MEYNDERT HOBBEMA *The Avenue: Middelharnis.* 1689. 40¾ × 55½ in (103 × 141 cm). NG, London

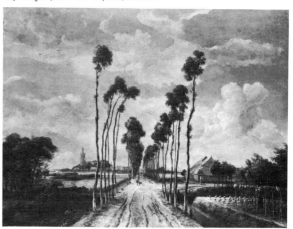

**Seascape.** The Netherlands had long been famed for its landscape painters, but early in the 17th century, in Haarlem, a school of landscape painting appropriate to the new Dutch nation was created by a group of painters who included Pieter Molijn (1595–1661), Esaias van de Velde (*about* 1591–1630), Salomon van Ruysdael (*about* 1600–70), Jan van Goyen (1596–1656) and Jan Porcellis (*about* 1584–1632). In contrast with the splendid, brightly coloured but highly artificial panoramas created by such earlier masters as ▽ Pieter Bruegel, this new generation painted small panels of sombre realism. They used low horizons, expanses of sky and a palette so muted that it was often in tones of grey or brown, called ☐grisaille. The favourite motifs of this time were canal banks and estuaries, but Porcellis specialised in marine subjects. He was part of a splendid tradition that had begun with Bruegel and Vroom and was to be continued by Vlieger (1600–53) van de Cappelle (*about* 1624–79) and the master of them all, Willem van de Velde the younger (1633–1707). But though many seascapes portray specific vessels and even important historical naval events, in his *grisaille, Dutch Ships in a Storm,* Porcellis appears to have intended an allegory of Faith, referring to Psalm 107, verses 23–8.

**Landscape.** Aelbert Cuyp (1620–91) was the oldest and one of the most brilliant of the generation of painters who, in the middle years of the century, developed and enriched the new Dutch realistic landscape. His early work followed the Haarlem tradition of low horizons and often bleak featureless stretches of water and dyke painted in muted colours. But he then began to paint bigger, more ambitious vistas, influenced by ▽ Rembrandt in their dramatic lighting. It was from Dutch landscapists working in Italy, influenced by the French painter ▽ Claude, that Cuyp discovered the golden quality of light that distinguishes his mature style. His favourite motif was a herd of cattle before a distant view of Cuyp's home town, Dordrecht, all gilded by the setting sun. Cuyp was one of the most versatile of landscapists, painting also splendid seascapes as well as occasional portraits and still-lifes.

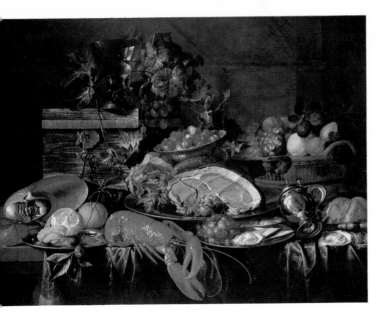

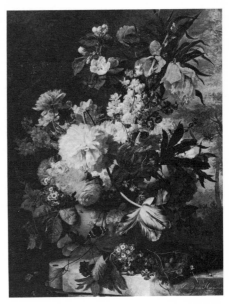

*Left:* JAN DE HEEM *Still-Life with a Lobster.* $31\frac{1}{4} \times 40\frac{7}{8}$ in (79 × 104 cm). Wallace Coll, London
*Right:* JAN VAN HUYSUM *Flowers in a Vase.* 1726. $31\frac{1}{2} \times 23\frac{3}{4}$ in (80 × 60 cm). Wallace Coll, London

**Jacob van Ruisdael** (1628/9–82) was undoubtedly the greatest Dutch landscape painter. He painted a far wider range of landscape subjects than any rival, including topographically accurate portraits of towns, quiet rural scenes, seascapes, panoramic vistas and wild, romantic mountain scenes. His work is always subtly composed and richly painted. He is the one landscapist who may justly be compared with ▽Rembrandt, both for the quality of his colour and light and also for his powerful sense of drama. His works have many moods, conjuring a variety of emotions in the spectator. Ruisdael was a strongly imaginative artist. His most splendid images of wild mountain landscapes with plunging cataracts were inventions, largely derived from the Scandinavian scenes of another Dutch landscapist, Allart Everdingen. His greatest and most solemn works are the two versions of the Amsterdam Jewish cemetery. The tombs are copied from an accurate drawing, but Ruisdael has set them in a wild, stormy landscape, beside a rushing stream, among lightning-felled trees by a ruined church, to create an image of universal death and – by the presence of a rainbow – of Hope.

Meyndert Hobbema (1638–1709) was Ruisdael's pupil but he had none of his master's versatility or imaginative vision. At a time when even landscape painting was divided into different types, each with its specialists, Hobbema was a specialist with only a narrow repertory. Yet, despite this, he was a considerable artist. What he did, he did superlatively well. He was a consummate draughtsman, able to paint a tree so that its limbs burgeon with vitality, its foliage scintillating in spring sunlight. Above all, he painted each work as if it were freshly minted and original. His most famous work is the accurate topographical landscape, *The Avenue at Middelharnis*, a view that was still recognisable until recently. Here the eye level and head height of the single figure coincide, a pictorial device that automatically produces a feeling of identification with the scene by the spectator.

**Still-life.** As in landscape, there were many types of still-life, each with its own specialists. There were flower pieces, breakfast pieces, banquet pieces, fruit pieces and even fish pieces. Some of the earliest still-lifes had an open religious significance: for example, a kitchen still-life would have Christ with Martha and Mary in the background. Another theme was the Vanitas, a reminder of the folly of all human endeavours and of the inevitability of death and the Last Judgement. Each object was emblematic: crowns and swords or books represented human ambitions; musical instruments were images of frivolous pleasure. These would be grouped round a symbol of mortality, typically a skull, but an hourglass, a watch, a guttering candle or a soap bubble would serve equally well.

One of the greatest of still-life painters was Jan Davidsz de Heem (1606–83), who worked in many styles. In his youth he worked in Leyden and adopted the frugal monochrome style of such Haarlem still-life painters as Pieter Claesz (1596/7–1661), and Jan van Huysum (1682–1749). But in the latter part of his life, he moved to Antwerp and effortlessly adopted the current exuberant ▽Baroque composition, piling his tables with mountains of food, especially exotic fruits.

| −5000 | −4000 | −3000 | −2000 | −1000 | BC 0 AD | 1000 | 2000 |
|---|---|---|---|---|---|---|---|

**1701** War of Spanish Succession.
**1703** John Wesley born.
**1705** Newcomens atmospheric steam engine, England.
**1710** Berkeleys 'treatise' concerning the Principles of Human Knowledge.
**1715** Accession of Louis XV (great grandson of Louis XIV).
**1718** Thomas Chippendale, furniture designer born.

**1724** Emmanuel Kant born. (d. 1804).
**1725** First steam engine in London, York Buildings Water Works.
**1728** First machine controlled by punched cards. Falcon's loom, France.
**1740** Accession of Maria Theresa, Austria. Accession of Frederick the Great, Prussia.
**1749** Goethe born. (d. 1832).

**1751** First volume of 'Encyclopedia' published, France. Clive's conquest of India begins.
**1753** Classification of plants by Linnaeus.
**1756-63** Seven Years' War.
**1762** Accession of Catherine the Great, Russia. J-L Rousseau, 'The Social Contract', France.
**1764** Voltaire's 'Dictionnaire Philosophique', France.

**1769** Napoleon born.
**1770** Beethoven born.
**1775-83** American War of Independence.
**1776** Adam Smith 'Wealth of Nations,' Britain. Declaration of Independence.
**1779** First iron bridge, England.
**1781** Kant's 'Critique of Pure Reason'.

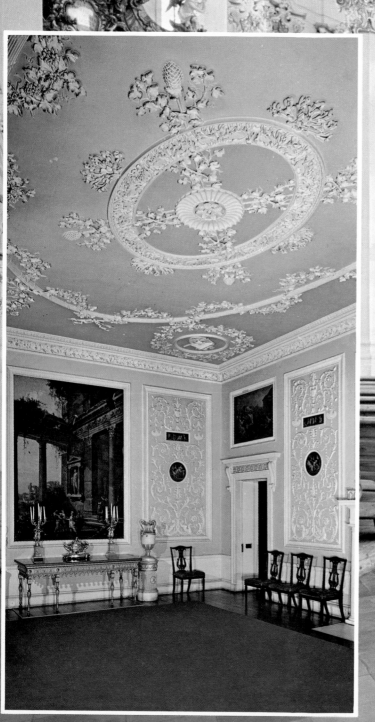

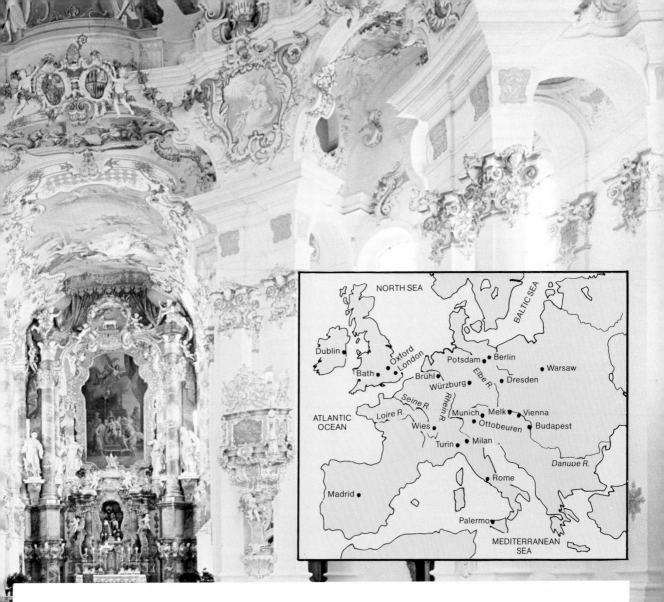

# The 18th Century in Europe

The 18th century shows the beginnings of the modern view of life as well as the final expression of Renaissance ideas. Religion ceased to be the focal point of all thought and the guide to all action, and the idea of 'Nature' replaced the idea of 'God'. It was the age of experimental and applied science, not only in agriculture and industry but also in politics, concluding with the drawing up of two constitutions, in France and America, which were entirely based on logical expediency without calling upon divine Providence.

It was also the age of classification, not only of plants, animals and the whole natural world, but of the arts and the emotional response to them, the new science of 'aesthetics'.

It was an attempt at classification which contributed to the crowning event of the century, the French Revolution. France still dominated European culture, and it was in France that the epoch-making 'Encyclopedia' was published, It attempted to classify all knowledge as it stood at that time, and all the leading radical thinkers contributed to it, calling into question such time-honoured ideas as the direct intervention of God in man's affairs, the existence of God, and the existence of royalty and aristocracy, of power as by right of inheritance. The intellectual turmoil that this engendered throughout the Western world has not yet abated. The whole of Europe was changed radically by the Revolution and its consequences, and the arts reflected that change.

The Renaissance may well be said to end with the eighteenth century; from that point on there would be no universal language for the arts based on Classical or any other styles.

# THE 18th CENTURY IN EUROPE

**Rococo** describes a style that captivated nearly the whole of Europe at the beginning of the 18th century. The term is not only applied to painting, but to architecture, music, theatre, literature and interior decoration. The term 'Rococo' was coined later, but it is related to the French word *rocaille*, meaning the rock work and shell work found in grottoes and gardens. The chief characteristics of the style are lightness, gaiety, playfulness and wit. In the visual arts the emphasis is on delighting the eye, without placing too great a demand on perception or intellect. The wide appeal of Rococo, both artistically and geographically, shows that in the broadest terms it was a style wholly appropriate to the mood of the age. Well before the turn of the century the authority of the Church and the belief in the ▽ Divine Right of Kings began to wane as both were called into question. There was a new spirit of freedom which, though not aggressive, was truly revolutionary. Enjoyment, and even a worship of nature in all its forms, replaced the old authoritarian creeds. Man, (and woman) was free, physically and intellectually, to move about his world as never before.

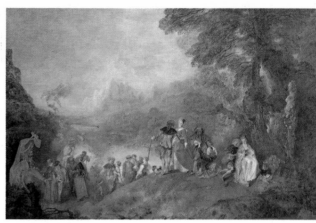

JEAN-ANTOINE WATTEAU *The Island of Cythera*. 1717. 51 × 76½ in (129·5 × 194·3 cm). Louvre, Paris

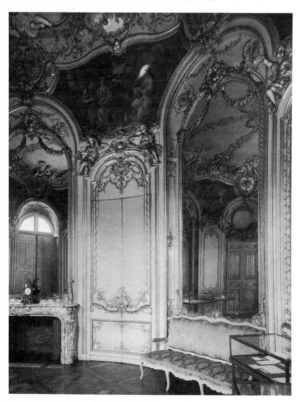

The Oval Salon at the Palais Soubise, Paris. 1736–9

**French Rococo.** The birthplace of Rococo was France. Even before the death of ▽ Louis XIV in 1715 French society had started to move away from ▽ Versailles and back to Paris. The Court was ceasing to be the absolute dictator of fashion and opinion, and the salons, cafés and clubs became the centres of intellectual life. The aristocracy began to build new town houses in a more graceful manner, free from formal columns and pilasters, where french windows permitted easy movement between the interior and cultivated nature outside. Above all the french window allowed the daylight to enter and play across decorated interiors. Carved mirrors reflected the light; curved walls eliminated dark corners. Delicate carved and gilded traceries, imitating the colour of the sun, scurried across white walls, uniting mirrors, paintings and furniture into a unified scheme. The paintings often portrayed pastoral themes and images of love. Light fittings, especially the chandelier, took on a new importance, and jewels and silks moved to catch both daylight and candlelight. The art of porcelain gained appropriate prominence, especially in charming figures of nymphs and shepherds. The enjoyment of leisure became a favourite pastime. French society played with nature, and much of their pleasure lay in the conscious recognition of the artificiality of their game.

**Jean-Antoine Watteau** (1684–1721) spoke directly to this society through a new type of picture, the *fête galante*, which showed man and woman in an earthly paradise, enjoying, literally in *galant* fashion, their mutual company. Watteau came from a humble background and in early life worked as a decorator helping to develop some of the motifs of Rococo. Then, with the influence of ▽ Rubens' paintings as a firm foundation, he developed as a painter, reaching maturity shortly after the death of Louis XIV. He was an acute observer of human nature, building up a large collection of drawings which were used in paintings whose delicate flickering brushwork belies the effort behind them. His masterpiece is *The Island of Cythera* (1717). Cythera (Cyprus) was the birthplace of Venus, goddess of love. Watteau shows the pilgrims ready to take their depature. It is a world owing much to the theatre where there is freedom to voyage between the realm of everyday experience and the realm of imagination. The love making is relaxed, as much intellectual as physical, and the women have the right to say 'no'. Watteau passes no moral comment, but as so often in his work, this picture carries an air of deep melancholy. The golden light indicates the close of day. Time passes and youth will become old age. This awareness of the brevity of life is a poignant reminder that Watteau was to die from tuberculosis only four years later at the age of thirty-seven.

# The Rococo

**François Boucher** (1703–70) has none of the acute perception and feeling for human nature of ▽Watteau, and his work often seeks to impress by its flamboyance and boisterous decoration. He played as influential a role in tapestry as in painting – he was appointed Director of the ▽Gobelins tapestry works as well as the coveted First Painter to the King under Louis XV – and he made models for the Sèvres porcelain factory. *The Rising of the Sun* (1753) was commissioned as a tapestry design by his patroness ▽Madame de Pompadour, the King's mistress. He considered this painting, with its companion, *The Setting of the Sun*, his greatest success. Watteau's elegantly dressed society has been replaced by naked gods and goddesses who fully understand, and grasp, the pleasures of physical love. Boucher avoids vulgarity by confining his eroticism to suitable mythological subjects: when he painted mortals they appeared comparatively reticent. The son of an obscure embroidery draughtsman he was an indefatigable worker, claiming to have done more than ten thousand drawings. Diderot the encyclopedist said of him 'He has everything except truth'.

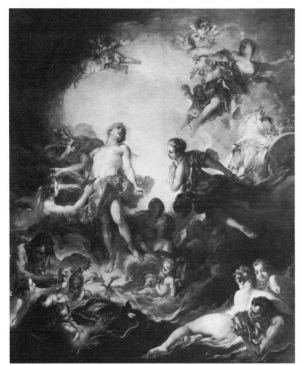

*Above:* FRANCOIS BOUCHER *The Rising of the Sun.* 126½ × 106½ in (351 × 270 cm). Wallace Coll, London

*Below:* JEAN-HONORE FRAGONARD *The Swing.* 1768. 32⅝ × 26 in (83 × 66 cm). Wallace Coll, London

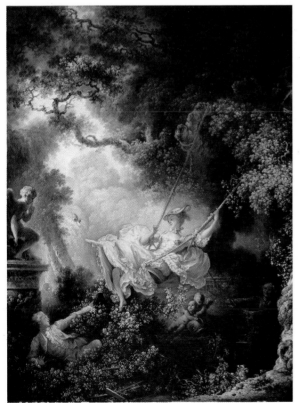

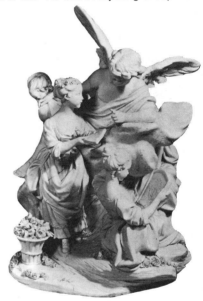

**Jean-Honoré Fragonard** (1732–1806). The death of ▽Madame de Pompadour in 1764 marked the beginning of the end of Rococo in France, but the style continued in the paintings of Fragonard. He began by copying ▽Boucher's canvases with great skill, and studied ▽Tiepolo in Italy. His star was in the ascendant during the reign of Louis XVI, and *The Swing* (1768) is typical of his successful style. It is a portrait of the Baron de St Julien and his mistress. The commission stated that she should be pushed on a swing by a bishop, and that the Baron should be in a position to see her legs. The landscape effervesces with unnaturally fertile vegetation, and mortals taste the fruits of love which Boucher reserved for the gods. The development from ▽Watteau's earthly paradise is clear, and it did not last long. By 1771 Fragonard's work became sentimental and moral, and when the French Revolution sent his patrons, ▽Louis XVI and ▽Queen Marie-Antoinette, to the guillotine he died impoverished and forgotten. (*See* Index for further references to Rococo.)

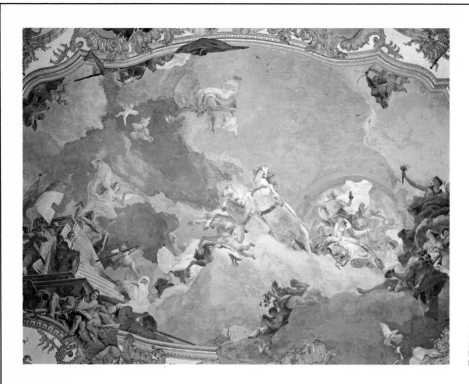

GIAMBATTISTA TIEPOLO *Apollo conducting Beatrice and Burgundy to Frederick Barbarossa*. 1751–2. Fresco in the Kaisersaal, Würzburg Residenz

**The Grand Tour.** No self-respecting artist, and no gentleman who had any claim to education, could afford not to visit Italy. These travels across Europe, often lasting several years, with Italy as the goal, are known as the ▽ Grand Tour. ▽ Dr Johnson said that a man 'who has not been to Italy is always conscious of an inferiority', and by 1769 there were said to be 140,000 Englishmen 'running up and down Italy'. A firsthand sight of ▽ Renaissance art and Classical Antiquity was the prize in an age when both were enormously influential, and accurate reproductions unknown. Florence offered the art galleries of the Uffizi and Pitti, and Zoffany's *Tribuna of the Uffizi* (1772–80) is a marvellous record of 18th-century taste and connoisseurship. It was commissioned by Queen Charlotte who had noticed Zoffany's domestic portraits and been impressed by them. Zoffany was given special privileges to execute the picture which shows the most famous room of the most famous gallery in Europe. In the room are the treasures of the ▽ Medicis, although Zoffany has exercised his artist's licence by adding some from the Pitti Palace and rearranging others. His final result would indeed have been a supreme experience for the English visitors whom he has included, and many of whom are recognisable. Rome offered architectural inspiration and statuary. Many works of art made the return journey to the private collections of those who undertook the Grand Tour, although the faking of antiques was no less common then than it is today.

▽ Venice was an obligatory call. The attractions were obvious: it was the great pleasure city of Europe, tinged with the exotic thrill of ▽ Byzantium, sparkling with light like ▽ Rococo decoration, and affording endless opportunities for amorous dalliance. Venice, too, had been the home of the great decorative artists and masters of colour. ▽ Veronese was an inspiration behind much Rococo painting and, in the early 18th century, the most

sought after living Italian painters were centered on Venice.

**Giovanni-Battista Tiepolo** (1696–1770). Although an accomplished easel painter, engraver and caricaturist, Tiepolo's crowning achievements are his great □fresco decorations. His style reflects the elegance, grace and lightness of ▽ Rococo: ceilings seem to disappear to reveal the sky itself and there is a recognisable playfulness and youthfulness in the angels and □putti, with a corresponding brilliance of brushwork and palette. But, for all this, he represents the ending of a tradition, rather than the future. He is the last of the great Venetian decorators. Tiepolo's work did not attract the patronage of the men who had broken free from the authoritarian beliefs of the previous century. Tiepolo stood by the ▽ Divine Right of Kings and the truth of the Catholic Church. His great commissions were to decorate palaces and churches and, in them, his art, in harmony with the architectural settings, exhilarates and overwhelms the spectator. Tiepolo's output was prodigious, achieved by his technique of painting sketches which, when approved by a patron, could be carried out by assistants whom he supervised. His first success was with the Archbishop's Palace at Udine. Commissions followed from all over northern Italy but his masterpieces are the decorations for the staircase and Kaisersaal of the Residenz at ▽ Würzburg. He was commissioned by the Prince-Bishop and spent three years there from 1750, helped by his two sons. In the *Marriage of Barbarossa* (1752) the □stucco curtain floats back to reveal an exotic and inaccurate pageant of an incident from the 12th century, the dress and behaviour owing more to the Rococo than the middle ages. In 1762, he went to Spain to decorate the Royal Palace in Madrid and, on its completion, re-

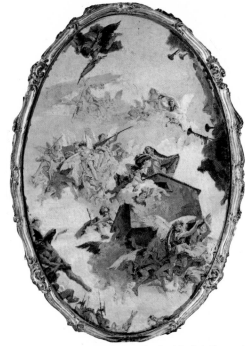

*Above:* GIAMBATTISTA TIEPOLO *The Miracle of the Holy House of Loreto.* 1743–4. $49\frac{1}{2} \times 34$ in (124 × 85 cm)

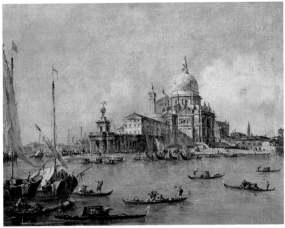

*Above:* FRANCESCO GUARDI *Venice: Sta Maria della Salute and the Dogana.* After 1770. $22\frac{1}{4} \times 29\frac{1}{2}$ in (56 × 74 cm). NG, London

*Below:* ANTONIO CANALETTO *Piazza San Marco.* 1730–5. $29\frac{9}{10} \times 43\frac{2}{5}$ in (76 × 114·5 cm). Fogg Art Museum, Cambridge, Mass.

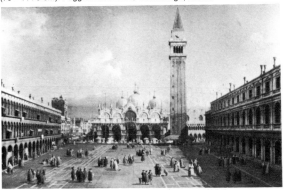

mained there to carry out a remarkable number of religious works. He died in Spain, but his last years were, unfortunately, not happy. Like so many artists, he was overtaken by changes in taste and fashion and his work was condemned as frivolous and insincere.

**Canaletto** (1697–1768). As well as works or aft by the old masters, visitors required souvenirs of their visit to Italy. Canaletto (Giovanni Antonio Canale), achieved considerable success with his views of Venice and the majority of his patrons were English. Rich clients often bought his pictures in large numbers; the Duke of Bedford bought twenty-four. He had a particular sensitivity for the play of light and shadow across water and architecture, but the increasing pressure of demand caused his style to become somewhat mechanical so that it could be easily taught to studio assistants and rapidly executed. His early training in the tricks of □perspective (he was the son of a theatrical scene painter) are easily detected, and he used a □*camera obscura* for preliminary drawings. Joseph Smith, British Consul at Venice, acted as his agent and in May 1745, after the War of the Austrian Succession had interrupted continental travel, Canaletto went to London to keep in contact with his English patrons. He remained until 1755, but his works of this period lack the flair of his earlier work and, after his return to Venice, he painted relatively few works. His nephew, Bernardo Bellotto (1720–80), achieved similar success, sometimes in competition with Canaletto. Bellotto travelled extensively in Northern Europe and finally settled in Warsaw, working for King Stanislas Poniatowski. His paintings of Warsaw were used by architects in this century when they restored the city to its former glory after its total devastation in the Second World War.

**Francesco Guardi** (1712–93) came from a well-known family of painters and, although he painted other subjects, his success was as a painter of views of Venice. These, like ▽Canaletto's, which influenced him, appealed to the tourists and were produced in great numbers, but Guardi's Venice is quite different from Canaletto's. He is not interested in the precise recording of architectural detail; and he had no qualms about adjusting a well-known scene or even inventing an architectural setting. Sometimes his churches seem almost ready to float away on a cloud of Venetian light and air, as if they were in one of the ceiling □frescoes of his brother-in-law ▽Tiepolo. Guardi's Venice extends beyond the squares and streets, into the islands and lagoons; for him the essential quality of Venice was not a familiar building or a fashionable crowd, but the magical flickering atmosphere that nature produces in the marriage of wide expanses of sunlit sky and water, so that no outline or building seems ever to stand still. In the same way, Guardi's brush flickers across the surface of his canvas with delicate transparent colours, momentarily suggesting the outline of a window or the prow of a gondola; as the spectator's eye hovers over one of his paintings he feels as though transported to the air of Venice herself.

# THE 18th CENTURY IN EUROPE

The peace of Westphalia in 1648 marked the end of the Thirty Years War in which Germany had been cruelly plundered and artistic activity brought almost to a standstill. The traditions of the artisans had been lost and many monasteries and castles destroyed. Although there were elected German Emperors, the Hapsburgs, who resided in Vienna, there was no German nation in the modern sense: the country was a patchwork of over three hundred independent States, bishoprics, free villages, and two kingdoms. Each prince and bishop had his own court, and was often ready to imitate the absolute style of ▽Louis XIV, even to the extent of creating his own ▽Versailles. Until about 1760 there was intense architectural activity as princes and bishops built palaces, churches and monasteries. China, tapestry and furniture manufacture was encouraged, and artists were brought in from Italy and France.

**Churches.** Southern Germany was Catholic and the influence of Italian church architecture remained dominant. Ground plans retained the oval motif of the ▽Baroque whose influence can also be seen in the façade of the Karlskirche, Vienna, begun in 1715. The architect was ▽Johann Bernard Fischer von Erlach (1668–1745), one of the most original architects of the time. He trained initially as a sculptor, but in Italy he turned to architecture, and was particularly influenced by the work of ▽Borromini. The tall soaring dome and the curiously stepped gables of the Karlskirche look back to the previous century, and the two columns are modelled on ▽Trajan's Column. They effectively assert the architect's freedom to select his ideas without strict regard for the rules and they are also the symbol of Imperial authority which, while undoubtedly pleasing the German Emperor, would not necessarily have found favour elsewhere in Europe. However it is in the interiors that German architects and craftsmen created a festive relationship between the visual play of French ▽Rococo decoration and the pomp of Baroque architecture which is quite unique and which represents the last great flowering of Christian art in Europe. Nowhere is this relationship more splendidly achieved than at the church of Vierzehnheiligen (so called because it was dedicated to fourteen saints), the masterpiece (1743–4) of ▽Balthasar Neumann. There is a great feeling of light and space; elaborate decorations link all parts of the building; curving walls seem to move and disappear as though anxious to lose their status as architecture, but lead inevitably to the climax of the High Altar. Vierzehnheiligen is a large church but such elaborate interiors did not necessarily demand huge spaces, or require that they should be announced by elaborate exteriors. The pilgrimage church known as Die Wies (1746–54) has a relatively plain exterior and is set among the meadows and mountains of Bavaria. The simple rustic setting is in complete contrast with the interior which is an ecstatic confection of white and gold, where cupids have been tempted in to play among the pulpit decorations. The same spirit (and similar naked cupids) appear in the pilgrimage church of Birnau above Lake Constance (*about* 1745) which is a single room whose □stucco decorations by Josef

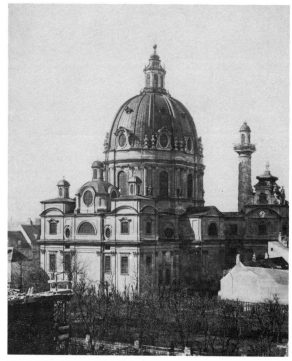

*Above:* FISCHER VON ERLACH *Karlskirche*, Vienna 1716–37
*Below:* DOMENIKUS ZIMMERMANN *Pilgrimage Church (Die Wies)* Bavaria. 1746–57

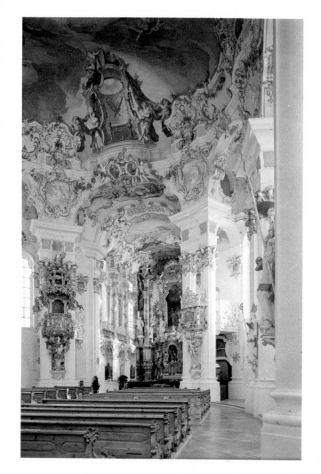

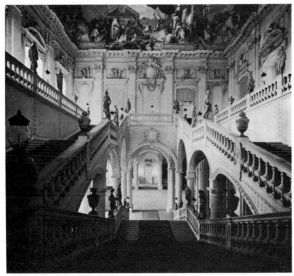

*Above:* BALTHASAR NEUMANN Central Staircase, Episcopal Palace, Würzburg 1719–44

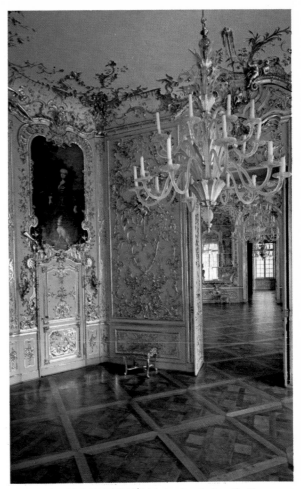

*Above:* FRANCOIS DE CUVILLIÉS Interior Amalienburg Pavilion, Nymphenburg, Munich 1734–9

Anton Feuchtmayer (1696–1770) are as unreal and playful as icing-sugar.

**Palaces and Gardens.** Both ▽Fischer von Erlach and ▽Neumann were employed as architects for palaces, and at ▽Würzburg (1737–44) Neumann achieved some of his most spectacular effects. The palace was commissioned by the Prince-Bishop of Franconia, and the large red sandstone building with its deep *Cour d'Honneur* illustrates the desire to emulate ▽Versailles. From the outside it has the same air of massiveness and sobriety, but just as the churches of the period do not necessarily show any continuity between exterior and interior, so Neumann feels no need to hint in the façade at the pleasures inside. It is the staircase, which was the artistic and ceremonial, as well as the physical centre of the German palace, that is the triumph. As the visitor ascends, space appears to expand around him both sideways and upwards, until it is crowned by ▽Tiepolo's magnificent ceiling □fresco in which the deceptively real crowds of people and their dogs seem anxious to step down from their painted architecture to the magnificent real architecture below.

Fischer's great rival Lukas von Hildebrandt (1668–1745) who like Neumann had been a military engineer, enriched Vienna with the Palace of the Belvedere (1721–4). Though undeniably German, it has a less formal attitude and is closer to French ▽Rococo with a design which consciously links Palace and garden.

Frederick the Great (1712–86) was the most enthusiastic admirer of French taste and civilisation in Germany (he collected ▽Watteau's paintings and knew Voltaire) and in his country retreat of Sans Souci (1745–7) near Potsdam he firmly embraced the French style. The design is generally considered to be by Frederick the Great himself. Pilasters have human figures and

vegetation sprouting from them rather over-exuberantly, although inside the long single-storey building a succession of rooms have traceries and ornament which show a decidedly French restraint.

The first use of French Rococo in Germany occurred outside Munich where the Elector of Bavaria built a small hunting lodge, the Amalienburg (1734–9), in the grounds of the Nymphenburg Palace. The architect was François de Cuvilliés (1695–1768), a court dwarf who had been sent to Paris to train as a decorator. Although the mirrors and curved walls remind one of the Hôtel de la Soubise (*see* pages 202–3), there is a riotousness about the decoration which places it firmly in southern Germany (Bavaria).

# THE 18th CENTURY IN EUROPE

**The Age of Reason.** The pursuit of truth and knowledge is one of the chief characteristics of the mid-18th century, gaining for it the epithet the 'Age of Reason'. Man believed that through the analysis of his world, and through the power of his own logical reasoning, he would come to terms with the secrets and problems of the universe. Physics, chemistry, biology, economics, philosophy, history, all took on a new maturity and significance.

**Joseph Wright of Derby** (1734–97) visited Rome in 1773–5. He was more impressed by fireworks and an eruption of Vesuvius than by Italian art. His friends were not writers or artists but practical men like ▽ Josiah Wedgwood, the pottery manufacturer. Wedgwood was a member of the Lunar Society which was founded by a group of Midlands intellectuals and included Erasmus Darwin, the grandfather of Charles Darwin. The members of the Society compared notes on the latest discoveries in the sciences, at first informally or by correspondence, but after 1780 they held regular 'lunar meetings' as Darwin called them, as they always took place on or near the full moon. Although Wright painted the portraits of some of the members he was not invited to join the Society, since he was not a professional philosopher or man of science. However his great picture, *Experiment with an Air Pump* (1768) summarises their spirit of scientific confidence. A bird has been placed in a glass bowl; as the air is pumped out it collapses to the point of death; when the air is replaced it revives. Man has control over life and death. Such demonstrations were often performed in private houses, not as research, but to popularise science. Wright's technique echoes his subject. The dramatic light effect from a single candle is precisely observed, and the scientific instruments are meticulously accurate.

**George Stubbs** (1724–1806) went to Rome in 1754 to prove to himself that 'nature is superior to art'. He too knew ▽ Josiah Wedgwood, with whom he experimented to produce enamelled china plaques as a better and more lasting paint surface. Stubbs is chiefly remembered as a horse painter. *Mares and Foals* (*about* 1760–70) shows perfect animals in an ideal setting, and although they could not have been created without painstaking scientific observation, they are also the work of a subtle imaginative mind. For a long period Stubbs withdrew to a deserted Lincolnshire farmhouse where he dissected a succession of carcases of dead horses, recording his findings with true medical precision. He published his work in 1766 in his book *The Anatomy of the Horse*, which is a true monument to his age.

**Sir Joshua Reynolds** (1723–92). Reason and analysis could be applied to art as well as nature, and as first President of the ▽ Royal Academy (founded 1768), Sir Joshua Reynolds delivered fifteen yearly ▽ Discourses to the students, urging on them a detached study of the old masters. The Discourses do not break new ground, but are a careful analysis of the standards of ▽ Renaissance art. They were enormously influential well into the next century. Imagination distinguishes the great artist, who is to express himself through the imitation of nature and the great Renaissance artists. Reynolds also laid down a category of desirable subjects. To be an artist in the □ Grand Manner (the summit of ambition) meant painting themes of heroic action or suffering based on Greek and Roman mythology. Animal painters like ▽ Stubbs, or painters of landscape, though not unworthy, came at the bottom of the list.

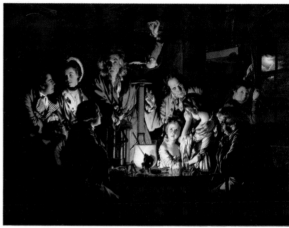

*Above:* JOSEPH WRIGHT *Experiment with the Air Pump.* 1768. $72\frac{1}{4} \times 96$ in (184·2 × 243·8 cm). Tate Gallery, London

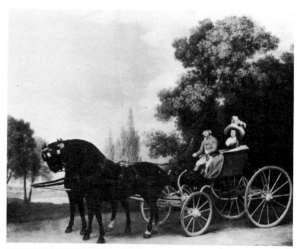

GEORGE STUBBS *A Lady and Gentleman in a Carriage.* 1787. $32\frac{1}{2} \times 40$ in (82·5 × 101·5 cm). NG, London

**The World of Dreams.** By the end of the century, the firm confidence in reason and analysis began to crumble. Nature continued to produce irrationally cruel disasters like the Lisbon earthquake (1755), and man continued to be motivated by illogical emotions. ▽ Reynolds, who had a romantic streak, put it cunningly: 'Reason without doubt must ultimately determine everything: at this minute [1786] it is required to inform us when that very reason is to give way to feeling'.

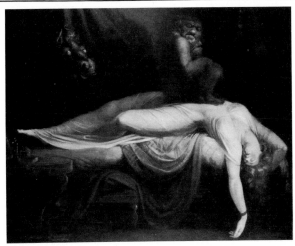

HENRY FUSELI *The Nightmare*. 1781. 40 × 50 in (101·6 × 127 cm).
Detroit Institute of Arts

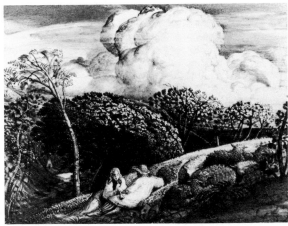

SAMUEL PALMER *The Bright Cloud*. 9 × 12 in (23 × 30·5 cm)
Tate Gallery, London

**The Nightmare Image.** Henry Fuseli (1741–1825) claimed that 'the most unexplored region of art is dreams', and the turbulent worlds of sadism, sexuality, death and hobgoblins run through his art. His painting *The Nightmare* (1782) points firmly to the new Romantic age where contemplation of the terrible was to become a source of pleasure. Fuseli was strongly influenced by ▽ Michelangelo (he spent eight years in Rome, much of it copying the ▽ Sistine Chapel), and the distortions and stylisations in his work owe nothing to the accurate observation of the natural world. This turning for inspiration to the private recesses of the inner mind, or the darker passages of ▽ Shakespeare, ▽ Dante, Milton and Northern Legends, became increasingly common as the century drew to a close, and there are stories of Fuseli eating raw meat in an attempt to fire his imagination – the very contrary of sober, rational behaviour. Nor was he alone in using artificial stimulants. Giovanni-Battista Piranesi (1720–78) in his *Carceri d'Invenzione* (1745) turned the ruins of Rome into images of terrifying prisons with endless stairs and corridors leading nowhere. It is possible that he (like some writers of the time) relied on opium to release these strange obsessions.

**The Pastoral Image.** William Blake (1757–1827) reacted strongly against the authority of reason and his copy of ▽ Reynolds' ▽ Discourses is peppered with his own infuriated comments. 'This man', he said, 'was hired to depress Art'. Thus, *Newton* (1795) was an enemy to Blake, circumscribing man's imagination with his rules and geometrical instruments, and he cast God in a similar role. Nevertheless, the pose he uses for Newton is borrowed from ▽ Michelangelo's ▽ Sistine Chapel, showing how even one of the most original minds still depended fundamentally on the ▽ Renaissance tradition. Blake is remembered as much as a poet as a painter and some of his most beautiful work is in the form of illustrations to his own writing. What Blake saw and recorded was a private mystical vision which, marvellous as it is, must to a large extent remain incomprehensible to outsiders. It was Samuel Palmer (1805–81), a follower of Blake, who between 1826 and 1835 found a perfect balance between an inner mystical vision and the outward observation of nature.

*Right:* WILLIAM BLAKE *Satan Arousing the Rebel Angels*
20⅜ × 15½ in (51·8 × 39·4 cm) Tate Gallery, London
*Below:* WILLIAM BLAKE *Newton*. 1795. 18⅛ × 23⅝ in (46 × 60·1 cm). Tate

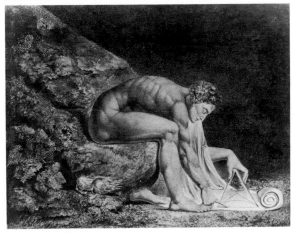

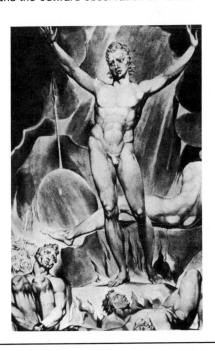

# THE 18th CENTURY IN EUROPE

**The Image of Man.** The Age of Reason gave man a new sense of dignity, and of individual responsibility for himself. He was afraid neither to see, nor to be seen. One one of the glories of 18th-century painting is British portraiture. No account is complete without the names of ▽Hogarth, Romney, Raeburn and Sir Thomas Lawrence, but pride of place must be given to ▽Sir Joshua Reynolds and Thomas Gainsborough (1727–1788). Nevertheless, although both were eminently successful as portrait painters, both had a first love in other branches of painting. Reynolds wished to paint the grand □History paintings which he urged upon his students; Gainsborough's first love was landscape, and sometimes working from little models in which he arranged parsley for trees and mirrors for water he produced exquisitely painted country scenes that show an idyllic union between peasants and bounteous nature. They are the closest that any English artist came to embracing the spirit of French ▽Rococo, but English society was not seduced. It wished for a record of its likeness, and to obtain it was prepared to wait on and handsomely reward these two artists. Much of Gainsborough's work was done in the fashionable resort of ▽Bath, and he worked without assistants, sometimes using candlelight to observe the softest gradations of tone. Reynolds employed studio assistants for drapery and backgrounds, and because of faulty technique many of his works have deteriorated sadly with time. There were rival factions in society who either supported or detested the styles of the two painters which are clearly contrasted in their portraits of Mrs Siddons, the leading actress of the day. Gainsborough painted a sensual and natural likeness (1785), lingering over her magnificent hat and fine clothes; he was well aware of the charms of a pretty woman, and preferred the sensual delights of music to the intellectual pleasures of literature. Reynolds, however, mixed with writers and intellectuals like ▽Dr Johnson. When he portrayed Mrs Siddons he showed her as the Tragic Muse (1784), borrowing a pose from one of ▽Michelangelo's figures in the ▽Sistine Chapel and flattering her by linking her with the gods of Antiquity. These two attitudes to portraiture, the one claiming the charm of natural truth, the other the benefit of educated associations, are typical of the age.

In France, Maurice Quentin de Latour (1704–88) followed the first attitude, capturing the fleeting expression with the coloured chalks of □pastel. In Italy, Pompeo Batoni (1708–87) followed the second path, painting fine portraits of the educated nobility, such as Lord Northampton, on the ▽Ground Tour.

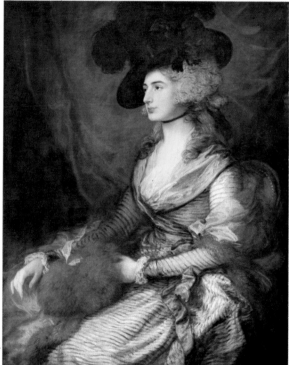

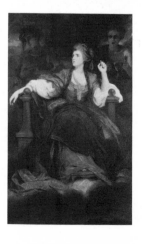

*Top:* JEAN-ANTOINE HOUDON *Voltaire.* 1781. Life-size. Théâtre-Français, Paris
*Centre:* THOMAS GAINSBOROUGH *Mrs Sarah Siddons.* 1785. 49½ × 39 in (125 × 99 cm). NG, London
*Bottom:* JOSHUA REYNOLDS *Sarah Siddons as the Tragic Muse.* 1785. 93 × 57½ in (236 × 146 cm). Huntington Art Gallery, San Marino, California

# Man and Enlightenment

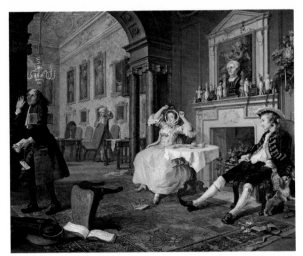

*Above:* WILLIAM HOGARTH *Marriage à la Mode: Shortly after the Marriage.* 1744. 27½ × 35¾ in (70 × 91 cm). NG, London

*Below:* THOMAS GAINSBOROUGH *Cornard Wood.* 1748. 48 × 61 in (121·9—154·9 cm). NG, London
*Bottom:* JEAN-BAPTISTE CHARDIN *Grace.* 1740. 19¼ × 15½ in (49 × 41 cm). Louvre, Paris

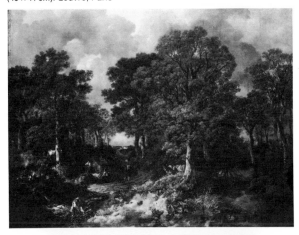

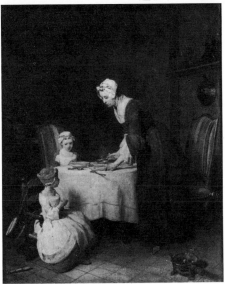

**Art and Morality.** William Hogarth (1697–1764) is often called the 'Father of English Painting', and he was the first English born painter of unquestioned European stature. He was a tough fighter, and the *Self-portrait with Pug* (1745) shows him plainly dressed, with fearless gaze, his hat pushed back to reveal the scar on his forehead. When foreign □history painters threatened to dominate, he competed with them; when foreign portrait painters appeared he did likewise, but his steadfast refusal to flatter sitters often failed to please.

Hogarth also secured for the first time a place in London where contemporary artists could show their work to fashionable society. His friend Thomas Coram had set up the Coram Foundation, a charitable institution to look after foundlings. Hogarth was a supporter and was elected to the governing body. He presented his magnificent full-length portrait of Thomas Coram to the Foundation and persuaded fellow artists to present examples of their work, knowing full well that society used the Foundation's house – the Foundling Hospital – as a meeting place. Its success opened the way to the eventual establishment of the ▽Royal Academy. Hogarth set out his aesthetic ideas in a book called *The Analysis of Beauty* but his supreme pioneering achievements are his Modern Moral Subjects, series of paintings which comment with biting frankness on the behaviour and morals of his age. They were extremely popular and engraved editions made by Hogarth himself were widely circulated. (He secured the passing of the first Copyright Act to prevent others pirating.)

Hogarth understood the seamier side of life. He was London born, and when a boy, his schoolmaster father had been imprisoned for debt. The first series, *The Harlot's Progress* (1732), tells the tale of the innocent country girl who, lured by the excitement of the town. falls into prostitution and dies a miserable death. Others followed. *Marriage à la Mode* illustrates the dire consequences of an arranged marriage. These works reveal, in their anecdotal presentation, Hogarth's love of the theatre and the writings of the satirist Jonathan Swift. They are superbly painted with a wealth of topical details, and Hogarth never missed the chance to have a dig at his enemies, such as ▽Lord Burlington.

Domestic scenes had, of course, been painted before, but what is new and typical of the 18th century is the variety of moral interpretations. Hogarth pokes fun at the bourgeoisie and man's weaknesses, but in fact makes no suggestion as to how they might be improved. In Venice Pietro Longhi (1702–85) showed a similar though less critical interest. In France Jean-Baptiste-Simeon Chardin (1699–1779) achieved success with bourgeois scenes of puritan simplicity. They too were widely known through engravings, and were understood to be morally uplifting. They show an idealised world where humility, sobriety, patient labour, and duty are the supreme virtues; and these words equally describe Chardin's brushwork, composition and colours. Jean-Baptiste Greuze (1725–1805), influenced by Hogarth, gave to his scenes of peasant life a tone of heroic virtue which was in full accord with the mood of his generation. The peasants show a natural, if over-sentimental goodness, and reassuringly show no hint of the Revolution that was to come, overtaking Greuze himself, so that he died impoverished and forgotten.

*Left:* PIERRE VIGNON and J-J-M HUVÉ The Madeleine Paris. 1806–42
*Right:* JACQUES-LOUIS DAVID *The Death of Marat.* 1793. 60 × 58⅜ in (165 × 128 cm) Musée Royaux des Beaux-Arts de Belgique, Brussels

**Neoclassicism.** Interest in Antiquity was quickened by the discovery, in 1748, of the remains of ▽Pompeii and ▽Herculaneum, the two Roman towns near Naples which had been buried alive by volcanic ash when Vesuvius erupted in AD 79. Sculpture, paintings and household articles were found, miraculously preserved, and gave an indisputable firsthand knowledge of Roman civilisation which in consequence seemed more closely linked to modern life than ever before. At the same time ▽Johann Joachim Winckelmann (1717–68), the German archaeologist and art historian, who was superintendent of the antiquities of Rome, expounded a theory which stated that beauty depended on calmness, simplicity and correct proportion – exactly those qualities to be found in Greek sculpture (*see* pages 44–5), and the opposite of those which characterised ▽Rococo. Indeed Rococo at its worst was undoubtedly frivolous and superficial so that a reaction was, in the end, inevitable. Winckelmann's writings had an enormous influence on those artists, painters, sculptors and architects, who throughout Europe adopted the Neoclassical style. But the wide appeal of their work rested not only on novelty, for in France in particular they spoke with feeling to a general mood. Neoclassical works recalled, as well as the austere style of antique art, the austere virtues of self-sacrifice, seriousness, and devotion to the Republic, and in a way that seemed immediately relevant. In France the generation which adopted Neoclassicism abolished the monarchy and founded a Republic in 1789, and this was the style that appealed so directly to the First Consul, ▽Napoleon Bonaparte.

*Below:* ANTON RAFFAEL MENGS *Parnassus with Apollo and the Muses.* 1761. Villa Albani, Rome

**Jacques-Louis David** (1748–1825) was the leading Neoclassical painter, and his famous *Oath of the Horatii* (1785), which, ironically, was bought by ▽Louis XVI, was resoundingly acclaimed when first shown in 1785. The subject did not have to be explained to any well-educated man of the time. The three Roman brothers, triplets, make their oath before going to their duel with the Curiatii, three brothers who represented Rome's enemies. The Horatii won the duel, thus saving the State; the last surviving of them then murdered his sister who was engaged to marry one of the Curiatii: loyalty to the State ranked higher than love of family. Such works had all the popular appeal and propaganda which the new French Republic was to require. David actively supported the Revolution and then in due course became a fervent Bonapartist. For two years he was virtually the Dictator of the Arts in the Republic. He abolished the Academy, and his design for a new civil costume based on Classical ideals illustrates how deeply his artistic ideas spread into all corners of daily life. When in 1793 the revolutionary leader Marat was assassinated by Charlotte Corday as he sat in the bath, David found a contemporary subject worthy of antiquity, and he commemorated the tragedy in a picture where every brushstroke declares the virtues of noble simplicity and patriotic devotion. Eventually David found himself on the wrong side in the complex power struggle of Revolutionary politics and was imprisoned, but he rose again under ▽Napoleon, producing paintings which celebrated the glories of the Empire, and heroic portraits of the Emperor. After the Battle of Waterloo and the defeat of Napoleon, David moved to work in Brussels, and eventually died there.

**Anton Raffael Mengs** (1728–79) was German, like ▽Winckelmann, whom he met in Rome in 1755. He was well regarded in his day, highly praised by Winckelmann, and taught ▽Goya. His style anticipates that of ▽David, but he has none of the fervent political and artistic conviction that causes David to stand alone.

**Neoclassic Sculpture.** The existence of Classical Greek and Roman sculpture gave the sculptor of the period a precise pattern from which to work. As a result Neoclassic sculpture has a clarity of form and idea which is not found in the painting or architecture.

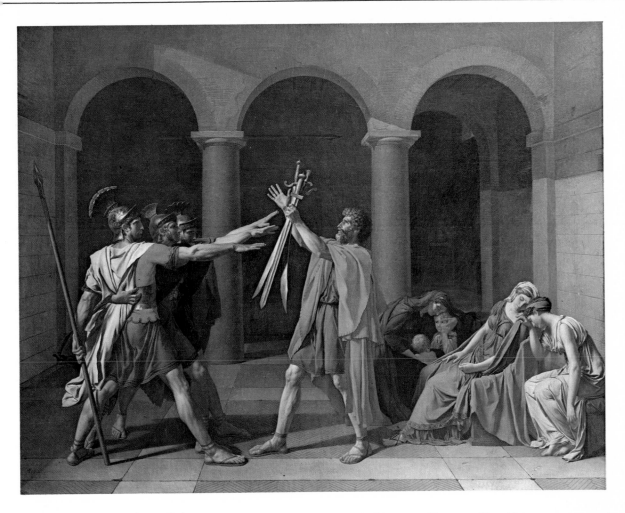

*Below:* ANTONIO CANOVA *Pauline Buonaparte Borghese as Venus.* 1804. Villa Borghese, Rome

Antonio Canova (1757–1822) was the leading sculptor. Born in Italy he became an admirer of ▽ Napoleon and translated his admiration into heroic Classical portraits of him and his family such as the marble of Pauline Borghese, Napoleon's sister.

Other Neoclassic sculptors are John Flaxman (1755–1826), who created for the newly founded firm of Josiah Wedgwood, Neoclassic □reliefs of great refinement, Jean-Antoine Houdon (1741–1828) perhaps the most sensitive sculptor and Berthold Thorwaldsen (1770–1844) a Danish follower of Canova.

**State Architecture.** The morality which was expressed in Neoclassical painting found an echo in the architectural projects of the Frenchman Claude-Nicholas Ledoux (1736–1806), who produced such visionary schemes as a Government Salt Works and an ideal industrial town. As so often happens with ideas that are wonderful in conception, they proved too expensive or impractical to build, and so remained unexecuted. Public buildings as far apart as the Bank of England in London and the New Admiralty in ▽ St Petersburg were built in the Neoclassical style, but the example of Classical architecture was particularly suited to the spirit of the new French and American Republics which wanted suitable buildings for their new government institutions whose names, Senate, Capitol, Tribunale, reveal their origins. ▽ Napoleon started to reconstruct the ceremonial centre of Paris, and his monuments still flank the ▽ Place de la Concorde. The Church of La Madeleine is conceived as a temple with a complete ▽ Corinthian colonnade. Originally designed as a temple of honour to Napoleon's troops, it was later turned into a church. Across the Seine a Classical portico was added to the ▽ Palais Bourbon which had become the legislative assembly, and at the head of the Champs Elysées, the Arc de Triomphe de l'Étoile (1803–1836) has a severity of design and symbolic presence which parallels the qualities of ▽ David's paintings.

213

# THE 18th CENTURY IN EUROPE

**Domestic Architecture.** In the 18th century Britain enjoyed a social and political stability which was often envied by leading philosophers on the Continent. Political power had passed from the monarch to Parliament, where the Whigs and Tories – the latter High Church and aristocratic, the former Low Church and supported by the gentry and the new successful merchants – were the rival parties. Each party favoured a different style of architecture. Between them they endowed the country with the great country houses which, with their contents, are one of the finest contributions to 18th-century art.

▽Blenheim Palace (1705–24) was designed by Sir John Vanbrugh (1664–1726) for the first Duke of Marlborough. The house and grounds were a gift to the Duke from a grateful nation for his military successes in Europe. The heavy imposing style looks back to the ▽Baroque and the building was designed to impress. As a house it was notoriously inconvenient to live in. Far different is the building which ▽Lord Burlington (1694–1753) added to his house at Chiswick to contain his state rooms. It is small, compact and practical, and epitomises the words 'good taste'. Lord Burlington, although born into the aristocracy, was a Whig supporter, and he had the standard classical education of the 18th-century gentleman, including the ▽Grand Tour. He became a highly influential leader of fashion, and his *Rule of Taste* which stated clearly what was permissible in architectural design appealed to the Whigs. These rules derived principally from▽Inigo Jones (1573–1652) and▽Andrea Palladio (1518–80), the outstanding Venetian architect whose books on architecture were translated into English by Giacomo Leoni (1686–1746). Lord Burlington was introduced to Palladian architecture by the Scots architect Colen Campbell (?1676–1729) and Chiswick House is, in fact, a reduced version of Palladio's famous ▽Villa Rotonda. The Palladian villa and house were to become major features of the English countryside. The English tended to spend their money and creative energy on their country estates, treating their town houses as subsidiary residences. (The French did the reverse.)

The Palladian style was an intellectual one, aiming to please by perfect proportion, and it contrasts with French Rococo (*see* pages 202–3), whose articiality was scarcely suited to country houses, and German Rococo (*see* pages 206–7), whose palaces and Catholic associations would have been anathema to the Whigs. The Palladian formula could be adapted to suit almost any scale of house, and offered practical solutions to problems of planning. In the largest houses, the family would have a wing or ground floor reserved for their every-day living, and open the public rooms when required; and in the smallest houses a neat arrangement of the small rooms gave the owner the confidence of being absolutely correct in matters of taste. This practical ease of living was also reflected in furniture.

The idea of correct taste is one aspect of the self-awareness which people acquired during the century. A consciousness grew that different ages and generations had characteristic styles of their own and Horace Walpole (1717–97) demonstrated in his 'gothick' house at Strawberry Hill near London how rules of taste could, consciously, be changed. (Walpole was the son of the first Whig Prime Minister who of course had a Palladian country house.) The new appeal of Strawberry Hill, built from 1748, lay in its romantic associations and it was part of an enthusiasm for exotic or rustic buildings which were intended to appeal to feeling rather than to intellect.

Neoclassicism was self-conscious as a style and the passion for antiquity affected British domestic architecture. Kedleston Hall, Derbyshire, shows how easy was the progression from Palladianism. The villa idea is still there, but a triumphal arch, with all its Classical associations, has been added. Kedleston was the work of ▽Robert Adam (1728–92) who with his younger brother James developed a highly refined style based on Greek and Roman buildings and the decorations of ▽Herculaneum and ▽Pompeii. Their light and flat plaster decoration had particular appeal for small town houses, as well as the attraction of relative cheapness.

*Above:* LORD BURLINGTON and WILLIAM KENT Chiswick House, London. *About* 1720

*Above:* ROBERT ADAM and others Kedleston Hall, Derbyshire. *About* 1760

*Below:* JOHN WOOD THE YOUNGER Royal Crescent, Bath. 1767–75

# Architecture, Gardens and Town Planning

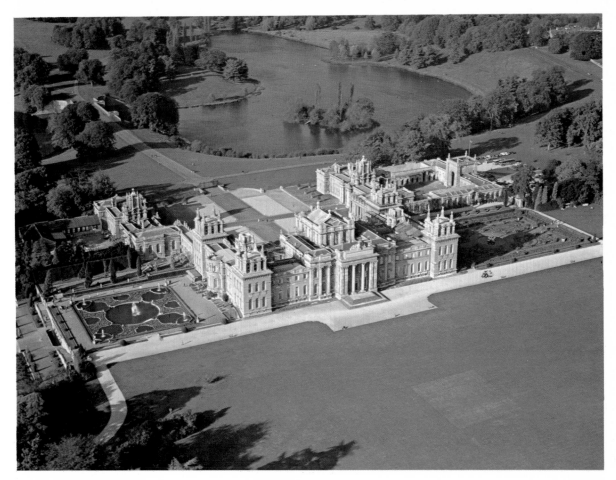

*Above:* SIR JOHN VANBRUGH Blenheim Palace, Oxfordshire. 1705–24
*Left:* The Village, Petit Trianon, Versailles. 1783

**Town Planning.** Increased prosperity meant the expansion of the towns, but different social circumstances saw different attitudes to town planning. Paris, for example, witnessed the development of spacious State plans like the ▽ Place de la Concorde and L'Étoile. The French nobility built independent *Hôtels*, and the bourgeoisie lived in one-floor apartments. In London, on the other hand, nobility and merchants were content with the elegant terrace houses which formed the new exclusive squares that spread northwards from Westminster. Nor were provincial towns neglected. Bordeaux and Reims adopted Parisian examples, and in fashionable ▽ Bath, John Wood the Younger (1728–81) adapted ▽ Palladian principles to the town house, producing the gracious regular crescents which to this day remain one of the supreme achievements of town planning.

**Gardens.** The century's worship of nature spelled the end of the formal geometrical garden. William Kent (1685–1748), a leading member of ▽ Lord Burlington's circle, transformed the relationship between house and garden, and he saw how the countryside could be moulded to resemble a landscape in a painting by ▽ Claude. Such an approach is evidently artificial, and it contrasts with that of 'Capability' Brown (1716–1783) who moulded the countryside to create the illusion that his man-made cascades and lakes, as at Blenheim, were the work of nature herself. Both attitudes, however, presuppose the new and confident relationship with nature, and a scientific understanding of horticulture. The picturesque English garden spread to Europe, and became especially fashionable in France. The most famous example is ▽ Marie-Antoinette's *village* at the Petit Trianon, ▽ Versailles, where she and her courtiers played at the simple rustic life.

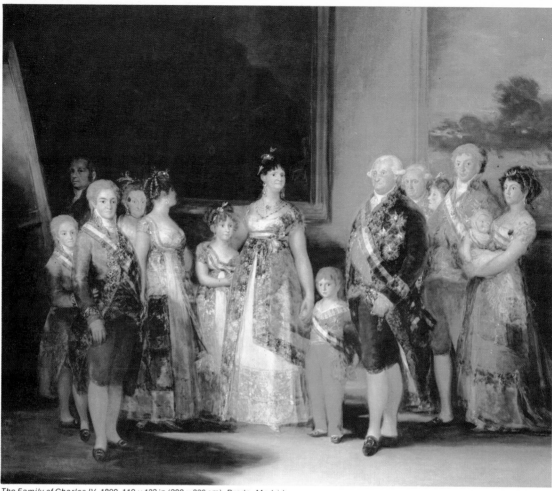

*The Family of Charles IV.* 1800. 110 × 132 in (280 × 336 cm). Prado, Madrid

**Francisco de Goya** (1746–1828). From time to time there appears an artist who has the ability to bring together the experience of both the past and his own age with such insight that his work continues to speak profoundly and forcefully to future generations. Such a man of genius was Francisco de Goya y Lucientes.

He was born in Spain and spent most of his life there. From the past he drew on the experience of ▽ Titian, ▽ Rubens and ▽ Velasquez. From his own century he knew of ▽ Rococo from ▽ Tiepolo; of ▽ Neoclassicism from ▽ Mengs; and of English portraiture (*see* pages 210–11) and caricature from engravings. In 1771 he paid a short visit to Rome.

**Early Life.** Goya was a successful artist in his own life-time, becoming Deputy Director of the Madrid Academy in 1785, and First Painter to the King of Spain in 1789. His early work expresses with delicate brushwork and glowing colours the charm and delight of the earthly paradise that was so much a feature of ▽ Watteau's art. *The Harvest* (1768) was painted as a cartoon for a tapestry (Goya was principal painter of the Royal Tapestry Works at the age of thirty and produced sixty-three cartoons), but even in a work so apparently carefree Goya reveals

an underlying awareness of the human condition. Behind the principal characters, peasants toil in the vineyards: the earthly paradise must be paid for by somebody; and the pleasure of the family is very simple. For Goya they are first and foremost human beings. Other artists, ▽ Boucher for example, sentimentalised the harvest or introduced Bacchus, god of wine, but Goya firmly declines to use such conventions.

**Portraits.** Indeed one of the characteristics of Goya's art, and perhaps unique in the 18th century, is his revelation of the isolation and vulnerability of the human being. Even when he painted a military giant like the ▽ Duke of Wellington (1812), he portrayed him not as a hero, but alone against a stormy background, his face showing all the doubts, hopes and fear which are a never-changing feature of humanity. The famous group portrait *King Charles IV and his Family* (1800), (Goya includes himself at his easel on the left) also reveals a collection of human beings as imperfect as any less exalted family. Other artists would have flattered their physical appearance or their rank, but so acutely perceptive of human nature is Goya that critics have sometimes made the mistake of thinking that he was attempting to caricature his sitters.

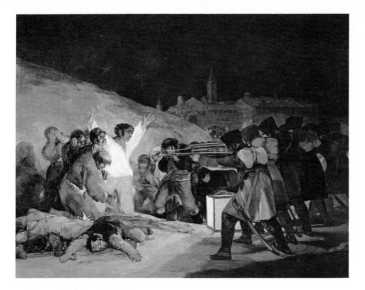

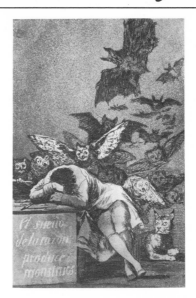

*Above: The Executions of the 3rd of May 1808.* 1814. 105 × 135 in
(266 × 345 cm). Prado, Madrid
*Above right: The Sleep of Reason Brings Forth Monsters.*
Title page to the *Caprichos* series of engravings. 1793–9. BM,
London
*Right: What More Can One Do?* from the *Disasters of War*.
1810–13. BM, London

**The Sleep of Reason.** In 1792 Goya suffered an illness
which must have tragically increased his awareness of
man's isolation and vulnerability. He suddenly went
stone deaf. To occupy his convalescence he painted a
few satirical works, and in 1799 he published *Los
Caprichos*, eighty prints, in the new medium of □aqua-
tint which allowed subtle shading, savagely attacking
society and the Church. Attacking society was not new.
▽Hogarth, for example, had done so, but whereas the
human weaknesses he portrays are essentially English
and 18th-century, Goya's observations and judgements
transcend the barriers of time and place. The frontispiece
of *Los Caprichos* shows Goya asleep. The inscription
reads 'The Sleep of Reason Brings Forth Monsters', and
nightmarish creatures flutter in the background. How-
ever these are not the monsters that caused ▽Fuseli's
heroine to swoon in ecstasy and Goya does not believe,
like ▽Blake, that Reason threatened to extinguish the
artist's private inner vision. Goya believed that man
could benefit through the proper use of his intellectual
abilities, (he admired Voltaire), but he also knew what a
heartbreaking struggle that could be. Other artists of the
century could, and did, show with great conviction one
aspect of human personality: The Man of Reason; Moral
Man; the Man of Dreams; the Descendant of Antiquity;
the partner of Nature. But only Goya expresses the
knowledge that man is a complex combination of all these
personalities which are continually, and sometimes
destructively, competing for priority.

**The Disasters of War.** In 1808 the reactionary Charles IV
abdicated, and ▽Napoleon's troops invaded Spain.
Like other Spanish intellectuals Goya welcomed the
revolution and looked to France as a fountain of en-
lightened civilisation. It was a dream. Napoleon's troops
behaved with unprecedented savagery. Goya recorded
their activities in a series of etchings called *The Disasters
of War* (1810–13), which are a terrifying commentary on
the bestiality of man. The etchings were not published
until 1863, after Goya had died, but he also recorded in a
brilliantly original painting, the *Third of May 1808* (1814),
an incident in the systematic massacre of five thousand
Spaniards by the French troops. Yet agonising as these
works are to look at, they are also curiously impartial, for
even in such scenes Goya simply allows the individual
to speak for himself without imposing any preconceived
notion or judgement.

The ▽Duke of Wellington drove the French from Spain
and Goya went back to work for the Spanish Court. His
power as an artist continued to develop until the end of
his life when he retired to France as opposition against
the Monarchy increased again. He died in voluntary
exile in Bordeaux, described by a friend as 'deaf, old,
awkward and feeble . . . and so happy and eager to see
the world'. It is that surviving optimism which is, in the
end, the great hallmark of the 18th century. (*See* Index
for further references to Goya.)

# NORTH AMERICA

Map of North America showing:

Yukon R.

ALASKA

CANADA

Seattle
San Francisco
Los Angeles
El Paso
Rio Grande
MEXICO

PACIFIC OCEAN

Winnipeg
Missouri R.
St. Louis
Kansas City
Ft. Worth
Dallas
Houston
San Antonio

Chicago
Detroit
Pittsburgh
Baltimore
Richmond

Quebec
Montreal
Toronto
Boston
New York
Philadelphia
Washington
Norfolk

New Orleans
Jacksonville
Miami

CUBA

ATLANTIC OCEAN

North America, with the temperate climate of the Eastern States so like that of Europe, seemed to the early settlers to be an unspoiled, undeveloped home from home–or even more, a potential new Garden of Eden. It attracted refugees and idealists from the very beginning of colonisation, who had hopes of founding a new life in a new country.

In the New England States first Dutch, then English Protestant zealots attempted to set up a community under religious laws and the government of Puritan pastors, a theocracy.

Further south, in Virginia and Carolina the opposite happened. Here it was Cavalier and Royalist refugees who tried to rebuild an aristocratic way of life on estates and plantations, where they imitated the life-style of English country gentlemen.

Both Puritans and Cavaliers were to see their ideals founder under the impact of reality, but each form of idealism produced its own art, architecture, music and literature. Conflicting idealism also inspired and divided the politics of the new Republic, eventually leading to the War between the States and a subsequent new westward migration.

As long as North American culture was centred on the Eastern States, its practitioners would look back to Europe. It was the American West, and contact with both Nature and the inhabitants there, particularly the old Spanish colonists, that finally liberated the American arts from provinciality. It was as if a wave of energy reached the West Coast, then broke and rolled back to rejuvenate the East.

| −5000 | −4000 | −3000 | −2000 | −1000 | BC 0 AD | 1000 | 2000 |
|---|---|---|---|---|---|---|---|

**1492** Discovery of New World by Columbus.
**1587** Colony of Virginia founded.
**1620** Mayflower sails for Massachusetts.
Colony of Massachusetts Bay.
New England Charter.
**1643** United colonies of New England incorporated.
**1664** New York colony founded.
**1732** Last English colony, Georgia, founded.

**1760** Spanish driven from Florida.
**1773** Boston Tea Party.
**1775** Outbreak of War of Independence.
**1776** Declaration of Independence.
**1783** End of War of Independence.
**1787** American Constitution adopted.
**1789** George Washington elected first President.

**1803** Louisiana purchase from France.
**1812** War with England.
**1820** Division and limits on slavery between North and South.
**1830** Earliest American railroads.
**1838** Atlantic crossed by steamship.
**1844** Samuel Morse invents telegraph.
**1846** War with Mexico, annexation of Texas.

**1847** Mormons found Salt Lake City, beginning of western colonisation.
**1860** Secession of South Carolina from Union: Lincoln elected president.
**1861** Outbreak of American Civil War.
**1865** End of Civil War: Lincoln assassinated.
**1875** Civil Rights Bill.
**1895-98** Spanish American War.
**1907** Work begun on Panama Canal.

# NORTH AMERICA

**The Early Settlers.** The 17th century saw the first concerted and successful attempts by Europeans to settle in the United States, but the problems and time-consuming difficulties of creating new communities in a new world did not leave the settlers much leisure or energy to devote to the visual arts. However, by the second half of the 17th century a tradition of native American painting was developed by the practical artisan artists who gathered in the metropolitan centres of New York and Boston. The self-portrait by Captain Thomas Smith of about 1690 and the portrait of Margaret Gibbs of 1670 show the mixture of styles from Europe that was to be basic to the development of American painting. The pictorial realism of Anglo-Dutch painting is married to such traditional European conventions as the open window in the corner of the Thomas Smith portrait, adding an idea of space.

Most 17th-century American portraitists relied on engravings from European originals to provide them with the basic structural framework for their portraits; ideas of composition, poses, and details of dress. Often only the heads were taken from life. These mainly anonymous artist-copiers did not receive positive encouragement from American puritans as there was, stemming from religious beliefs, a general disapproval of visual images. Religious revelation was to come through the written scriptures, not through allegorical imagery. The only area of visual expression officially excluded from this general prohibition were the gravestone carvings where images of life and death, strength and fortitude were symbolised.

However there were other outlets for pictorial expression and a vigorous vernacular tradition of decoration flourished in the form of heraldic devices, inn and shop signs, coach and furniture ornamentation. Not all the American puritans were dour religious zealots dressed in black. The colourful portraits of Elizabeth Freake and her child (*about* 1674) reveals a growing informal worldliness in American portraiture. The portrait was commissioned by her husband John Freake, a Boston attorney, merchant, and shipowner, to demonstrate his social status. With the increasing wealth of the American colonies, American artists by the end of the 17th century began to find patrons like John Freake. By 1690 Boston was a flourishing port of 7,000 inhabitants and the thriving communities of New York and Philadelphia both numbered 4,000. These metropolitan centres of industry and commerce created the conditions for a more stable system of art patronage.

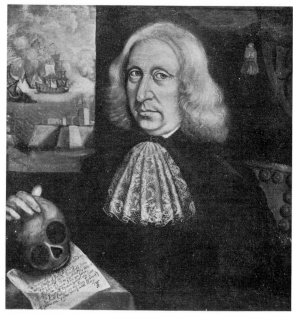

THOMAS SMITH *Self-portrait. About* 1690. $24\frac{1}{2} \times 23\frac{3}{4}$ in (62·2 × 60·3 cm). Worcester Art Museum, Massachusetts

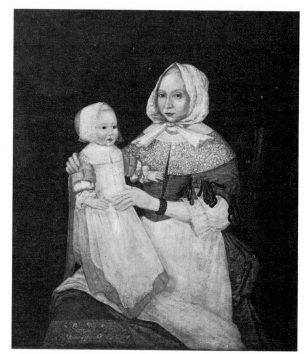

*Above:* ANONYMOUS *Mrs Elizabeth Freake and Baby Mary. About* 1674. $42\frac{1}{2} \times 36\frac{3}{4}$ in (108 × 93·3 cm). Worcester Art Museum, Massachusetts
*Left:* John Eliot's Church, mid-18th century. South Natick, nr Boston, Massachusetts

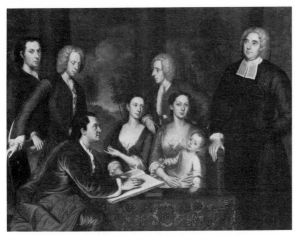

JOHN SMIBERT *Bishop Berkeley and his Family*. 1729. 69½ × 93 in (176·5 × 236·2 cm). Yale University Art Gallery

## The First American Painters.

The second period of American colonial art is characterised by two main features, first the establishment of a native group of artisan artists, and secondly the influence of visiting artists from Europe commissioned by some wealthy Americans to stay with and paint their families. The native American artists, though still copying European models gave their paintings a strong individualism indicated by severe lines and box-like proportions within the painting. The portrait of Ebenezer Devotion by Winthrop Chandler (1770) used a background of books both to symbolise learning and to provide a strong element of design. These artisan artists advertised a variety of services for the community – glass-painting, gilding, as well as portraiture. They occupy a middle group between the fine artists and the applied practical arts that has been a strong and characteristic feature of the American visual arts.

The visiting artists from Europe included Gustavus Hesselius who settled in Philadelphia in 1712 and Charles Bridges who arrived in Virginia in 1735 and painted the Byrd family and other southern families, returning to England in 1740. One of the most accomplished artists of this group was John Smibert who in 1728 crossed the Atlantic as the Professor of Art and Architecture attached to Bishop Berkeley's visionary project to found a college for the education and conversion of Indians in Bermuda. The project failed but Smibert settled in Boston in 1730 and created a studio full of European paintings which became a mecca for future American artists such as ▽Copley, ▽Charles Peale and ▽Trumbull. The unsuccessful Bermuda project was the origin for Smibert's most famous American painting *The Bermuda Group* (1729), which depicts Berkeley and his associates. The painting set a style for group portraits in America, combining ▽Baroque elements in direct imitation of ▽Sir Godfrey Kneller. In America the social image of the sitter was of prime importance to indicate social status. Most wealthy Americans of this era wanted to add an aristocratic bearing and life style to their merchant or

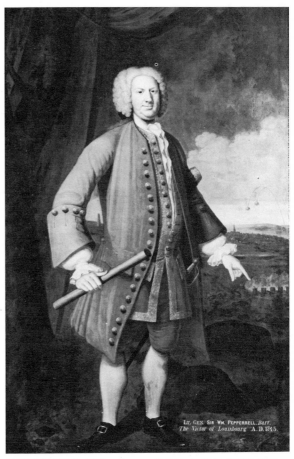

JOHN SMIBERT *Sir William Pepperrell*. Essex Institute, Salem, Mass.

land-owning affluence. In New York a group of artists known as the □ 'patroon' painters flourished in this genre of status painting between 1715 and 1730. Other important portrait painters of this era were Robert Feke (1706–50), Joseph Badger (1708–65), and John Wollaston (active in America 1749–58).

The process of colonisation involved several distinctive European cultures. On the far west coast of California was Spanish Roman Catholic ▽Baroque, in Canada and Louisana were the French of ▽Louis XIV and XV, and on the east coast were the Dutch and English.

The latter were to be the strongest and most lasting influence. Two distinct streams of English settlers were seeking their own version of a 'Garden of Eden' in the New World. In New England, along the coast and up the Hudson River Valley the Puritans hoped to build a pious theocratic state free from persecution and based on their own fundamental religious principles. Further south, in Virginia, were settlers expecting to lead the life of rich English gentlemen on plantations and estates, in almost complete opposition to the ideals of their Puritan neighbours. All looked back to the Old World for their culture. The Puritans built sober Anglo-Dutch houses and churches in neat little towns. The Virginians looked to the court of Charles II and built in the manner of Sir Christopher Wren.

# NORTH AMERICA

**The New Republic.** The next generation of American painting coincided with the formation of a Republic, which was politically independent of the British crown. This emerging confidence can be seen in the work of the two major artists of the period, both born in 1738, John Singleton Copley and Benjamin West. These two artists extended the range of subject matter in American painting to include historical, mythological and landscape subjects as well as the traditional portrait. Copley's aspirations and attitude to the role of the painter in the colonies can be seen in his own remark: 'was it not for preserving the resemblance of particular persons, painting would not be known in the place. The people regard it as no more than any other useful trade . . . like that of a carpenter, tailor, or shoemaker, not as one of the most noble arts in the world'. Both artists realised their ambitions to raise the status of the artist in America. Benjamin West moved to Europe in 1760, eventually becoming President of the Royal Academy in 1792. Copley remained in America until 1774, becoming the foremost portraitist in New England.

**John Singleton Copley** (1738–1815). Copley's painting career in America as part of Boston's elite exhibits two of the fundamental characteristics of American painting in this era, technical virtuosity and the ability to localise and particularise the uplifting sentiments that painters in the 18th century were expected to transmit through their paintings.

In 1748 Copley's mother had married the engraver Peter Pelham whose workshop was one of the centres for Bostonian artists. Through this family connection Copley was trained in the figurative realism of the colonial □limners but he increasingly infused his portraits with patriotic sentiments as in his famous *Paul Revere* (1768). Paul Revere, a Republican patriot, had led the protest against the Stamp Act of 1765. He was a highly skilled silversmith and the portrait conveys the informal democratic dignity of the shirtsleeved craftsman, teapot in hand, an image that relates to the rise of national pride in the increasingly assertive American colonies.

Copley, however, did not distinguish between the politics of his sitters and he painted many Bostonians who remained loyal to the Crown; on moving to England in 1774, he painted a number of heroic incidents from British history including *The Death of Chatham* in the House of Lords (1779), *The Death of Major Pearson* (in a skirmish with the French in the Channel Islands) (1782), and *The Siege of Gibraltar* (1791). This combination of the selection of an incident from contemporary history married to a style of meticulous realism was novel. Copley always preferred to paint contemporary historical subjects, saying, 'I have as much as possible employed myself in events that have happened in my own life time'. His major painting of 1778, *Watson and the Shark*, exhibits many of these features. Watson, a friend of Copley, told him of a youthful encounter with a shark in Havana Harbour. The linear flow of waves, ships, and the naked Watson is opposed by the strong vertical of the sailor attempting to spear the shark. Copley dramatises a real-life incident of natural hazard allowing the subject matter to determine the style; the waterfront characters are not given mythological significance in the ▽Neoclassical manner.

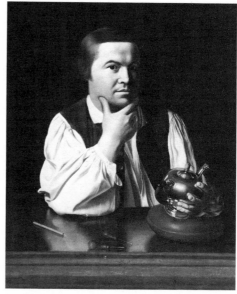

*Above:* JOHN SINGLETON COPLEY *Paul Revere.* 1768–70. 35 × 28½ in (88·9 × 72·4 cm). Museum of Fine Arts, Boston

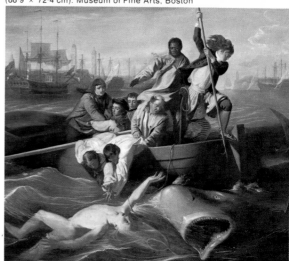

*Above:* JOHN SINGLETON COPLEY *Watson and the Shark.* 1778. 72 × 90⅛ in (180 × 225 cm). Museum of Fine Arts, Boston

*Below:* THOMAS JEFFERSON Monticello, Albemarle, Virginia, begun 1771

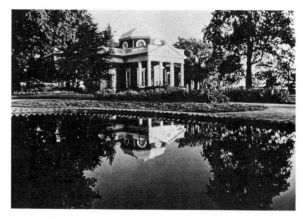

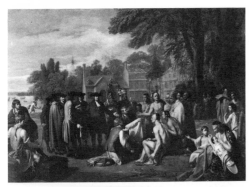

*Above:* BENJAMIN WEST *Treaty of William Penn with the Indians.* 1771. 75½ × 107½ in (191·8 × 107·5 cm). Pennsylvania Academy of the Fine Arts

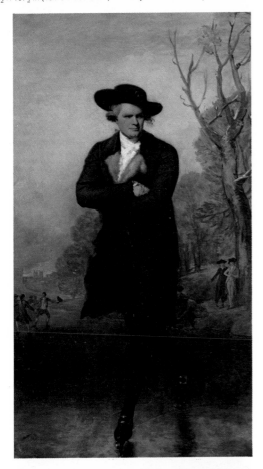

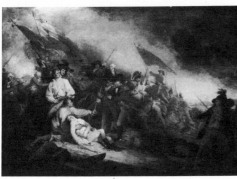

**Artists of the Republic.** From his position as a major figure in both British and American painting, Benjamin West (1738–1820) became a focal point for American artists who increasingly came to Europe to make their grand European tours. West was more consciously heroic in his style, but like ▽Copley firmly believed in choosing subject matter from contemporary events. West's *Treaty of William Penn with the Indians* (1771) shows the grave Quakers making a solemn treaty with the native chieftains, investing the scene with all the stoic dignity of an event from Greek or Roman political history. In 1772 West became George III's Royal Painter of ☐ history pieces. West's subjects ranged across a wide field, Biblical, ▽Shakespearean, historical and Classical themes, and he actively encouraged American painters to extend their range.

One of his pupils was John Trumbull (1736–1843) who in 1786 embarked on a series of paintings which would commemorate the events that led to the independence of the American colonies. These include *The Battle of Bunker's Hill* (1785) and *General George Washington before the Battle of Trenton (about* 1792), paintings which develop the tradition of history painting established by West and Copley, adding Trumbull's own qualities of flowing movement and softened outlines. Other followers of West concentrated on particular genres. Gilbert Stuart (1755–1828) was a leading portrait painter of his age (*The Skater* 1782) and Charles Wilson Peale (1741–1827) combined interests such as eyewitness paintings of American scientific wonders. *Exhuming the First American Mastodon* (1806–8) was exhibited in Peale's famous museum of natural wonders in Philadelphia. The achievements of the generation of Copley and West were considerable; American subject matter and style had been defined.

Republications in Europe looked back nostalgically to the ▽Roman Republic as an egalitarian ideal; a myth largely of their own making. ▽Neoclassicism was the recognisable symbol of the Republican spirit, not the theatrically gilt and mirrored ▽Baroque that ▽Renaissance Classical had become, but a chaste, pure and clearly defined Classical style as idealistic and bearing as little relation to its origins as the politics it symbolised.

The white or cream painted neo-▽Palladian house was the American ideal. The defeat of the British was also a defeat for the old Puritan ascendancy, although not seen as such at the time, and the early days of the Republic saw its political domination by Southern landowners rather than Northern merchants. Thomas Jefferson (1743–1826), legislator, economist, educationalist and Third President of the United States, was a professional and influential architect. The son of a surveyor, he built his mansion home, Monticello, in 1769 on his inherited estate. He also designed the Virginian State Capitol Building, the Washington Capitol, burnt in 1817, and the University of Virginia, Charlottesville, the prototypical American campus. Influenced by Palladio, Jefferson found in Roman Classicism authority for social and architectural theories suitable for a new Republic.

*Centre:* GILBERT STUART *The Skater.* 1782. 86⅝ × 58⅛ in (243 × 145 cm). Andrew Mellon Collection, National Gallery of Art, Washington DC
*Left:* JOHN TRUMBULL *Battle of Bunker's Hill.* 1775. 25 × 35 in (63·5 × 86·4 cm). Yale University Art Gallery

# NORTH AMERICA

**The American Landscape.** The first half of the 19th century saw the rise of two forms of painting that had never really established themselves in America, landscape scenes of the American wilderness in various stages of cultivation, and anecdotal, highly detailed studies of social life in rural, frontier and small town America. Landscape painting in America owed much of its impetus to the first real school of American painting, the Hudson River School of Thomas Cole (1801–48), Asher B. Durand (1796–1886), and Frederich Church (1826–1900). This group was preceded by America's first romantic painter, Washington Allston (1779–1843), whose canvases are full of atmospheric effects. Thomas Cole, the leader of the group, painted visual sermons on the panoramic sublimity of the virgin American wilderness often in the form of a 'Garden of Eden'. The usual compositional technique of a Cole painting is to place a blasted tree stump in the foreground which gives way to an endlessly receding horizon as in his painting *The Oxbow* (1836). Cole in common with many painters of the romantic age introduced historical themes of decline and fall. He also painted allegorical visionary paintings, such as *The Course of Empire*, *The Departure* and *The Return*, *The Past and the Present*, and *The Voyage of Life*.

Asher B. Durand took a more detailed perspective on the American landscape concentrating on particular effects of light, avoiding the effects of mass and epic vista that were the signature of Cole. Durand was trained as an engraver and preferred to record the topographical structure of the uncultivated but benign American wilderness. An artist who went even closer into the detailed floral and animal life of the American landscape was John James Audubon (1785–1851) whose medium was vivid watercolour. No account of American landscape of this period would be complete without mention of the fantasy landscape of Edward Hicks (1780–1849) who peopled a peaceable pastoral kingdom with friendly lions and cherubic children.

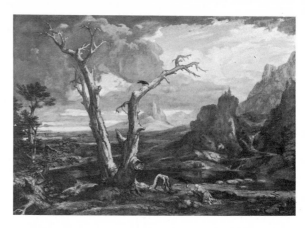

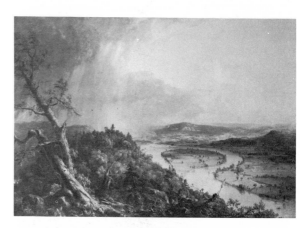

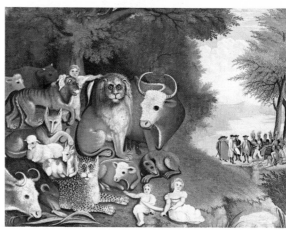

*Top:* WASHINGTON ALLSTON *Elijah being fed by the Ravens.* 48¾ × 72½ in (123·8 × 184·2 cm). Boston, Mass.
*Centre:* THOMAS COLE *The Oxbow.* 1846. 51½ × 76 in (129·8—193 cm). MM, New York
*Right:* EDWARD HICKS *The Peaceable Kingdom.* 1844. 17½ × 23⅝ in (44·5 × 60 cm). Brooklyn Museum, New York
*Below:* JOHN JAMES AUDUBON *The Bald-headed Eagle.*

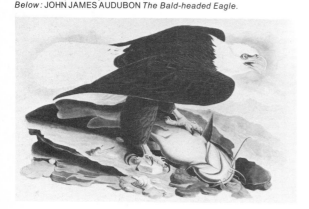

**The American People.** William Sidney Mount (1807–68) began to depict the social life of his native Long Island in the 1830s. Drawing from the techniques of 17th-century Dutch painters, Mount's ☐genre paintings of such scenes as bargaining for a horse, cidermaking and barndancing create a sense of both detail and space between the activities; every action and gesture within the paintings are organically, communally integrated as in his *Eel Spearing at Setauket*. The landscape environments are cultivated and clearly illuminated the human activities at the centre of the painting, creating an idealised balance between landscape and society.

# The Age of Landscape and Genre

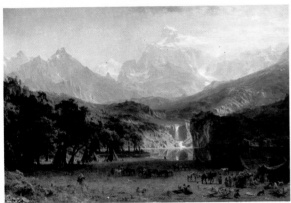

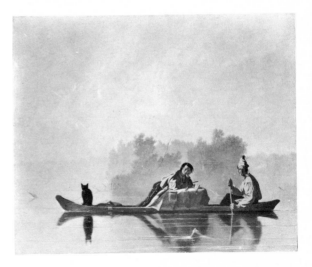

George Catlin (1796–1872) and **Seth Eastman** (1805–75) devoted most of their painting careers to the task of recording the civilisation of the first Americans despite their knowledge that the march of progress from the East would destroy this Indian civilisation. Both Catlin and Eastman invest their scenes and figures with nobility and meticulous ethnographic detail.

Another group of artists were less interested in the American Indians than in the spectacular natural wonders of the far-western Rocky Mountains. *The Rocky Mountains* (1863) of Alfred Bierstadt (1830–63) was one of the great popular successes of the 19th century. Increasingly the cultural leaders of the east developed a taste for the theatrical show pieces of nature such as Niagara Falls. ▽Thomas Cole's pupil Frederick Church extended the geographical range of this □genre with paintings recording his impressions of Latin America and the Middle East. In these landscapes human figures are only important to the extent that they provide a contrast in scale.

Frederic Remington (1861–1909), ex-cowboy, illustrator, painter and sculptor, depicted the 'Wild West' as it was coming to an end and in doing so did more to create the popular myth that has persisted in stories and movies more than any one man. As a sculptor he was influenced by the French □*animaliers*, but modelled western subjects in bronze with an authenticity and energy that transcends provincialism and frees him from any comparison to a European counterpart at a time when American sculpture was largely looking towards high Victorian Classical models. The latter was typified by Hiram Powers' (1805–78) *The Greek Slave* (1847), which was a show-stopper at the Crystal Palace in 1851 and is probably the most famous, or notorious, sculpture of its day.

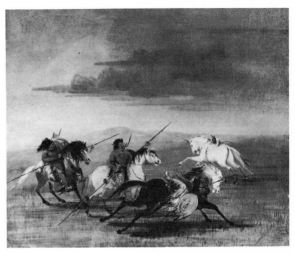

George Caleb Bingham (1811–79). Bingham's □genre scenes are usually set further into the American wilderness at the edge of civilisation in the frontier areas of Missouri and the mid-west. Trappers, boatmen and settlers are recorded in his paintings as they move through a landscape of reflections and clearly defined shadow and light. Bingham was also fascinated by the informal democracy of political life on the frontier and painted many scenes of elections. Other artists of this period went even further into the American wilderness, adding another dimension to American landscape painting through the encounter between painters and the cultural life of the first Americans, the Indian peoples of the Plains and the Far West.

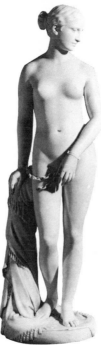

*Top Left:* ALBERT BIERSTADT *The Rocky Mountains.* 1863. 73¼ × 120¾ in (186 × 306·7 cm). MM, New York
*Top right:* GEORGE CALEB BINGHAM *Fur Traders descending the Missouri.* 29 × 36½ in (73·7 × 92·7 cm). MM, New York
*Above:* GEORGE CATLIN *Comanche Feats of Horsemanship – Sham Battle.* 1834. 22⅝ × 27⅝ in (57·5 × 70·2 cm). Smithsonian Institute, Washington DC
*Left:* HIRAM POWERS *The Greek Slave.* 1847. Marble. h. 65½ in (166·4 cm). Newark Museum, New Jersey

# NORTH AMERICA

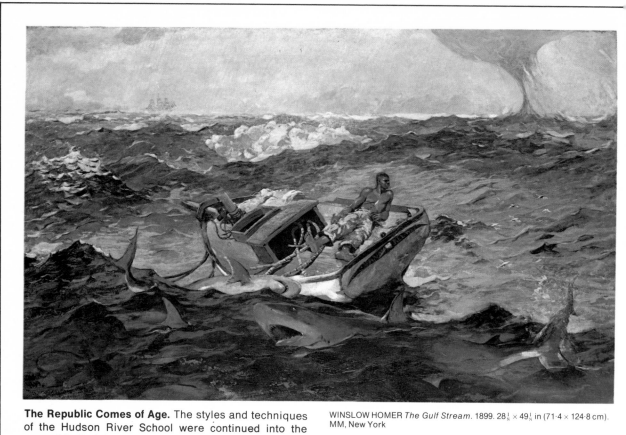

## The Republic Comes of Age.

The styles and techniques of the Hudson River School were continued into the second half of the 19th century but with adaptations. In the works of John Frederick Kensett (1816–72), Fitz Hugh Lane (1804–65) and Martin Johnson Heade (1819–1904), American landscape paintings became vehicles for the precise notation of atmospheric and light effects or for subjective emotional moods as in the work of George Inness (1825–84). Kensett represents a link with the Hudson River School though his composition and perspectives become invariably flatter with an invariable setting of sunny tranquillity and carefully controlled unobtrusive colours suffused over the canvas. Heade and Lane continue this growing tendency to view landscape as primarily a scientific enquiry into the effects and shapes of light, hence their description as the □luminist painters. The usual elements of a luminist painting are a static atmosphere, a high noonday sun and objects brought into telescopic focus. The composition is completed by wide areas of sky and water to provide maximum study of reflection.

While these experiments in technique were taking place within American painting, particularly in the work of the two famous expatriate American artists John Singer Sargent and James McNeill Whistler, three major American artists of the second half of the 19th century Eastman Johnson, Winslow Homer and Thomas Eakins stayed firmly within the traditipnal subject matter of American painters, painting scenes of social life, and figures in landscape. Eastman Johnson (1824–1900) travelled in Europe from 1849–55 and studied in Düsseldorf, The Hague (where he absorbed the techniques of ▽Rembrandt) and then in Paris. All these European influences were absorbed into American □genre painting as shown in the famous *Not At Home* (1870).

JOHN FREDERICK KENSETT *White Mountain Scenery*. 1859. 45 × 36 in ; (114·3 × 91·4 cm). New York Historical Society

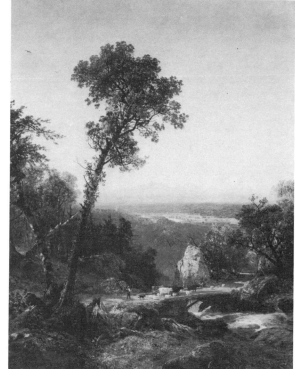

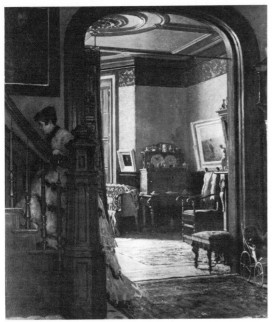

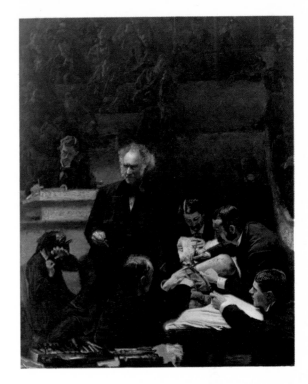

*Above:* EASTMAN JOHNSON *Not At Home.* 1870/80. 26½ × 22½ in
(67·3 × 56·5 cm). Brooklyn Museum, New York
*Right:* THOMAS EAKINS *The Gross Clinic.* 1875. 96 × 78 in
(243 × 198·1 cm). Jefferson Medical College, Philadelphia

**Winslow Homer** (1836–1910) was trained as a ☐lithographer and gained his first success with his illustrations of Civil War incidents that appeared in the popular illustrated periodical *Harper's Weekly*. He worked in both watercolours and oils and brought into the somewhat sentimental ☐genre tradition both social and psychological realism. In such oil paintings as *The Country School* and such watercolours as *The Berry Pickers* he transformed American genre painting. After travelling in New England, Virginia, the Adirondacks and the Bahamas, he finally concentrated on two geographical areas – the Adirondacks and the Atlantic coast around Prout's Neck in Maine and conducted a careful examination of the ways in which human figures interact with landscape, and the ways in which natural forms of light, seasonal change, storm and calm define man's relationship to nature.

Though he did paint scenes of leisure at seaside resorts, Homer increasingly concentrated on figures who had a functional, working role in the landscape; sympathy with nature; axe or gun in hand, pulling in nets or on oars, Homer's figures battle for survival. Along with this change in psychological attitude went a change in style. His seascapes of the Maine Coast after 1883 invest water with a new solidity and separateness. His seas have a life of their own, rather than being the occasion for a display of reflecting light: colours in these paintings are organised in broad channels. Homer wanted to record the objective inner forces of nature rather than its surfaces, aspirations memorably achieved by *The Fox Hunt* (1893) and *The Gulf Stream* (1899).

**Thomas Eakins** (1844–1916) also transformed American ☐genre, portrait and landscape painting, but with a much stronger emphasis on description than on sym-

bolic interpretation. Eakins studied in Paris between 1866–70 but made his lifelong home in the city of Philadelphia. In his pursuit of exact visualisation of objects and human figures Eakins dissected corpses and used a primitive form of moving picture in order to break down human movement into its distinct phases. 'All the sciences are done in a simple way', he once said. 'In mathematics the complicated things are reduced to simple things, so it is in painting'. *The Swimming Hole* of 1883 conveys this precision and orchestration of movement and body and a sense of stillness is heightened by two triangles of nude figures. His transformation of genre painting is impeccably conveyed by *Max Schmitt in A Single Scull* (1877) where a simple human activity is made memorable and sacred with a technique of absolute precision of perspective, spatial relationships and reflections of light.

**Architecture.** The architecture of the western expansion was the wooden fort and log cabin until the migration came to a halt on the Pacific Coast. Here, on the outskirts of old Spanish towns, grew the new Californian cities, and merchants built themselves mansions of wood and tile, counterparts of the millionaires' 40-bedroomed 'cottages' being built on Long Island in the east. The 'shingle style' of architecture is a purely indigenous Euro-American style developed from a building trade dominated by carpentry. Lumber was a boom industry. Forests were full of tall straight timber, and as a material wood was easily transported. Outside the comparatively few city centres the 'shingle-board' or 'clap-board' building, fretted and elaborated with every conceivable fancy, was built on a scale in both size and number with no parallel in the world.

# THE 19th CENTURY IN EUROPE

| −5000 | −4000 | −3000 | −2000 | −1000 | BC 0 AD | 1000 | 2000 |
|---|---|---|---|---|---|---|---|

**1804-15** Napoleon becomes Emperor of France.
**1804** Battle of Trafalgar.
**1812** Napoleon invades Russia. Retreat from Moscow.
**1815** Battle of Waterloo. Congress of Vienna.
**1818-22** Wars of Independence of Latin American states.
**1820** Greek War of Independence.

**1825** Stockton and Darlington Railway, England.
**1834** British abolition of slavery.
**1837** Accession of Queen Victoria.
**1838** First Atlantic crossing under steam only.
**1839** Photography perfected by Fox Talbot, England and Daguerre, France.
**1848** Year of Revolutions. First Communist Manifesto (Marx, Engels).

**1851** Great Exhibition at Crystal Palace, London.
**1852-70** French Second Empire under Napoleon III
**1853-56** Crimean War.
**1859** 'Origin of Species' published in England by Charles Darwin.
**1859-61** Unification of Italy – Risorgimento – under Garibaldi and Cavour.

**1867** Karl Marx publishes 'Das Kapital'.
**1877** Invention of phonograph by Thomas Edison.
**1887** Internal combustion powered vehicle, Daimler, Germany.
**1889** Eiffel Tower, Paris Exhibition.
**1895** Wireless telegraphy, Marconi, England.
Motion pictures on film, Lumière Brothers, France.

The nineteenth century, the age of industrialisation and mechanisation, saw the birth of the modern world. All the arts developed against a background of smoking factory chimneys, fast expanding cities, steamships, railways, mass literacy and social unrest.

The rapid expansion of means of communication and travel (much aided by the mid-century invention of mass produced steel) led to the domination of world culture by the Western States including, for the first time, the United States of America. By the end of the century America was achieving a new position of power in political and cultural influence.

Britain led the rest of Europe in world colonisation, the cultural effect of which was the introduction of exotic (e.g. Far Eastern) styles into the arts.

Power came into the hands of the new industrial middle classes who became the new patrons of the arts. The artist could no longer enjoy the protection of a rich and powerful patron, or of the church. He had to sell pictures in open competition with his rivals on the walls of a Salon, an Academy or in other public and private galleries. Architects too had to compete openly and publicly for the new state patronage in the form of large public buildings in towns and cities.

Such competition naturally produced a 'free for all' and a consequent wide variety of styles in painting and building. Artists turned to history for examples, or to the exotic arts of the non-European world, and the Renaissance itself became merely another historical style.

# THE 19th CENTURY IN EUROPE

**The Empire.** With the ▽French Revolution of 1789 disappeared both the monarchy and the art that it supported. A different kind of painting was called for to celebrate the heroism of the new Republic, and it was ▽Jacques-Louis David (1748–1825) who proved himself equal to the task in such stark images as *The Death of Marat* (1793). As France proceeded to create an Empire, under ▽Napoleon, painting was required to record the events of the present for posterity. One of David's favourite pupils, Baron Antoine-Jean Gros (1771–1835) was taken by Napoleon into his immediate entourage, and so had first-hand experience of the type of epic scenes he painted. *The Pest House at Jaffa* (1804) depicts an actual incident of the Egyptian campaign, when Napoleon visited the sick and dying to boost morale. Like a saint he is shown touching the sores of the afflicted, but a note of ambiguity raises the picture above propaganda. The gigantic figures of the sick, like ▽Michelangelo's damned (*see* pages 150–1), dominate the composition, and Napoleon seems more like Doubting Thomas feeling the wounds of the risen Christ. And the order and moral clarity of a Neoclassical history picture are replaced by a confusion of figures, exotic architecture, and a troubling note of disillusion.

**Restoration and Disillusionment.** The heroism of the soldiers that Théodore Géricault (1791–1824) painted on the eve of the collapse of the Empire is tempered by a strong feeling of melancholy. His *Wounded Cuirassier* is shown leaving the battlefield. This disillusion was to grow after 1814, when artists found themselves under a reactionary monarchy without contemporary heroic subjects to paint. *The Raft of Medusa* (1817) takes for its theme a topical catastrophe. In that year a naval frigate, the *Medusa*, foundered on its way to Senegal. A raft carrying the shipwrecked was abandoned by the officers and many died. Géricault based his picture on the accounts of survivors, and saturated himself in his subject, painting studies of corpses, and severed heads and limbs. Finally naturalism is sacrificed in the interests of monumentality, and the huge painting becomes more universal in its implications. A few anonymous figures, welded into a pyramid of light and shade, signal a distant ship, as vast waves threaten to engulf them. Géricault's stark pessimism was not appreciated. The picture passed unrecognised at the ▽Salon of 1819, and the artist, a depressive by nature, became mentally ill, haunted by paranoiac fears. A mixture of sympathy and self-identification shows in his portraits of mad people, painted about 1820 when he was in the care of a doctor. In England, where he travelled with *The Raft of Medusa*, he tried to commit suicide, and his last paintings, such as *The Lime Kiln*, painted shortly before his death in 1824, are almost monstrous in their heavy, leaden colouring and thick paintwork.

**Romantic Individualism.** At the ▽Salon of 1824, Eugène Delacroix (1798–1863), a young admirer of ▽Gros and ▽Géricault, exhibited *The Massacre at Chios*, a subject drawn from the Greek war of independence, and was acclaimed as the leader of the modern school – a colourist and a Romantic. At the same Salon, an artist 18 years his senior, Jean-Auguste-Dominique Ingres (1780–1867), exhibited his *Vow of Louis XIII*, a large religious picture owing much to ▽Raphael, which established him as the champion of Classicism. The two artists were to remain lifelong artistic opponents.

Ingres had studied with ▽David and at the French Academy in Rome. He regarded himself as an orthodox Classicist, worshipped the antique and Raphael and despised casualness in technique. He aspired towards the expression of a fixed ideal opposed to passing emotions. Yet at the Salon of 1806, the linear clarity of his portraits struck his contemporaries as 'gothic' and perverse. Through striving towards a greater purity, Ingres transformed David's Classicism into an idiom of his own. The *Jupiter and Thetis*, painted in Rome in 1811, already shows the distortion of form, the flattening of planes and the elaboration of linear rhythms, characteristic of Ingres' mature style. The poses are drawn from antique sculpture and vase-painting, but the sensuality of the image is peculiar to Ingres.

Delacroix was not content to seek originality within the Classicist school. Like other painters and writers of his generation he turned away from Italy and the Classical world and looked to ▽Shakespeare, Byron, Walter Scott and medieval history for themes, often violent and dramatic in character. In the eyes of the art establishment, Delacroix, the accepted champion of the movement, was a dangerous rebel. His early works, like the *Death of Sardanapalus* (1827), were severely attacked by conservative critics as confused and degenerate. Delacroix was ambitious for public recognition and after 1827 he chose easily acceptable themes. In both his writing and his art he tried to demonstrate a respect for tradition. The composition of *The Taking of Constantinople by the Crusaders* (1840), a large historical picture commissioned by Louis-Philippe, is consciously derived from such artists as ▽Veronese and ▽Rubens. But the psychological drama, in the image of cruel victor bearing down upon suppliant victims, is Delacroix's own. And it is effective pictorially because of the flickering light and colour which animate the surface. This nervous agitation of the picture surface grows in Delacroix's later work, at the expense of naturalism, as it becomes increasingly removed from the contemporary world. He felt rejected, threatened by the changing conditions of modern life, and many of his late pictures, often religious in subject, seem to represent his own despair and alienation from society.

**The Painter of Modern Life.** Surprisingly it is ▽Ingres, the doctrinaire Classicist, who in his old age proved himself able to respond with undiminished vigour to contemporary life. While in his allegorical pictures there is often a conflict of subject and style, he succeeds in his late portraits in reconciling the realistic rendering of detail – which is here appropriate to his theme – with the artificial organisation of his subject on the canvas. Although the pose in *Madame Moitsessier* (1856) is Classical in origin, the effect of the portrait is triumphantly middle class and modern. The decor and costume are of the latest style. And the waxen face, supported by an unnaturally plump and boneless hand, possesses all the authority of wealth in the Second Empire.

*Above left:* JEAN-ANTONE GROS *Napoleon's Visit to the Pest House at Jaffa.* 1804. 209 × 283 in (530 × 718 cm). Louvre, Paris
*Left:* THEODORE GERICAULT *The Raft of the Medusa.* 1819. 193 × 283 in (489 × 718 cm). Louvre, Paris
*Above:* JEAN-AUGUSTE-DOMINIQUE INGRES *Madame Moitossier Seated.* 1856. NG, London

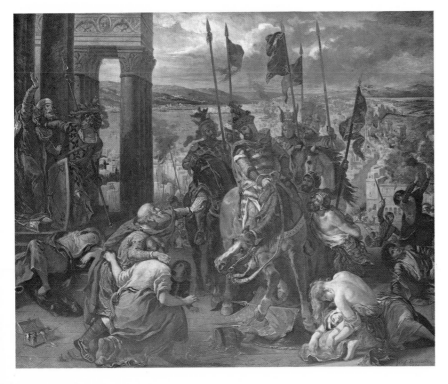

EUGENE DELACROIX *The Taking of Constantinople by the Crusaders in 1204.* 1840. 161⅜ × 196 in (410 × 498 cm). Louvre, Paris

# THE 19th CENTURY IN EUROPE

JEAN-BAPTISTE COROT *Chartres Cathedral.* 25¼ × 20 in (64 × 51 cm). Louvre, Paris

THEODORE ROUSSEAU *Edge of the Forest of Fontainebleau, sun setting.* 55½ × 77⅝ in (141—197 cm). Louvre, Paris

**Natural Vision.** For landscape painting to be officially acceptable at the beginning of the 19th century it was necessary that nature should be improved along the lines set down by the Classical landscapists of the 17th century, notably ▽ Claude and ▽ Poussin. The pictures that Camille Corot (1796–1875) exhibited at the ▽ Salon from 1827 were highly finished studio works, Classically composed, and peopled with conventional Biblical figures or arcadian peasants. Yet the studies he produced at the same time in Italy and France are revolutionary in their broad treatment and in their direct observation of light and tonal effects.

Achille Michallon and Victor Bertin, a pupil of the 18th-century landscapist Valenciennes, taught Corot not only how to construct landscapes in an acceptable academic style, but also how to paint outdoors from nature. Michallon and Valenciennes had both done likewise and their studies are notable for their freedom from preconceptions. In the case of Corot these small informal studies are the essence of his work, and their calm objectivity dominates every other sentiment. *Chartres Cathedral* was painted in 1830, the year of the Revolution. Unconcerned with politics, Corot just records what he sees, reducing a complex scene to a simple pattern of harmonious tones. Nor is there any sign of a Romantic response to his subject, to the idea of a medieval Christian past associated with it.

**Art and Nature.** It is in his freedom from Romantic preconceptions that Corot anticipates the ▽ Impressionists and distinguishes himself from the Barbizon

School. Corot's roots are in the Classical tradition, Theodore Rousseau's (1812–67) in ▽ Constable and Dutch landscape (*see* pages 198–9). 'Monsieur Rousseau', the poet and critic Baudelaire wrote, 'seems like a man who is tormented by several devils and does not know which to heed. Monsieur Corot who is his absolute antithesis has the devil too seldom within him.' Rousseau's devils are just these very Romantic preconceptions. Nature is for him the object of veneration, the embodiment of wisdom and morality in their purest form, and Barbizon, on the edge of the forest of Fontainebleau, where he retired to paint with Dupré, Diaz and Millet among others, provided a retreat from the corruption and ugliness of Paris. He was considered an artistic heretic by the establishment on account of the lack of conventional composition and finish in his work. An independent system that elevated one man's vision of nature into a creed was also to be feared on political grounds and Rousseau was excluded from the ▽ Salon for twelve years until the Revolution of 1848 abolished the Salon Jury. It was the new Republic that commissioned from him the *Sunset* in which trees of monumental scale frame a correspondingly vast tract of plain.

Rousseau's friend, Jean-François Millet (1814–75), was considered to be politically dangerous for similar reasons. In his paintings peasants, either at home or at work in the fields, assume the nobility of Classical heroes. Castagnary, the liberal critic, recognised that in such everyday subjects as *The Gleaners* was contained all the pathos and grandeur previously reserved for religious and historical subjects. These three poorly-clad women, their heads averted as they stoop at their work, appear like figures in a Classical freize. The action becomes timeless. Rural life is Millet's constant theme, and implicit in it is a contrast with the degradation of the city-dweller. Like Rousseau he believed that outside the city survived a lost innocence, and only the directness of his vision and the simplicity of his compositions preserve some of his domestic scenes from sentimentality. Corot failed finally to keep such a grip on reality. In his late twilight scenes, where colours and contours merge into a soft grey haze, he indulges in a mood of nostalgia that successfully ignores the social issues of his day. Requiring no effort and offering an easy escape, these Romantic idylls were immensely popular.

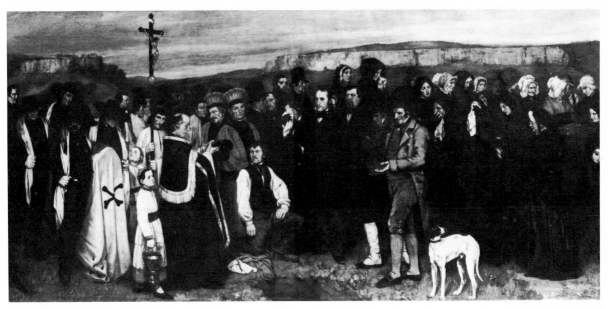

*Above:* GUSTAVE COURBET *The Burial at Ornans.* 1850. 123⅔ × 261⅞ in (314 × 665 cm). Louvre, Paris

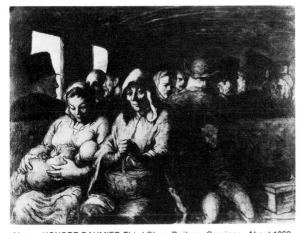

*Above:* HONORE DAUMIER *Third Class Railway Carriage.* About 1862. 26 × 35½ in (66 × 90 cm). MM, New York

*Below:* JEAN-FRANCOIS MILLET *The Gleaners.* 1855. 33⅓ × 43⅓ in (85·5 × 111 cm). Louvre, Paris

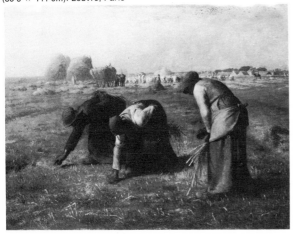

**Realism as Social Criticism.** In his subjects, based on direct observation of the things around him, Gustave Courbet (1819–77) was reacting not only against the sterile academic painting of his day, but also against the exotic fantasies of the Romatic school. In his landscapes the solid vigorous paintwork, broadly applied, conveys a powerful sense of trees and rocks as physical presences. Painting he felt should depict only what is tangible and visible, and on his writing-paper he advertised himself as 'the master-painter without ideals or religion'. The heroes of his art are all of common stock, and implicit is the conviction that sincerity and true feeling are only to be found among the working people. *The Burial at Ornans* (1850) shows a crowd of villagers gathered at a grave, and no rhetorical gesturing or hint of religious feeling breaks the matter-of-fact gloom. When the picture was exhibited at the ▽ Salon of 1850, the public was outraged at the vulgarity of the figures, and the coarseness of the faces of the priests. Encouraged by his friend, the philosopher Pierre Proudhon, Courbet became committed to socialist ideas, and the element of protest in his art grew stronger. in 1855 he defied the art establishment by mounting his own exhibition of 'Realism' at the Exposition Universelle, and in 1870 he participated in the insurrection of the Commune. The paintings of Courbet impress by their size and directness, but Honoré Daumier (1810–79) surpassed him as a social critic through the sharpness of his intellect. He avoided the sententiousness and sentimentality that sometimes mar the work of his friends Corot and Millet, and in his satirical lithographs, which appeared in French journals from the 1830s, he surveyed the whole range of Parisian society with an eye that is both savage and compassionate. A staunch republican, he attacked the corruption of the government and the vanity and hypocrisy of the bourgeoisie. His breadth of vision makes him the most profound of realists, but his monumental style is not naturalistic. In the *Third Class Railway Carriage*, for example, the caricaturist's freedom allows Daumier to generalise his figures so that they become representative of a section of society.

# THE 19th CENTURY IN EUROPE

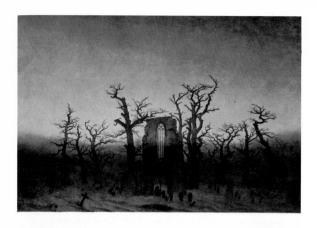

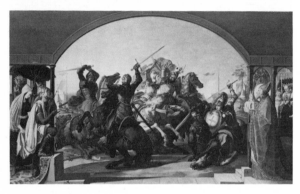

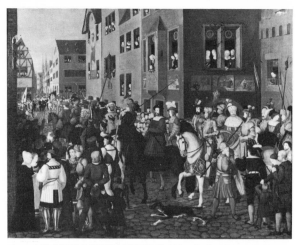

*Above left:* CASPAR DAVID FRIEDRICH *Abbey in the Eichwald.* 1809.
43 × 67 in (109 × 170 cm). Schloss Charlottenburg, Berlin
*Left:* JULIUS SCHNORR VON CAROLSFELD *The Battle of Lipadusa.*
1816. Casino Massimo, Rome
*Above:* FRANZ PFORR *Entry of the Emperor Rudolf of Hapsburg into
Basle in 1273.* 1810. 35⅔ × 46⅘ in (90·5 × 119 cm). Städelsches
Kunstinstitut, Frankfurt

**The Romantic Movement** began in the late 18th century,
as a reaction against the Classicism of the preceding age.
Throughout western Europe, a new mood emerged.
Although the writers, artists and composers who express
it vary greatly in style and subject, certain central
themes are common to them all: a love of nature, a new
interest in the historical past, a passionate involvement
with the idea of liberty, and, above all, a belief in the
mysterious and spiritual nature of man himself.

The early years of Romanticism formulated the
concept of man's oneness with the world around him.
Instead of the balanced, calm landscape of the Classical
painters like ▽Claude and ▽Poussin, the Romantic
landscapists explored a highly subjective world, into
which man entered fully, and which could become either
a substitute for God, or, as in the case of the German
artist Caspar David Friedrich (1774–1840), a way of
expressing a belief in God through painting. Friedrich's
favourite settings are lonely and remote places, moun-
tain peaks, the deserted Baltic seashore, all painted at
sunrise, sunset, or in the moonlight. A second and
poetic strand of Romanticism is evident in Friedrich's
numerous paintings of the ruined Cistercian abbey of
Eldena, near his native Greifswald in Pomerania. Such
ruins are an important element in early Romantic
writing and painting, symbolising a lost age of faith
through the contemplation of a setting of melancholy
beauty. Each of Friedrich's works has a carefully
organised symbolism, and in his painting of the burial
of a monk in a snowy graveyard, the ruined abbey
suggests the death of an earlier world, while the moon
above reminds us of the better life for which the departed
soul is destined.

**The Nazarenes.** Friedrich was a solitary painter, an
inspired egoist. By contrast, the Nazarene school, a
group of German artists living in Rome, formed them-
selves into the Brotherhood of St Luke, living a com-
munal and semi-monastic life. The first leaders of the
brotherhood were Friedrich Overbeck (1789–1869) and
Franz Pforr (1788–1812), both of them in rebellion against
the oppressively traditional teaching of the Vienna
Academy of Arts. The Nazarenes usually chose narrative
subjects, either biblical works in a manner reminiscent
of the painters of the early ▽Renaissance or of ▽Raph-
ael, or historical scenes in a style which may be des-
cribed as romantic medievalism. Pforr's *Entry of the
Emperor Rudolf of Hapsburg into Basle in 1273* brings to
mind 16th-century German □woodcuts. The picture is
painted in brilliant colours, quite unlike the softer tones
of ▽Neoclassical art, and it is unashamedly anachron-
istic, the figures wearing 16th-century costumes for a
13th-century subject.

The death of Pforr when only 24 years old brought the
old brotherhood to an end, but the survivors were later
joined by younger artists from Germany. The two most
important newcomers were Peter Cornelius (1783–1867)
and Julius Schnorr von Carolsfeld (1794–1872), who
joined the group in decorating two Roman palaces with
frescoes. One series, painted for the Casa Bartholdy,
tells the story of Joseph in Egypt (1815–17), while the
second series, in the Casino Massimo, illustrates the
works of ▽Dante, ▽Ariosto and Tasso (1817–27). Here
one room is entirely the work of Schnorr von Carolsfeld,
illustrated with scenes from Ariosto's *Orlando Furioso.*
One was adapted from his earliest surviving oil painting,
*The Battle of Lipadusa* of 1816, which shows Orlando's
defeat of the Saracens. With its framing wings, contrast-
ing the Pagan and Christian worlds, this vivid and excit-
ing painting, in which three groups of warriors are shown
in hot combat, resembles a stage set.

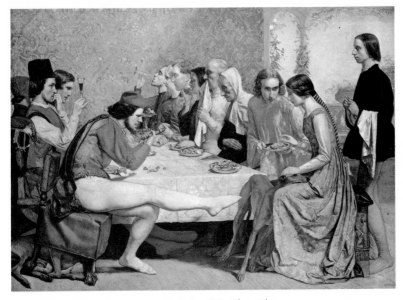

JOHN EVERETT MILLAIS *Lorenzo and Isabella.* 1849. 40½ × 56¼ in (101·2 × 147 cm). Walker Art Gallery, Liverpool

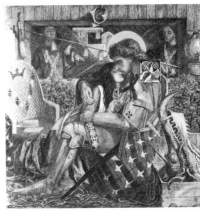

*Above:* DANTE GABRIEL ROSSETTI *The Wedding of St. George and Princess Sabra.* 1857. 14 × 14 in (35·6 × 35·6 cm). Tate Gallery, London

*Below:* WILLIAM HOLMAN HUNT *The Lady of Shalott.* 1886. 74 × 57 in (183 × 144·8 cm). Wadsworth Atheneum, Hartford, Connecticut

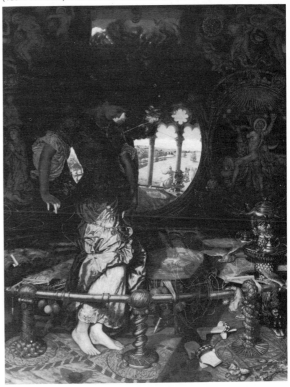

**The Pre-Raphaelite Brotherhood** had much in common with the Nazarenes. Founded in 1848 by Dante Gabriel Rossetti (1828–82), William Holman Hunt (1827–1910) and John Everett Millais (1829–96), this English group was also in revolt against the ▽Neoclassical traditions of the ▽Academy. To an even greater extent than the Nazarenes, they were obsessed by truth to nature, and by accuracy in representation of the external scene. A typical Pre-Raphaelite work has the same brilliant colouring, clear-cut outlines and predilection for narrative as a Nazarene painting. It also represents months of work, often in the open country, while every detail of the natural world was carefully recreated on the canvas.

The Pre-Raphaelites took themes from the poems of Keats and Tennyson, and turned to the legend of King Arthur for inspiration. Keats' poems were largely unknown in the 1840s and 1850s, but the members of the group painted several scenes from his medieval narrative poems *Isabella*, *La Belle Dame Sans Merci* and *The Eve of St Agnes*. *Lorenzo and Isabella* by Millais depicts Isabella and her humble love, Lorenzo, at the table with Isabella's haughty brothers, one of whom is ill-naturedly kicking the dog. The harsh gesture was one of many Pre-Raphaelite features which was disliked by contemporary critics, and for many years the brotherhood was regarded as provocative and outrageous.

Rossetti identified himself with the Italian poet Dante whose name he bore, and his wife, Elizabeth Siddal, with Dante's Beatrice. An early watercolour, *The First Anniversary of the Death of Beatrice*, shows Dante drawing the head of an angel in a constricted room in which the steep ▢perspective accentuates the strange and intense medieval atmosphere. By the 1850s, the impetus of Romanticism had run down, and the rapid break up of the Pre-Raphaelite group reflects this loss of momentum. Rossetti retreated into a dream-world of his own, painting female figures with a deep symbolical and personal significance. Millais, after a brilliant beginning, was absorbed into the fashionable academic world. Only Hunt remained true to the early principles of the brotherhood, but even his work lost its freshness and inspiration. Among the younger painters influenced by the group was Edward Burne-Jones (1833–98), in whose work a passionate interest in literature and a strain of intense melancholy combine to produce memorable paintings which lead us from Pre-Raphaelite romanticism into the world of the symbolist artists.

## Turner and Constable.

The two great painters of nature of the early 19th century were both English. Although Joseph Mallord William Turner (1775–1851) and John Constable (1776–1837) were of the same age and generation, their personalities and their art are a fascinating contrast. Turner, born in London, the son of a barber, won wide acceptance at an early age and became a full member of the ▽Royal Academy at 27. He was financially successful, a great foreign traveller, but secretive, pessimistic and, though father of several children, unmarried. Constable, born in Suffolk, was the son of a prosperous miller. His art developed only slowly, he sold few major paintings, and when he was finally, grudgingly, elected a Royal Academician, he saw one of his paintings rejected for exhibition by his fellow members. He never went abroad and his public and private life is revealed in frank and charming letters to his friends. After six years' dedicated courtship, he married the grand-daughter of a vicar, who bore him seven children. Yet different as they were, both men were untiringly professional and ambitious. Both learned from the great landscapists of the 17th century, ▽Claude and ▽Poussin, and from the Dutch masters (*see* pages 192–9). Yet their different sensitivities to the relationship between man and nature are uniquely English, and they were aware of their tradition. As a young man, Constable said 'I fancy I see ▽Gainsborough in every hedge and hollow tree'. Turner said 'Had Tom Girtin lived, I should have starved'. Turner in particular acknowledged his debt to Claude and through him the Italian masters, for in his will he left to the National Gallery in London his painting *Dido Building Carthage* (1815) on the express condition that it should hang for ever next to Claude's *Seaport*, a condition which is still observed today. Turner was no doubt rightly confident that the comparison would do him no harm.

## 'The Sun is God.'

These, reputedly, are Turner's last words. When he died, he left over 19,000 separate works, ranging from large detailed oil paintings to the briefest watercolour sketches. A preoccupation with light is one theme that runs through all his work, but Turner was captured by the deep emotional significance of light rather than its natural or scientific qualities. Thus, in ▽*The Decline of Carthage* (1817), the sun sets 'portentous' on

*Top left:* J M W Turner *Norham Castle : Sunrise. After* 1830.
$35\frac{1}{2} \times 47\frac{1}{2}$ in (90·2 × 121 cm). Tate Gallery, London
*Top:* J M W TURNER *Snowstorm: Steamboat off a Harbour's Mouth.*
1843. $35\frac{1}{2} \times 47\frac{1}{2}$ in (90·2 × 121 cm). Tate Gallery, London
*Above:* J M W TURNER *The Decline of Carthage.* 1817. 67 × 94 in
(170 × 239 cm). Tate Gallery, London

a once great Empire; and the old master 'look' of the painting reminds one of his desire to prove he was their equal. In 1819, Turner went to Italy for the first time. It was a great turning point in his life. The discovery of Mediterranean light loosened the power of the old masters, and in one of his late works, *Norham Castle* (about 1835–40), the almost abstract painting glows as if it were light itself. The transparent glazes of pure colour in this unfinished work are a reminder too of Turner's consummate skill as a watercolourist, and bring to mind the artist, working far into the night by a hotel lamp in Venice, striving in endless private experiments to capture the emotions he had felt in the face of nature.

## Tragedy.

Another continual theme in Turner's art is the destructive force of nature and man's insignificance in the face of such powers. The sea and shipwrecks were a great source of inspiration and, at the age of sixty-seven, Turner himself nearly died in a sea storm. He recorded the experience in a work which he said was to be neither liked nor understood, *Snowstorm: Steamboat off a Harbour's Mouth* (1843). The critics regularly despaired of such paintings, not realising that Turner was foretelling new traditions which would blossom in the 20th

century. Turner witnessed the rise and fall of the ▽Napoleonic Empire; ▽*The Decline of Carthage* shows his awareness of the historical parallels, and through them the tragic nature of the human condition. When in 1834, Turner witnessed and recorded the burning of the Palace of Westminster, the symbol of man's authority, blazing like the sun, reflected in the night waters of the Thames, he must have found an almost perfect expression of his beliefs.

**'The sky . . . governs everything'.** So Constable wrote to his friend Archdeacon Fisher. Constable attempted to do what no previous painter had done: to capture with paint the freshness, sparkle and physical sensation of nature. When ▽Fuseli jokingly called for his greatcoat and umbrella as he looked at Constable's work, he was making a good point, but Constable's purpose was not understood by his contemporaries, and (unlike Turner) he resolutely refused to produce the Classical landscapes the connoisseurs demanded. As a miller's son, Constable learned to look at the weather with a detached and scientific eye; and behind his great paintings lie many sketches, which painstakingly record the appearance of nature at a particular time, date and place. These came to fruition in his 'six-footers', large, highly worked canvases of which *The Hay Wain* (1821) is the best known and in which with superb technique Constable achieves a unique unity between sky and earth, the one genuinely appearing to affect the other. Constable's original title for the picture was simply *Landscape: Noon*. It failed to sell when shown at the ▽Royal Academy in 1821. Later Constable agonised whether or not to accept an offer of £70. However, an enterprising dealer called Arrowsmith persuaded Constable to let it go to Paris where it caused a sensation at the ▽Paris Salon of 1824. Charles X awarded Constable a gold medal, and ▽Delacroix went away and repainted parts of one of his pictures after seeing it, impressed by Constable's broken brushstrokes which gave great vibrancy to his colours. Unaware that he would have considerable influence on future generations of French landscape painters, and so on the whole development of European art, Constable did not go to Paris and was deeply suspicious of the praise given by French critics.

*Top:* JOHN CONSTABLE *The Hay Wain.* 1821. 51¼ × 73 in (130·5 × 185·5 cm). NG, London

*Above:* JOHN CONSTABLE *A woman crossing a footbridge, and a horse and cart.* 1813. 3½ × 4¾ in (89 × 121 mm). V & A, London

*Below:* THOMAS GIRTIN *Kirkstall Abbey at Evening.* Watercolour. 12 × 20⅛ in (30·5 × 51·1 cm). V & A, London

**Constable's Country.** Constable was able to paint only those places he knew best. The unknown and the exotic had no appeal, and he frequently turned to the country of his boyhood, the Stour Valley. Yet from 1816, he lived permanently in London and all the subsequent paintings of Constable's country are, in fact, memories, though based on the tiny sketches he made as a young man. It is nearly always spring and high summer in Constable's country, and the tranquil, optimistic note he so frequently conveys hides the bitter agricultural depression which fell on the Stour Valley after the ▽Napoleonic Wars. But a happy, and perhaps paternalistic, union between man and well cultivated land is what Constable believed in, although as success escaped him, and his wife died, storm clouds gathered in his skies, and the optimism turned to melancholy. (*See* Index for further references to Constable and Turner.)

**Art and Conformity.** Academies of the 19th century have not had a good press. Representing the world of official art and patronage, they have suffered by comparison with the non-conforming groups of artists, whose work they rejected. Later critics have ignored them and concentrated exclusively on such groups as the realists and ▽Impressionists, condemning everything that does not conform to their vision. The balance is now slowly being redressed. As more research is done, it becomes clear that the divisions between academic and independent artists were not nearly as clear-cut as we had been led to believe. And, more important, we are coming to recognise the qualities of certain academic artists for their own sake.

**The Salon.** Nowhere was the academic tradition stronger than in Paris, which by the mid-19th century had become the greatest art centre in Europe. The academy was dominated by ▽Ingres and his followers, and the leading figures were almost exclusively 'academic'. Yet we should not understand by that word that they were either sterile or dogmatic. Many of the ▽Impressionists trained under Charles Gleyre (1806–74), whose *Lost Illusions*, showing a philosopher watching the twilight departure of a boat-load of maidens, caused a sensation at the Salon of 1843. ▽Monet, ▽Renoir and ▽Whistler learnt much from Gleyre in the handling of paint, and they were certainly influenced by some of his informal studies and landscapes. *Lost Illusions* is full of a dreamy poetry entirely contemporary in its appeal. The same is true of another Salon success, the *Decadence of the Romans* (1847) by Thomas Couture (1815–79), who was as influential as Gleyre.

His influence was felt strongly in Germany, where artists like Anselm Feuerbach (1829–80) and Arnold Böcklin (1827–1901) painted Classical subjects that are disturbingly modern in mood.

Among the leading French academics of the next generation, Paul Baudry (1828–86), Adolphe William Bouguereau (1825–1905), Alexander Cabanel (1823–89), Jean Léon Gérôme (1824–1904), and J. J. Henner (1829–1905), there was perhaps a more conscious desire to please and impress. The composition of Bouguereau's *Nymphs and Satyr* is complex and subtle, expressing eroticism not only in the brilliant rendering of the female nude, but in the rhythmic movement of arms and legs as in the pattern of a dance.

**The Royal Academy.** In England academic art never possessed the same prestige that it did in France. The English were always distrustful of high art, and they preferred homely subjects, landscapes and portraits. Lord Leighton (1830–96) and Sir Edward Poynter (1836–1919), both presidents of the Royal Academy and two of the leading Classical painters of their day, never achieved the same popularity as did W. P. Frith (1819–1909) with his famous scene of *Derby Day*. Sir Lawrence Alma-Tadema (1836–1912) was more popular in approach, painting detailed domestic scenes of Roman life.

*Top:* WILLIAM BOUGUEREAU *Nymphs and Satyr.* 1873. 102⅜ × 70⅞ in (260 × 180 cm). Sterling and Francine Clark Art Institute
*Above:* SIR FREDERIC LEIGHTON *Garden of the Hesperides.* Lady Lever Art Gallery, Port Sunlight, Cheshire
*Below:* CHARLES GLEYRE *Lost Illusions.* 66½ × 66½ in (169 × 169 cm). Louvre, Paris

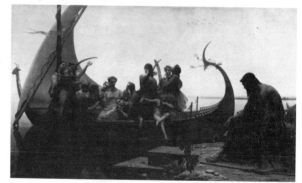

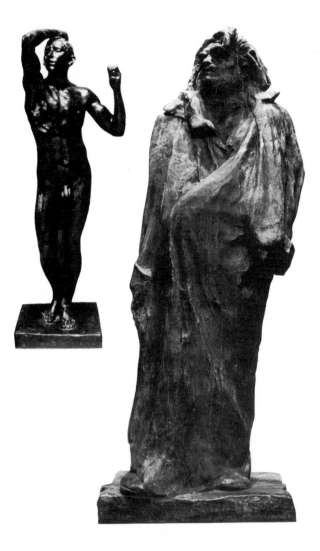

**Sculpture in the Nineteenth Century.** Throughout the century, demand for public sculpture was unprecedented and output was enormous. Industrial expansion and the wealth it created produced a demand for town halls, opera houses, theatres, stores and great shops, hotels and large private houses, all requiring elaborate decoration to confirm the grandeur and importance of each establishment. Victorian buildings were encased in decorative sculpture in portentous and theatrical profusion. Unfortunately most of the work was undistinguished in both feeling and technique; only occasionally, as in Carpeaux's sculptured group *La Danse* (1869) for the façade of Garnier's Opera, Paris, are works of refinement and sensitivity found.

In the squares, streets and boulevards, sculptures, usually in bronze, were erected of the then famous in heroic poses which, as their subjects sank into anonymity, began to look ridiculous or pathetic. In the houses of the rich, figures in Classical style were placed in corners and niches. There was too much work for the talent that could have been available. There are exceptions to this largely uninspiring scene and, as time passes, we may discover that other forgotten sculptors were more senstitive than we now believe.

**Auguste Rodin** (1840–1917). In an age of mediocrity one great figure, a giant of European sculpture, stands out, much as ▽Bernini had done in the 17th century. Rodin, who was born in Paris and died at his home just outside at Meudon, was essentially a Parisian. His work is based on two qualities; an extraordinary technical facility and a deep understanding of the human form acquired through almost endless drawing matter and modelling in clay. His working life was not an easy one and his sculptures usually provoked controversy. This began with *The Age of Bronze* (1877), a careful nude male study which offended by its sense of actuality which was very different from the 'Classical' academic work then admired. The last of his works to provoke the anger of the critics was *Balzac* (1897). In this study pf the great humanist novelist he found a subject both worthy of his abilities and sympathetic to his own view of life. His treatment in wrapping Balzac in a formless dressing-gown and thus laying emphasis on the lion-like head offended the current taste for heroically posed portrait sculpture, but the work is perhaps his masterpiece. *The Gates of Hell*, on which Rodin worked for twenty years from 1880, based on ▽Dante and containing a large number of figures which have been cast separately (such as *The Thinker*, *The Shades*), was a state commission designed for the Musée des Arts Decoratifs and was never erected. It contains most of his artistic ideas and is a *tour de force*. His *Burghers of Calais* (1884–94) is, however, a more successful group composition.

Although in some ways an ▽Impressionist sculptor, Rodin's work is less Impressionist than his Italian contemporary, Medardo Rosso (1858–1928), produced in his small wax figures.

*Above left:* AUGUSTE RODIN *The Age of Bronze.* 1875–7. Bronze, h. 71¼ in (182 cm). Tate Gallery, London
*Above right:* AUGUSTE RODIN *Balzac.* 1897. Bronze. h. 118 in (299·7 cm). Rodin Museum, Paris
*Left:* MEDARDO ROSSO *Yvette Guilbert.* 1894. Bronze. Galleria Nazionale d'Arte Moderna, Rome

# THE 19th CENTURY IN EUROPE

**The Naming of a Style.** The enormous and continuing popularity of Impressionist painting tends to conceal the fact that Impressionism was a phase in art, like any other – ▽Gothic, ▽Romanesque, or ▽Rococo. It was subject to the same laws of growth and decay, and it developed in opposition and so in close relation to the artistic doctrines of the day. Hence the initial wave of abuse to which the Impressionists were subjected: critics, as well as the general public, knew exactly what the movement was up to. The word *Impressionism* was originally coined by a journalist named Louis Leroy, in a review of the first Impressionist Group Exhibition in 1874 published in the satirical magazine, *Le Charivari* (25th April issue), and it was intended to be dismissive. Pictures like Monet's *Impression, Sunrise, Le Havre* (1874), were just an 'impression' of nature, nothing more.

The 'Establishment' – the organisers and patrons of the annual Paris ▽Salon that could make or break a reputation – approved of art with a strong narrative content; a high degree of finish and technical virtuosity; idealised forms, especially that of the female nude, but also in landscape; and subtle modulations in colouring and shading. The Impressionists challenged this doctrine, point for point. They valued the unidealised nude (Manet's *Olympia* (1863) caused a scandal); everyday life as subject matter, without dramatic overtones, such as Manet's *Music in the Tuileries Gardens* (1862), Degas' *Beach Scene* (1876/7); compositions that employed asymmetry and even cut off part of a figure, as in Degas' *Dancers on a Stage* (1874), and which did away with 'framing' motifs at the sides, especially in landscape, as in Monet's *Thames at Westminster* (1871). Above all, the Impressionists believed in a type of landscape painted out of doors that would truthfully record how nature actually looked, how forms and colours were affected by the play of light and atmosphere and the optical distortions of distance, as in Pissarro's *Entrée du Village de Voisins* (1872).

**The Leading Figures.** Impressionism was evolved in the 1860s, perfected in the early 1870s and became subject to change and disintegration in the 1880s. The 1860s were the formative years. All the Impressionists were born between 1830 and 1841: Camille Pissarro (1830–1903), the one-time pupil of ▽Corot, whose landscapes painted in the open air, going back to the 1820s, were a factor in the development of Impressionism; Edouard Manet (1832–83), the most conservative of the group, much influenced by the old masters, especially Spanish artists like ▽Goya; Edgar Degas (1834–1917), who had studied under a pupil of ▽Ingres and became primarily concerned with reconciling the imagery and stylistic devices of Impressionism with the Classical tradition of European painting; Alfred Sisley (1839–99), the most single-minded of the group – he painted virtually nothing but small landscapes – Paul Cézanne (1839–1906), who is invariably placed with the Impressionists but who is best seen as a ▽Post-Impressionist painter; Claude Monet (1840–1926), arguably the most brilliant painter of landscape in the group and certainly the artist who carried the depiction of optical sensations the furthest; and Pierre-Auguste Renoir (1841–1919), who was to become one of the great masters of the female nude.

**The Formative Years.** The major figures came together as students in Paris studios in the early 1860s. Impatient with the conservative teaching, they soon began to prefer painting out of doors. During the second half of the 1860s, the Channel Coast and the estuary of the Seine also became popular subjects. Monet's work at this point was probably the most significant; stimulated by contact with Boudin (1824–98) and Jongkind (1819–91), who liked to work out of doors, he began to paint much more freely and to use much lighter and stronger colours to record light and atmosphere.

**The Problem.** The great years of Impressionism, from about 1869 to 1876 (with one or two later masterpieces from Manet and Renoir – such as Renoir's quintessential *Seine at Argenteuil* (*about* 1879) – will always be associated with the landscapes painted along the banks of the river Seine, at small centres within easy reach of Paris. It was here that Monet and Renoir, in trying to record the restless movement of the water, perfected the characteristic Impressionist method of breaking up the forms into fragments of pure colour, a mosaic of paint strokes that fuse only when seen from a certain distance.

In their desire to achieve immediacy and freshness, the qualities they felt contemporary academic landscape painting so conspicuously lacked, the Impressionists rejected the traditional preparatory processes. They made much of the act of painting, out of doors in front of the subject; spontaneity counted for much, and inspiration became a matter not of imagination but of emotion. Impressionism ran into trouble in the late 1870s because the artists, being only human and incapable of repeating the same thing without loss of inspiration, exhausted the possibilities of the 'programme' as it had been evolved from the mid-1860s. Sisley refused to believe this; he went on painting the same kind of landscapes until his death in 1899; but the results, after about 1878, are often disastrous: monotonous in mood, hard in tone and slack in style. There was of course an alternative, which the better minds immediately appreciated: and that was to change the nature of the 'programme'.

**The Response to the Crisis.** Of all the great movements of art, Impressionism owed least to intellectual theory. It looked to no oracles or treatises for approval and it was not until the second half of the 1870s that serious literature about the style began to appear. *The New Painting* by Duranty came out in 1876; *The Impressionists* by George Rivière was published in 1877; and Duret brought out his book, *The Impressionists*, in 1878. The Impressionists exhibited together eight times between 1874 and 1886; but by the time of the last show the initial unity, the general acceptance of a common purpose, had long since withered away. This was partly a matter of temperament but also a direct result of the aesthetic crisis that threatened the movement in the early 1880s. 'I find it harder and harder to produce work that satisfies me', Monet wrote to the art dealer Durand-Ruel in 1883; while Renoir later told the collector Vollard: 'about 1883 there occurred a kind of break in my work. I had carried Impressionism as far as I could, only to realise that I didn't know how to paint or draw. In a word, I was in a fix.'

*Above:* EDOUARD MANET *Concert in the Tuileries Gardens.* 1862. 30 × 46½ in (76 × 141 cm). NG, London

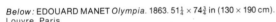

*Above:* EDGAR DEGAS *Dancers on a Stage.* 1873–94. 24½ × 18¼ in (62·3 × 46·4 cm). Courtauld Institute Gallery, London

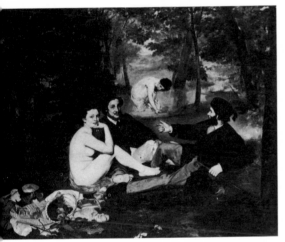

*Above:* EDOUARD MANET *Déjeuner sur l'Herbe.* 1863. 84½ × 106¼ (215 × 270 cm). Louvre, Paris

*Above right:* ALFRED SISLEY *La Berge à Sante-Mammes.* 1879

*Below:* EDOUARD MANET *Olympia.* 1863. 51¼ × 74¾ in (130 × 190 cm). Louvre, Paris

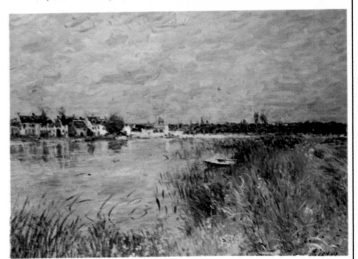

*Below:* CAMILLE PISSARRO *Entrance to the Village of Voisins.* 1872. 18⅛ × 21⅝ in (45·8 × 54·8 cm). Jeu de Paume, Paris

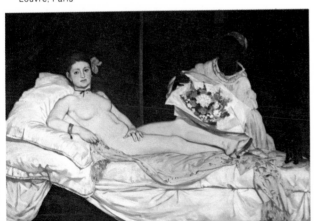

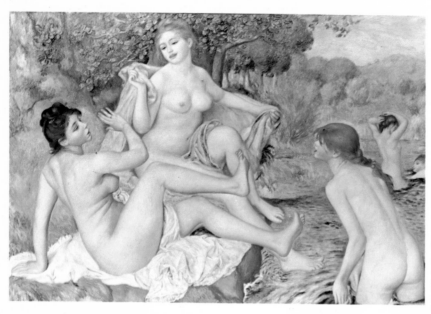

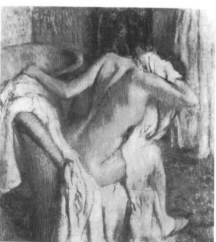

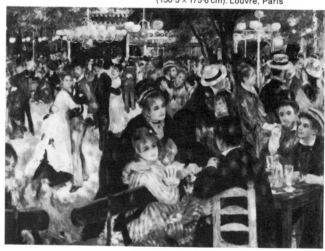

*Left:* AUGUSTE RENOIR *The Bathers.*
1887. $46\frac{3}{8} \times 67\frac{1}{4}$ in (116·8 × 170·8 cm).
Philadelphia Museum of Art
*Below left:* EDGAR DEGAS *Woman
Drying Herself.* $40\frac{7}{8} \times 38\frac{3}{4}$ in
(103·8 × 98·4 cm) NG, London
*Below right:* AUGUSTE RENOIR *Le Moulin
de la Galette.* 1876. $51\frac{1}{2} \times 69$ in
(130·5 × 175·6 cm). Louvre, Paris

**Freedom of the Style.** The major figures met the crisis in different ways. Renoir, who had always revered the old masters, briefly came under the influence of ▽ Italian Renaissance painting and began to give his figures a clearer, more carefully defined outline. *The Bathers*, on which he laboured for several years, shows the linear emphasis, but still combined with the light, clear colours of Impressionism. The result has great charm – Renoir communicates his perennial delight in the female body – but is nonetheless rather laboured. He later returned to more loosely painted figures, which are often quasi-mythological in character, but his colouring became far hotter. The late Renoir nudes no longer belong to the real world; they are the inhabitants of a dream-scape.

Monet's response was different. On the one hand, he pursued increasingly subtle effects of light, notably in several series of paintings illustrating a certain place or motif (the Gare St Lazare, haystacks, the front of Rouen Cathedral, the Thames at Westminster) at different times of the year or even of the day. On the other hand, he realised, perhaps more sharply than any of his contemporaries, that the richness and boldness of the Impressionist style, created to convey truthfully natural effects, was itself part of the thing seen. This is already evident in the rippling water in the early *Thames at Westminster*: the strokes of paint vividly suggest water but they also constitute a bold pattern of an almost abstract kind. Much of Monet's work, from the early 1880s onwards, was concerned with finding an increasing pictorial richness in the means without sacrificing the still Impressionist ends. The late *Thames and Parliament* is no longer a naturalistic 'snapshot' of nature, like the 1871 canvas; yet, while manifestly artificial, it conveys a feeling for light so strong and so subtle that it remains entirely credible. An 'impression' has given way to a 'vision'. In the many paintings of water-lilies, based on an elaborate water-garden that he built on to his home at Giverny, Monet carried the process even further. He found richer and richer effects in formations of pigment and webs of colour whose relationship to natural forms grew increasingly tenuous.

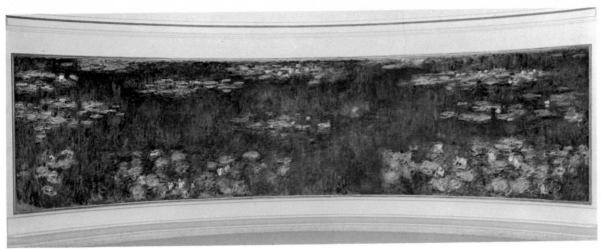

CLAUDE MONET *Les Nympheas. About* 1920. L'Orangerie, Paris

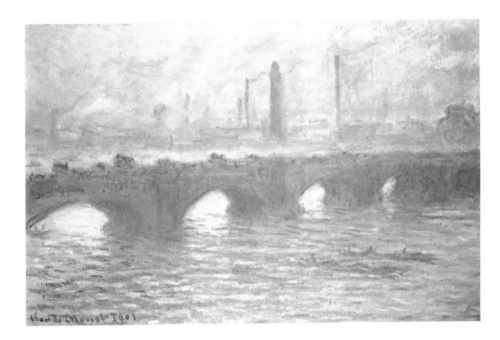

*Right:* CLAUDE MONET
*Waterloo Bridge.* 1901

**The Individual Answer.** Monet's development was characteristic of this second phase of Impressionism, when the style itself was subject to as much, if not more, scrutiny than the world it was supposed to recapture on canvas. Degas's later work, often in pastel (which allowed him to retain a linear emphasis without sacrificing colour), reveals an obsession with perhaps half a dozen themes, endlessly repeated. One of them was the nude in domestic surroundings; and the *Woman Drying Herself* shows that Degas was just as aware as Monet that the richness of the medium (in this case pastel) could contribute as much to the final effect as accurately observed forms and lighting. Who could say of what precisely the carpet or the 'wallpaper' are made?

If Monet gloried in the increasing freedom of the brush-stroke, Camille Pissarro sought to 'tidy up' the style by breaking up the strokes of pure colour into an orderly pattern. This style was partly influenced by contacts with ▽ Seurat and is variously known as ▽ Neo-Impressionism and □▽ Pointillism. But although the style might change, Pissarro's subject matter remained much the same. His Pointillist phase fortunately passed (he was not, by temperament, a Classical artist like Poussin or Seurat, and the Pointillist canvases are often laboured) and in the last ten years of his life Pissarro found renewed inspiration in a form of Impressionism much closer to his work of the 1870s.

Manet died in 1883. As he had come to 'pure' Impressionism relatively late (he was not converted to painting out of doors until 1874), he had not worked through all the possibilities of the style by the time of his death. Some of his later works show signs of weakness, due to ill health, but *The Bar at the Folies-Bergères* (1881–2), once owned by the composer Chabrier, is among his greatest achievements.

**After Impressionism.** The word Post-Impressionism means, quite simply, 'after Impressionism'. As has been indicated, the Impressionists came to realise that they had created an impasse for themselves; and the later phase of Impressionism merges into Post-Impressionism, whose chief exponents, while retaining most of the gains of Impressionism – the everyday subject matter, the feeling for light, expressed in strong, clear colours— sought to re-emphasise structure and content.

PAUL CEZANNE
*Left: Zola's House at Mèdan.*
About 1880. 23⅜ × 28¼ in
(59 × 72 cm). Glasgow
*Right: Portrait of Gustave
Geffroy.* 1895. 42⅔ × 35 in
116 × 89 cm). Coll Pellerin,
Paris
*Below right: The Basket of
Apples.* 1890–4. 25¾ × 32 in
(65·4 × 81·3 cm). Art Institute of
Chicago

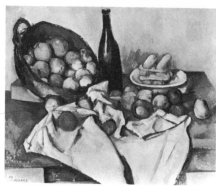

*Below:* PAUL CEZANNE *Bathers.* 1900–5. 51¼ × 76⅞ in (130 × 195 cm).
NG. London

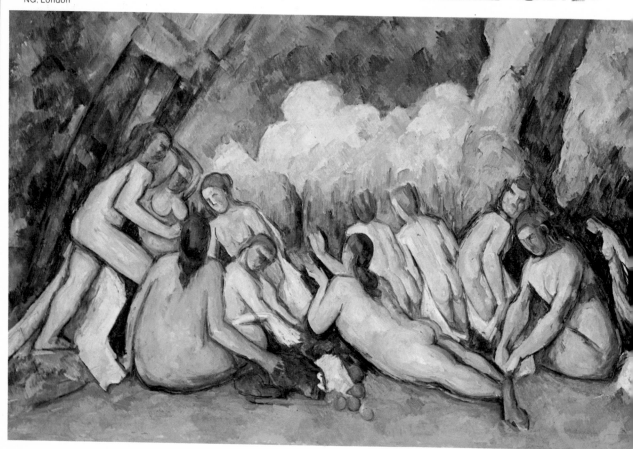

**Paul Cézanne** (1839–1906) was the oldest of the group. He was born (and died) in Aix-en-Provence, the son of a successful hatter who later became the head of a bank. The young Cézanne was obliged to work at banking until 1861, although he also studied at the Aix Academy of Drawing. Much of his early work is clumsy; but it was precisely this stumpy, insistent force, transmuted by years of experience working out of doors in front of the motif (basic subject) and filtered through an exceedingly delicate and beautiful sense of colour, that gives to the best of his mature work an underlying energy, interest and passion that is missing from the pictures of his many imitators and disciples.

Cézanne developed into an Impressionist and worked for a short time with ▽Pissarro; but he was unsympathetic towards the easy freedom of the classic Impressionist style. The lack of structure, and what he felt was an inherent risk of triviality, worried him. He was later to say that he wanted to make of Impressionism something 'solid and durable, like the art of the museums'; 'to do Poussin again, from Nature'.

**Observation and Structure.** *Zola's House at Médan* is a characteristic masterpiece from Cézanne's early maturity and shows his methods fairly clearly. He took over from Pissarro, ▽Monet and ▽Renoir the conception of modelling by means of the small, independent brushstroke loaded with pure colour; but he went a step further. Cézanne realised that if the strokes were arranged parallel to each other, instead of at all kinds of angles, they would add to the overall coherence of the design, and contribute to its weight and stability. Renoir's *Seine at Argenteuil* (*about* 1879) shimmers with light and intimations of happiness. The ingredients of Cézanne's picture of the house of Émile Zola (they were old friends) are not dissimilar; but there is nothing in the least dreamy or overtly lyrical about Cézanne's interpretation. He was not interested in how sunlight dissolves form, but in how its impact on forms (trees, rocks, roofs) and how their colouring changes in relation to sunshine, shadow, and half-shadow, could reinforce structure.

This interest in structure, rather than in the faithful recording of forms dissolving in light and surface textures, applied equally well when sunlight was not directly in play – as in the celebrated portrait of the writer and supporter of Impressionism, Gustave Geffroy (1855–1926). The conception must have been influenced by Degas's earlier *Portrait of Duranty* but the differences are, again, revealing. Degas's image is more of a character study; it suggests an habitual pose. Cézanne's portrait is much cooler, seemingly less involved, and has no obvious social or psychological overtones. The almost logical outcome of this line of development was *The Bathers*, a very late work which shows just how far Cézanne was prepared to take his passion for structure. The figures on the left already anticipate the non-naturalistic ▽Cubism of ▽Picasso and ▽Braque.

**Georges Seurat** (1859–91), like Degas, studied for a while with a pupil of the great Classicist, ▽Ingres; but his approach to the problem of structure was to be very different from that of either Degas or Cézanne. Seurat became fascinated with theories of colour harmony and, in particular, with a method of juxtaposing not just

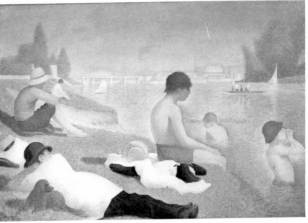

*Above:* GEORGES SEURAT *The Bathers. Asnières.* 1883–4. 79⅛ × 118⅛ in (201 × 301·5 cm). NG, London
*Below:* PAUL SIGNAC *Lighthouse at Portrieux.* 1888. 18 × 25⅗ in (46 × 65 cm). Kröller-Müller Museum, Otterlo

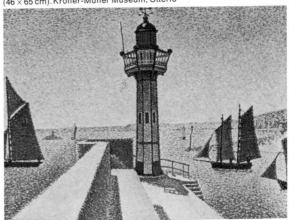

strokes of colour (like ▽Monet or ▽Renoir) but also the constituent ingredients of a particular tone. In depicting grass, for example, he might paint strokes of blue next to yellow; so that its green colour (blue and yellow, when mixed, making green), as well as its shape, would only become apparent when seen from a distance.

**Science and Colour.** This theory, sometimes known as ☐Pointillism, was used rather cautiously in Seurat's first (and in many ways greatest) masterpiece, *The Bathers* (1883–4), but with complete assurance in *The Parade* (1887–8). Common to both – and to his other mature works – is the way in which the figures are related to each other and to the setting in a geometrical way. The effects are highly calculated and serene.

As in the case of Cézanne, Seurat's style was a dangerously attractive example to follow. But although Seurat liked to think of Pointillism as scientific, and made much of the optical discoveries of the scientist Chevreul, the method depended for its success entirely on the delicacy of the painter's sensibilities. In the hands of some followers, indeed, the vision did degenerate almost to the level of painting by numbers. By far the ablest of Seurat's followers was Paul Signac (1863–1935), who published the 'text-book' of the movement, also known as Neo-Impressionism: *D'Eugène Delacroix au Néo-Impressionisme* (1899), and whose influence on ▽Matisse and the ▽Fauves was significant.

# THE 19th CENTURY IN EUROPE

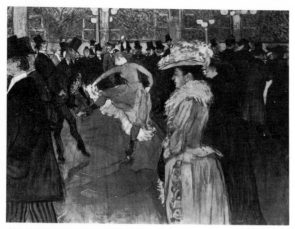

*Above:* HENRI DE TOULOUSE-LAUTREC *Dance of the Moulin Rouge.*
1890. 45¼ × 59 in (115·5 × 150 cm). Museum of Art, Philadelphia

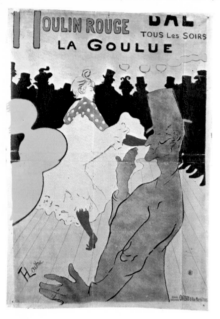

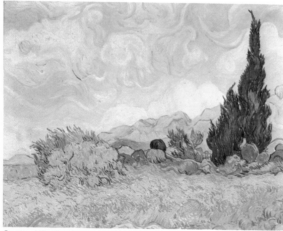

*Centre:* HENRI DE TOULOUSE-LAUTREC *Moulin Rouge – La Goulue.*
1891. 76¾ × 48 in (195 × 122 cm). Reinhardt Coll, Winterthur
*Above:* VINCENT VAN GOGH *Cornfield with Cypress.* 1889. 28½ × 36 in
(72 × 91 cm). NG, London

Cézanne and Seurat were not particularly interested in the emotional content of a theme. This aspect of Post-Impressionism was left to the other three great artists: Henri de Toulouse-Lautrec (1864–1901), Vincent Van Gogh (1853–90) and Paul Gauguin (1848–1903).

**Henri de Toulouse-Lautrec.** Lautrec's art had its roots in the work of Degas, as the important and characteristic *Dance of the Moulin Rouge* (1890) demonstrates. There is the same kind of informal viewpoint, similar somewhat flattened space, a comparable emphasis on the outline of the figures, which are also cut into by the edges of the composition. More personal to Lautrec, however, are the flatness of the figures (there is also an influence here from Japanese colour prints, which were very popular in Impressionist circles), the tinge of caricature that is even more evident in other paintings and the bold, simplified essentially non-naturalistic colour.

Lautrec was a cripple from childhood and he found the 'easy come, easy go' atmosphere of the Parisian bars and music halls much more sympathetic than the aristocratic society into which he was born. Many of his best pictures feature singers and dancers and other performers of the day, at the height of their short-lived fame. The skeletal dancer in *Dance of the Moulin Rouge* was the well-known Valentin-le-Désossé. Lautrec's temperament as much as the incisive, often witty brilliance of his draughtsmanship, puts him among the greatest of all designers of posters (in all a total of 31). The right flair and panache he certainly had; also the right sense of exaggeration. In posters Lautrec's feeling for life as gamey but vivacious found a perfect outlet.

**Vincent Van Gogh.** Of all the Impressionists and Post-Impressionists, Van Gogh had perhaps the most wretched life. He also created the movements's most intense pictures. Always suffering from poverty and illness his art, the only real outlet for his deeply human sympathies, was scorned by the public he longed to please. Born in Holland, the son of a pastor, Van Gogh worked in the picture trade, and tried to be a Church missionary ('I feel drawn to religion. I want to comfort the humble') before taking art seriously as a career. His early pictures, influenced by the Hague School and by English journalist illustrators (whose style he admired), are dark in tone and usually sombre in mood (eg the famous *Potato Eaters* of 1885).

After moving to Paris in 1886, Van Gogh was strongly influenced by the Impressionists: by their subject matter, their compositions and by their technique. The *Self-Portrait with a Bandaged Ear* (1889) is an exceptionally fine example of Van Gogh's mature style: note the influence of Japanese colour prints (one is even hanging in the background), especially in the clear-cut silhouette and the simplification of the colouring. The portrait was painted shortly after Van Gogh had cut off his ear after a violent quarrel with Gauguin – an indication of the extreme nervous tension that eventually led to Van Gogh's suicide in July 1890. This tension comes out in his work in the underlying rhythm of a composition, the restless sense of movement that transforms quite ordinary themes (such as the *Cornfield with Cypresses*).

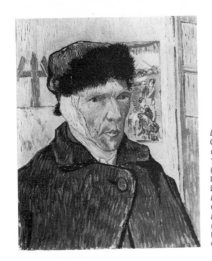

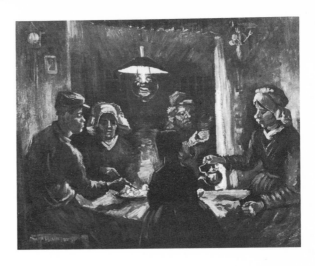

*Left:* VINCENT VAN GOGH *Self-portrait with a Bandaged Ear.* 1889. $23\frac{1}{2} \times 19\frac{1}{4}$ in (60 × 49 cm). Courtauld Institute Gallery, London.

*Right:* VINCENT VAN GOGH *The Potato Eaters.* 1885. $28\frac{1}{2} \times 37$ in (72 × 93 cm). Kröller-Müller Museum, Otterlo.

**Paul Gauguin.** Paul Gaugin was born in Paris, taken as a baby to Peru (the colourful sights, absorbed in infancy, were to haunt him all his life), but brought back to Paris in 1855. After a short spell in the French Navy, he became a stockbroker (1871), and began to paint in his spare time. His still tentative early work is in the usual Impressionist idiom; but by the mid-1880s, Gauguin had grown restless, both with his career and with his style.

For his temperament, impressionism was simply too prosaic. Gauguin wanted to 'invoke beautiful thoughts with form and colour', and he needed a style that was at once richer and more artificial, simpler and more barbaric, aspiring to the condition of folk art – and, to go with it, an environment unspoilt and undistorted by the pressures of 19th-century industrialisation.

Gauguin thought he had found it in Brittany. *The Vision after the Sermon* dates from 1888 and is the key work of this phase. Gauguin explained its point in a letter to Van Gogh: 'I believe that I have attained a great rustic and *superstitious* simplicity in these figures'.

Brittany did not live up to his high expectations. The South Seas seemed more promising; and Gauguin indeed spent much of the rest of his increasingly disillusioned life among the Islands (Martinique, Tahiti,

the Marquesas). *Nevermore*, painted during the second visit to Tahiti in 1897, is among the masterpieces of his maturity. The combination of rich colour and linear rhythm are typical; and so is the carefully contrived simplicity of the forms. 'I wanted to suggest', he wrote of *Nevermore*, 'by means of a simple nude a certain long-lost barbarian luxury'.

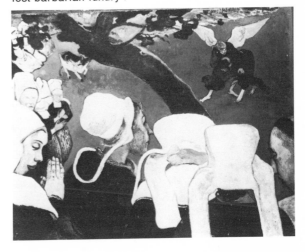

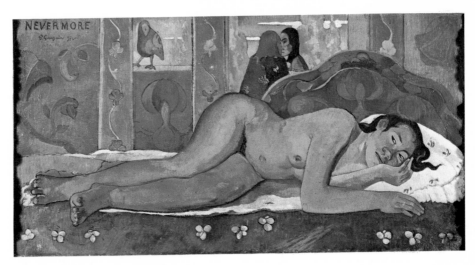

*Above right:* PAUL GAUGUIN *Vision after the Sermon.* 1888. $28\frac{3}{4} \times 36\frac{1}{4}$ in (73 × 92 cm). National Gallery, Scotland.

*Right:* PAUL GAUGUIN *Nevermore.* 1897. $23\frac{3}{8} \times 45\frac{5}{8}$ in (59·4 × 115·8 cm). Courtauld Institute Gallery, London.

# THE 19th CENTURY IN EUROPE

**John Ruskin** (1819–1900) was the most thoughtful, the most articulate and influential of father figures of the Arts and Crafts Movement. For the major part of his long career he preached, in books and articles and on the lecture platform, the primacy of human values to a world seemingly careless of the individual in the pursuit of ever stricter economic efficiency – demanding standards of design and manufacture which allowed makers and users equal dignity and enjoyment. 'You must either,' he wrote, 'make a tool of the creature or a man of him. You cannot make both. Men were not intended to work with the accuracy of tools, to be precise and perfect in all their actions. If you would have that precision out of them, and make their fingers measure degrees like cogwheels, and their arms strike curves like compasses, you must unhumanise them.' (*The Stones of Venice*, 'The Nature of Gothic', 1853.) Such beliefs directly animated a succession of remarkable men and, indirectly, transformed the relationship between art and industrialism.

**William Morris** (1834–96) sought to practise what Ruskin preached. He took up energetically Ruskin's conviction that in the middle ages social coherence and artistic utility had run together, and tried to organise his own existence on medieval models. After brief periods of theological study, architectural draughtsmanship, and painting, he founded, in 1861, the firm of Morris, Marshall & Faulkner (later known as Morris & Co). The plan was for a workshop rather than factory, where a small group of handworkers could see through from start to finish a range of goods for clients who shared their creed. Morris himself designed wallpapers, furniture, stained glass, chintzes, carpets, tapestries and woven upholstery. In 1890 he founded the Kelmscott Press, producing books and designing typefaces as well as decorated initials and borders.

The painting and applied arts of the middle ages were obviously Morris's chief inspiration but he was no mere facsimilist. His work is utterly distinctive – rich yet controlled, abounding in shapes, textures and colours drawn from forest and field. He took pains to learn the processes involved and arrived at numerous novel effects. However, the fact that he actually lived in the 19th century meant that he had to come to some terms with with modern production methods and marketing techniques. Much of his finest invention arose from the need to devise production repeats. Morris advertised constantly, in poetry and prose, the Ruskinian ideal of a face-to-face, intimately co-existing society, which would revolve around creative endeavour, and in the end endorsed socialism. Morris's sway was considerable and the examples of his work was widely copied.

**Architecture.** The Arts and Crafts spirit even touched, somewhat awkwardly, architecture. After his marriage, Morris had asked Philip Webb to design him a country home. The Red House, Bexley Heath (1859–60), was an amalgam of medieval manor and traditional cottage and it helped to establish middling-sized domestic architecture as a proper area for creativity. Norman Shaw's Bedford Park, London, and all subsequent English garden suburbs, owed a good deal to Morris.

*Above:* WILLIAM MORRIS Artichoke wallpaper. *About* 1875. V & A, London

*Below:* PHILIP WEBB The Red House Bexley Heath. 1859–60. Designed for William Morris

# The Arts and Crafts Movement

**The Crafts.** The idea of an individual solution to a particular design problem, utilising craft skills, is more easily accommodated to work of a smallish kind. A number of the architects – Webb, Voysey, C. R. Ashbee, for instance – who, like Morris, looked to architecture as 'a union of the arts, mutually helpful and harmoniously subordinated one to another' went on to create furniture, wallpaper, fabrics, pottery and metalware. But many more who had no architectural background were able to fit their chairs, hangings and domestic utensils to the Morris ideal of art-conscious intimacy. A vast amount of personal and personable stuff, proclaiming dexterity of hand and acuteness of eye or, leastwise, the sincere striving for these, came from Arts and Crafts enthusiasts. Several private presses based themselves on the Kelmscott model, all treating book design and production as an artistic effort. The Ashendene Press (1894), Ashbee's Essex House Press (1898), Rickett's Vale Press, Lucien Pissarro's Eragny Press and the Doves Press served to spread the Arts and Crafts message while answering very different aesthetic needs.

Associations of Ruskinians and Morrisites and their sympathisers were formed. Ashbee's Guild and School of Handicraft (1888) was probably the most unified, though apart from its furnishing of Ashbee's house (*about* 1894) it was only loosely collaborative. The Century Guild of Mackmurdo (1882) and the Artworkers' Guild (1884) – a 'spiritual oasis in the wilderness of modern life' – gave impetus and sustenance to the best of the later 19th-century designers in England. The Arts and Crafts Exhibition Society (from 1888) provided a shop-window and the *Studio* magazine (from 1893) gently promoted their work.

**Design and Education.** Craft, though with a somewhat reduced accent on its social implications, became a firm and sizeable part of academic education in the visual arts when the Central School of Arts and Crafts opened in 1896 under W. R. Lethaby. 'Exquisite living on a small scale is the ideal', said Lethaby: 'preference should be given to local materials and traditional ways of using them'. But he was quite ready to accept the industrial world as the setting for artistic activity. Indeed, a willingness to countenance the machine and a determination to reconcile individualism and mass production methods was an increasingly vital factor in design at large. Ashbee wrote: 'the purpose of the Arts and Crafts is to set a standard of excellence in all commodities in which the element of beauty enters'.

On the Continent and in North America too Arts and Crafts attitudes were adopted and adapted. In Germany there were 'workshops': the Deutsche Werkstätte für Kunst und Handwerk of Munich (1897) was followed by similar bodies in Dresden, Hellerau, Berlin and Hanover. Their successes were local. In 1907 Hermann Muthesius, who had studied English housing when cultural attaché, said: 'the Arts and Crafts are called upon to restore an awareness of honesty, integrity and simplicity in contemporary society'. He helped to found the Deutsche Werkbund, which promoted a comprehensive review of the designer's role. And through the discussions a readiness to foreclose the historical perspective and define, positively, the reasonable and humane existence

*Above:* C. F. A. VOYSEY The Orchard, Chorleywood, Hertfordshire. 1900

*Above:* C. R. ASHBEE Silver bowl. *About* 1900

*Below:* A. H. MACKMURDO *The Hobby Horse* Title Page. 1884

in markedly 20th-century terms is discernible. When the Weimar ▽Bauhaus was set up (1919) the machine and the technological revolution were fully endorsed. This was at once a school of art and architecture and a technical college. The director, ▽Walter Gropius, an earnest reader of Ruskin and Morris, could confidently declare 'the artist has the power to endow the lifeless machine-made object with a soul'.

# THE 19th CENTURY IN EUROPE

**The Symbolist Movement** developed first amongst poets as a reaction to materialist values and their counterpart in the Arts. Baudelaire, Mallarmé, Rimbaud and Verlaine were the inspiration for a new literature proclaimed in 1886 by the poet Moréas in a Manifesto of Symbolism. They sought to re-establish the imagination in art and life and looked for a counterpart to this poetic approach in painting. Mallarmé laid great stress on word sounds and design layouts to suggest ideas and moods and a parallel interest in the means of their art developed amongst those painters interested in emotional nuance rather than the description of everyday life. The novel *A Rebours* by Huysmans encouraged an extreme form of Symbolist sensibility in which the life of the imagination was pursued into a taste for luxury, exoticism and the perverse.

It was in the sumptuous art of Gustave Moreau (1826–98) that such writers and critics first found a sympathetic spirit and he remained the painter most admired by the 'Decadents' of literary Symbolism. Characteristically he uses Biblical or mythological subjects suggestive of ambiguous or extreme psychological conditions. His figures often have an androgynous quality and the settings are remote and exotic – oppressive rocky landscapes or fantastic opulent interiors. An eerie, twilit, languorous mood is established by broad areas of rich colour over which passages of fine detail are inscribed to give focus and definition. In his expressive use of colour, Moreau forms a link between ▽Delacroix and ▽Chasseriau, his acknowledged masters, and ▽Post-Impressionist developments. At the close of his career, ▽Matisse and other ▽Fauves-to-be flourished in his liberal studio at the École des Beaux-Arts. *L'Apparition* exhibited at the Salon of 1876 and later eulogised in *A Rebours* established his reputation amongst the Symbolists.

Odilon Redon (1840–1916), like Moreau, was acclaimed by younger artists as a Symbolist in the 1880s. The charcoal drawings which he produced from 1865 onwards display his unusual graphic art, in marked contrast to the contemporary work of the ▽Impressionists. Based solely on the free rein of the imagination, Redon developed a vocabulary of striking images with which to translate his dreams into a visual reality. To overcome the problems of selling and exhibiting these drawings he turned to lithography and produced several albums. 'The Eye floats towards infinity like some weird balloon' from the series *To Edgar Poe* (1882) demonstrates the bizarre nature of his work and his specific choice of caption which was much admired by his great friend Mallarmé. In the 1890s his work underwent a marked change and he began using pastel and oil. These late mythological subjects and flower pieces are represented with intense, brilliant colour schemes but still convey a unique and personal interpretation. Redon's wide cultural interests are reflected in the remarkable journal which he kept throughout his life.

*Above:* GUSTAVE MOREAU *The Apparition.* 1876. 41¾ × 28⅓ in (106 × 72 cm). Musée G. Moreau, Paris.

*Below:* ODILON REDON *The Eye Floats Towards Infinity Like Some Weird Balloon.* 1882. 10⅛ × 7¾ in (26 × 20 cm). Bibliothèque Nationale, Paris

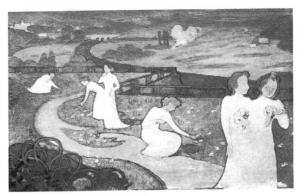

*Above:* MAURICE DENIS *April.* 1892. 14⅝ × 23¾ in (37·5 × 61 cm). Kroller-Muller Museum, Holland

*Above:* EDOUARD VUILLARD *Mother and Child. About* 1890. 19⅛ × 22¼ in (40·6 × 56·5 cm). Glasgow

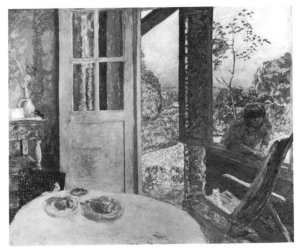

PIERRE BONNARD *Dining-room in the Country.* 1913. 64¾ × 81 in (164·5 × 205·7 cm). Minneapolis Institute of Art

**The Nabis.** Maurice Denis (1870–1943) was the leading spokesman for ▽ Gauguin's ideas among the younger painters in Paris. In 1888 Paul Sérusier (1863–1927) returned from Pont-Aven with a small landscape, known as *The Talisman*, painted under Gauguin's supervision, in which simple forms and flat colours were employed for their emotional effect. It was Denis who enlisted the support of his fellow students in the Académie Julian for the new style known as 'Synthetisme'. Following Denis' religious inclination *The Talisman* was invested with a mystical significance and became a model for the group including Ranson, Roussel, Maillol, Bonnard and Vuillard, who adopted the name *Nabis*; the Hebrew word for prophet. In 1890 Denis published his theories in an article which included the famous statement that, 'a picture, before being a war-horse, a nude woman, or some sort of anecdote, is essentially a flat surface covered with colours arranged in a certain order'. The painting *April* is an example of these theories in practice but beyond the pattern alone, the figures and colours are used in a symbolic way to evoke the essence of the season. Denis' artistic career was extensive, covering various media, and much of his work is concerned with the attempt to develop a suitable style for religious art.

Pierre Bonnard (1867–1947) and Edouard Vuillard (1868–1940), shared a studio with Denis in the early 1890s, and at this stage their work also displayed the bold arrangements of forms and colours and decorative line inspired by Gauguin. But Bonnard and Vuillard were less concerned with mystical and philosophical ideas and their expression than Denis. They took contemporary bourgeois Parisian life for their subjects; usually intimate, domestic interior scenes, which has led to their art being dubbed *Intimisme.* Where the other Nabis saw themselves as spiritual initiates for whom the vulgarity of such life was something to be transcended, Bonnard and Vuillard invested ordinary experience with a heightened response.

Their sense of design on a flat surface was greatly influenced by ▽ Japanese prints, and the compositional devices and unusual viewpoints which ▽ Degas had also exploited gave to their works a sense of the impromptu moment captured. Within this pictorial structure they introduced the broken brush mark and vibrant surface of ▽ Impressionism. In their mature works a sumptuously coloured and patterned surface dominates. Foreground and background, figures and ornamental patterns are integrated in an overall glow of rich colour imparting visual poetry to commonplace experience.

The Nabis' style was admirably suited to poster design and other illustrative work and Bonnard particularly excelled in these fields. His poster for *La Revue Blanche* (the magazine which promoted Symbolist writers and Nabis artists from 1891 to 1903) illustrates his parity even with ▽ Lautrec. In his later work he often used canvases of considerable size and colour of great splendour. But his approach remained reverential, sensual, intimate and often witty. Vuillard tends to smaller scale and more muted colour. Occasionally his works suggest an ambiguous psychological mood or theatrical situation, but generally the atmosphere is peaceful and harmonious.

# THE 19th CENTURY IN EUROPE

**Art Nouveau** is usually deemed a matter of 'style' rather than a philosophy: but, in fact, distinctive ideas and not only fanciful desires prompted its appearance. Common to all the most consistently Art Nouveau creators was a determination to push beyond the bounds of historicism – that exaggerated concern with the notions of the past which characterises the greater part of 19th-century design: they sought, in a fresh analysis of function and a close study of natural forms, a new aesthetic. It is true that the outer reaches of Art Nouveau are full of mindless pattern-making but there was, at and around the centre, a marvellous sequence of works in which the decorative and the functional fuse to novel and compelling effect. Art Nouveau means much more than a single look or mood: we are reminded of tall grasses in light wind, or swirling lines of stormy water, of cloven rock – the coherent but multifarious life of organic nature is always the ultimate model.

**The Forming of a Style.** The ideological and formal sources of Art Nouveau are numerous and include ▽ Celtic illumination, ▽ Gothic sculpture, the drawings of ▽ William Blake, and Christopher Dresser's *Unity in Variety* (1859) – a treatise on botany for artists. But it is Arthur Heygate Mackmurdo (1851–1942) who is often identified as the first designer in whom historical precedents were sufficiently subdued for the new mode to show clearly. His buildings, furniture, graphics and textiles derive definitely, though not exclusively, from the natural world, convey a strong sense of their materials, and are structurally elemental. Mackmurdo accepted a good deal of ▽ Ruskin's involvement with the social and economic conditions of art and turned eventually to the composition of political tracts. Few of those who followed were so overtly political but an awareness of art's social concomitants was common: and the interest in organic nature should be understood as proceeding from a sense of life's order lost or perverted amidst urban industrial stress.

**Europe.** From Mackmurdo on, the story of Art Nouveau is complex and crowded with incident. Art Nouveau was by no means an English movement. Indeed, it was one of the great ubiquitous cultural impulses, its peculiar devices appearing virtually throughout Europe and Scandinavia, and in America too.

A particularly vigorous strain developed in Belgium, where Henri van de Velde (1863–1937) (he was decorator of the Paris shop, Maison Bing, L'Art Nouveau, whence comes the phenomenon's generic name) pared away the conventions of art and architecture in favour of a rather rigid floral style (his house at Uccle, 1895), and Victor Horta (1861–1947) seems to have passed the rule-book through a maze of botanical fact (the Hôtel Tassel, 1892–3, and the Maison du Peuple, 1896–9 in Brussels). Horta was widely admired for his readiness to reconsider basic design problems and for the fluency of his adaptations of organic principle. For the Tassel house he opened up the centre into a sort of conservatory space in which the exposed cast iron supports are themselves stylised plants. And the Maison du Peuple he constructed around a sinuous iron frame, every

*Above:* VICTOR HORTA Lamp. *About* 1895

*Below:* VICTOR HORTA Doorway, Hotel Deprez, Brussels. 1900

decorative element of which arose from the containment of stresses. It was said that 'he follows the secret law obeyed by vegetation, which grows in immutable and ever harmonious forms, but he compels himself never to draw a motif, nor to describe a solitary curve which could be seen as a *pastiche* of natural form'.

In France, Art Nouveau had the State's seal of approval when Guimard's designs for the Paris Metro stations were accepted and above the subways (1898–1900) sprouted elaborate arrangements of iron and glass resembling large beanshoots and seedpods. Hector Guimard (1867–1942) had liked Horta's work in Brussels and hoped to extend its radical disruption of expected architectural behaviour. His furniture – webbed, spiny, bone-like nodules jutting from broad swoops of wood and metal – is no less surprising. Even outside Paris, originality found a ready market. Émile Gallé of Nancy (1846–1904), an enthusiast of the botanist Godron (*Flora of Lorraine and France*), declares, earnestly, 'a love of flowers was my salvation', and from a minute analysis of plant structure and constant experiment with his substances he evolved a repertory of gorgeous contour and surface for ceramics and glassware.

*Above:* HECTOR GUIMARD. Anvers Station on the Métro. 1909

*Below:* ANTONI GAUDÍ Güell Park entrance steps. 1914

**America.** The giant office blocks of Louis Sullivan (1856–1924) – the Wainwright Building, St Louis (1890), the Guaranty Building, Buffalo (1894), the Carson, Pirie & Scott Store, Chicago (1899–1904) – reveal in their façades, their honeycomb insides and the strips and panels which divide the cells a riot of plant-like ornament. 'All things in nature', Sullivan said, 'have a shape . . . an outward semblance, that tells us what they are. . . . Unfailingly . . . these shapes express the inner life, the native quality of the animal, tree, bird, fish'.

Louis Comfort Tiffany (1848–92) was an adventurous creator of luxury objects, mainly in glass, often utilising the shot-silk glow of metallic iridescence, and inspired by flower and feather. Tiffany's firm was enormously successful and his goods were much imitated.

LOUIS COMFORT TIFFANY Iridescent 'favrile' glass. Bethnal Green Museum, London

**Spain.** The most spectacular results of the decision to rethink design from the ground up, so to speak, are to be found in Spain. Antoni Gaudí (1852–1926) conceived for Barcelona a series of architectural extravaganzas, apparently pervaded by thoughts of nature in its less attractive manifestations – the rabbit warren or termite hill, reptilean anatomy, weeds on the rampage. The Palacio Güell (1885–9) has already the ebb and flow, the rhythmic asymmetry of his mature efforts, but is relatively urbane. The Casa Milá (1905–07) is a riotous assembly of pitted stone and twisting iron, with a ground plan which altogether ignores the right-angle. And the church of the Sagrada Familia (1884, uncompleted) bemuses the visitor, with its four towers like monster decaying cucumbers: it resembles, on the whole, a vegetable garden in the grip of some ferocious virus and mutating freely.

**The End of Art Nouveau.** The style has been said to end in the work of Charles Rennie Mackintosh (1868–1928). Painter, architect and designer, he was initially attracted to the creative freedom of Art Nouveau and its encouragement of the fanciful, but he used a cooler treatment. The essentials of his passage may be traced in one place, the Glasgow School of Art. A system of repeated curving forms in the main building (1897–9) gave way to regimented verticals and horizontals in the library (1907–09): the new order fell to a new orderliness.

From then on, the need and the wish for economy of means, a desire to exploit easy mechanical replication, became dominant. Both architecture and the applied arts contrived an ethic and an aesthetic based on meaner notions of utility.

# THE 19th CENTURY IN EUROPE

Two principal characteristics distinguish 19th-century architecture; the use of a variety of historical styles and the development of new materials and structural methods.

The first arose from the needs that the new societies, brought into existence by the industrialisation of production, imagined that they had to continue in the traditional styles of their predecessors. Elements of these earlier styles were put together to give an air of authority to town halls (Birmingham), railway stations (Euston, London), opera houses (Paris Opera) and legislatures (Houses of Parliament, London). Restraints of taste and careful application of Classical standards, which had characterised the 18th century, gave way to a variety of styles which could be either quaint, bombastic or severe and generally, to modern eyes, of great curiosity.

The second characteristic emerged from the development of new materials as a result of the new industrial needs. In building, new forms – factories, warehouses, railway terminals, administrative centres, hospitals – were demanded. In the mid years of the century, cast iron was used structurally in large buildings such as warehouses and libraries. The Crystal Palace, designed by Joseph Paxton for the 1851 International Exhibition in London, provided a spectacular example of the possibilities of cast iron and glass that had worldwide publicity. In 1899 ▽ Gustav Eiffel designed the exhibition tower for Paris which bears his name and provided the same form of publicity for the new material – steel.

In the United States of America, it was the possibilities of cast iron and steel in the building of multi-storey unit constructions that were most effectively exploited. After the installation of the first safety elevator by Otis in 1889, it became possible to use as well as build tall buildings. 'Skyscrapers' first appeared in Chicago and New York and became synonymous with American architecture since the 1890s.

In their earlier use, the new ferrous building materials were made to conform to the taste for Classical, medieval or other exotic styles (Brighton Pavilion); for example the glass and iron vault for Paddington Station by Brunel and Wyatt was supported on 'Gothic' columns.

**The Battle of the Styles.** Whilst the 18th-century architect, mainly employed by cultured clients with Classical tastes, had no doubt that 'Classical' was the right form of architecture, the architects of the 19th century had no such certainty – nor the clients with the same formed tastes. They were also designing for an aggressively changing society which was often deplored by sensitive and influential critics like ▽ Ruskin. Two main possibilities confronted them; the old and tested Classical style or the medieval Christian style – virtuous, worthy and romantic. Both had powerful propagandists. ▽ Augustus Welby Pugin, for instance, having concluded that the medieval was the last 'moral' style and architecture was either good or bad, wrote for and designed in 'Gothic' forms (his book *Contrasts* is a comparison of Classical and medieval buildings always to the detriment of the Classical). The Classical view was that the only true forms for a modern society were the worldly and civilised Classical columns and pediments.

Battle was joined between the two factions and the middle years of the century are filled with triumphs for one or the other. In Britain, Pugin scored a great victory with the Houses of Parliament, in France, Viollet le Duc patched, restored and wrote with great medievalist vigour. In the United States Thomas Walter and others built the Classical Capitol, Washington 1851–63) while Garnier in Paris (the Opera), 1861–9) and George Gilbert Scott in London (Foreign Office, 1861) made Classical monuments. There never was a result to the battle – indeed it still continues as an opposition of taste.

*Above:* SIR JAMES BARRY and A. W. N. PUGIN The Houses of Parliament, London. 1840–65

**Engineering Architecture.** While the battle of styles was engaging the energies of the architects, great changes were being introduced in industry. Mass production became possible in glass, iron and later steel. The machine tool industry introduced a precision in manufacture which, when applied to building, enabled the erection of large and safe structures built of uniform components. The demands for manufactories, storage and transport led to new types of utility buildings in manufacturing cities and ports. The railways needed stations, great bridges and viaducts.

The architects were hardly by training equipped to supply the design demand – except perhaps to suggest a style – and the engineer-builder appeared to answer the need. Telford's Katherine Dock warehouses, London, and the Marshall Field Warehouse, Chicago, by Richardson are early and late examples of storage design whilst the London rail termini provide a range of solutions from the □Doric portico of Euston (1838) designed by the architect Philip Hardwick to the plain brick arch frontage of Kings Cross station by Thomas Cubitt.

For the same exhibition in Paris for which Eiffel built his tower, in 1889, two engineers designed the Galeries des Machines, the largest free span then attempted, and rested it on rocker pads which gives the appearance of lightness to the large and heavy structure – a purely engineering solution. Near ▽ Milan Cathedral, the Galleria Vittorio Emmanuele was built to rival in height the Cathedral's nave in glass and cast iron. At the end of the century the Amsterdam Bourse (Stock Exchange) was built by Berlage in brick, steel and glass in an undecorated bare functional style which heralds the new architecture of the 20th century perhaps more than any of the Classical or medieval examples resulting from the battle of styles.

# Architecture

*Above:* H. E. ELMES St Georges Hall, Liverpool. 1838

*Above:* SIR JOSEPH PAXTON The Crystal Palace, rebuilt at Sydenham, 1854. (Lithograph by Vincent Brooks)

*Right:* LOUIS SULLIVAN Guaranty Building, Buffalo, NY. 1894. Chicago Architectural Photo Co.

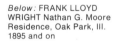

*Below:* FRANK LLOYD WRIGHT Nathan G. Moore Residence, Oak Park, Ill. 1895 and on

**The Rise of the Skyscraper.** Richard Upjohn's Trinity Church (1841–6), now dwarfed by the skyscrapers of New York's Wall Street, soared above its surroundings when it was built and symbolises the defeat of the styles by the growth of skyscraper architecture. New materials, concentration of population in new fast growing urban areas, particularly Chicago and New York in the mid-19th century, solid rock foundations, available capital and such inventions as the elevator resulted in the growth upwards of American city buildings. The engineers provided the means and the architects, taking over, exploited them.

The first design, not executed, for a real skyscraper of 28 storeys in Chicago by L. S. Buffington in 1887 preceded Louis Sullivan's Wainwright (1890) and Guaranty (1896) buildings by only a few years. Sullivan's buildings were however much ahead of Buffington's and indeed later scrapers such as Cass Gilbert's Woolworth Building (1934) in showing the way in which scraper architecture design was to go. Sullivan's vertical emphasis through the load-bearing columns became the later theme rather than the attempt to extend vertically an historically based design – for example a vertical Italian palazzo.

The Reliance Building (Burnham and Root, 1890) and the Carson Pirie Scott Store (Sullivan, first stage 1899) are early famous examples of offices and stores applying the essential unit construction of skyscraper design.

**Housing.** During the century great changes occurred in the provision of dwellings. Housing for workers had been previously of the cottage type designed locally by masons and carpenters without architects or plans. The newly rising middle classes, merchants and manufacturers, business and professional men had only the great houses of the landed gentry to copy or envy. There was no housing for industrial city workers – a new breed. In the cities too, the merchant's clerks and other than manual workers came to live to be with their work. A complex class structure, particularly in Britain, developed. In the United States the same effect came out of money-conscious and race-conscious distinctions.

The outcome was a new variety and quality in domestic building. All ranges of taste, cost, social level and convenience of location were variously catered for. Before the 19th century, architecture was for the better off, building for the workers – with successful and satisfying solutions in each category: during the 19th century the two were fused into a new great industry – building homes.

At the most deplorable end were the jerry-built slums of the world's great cities. The pretentiousness of much of the middle-class housing is reflected in the proliferations of styles on pompous façades but during the century there was much serious consideration of the needs of housing, especially through the ▽Arts and Crafts movements and the social revolutions that were heralded during the middle years of the century. Before the end of the century ▽Philip Webb, ▽Norman Shaw and ▽C. F. W. Voysey had produced a new domestic architecture in England, while in America H. H. Richardson was introducing a style that ▽Frank Lloyd Wright exploited in Oak Park, Chicago.

**1900** 'The Interpretation of
Dreams' by Sigmund Freud.
First Zeppelin flies.
**1901** Death of Queen Victoria:
succession of Edward VII.
**1902** End of Boer War.
**1903** First powered aircraft flight
by Wilbur & Orville Wright.
Henry Ford founds Ford Motor
Company.
**1904** Russo-Japanese War begins.
Theodore Roosevelt US President.
**1905** General strike in Russia.
Workers form Soviet in
St. Petersburg.
Einstein formulates Special Theory
of Relativity.
**1906** Amundsen reaches North
Pole.

**1910** Edward VII dies: succeeded
by George V.
**1911** Chinese Republic proclaimed:
end of Manchu Dynasty.
**1914** First Chaplin films.
Outbreak of First World War.
**1917** Russian Revolution:
Lenin Chief Commissar.
**1918** End of World War I.

**1920** End of Civil War in Russia.
**1922** Mussolini forms Fascist
Government in Italy.
USSR formed.
**1923** Inflation in Germany
**1924** Lenin dies: Stalin takes
power.
**1926** General strike in Britain.
**1927** 'The Jazz Singer' the first
talking picture.
Lindbergh flies Atlantic.
**1929** Wall Street Crash, New York.

**1932** Franklin Roosevelt US
President.
**1933** Hitler comes to power in
Germany.
**1935** Mussolini invades Abyssinia.
**1936** George V dies: succeeded by
Edward VIII who abdicates.
Germans occupy Rhineland.
Italians annex Abyssinia.
Spanish Civil War begins.
**1937** George VI crowned.
**1938** Germans march into Austria.
Fascist victory in Spainsh Civil
War.
**1939** Italy invades Albania.
Germany invades Poland.
World War II begins.

**1940** Germans occupy Western
Europe.
**1941** Germans invade Russia.
Japanese attack Pearl Harbour: US
enters war.
**1944** British-US invasion of
Europe.
**1945** Germany capitulates.
Mussolini killed.
Hitler commits suicide.
Atomic bombs dropped on Japan.
Japan capitulates.
**1947** Supersonic flight.
India granted independence.
**1949** Communist People's
Republic declared in China.

**1950** Korean War.
**1952** George VI dies: succeeded
by Elizabeth II.
**1953** Korean War ends.
**1959** USSR Lunik reaches Moon.

**1960** J. F. Kennedy elected US
President.
**1961** First US and USSR manned
space flights.
**1967** Six-Day Arab-Israeli War.
**1969** First man on moon (US).

**1972** Space craft lands on Venus
(USSR).

# THE MODERN WORLD

The twentieth century was born in a spirit of optimism. The worst excesses of the 19th century seemed to be over. Social reform was well under way in industrialised countries; the importance of the environment to the individual and to society had been scientifically demonstrated by the greatest thinkers of the time –Darwin, Marx and Freud– and with the idea of democracy more or less universally accepted, artists and architects thought that they were helping to build a new society and a new world.

The early years of the century saw perhaps the greatest burst of invention and innovation in the arts and sciences that the world has ever seen. The new architecture was born, new music, the new physics and cosmology, modern psychology, literature and a bewildering number of new movements in the visual arts. The first practical aircraft flew, and wireless telephony and telegraphy became universal.

The early optimism was all but shattered by two world wars, and disillusion seems to have been the major fruit of political reform. But above all this is the age of mass communication in which all, artist and spectator alike, are constantly bombarded by new ideas in print, sound and picture.

The result is apparent confusion in the arts. Apparent because as with any other age, time will one day resolve differences and emphasise similarities, so that our culture will appear to be more homogeneous than we can now comprehend.

# THE MODERN WORLD

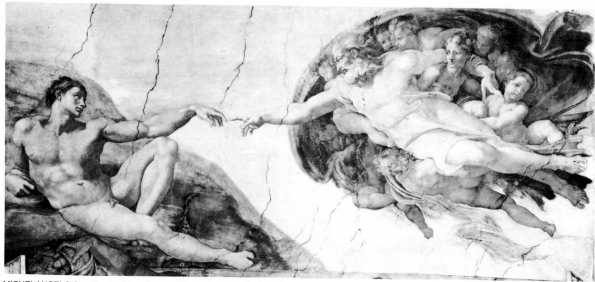

MICHELANGELO *Creation of Adam*. Detail of Sistine Chapel ceiling.
1508–12. Vatican, Rome

'Our art consists entirely of imitation, first of Nature, and then, as it cannot rise so high of itself, of those things which are produced by the masters with the greatest reputation.'

These words come from the introduction to the great ▽ Renaissance book *Lives of the Painters, Sculptors and Architects* by ▽ Vasari (1550). Until the end of the last century the principle that he states had remained unaltered and virtually unquestioned since the time of ▽ Giotto in the early 14th century. By 'imitation' Vasari did not mean mechanical copying, and the great masters of western European art from the early Renaissance onwards produced works of the greatest spiritual and intellectual inspiration. Nevertheless, no matter how profound the content of their work, the means by which they expressed themselves was the imitation of nature: by first learning to produce, in painting or sculpture, recognisable objects from the world of natural experience, especially the human figure, the artist could then imaginatively order and adjust them so that they communicated with man's deepest emotions.

It is obvious that much 20th-century art has nothing whatsoever to do with imitation in the sense used by Vasari. That is not to say that artists have not been profoundly concerned with man's spiritual and emotional make-up, but it does mean that they have sought other means of expressing themselves. There are a number of reasons for this change. The great innovation of the Renaissance was the accurate representation of the three-dimensional world on a flat picture surface through the use of □ perspective and □ tone. In the early Renaissance artists had a deeply felt message to convey and positively needed new means of expression which would be meaningful to modern man as he was then developing. □ Illusionist painting had a direct appeal to men who were beginning to look at their world in a new and more scientific light; geometrical perspective created space in which realistic figures could communicate with a psychological awareness outside the scope of the old ▽ Byzantine painting. But by the end of the 19th century this Renaissance tradition was becoming

tired. Its ideals were thought to be less and less relevant to the consciousness of modern industrial man whose experiences became increasingly removed from those of Renaissance man.

Just as the early Renaissance evolved a new means of expression, so much of the development of 20th-century art has been an attempt, often a struggle, to find a way of expressing modern awareness and truth. Much of the confusion about, and rejection of, 20th-century art arises because people try to apply to it the same standards and concepts by which they judge Renaissance art. To do so is as fruitless as trying to evaluate a game of football by applying to it the rules and critical judgements of another ball game such as tennis. ▽ Picasso has said: 'Certainly we have achieved a profound break with the past. The proof that the revolution has been radical is demonstrated by the fact that the words expressing fundamental concepts – drawing, composition, colour, quality – have completely changed meaning.'

This 'profound break' does not necessarily mean a total rejection of Renaissance ideas. Many artists of this century have used the means of imitation to express deep insights. It does not mean that the only alternative means of expression is □ abstraction. Many artists, including Picasso, have used the recognisable natural world as their means of expression but without imitating it in the Renaissance manner. What is implied is that an artist today has an unprecedented choice of ways in which to express himself, and so achieve fulfilment for both himself and the spectator. The wide psychological and physical complexity of the modern world needs this choice of alternatives, and some will inevitably speak more directly than others to different individuals. Compared with the long tradition of Renaissance art, modern art has just begun.

The idea of creating the presence of a recognisable object without imitating it exactly is found frequently in cultures outside Europe, and they have strongly influenced modern art. A wholly □ abstract art (as distinct from abstract □ decoration) is, however, a 20th-century

WASSILY KANDINSKY *Yellow Accompaniment.* 1924. 39¼ × 38⅜ in
(99·7 × 97·5 cm). Solomon R. Guggenheim Museum, New York

phenomenon, and it crystallised in the works of several artists in about 1910. Perhaps the most influential of these was Wassily Kandinsky (1866–1944). Russian born, he gave up a promising career in law at the age of 30 to devote himself to painting, and spent most of his working life in Germany. For Kandinsky, as for others, 'pure' abstraction was achieved slowly and with deep questioning. Kandinsky discovered that coloured forms can have expressive qualities which enable the artist to speak directly to the spiritual or mental state without communicating first through the recognisable material world. He elaborated his ideas in writings which are not easy to follow, but two quotations may help understand his and the aims of some other abstract artists: 'The spectator is too ready to look for a "meaning" in a picture. . . . Our materialistic age has produced a type of spectator . . .

who is not content to place himself in front of a picture and let it speak for itself. Instead of letting the intrinsic values of the picture work on him, he worries himself into looking for "closeness to nature", "temperament" . . . "perspective" and so on. His eye does not probe the outer expression to arrive at the inner meaning.' (*Concerning the Spiritual in Art,* VII, 1912) 'The impact of an acute angle of a triangle on a circle produces an effect no less than the finger of God touching the finger of Adam in Michelangelo; and if fingers are not just anatomical or physiological, but something more, a triangle or a circle is something more than geometry.' (*Reflections on Abstract Art,* 1931)

# THE MODERN WORLD

**Colour.** Today we accept in our lives the existence of a vast range of intensely bright colours without question. In painting, the great colourists of the 19th century, such as ▽Turner and ▽Delacroix, had only a very limited palette largely confined to the traditional earth colours which had served since the dawn of civilisation, and these needed to be ground and mixed in the artist's studio. From the middle of the 19th century there was a sudden and dramatic introduction of new artificial colours which very soon were available in paints for artists to use. The immediate cause was the discovery of chemical in coal tar dyes which gave new bright colours to the textile industry. These artificial colours were not only cheaper than many of the traditional substances; they could also be produced commercially to high standards of uniformity hitherto unobtainable. But of the most vital significance for the development of modern art was the sheer brilliance of the colours and their variety. They eclipsed anything that had been known before, and were one of the reasons for the 'shock' of Impressionist and Post-Impressionist painting.

**The Wild Beasts.** Fauvism (literally 'wild beast-ism') is the first modern movement of 20th-century art. The name 'wild beast' was not used to describe the artists who, by and large, were soberly behaved, but to describe their paintings whose screaming colours and distorted forms quite openly failed to correspond with those of the physical world (Matisse's *Portrait with Green Stripe* of 1905). Such paintings were shown by a group of young artists in Paris at the Salon d'Automne in 1905. The Salon d'Automne was supported by men who were opposed to the dreary banality of the official and semi-official Exhibitions held in Paris. During the 1905 Salon the art critic, Louis Vauxcelles, remarked that a piece of relatively conservative sculpture in the same room as the bright paintings 'looked like ▽Donatello among the wild beasts (*fauves*)', and the label has remained.

HENRI MATISSE *The Red Room*. 1908. 71 × 86·5 in (180 × 220 cm). State Hermitage Museum, Leningrad

HENRI MATISSE *The Green Stripe: Portrait of Mme Matisse*. 1905. 15¾ × 13⅝ in (40·5 × 32·5 cm). Museum of Fine Art, Copenhagen

**Henri Matisse** (1869–1954). The leader of this group of painters was Henri Matisse. In 1904, while working with ▽Signac in St Tropez in the south of France, he fully grasped the possibilities of strong areas of plain colour. His refusal to imitate natural appearances closely in terms of either colour or precise drawing was not, as some people at the time supposed, wilful and offensive, but was because he saw the function of painting, and the purpose of the artist, in a new way. His works were based not on imitation, but on feeling. His colours were intended to convey not what he saw, but the emotion that he felt. As he later explained in a famous and influential statement of his ideas, *Notes of a Painter* (1908): 'I am unable to distinguish between the feeling I have for life and my way of expressing it. . . . I want to reach that state of condensation of sensations which constitutes a picture. . . . A work of art must carry in itself its complete significance and impose itself upon the beholder even before he can identify the subject matter'. It is one of the first claims that an artist's primary loyalty is to his own experience, and that in seeking to express it he is bound by no rules other than those he chooses to make for himself. Fauve painting was really the first manifestation of this idea which is a fundamental one in 20th-century art.

ANDRE DERAIN *Houses of Parliament. London 1905*
*Below:* MAURICE DE VLAMINCK *Houses at Chatou.* 1906. 32 × 39⅝ in (81·3 × 100·7 cm). Art Institute of Chicago

*Below:* GEORGES ROUAULT *Christ mocked by Soldiers. About* 1932. 36¼ × 28⅜ in (92 × 72 cm). MOMA, New York

**André Derain** (1880–1954) was, for a short while, a highly influential leader of new artistic ideas, painting alongside ▽Matisse, and showing to ▽Picasso ▽African sculpture. In the summer of 1905 he and Matisse spent

south of France, near the Spanish border. With the benefit of the intense Mediterranean light which seemed to cast no shadows, and the example of Van Gogh's and ▽Gauguin's work which they understood and admired, they progressed from ▽Divisionist technique of short separate brush marks to the large flat areas of unmodulated colour which are one of the chief characteristics of developed Fauve painting. Some of Derain's best work was done in London. He went there for the first time in early 1905, when he was still painting with touches of colour in individual brushstrokes, and again in 1906. His second visit was commissioned by the dealer Ambroise Vollard who had appreciated ▽Monet's paintings of the Thames with their subtle gradations of misty light. Derain was a great admirer of English taste, and cultivated English dress and manners. The bold areas of bright unnatural colour in his London paintings are far from Monet's pictures of misty light and fog, but they capture an intense feeling which still speaks unmistakably of London.

**Maurice de Vlaminck** (1876–1958). ▽Derain was a highly educated and somewhat introspective character, very different from the extrovert Maurice de Vlaminck with whom he at one time shared a studio. Vlaminck loved the brash vitality of modern life. He was self-taught and liked to decry education. He too showed at the Salon d'Automne in 1905 (there were nine main Fauve artists in all), and a work such as *Landscape near Chatou* (1906) shows a wilder and more spontaneous emotional reponse than Derain's or ▽Matisse's. Vlaminck's later work, however, serves as a reminder that truth to personal emotion is not in itself sufficient unless accompanied by the ability to translate it into creative artistic order.

By 1908 the Fauve painters had ceased to show together as an identifiable group. Some were attracted to the new ideas of Cubism (*see* pages 262–3). Derain eventually abandoned the modern movement. Only Matisse continued to develop Fauve ideas of feeling, colour and decoration for the purpose of celebrating a sensual joy of life (*see* pages 276–7).

**Georges Rouault** (1871–1958) showed at the Salon d'Automne in 1905, and consequently his name was linked with the ▽Fauves. He too departed from any idea of imitation, but the feeling which he wished to express was a very different one. He was an ardent Catholic and deeply religious, and his works, sombre in tone and heavily overpainted, have a moral and social concern which links him to the Northern Expressionist tradition (*see* pages 272–3) rather than the Mediterranean tradition of exuberance for life. His range of subject matter and his style are limited, but the images of prostitutes are biting comments on the corruption of the flesh; the clowns are part self-portrait, part an image of everyman and sometimes the figure of Christ. Judges and lawyers symbolise the abuse of power against the weak and innocent. Almost alone amongst 20th-century artists Rouault believed in the possibility of the rebirth of Christ in an industrial world.

# THE MODERN WORLD

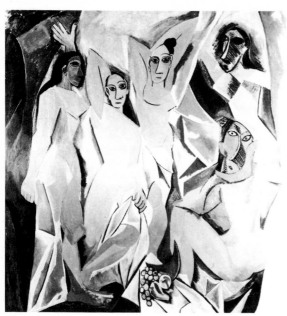

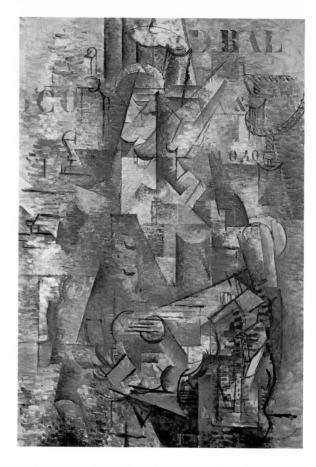

*Above:* PABLO PICASSO *Demoiselles d'Avignon.* 1907. 96 × 92 in
(244 × 234 cm). MOMA, New York
*Right:* GEORGES BRAQUE *The Portuguese.* 1911. 453¾ × 32 in
(115 × 80 cm). Kunstmuseum, Basle

In the year 1907 the two leading Cubist painters, Pablo
Picasso (1881–1973) and Georges Braque (1882–1963),
were preoccupied with the formal problem central to the
art of painting: that of painting the three-dimensional
natural world on a flat, two-dimensional surface. The
▽ Renaissance solved the problem by means such as
☐ perspective, which provided the eye with an illusion of
three-dimensional space. Picasso and Braque solved
the problem in a manner no less far reaching which, by
contrast, emphasised the flatness of the paint surface.
Theirs is one of the great artistic innovations and it
should be seen against the background of a world where
many other well established rules and principles were
being reconsidered or overthrown. The smashing of the
atom, the discovery of X-rays, Relativity, the realisation
of flight and telecommunications, challenged all the old
firm definitions of space, time and mass. In literature
and music too new and more flexible principles of con-
struction were established, and Freud's theories inter-
preted human personality and consciousness as much
less rigid and stable than before.

**Analytical Cubism.** Picasso's *Demoiselles d'Avignon*
of 1907, the first Cubist painting, is not a fully resolved
picture in the traditional sense. In it Picasso tried out a
number of ideas. There is no illusion of deep space.
The figures remain on the surface of the canvas. The
seated figure on the right shows both a side view
and a back view at the same time. By the traditional
rules of ☐ perspective with a fixed viewpoint this cannot
be allowed. Yet figures do exist in the round, with sides
and backs, and one of the aims of Cubist painting was to
show all those parts simultaneously, rather than show
only that view which can be seen from a single fixed
position. The faces on the right are recognisable as
such although no single feature is truly descriptive of that

in the human face. They derive from ▽ African masks
which Picasso had recently seen and become interested
in. The almond-eyed faces on the left are influenced by
Iberian sculpture. The two that are full face have their
noses drawn in profile, so they combine in a single image
information taken from different viewpoints.

Picasso and Braque did not work according to any
preconceived theory. They worked furiously and in-
stinctively in the closest co-operation, attempting to
produce recognisable images free from the rules of
imitation, and their work of this period should be judged
as experiments. Painstakingly they analysed what they
had done and worked from one picture to another. Much
of their initial inspiration came from the late works of
▽ Cézanne who had seemingly started along the same
path to simplified forms, and whose works they had seen
in a large retrospective exhibition in 1907. Braque's
*Houses at Estaque,* for example, shows him examining
and opening the volumes of the buildings. They do not
recede into a semblance of deep space, but climb
flatly towards the top edge of the painting as in a low
relief. These sort of ideas were refined in innumerable
canvases. whose subject matter was generally the
simple still-life objects or musical instruments with which
they surrounded themselves.

By 1911, Picasso and Braque were producing very
similar works such as Braque's *The Portuguese* whose
delicate but distinct brush marks and flat painted letters
continually emphasise that a painting is essentially
paint on a flat surface.

*Left:* JUAN GRIS *The Checkerboard.* 1915. 36¼ × 28⅞ in (92·1 × 73·3 cm). ;
Art Institute of Chicago
*Below left:* PABLO PICASSO *Guitar, Glass and Bottle.* 1913. Tate
Gallery, London
*Above:* ROBERT DELAUNAY *Circular Forms: Sun and Moon.* 1912–13.
80 × 79 in (200 × 197 cm). Kunsthaus, Zurich

**Synthetic Cubism.** Works like *The Portuguese* hover on the brink of complete abstraction, but if Picasso and Braque had followed that path they would have abandoned the purpose of their search by losing the image of the natural world. Instead they came up with another idea. Rather than give semblances of the material world, they chose to include the materials themselves in the painting. Why imitate the appearance of a newspaper with paint, if the newspaper can be included in fact? Both artists developed this idea with delightful subtlety and wit. Thus in Picasso's *Guitar, Glass and Bottle*, the newspaper not only represents itself; it is also an abstract decorative element in the whole composition; the carefully preserved word 'Figaro' has associations with the character in Mozart's opera and so with wine, women and song; the curving shape of the guitar echoes those

of the female body and the columns of words in the newspaper suggest speech and conversation. Worked out to the full, this apparently simple work becomes full of imaginative suggestion and delight.

Braque's *Aria de Bach* (1914), although one of his simplest works, is more poetic and openly decorative, yet affirms that he too has created a work of art, complete in itself, owing virtually nothing to the rules of imitation, but offering to the spectator who is willing to participate in the visual and mental play, a complete recognisable image. This idea of active participation by the spectator in the work of the artist, so that the final result is their joint creation, has become central to 20th-century art.

**The Influence of Cubism.** Picasso's and Braque's paintings and ideas had an immediate and deep influence. In France, Cubists exhibited as a group at the Salon des Indépendants of 1911. Among the artists were Albert Gleizes (1881–1953) Jean Metzinger (1883–1956), Fernand Léger (1881–1955), Robert Delaunay (1885–1941) and others. Gleizes and Metzinger wrote a treatise *Du Cubisme*, (1912) followed by Apollinaire's *Les Peintres Cubistes* (1912). Cubist work was shown in London, Amsterdam, Prague, Moscow and Berlin. Cubist forms found an echo in the modern movement in architecture and influenced decorative design. Juan Gris (1887–1927), another Spaniard who lived in the same building as Picasso, brought a sombre poetry of his own to Cubism to which he remained faithful until his death. In sculpture too Cubism has had a lasting influence. Cubism has given 20th century art a new visual language which has been used universally, not least in textile design, advertising art, and all forms of applied art.

# THE MODERN WORLD

*Above:* GINO SEVERINI *Suburban Train arriving at Paris.* 1915.
$34\frac{7}{8} \times 45\frac{1}{2}$ in (88·6 × 115·5 cm). Tate Gallery, London
*Above right:* GIACOMO BALLA *Swifts: Paths of Movement and Dynamic Sequences.* 1912. $38\frac{1}{8} \times 47\frac{1}{4}$ in (96·8 × 120 cm). MOMA, New York
*Below right:* GIACOMO BALLA *Abstract Speed – Wake of a speeding car.* 1919. $19\frac{3}{4} \times 25\frac{3}{4}$ in (50·2 × 65·4 cm). Tate Gallery, London

**Futurism.** In February 1909 a young Italian poet, Tommaso Marinetti, published in Paris, the first futurist manifesto. Although it was concerned with modern poetry it attracted to him a group of young Italian writers and artists who, fired by his ideas, published and exhibited under the name 'Futurists'.

The style and message of Marinetti's manifesto is best conveyed by a short extract. He declared: 'The world's splendour has been enriched by a new beauty: the beauty of speed. A racing motor car, its frame adorned with great pipes like fiery snakes, a roaring motor car, which seems to run on shrapnel is more beautiful than the ▽ Winged Victory of Samothrace . . . We shall sing of the great crowds in the excitement of labour, pleasure or rebellion, of greedy stations swallowing smoking snakes . . . We shall sing of the factories suspended from the clouds by the strings of smoke . . .' The Futurist artists tried to match the energy and rebelliousness of Marinetti's provocative and destructive language in their work, in their words and activities such as concerts and recitals. They attacked Italy's political decline, Italian art, and the system of museums, dealers and critics. They wished to destroy Italy's artistic past and replace it with an industrial present.

It can be argued that the Futurists' aggressive demonstrations and their documents in which they proposed new approaches to architecture and music as well as painting and sculpture, were more successful than the works they created. At first the Futurist painters tried to use the techniques of Impressionism and Post Impressionism to capture the dynamism of modern life, un-

aware of the latest artistic developments in Paris. Then in 1911 Gino Severini (1883–1966) a compatriot living in Paris introduced them to ▽ Cubist painting. At first sight, the carefully considered studio works of ▽ Picasso and ▽ Braque seemed to have little to do with the Futurist ideas. But the Italians immediately grasped that the shifting interpenetrating geometric planes of Cubist painting could be coloured and agitated and used to express speed and dynamic motion. Severini translated mechanical speed into paint in an almost literal way by combining Cubism and colour. In a work such as *Suburban Train Arriving in Paris* (1915), the glimpses of roofs, smoke signals and advertisements constitute the visual sensations of a passenger in a fast train.

Giacomo Balla (1871–1958) set out to represent not an object in motion but the abstract idea of speed itself. In *Abstract Speed: Wake of a Speeding Car* (1919), the vehicle has already disappeared, leaving behind an interpenetrating pattern of force lines. 'Force lines' were fundamental to Futurist painting and were no doubt derived from attempts to photograph moving bodies at speed. They considered that these lines showed how an object 'would resolve itself were it to follow the tendencies of its forces'. Although they were talking in artistic, rather than scientific, terms, the idea that light and motion could change the physical quality of an object is one that contemporary physicists were discussing in considering the theory of relativity. One of the finest examples to be found in Futurist painting is Umberto Boccioni's (1882–1916) *Dynamism of a Cyclist* (1913). Boccioni was the most original of the Futurist artists and

UMBERTO BOCCIONI *Unique Forms of Continuity in Space.* 1913.
Bronze. h. 43⅞ in (111·4 cm). MOMA, New York

PERCY WYNDHAM LEWIS *Workshop.* 1914. 30 × 24 in (76·5 × 61 cm).
Tate Gallery, London

he applied his talents to sculpture as well as painting.
He claimed that the sculptor should turn to materials
like metal, wood, glass, hair, even electric light bulbs and
*Dynamic Construction of a Gallop* (1913) is one of his
more successful attempts to carry these ideas into
practice.

The technical Manifesto of Futurist Painting (1910)
was signed by two other artists, Luigi Russolo (1885–
1947) and Carlo Carra (1881–1966). The romantic
enthusiasm for modern industrial life and energetic
mechanical and political confrontation was exposed
to the tragic reality of the First World War. Boccioni
volunteered for the Army and died on active service in
1916. After the war some of the remaining artists,
horrified by the real result of their dreams, returned to
more traditional paths, but in so doing failed to achieve
anything like the originality and flair of their pre-war
work; others transferred their ideas to revolutionary
Fascism. Nevertheless, Futurism had an immediate
influence across Europe, from England to Russia, and
established beyond doubt that modern industrial life,
mechanical energy, and politics, were subjects which
were appropriate to the 20th-century artist.

**Vorticism.** For a short period before and during the First
World War, a group of English artists exhibited under
the name of Vorticists, a title coined by the poet Ezra
Pound. The leader of the group was Percy Wyndham
Lewis (1884–1957). They had contact with the Futurists,
and followed their style of shocking the public with out-
spoken manifestos and publicity, but they criticised the
Futurists for being too romantic in their attitude towards
man and machine. In 1914 Lewis published the first of
two issues of a journal called Blast which attacked the
comfortable complacency of the British way of life, and
offered in its place a 'vast island machine' in which all
traces of sentiment and 'vegetable humanity' would
disappear. The *Workshop* shows Lewis expressing
through complete abstraction a powerful visual equiva-
lent of this philosophy for the bright jarring colours and
harsh undecorative geometrical elements do indeed
eliminate all comfortable associations or thoughts of
sentiment or 'vegetable humanity', and communicate a
disturbing sense of mechanical domination. Like Futur-
ism, the Vorticist movement was broken by the tragic
reality of the First World War. Lewis's intolerant tem-
perament and ideas lead him to flirt with fascism in the
1930s, and it was William Roberts (1895–) a close
associate of Lewis's in the Vorticist period, who went on
to establish a quiet and personal interpretation of mod-
ern industrial man.

# THE MODERN WORLD

**Dada.** As the First World War ground to a murderous stalemate, in 1915 Dadaism began in neutral Zurich. The word 'Dada' was chosen because of its childish associations. Originally Dada activity was cabaret-based and consisted of recitals and performances intended to shock and insult the public. At the Dada 'happening' in Cologne in 1920, an 'exhibition' was held in a room which was entered through a public lavatory: visitors were met by a girl in Communion dress who recited obscene poetry, and they were invited to destroy a large wooden sculpture with an axe. The young men involved were not aiming to create works of art or even rewrite the rules of art in modern terms. Their activities were a protest against war, and the habits of thought, and the values, political, social and aesthetic, which led to it. The ephemeral Dada activities left no permanent record and were not intended to, and the magazines and manifestos which were produced are strictly speaking a literary phenomenon. Visually, however, these pamphlets imitated the cheap vulgarity of commercial printing, and the coarse type faces and heavy rules they used were taken up by other artists. Paradoxically perhaps, a relationship grew between Dada anti-art manifestations and the visual arts generally through their common interest in questioning established rules and values.

**New York.** Marcel Duchamp (1887–1968) arrived in New York from Paris in 1915. In trying to push the artist's freedom to make his own rules to its limits he placed a factory-made urinal on a stand and stated that it was a work of art if he chose to define it as such, an act closely parallel to Dada. His deliberately unfinished masterpiece, *The Bride stripped bare by her Bachelors, even* (1915–23), examines pessimistically the relationship between man and machine, and the futility of existence. It is not comprehensible without Duchamp's own notes, but then Duchamp always maintained that a work of art can only be defined as an intellectual and mental, not a visual, fact.

**Zurich.** Less than a decade old, □abstract art had all the characteristics of disturbing newness and attack; it thus had a particular attraction for Dadaists. Abstract art from all over Europe was shown in a gallery by Tristan Tzara, one of the founders of Dada; but it was Jean (Hans) Arp (1887–1966) who introduced anti-art methods into permanent visual works. He attempted to do this by exploiting chance. He tore up coloured papers and drawings and let them fall to the floor at random. He then stuck them down, and sometimes worked further on them, but his intention was to produce a work over which he had no control. 'I submit', he said, 'that whoever submits to this law (the law of chance) attains perfect life.'

**Germany.** Dada activities had a particular appeal in Germany at the end of and after the 1914–18 war, when real social and political revolution broke out. In Hanover, Kurt Schwitters (1887–1948) transformed rubbish, by collage, into an art of exquisite refinement (*Merz 163, With Woman Sweating*, 1920) and in Cologne Max Ernst (1891–1976) cut up and reassembled advertising images to create a world of sub-conscious terror.

# Dada and Surrealism

**Surrealism.** Many of the Dada activists, like ▽Ernst and ▽Arp, moved to Paris, and in 1924 André Breton published the First Surrealist Manifesto. Like Dada, Surrealism rejected the necessity for rational thought and behaviour, but unlike Dada it had reasonably well defined aims and purposes. It was firmly based on the ideas of pyschoanalysis and its language and symbolism. In particular Surrealists were fascinated by the world of dreams as a gateway to the sub-conscious, and often portrayed dream fantasies in paint. Surrealism proposed the legitimacy of sub-conscious desire as a basis for action, and in developing this idea Breton relied heavily, and not unnaturally, on the writings of Freud, who stressed the motivating forces of sexuality and death. The Surrealist movement was entirely literary at first: Breton did not see how visual artists could assist his ideas. Nevertheless, painters and sculptors soon found that the ambiguity inherent in visual communication offered a powerful means of access to the sub-conscious, and that both imitative and abstract art were full of potential in this respect.

Some Surrealist painters sought an exact equivalent to the literature of Surrealism and ▽Freudian psychoanalysis by adopting a highly finished technique in which all the expression lay in the content of the images and not in the way that they were painted.

Ernst's influential painting, *The Elephant Celebes* (1921), shows a creature half animal, half machine, which is more immediately recognised by the dreaming (or nightmare) mind of the sub-conscious than by the rational conscious mind; and the picture is full of logical inconsistencies such as fish swimming in the sky. The tension produced by the presence of a totally irrational image painted with meticulous photographic realism has been used by Salvador Dali (1904– ) who has called his paintings 'hand-painted dream images'. Just as paranoiacs interpret innocent events as threatening, so Dali in his paintings continually forces the spectator to re-examine the nature of supposed reality. René Magritte (1888–1976) exploited in many of his paintings the mental tension which results from the juxtaposition of objects which apparently have no connection.

None of these artists had the slightest interest in ☐formal or ☐decorative artistic problems, and the same comment applies to the Abstract Surrealist artists. Wherever the artist's inspiration may come from, his hand normally moves as the result of a rational trained process, but it is possible to bypass this and allow it to be moved primarily by the unconscious. Joan Miró (1893– ) came from Spain; he signed the First Surrealist Manifesto, and some of his finest works (*Painting*, 1927, for example) which were painted under the influence of deliberately induced hallucinations communicate a sense of the most primitive life force and forms which still lie buried in the depths of civilised man.

The first phase of the Surrealist movement came to an end with the Second World War, but recently, both Surrealism and Dada have had revivals. Their style has been taken up by a second generation, who, starting as imitators and revivalists, have sometimes given new direction and new life to the movements.

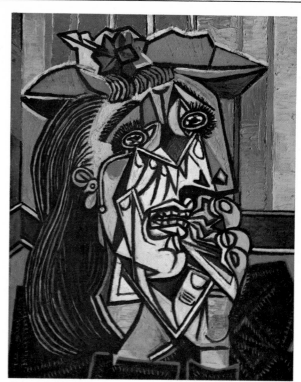

*Above left: Seated Woman with Hat.* 1923. Edward James Foundation
*Above: Weeping Woman.* 1937. $25\frac{5}{8} \times 19\frac{1}{4}$ in (60 × 49 cm). Sir Roland Penrose Coll

To many people Pablo Picasso (1881–1973) epitomises 20th-century art. His influence on modern art in terms of technique and imagery alone, has been enormous, and in popular imagination, his paintings, his private life, and his fortune have achieved a dimension that continues to be legendary.

**Tradition.** Picasso was born in Malaga in 1881 but spent his early years in Barcelona where his father was an artist, a professor and Academician. Barcelona was a second Paris, an intellectual melting pot for the artistic ideas then current all over Europe, and they were fully absorbed by the young Picasso. He was also exceptionally gifted as a student painter – he won a place at the Barcelona Academy at the age of 15, passing in one day the examination for which one month was normally allowed. Indeed one of the outstanding features of Picasso's mature art, is that in spite of the fundamental changes he helped bring to the form of western European art, he never abandoned the broad traditions of the Renaissance.

From 1904 he settled permanently in France, moving between Paris and the south. In the late 1930s he imposed upon himself voluntary exile from Spain, for after Franco's victory in the Spanish Civil War Picasso vowed he would never again set foot in Franco's Spain.

*Still Life.* 1914 (Painted wood with upholstery fringe) 18 in long. Tate Gallery, London

**Private Life.** This passionate commitment in issues outside art was very much the essence of Picasso's personality, and he was never afraid to reveal his emotional life in his work. His great painting, *Guernica* (1937), was not just an agonised response to the bombing of the small Basque town by the Fascists: it was also Picasso's protest against inhumanity and barbarity in general. Perhaps in answer to those who found much of his work distasteful he once said: 'Painting is not made to decorate apartments. It's an offensive and defensive weapon against the enemy'. His own private sexual and emotional life frequently and openly appeared in his work as it ran the full range from happiness and harmony when his first child was born (*Woman with Hat*, 1923), to frustration, and break-up, as his relationship with his first wife disintegrated (*The Three Dancers*, 1925).

**Metamorphosis.** Duality of form and image is fundamental to Picasso's work – allowing one form to act simultaneously as itself and several others. One of the simplest, wittiest, and most famous examples is the *Bicycle Seat* (*Bull's Head*) (1944), which, cast in bronze, is at one and the same time a sculpture, the scrap metal of the bicycle, and the animal's head. The early investigations in ▽Cubism (*see* pages 262–3) suggest the scope that this type of ambiguous visual play could have, and although Picasso used it on many occasions in a playful and light-hearted manner, he also used it to produce immense visual and psychological tension. In *The Three Dancers* for example, the female figure on the left is both substantial and shadowy; she has more than two breasts, although the central blue breast is also the

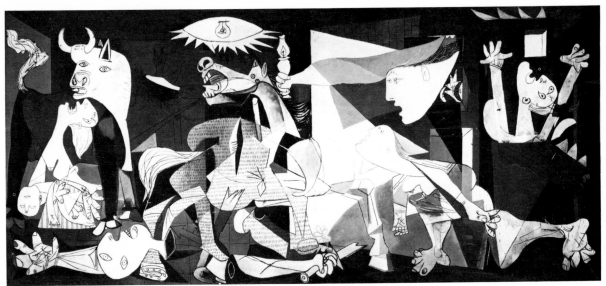

*Above: Guernica.* 1937. 137½ × 305¾ in (349·3 × 776·6 cm). MOMA, New York
*Below: The Three Dancers.* 1925. 84⅝ × 56¼ in (215 × 143 cm). Tate
Gallery, London

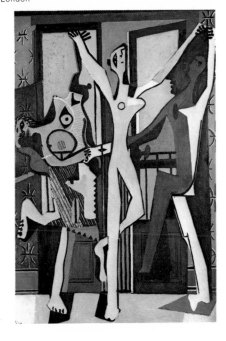

space between her right arm and her body; her face is also a skull; and the black forms on her feet delineate her toes while being at the same time like the nails of the crucifixion. Such an image hovers continually between the different worlds of material experience and the emotional sub-conscious, and is entirely in accord with the condition of modern man who accepts that reality is a complex fusion of these two worlds. Such continual interpretation on different levels of Picasso's images requires creative imagination on the part of the spectator as well as from the artist, and the idea that a work of art is to be experienced as well as observed, and that there is an active relationship between artist and spectator, was fundamental to Picasso's work and continues to be central to the whole of 20th-century art.

**Independence.** In spite of his immense influence, Picasso remained an essentially solitary painter. He founded no school or movement as such. His close co-operation with ▽ Braque in his ▽ Cubist phase and his brief involvement with the theatre were exceptional. Works like the *Three Dancers* naturally had great influence on the ▽ Surrealists, but Picasso was never a part of their movement. Nor did Picasso himself become an abstract painter though his Cubist work influenced many artists. He wrote no manifestos or philosophical works, so often necessary for a proper understanding of many 20th-century artists. He believed that a visual work should reveal it self by itself, and he is reported to have said: 'Everyone wants to understand art. Why not try to understand the songs of a bird? Why does one love the night, flowers, everything around one, without trying to understand them? But in the case of painting people have to *understand*. If only they would realise above all that an artist works of necessity, that he himself is only a trifling bit of the world, and that no more importance should be attached to him than to plenty of other things which please us in the world, though we can't explain them. People who try to explain pictures are usually barking up the wrong tree.'

Picasso painted very few self-portraits although the figures of harlequins which appear in his early work, and the Greek god which appears later are almost certainly symbolic references to himself. His creative energy was prodigious, in both the amount of work he left behind and its range: painting, book illustration, graphic work, stage sets, ceramics, were all given new and independent life by him. His work as a sculptor has been no less influential than his paintings. It was not a continual activity like painting, although many of his painted images had all the potentiality of being transposed into three dimensions. One of Picasso's greatest contributions to 20th-century art was the construction (*Still Life*, 1914), an entirely new three-dimensional form unlike traditional carved and moulded works, which continues to have the deepest influence on both sculptors and painters.

# THE MODERN WORLD

**Kasimir Malevich** (1878–1935). Shortly before the First World War there was a ferment of activity in Russia in the visual arts. Russian artists combined the formal qualities of ▽Cubism and the dynamism of ▽Futurism into a lively 'Cubo–Futurist' style. The best paintings in this idiom were by Kasimir Malevich. From this he developed an extraordinarily simple, completely □abstract way of painting, which he called Suprematism. The most extreme of his works of this kind were a black square on a white background and, rather later, a white square on a white background. The black square seems to have been derived from a stage design Malevich produced for the Futurist Opera *Victory Over the Sun*, by the Russian Futurist author Alexei Kruchenikh. This was done in 1913, but it was probably not until about 1915 that Malevich took the daring step of using this simple backdrop as an idea for an abstract painting. He believed that art should express the supreme spiritual striving of human emotion – hence Suprematism. Many of his abstract works painted during the war are more complex. Geometric elements dance across the canvas in a vigorous and colourful play of tensions.

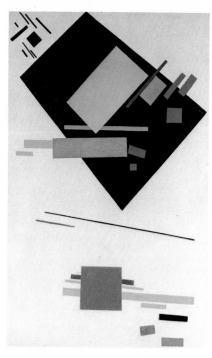

*Above:* KASIMIR MALEVICH *Suprematist Composition.* About 1915. 23 × 19 in (58·4 × 48·3 cm). MOMA, New York

**Vladimir Tatlin** (1885–1953). In 1915 Vladimir Tatlin made a series of 'corner-reliefs' which were built in the angle of two walls of a room from metal and wire: daring spatial compositions which have all been destroyed and only exist in photographs and reconstructions. After the revolution Tatlin designed a Monument to the Third International. This was to be Moscow's answer to the ▽Eiffel Tower, which was to be twice the height of the ▽Empire State Building, with conference rooms revolving inside its steel structure and neon lights flashing the news at night. Trotsky criticised the design as impractical and it probably could never have been built. Tatlin made a large model which was later destroyed although several reconstructions have been made recently from photographs and drawings. It is a daring and imaginative structure which expressed the early hope and optimism of the first years of the Russian revolution.

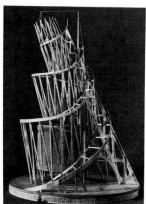

*Left:* VLADIMIR TATLIN Model of the *Monument to the Third International.* 1919–20. Remnants of maquette in Russian Museum, Leningrad

**Rodchenko and Lissitzky.** Alexander Rodchenko (1891–1956) was one of the hard-line 'Constructivists' who believed that art must have a practical function in everyday life. He collaborated on typography with the poet Mayakovsky in advertisements for state-owned enterprises like the GUM department in Moscow and designed cinema posters and furniture and clothes (as did Tatlin).

El Lissitzky (1890–1941) was one of those fertile synthesisers like ▽Van Doesburg and ▽Moholy-Nagy. A pupil of ▽Malevich at Vitebsk art school, he translated the older man's ideas into vigorous graphic and exhibition design, book jackets and posters, as well as producing some fine paintings. Like Rodchenko he experimented with 'photomontage' – juxtaposing one or more photographs to make a new exciting whole, for book jackets, posters or displays. Experimentation was frowned on after the mid-20s under Stalin. In exhibition and photography artist-designers like Lissitzky and Rodchenko were able to work relatively freely into the 1930s. But many artists had already left the country in the early 1920s and the Russian experiment ended.

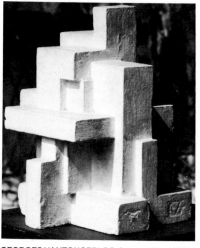

GEORGES VANTONGERLOO *Composition.* 1920. Peggy Guggenheim Foundation, Venice

# Constructivism and De Stijl

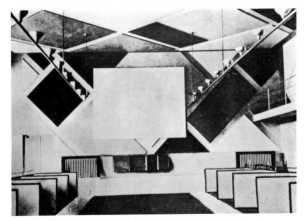

THEO VAN DOESBURG The Aubette Cinema, Strasbourg. 1928

*Above:* PIET MONDRIAN *Composition with Red. Yellow and Blue.* 1939–42. 28⅝ × 27¼ in (72·6 × 69·2 cm). Tate Gallery, London

*Above:* GERRIT RIETVELD The Schröder House. Utrecht. 1924

**De Stijl** was a group of artists and designers formed in Holland in 1917. Initially the members were all Dutch and included the painters Piet Mondrian (1872–1944), Theo Van Doesburg (1883–1931) and Bart Van der Leck (1876–1958) and the architects J. J. P. Oud (1890–1963) and Gerrit Rietveld (1888–1965). Reacting against ▽ Art Nouveau and other turn-of-the-century examples of what Van Doesburg called 'neo-baroque', they believed in a purified aesthetic of horizontal and vertical lines and the primary colours: red, yellow and blue, plus black and white. They were influenced both by the Dutch Calvinist tradition and the physical lie of the Dutch countryside – largely man-made, geometrically divided by dykes and polders and built over with neat streets of standardised houses. But although their beliefs might appear puritanical, they were also inspired by spiritual aspirations and socialist principles, believing that art should change the face of urban life and be integrated with the community.

Rietveld's extraordinary *Red-Blue chair* was actually made before he was a member of the group. More comfortable than it looks, it is a statement about how a piece of furniture is constructed, stripped down to the very skeleton. The group was largely held together by Van Doesburg's powerful personality and the *De Stijl* magazine which he edited. Although Rietveld and Mondrian never in fact met, there is a remarkable stylistic similarity between the *Red-Blue chair* and Mondrian's paintings. (*De Stijl* is, in fact, Dutch for The Style.) Van Doesburg introduced powerful dynamic diagonals into his own painting in the early 1920s under the influence of Russian ▽ Constructivism. In 1921 the format of the magazine was changed and the typography became much more dynamic. Van Doesburg made an important contribution to the development of the New Typography which revolutionised graphic design in the 1920s.

Rietveld designed his superb little Schröder house in Utrecht in 1924–5. This pioneered the open-plan and fulfilled De Stijl principles in fully-fledged architectural form. Van Doesburg turned increasingly to architecture and design. His last important work, in 1927, was the remodelling and decoration on De Stijl lines of the Café Aubette – a complex of restaurants, dance hall and cinema in the centre of Strasbourg. This has unfortunately been destroyed. After 1921 Van Doesburg increasingly recruited foreign artists and designers to the group and it became international and wide-ranging, although less cohesive stylistically. It had already ceased to have any binding function by the time of Van Doesburg's death in 1931. The magazine was discontinued after a memorial issue.

# THE MODERN WORLD

*Above:* WASSILY KANDINSKY *Composition 8, No. 260.* 1923. $55\frac{1}{2} \times 79\frac{1}{8}$ in (141 × 202·7 cm). Solomon R Guggenheim Museum, New York

*Above:* ERNST KIRCHNER *Street Scene.* 1913. Staatsgalerie, Stuttgart
*Below right:* FRANZ MARC *The Fate of Animals.* 1913. $76\frac{3}{4} \times 105\frac{1}{2}$ in (195 × 263·5 cm). Kunstmuseum, Basle

**Die Brücke.** In 1905 a group of young artists founded a communal art group in Dresden called Die Brücke. The name means literally 'the bridge', and they hoped to cross the gap which extended between academic and modern art. They had no wish to shock the public and they had no manifesto or programme. Their unity came through shared ideals and joint exhibitions, and the public could become lay members of the group. Its leader was Ernst Ludwig Kirchner (1880–1938) whose work exemplifies the spirit of the group by expressing the sense of agitation and psychological distress, which are often the consequences of loneliness and other pressures of industrial society. Although the works of the ▽ Fauvists were well known in Germany and much admired, the emotions in Kirchner's picture are very different, and he uses unnatural colour in a harsh way to give a feeling of unease. The sharp angular forms are like those found in medieval wood-cuts, and primitive carvings in which he found potent emotional symbols. Military service in the war broke Kirchner's physical and nervous health. He retired to Switzerland but the traumatic events in Germany in the 1930s led to his suicide. Other members of the group were Max Pechstein (1881–1955) and Emil Nolde (1867–1956) who produced outstanding Expressionist works. The group broke up in 1913 when the artists pursued different and separate interests in their work.

**Der Blaue Reiter.** The 'Blue Rider' group was formed in Munich in 1911. Like Die Brücke, they had no programme or manifesto and came together to form an exhibiting society. They were not interested in social comment or reform. The leader of the group was ▽ Wassily Kandinsky whose primary concern was with the mysteries of man's spiritual and mental make-up. The group exhibited child-art and folk-art, as it was stated by one of the leading members, August Macke (1887–1914), that such works powerfully expressed man's inner life. Franz Marc (1880–1916) had a deep interest in animals and believed that they enjoyed a more spiritual existence than man. Influenced by the techniques of contemporary Parisian artists, he painted gentle and emotionally expressive pictures which became increasingly abstract. The war terminated the association of the Blue Rider group and both Macke and Marc were killed in action during the war.

*Above:* GEORGES GROSZ *Suicide.* Tate Gallery, London

*Above:* MAX BECKMANN *The Night.* 1918–9. 52⅜ × 60¼ in (133 × 154 cm). Kunstsammlung Nordrhein, Westphalia

that through design and building, society could be changed for the better, and this, together with an optimistic view of the material benefits that an industrialised society could bring, was the intended principle underlying Bauhaus training and education. Pupils underwent a rigorous theoretical and practical training, and the Bauhaus attracted to it the most eminent names in German art, including ▽Klee and ▽Kandinsky. The influence of Bauhaus design has been enormous, but at the time it was inevitably viewed with deep suspicion in conservative circles and was closed by the Nazis in 1933.

**Paul Klee** (1879–1940) was associated with the artists of the ▽Blue Rider group, and was a dedicated teacher at the ▽Bauhaus. From Parisian art he learned the values of strict pictorial order, but in keeping with the Northern tradition the aim of his influential, and often quietly humorous work, was to express an inner vision in which man would find complete harmony with the natural and spiritual worlds.

PAUL KLEE *Dance You Monster to My Soft Song!* 1922. 17⅝ × 12⅞ in (44·8 × 32·7 cm). Solomon R Guggenheim Museum, New York

**Grosz and Beckmann.** German society underwent great strain during the war, and this continued and even increased after it, when democratic institutions collapsed and inflation destroyed the way of life of many thousands. George Grosz (1893–1959) bitterly attacked the war and the self-interested attitudes of the well-to-do and the military. During the war he was nearly shot for insubordination. Max Beckmann (1884–1950) served in the medical corps in the war. The memories of that horror remained with him throughout his life, and in powerful Expressionist works he depicted the cruelties of modern life, its greed, indifference, and above all its emotional and spiritual barrenness.

**The Bauhaus.** Originally founded as a workshop-based school of craft and design before the First World War, the Bauhaus took on a new life under the directorship of Walter Gropius (1883–1969). Gropius already had a reputation as an influential modern architect. He believed

**Degenerate Art.** The Nazis recognised that art and design could be powerful propaganda weapons, and immediately imposed a strict censorship. They dictated an art totally without imagination and of the monumental banality often found in totalitarian regimes. Original and creative artists were dismissed from their posts in art schools, and many were persecuted so that they fled to free countries. Works by leading modern artists of all nationalities were seized and either sold or destroyed. In 1937, Hitler held his notorious exhibition of 'Degenerate Art' (*Entartete Kunst*), which aimed to make its point by juxtaposing works by leading Expressionist and other modern artists with those of no merit and with works done by mental patients.

# THE MODERN WORLD

Until 1910 British artists and the British public remained almost wholly oblivious of the developments taking place on the Continent. Younger artists had reacted against the dominant authority of academic art – in 1886 the New English Art Club had been founded and showed works of the ▽Impressionists such as ▽Degas and ▽Monet – but their influence was negligible. One of the leading members was W. R. Sickert (1860–1942), and although a work such as *Café des Tribunaux* (about 1890) shows a more or less Impressionist subject matter, he has none of the Impressionist palette and little of its freedom of paint handling.

In 1910 Roger Fry (1866–1934), a member of the intellectual Bloomsbury group, shocked the British public with his first ▽Post-Impressionist exhibition. The exhibition contained not the most recent developments of Parisian art such as ▽Cubism, but for the most part works by ▽Cézanne, ▽Gauguin and ▽Van Gogh. Nevertheless, they were new to the British and influenced a number of young artist friends of Sickert's, who together formed the Camden Town Group in 1911. In 1912 Roger Fry organised a Second Post-Impressionist Exhibition which showed ▽Fauve and Cubist paintings from Paris, and by 1914 Cubist and ▽Futurist influences could be seen, somewhat belatedly, in the work of young British artists.

**Ben Nicholson and The Modern Movement.** With the brief exception of ▽Vorticism, however, a full exchange of ideas between contemporary British and European painters did not occur until the early 1930s. Then, Ben Nicholson (1894– ) and Barbara Hepworth (1903–75) visited Paris, met ▽Picasso, ▽Brancusi and ▽Mondrian, and joined the Abstraction-Creation Group in 1932. Nicholson's work reached its peak of cool detachment in the mid-1930s. *White Relief* (1935) has a sophisticated understanding of the formal arrangement and play of planes which comes from ▽Cubism, and an austerity which is close to Mondrian. Nicholson is an artist who has been equally at home with both pure and semi □abstraction: through the latter he had a strong influence on the St Ives group while living for a time in Cornwall.

**Landscape.** The particular English sensibility to landscape has remained a strong feature in British art in the 20th century in spite of the social and industrial changes which have taken place. Paul Nash (1889–1946) had a special ability to capture the feel of a particular place, usually somewhere in the south of England. He was especially conscious of man's actions on nature and landscape. In the First World War, as a young Official War Artist, he produced some of his finest oil paintings which reveal the destruction of nature and the eerie emptiness of the battlefield rather than the war's destruction of man. In the 1930s he was among the few British artists who really understood the ▽Surrealists and he used their technique of juxtaposing mysterious objects to produce a poetic feeling for landscape.

Graham Sutherland (1903– ) has been powerfully influenced by the Pembrokeshire landscape. In its wild formations and in the quality of its light he found an emotional response which was the greatest stimulus on his imagination. He has not sought to reveal the forces of nature or man's relationship with them; rather, he has seen in natural forms an expression of the deepest emotions of man. His work often isolates strange objects which are not identifiable as human, vegetable or fossil,

WALTER SICKERT *The Old Bedford. About* 1890. 50 × 30½ in (127 × 76·2 cm). NG Canada, Ottawa

PAUL NASH *Landscape from a Dream.* 1936–8. 26¾ × 40 in (67·9 × 101·6 cm). Tate Gallery, London

but which are highly charged with emotion. The continual interchange between growth and decay is a major theme in his painting. Sutherland did not go to Pembrokeshire until 1934 and the early influences on his art were those of ▽Turner, ▽Palmer, and ▽Blake, rather than modern continental artists. He continued in this English landscape tradition in work which has attained international recognition.

**Stanley Spencer** (1891–1959). During the Second World War Sutherland, too, was an Official War Artist. Both wars produced schemes in which the leading British artists were commissioned by the Government to record their experiences and reactions with almost total freedom of personal expression. Although few outstanding individual masterpieces were produced, the complete body of work is a remarkable record of a nation at war,

*Above:* STANLEY SPENCER *The Resurrection, Cookham.* 1923–7. 108 × 216 in (274·3 × 548·6 cm). Tate Gallery, London

*Above:* GRAHAM SUTHERLAND *Forest with Chains.* 1954. 43⅞ × 66 in (111·4 × 167·6 cm). Marlborough Fine Art, London

*Below:* BEN NICHOLSON *White Relief.* 1947. Tate Gallery, London

acknowledging the importance of creative artistic activity even in the darkest days. Perhaps the best work done in both wars was by Stanley Spencer. Spencer followed a totally independent and eccentric artistic career inspired by an inner vision that 'would make me walk with God'. Eccentric visionaries like Spencer are very much a part of the British tradition, and his deep· Christian belief and precise technique link him closely to the ▽Pre-Raphaelites.

**Francis Bacon** (1909– ). Few British artists have ever achieved a contemporary international reputation to equal that of Francis Bacon. His work is dominated by the human figure in attitudes of acute distress: isolated in bare rooms; hemmed in by carcases of meat or imprisoned by cages; vomiting, screaming, or gratifying aggressive sexual desires. Bacon did not devote himself to painting until he was 35 years old, and he has used unique sources for his potent imagery, such as a medical text book detailing diseases of the mouth, and the screaming head from an early Russian film. However, his images are not preconceived but build up from the free accidents and action of his brush on unprimed canvas; Bacon himself distinguishes between painting which communicates intellectually and painting (like his) which acts directly and rawly on the nervous system. Behind his work lies a personal experience of many of the horrifying events of the century, and, perhaps understandably, he destroys much of his work.

*Below:* FRANCIS BACON *Study for a Pope.* 1955. 60 × 46 in (152·5 × 117 cm). Private collection

# THE MODERN WORLD

Until the end of the Second World War Paris was the undisputed world capital of the visual arts. The most crucial movements from ▽Fauvism to ▽Surrealism were centred there, and ▽Picasso and Chagall (1887– ) among other non-French artists chose France as their place of work; and it hardly needs to be said that many of the greatest artists of this century were French born.

Modern French painting of the inter-war period owed much of its influence and leadership to its propagandist experimental nature. French painters, such as Braque and Matisse, may be said to have taught, by example, their contemporaries all over the world.

At the same time highly personal painters remained outside the main stream.

**Abstract Art.** In general, French artists did not turn to abstraction but remained firmly attached to the recognisable material world, taking positive delight in those things it offered to the mind and eye. The French artist who first and most successfully explored abstraction, and who had considerable influence before the First World War, particularly with the ▽Blue Rider Group in Munich, was Robert Delaunay (1885–1941). By 1912 he had developed an art which glowed with prismatic colour fulfilling his belief that colour by itself could be the form and subject of a painting. The poet Apollinaire described his work as 'pure art', compared it with music, and applied to the style the word 'Orphism'.

**Henri Matisse** (1869–1954). As a young man, Henri Matisse was told that his achievement would be to simplify art, and in retrospect it is possible to see his work as a continual progress to this end. Throughout his career he constantly repeated themes of open windows, still-lifes, and the naked female figure; thus the apparent simplicity of *Pink Nude* (1935) is entirely deceptive, hiding both the long experience which enabled him to reject everything except the essential, and the constant adjustments and re-workings of this painting which were recorded at the time in a remarkable series of photographs. (The painting is recorded in no less than eighteen different states between May and September 1935.) When a visitor once remarked that one of his figures looked distorted Matisse replied: 'This is not a woman, this is a picture', thus expressing neatly one of the essential attitudes of his art. (*See also* pages 260–1).

From 1914 Matisse lived in the south of France, finding the Mediterranean atmosphere and light to be essential to his creative activity. He was a gifted sculptor, and worked also with stained glass, tapestry and book illustration. Above all he showed himself to be one of the greatest masters of colour. He achieved a new relationship between colour, drawing and sculpture which is shown in the huge paper cut-outs made just before he died. *L'Escargot* (1953) glows with all the essential qualities of the Mediterranean, and is Matisse's final simplification of his many open windows. The areas of colour are cut and torn out of large sheets of paper, an activity which Matisse described as like cutting into a block of colour.

**Georges Braque** (1882–1963). Braque's mature paintings are the logical combination of the feel for colour and paint which he showed in his ▽Fauve work and the ▽Cubist means of expression which he developed with ▽Picasso (*see* pages 262–3). Although he produced a small amount of sculpture and some fine graphic work, Braque excelled as a painter. His range of subject matter was small, mostly still-lifes and the interior of his studio, which are seen at their finest in the large paintings made between 1948–56. In these, forms emerge slowly from the dark backgrounds almost as though Braque had found a way of introducing the passage of time into painting. In many respects Braque's work is about this act of creation itself. His handling of paint and his feeling for decorative qualities have been surpassed by no other artist yet this century. Coming from a family of professional painter-decorators, he used their techniques of imitation marbling, woodgraining, and texturing by mixing paint with sawdust or sand.

**Fernand Léger** (1881–1955). The First World War had a profound effect on the art of Fernand Léger. Whilst in the trenches as a private soldier, he conceived the creation of an art that would be accessible to the ordinary working man. Nor was he depressed by his war experiences. Léger delighted in machinery and was dazzled by the beauty of the massive and precision-made armaments. After the war, he abandoned his early abstract experiments and, without any trace of hesitation or self-doubt, developed an art which took a highly optimistic view of the relationship between man and machine, robustly expressed by strong simple drawing and intense primary colours.

Indeed, in much of Léger's work his people, male or female, appear almost as machines, with arms and legs that have the power of pistons, and hair that looks as if it were cut out of sheet metal. Yet, although he endows them with such mechanical outward forms, Léger never allows them to lose their soul, and they are perfectly integrated with their modern world. Features of modern life such as the cinema or huge bright advertising hoardings by a country road, which have offended some sensibilities, were a source of sheer delight for Léger.

**Pierre Bonnard**, see p. 251, has already been mentioned in connection with the ▽Nabis. Throughout this period of argument and experiment he continued to paint with a technique developed by the Impressionists in the late nineteenth century. The subject and content were both personal and intimate. Using his wife as model and the bath as setting he painted luminous nude studies with a delicate touch but on canvases that are heroic rather than intimate in scale.

**Marc Chagall** (1887– ) was born in Vitebsk, Russia. He found post-revolutionary Russia, with its official anti-religious policy, increasingly difficult to work in, and, in 1922, he emigrated to France. Here he continued to paint in a personal style based on a complex mixture of the ▽Russian icon and Russian peasant art, using themes from Russian fairy tales and Jewish folk lore. At the same time he combines ▽Fauvist colour with ▽Cubist form.

*Above:* HENRI MATISSE *L'Escargot.* 1953. 112¼ × 113 in (287 × 288 cm). Tate Gallery, London

*Above:* MARC CHAGALL *The Blue Circus.* 1950. 13¼ × 10½ in (35 × 27 cm). Tate Gallery, London

*Left:* FERNAND LEGER *Composition with Two Parrots.* 1935–9. 157½ × 133 in (400 × 337·5 cm). Musée National d'Art Moderne, Paris

*Below:* PIERRE BONNARD *The Window.* 1925. 43¾ × 34⅞ in (108·6 · 88·6 cm). Tate Gallery, London

*Below:* GEORGES BRAQUE *The Studio.* Aimé Maeght Coll

# THE MODERN WORLD

JACKSON POLLOCK *Autumn Rhythm*. 1950. Oil on canvas.
105 × 207 in (267 × 526 cm). MM, New York

**America.** By the end of the 1940s, the centre of gravity of the art world had shifted from Paris to New York. There were many reasons for this change. Because of persecution and war in Europe, a number of leading artists sought refuge in America in the late 1930s and early 1940s, including ▽ Surrealists. And from the mid 1940s there developed a strong and highly influential school of painting which is now usually known as the New York School or Abstract Expressionism. These artists were influenced at first by their contracts with European artists; and much of the best 20th-century art had been seen at the Museum of Modern Art in New York (founded in 1929), and at the Guggenheim (initially called The Museum of Non-Objective Painting), which was opened in 1939. Although the artists came from all over the United States, and in some cases were immigrants, they had been drawn to New York under President Roosevelt's public works of art projects, which were able to provide employment for young out of work artists during the Depression. Many of these Federal commissions were for mural paintings, on a very large scale, and this certainly influenced the large size that was to become a feature of Abstract Expressionist paintings.

The Depression also influenced the emotional attitude of the artists, making them acutely aware of the tragedy and isolation that can be, and in the Depression most certainly were, a part of the human condition. They were also influenced to some extent by Existentialist philosophy, adopting the idea that what an artist does is much more important than what he creates. Simply to be a painter was all important; and they considered it better to attempt to reach great heights and risk failure, than to settle for safe mediocrity. From these varying strands, coupled with a new awareness of America's own Indian art (*see* pages 290–1) Abstract Expressionism became the first genuinely American fine art movement. Until the 1940s, the history of American painting and sculpture had often been the history of European art as done in America. From the mid 1940s, European art has often had to be content with following the example of America.

**The Gesture Painters.** It is customary to divide the Abstract Expressionist artists into two groups: the Gesture painters, and the Colour Field painters. This is a useful distinction, but it classifies the appearance rather than the content of the works and in fact most of the artists were impatient of the problems of style which modern European artists had posed themselves, and sought instead to reinstate the importance of the subject in painting. Jackson Pollock (1912–56) is the best known of the Gesture painters. He developed a method of painting in which he walked about on his canvas, flat on the floor, dripping paint on to its unprimed surface. His every gesture can be reconstructed by careful examination of the paintings, which are not as random as might be supposed (*Autumn Rhythm*, 1950). The complex webs of paint were built up over a period of time with assessment at every stage, and Pollock consciously rejected and destroyed much of his work. In this method of work Pollock achieved complete unity between himself the creator, and the object of his creation, and to experience fully one of his works is to experience his activity of creation. When unable to create Pollock suffered deep depression, and he committed suicide in one such prolonged period of inactivity and frustration.

The German artist Hans Hofmann (1880–1966), who settled in New York in 1932, was the inspired teacher of many of the New York artists. He advocated the free use of loose dribbles of paint and fluid brush marks, but it was Arshile Gorky (1905–48) who was perhaps the first American painter to consolidate a style independent of European influence. He strongly influenced Willem de Kooning (1904– ) in much of whose work the image of woman is dominant (*Woman I*, 1950–2) or shares an equal place with the violent brush marks which are the evidence of de Kooning's own creative act and energy. He explained that the female, as a subject, aroused in him powerful passions: these being a reflection not just of sexuality, but also the anxious, rootless, and often violent quality of American urban life.

# Abstract Expressionism

*Above:* WILLEM DE KOONING *Woman I.* 1950–2. $75\frac{7}{8} \times 58$ in (192·7 × 147·3 cm). MOMA, New York

*Below:* BARNETT NEWMAN *Adam.* 1951–2. $95\frac{5}{8} \times 79\frac{7}{8}$ in (242·9 × 202·9 cm). Tate Gallery, London

*Above:* MARK ROTHKO *Green on Blue.* 1956. $89\frac{7}{8} \times 63\frac{1}{2}$ in (228·3 × (228·3 × 161·3 cm). University of Arizona Museum of Art
*Below:* CLYFFORD STILL *1954.* 1954. $113\frac{1}{2} \times 156$ in (288 × 396 cm). Albright-Knox Art Gallery, Buffalo, NY

**Colour Field Painters.** Clifford Still (1904– ) was the first to exhibit paintings saturated with large areas of colour, which were intended to act dramatically on the spectator and release him from familiar and material thoughts, so opening the way to transcendent experience. Still's abstractions evolve from two symbolic images: the free and upright standing figure; and the duality which is inherent in sun and dark earth, or female and male. To experience his painting is to share his artistic journey to reach, as he said, 'a high and limitless plain (where) Imagination, no longer fettered by laws of fear, became as one with Vision'.

Mark Rothko (1903–70) also intended his works to be experienced, not regarded as formal objects. He said 'I am interested only in expressing the basic human emotions, tragedy, ecstasy, doom and so on . . . the people who weep before my pictures are having the same religious experience I had when I painted them . . .'. Time spent with his work induces a state of mind which in the early 19th century was called 'sublime', and which then could be achieved by the contemplation of the in-

comprehensible forces of nature. In a material scientific age, Rothko recaptured such transcendent experiences through new visual means; and the Rothko Chapel at Houston, Texas, bears witness to his achievement.

Barnett Newman (1905–70) was the one artist to discuss the aims and purposes of the movement at length, in major and influential writings. His paintings were influenced by ▽North West Coast Indians and ▽Pre-Columbian art. The single line which is a characteristic of his work (*Adam*, 1951–2) implies a gesture – indeed the first creative gesture by man. Newman wrote: 'In our inability to live the life of a creator can be found the meaning of the fall of man . . . Man's first expression . . . was a poetic outcry . . . of awe and anger at his tragic state, at his own self-awareness and at his own helplessness before the void . . .'.

# THE MODERN WORLD

**Anxiety.** The decade which followed the ending of the Second World War was one of anxiety, particularly in Europe. The war had left much of Europe physically destroyed; it was a time of economic scarcity and hardship; the 'Iron Curtain' divided the Continent into two ideologically opposed camps; and the threat of the nuclear bomb, and with it the possibility of man's final extinction by his own science, lurked always as a real danger. Against such a background it is scarcely surprising that few young European artists found it possible to develop an art which celebrated the pleasures of life, and the intellectual climate was dominated by Existentialist philosophy. Existentialism stressed the isolation of the individual and his obligation to choose, often in a state of anxiety, not simply for himself but for the whole of mankind: ultimately how an individual chose to define himself through his own actions formed the definition of humanity as a whole. In other words, man, individually and collectively, was utterly alone.

This mental and spiritual isolation is compellingly expressed in the sculpture of Alberto Giacometti (1910–66). Giacometti was born in Switzerland but spent most of his life in Paris, and in the 1920s and 1930s was closely linked to the ▽Surrealists. After the war, he began to create his long angular figures which were modelled in plaster on a wire frame and then cast in bronze. Giacometti worked first from the live model, and then from memory. He explained that in trying to create from memory what he had seen, the sculpture began to get smaller and smaller: yet he was revolted by these small dimensions, and the only way he could produce an image which expressed his conception of reality was by thinness and elongation. He was also a gifted painter, and he worked, in his own words: 'to resist death and be as free as possible'.

The work of the American ▽Abstract Expressionists was soon known in Europe for one of the characteristics of the post-war world has been the enormously increased scale, speed, and variety of visual communication. The Spaniard Antonio Tapies (1923– ) went to New York in 1953, and developed an informal and gestural style of his own. He placed much more emphasis on the materiality of the picture's surface than the American painters, and in common with many European artists of the time incorporated 'junk', such as plaster and sacking, into his work. The purpose of his work is serious: he tries, as he says, to force the inert materials in his work to speak, and so to shock man into thinking about what he really is.

Highly influential in this period was the French painter Jean Dubuffet (1901– ) who has used deliberately coarse and crude materials and images, in a way intended to decry technical skill and aesthetic sensitivity. Dubuffet has been strongly influenced by the works of psychotics and children, which he collects. He coined the term *L'Art Brut* (rough, uncultured art) to denote the 'non-art' quality of such work, and his use of it is deliberate. Like ▽Francis Bacon, Dubuffet has used painting to bring the spectator face to face with the absurd and futile, and so force him to examine the nature of his own existence.

*Left:* ALBERTO GIACOMETTI
*Man Painting.* 1947. Bronze.
$69\frac{1}{2} \times 35\frac{1}{2} \times 24\frac{1}{2}$ in
($176\cdot5 \times 90\cdot2 \times 62\cdot2$ cm). Tate Gallery, London

*Right:* JEAN DUBUFFET
*Man With a Hod.* 1955–6.
$40\frac{1}{4} \times 19\frac{7}{8}$ in ($102\cdot2 \times 50\cdot5$ cm).
Tate Gallery, London

*Right:* BRIDGET RILEY
*Nineteen Greys.* 1968.
Each section $29\frac{3}{4} \times 29\frac{1}{2}$ in
($75\cdot6 \times 74\cdot9$ cm). Tate Gallery, London

*Above:* PETER BLAKE *Toy Shop.* 61¼ × 76⅜ × 13⅜ in (156·8 × 194 × 34 cm). 1962. Tate Gallery, London

*Below:* ROY LICHTENSTEIN *Whaam!* 1963. Acrylic. 68 × 160 in (172·7 × 406·4 cm). Tate Gallery, London

*Below:* MORRIS LOUIS *Alpha-Phi.* 102 × 180¼ in (259 × 459 cm). Tate Gallery, London

**Pop Art.** By the mid to late 1950s, the economic and social climate was changing enormously, and a new generation of painters was beginning to find its interests in a society whose anxiety was coupled with affluence. Pop Art developed simultaneously in London and New York, two rich capital cities, and although there are different national characters to the Pop Art style in Britain and America, both shared a core of common assumptions. The British artist Richard Hamilton (1922– ) listed the qualities of Pop Art as: 'Popular (designed for mass audience); Transient (short term solution); Low Cost; Mass Produced; Young (aimed at Youth); Witty; Sexy; Gimmicky; Glamorous; Big Business'.

Artists such as David Hockney (1937– ) in Britain and Andy Warhol (1930– ) in America, were, in their turn, feted as though they were pop stars. The techniques of mass communication, such as comics, photography, silk-screen printing, were taken up by Pop artists and re-used in a fine art context. Thus, Roy Lichenstein's (1923– ) work, which was so often thought to be a straight enlargement of comic strip frames, is in fact arranged and composed with highly sophisticated artistic precision, and his single images have a subtle and self-contained interplay with their words which is not to be found in the multiple comic strip. Many Pop artists have used the materials jettisoned by the affluent society in their work, and it is interesting to compare their use of 'junk' with that of the previous generation. The crushed remains of a car had been used to express the tense feelings of anxiety and tragedy implicit in the violent twisted wreckage; but by the 1960s, the sleek, shining image of the car was used as the ultimate symbol of material prosperity. British Pop Art reveals an overtone of nostalgia which was not shared by the American artists. Peter Blake's (1932– ) *Toyshop* (1962), for instance, faithfully preserves in its real window the actual cheap products of industrial society and commemorates a type of shop and community now often supplanted by mass-produced new developments with huge supermarkets and tower blocks of flats.

**Op Art.** The precise figurative images of the Pop artists were a conscious rejection of the painterly abstract images of the 1940s and early 1950s. Alongside them, however, a number of painters used (and continue to use) ☐abstraction to investigate and create optical effects. These frequently enable the viewer to see, by optical illusion, things that are not there at all. The intense colours and hard edges are not really so different from those used in advertising hoardings or cornflake packet design, and some artists have experimented with another symbol of modern life – the neon light. In America, Morris Louis (1912–62) worked methodically towards large paintings in which bright rivers of paint appear to the eye to be running down the edges of the canvas. This is perhaps the first time any artist has captured that essential quality of paint: liquidity. In Britain Bridget Riley (1931– ) has produced large paintings which assault the spectator's retina with a force that can result in symptoms of acute physical distress.

# THE MODERN WORLD

Sculpture has undergone changes during the 20th century as drastic as those which have taken place in painting. Sculpture, traditionally, had been primarily more concerned with the human figure, but sculptors have succeeded in escaping from the obligation to imitate the appearance of the material world. Just as painters have re-stated the fundamental truth of their art – that a painting is paint on a flat surface – so sculptors have sought to emphasise the nature of the materials they work with, and to stop creating the illusion of flesh and blood in a block of marble. All three-dimensional work has one characteristic which is quite foreign to the art of painting: it exists in the same space as the spectator, and the spectator is free to move round it. Much more so than painters, sculptors have experimented with a whole range of new materials, both soft and hard, which industrial society has made readily and cheaply available. In the ▽ Renaissance tradition, the distinction between the painter and the sculptor was easy to draw. In the 20th century, they overlap.

**Constantin Brancusi** (1876–1957). Much of the finest and most expressive three-dimensional work produced in this century has used the traditional materials, such as stone and wood, which are carved, and clay and plaster which can be modelled and cast in bronze. In 1904, Constantin Brancusi, the uneducated son of a Rumanian peasant, arrived in Paris, attracted by the work of ▽ Rodin. In many respects, Brancusi aided the rebirth of the art of sculpture which had fallen into a serious decline in the 19th century (Rodin being one of the notable exceptions). However, Brancusi politely declined an invitation to work with Rodin, and in his work broke free from the tradition that ran from ▽ Michelangelo to Rodin, which caused sculptors, as Brancusi himself put it, 'to work in beefsteak'. He radically simplified the sculptured work, rejecting all exterior and imitative details, so that he could penetrate to, and reveal, the inner force or essence of things. Such an aim was not to be achieved hurriedly, and Brancusi's work is cool and dispassionate, though never cold and lifeless. One of his favourite themes was the human head. Over the years he refined its essential shape and quality until he was left with its essence – a smooth egg-shaped form of marble which he called *Sculpture for the Blind (The Beginning of the World)* (1924). The title emphasises two things which are central to his art and to much of modern sculpture: the essence of life, which has evolved from the egg to our present level of consciousness centred in the brain; and the idea that sculpture should appeal as much, if not more, to the sense of touch, as to perception by the eye.

**Raymond Duchamp-Villon** (1876–1918). One of the most tragic losses in the First World War was Raymond Duchamp-Villon, who died from typhoid. His *Horse* (1914) is an immensely powerful expression of energy and motion in virtually □abstract terms, transforming one of the oldest sculptural and artistic images into a modern mechanical perception of horse power.

*Above:* HENRY MOORE *Mother and Child*. 1924–5. Hornton stone. 22½ in (57·2 cm) City of Manchester Art Gallery

*Above:* CONSTANTIN BRANCUSI *Blond Negress. Version II*. 1933. Bronze and stone. H. about 24 in (61 cm). MOMA, New York

*Below:* RAYMOND DUCHAMP-VILLON *The Horse*. 1914. Bronze. 40 × 39½ × 22⅜ in (101·6 × 100 × 56·8 cm) MOMA, New York

**Henry Moore** (1898– ), who was born in Yorkshire, has gained the foremost contemporary reputation. He was much influenced as a young man by primitive objects which he studied at the British Museum, and by Mexican figures in which he found his theme of the reclining woman. Moore's subjects and materials are traditional, but like ▽Brancusi what he has sought to express is the essence of them both. *Recumbent Figure* (1938) has the quality of an object formed by the forces of nature which might have slowly worked at, smoothed, and worn through the green Hornton stone to produce a deeply appealing maternal image. The human psychological meaning of his work has been as important to Moore as its formal qualities; many of his figures seem to be as much nature's landscape as human forms, and so express that acute and particularly English awareness of the inter-relationship between the human personality and the forces of the natural world.

**Constructions.** When ▽Picasso and ▽Braque started to use newspaper and other scraps in their ▽Cubist 'paintings', it was virtually inevitable that before long they would start to construct three-dimensional artistic works out of paper or wood. Their modest works had an immediate influence, for they introduced an entirely new artistic object which fell outside the traditional definitions of sculpture and painting. In the late 1920s, Picasso was able to develop the potential of these 'constructions' when his friend, Julio Gonzales, (1876–1942), who had worked in the Renault car factories, introduced him to the technique of welding. By joining thin strips and rods of metal, they produced works which caused no displacement of space (as a block of marble must do) but were more like three-dimensional drawings.

The welding torch has meant that almost any metal can be exploited to the full by sculptors, to produce something as permanent as traditional bronze, but totally removed from it in both appearance and expression. Even iron, which had always resisted the sculptor's touch, could be handled relatively easily, and since the Second World War particularly, many sculptors have sought to investigate and exploit the formal properties of such metals, just as ▽Brancusi and ▽Moore have brought out the essence of natural materials. The American sculptor David Smith (1906–65), who also worked at one time in a car factory, exploited the cool, clean qualities of stainless steel, delighting especially in the reflecting polished surfaces that can be given to it. Nearly all sculpture, whatever its form, has one fundamental constraint: the pull of gravity which ties it inescapably to the ground. Alexander Calder (1898–1976), however, produced what he termed 'mobiles', which defied even this consideration. The flat shapes move freely on their long, thin rods when disturbed by the slightest movements in the air around them. Movement has always interested the sculptor, but traditionally it could only be implied by a self-contained static form, such as ▽Duchamp-Villon's *Horse*. Today, assisted by electro-mechanical motors, sculptors can create three-dimensional work which moves in fact, illustrating vividly how radically the whole definition of sculpture has changed in this century.

*Above:* HENRY MOORE *Recumbent Figure.* 1938. Hornton stone. $35 \times 52\frac{1}{4} \times 29$ in ($88 \cdot 9 \times 130 \cdot 2 \times 73 \cdot 7$ cm). Tate Gallery, London

*Above left:* JULIO GONZALEZ *Woman Combing Her Hair.* 1936. Iron. $52 \times 23\frac{1}{2} \times 24\frac{5}{8}$ in ($132 \times 59 \cdot 7 \times 62 \cdot 5$ cm). MOMA, Yew York
*Above right:* DAVID SMITH *Cubi XIX.* 1964. Metal. h. 113 in (287 cm). Tate Gallery, London

*Below:* ALEXANDER CALDER *Lobster Trap and Fish Tail.* Metal sheet and wire. 1939. $104 \times 114$ in ($259 \cdot 1 – 289 \cdot 6$ cm). MOMA, New York

# THE MODERN WORLD

**Origins of the Modern Movement.** The pre-First War decade of this century was a peak period of innovation in all the arts and sciences. The modern movement in painting and sculpture was paralleled by music and literature. It was the age of powered flight, of the motor vehicle, of wireless telegraphy and telephony and of fundamental discoveries in atomic physics leading to new ideas about matter and energy. Architecture, too, shared this heroic phase of creativity. Its innovations were not even thought to be bizarre or revolutionary as in the other arts, but enjoyed powerful patronage from state and industry, particularly in Central Europe led by Prussia and Austria.

The philosophical origins of modern architecture lay in the idea of social reform, not social revolution. The notion had developed in the 19th century, epitomised in the work of such thinkers as Charles Darwin, Marx and ▽Freud, that man is biologically, socially and even spiritually a product of his environment. Leaders of the modern movement argued that if this is so, then, especially in a man-made, industrialised age, by changing the environment we can change both the individual and society. They pointed to the example of the 19th-century industrial town with its poverty, slums, epidemic diseases and crime, and said that the architect must lead the way out.

It was this philosophy that linked men like ▽William Morris to ▽Walter Gropius (1883–1969). Gropius began as an industrial architect in Germany, and his model factory for the Werkbund exhibition in Cologne in 1914 epitomises all the elements of architecture which were stylistically to identify the modern movement. It was not an isolated example. Factories, market halls, post-office buildings and factories throughout Central Europe share this distinction.

**The Modern Movement as a Style.** Gropius, as director of the post-war ▽Bauhaus school, became more important as a theoretician and as an educator than as a designer. Looking back to the 'free for all' of the 19th century he thought it essential that the modern movement should not become yet another style among others, but that its buildings should result from pure building technology allied to the purpose of the plan. But since, historically, all style had their origin in building technology and materials, so it was inevitable that a modern style should evolve.

This style may be identified by characteristics such as the use of a frame, rather than load-bearing walls, which can have a screen infilling of any materials, stone, brick, metal, glass or synthetics. The frame can be of metal, or reinforced concrete, and can be extended in any dimension to create buildings of a size hitherto impossible. The popular image of a modern building using slabs of concrete, large areas of glass, over-hanging flat roofs, free-standing spiral staircases and horizontal glazing bars has a great deal of justification in fact, just as columns and pediments are 'Classical'.

These clear-cut, sculptural forms have led to comparisons with modern painting and sculpture, but these are coincidental rather than intentional. The style described has become labelled the 'International Style'. It is in reality to be found in most countries of the world unless under an ideological ban, but the attempt to establish an actual international movement of architects failed politically.

In practice such buildings have many drawbacks. They use a great deal of energy for heating, ventilation, water and power supply, lifts and other services. They are vulnerable to power shortages, when they completely break down as a way of life, and are hostage to the cost of energy. They are socially isolationist and unadaptable, and architects and planners are beginning to re-evaluate the terrace house. For public buildings, offices and hotels, where services are paid for and maintenance is high, they are probably still the most economic type of building and are capable of an impressive kind of beauty.

**The Dilemma of the Modern Movement.** Although the origins of the modern movement in architecture coincided with the development of early aircraft it is obvious that the two have not kept pace. Many buildings and civil engineering works have fallen well below the standards set by early pioneers.

Once the aircraft was invented, no engineer had to reinvent it for himself. But because modern architecture was innovatory, then every student has had to work in an innovatory tradition and reinvent modern architecture for himself. The result has been as chaotic as any battle of styles of the past.

It is the civil engineer, once more, who has been able to prescribe a certain amount of freedom as in the nineteenth century. The vast Italian concrete stadia and exhibition halls of Pier Luigi Nervi (1891– ) with their elegant structures, bear comparison with any great master work of the past, Classical, □Gothic or □Renaissance, while the bridges of Robert Maillart (1872–1940) the Swiss engineer have, from the first bridge of 1905 onwards, a sculptural and mathematical purity and thoroughbred elegance of complete originality.

**The International Movement** with local variations has proved adaptable to many uses. It had its origin in functional public buildings, but its most interesting use has been in housing, private and individual, and in mass state housing.

In the former, its purist aesthetic dictates a way of life to the inhabitants, whether in a house by Le Corbusier (1887–1966), by Mies van der Rohe (1886–1969), both pure 'machine style architects', or the more 'cottage style' houses of Frank Lloyd Wright (1869–1959). The basic idea of the modern architect always led him to dictate to his client rather than be dictated to by him. The architect's own personality and individualism thus became an important factor in his work, and this contained the seeds of disintegration in the movement. In mass housing limitations on city space and the consequent overcrowding led to housing people in point blocks. The vertical city with its streets stacked or stored on end became an architect's dream. Le Corbusier was a leading advocate of this new Utopia, but many supporters followed the example of his pioneer buildings in this field.

*Above:* FRANK LLOYD WRIGHT Unity Church, Oak Park, Chicago. 1906.

*Above:* FRANK LLOYD WRIGHT Falling Water. Bear Run, Pennsylvania. 1936

*Above:* View of Manhattan, New York City

*Below:* LE CORBUSIER Unité d'Habitation, Marseilles. 1947–52

*Above:* MIES VAN DER ROHE Seagram Building, New York. 1956–8

*Below:* KENZO TANGE Olympic Pool. Tokyo. 1964

# THE MODERN WORLD

'O, thoughts of men accurst!
Past and to come seem best; the present worst.'

The words are ▽ Shakespeare's but the sentiment is universal. In western European civilisation, we are well aware of the fact that we do not live in isolation, but are part of a continuum that links the past and the future. And even those who argue that art is concerned only with itself and has no wider context, paradoxically comment on their own times and their relationship with the past and the future.

The urge to create visual images is one of the oldest instincts of civilised man. Today the number of people who work, or claim to work, in an artistic context is greater than ever before. There are a number of explanations. The expansion of the population has meant more artists numerically, if not proportionately; there are more art schools; new systems of patronage, particularly through State organisations, help young artists to experiment with ideas that are commercially unappealing or of no interest to the private patron; and there is a vastly expanded definition of artistic activity which is one of the chief features of the development of art in the 20th century. Even the definition of what a work of art is, is uncertain, or at least is a topic for controversial argument in which tempers and passions can be inflamed. Art does not, and never has, stood still, although it is perhaps not far from the truth to claim that the problems facing artists, and the questions which they consider, vary little from generation to generation, and that what does change are their answers and solutions.

The death of painting and sculpture has been announced countless times, and the announcement has always been premature. Having said that, however, it should be pointed out that for many people one of the most bewildering aspects of much artistic activity today is that it seems to place no great priority on visual appeal, (as opposed to communication by visual means), has little regard to the traditional yardstick of manual dexterity and craftsmanship, and in many cases is not concerned to leave any permanent record.

A number of artists now defy the traditional showplace of gallery, museum or private house, by working directly in or with the landscape, although this, in itself, can be considered symptomatic of the environmental concerns of the present time. The instant title 'Land Art' has been applied to such activities, which can be brought to the attention of the spectator only through photographs that are a record of, rather than a part of, the 'land' activity – thus raising difficult questions, for are such photographs in fact works of art, or are they more akin to a reproduction of a painting? The love of instant titles which allows an artist to be neatly filed away is a major characteristic of 20th-century art criticism and commentary, and not necessarily very helpful. In the 18th century no artist had any idea that he was ▽ Rococo

*Above:* ROBERT MORRIS *Untitled.* 1966. 36 × 48 × 90 in (91·4 × 121·9 × 228·6 cm). Whitney Museum of American Art, NY

*Left:* CARL ANDRE Untitled 1966. 5 × 90½ × 27 in (12·7 × 229·1 × 68·6 cm). Tate Gallery, London

or ▽ Neoclassical, for example, but in this century it has not seemed absurd to apply the label 'Cubist', 'Pop artist', 'Body artist', 'Conceptual artist', and so on, almost at once.

This approach is probably the result of the narrow specialisations which have taken place in almost every walk of life, and the wish to attempt to impose some sort of discipline on an art world that is, by any standards, distinguished by its remarkable and dazzling variety. When one is in the thick of the fray, so to speak, it is easier to categorise and point out the differences between various types of artistic activity than to point out the similarities, for only the perspective of time allows the broad course of developing ideas to be mapped out with any clarity. The perceptive observer today will be able to pick out some of the following trends: the artist revealing the processes by which he creates his work; the communication of an □ abstract or even mathematical concept; direct political and social comment, often in a manner which will intentionally revolt and disgust the spectator; performances by the artist himself in front of an audience, as opposed to the usual contact at one remove through an art work; consideration of the role of women; paintings which apparently have the impersonal quality of photographs. If these become too bewildering he can always find a haven with artists who have been happy to develop more familiar means of expression, but ultimately it is for the spectator himself to decide and judge what value he puts on these works and activities, and whether they make a useful contribution to the development of his individual and collective consciousness. Just as the definition of art has changed, so has the type of person who has felt the call to become an artist. Much art in this century has sought not to give pleasure as such, but to shape man's spiritual relationship with his world; equally, however, such good intentions alone have never been sufficient, and it is relatively few who have the dedication and the talent to make what will turn out to be a lasting contribution.

The number of artists who have been acclaimed as the 'Michelangelo of our time', only to sink into total obscurity, is far greater than those who have been wholly neglected in their lifetime and later hailed as geniuses. Just as contemporary art is continually changing, so our view of the past and our assessment of its artistic contribution is never static. A short while ago Victorian painting was considered to be of little merit, but now it is being reassessed, in scholarly and critical circles as well as in the salerooms. But by the same token the early Victorians disregarded the value of early Florentine painting, for instance, and it was only a few brave pioneers that gave it serious consideration; but in so doing they eventually brought about a change of relationship with the past, which in turn affected the art that was to be done in the future. We can only judge the art of the past by the works that have fortuitously been preserved. In his lifetime an artist has the advantage (or handicap) of his own personality to contend with, and this may inevitably affect his reputation, and so the financial support that he does, or does not receive; and this may finally decide whether he can go on working to achieve his full potential. Today many artists have reacted strongly against what they see as the commercial exploitation of the artist and works of art (possibly a legacy of the affluent 1960s), and for this reason have tried to create artistic work which will be incapable of financial manipulation. Nevertheless, lasting visual works, the products of man's own hand and spirit, are one of our most potent contacts with the stream of human consciousness which, for better or worse, has made us what we are today. A quotation from the painter ▽ Francis Bacon, published in 1973, still holds good: 'After a hundred years or so, all they think about is what a society has left. I suppose it's possible that a society may arise which is so perfect that it will be remembered for the perfection of its equality. But that hasn't yet arisen, and so far one remembers a society for what it has created.'

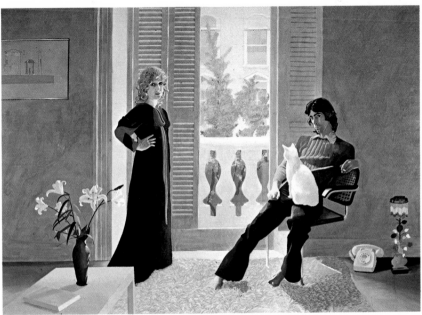

*Bottom left:* JOSEPH KOSUTH *Clock (one and five) English/Latin Version.* Tate Gallery, London
*Right:* DAVID HOCKNEY *Mr and Mrs Clark and Percy.* 1970–1. 84 × 120 in (213·4 × 304·3 cm). Tate Gallery, London

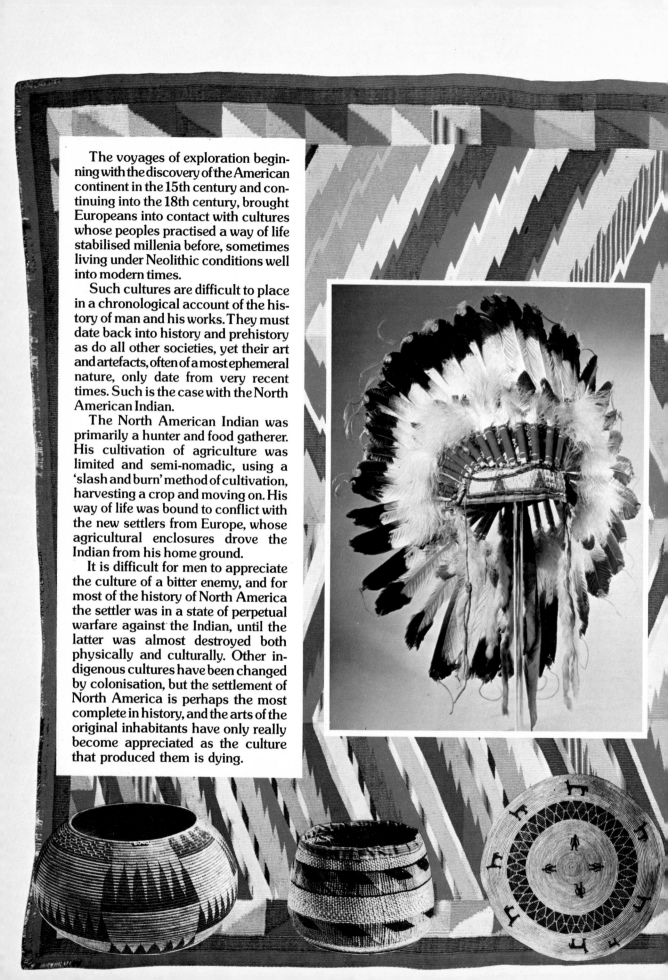

The voyages of exploration beginning with the discovery of the American continent in the 15th century and continuing into the 18th century, brought Europeans into contact with cultures whose peoples practised a way of life stabilised millenia before, sometimes living under Neolithic conditions well into modern times.

Such cultures are difficult to place in a chronological account of the history of man and his works. They must date back into history and prehistory as do all other societies, yet their art and artefacts, often of a most ephemeral nature, only date from very recent times. Such is the case with the North American Indian.

The North American Indian was primarily a hunter and food gatherer. His cultivation of agriculture was limited and semi-nomadic, using a 'slash and burn' method of cultivation, harvesting a crop and moving on. His way of life was bound to conflict with the new settlers from Europe, whose agricultural enclosures drove the Indian from his home ground.

It is difficult for men to appreciate the culture of a bitter enemy, and for most of the history of North America the settler was in a state of perpetual warfare against the Indian, until the latter was almost destroyed both physically and culturally. Other indigenous cultures have been changed by colonisation, but the settlement of North America is perhaps the most complete in history, and the arts of the original inhabitants have only really become appreciated as the culture that produced them is dying.

# THE NORTH AMERICAN INDIAN

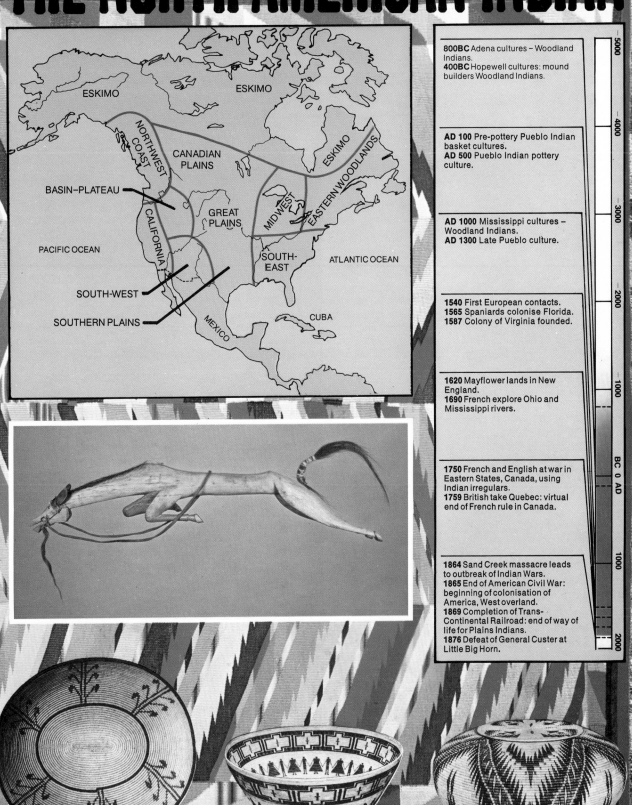

**800BC** Adena cultures – Woodland Indians.
**400BC** Hopewell cultures: mound builders Woodland Indians.

**AD 100** Pre-pottery Pueblo Indian basket cultures.
**AD 500** Pueblo Indian pottery culture.

**AD 1000** Mississippi cultures – Woodland Indians.
**AD 1300** Late Pueblo culture.

**1540** First European contacts.
**1565** Spaniards colonise Florida.
**1587** Colony of Virginia founded.

**1620** Mayflower lands in New England.
**1690** French explore Ohio and Mississippi rivers.

**1750** French and English at war in Eastern States, Canada, using Indian irregulars.
**1759** British take Quebec: virtual end of French rule in Canada.

**1864** Sand Creek massacre leads to outbreak of Indian Wars.
**1865** End of American Civil War: beginning of colonisation of America, West overland.
**1869** Completion of Trans-Continental Railroad: end of way of life for Plains Indians.
**1876** Defeat of General Custer at Little Big Horn.

# NORTH AMERICAN INDIAN ART

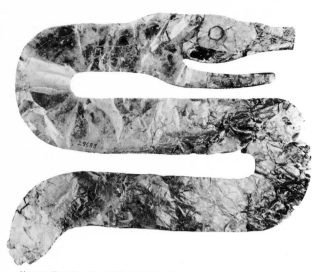

*Hopewell snake. About* 200–500. Mica. Peabody Museum, Harvard University

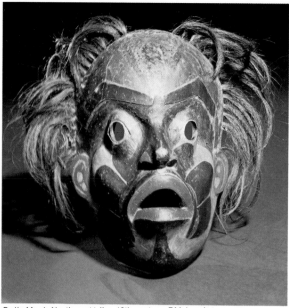

*Bella Mask*, Northwest tribe. 19th century. BM, London

**North American Indian Art.** To appreciate the nature of the visual arts of the Indian peoples of North America, one has to visualise cultures in which daily life, religious belief and artistic expression are not seen as separate activities but as communal rituals, celebrating either the power of natural and supernatural forces or some essential human activity such as hunting. A pot made by an Indian artist of the south-west has a break in the encircling line of the jar, the 'exit trail of life', because the pot has a life of its own. A child's moccasin, made by a ▽ Plains Indian, is embroidered with a zig-zag snake pattern as a protection against snake-bite. Once we recognise the nature and purpose of visual decoration in North American Indian civilisation, we can respond to the design and symbolism of a whole range of artefacts, baskets, blankets, pots, murals, beadwork on pouches and bags, head masks, and sculpture.

**Early Woodland Art.** The North American continent was first peopled by hunters who crossed from Siberia across the Bering Straits about 25,000 years ago. Gradually with the cultivation of maize, nomadic hunting communities became settled agricultural ones, and the making of effigies, pipes, and other cult objects became distinctive elements in a diverse culture that spread in the eastern seaboard area of North America known as the woodlands. Two areas in particular developed a strong visual arts culture, the Hopewell near Ohio (AD100–500) and the Mississippian (AD1300–1500). The Hopewell Turner mound serpent made from mica is thought to be a clothing ornament and its production was based on a technology that included whetstones, grindstones, hand hammers, chisels, and flint knives. Many of these objects have been found in burial mounds together with stone tobacco pipes decorated with bird imagery, and ornaments of stone, flint, mica, and pearl. The Hopewell artists also left fine pottery, textile fragments and miniature clay figures often with infants on their backs, kneeling or standing, representing the first clearly humanistic □genre in Amerindian art.

**Late Woodland Art.** Woodland artists developed a many-sided design of visual decoration that depicted and propitiated the supernatural spirits who inhabited the flowers, animals, the sky and the stars. Animals like the otter and the muskrat became clan symbols, and medicine bags were made from their pelts to propitiate the essences of Nature. A beautiful 18th-century Michigan pouch celebrates the power of the underwater panther, a very widespread image of unpredictable force.

The encounters between this woodland culture and the first European colonists from the 16th century onwards led in many instances to the complete destruction or removal further west of the woodland peoples. We can however gain a sense of the naturalistic power of the arts of this woodland culture from such artefacts as the mantle of Powhatan (the leader of the Algonquin tribes shortly before the founding of the Jamestown colony in 1607), or from the embroidered belts, porcupine quill-work, pouches and moccasins that continue to be made to the present day.

**The Art of the Plains.** The plains area of North America extends from west of the Mississippi river to the Rocky mountains, and from the Saskatchewan river in Canada to central Texas. A distinctive nomadic culture developed in this area built around the horse and the buffalo, though there were some agricultural communities. Many of the tribes, the Sioux, the Commanche and the Blackfeet were warrior societies with a complex system of hours and rewards signified by pipes, feathered bonnets, horse-hair and scalp-fringed war-shirts, and medicine hoops, all decorated with signs and emblems. Battle and hunting scenes were painted on to skin robes and rawhide with paints made from coloured earths. Beadwork was an essential part of Plains art. A hundred and twenty thousand beads have been counted on a single Commanche cradle.

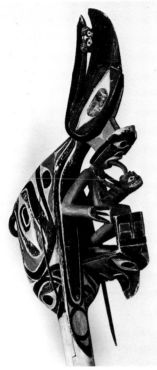

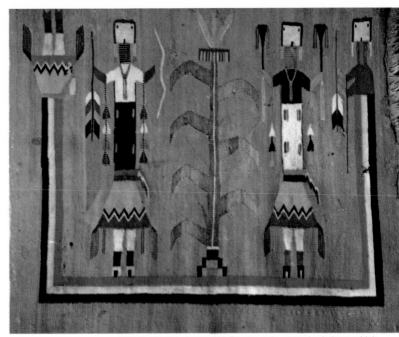

*Navaho blanket. About* 1800. Representing a sand painting to which the women had access

*Above: Haida cedarwood rattle.* Early 19th century. Royal Scottish Museum

*Below:* Northern Plains Indian coat. Probably Cree. 19th century. BM, London

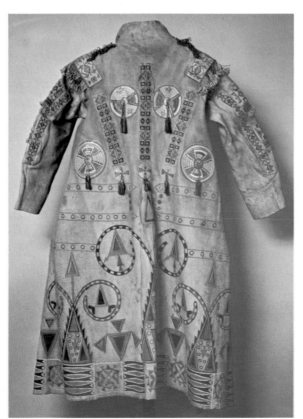

**Southwest and Far West.** The Navajos, Hopi, and Pueblo peoples of New Mexico and Arizona represent one of the strongest surviving cultures of North America, stretching in a continuous arc of change and development from AD 400 to the present day. Examples of woven baskets and blankets, pottery, jewellery, and sand-painting survive and flourish. A refinement of the picture-writing of the Plains are the Navajo sand-paintings. The designs are formed by sprinkling coloured powder made from earths, rocks, and charcoal, spread on the floor of the medicine lodge. The artists are medicine men and the paintings are part of a healing ceremony. Colours are sifted through thumb and forefinger and the design is from memory. After the ritual the painting is destroyed.

**Eskimo and Northwest.** The Eskimo culture was one of the most precariously balanced on the North American continent, hovering between subsistence and survival. However a variety of carving in ivory and wood, festival masks, sealskin and woven bags decorated with magical natural symbols, are all featured within the Eskimo arts. Further south are the Northwest coast tribes, Kwakiutl, Bella Coola, Haida, Tsimshian, and Tlingit. A highly expressive sculpture developed amongst these peoples that ranks with the sculpture of the rest of the world in its variety and its stylistic vigour. Based on the Potlach feast that celebrated Nature's abundance, a connected symbolism of totem poles displaying tribal, human and animal forms, often in heavy masks, was created. A visual vocabulary of animal eyes, ears, paws, tails, and fins recalled past, present, and future in one of the most elaborate rituals of the native Americans. The designs are highly abstracted, expressionist and vividly coloured. This powerful iconography is also present in Northwest Coast blankets, baskets, and bracelets.

# Pre-Columbian Civilisations

The civilisations of Central America–Mesoamerica–and the Pacific Coast of South America were roughly contemporary with the European Christian era. Both were rapidly brought to an end by the Spanish conquest following on the voyages of discovery of Columbus. The conquerors immediately found themselves in conflict with the original inhabitants. The soldiers were looters and treasure hunters seeking for gold. The priests were seeking to save human souls, and took with them the no less violent methods of the Inquisition, and in the name of their religion they eventually destroyed a whole culture.

There were two empires, the Aztecs of the Mesoamerica and the Incas of Peru. Both were agriculturally settled and competent, and supported art and architecture. The monuments left behind are impressively massive, yet the societies that produced them were surprisingly primitive. The Mayan culture of Mesoamerica made advances in mathematics and astronomy, but it was over-run by Aztecs from the north in the eleventh and twelfth centuries, who in turn were conquered by the Spanish in 1519. The conquest of Peru followed in 1532.

The Pre-Columbian cultures seem to have been dominated by millenarianism–a belief that the end of the world was periodically imminent. This could only be averted by human sacrifice, and of course once such a belief gains an ascendancy there is no way of disproving it. Their gods were protrayed as terrifying monsters whose hostility could only be appeased by blood, by torture and sacrifice. Certain elements in Pre-Columbian superstition have never died out, and flagellation and other forms of self-torture were incorporated into a form of Christian ritual still peculiar to the sub-continent.

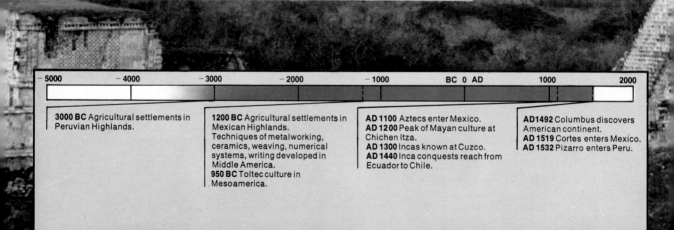

| −5000 | −4000 | −3000 | −2000 | −1000 | BC 0 AD | 1000 | 2000 |
|---|---|---|---|---|---|---|---|

**3000 BC** Agricultural settlements in Peruvian Highlands.

**1200 BC** Agricultural settlements in Mexican Highlands.
Techniques of metalworking, ceramics, weaving, numerical systems, writing developed in Middle America.
**950 BC** Toltec culture in Mesoamerica.

**AD 1100** Aztecs enter Mexico.
**AD 1200** Peak of Mayan culture at Chichen Itza.
**AD 1300** Incas known at Cuzco.
**AD 1440** Inca conquests reach from Ecuador to Chile.

**AD 1492** Columbus discovers American continent.
**AD 1519** Cortes enters Mexico.
**AD 1532** Pizarro enters Peru.

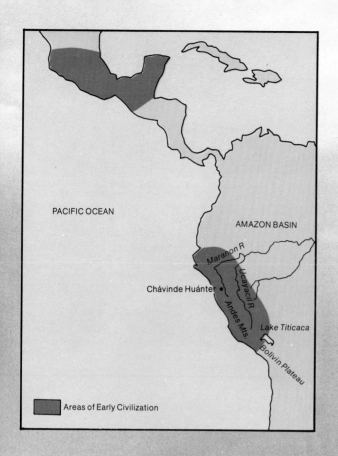

PACIFIC OCEAN

AMAZON BASIN

Marañon R

Ucayacil R

Chávinde Huánter

Andes Mts

Lake Titicaca

Bolivin Plateau

Areas of Early Civilization

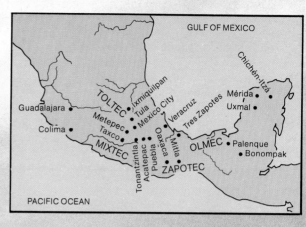

GULF OF MEXICO

Guadalajara

Colima

TOLTEC

Ixmiquilpan

Tula

Metepec

Mexico City

Taxco

Veracruz

Tres Zapotes

Chichén-Itzá

Mérida

Uxmal

MIXTEC

Tonantzintla

Acatepac

Puebla

Oaxaca

Mitla

ZAPOTEC

OLMEC

Palenque

Bonompak

PACIFIC OCEAN

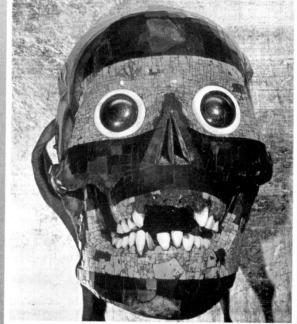

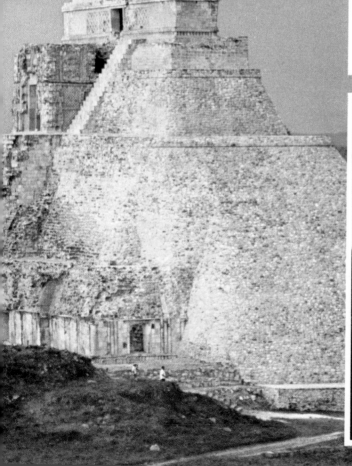

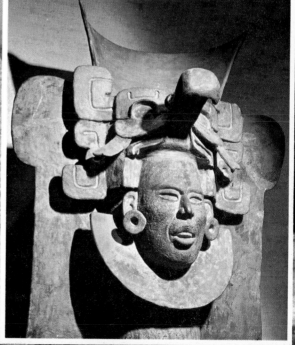

# PRE-COLUMBIAN CIVILISATIONS

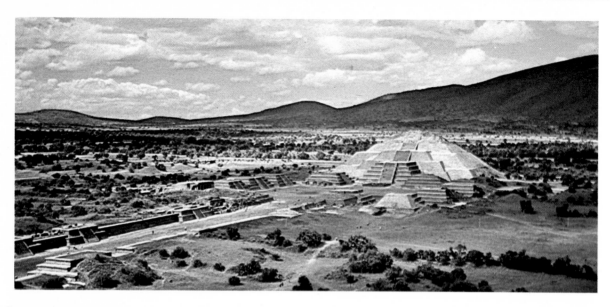

**Ceremonial Building.** From around 2000 BC the erection of large ceremonial buildings, usually clustered in a ceremonial centre complex, became central to Central American society. The principal type was a pyramidical platform mound – similar to Egyptian forms (*see* pages 32–3), but terminating in a flat top, to which one to four flights of steps led, for the enactment of ritual practices. Pyramids in Central America were of a ceremonial rather than funerary function and were central to the performance of religious rites. At Monte Albán in Oaxaca, and Palenque in the ▽Maya Lowlands, these structures were found also to contain rich burials of civic or religious dignitaries, but these were of secondary importance to the main purpose of the pyramid.

Within Central America there were two main types of architectural style, especially clear in pyramid construction: the broad square *talud-tablero* of Mexico and the tall, narrow based Maya form. □Corbel vaulting of overlapping, flat, balanced stones is also typical of Maya architecture and was used extensively as a technique in the construction of palaces and temples. The true arch was never known in the New World.

Another typical feature of the Central American cultural tradition was the ball-court where the sacred ball game was played. This made its first appearance, as did the pyramid, with Central America's first large civilisation – the ▽Olmec of the Mexican Gulf Coast. It was shaped like the capital letter 'I' with accentuated crosspieces; later examples had stone rings at either end through which the ball was passed. Spectators' seats were arranged each side of the main court.

Palaces and temples of the aristocracy and the single-storey living quarters and workshops of the artisans were organised in an orderly grid plan around the main ritual complex. The city of ▽Teotihuacan in Mexico, which prospered around AD 500, is one of the most remarkable examples of a planned urban and religious centre.

**Sculpture.** Art flourished mainly in the medium of sculpture in Central America. Figures and freizes ranging in scale from gigantic to very small are fundamental to the

*Above:* View of Teotihuacan. *About* AD 500

*Below:* The Great Ball Court, Chichen Itza. *About* AD 500

artistic consciousness of the cultural tradition. Serpents, skulls, snarling jaguars and the grim-looking rain-god Tlaloc decorate many of the temples and palaces as whole sculpture or friezes

Sculptural style varies, naturally, through time and with the different regions and different local cultures. The ▽Olmec culture, for example, produced giant basalt heads representing warriors or ball-players, the largest of which are nine feet high and weigh up to twenty tons. Their heavy, almost negroid looks are very different from the graceful, slender features of the Maya sculptured or □stucco figures, with their tall, intricate head-dresses. In the ▽Maya lowlands, the erection and elaborate carving of pillars or □*stelae* typified this particular civilisation at its height, recording astronomical, religious and civic events in hieroglyphic symbols. The *stela* itself

# Mexico and the Maya Lowlands

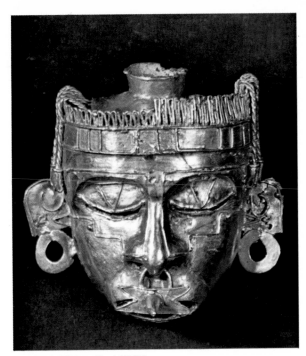

Gold Mask, Mixtec. *About* AD 900

often represented gods or dignitaries, their bodies covered with intricate flowing designs in □bas-relief.

The Aztec Mexican cultures terminating in the 16th century with the conquest of the Aztecs by the Spanish produced finely executed sculptures of grim ferocious beings and animals and very naturalistic versions of rattlesnake, coyote and jaguar. The human skull was always a popular subject and the finest existing example is carved from the pure crystal. The ▽Aztecs' immediate forbears, the Toltecs, were also a war-loving and death-worshipping people, evidenced by the giant stone warriors in the pillared temples at Tula, their capital, and the widespread appearance of the skull-cult and the *chacmool* – a reclining stone figure bearing a sacrificial bowl on his belly. Smaller sculptures exist in the form of figurines of clay or polished jade. The Olmecs hoarded caches of jade figurines and were fond of realistic models of fat babies.

**Ceramics.** Pottery manufacture was known in Central America by 2000 BC, although glazing and the potter's wheel were never known. Pots were either fashioned by hand or mould-made and fine polychrome highly burnished wares were being produced by the early centuries AD. The variety of form and decoration is immense. Most standard forms produced in the Old World with a potter's wheel were common: plate, bowl, jar, vase and beaker with many elaborations of these. Pottery was decorated in a variety of different methods, from stamping, incision, excision, and appliqué in geometric designs, to polychrome painting of ritual scenes with dignitaries, prisoners and slaves. These latter were especially common in □Maya ceramics. Among the most beautiful wares produced were those from the Mixteca-Puebla culture in Mexico. Later taken over by

the ▽Aztecs, it manufactured a type of lacquered polychrome of mainly geometric motifs. Effigy urns and vases were also popular, depicting a variety of human, animal and imaginary characters.

**Codices and Murals.** □Hieroglyphic writing had been discovered in Central America by the 1st century AD and was carved principally on commemorative *stelae*. More recent were the production of □codices where pictographic symbols were painted on prepared strips of deer hide or bark cloth and form the few precious written accounts the Pre-Columbian peoples made of themselves. There are three ▽Maya codices and many more from Mexico. They detail tribal histories and legends and also contain aspects of daily life and such interesting details as the tribute received for Emperor Montezuma II from his subjects.

Little mural-painting has survived, but fine colourful examples exist from cave-paintings of ▽Olmec date to the more elaborate ritual scenes from the temple walls at ▽Teotihuacan in Mexico and Bonampak in the Maya Lowlands.

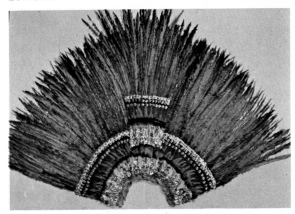

Feather Head-dress. Given by Montezuma to Cortes Mixtec. 16th century

**Featherwork and Mosaics.** Shields, standards, head-dresses and capes for the nobility were often created in ornate and colourful lapidary work, from feathers traded from the tropical rainforests. This craft was particularly prized in Central America and the best examples that exist today had been given in token to the Spanish sovereigns of the Conquistadores.

The inlaying of serpentine, turquoise, malachite and shell to make mosaics was also a popular craft and is known from ▽Olmec times. The Olmecs are best known for their beautiful pavements of inlaid serpentine representing stylised jaguar masks and purposely buried, probably for ritual reasons. The ▽Aztecs created wonderful masks and skulls overlaid with turquoise, malachite and shell with eyes of iron pyrites. One of their most famous mosaic artefacts is the chalcedony-bladed sacrificial knife with inlaid handle in the form of a crouching eagle warrior. Larger mosaics decorating the walls of palaces and temples exist in complex geometric motifs; these occur mainly after AD 800 in the architecture of the ▽Maya although fine examples exist at Mitla in Mexico.

**Architecture.** Building materials were of either stone or adobe – mud-brick. The former is mainly found in the highlands and the latter on the coast where vast urban and defensive complexes were created solely from this material, such as at ▽Chanchan, capital of the ▽Chimu coastal empire in north Peru.

From 1000 BC, the peoples of Peru were constructing complex temples and ritual structures, as at ▽Chavin de Huantar in the North Highlands where the main temple platform was found to be honeycombed with labyrinths on at least three levels. The best-known architecture is that of the ▽Inca, who constructed mighty fortresses. Sacsahuaman near ▽Cuzco has three ringed zig-zag defences with the basal stones measuring sometimes over 25 feet high. Mortar was not used, but perfect joints were made by carefully cutting and dressing each stone. Built thus and slightly tapered from base to top, they were strong enough to withstand the severe earthquakes of the region.

**Sculpture.** As with architecture, fine sculpture occurs from around 1000 BC with the Chavin culture. A great white granite monolith over 12 feet high was found at the centre of the temple mound at ▽Chavin de Huantar, at the crossing of the galleries. This 'Great Image' was carved intricately as a snarling fanged man-like being with hair of snake-heads and a girdle composed of serpent-jaguar heads – concepts all central to Chavin and other South American art-styles. Cornices were carved to represent condors with feline attributes or □bas-reliefs of felines with snake-like attributes. About the same time, at Cerro Sechin on the coast of Peru, temple walls are composed of monoliths elaborately carved with □reliefs of warriors and their dead or dis-membered captives, also a popular theme. Much later around AD 1200 at ▽Chanchan, a very different type of sculpture can be seen with the mud-plaster friezes on the temple walls, where entirely mythical creatures of dragon-like appearance were represented together with sea-birds and fishes, underlining the importance of the coastal economy here. In highland Bolivia on the shores of Lake Titicaca, ▽Tiahuanaco, centre of another great civilisation, displays competence in the execution of whole sculpture and carved reliefs with principal figures also representing snarling man-jaguar beings and condor-headed deities bearing staffs. Heavier whole stone figures of squat, slanting-eyed men are found nearby at Pucara.

**Ceramics.** Pottery manufacture was introduced about 1800 BC and later periods show great competence in this field. All visual forms were common and, the potter's wheel being unknown, were produced by hand or from moulds. The stirrup bottle and from this form, the whistl-ing jar, often decorated with life-like figures of humans and animals, were especially popular. Pottery provided the Pre-Columbian craftsman with one of his main art media and the consequent variety and vitality of form and decoration exemplify this. Around AD 400 the ▽Mochica of North Coastal Peru produced vast quan-tities of finely moulded pots, some in the likeness of local dignitaries, others showing the manifold daily pastimes

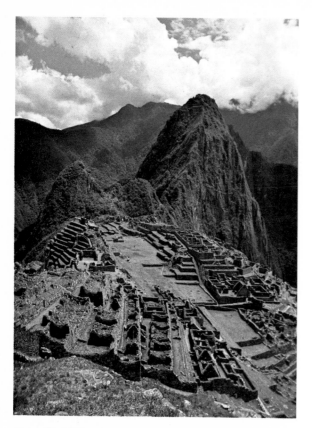

*Above:* Citadel, Macchu Picchu, Peru. Inca. 15th century

*Below:* Figure Pot. Mochica, Peru

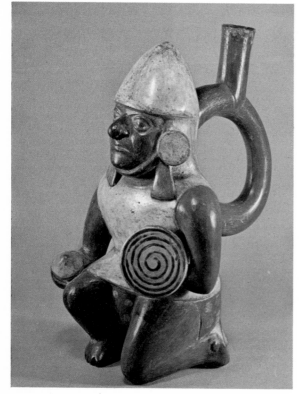

# South America: Andean and Coastal Kingdoms

and occupations of the people from weaving to making love. Painted scenes of battles, the parading of nobles and the punishment of naked prisoners were common. Some of the most beautiful pots were made on the South Coast of Peru in the Nazca Valley up to AD 600. Bowls, bridge and spout jars or figurine-urns were commonly decorated in bright burnished polychrome designs of life-like birds, fishes, animals and people. The Huari-▽Tiahuanaco culture similarly depended upon ceramics for the spread of its own bold and distinctive art style. Fanged beings with rayed sun-like head-dresses, snakes and eagles still abound. The ▽Incas decorated their pottery in mainly intricate geometric motifs. The *aryballus* – a large globular jar with pointed base and tall widely everted mouth – was a classic Inca form used for the storage and transport of water or the alcoholic beverage *chicha*.

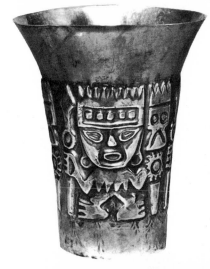

**Metalworking** appeared in general use around ▽Chavin times, by 900 BC, although the techniques known were limited to hammering, annealing, soldering and □re-poussé working of sheet gold and silver. By Mochica times, every technique was used including casting – simple and □cire perdue – alloying and gilding. By then, metal was used for utilitarian purposes in the production of weapons and agricultural tools as well as plate and jewellery. The ▽Chimu of North Coastal Peru were especially known for a high degree of competence in metallurgy, producing quantities of gold and silver figurines, ceremonial knives, tweezers, earspools, plate, bowls and beakers, many decorated with fine repoussé designs of gods, animals and mythical creatures. It was from them that the Incas and then the Spaniards acquired much of their wealth. At the Spanish Conquest (AD1519), South and Middle America were still technically in the ▽Bronze Age, having no knowledge of iron working.

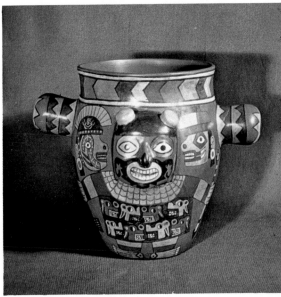

**Textiles.** The exceptionally arid conditions of coastal Peru, particularly in the south, account for the remarkable state of preservation of organic matter, especially cloth. In the Paracas Peninsula are the cemeteries of a culture whose artisans specialised in weaving intricate and complex designs of many rich colours in cotton and fine alpaca and llama wool, for themselves and for their lords. The Spaniards made comment on the exquisite fabrics they saw and noted that in Peru, techniques were more refined than in Europe – a fabric similar to silk being woven for exclusive wear by the ▽Inca Emperor from the wool of the wild vicuna. Every technique was known: tapestry-work, brocading, embroidery, double-cloth and open-works being the most favoured. Interlocking motifs of cat heads or double-headed serpents were also very popular. As with the decoration of pottery, textiles were often the medium for the transmission of cult ideas with heavy emphasis on designs representing deity forms. Some of the figures are realistic, but are more often highly stylised, conforming to the needs of the weaving technology, and the figures at times seem almost geometric in their execution.

*Top:* Gold beaker with raised design. Chimu, Peru. *About* 1000–1450. Royal Scottish Museum
*Above:* Polychrome pot. Nazca, Peru
*Below:* 'Gateway of the Sun' (detail) Tiahuanaco Lake Titicaca, Bolivia. *About* AD 100–600

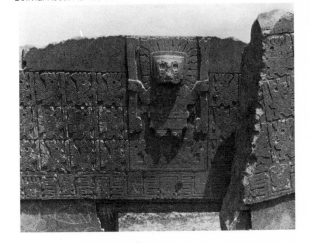

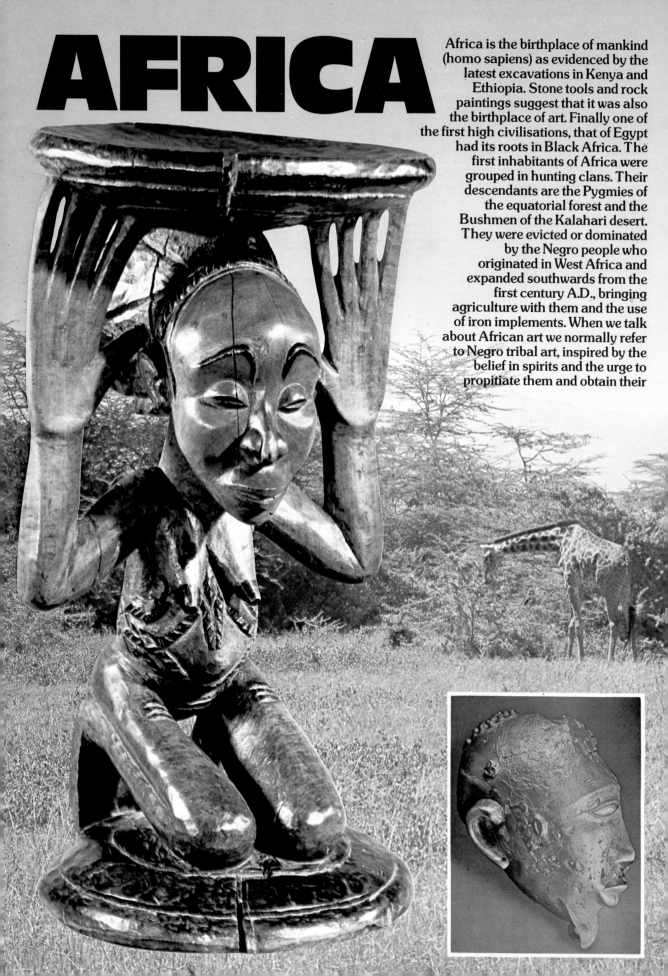

# AFRICA

Africa is the birthplace of mankind (homo sapiens) as evidenced by the latest excavations in Kenya and Ethiopia. Stone tools and rock paintings suggest that it was also the birthplace of art. Finally one of the first high civilisations, that of Egypt had its roots in Black Africa. The first inhabitants of Africa were grouped in hunting clans. Their descendants are the Pygmies of the equatorial forest and the Bushmen of the Kalahari desert. They were evicted or dominated by the Negro people who originated in West Africa and expanded southwards from the first century A.D., bringing agriculture with them and the use of iron implements. When we talk about African art we normally refer to Negro tribal art, inspired by the belief in spirits and the urge to propitiate them and obtain their

favour through the medium of statues and masks, with the help of music, mimicry and magic. This excludes the Islamic world of North Africa which shunned figurative representation. The two main centres of Negro art and culture were the catchment areas of the Niger river in the West, extending to the Guinea coast, and the basin of the congo river with its tributaries in the equatorial region. West Africa was populated by the tall Sudanese Negroes, whose culture goes back at least to the 3rd century B.C., witness the Nok terracottas. The Congo area was settled by the Bantus, also Negroes whose migrations to the South started in the first century A.D., from Southern Nigeria and came to a halt on the Fish river when the Zulu Bantus encountered the Dutch Boers on their northward expansion.

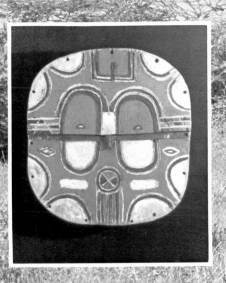

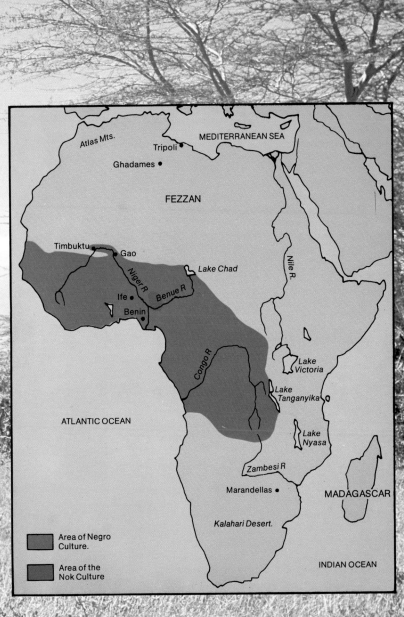

Atlas Mts.
MEDITERRANEAN SEA
Tripoli
Ghadames
FEZZAN
Nile R.
Timbuktu  Gao
Lake Chad
Niger R.
Benue R
Ife
Benin
Congo R.
Lake Victoria
Lake Tanganyika
ATLANTIC OCEAN
Lake Nyasa
Zambesi R
Marandellas
MADAGASCAR
Kalahari Desert.
INDIAN OCEAN

Area of Negro Culture.

Area of the Nok Culture

| −5000 | −4000 | −3000 | −2000 | −1000 | BC 0 AD | 1000 | 2000 |

**1482** Portuguese discover mouth of Congo, found trading settlements in West Africa.
**1487** Bartolomeu Dias discovers Cape of Good Hope.
**1497** Vasco da Gama sails round Cape of Good Hope, explores East Africa.
**1541** Vasco da Gama explores Abyssinia.
**1588** Africa Company given charter by Elizabeth I.

**1620** East Indian Company claims Table Bay.
**1650** Dutch colonise Cape.
**1770** Bruce explores source of Blue Nile.
**1788** African Association founded in London for anti-slavery and African exploration.
Sierra Leone founded by British for settlement by freed slaves.
**1795** Mungo Park explores Niger.
**1802** First recorded crossing of Africa from West to East.

**1814** Cape colony ceded to British.
**1832** City of Zanzibar founded.
**1843** Natal colony founded.
**1849** Livingstone travels.
**1855** Livingstone discovers and names Victoria Falls.
**1862** Speke discovers source of Nile.
**1869** Diamonds found in South Africa.
**1871** Zimbabwe ruins discovered.
**1880s** Scramble for Africa by European powers.

**1890** Rhodesia chartered.
**1897** Expedition and sack of Benin by British: Benin bronzes and regalia come to London.
**1900** Africa completely partitioned by European powers: only Ethiopia remains independent.
**1918** Africa repartitioned by France and Britain after defeat of Germany.
**1936** Italo-Abyssinian War: last war of European conquest in Africa.
**1960s** Gradual independence of ex-European colonies in Central Africa.

# AFRICA

**Tribal Society.** The Africans who escaped the influence of Islam did not practise the written word. They expressed themselves in music, dance, ballads and sculpture. Before the missionaries' arrival, woodcarving and story-telling were the African Bible. But the Africans did not intend simply to represent supernatural beings as did Europeans with the statues of saints. They believed that the God or ancestor spirit actually invested the carving, filling it with its power to help or destroy. The basic religious tenets were the same all over the Negro world. There existed a supreme God who created the world and was the source of energy, the vital force from which all life proceeds. But the creator is invisible, inaccessible and does not trouble himself with human problems. He has delegated his powers to secondary gods who act as intermediaries and manage the world, each one according to his or her special function. From them proceed even more specialised spirits controlling rain and wind, rivers, vegetation, crops, war, peace and so on. These were extensions of God's energy and it is through them that man hoped to influence the natural forces on which he depended. The carvings in which these spirits descended with the help of the appropriate ritual were seen as media through which men could approach them and obtain favour.

This also applied to the tribal ancestors who proceeded from the primeval couple set on earth by the gods. The Africans believed in an after-life; the souls of the ancestors departed for another world and it was essential for the tribe or the family to remain on good terms with them and to consult them over important issues. They embodied the principles of identity, cohesion and continuity in a cruel world where the individual left to himself would be lost and doomed. The ancestors dwelt in the carvings representing them. The clan ancestors were kept in caves or sacred groves, under the guard of the secret society; the figures of family forbears were kept at home.

Masks were worn on specific occasions (such as harvest festivals or initiation ceremonies) and were fitted with complex headgear and completed by robes or skirts; the heavy ones were carried on the shoulders. As soon as the mask-bearer donned his mask and robe, and stepped out to the sound of the appropriate music or song, he became the spirit he represented; he became war, justice or fertility; he became the ancestor or the symbolic animal, the evil spirit to be expelled or the good one to be coaxed into action. Statues and masks form the bulk of the artistic production of black Africa. The sacred figures or masks and the tribal ancestors were made by acknowledged and specialised wood-carvers who were often the blacksmiths-cum sorcerers. The ordinary masks, like those used for initiation, were often made by the bearer himself.

Some regions developed the art of bronze-casting (Nigeria); others worked with wrought iron (Dogon) or copper (Bakota). Superb objects in ivory were found in Benin and Zaire (Lega). The Ashanti specialised in goldwork, and all over the continent were to be found textile fabrics, the most beautiful woven in the West.

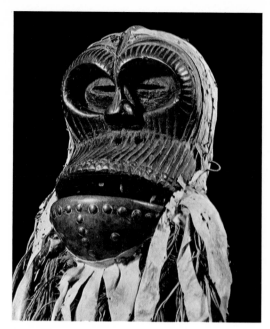

*Above:* Mask. Ngere tribe Ivory Coast. 14 in (36 cm)

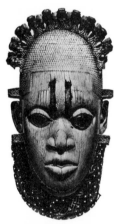

*Left:* Ivory pectoral mask. Benin. Early 16th century. BM, London

*Below:* Figure from an ancestral reliquary. Bakota. h. 19¼ in (49 cm). Musée de l'Homme, Paris

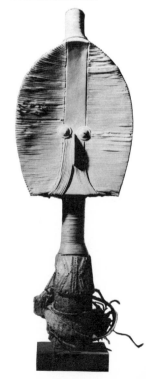

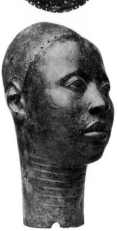

*Above:* Head of a man. Ife. *About* 11th century AD. Ife Museum, Nigeria

**Early African art.** The earliest instance of artistic expression is to be found among the Bushmen, the nomadic hunters and food-gatherers who preceded the Negro agriculturalists. It took the form of rock-paintings and engravings located in the Bushmen's hunting grounds, such as the Sahara (before it dried up in the 2nd millennium BC), the Nubian desert, East and South Africa. These paintings and engravings display a remarkable feeling for animal movement, as well as showing the protruding buttocks still to be seen among the Bushmen of the Kalahari desert. In the 5th century BC, the African Iron Age, appeared the first specimens we know of Negro art, the Nok □terracottas of northern Nigeria. There is an ▽Egyptian air about some of them; some influence from the Nile valley could have trickled in through the caravan routes; but there is no evidence.

The first fully developed Negro civilisation is associated with bronze and appeared in southern Nigeria, at Ife, the sacred city of the Yoruba races who still occupy the territory. The Ife creations in bronze or brass were cast according to the □*cire-perdue* (lost-wax) technique with an expertise equal to that of the craftsmen of China and Europe. Several of them represent the Oni, or King of Ife; they are busts or figures in the round, in a naturalistic manner, describing perfectly the facial type of the tall Sudanese. The Yoruba of Ife showed the same artistic feeling in their terracotta figures. In the 13th century the ancient kingdom of Benin, further south, asserted itself and annexed the Ife craftsmen. Bronze-casting was developed on a great scale at the Benin court, and went on until the 19th century. Most of the production consisted of royal portraits and symbols, but they also made reliefs which celebrated important events, for example the arrival of the Portuguese. The best works are those of the 15th and 16th centuries, as powerful in their expression as they are technically refined. The kingdom of Benin survived until 1897 when it was overthrown by a British punitive expedition. Two thousand bronzes were then brought to England where they were auctioned.

**Nigeria.** Wood does not survive for very long in the African climate. Few of the works we know go back beyond the 1850s. The artists of Nigeria belong to a variety of ethnic or cultural groups working in very different styles. The most numerous are the Yoruba, famous for their great masks of the *gelede* and *epa* societies; the latter are painted in bright colours and crowned by whole groups of figures. They are incarnations of ancestors. The *gelede* dance in pairs; the *epa* can weigh up to 50 kilos. The tradition is still alive and strong. In the south of the country live the industrious Ibos; their ancestors are represented by tall, stiff, post-shaped figures. The Ibos are also known for their white death masks. The Ibibio of the delta show extraordinary medicine masks representing the diseases to be exorcised, whilst the Ijos in the same area flaunt great rectangular hippopotamus masks, representing the spirit of the river. The Ekoi practise a naturalistic style and cover their carvings in painted leather.

Epa society mask. Yoruba. 52 in (130·5 cm). Museum of Ethnic Arts, UCLA

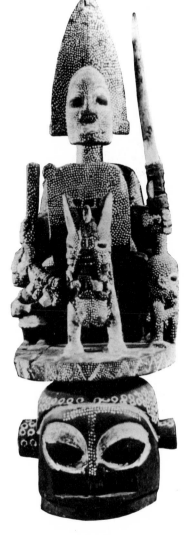

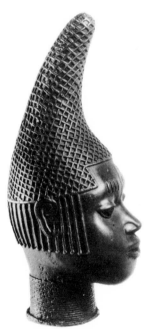

*Left:* Bronze head, Benin

# AFRICA

**The Coastal States.** Within the great loop of the Niger live tribal communities who developed a characteristic style of cubistic, tubular, angular sculpture which was to inspire the European artists of the early 20th century. The best known of them are the Dogon who dug themselves into a natural fortress protected by steep cliffs where they preserved their traditions from Muslim onslaughts. They evolved an elaborate cosmogony where god sent six hermaphrodite couples to organise the world. They were called *nommos*. The seventh *nommo* was the blacksmith, patron spirit of arts and crafts; descending to Earth in an ark he made a crash-landing and broke his limbs; thus were created the joints which allow men to work and dance.

The Bambara are the descendants of a warlike kingdom which dominated the area in the 17th and 18th centuries. They sculpture elongated figures with jutting breasts and make most elegant antelope masks, the *tyi-wara*, whose bearers dance in groups around the fields, by moonlight, to ensure a successful harvest. The Mossi and Bobo are also the offspring of powerful empires of the past and their sculpture beongs to the same so-called 'pole-style' group: spare, elongated, and very stylised. Further south towards the Ivory Coast are the Senufo; they were never a kingdom but a congregation of clans. They produced great black, burnished figures with powerful shoulders and jutting chins, resting on a cylindrical base; they are called *deblé* and were used by young men to pound the ground rhythmically during harvest dances. Further south are the Baule who emigrated from the Ashanti world of the Gold Coast; they carved actual portraits of their deceased parents and relatives, standing figures with heart-shaped faces, sculptured and patinated with supreme refinement and precision; they are recognisable by their elaborate hair styles, their scarifications and their polished surface. Their monkey-figures, embodying the spirit of justice, are as impressive as High Court Judges. These areas fell under the control of a military nation, the Ashanti in the 17th century. They concentrated on metalwork instead of wood and produced gold masks, jewellery and also bronze weights in the form of fantastic animals; these were used to weigh the gold dust. Their funerary □terracottas are elegant and lively.

Two contrasting strains are apparent in African sculpture, and in many places they exist side by side. One is naturalistic and the other is abstract or highly stylised, even when figurative. The first trend is represented by the ancient bronzes of Ife and Benin, the royal portraits of the Bamileke and of the Bakuba. It is associated with court art and is usually to be found in the 'empires' or royal federations. The second trend is connected with religious art and magic, when the carvings represent not portraits of individuals but spiritual concepts, as with the Dogon or the Bateke. This is particularly evident in masks all over Africa.

**Cameroon and Gabon.** South of Nigeria the hilly grasslands of Cameroon were dominated by warlike kingdoms of Sudanese origin, such as the formidable Bamileke, whose art is dynamic and expressionistic. Particularly striking are the mother and child groups, fertility symbols and the life-size twisting, gesticulating figures. Majestic royal statues were covered in blue, white and green beads. The thrones were of the same material. Some heads or masks, with thick lips and globular eyes, sheathed in copper, come from the same workshops. Contrasting with them are the highly stylised, striated masks of the Bacham, a sub-group. So we see all over Africa the two opposite types, one naturalistic and often forceful, the other stylised sometimes to the point of abstraction. Court art tends to adopt the first approach; there were many despotic kingdoms in Africa and they required royal portraits. Religious art tends to be allegorical; the dwelling-place of a spirit is a sacred object, a spiritual sign, defined by tradition. The Gabon country is partly Bantu; from it come the reliquaries of the Pangwe and the Bakota, boxes or *bieri*, filled with magical substance and bones of ancestors, and surmounted by a figure; amongst the Pangwe it is a human figure in the round, very dark, impregnated with oil, soot and sometimes blood; with changes of temperature the statue sweats and becomes sticky. For the Bakota it is a flattened wooden face covered with copper sheet, and very abstract. Remarkable also are the very long, white masks of the Fang which may have inspired ▽ Modigliani.

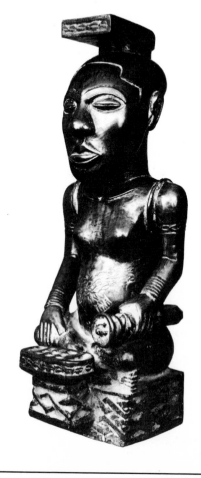

*Right: Effigy of King Shamba Bolongongo.* Bakuba. Said to be carved from life in the early 17th century. Wood. h. 24¼ in (54 cm). BM, London

302

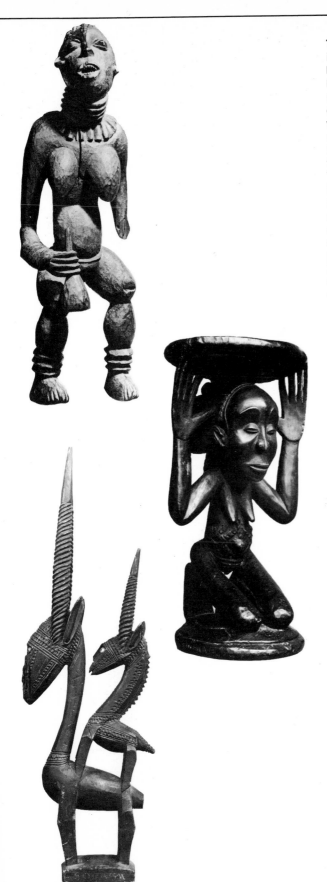

**The Congo.** Before Stanley sailed down the Congo river in 1877 the equatorial centre of Africa was unknown to Europe, except for the coastal fringe visited or settled by Portuguese traders. But it is a region with a history, peopled for centuries by the Bantu Negroes. Great empires flourished, such as the Bakuba of Lower Congo who could boast of a line of 124 kings, all known by their names; some of their dignified, massive, sitting effigies have survived. The Bakongo of the estuary were on good terms with the Portuguese, at least in the beginning. Their style is naturalistic, perhaps under European influence; it is recognisable by the jutting chins and thick lips. They were steeped in magic like all Congolese and made impressive nail fetishes of great size, as well as smaller mirror fetishes, full of magic matter, used sometimes for the good, sometimes for evil. Another great empire was that of the Baluba, in the south of Zaire. It goes back to the 15th century. The Baluba and their subjects produced many noble, standing figures with a dark, lustrous patina, coffee-bean eyes and a cruciform hairstyle. One of their most famous artists was the 'Master of Buli', whose female figures, often kneeling with bowl in hand, look half asleep, with heavy drooping eyelids and elongated hands.

We find every variety of style among the tribes of the vast equatorial forest, the warrior Azande with their porky-nosed masks, the long-headed Mangbetu, the abstract Teke, all in the North, the magic-haunted Basongye in the centre, whose signature is the figure-of-eight mouth; their colossal fetishes, covered in cloth, rags, metal, fur, hair and snakeskin are among the most powerful of all; equally haunting are their striped initiation masks, the *kifwebe*. The Basongye were famous not only for sorcery, but also for the beautifully sophisticated weaponry they made. Buried in the north-eastern forests, to escape the Arab slave-traders, live the elephant-hunting Lega whose little ivory figures of the Bwami society are amongst the most dynamically attractive products of the African genius. The Bantus colonised Angola on the border of which reigned the Tshokwe (or Bajokwe), whose furniture is unique in Africa, as well as their whistles and vigorous, contorted, bearded black figures with great curving headdresses.

Further south we do not meet with the same wealth of art, except for the monumental medieval ruins of ▽ Zimbabwe. Eastwards the Bantus reached the Great Lakes where they clashed with the pastoral, warrior tribes of Hamitic stock, descended from the North (Tutsi and Masai), who, like all pastoralists, are not interested in carving. Further east and south-east lies the world explored by Livingstone and decimated by the Arab slave-traders who played in the East and Centre the same destructive role that the Europeans had in West Africa before the days of the English Wilberforce and the anti-slavery campaign.

*Top:* Figure of a dancing woman. Bamileke, sub-tribe Bangwa. Wood. h. 33 in (84 cm). Mr and Mrs Harry Franklin Coll, Beverley Hills
*Centre:* Baluba stool carved by the Master of Buli. Late 19th century. Wood. h. 20½ in (52 cm). BM, London
*Left:* Bambara *Tyi-wara* headdress representing the mythical antelopes who taught people agriculture. BM, London

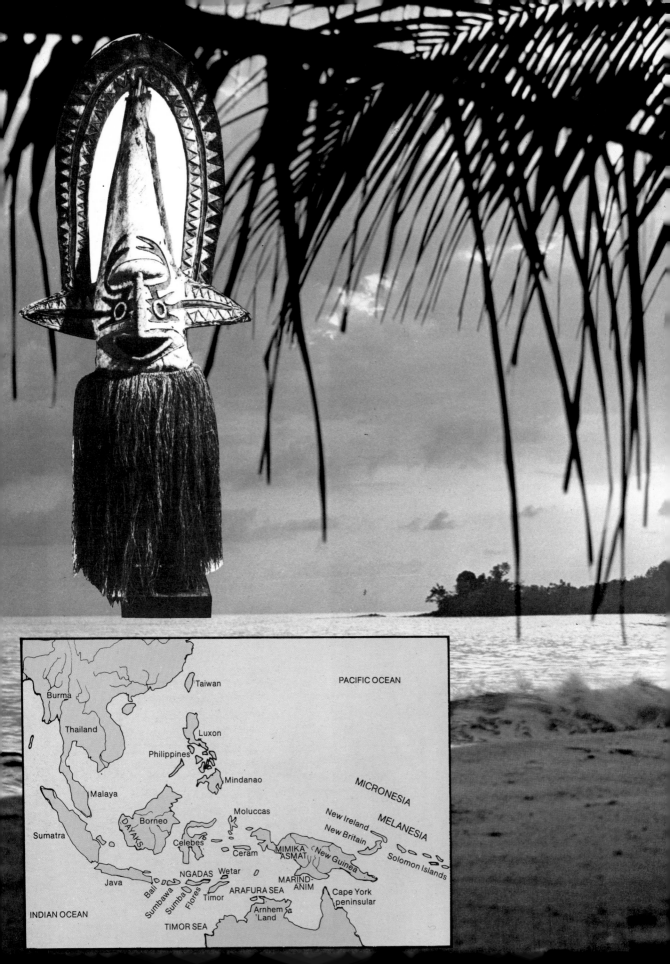

PACIFIC OCEAN

Taiwan

Burma

Thailand

Luxon

Philippines

Mindanao

MICRONESIA

Malaya

Moluccas

New Ireland

MELANESIA

Borneo

New Britain

DAYAKS

Celebes

Ceram

MIMIKA

New Guinea

Solomon Islands

Sumatra

ASMAT

Java

NGADAS    Wetar

MARIND-

Bali        Sumba   Flores   Timor    ANIM    Cape York

Sumbawa                    ARAFURA SEA         peninsular

Arnhem

'Land

INDIAN OCEAN

TIMOR SEA

**3500BC** Sea-going migrations of Neolithic peoples to New Guinea and Melanesia.
**1500-700BC** Neolithic light-skinned migrants from Asia.
**500 BC-AD 300** Migrations by 'Austronesians'.

**AD 1000** New Zealand settled by Polynesians.
No metals known or worked in Oceania before arrival of Europeans.

**1520** Magellan enters Pacific Ocean and names it.
**1567** Voyages of Mendana (Portuguese).
**1578** Francis Drake's voyages of exploration.

**1642** Abel Tasman discovers Australia and New Zealand.
**1768** James Cook's voyages of discovery to Tahiti, etc.
**1770** Cook reaches Australia and claims coastal region for Britain.

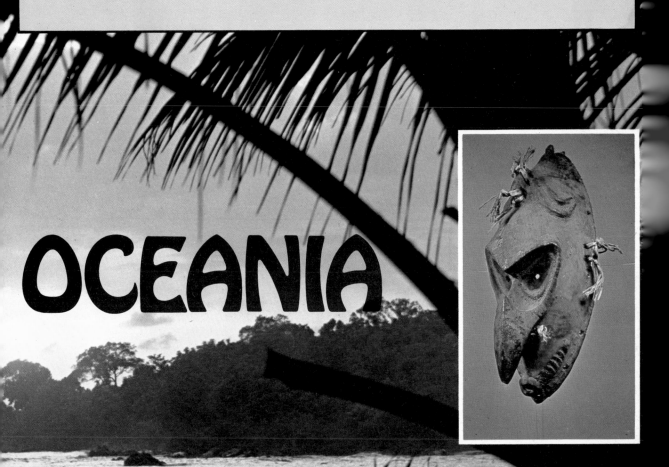

# OCEANIA

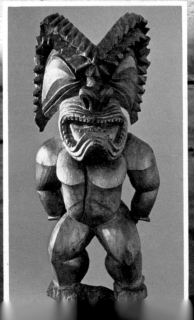

Australia and the islands of the South Pacific were peopled by dark-skinned refugees or emigrants from the Asian mainland. The migrations succeeded each other from 8000 BC. (Australia) to the beginnings of our era (Polynesia) and they involved a variety of ethnic groups. Over the centuries the settlers developed specific cultures grouped into three main families: the Australians, the Melanesians (New Guinea and the outlying islands) and the Polynesians (the archipelagoes of the South Pacific). They were cut off from the rest of the world until the arrival on the scene of Captain James Cook in 1769; he was the first to chart scientifically the South Seas and the descriptions he brought back of handsome, friendly and free-loving Polynesians contributed greatly to the myth of the good and happy savage. Artistically speaking it is the sur-realists who put the Melanesian culture on the map; they found in its sculpture an inspiration for their macabre and sexual fantasies; they were also fascinated by the apparent freedom displayed in the treatment of form and the choice of materials. It was a dream-world, the world of sur-reality.

# OCEANIA

**Australia.** Australian migrants followed on the heels of the Tasmanians (now extinct) and were established all over the continent in 4000 BC. They were small, dark-skinned people, with fuzzy hair. They were and remained a nomadic people, hunters and food-gatherers. Previous to European colonisation in the 19th century they lived undisturbed, and isolated from foreign influences. They are still, in their territories, our best living example of a Stone Age culture. They possessed an equipment of extreme simplicity adapted to the conditions of life in a country of withering aridity except for the coastal belt. They travelled light, carrying only spears, shields, boomerangs and wooden dishes. Carvings were very rare. Their rich mythology incorporated their beliefs concerning the origin of the world and the workings of nature. They illustrated this in painting, in sacred caves, and also, in abstract forms of great subtlety, on shields, on bark and even on the body. It is in the Northwestern desert that the most interesting rock-paintings are to be found, depicting the moon-faced *Wandjinas*, (who lived in water-holes), the *Mimis* or 'little men' and other spirits. They were renewed every year at the end of the dry season, in order to ensure that the rains would not fail. Most notable also are the 'X-ray' paintings showing the internal organs of animals and men. Hunting scenes with magical purposes are to be found; they are similar to those found in Africa. Rock engravings are scattered about the country as well as magic stencillings of hands and feet.

**Melanesia.** The centre of Melanesian culture is the huge island of New Guinea, with a motley population of about three million, speaking more than seven hundred languages, cut off from each other by high mountains and swamps. The majority belonged to the Papuan group; they were addicted to ritual cannibalism and head-hunting. They probably go back to the 3rd millennium BC and belong to what is called the culture of the round adze as opposed to the later one of the square adze (Austronesians and Polynesians).

The richest area of artistic creation is the valley of the Sepik river, 700 miles long, with its many tributaries. It contains a variety of tribes, each of which has its individual style. Few of the objects that survive can be earlier than the 1880s when they were carved with stone adzes. They consist mainly of dance masks, war shields, ancestor figures or representations of spirits, brightly painted and sumptuously adorned with wild berries, cowrie shells, boars' tusks and the feathers of parakeet, cassowary and paradise bird. These carvings reveal an outstanding sense of decoration and a most powerful imagination. Their variety is infinite, but there is a predilection for hooks, spirals and concentric circles in the patterns of decoration.

Next to the Sepik region we must mention the Abelam hill tribes and their tricolour figures with stalactite and stalagmite design and T-shaped faces. The Gulf of Papua in the south shows ancestor boards and skull-racks with a chevron and triangle decoration. The Asmat people live in the vast swamps of the south-west; they worship the sago-tree, feed on its pith and carve it into colossal ancestor phallic poles called *bis*; the favourite symbols used in their painted, grooved-in

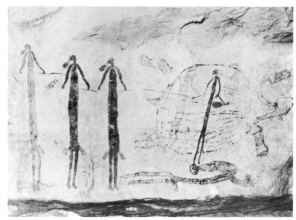

*Above:* Hunting Scene. Aboriginal. Australia

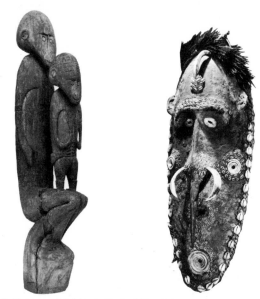

*Left: Mother and Child,* Lake Sentani, New Guinea. h. 36¼ in (92 cm). Museum für Volkerkunde, Basle
*Right:* Face mask, Sepik River, New Guinea. h. 18 in (45·7 cm). City of Liverpool Museums

decoration are the praying mantis and the flying fox, symbols of head-hunting. Out of Lake Sentani on the northern coast were fished impressive figures in the round, representing mother-and-child and ancestors or animals. The Trobrianders produced refined, ebony-like lime-spatulas, to take lime with the acid betel nut they were in the habit of chewing as a stimulant, for it is an absolute law in all tribal societies that every object of art has a precise purpose and function, either religious or practical, generally both. There is no art for art's sake.

But Melanesian culture does not stop at New Guinea. It includes a string of islands extending for thousands of miles from New Britain and the New Hebrides, with their fantastic festival masks, dear to the ▽ Surrealists, through New-Ireland (open-work wood carvings) and the Solomon Islands (black burnished wood sculptures with mother-of-pearl inlays, sometimes in a naturalistic manner) down to New Caledonia. Theirs is no Melanesian style, as can be seen, but a congregation of styles.

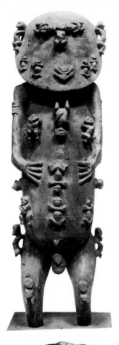

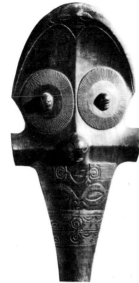

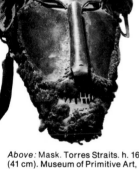

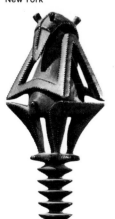

**Polynesia.** 'Polynesia' (the many islands) was a name invented in the 18th century to designate the innumerable archipelagoes of volcanoes and coral atolls scattered about the South Pacific within an equilateral triangle the sides of which measure 5000 miles each, with the apex on Hawaii and the base extending from New Zealand to Easter Island. The Polynesians left Asia from 1000 BC onwards under the pressure of the yellow or Mongaloid races.

There is a common language all over the South Pacific, as Captain Cook discovered to his surprise. Seafarers, like the Vikings, they designed ocean-going double-hull sailing boats which outpaced the 18th-century ships of Europe; and they acquired a precise knowledge of navigation, star-reading and meteorology. Life was regulated, as in Melanesian belief, by a positive force or vital energy of supernatural origin, called *mana*, and a negative force, of interdiction and inhibition, called *tapu* (taboo). The artists or craftsmen had a considerable share of *mana*, what we would call 'genius'; they were closely connected with the priestly class, itself part of the aristocracy; in some places they were members of a hereditary group. They had the monopoly of religious carving and of canoe-building and they went about both activities with the greatest care and professional competence, after a prolonged initiation and with the seriousness of a sacred function, singing and praying as they worked.

All this helps to explain the quality and refinement of the little that remains of Polynesian art. It is not an exaggeration to say that the Polynesians were among the greatest woodcarvers of all time. They selected their material with the utmost care, and the quality of the wood was such that they did not feel the need to paint it; at most they decorated it with light incisions (Austral Islands) or tattoo-like patterns (Maoris) or facets (Hawaii). Every island had its own style, immediately recognisable. The subjects carved were the gods, the culture heroes, spirits such as the fishermen's god or the spirit of the sea or the powerfully stylised lizards and birds of Easter Island. Their art is always marked by restraint and elegance. They also carved figurines in ivory from walrus tusks or out of whalebone or nephrite (Maoris). Only a few stone sculptures remain: the basalt *tikis* of the Marquesas and, more famous, the colossal statues standing around the shrines of Easter Island.

The Polynesians did not practise the art of pottery and weaving but they produced powerfully beautiful fabrics with abstract patterns made out of the inner bark of the mulberry tree, called *tapa* (Samoa and Hawaii). The Hawaiians made gorgeous cloaks, helmets and even figures with red and yellow feathers. Finally, all over the Polynesian world were produced headrests, stools, bowls and other household utensils, not to speak of weapons, staffs and clubs, the design of which rivals in elegance and functional simplicity the finest creations of the ▽ Bauhaus.

# Key to Charts

**1** Interior of cave at Lascaux, France. Paintings of cattle, 15,000–10,000 BC
**2** Venus figurine found at Willendorf, Austria, 30,000–25,000 BC

**The Stone Ages**

**1** Yi Chong print of Bamboo, end of 16th century
**2** Honan pottery vessel, Sung Dynasty

**China**

**1** Beehive dwellings: Syria
**2** Stonehenge, England, 1900–1600 BC
**3** Ctesiphon, Iraq. Ruins of brick vaulted Banqueting Hall and Palace, Sassanian, 3rd century

**From Caves to Cities**

**1 & 2** Relief sculptures from Bhubaneshwar, c 12th century

**India**

**1** A view of Pyramids, Egypt
**2** Narmer palette, King smiting an enemy, 1st Dynasty
**3** Tutankhamun: Tomb mask, 18th Dynasty

**Egypt**

**1** Screen, Irises, late 17th–early 18th century. Netzu Art Museum, Tokyo
**2** Haniwa tomb figure 3rd–6th century
**3** Unkei: *The Patriarch Mujaku* Kamakura period 1208
**4** House at Nara (traditional form)

**Japan**

**1** Aerial view of Knossos
**2** Faience figurine (snake goddess) from Knossos, c 1600 BC
**3** Octopus decoration. Wine jar from Knossos

**The Aegean Civilization**

**1** Saint Apollinare in classe: the Apse showing mosaic of Christ the Shepherd, 5th century
**2** Sarcophagus of Adelphia, 4th century

**Early Christian and Byzantine Society**

**1** View of the Acropolis, Athens
**2** Kouros figure, 6th century BC. Athens National Museum
**3** Venus de Milo (Hellenistic), 4th century BC. Louvre

**Greece**

**1** View of Kremlin Buildings
**2** Icon: St. Basil and Artemy Verkolsky, early 17th century. Strogonov School
**3** Wooden church at Kizhi
**4** Church of St. George, Uksovichi. 1493 (oldest wooden church in North Russia)

**Russia**

**1** The Roman Forum
**2** Roman Imperial Coin (Hadrian), 2nd century
**3** Roman Imperial Coin (Claudius), 1st century
**4** The Capitoline Wolf suckling Romulus and Remus, 6th or 5th century BC

**Rome**

**1** Isfahan, Masjid: Shah Mosque, Safavid period 1612 AD
**2** Mosque lamp (glass) from Mosque of Sultan Hassan, 1363 AD
**3** Buchara, Madrassa Miri-Arab, 1535–6

**The World of Islam**

**1** Norse Helmet found at Vendel, Sweden, 7th century
**2** Belt shrine Ireland *c* 700 AD
**3** Genesis Scenes Moutier Grandval Bible (BM Add MS 105 46 Fol 5v)
**4** Head of Sea Monster: from ship, pre-Viking

**The Dark Ages**

**1** Segovia, Spain: the Alcazar, begun 11th century, mainly 15th century
**2** Chartres cathedral, *La Belle Verriere* window, 12th and 13th century (see page 128)

**The Medieval World**

**1** View of Florence with the Cathedral (Duomo)
**2** Michelangelo *David* 1504
**3** Venice, Palazzo Pisani, 15th century
**4** Leonardo da Vinci *Mona Lisa* (*La Gioconda*), *c* 1500

**The Italian Renaissance**

**1** De Bry: Map of the Western Hemisphere 1594
**2** Hans Holbein *Henry VIII*, *c* 1536. Thyssen collection
**3** Martin Droeshout: William Shakespeare. N.P.G.
**4** Jean Clouet *Francis I*, *c* 1527. Louvre

**15th & 16th Centuries Outside Italy**

**1** Mansart Versailles, Salon de la Paix
**2** J. Harwood Commemorative Bust of Oliver Cromwell, 1759
**3** Velasquez *Philip IV*, *c* 1635. Prado

**17th Century in Europe**

**1** Zimmermann Die Wieskirche, pilgrimage church, Bavaria, 1746–57
**2** Robert Adam Osterley Park near London: Dining Room, 1767
**3** Harrison's No. 4 Chronometer, 1759

**18th Century in Europe**

**1** The Old School House, Tucson, Arizona, mid-19th century

**North America**

**1** Paris: Eiffel Tower, 1889
Portrait engravings of
**2** Emperor Franz Joseph of Austria, **3** Queen Victoria, **4** Bismarck and **5** Garibaldi

**19th Century in Europe**

**1** Rocket lift-off

**The Modern World**

**1** Decorated woven blanket
**2** Feathered headdress, 19th century. B.M.
**3** Wooden Horse effigy, Sioux, 19th century
**4** Group of Baskets: Chemehuevi, Yokuts, Coiled, Mono, Modoc, Pomo

**The North American Indian**

**1** Mexico: Temple of the Magician. Uxmal
**2** Skull mask: stone inlay and mosaic. Mexican, *c* 15th century
**3** Funerary urn, Zapotec, Mexico, *c* 500 AD

**Pre-Columbian Civilisations**

**1** African view with Mount Kilimanjaro
**2** Sculptured stool of tribal chief. Bouli
**3** Ashanti Gold Head. Wallace Collection
**4** Bateke Mask

**Africa**

**1** View of islands, S. Pacific
**2** Helmet mask, Gulf of Papua
**3** Temple image, Hawaii

**Oceania**

# Glossary

**Abstract Art:** Non-naturalistic painting and sculpture in which the shapes, two and three dimensional, or line tone and colour, become more important in their own right than the subject matter or the objects represented. There are degrees of abstraction ranging from simplification and stylisation that still leaves a subject identifiable to a complete non-figurative and self-sufficient abstract art.

**Abstraction:** *See* Abstract Art.

**Aerial perspective:** Atmospheric perspective, distance implied in painting by changing tone and colour. Distant colours are paler and cooler, tending towards blue and violet grey, and objects are not so clearly defined, approximating to what we see in nature.

**Aggregate:** Solid matter added to cement to make concrete: may be coarse or fine: pebbles, crushed stone or brick.

**All' antica:** Literally in an antique manner, particularly applied to any form of Classical revival.

**Ambulatory:** A semi-circular or polygonal aisle round an apse or the end of a church, enclosing the high altar or sanctuary.

**Animaliers:** A group of sculptors, mostly French, of the middle to late 19th century who worked in bronze and specialised in studies of animals in action.

**Anthropomorphic:** The attribution of human characteristics to non-human animal life and plant life, to inanimate nature and to man-made objects and works of art.

**Apse:** Roman in origin. A half-circular end to a hall, or an opening off a hall, with a half-domed vault. *See* page 83.

**Apsidal:** Adjective meaning in the form of an apse.

**Arabesque:** Surface decoration composed of flowing lines, covering the ground with an elaborate network of tracery. Essentially plant forms, not animal forms were used. Popularly named after Islamic origins.

**Baluster:** A pillar, often turned or carved in the form of an elongated vase or short column to support a rail: the railing being known as a balustrade.

**Balustrade:** *See* Baluster.

**Baptistery:** Part of a church, or a detached building in a church complex reserved for baptismal rites. Since the font is the centre of the ceremony a baptistery would be of a central plan.

**Baroque:** A term of disputed origin that first meant 'deformed' or 'distorted', or 'imperfect'. Used to describe art and architecture of the 17th and 18th centuries which broke classical rules in order to intensify the emotional content of the work in order to produce a corresponding response in the spectator.

**Barrel vault:** Also called tunnel vault or wagon vault: is the simplest form of vault consisting of a continuous, unbroken arched-over roof, either semicircular or pointed in cross section.

**Bar Tracery:** *See* Tracery.

**Basilica:** Originally a large hall with symmetrical side aisles used by the Romans for public administration. Used as the basic plan for non-centrally planned Christian churches.

**Bas relief:** Low relief sculpture that only slightly projects from background slab. Nearest of all sculpture to painting in form.

**Bay:** A single vaulted or arched compartment in a building, the whole of which is composed of multiples of such bays.

**Book of Hours:** A devotional book for private use based on the Christian church calendar. Often richly decorated and illustrated. *See* page 135.

**Buttress:** A massive support projecting from or built against a wall to strengthen it. A flying buttress is an arch or part of an arch which transfers thrust on to a buttress. *See* page 122.

**Calligraphy:** Formal script, Roman or Oriental, written with a pen or brush. The derived adjective calligraphic is used to describe a free flowing, cursive style in painting or drawing.

**Cameo:** A miniature relief carved in a layered or banded material such as agate, shell or a glass 'sandwich' which gradually exposes the successive contrasting layers, so that the subject is of one colour on the background of another. The technique was largely used in gem working. The word cameo is also used to describe anything 'miniature'.

**Camera:** An optical instrument that enables an image to be fixed chemically on film and then reproduced.

**Camera lucida:** A more compact device than the camera obscura that uses a prism. Enables the artist to trace his subject on to a flat surface.

**Camera obscura:** An optical instrument of lenses and mirrors that projects the image of the subject on to a surface where it can be traced by the artist. It can be the size of a dark room or a small portable box. In use from the 16th century.

**Canopies:** A canopy is an umbrella-like shelter or shield supported or suspended over a religious or secular monument such as a throne, altar or tomb. Canopies are used as a mark of special distinction all over Europe and Asia.

**Cantilever, Cantilevered:** A horizontal projection (a beam, canopy or balcony) with one end unsupported, the other held by some sort of downward force or counterweight.

**Capital:** The enlarged head of a column.

**Caravanserai:** A stopping place for caravans and travellers with accommodation built round a large courtyard, made secure with walls and gates. Sometimes they were extremely large. Found in Islamic countries.

**Cartouche:** A framed ornamental panel bearing an inscription or a symbol.

**Caryatids:** An architectural column sculptured in the form of a human figure.

**Casting:** The process whereby a clay or wax model is reproduced in metal. A mould has to be made from the original in damp sand or clay or plaster; the core or model is removed and molten metal is poured in. *See also* Cire perdue.

**Chased:** Raised or indented designs produced on metal surfaces by steel tools or punches.

**Chiaroscuro:** A heightened or exaggerated system of light and shade in painting, often similar in effect to a spot lit scene in the theatre. *See* page 182. (Caravaggio, etc.).

**Chip carving:** A jewellers' and metal-workers' technique of the post-Roman period in Northern Europe in which forms and patterns are carved out in tiny chamfer-like cuts.

**Cire perdue:** French for 'lost wax'; a casting technique in which the model is made of wax or carved in wax and encased in a shell of clay. When the shell is set molten metal is poured in. The wax melts and runs out, and metal takes its place. When it cools the outer mould is chipped away. The wax models may themselves be cast from an original master.

**Classical:** Art and architecture based on the principles of Greek and Roman art and design. The word implies an accepted authority of rules of style. It also describes attempts to revive these rules and principles

**Clearstorey: clerestory:** The upper stage of a great hall such as a basilica or church pierced by windows to increase daylight.

**Cloisonné:** French *cloison:* partition or wall. A technique for enamelling whereby the design is made with thin ribbons of metal which form fences or enclosures which are filled with enamel colours. The separations show as metal outlines.

**Codex:** Originally meaning a set of rules or laws, a codex is a manuscript in continuous scroll form.

**Coffering:** Decoration of a ceiling, dome or vault by regular sunken square or polygonal panels, sometimes used functionally to relieve the dead weight of a structure.

**Colossus:** pl. **colossi:** Giant larger-than-life size sculptured figures used for theatrical effect in architecture or architectural settings.

**Concrete:** An artifical stone made by mixing cement with aggregate, sand and water. Roman cement was made from natural volcanic limestone. Man-made cement was invented in 1824.

**Condottiere:** A mercenary, or soldier of fortune in the service of Italian city states or princes of the Renaissance. *See* page 145 (Donatello).

**Corbel-vaulting:** Is made by a series of projecting blocks each one built out beyond the lower and held together by the weight of the mass; from below looking like an inverted flight of steps.

**Cornice:** The top projecting section, sometimes moulded and ornamented, along the top of a building, wall, pediment, arch, etc.

**Crocket:** Decorative knobs of stone projecting at regular intervals on the angles of spires, pinnacles, and arches in Gothic architecture. They are usually carved as leaf shapes and foliage.

**Cuneiform:** A system of writing with a stylus on tablets of damp clay which were afterwards dried or baked. The writing developed in Mesopotamia from pictographs (late 4th millennium) to wedge-shaped characters. It was used for 3000 years. *See* page 26.

**Cupola:** A dome, especially a small dome on a pavilion, a turret or tower, or sometimes over a 'lantern' or top light on a larger dome.

**Cusp:** A projecting point formed by the intersection of curves and circles, particularly applied to Gothic arches and tracery, but also found in Islamic architecture.

**Cylinder seal:** A small, stone cylinder, carved with a design which forms a frieze when the seal is rolled out on a clay tablet or jar stopper. Developed in Mesopotamia and used wherever cuneiform writing was used. *See* page 26.

**Diaper:** An all-over surface decoration in a simple repeat pattern of squares or diamonds.

**Diptych:** Paintings or relief sculpture, generally an altarpiece or other devotional work, in two panels.

**Embossed:** Strictly speaking, an embossed pattern or design is a raised impression on metal, leather, paper, textiles or other sheet materials produced by stamping with an engraved die or plate, although raised patterns made by other means are also commonly called embossed.

**Engraving:** The working of a design into a flat surface of metal or wood, particularly so that a series of prints can be made of the artist's work.
**Relief:** The background material is cut away leaving the design to be printed free standing. This includes wood cuts, wood engravings and lino cuts. Wood cuts are made in the side or plank of a block. Wood engravings are made in the end grain of a block. A separate block is made for each colour to be printed.
**Intaglio:** The design is cut or etched into a metal plate. Ink is held in the line, not on the polished plate, and printing is made under great pressure.
**Line engraving:** The design is cut into the metal plate with a sharp steel tool to make a V section cut.
**Dry point:** The design is scratched onto the plate with a steel point or stylus. The print is made from the burred edge of the furrow.
**Etching:** The metal plate is covered with an acid-resisting coat (ground). The design is scratched through the coat with a needle. The plate is then immersed in an acid which eats into the exposed metal. The etched metal is the part that prints. The process is carried out in repetitive stages to arrive at the right range of depth.
**Aquatint:** Is a form of etching made on a porous ground that will print a half tone texture.
**Mezzotint:** The plate is worked all over with a tool that covers the plate with dots. The consequent raised burrs are carefully scraped off. Printing is made from the remaining burrs. The process gives a smooth gradation of light and shade.
**Stipple engraving:** Is a form of etching. The prepared plate (ground) is worked on with a textured tool that produces a grained effect.

**Equestrian:** A figure sculpted or painted mounted on horseback. *See* page 145.

**Erotic:** Appertaining to Eros, the god of love. Art that is explicitly or implicitly sexually stimulating, but not pornographic.

**Façade:** The main front wall or face of a building.

**Faience:** Fine-glazed earthenware; either in pottery, plaques or tiles; originally named after Faenza, the Italian town where the process was developed. Recently, the term is also used to refer to Egyptian glass beads.

**Fan vault:** Consists of concave cones which spring from the tops of pillars or walls to meet at the centre of a vault. The cones are decorated with tracery, often outlining panels.

**Festoons:** Imitation carved garlands of fruit, flowers and foliage used in architectural decoration. *See* page 175.

**Finial:** A sculptured ornamental top to a spire, gable or pinnacle in Gothic architecture. *See* page 127.

**Foreshortening:** Exaggerated perspective applied to single figures or objects.

**Form:** The external shape, appearance or configuration of an object or a work of art, as against the content. Thus a work may contain excellent ideas and intentions in its matter or content, but the manner of arrangement or competence in execution – the form – may be bad.

**Formal:** A work carried out within a recognised canon of form within the style or language of its own time and place.

**Frame:** In architecture and building a form of construction in which the main structure is a cage-like frame filled in or clad with panels which do not actually have any function as supports; frame buildings range from simple wooden domestic structures with infils of brick or plaster to vast modern buildings framed with steel or reinforced concrete and clad with non-structural materials such as glass.

**Fresco:** True fresco is painted on wet lime plaster using pigment ground in lime water. The plaster sets, and the colour is locked behind the crystalline surface of the plaster. Fresco painting has to be carried out rapidly, and allows for no overpainting, correction or alteration. Each section of a large work has to be carefully planned. Fresco paintings deteriorate quickly in a damp climate such as that of Northern Europe. *See* page 151.

**Fret:** A regular geometrical repeating ornament of intersecting straight lines.

**Frit:** A recipe for a pottery glaze using a glazing material such as flint or silica sand that has already been fired, and is then ground up again and used as a glaze. In Egypt sand was fired to make a coarse glass, which was then crushed, mixed with clay and refired into glass beads to imitate turquoise or lapis lazuli.

**Genre:** French for 'sort', 'variety' or 'type'. A category of painting that takes its subject matter from scenes of everyday life as against heroic, mythical, historical or religious subjects. *See* page 193.

**Grand Manner:** Painting and sculpture of the High Renaissance that exalted man in a heroic, idealised manner. The Grand Manner was the style of the Academies in the service of the state. *See* pages 186–7.

**Grisaille:** French for 'gray'. A monochrome: painting in shades of grey, sometimes imitating relief sculpture. *See* page 198.

**Groin vault:** Has strong diagonal lines produced by the crossing intersection of two barrel vaults, either round arched or pointed. The groins are the diagonal lines of intersection.

**Grotesques:** A form of decoration using graceful scroll-like forms combining fantastic human, animal and foliate shapes. This form of decoration was used originally by the Romans, and when first found by excavators in the buried rooms these were misguidedly thought to be 'grottoes'.

# Glossary

**Hieroglyph:** The form of stylised picture writing developed by the ancient Egyptians. *See* page 34.

**Historicism:** The use of past styles in art and architecture.

**History painting:** The use of scenes and subjects from ancient history, mythology or biblical history to symbolise ideals and passions. Contemporary history was excluded.

**Humanism:** Man-centred philosophy focused on the reality of this world rather than speculating on the next.

**Icon:** Greek for 'image'; originally limited to highly conventional paintings of Christ, the saints, and incidents from their lives, particularly in the Orthodox Church. Lately it has become critics' jargon for any kind of image in art. *See* page 94.

**Iconography:** The analytical study of the material forms of works of art.

**Iconology:** The analytical study of the content of works of art.

**Ideograph:** A form of written symbols or characters which represent ideas and objects, not sounds, as in Egyptian hieroglyphs or Chinese characters.

**Illuminated Manuscript:** *See* Manuscript.

**Illusionist painting:** A form of architectural decoration which apparently extends the building into space by means of false architecture and scenes beyond, making full use of the imitation of materials, perspective and foreshortening, light and colour.

**Interlacing:** Intricate linear knotted patterns carved in wood and stone and used in metal work, jewellery and book decoration of Celtic origin. *See* page 113.

**International Gothic:** A hybrid style of painting and sculpture that appeared in Europe in the 14th century, combining the new realism of the Renaissance in treatment of individual details, with the antiquated Gothic principles of composition and space.

**Iwan:** A large, vaulted audience hall, open at one end, found in Persia from Parthian times onwards. It became a feature of Islamic architecture. *See* pages 98–9.

**Jamb:** The upright side of an archway, doorway or window opening.

**Lancet:** A slender pointed arch window. *See* page 127.

**Lierne vault:** Liernes are ribs additional to those which occur naturally at the intersection of a vault.

**Limner:** An archaic name for a painter of portrait miniatures.

**Linear:** Line-like, either in painting with a clarity of outline and no atmospheric blurring of boundaries; or a drawing with clear outline and little or no shading.

**Lintol: Lintel:** A horizontal beam of wood or stone bridging an opening. *See* pages 38–9.

**Lithography:** A printing process which uses greasy chalk or ink on stone. When the stone is damp, printing ink can be rolled on to the drawing but is repelled by the unmarked stone. The print reproduces all the texture of the penline or grain of the chalk. The process dates from the early 19th century.

**Loggia:** A pillared gallery with an open side such as a porch or arcade.

**Madrasah:** An Islamic theological college.

**Mandala:** A magic circle or ellipse which is often used as the frame or container of religious images; found in Christian and Eastern art.

**Mannerism:** The name given to a sometimes artifical, sophisticated style of art that developed as an emotional reaction to the classical rules of the Renaissance. *See* pages 154–5.

**Manuscript:** A book written by hand: an illuminated manuscript is such a book decorated and illustrated. Often written Ms. *See* page 135.

**Mausoleum:** The monumental tomb of King Mausolus; it became known as one of the seven wonders of the world and its name became generic for any grand tomb or funeral monument. *See* page 84.

**Mihrab:** A niche in the *qibla* wall of a mosque to serve as a focal point for prayer and to mark the direction of Mecca. *See* page 104.

**Miletus:** An ancient seaport town of Asia Minor and the most important city of the Greek Ionian colonies.

**Mille-fiori:** Italian for 'many flowered'. A technique in which bundles of coloured glass rods are fused together, drawn out very fine, and then sliced into 'flowers' to be used in decorative glass and mosaic.

**Minaret:** A watchtower attached to a mosque from which a watchman would announce the prayer times prescribed by Islam.

**Minbar:** A high pulpit, reached by a flight of steps in a mosque. *See* page 104.

**Mosaic:** A decorative covering for walls, vaults, floors and panels made up of small coloured fragments or tesserae set in cement to form patterns or pictures. Tesserae can be made of natural coloured stone, of pottery and of coloured glass, including metal foil sandwiched in glass. *See* pages 86–7.

**Mosque:** An Islamic place of worship and hall of religious instruction. A Friday mosque is the equivalent of a cathedral, originally large enough to hold an entire community for the ritual prayers and sermon. *See* pages 104–5.

**Mould:** The hollow shape or negative image into which liquid metal or plaster is poured to set as a positive model, as in metal working for weapons or tools, or in sculpture.

**Mouldings:** In architecture and the applied arts mouldings refer to the cross section of those linear components carved for decoration and emphasis, such as the frame of a door or window, or a line to mark the division of floors on a façade.

**Mural painting:** Literally wall painting in any media, distemper, wax, oil or fresco. The term 'fresco' is popularly, frequently and wrongly used as a synonymous term for mural painting.

**Nave:** The main body of a church building: the centre aisle. The word is taken from the Latin for ship, the wooden roof structure being similar in technique to shipbuilding or the hull of a boat upside down.

**Niche:** A shallow scooped out compartment in the thickness of a wall.

**Niello:** A method of decorating a metal surface, generally silver, by filling incised lines and shapes with a black amalgam, usually silver sulphide. The technique results in fine black lines and precise shapes on a polished silver ground. See pages 39, 111.

**Non figurative:** *See* Abstract Art.

**Oculus:** A round window: bull's eye.

**Ogee:** A form made of an S shaped or reversed curve, in two dimensional pattern such as in printed textiles, or three dimensional as in the profile of an arch or window frame.

**Opus Anglicanum:** English church embroidery of the Middle Ages in which pictorial panels of great virtuosity rivalled miniature painting as an art. *See* page 137.

**Orders:** The original three basic variations of columns and lintels in Greek architecture, Doric, Ionic and Corinthian to which were later added Tuscan and Composite, all governed by sets of rules in use, in conjunction with each other and in their proportions and decoration. The Orders became the basis of all classical revivals in architecture.

**Painting:** Paint consists of pigments, or colours, mixed with a fluid medium such as water, glue, milk, drying oil or varnish, natural or synthetic. It is applied to a surface by brushing, spraying or on a pad or roller. The surface or support may be a natural rock wall, or stone, wood or plaster, or a wooden panel or stretched canvas. A portable painting is sometimes referred to as an easel painting.

**Pantocrator:** The depiction of Christ as the original creator of all things, the source of life. *See* page 87.

**Papyrus:** Ancient Egyptian forerunner of modern paper made from the pithy fibres of the papyrus reed.

**Parchment:** Specially selected and treated skin of young sheep, calves or goats. Used for scrolls, books and documents in Europe before the introduction of paper in the thirteenth century. Vellum is an especially fine parchment.

**Pastels:** Powdered colours mixed with gum as a binder and pressed into sticks. Pastels can be used as dry painting with all the range and gradation of oil painting, or simply for drawing. The word is also used in a different context, loosely to describe pale, light colour mixtures. *See* page 242.

**Patroon:** The Dutch-American landed gentry of colonial New England.

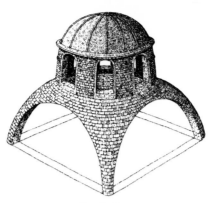

Pendentive

**Pendant:** A knob at the centre of a vault or ceiling panel so exaggerated as to appear to hang down. *See* page 124.

**Pendentive:** A concave infilling of the corners left by covering a square plan with a circular or polygonal drum or dome.

**Perspective:** A geometrical system for portraying three dimensional objects and space on a two dimensional surface.

**Piano nobile:** The main floor of a great house containing the reception rooms, usually the first floor.

**Pictogram:** A pictorial sign such as an international road sign or symbol.

**Pictograph:** A system of writing using picture symbols. *See* page 35.

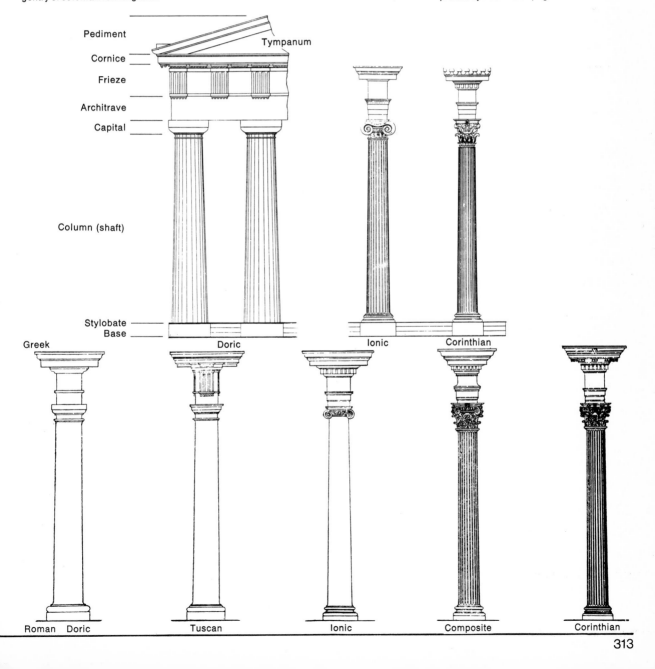

Pediment
Tympanum
Cornice
Frieze
Architrave
Capital

Column (shaft)

Stylobate
Base

Greek     Doric     Ionic     Corinthian

Roman   Doric     Tuscan     Ionic     Composite     Corinthian

# Glossary

**Picture Plane:** The apparent front surface of a picture, as if the picture were behind a window or transparent screen.

**Pietro serena:** A cool, gray stone used for decorative achitectural framing and contrast in Florentine Renaissance architecture.

**Pilasters:** A pier or rectangular column attached to a wall. *See* page 156.

**Pinnacle:** A pyramidal or conically shaped cap or crown to a spire, buttress, gable or corner, usually ornamented with a finial and crockets.

**Plastic, plasticity:** In painting and sculpture means a pliant, flexible quality and an ease and confidence in handling or implying three dimensional forms.

**Plate tracery.** *See* Tracery.

**Pointillist, Pointillism:** Painting by using small dots of colour which are blended by the eye at a distance to give tonal and colour mixtures. The technique is also known as Divisionism. *See* page 245.

**Polyptych:** Paintings or relief sculpture in more than three panels.

**Porcelain:** A fine white translucent china with a high silica content and fired at very high temperatures, and originating in China. *See* page 63.

**Portal:** A door opening of jambs, or posts, bridged by a lintel; or any frame of uprights and beam.

**Predella:** The base panels, often painted or carved, of a large altarpiece.

**Ptolemy, Ptolemaic:** The family name of the Greek rulers of Egypt 304–30 BC. The original Ptolemy was one of the Diodochoi, the 'inheritors', generals of Alexander the Great who divided the empire between them after Alexander's death.

**Putti:** Italian for 'boy': infant angels and cherubs that appear in much painting, sculpture and architectural decoration of the Renaissance and Baroque. *See* page 175.

**Qibla:** The direction towards Mecca, to which a Muslim must turn to pray, indicated in a mosque by the qibla wall.

**Quadripartite vault:** A vault divided in plan in four distinct parts.

**Relief:** Sculpture which is not free standing but carved into or attached to a panel. *See* page 44.

**Renaissance:** Literally meaning 'rebirth', and originally coined to identify the revival of classical art, architecture and literature in fifteenth century Italy, and now loosely used to describe any revival or resurgence in the arts.

**Repoussé:** A technique for decorating metal in relief by hammering sheet metal over a master form. *See* page 55.

**Ribvault:** A vault in which the lines of intersection are accentuated as projecting ribs.

**Rilievo schiaccatio:** Italian for 'shallow relief' (bas relief: *basso relievo*). *See* page 145.

**Rose window:** A large circular Gothic stained glass window in which the frame mullions radiate like the spokes of a wheel. Usually found high in the end walls of the nave, or the transepts, of a church or cathedral. *See* page 129.

**Runes:** A geometrical non-Roman alphabet used by the Vikings and other northern Europe migrant tribes.

**Runic Stones:** Standing stones carved with runic inscriptions erected as personal or religious monuments by Scandinavian migrants in their homelands and colonies.

**Rustication:** Blocks of masonry separated from each other by deeply cut joints and often with surface carving to make them look knobbly and rough hewn in order to give them a look of exaggerated solidity and strength.

**Sarcophagus:** An ornamented stone coffin, originally made from a limestone that was believed to dissolve the fleshy parts of the body.

**Sacra conversazione:** A religious picture in which the Madonna and child or Holy Family are placed in the centre of a group of saints and angels, and in which the donors or patrons may appear on the same panel, emphasising the human nature of the sacred figures. *See* page 158.

**Scalloped:** Carved or modelled in the form of a scallop shell.

**Scroll:** A spiral ornament or decoration, or a Gothic moulding resembling a rolled sheet of paper.

**Sculpture:** Made of solid material, and three dimensional either in relief or in the round, sculpture can be carved from the solid in wood or stone, modelled in wax or clay, cast in terra cotta, plaster or metal, or assembled from ready made or prepared materials.

**Sexpartite vault:** A vault divided in plan into six distinct parts.

**Sfumato:** 'Smoky': the blurring and blending of outlines and forms in painting to give a soft, atmospheric effect. *See* Leonardo, Correggio.

**Sgraffito:** A method of wall decoration in which successive layers of coloured stucco or plaster are applied to a wall, and then are carved and cut back to reveal the coloured layers beneath, producing a cameo-like effect.

**Slip:** A very liquid form of pottery clay which can be poured or painted by brush.

**Sphinx:** Egyptian animal (usually lion) with pharoah's head – a symbol of power. Occasionally of a Queen as a female sphinx.

**Spire:** The pinnacle crowning the towers of a church or cathedral, which may simply be quite a small structure to cover and weatherproof a flat roof, or a major triangular or conic structure hundreds of feet high. *See* page 124.

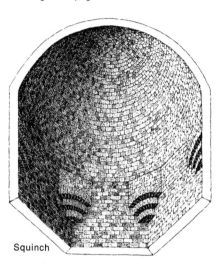

Squinch

**Squinch:** If a circular drum or dome is built over a square plan the corners projecting beyond the circle will have to be filled in. Squinches are arches or series of arches placed diagonally across these corners as both supports and infilling to the structure above.

**Stalactite vault:** A ceiling ornament in an Islamic vault in which corbelled squinches are scalloped to suggest stalactites – natural pendants of limestone hanging from the roofs of caves. *See* page 105.

**Stanza:** (plural *stanze*) Italian for 'room', 'rooms'. In art the word usually refers to a series of rooms in the Vatican decorated by Raphael between 1509 and 1520. *See* page 153.

**Stele:** A classical sculptured memorial panel or tombstone. *See* page 27.

**Strapwork:** Decorative plaster work that imitates curled and stamped leather straps. popular in Mannerist decoration. *See* page 175.

**Stucco:** A plaster finish or coating on walls, sculpture, etc. Stucco can be tinted, painted, or decoratively moulded, or decorated by sgraffito.

**Stupa:** A symbolic burial mound in Buddhist architecture signifying the universal presence of Buddha and often containing relics of a saint.

**Swags:** Imitation carved drapery used in architectural decoration.

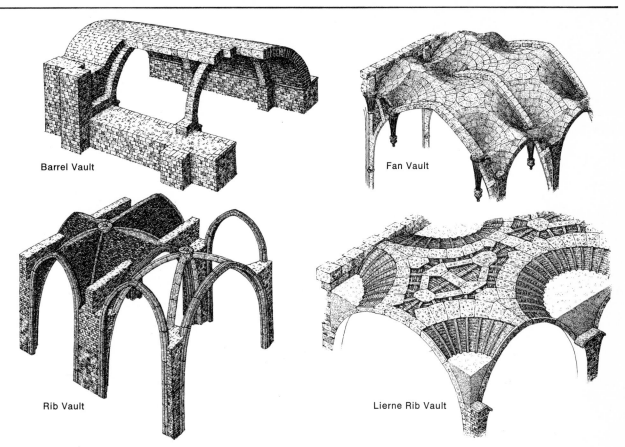

Barrel Vault

Fan Vault

Rib Vault

Lierne Rib Vault

**Tapestry:** A woven wall hanging, often pictorial, always decorative. Tapestry is now often misused to describe pictorial or decorative needlework.

**Tel:** Arabic for 'hill'. A term for a mound of rubble marking the site of a vanished city found particularly in the Middle East.

**Tempera:** A painting technique in which pigment is mixed with a binding medium capable of being diluted with water, or an emulsion. The traditional emulsion was egg yolk, oil and water, but there are many other emulsions, both natural and synthetic.

**Tenebrist:** Italian for 'dark', 'twilight', the term is applied to the seventeenth century followers of Carravaggio (pages 182–3) who very much exaggerated the contrasting, theatrical light and shade, and who particularly specialised in reproducing the effects of artificial light.

**Terracotta:** Italian for 'cooked earth'. A ceramic material made from red-brown clay which is suitable for architectural work in tiles and relief decoration and sculpture. See page 142.

**Tetramorph:** Greek for 'in four forms': fourfold.

**Tondo:** Italian for 'round': a circular painting or relief sculpture. See page 150.

**Tone:** Light and dark in painting, grading of shades within a single colour, and the shading of three dimensional forms. See page 151.

**Tracery:** The decorated and ornamented stone framework of a Gothic window cut into an elaborate lace-like pattern. Plate tracery is treated as if it is cut out of or punched into a flat sheet of stone with complete emphasis on the shapes. Bar tracery is more elaborate in its combination of geometrical forms and patterns. The terms are also applied to 'blind' tracery on stone walls or wooden panels.

**Triforium:** A gallery in a Gothic church above the arcade and below the clearstorey.

**Tripytch:** Paintings or relief sculpture in three panels. See page 169 (Grunewald).

**Trompe l'oeil:** French for eye-deceiving: painting in which three dimensional objects are so carefully painted that they appear to be real.

**Tympanum:** When a rectangular doorway is set in an arch, the space enclosed between arch and lintel is the tympanum; also the triangular or semicircular space enclosed by a pediment. See page 132.

**Unglazed:** Pottery that is fired once, without the second coat of a silica based glaze which gives it a glassy hard finish, and is consequently matt surface. See page 38.

**Vault:** A self-supporting arched structure covering a building, or the unit compartments of which a building is made, usually constructed of stone, brick or concrete.

**Vellum:** See Parchment.

**Veneer:** A thin sheet of wood, or marble used as a finishing cover to a coarser material. The word is also used critically to imply culture or learning that is superficial or only skin deep.

**Volute:** A spiral form used on decoration or architectural ornament. See Orders.

**Voussoir:** The segmented stones which are wedged together to form an arch. See page 54.

**Wood block:** A prepared wood block from which prints are made, either by engraving on the end grain, or cutting on the plank.

**Woodcut:** A print made from an image cut into the side plank of a block of wood.

**Wood engraving:** A print made from an image engraved into the end grain of a block of wood.

**Ziggurat:** An artifical, stepped temple-tower, with ramps or vaulted stairways giving access to a temple at the summit. It probably developed from the fact that early Mesopotamian temples were raised on a platform above the level of the flood-plain. See page 26.

# Museum Location Index

Column headers (left to right): Palaeolithic · Caves to Cities · Egyptian · Greece · Rome · Christian/Byzantine · Dark Ages/Islamic · Medieval · Renaissance · 17th Century · 18th Century · 19th Century · 20th Century · Ethnological · India/Japan/China

| Location | Pal | C2C | Egy | Gre | Rom | Chr | Dark | Med | Ren | 17 | 18 | 19 | 20 | Eth | IJC |
|---|---|---|---|---|---|---|---|---|---|---|---|---|---|---|---|
| **AFRICA** | | | | | | | | | | | | | | | |
| *Zambia:* Livingstone  Livingstone Museum | | | | | | | | | | | | | | ■ | |
| *Nigeria:* Museums at Benin, Ife, Oron, Owo | | | | | | | | | | | | | | | |
| **AUSTRIA** | | | | | | | | | | | | | | | |
| *Linz:* Neue Galerie der Stadt Linz | | | | | | | | | | | | ■ | ■ | | |
| *Salzburg:* Residenz Galerie | | | | | | | | | ■ | ■ | ■ | | | | |
| *Vienna:* Albertina Graphic Collection | | | | | | | | | ■ | ■ | ■ | | | | |
| *Vienna:* Austrian Gallery | | | | | | ■ | | | ■ | ■ | ■ | ■ | ■ | | |
| *Vienna:* Gallery of Academy of Fine Arts | | | | | | | | | ■ | ■ | ■ | | | | |
| *Vienna:* Gallery of Academy of Fine Arts Graphic | | | | | | | | | ■ | ■ | ■ | | | | |
| *Vienna:* Museum of Fine Arts | | | ■ | ■ | ■ | ■ | | | ■ | ■ | ■ | | | | |
| *Vienna:* Twentieth Century Museum | | | | | | | | | | | | | ■ | | |
| **AUSTRALIA** | | | | | | | | | | | | | | | |
| *Adelaide:* Art Gallery of South Australia | | | | ■ | ■ | ■ | | | ■ | ■ | ■ | | | | |
| *Brisbane:* Queensland Art Gallery | | | | | | | | | | | | | | | |
| *Melbourne:* National Gallery of Victoria | | | ■ | ■ | | | | | ■ | ■ | ■ | ■ | ■ | | |
| *Sydney:* Art Gallery of New South Wales | | | | | | | | | | ■ | ■ | ■ | ■ | | |
| **BELGIUM** | | | | | | | | | | | | | | | |
| *Antwerp:* Royal Museum of Fine Arts | | | | | | | | | ■ | ■ | ■ | | | | |
| *Antwerp:* Rubens Huis | | | | | | | | | | ■ | | | | | |
| *Antwerp:* Open air Sculpture Museum | | | | | | | | | | | | | ■ | | |
| *Antwerp:* Museum Smit Van Gelder | | | | | | | | | | | | | ■ | | |
| *Antwerp:* Museum Mayer Van den Burgh | | | | | | | | | ■ | ■ | ■ | | | | |
| *Bruges:* Groeningemuseum | | | | | | | | | ■ | ■ | | | | | |
| *Bruges:* Memling Museum | | | | | | | | | ■ | | | | | | |
| *Brussels:* Musée des Beaux Arts d'Ixelles | | | | | | ■ | | | ■ | ■ | ■ | | | | |
| *Brussels:* Musées Royaux d'Art et d'Histoire | ■ | ■ | ■ | ■ | ■ | ■ | | | | | | | | | |
| *Brussels:* Musées Royaux des Beaux Arts de Belge | | | | | | | | | | | | | | | |
| *Brussels:* Royal Central African Museum | | | | | | | | | | | | | | ■ | |
| *Liège:* Musées des Beaux Arts | | | | | | | | | ■ | ■ | ■ | ■ | ■ | | |
| *Liège:* Musée Curtius | | | | ■ | | ■ | | | ■ | | | | | | |
| **BRAZIL** | | | | | | | | | | | | | | | |
| *São Paulo:* Museu de Arte | | | | | | | | | ■ | ■ | ■ | ■ | ■ | | |
| **CANADA** | | | | | | | | | | | | | | | |
| *Montreal:* Museum of Fine Arts | | ■ | | | | | | | ■ | ■ | ■ | | | | |
| *New Brunswick:* Beaverbrook Art Gallery | | | | | | | | | | ■ | ■ | ■ | | | |
| *Ottowa:* National Gallery of Canada | | | | | | | | | ■ | ■ | ■ | ■ | | | |
| *Toronto:* Art Gallery of Ontario | | | | | | | | | | ■ | ■ | ■ | ■ | | |
| *Toronto:* Royal Ontario Museum | ■ | ■ | ■ | ■ | | | | | | | | | | | |
| **CZECHOSLOVAKIA** | | | | | | | | | | | | | | | |
| *Bratislava:* Municipal Gallery | | | | | | | | | ■ | ■ | ■ | ■ | ■ | | |
| *Prague:* National Gallery | | | | ■ | ■ | | | | ■ | ■ | ■ | | | | |
| **DENMARK** | | | | | | | | | | | | | | | |
| *Copenhagen:* Danish Museum of Applied Art | | | | | | | | ■ | ■ | ■ | ■ | ■ | ■ | | |
| *Copenhagen:* Royal Museum of Fine Art | | | | | | | | | ■ | ■ | ■ | ■ | ■ | | |
| *Copenhagen:* Thorwaldsens Museum | | | | | | | | | | | ■ | | | | |
| **EGYPT** | | | | | | | | | | | | | | | |
| *Cairo:* Coptic Museum | | | | | | ■ | | | | | | | | | |
| *Cairo:* Greco Roman Museum | | | | ■ | ■ | ■ | | | | | | | | | |
| *Cairo:* Museum of Islamic Art | | | | | | | ■ | | | | | | | | |
| *Cairo:* National Museum | | ■ | ■ | ■ | | | | | | | | | | | |
| **EIRE Republic of Ireland** | | | | | | | | | | | | | | | |
| *Dublin:* Municipal Gallery of Modern Art | | | | | | | | | | | | ■ | ■ | | |
| *Dublin:* National Gallery of Ireland | | | | | | | | | ■ | ■ | ■ | ■ | ■ | | |
| **FRANCE** | | | | | | | | | | | | | | | |
| *Aix en Provence:* Musée Granet | | | | ■ | ■ | | | | ■ | ■ | | | | | |
| *Amiens:* Musée de Picardie | | | | ■ | ■ | | | | | | | | | | |
| *Antibes:* Musée Picasso | | | | | | | | | | | | | ■ | | |
| *Avignon:* Musée Calvet | ■ | | | ■ | ■ | | | | ■ | ■ | | | | | |
| *Besancon:* Musée des Beaux Arts | | | | ■ | ■ | | | | ■ | ■ | ■ | | | | |
| *Biot:* Musée National Fernand Léger | | | | | | | | | | | | | ■ | | |
| *Chantilly:* Musée et Chateau | | | | | | | | | ■ | ■ | ■ | | | | |
| *Lyon:* Musée des Beaux Arts | | | | | | | | | ■ | ■ | ■ | ■ | | | |
| *Marseille:* Musée Borely | | | | ■ | | | | | | | | | | | |
| *Nice:* Musée Matisse | | | | | | | | | | | | | ■ | | |
| *Paris:* Centre Nationale Georges Pompidou | | | | | | | | | | | | | ■ | | |
| *Paris:* Galerie du Jeu de Paume | | | | | | | | | | | | ■ | | | |
| *Paris:* Musée Carnavalet | | | | | | | | | ■ | ■ | ■ | | | | |
| *Paris:* Musée d'Art Moderne | | | | | | | | | | | | | ■ | | |
| *Paris:* Musée de l'Homme | ■ | | | | | | | | | | | | | ■ | |
| *Paris:* Musée de l'Orangerie | | | | | | | | | | | | ■ | ■ | | |
| *Paris:* Musée des Antiquities Nationales | ■ | ■ | | | | | | | | | | | | | |
| *Paris:* Musée des Arts Decoratifs | | | | | | | | ■ | ■ | ■ | ■ | ■ | ■ | | |
| *Paris:* Musée des Thermes et d'Hotel de Cluny | | | | | | | | ■ | ■ | | | | | | |
| *Paris:* Musée du Louvre | ■ | ■ | ■ | ■ | ■ | ■ | | | ■ | ■ | ■ | ■ | | | |
| *Paris:* Musée du Petit Palais | | | | | | | | | ■ | ■ | ■ | ■ | | | |
| *Paris:* Musée Marmottan | | | | | | | | | | | | ■ | | | |
| *Paris:* Musée National de Fontainebleau | | | | | | | | | ■ | ■ | ■ | | | | |
| *Paris:* Musée National de Versailles et des Trianons | | | | | | | | | ■ | ■ | ■ | | | | |
| *Paris:* Musée Rodin | | | | | | | | | | | | ■ | ■ | | |
| *S. Paul de Vence:* Fondation Maeght | | | | | | | | | | | | | ■ | | |
| *Vallauris:* Musée National | | | | | | | | | | | | | ■ | | |
| **GERMANY EAST** | | | | | | | | | | | | | | | |
| *Berlin:* Staatliche Museen zu Berlin | | | ■ | ■ | ■ | ■ | ■ | | ■ | | | ■ | ■ | | |
| *Berlin:* National Gallery | | | | | | | | | | | ■ | ■ | ■ | | |
| *Dresden:* Barockmuseum | | | | | | | | | | ■ | | | | | |
| *Dresden:* Staatliche Kunstsammlungen | | | | | | | | | ■ | ■ | ■ | ■ | ■ | | |

| Location | Pal | C2C | Egy | Gre | Rom | Chr | Dark | Med | Ren | 17 | 18 | 19 | 20 | Eth | IJC |
|---|---|---|---|---|---|---|---|---|---|---|---|---|---|---|---|
| **GERMANY WEST** | | | | | | | | | | | | | | | |
| *Berlin:* Prussian State Culture Museums include: | | | | | | | | | | | | | | | |
|   Aegyptisches Museum | | | ■ | | | | | | | | | | | | |
|   Antiken Museum | | | | ■ | ■ | | | | | | | | | | |
|   Gemaldegalerie | | | | | | | | | ■ | ■ | ■ | | | | |
|   Museum of Ethnographic Art | | | | | | | | | | | | | | ■ | |
|   Museum of Far Eastern Art | | | | | | | | | | | | | | | ■ |
|   Museum of Indian Art | | | | | | | | | | | | | | | ■ |
|   Museum of Islamic Art | | | | | | | ■ | | | | | | | | |
|   Museum of Pre-Historic Art | ■ | ■ | | | | | | | | | | | | | |
| *Berlin:* Brucke Museum | | | | | | | | | | | | | ■ | | |
| *Berlin:* Neue Nationalgalerie | | | | | | | | | | | | ■ | ■ | | |
| *Berlin:* Skulpturengalerie | | | | | | ■ | | ■ | ■ | | | | | | |
| *Bonn:* Rheinisches Landes Museum | ■ | ■ | | | | ■ | | | | | | | | | |
| *Bonn:* Stadtische Kunstsammlungen | | | | | | | | | | | | | ■ | | |
| *Dusseldorf:* Neanderthal Museum | ■ | | | | | | | | | | | | | | |
| *Munich:* Bavarian State Collections include: | | | | | | | | | | | | | | | |
|   Alte Pinakothek | | | | | | | | | ■ | ■ | ■ | | | | |
|   Neue Pinakothek und Staatsgalerie Moderner Kunst | | | | | | | | | | | | | | | |
|   Schackgalerie | | | | | | | | | | | | ■ | | | |
|   Neues Schloss Schleissheim | | | | | | | | | ■ | ■ | ■ | | | | |
| *Munich:* Glyptotek (sculpture) | | | | ■ | ■ | | | | | | | | | | |
| *Munich:* Museum of Ethnography | | | | | | | | | | | | | | ■ | |
| *Munich:* Prehistorische Staatssammlung | ■ | ■ | | ■ | ■ | ■ | | | | | | | | | |
| *Munich:* Staatliche Antikensammlungen | | | | ■ | | | | | | | | | | | |
| *Munich:* Stattliche Sammlung Aegyptischer Kunst | | | ■ | | | | | | | | | | | | |
| *Munich:* Stadtische Galerie im Lenbachhaus | | | | | | | | | | | | | ■ | | |
| *Nuremburg:* Albrecht Durer Haus | | | | | | | | | ■ | | | | | | |
| **GREECE** | | | | | | | | | | | | | | | |
| *Athens:* Acropolis Museum | | | | ■ | | | | | | | | | | | |
| *Athens:* Benaki Museum | | | | | | ■ | | | ■ | ■ | | ■ | | | |
| *Athens:* Byzantine Museum | | | | | | ■ | | | | | | | | | |
| *Athens:* National Archaeological Museum | | ■ | ■ | ■ | | | | | | | | | | | |
| *Athens:* Stoa of Attalos Agora Museum | | | | ■ | | | | | | | | | | | |
| *Corinth:* Archaeological Museum | | | | ■ | | | | | | | | | | | |
| *Delphi:* Archaeological Museum | | | | ■ | | | | | | | | | | | |
| *Heraklion Crete:* Archaeological Museum | | ■ | | ■ | | | | | | | | | | | |
| *Olympia:* Archaeological Museum | | | | ■ | | | | | | | | | | | |
| **INDIA** | | | | | | | | | | | | | | | |
| *Baroda:* Museum and Picture Gallery | | | | | | ■ | ■ | | | | | | | ■ | ■ |
| *Jaipur:* Maharaja Sawai Man Singh II Museum | | | | | | | | | | | | | | | |
| *Mathura:* Archaeological Museum Sculpture Collection | | | | | | | | | | | | | | | ■ |
| *New Delhi:* National Museum of India | | | ■ | ■ | | | | | | | | | | | |
| **IRAN** | | | | | | | | | | | | | | | |
| *Teheran:* Archaeological Museum | | | ■ | ■ | | | | | | | | | | | |
| **IRAQ** | | | | | | | | | | | | | | | |
| *Baghdad:* Iraq Museum | | | ■ | ■ | | | | | | | | | | | |
| *Baghdad:* Museum of Arab Antiquities | | | | | | | ■ | | | | | | | | |
| **ISRAEL** | | | | | | | | | | | | | | | |
| *Haifa:* Museum of Ancient Art | | | | | | ■ | | | ■ | ■ | ■ | | | | |
| *Haifa:* Museum of Modern Art | | | | | | | | | | | | | ■ | | |
| *Haifa:* Tikotin Museum of Japanese Art | | | | | | | | | | | | | | | ■ |
| *Jerusalem* Archaeological (Rockefeller) Museum | | ■ | ■ | | ■ | ■ | ■ | ■ | | | | | | | |
| **ITALY** | | | | | | | | | | | | | | | |
| *Florence:* Galleria degli Uffizi | | | | | | ■ | | ■ | ■ | ■ | | | | | |
| *Florence:* Galleria dell Academia | | | | | | | | ■ | ■ | | | | | | |
| *Florence:* Galleria Palatina | | | | | | | | | ■ | ■ | | | | | |
| *Florence:* Museo Archaelogico | | | ■ | ■ | ■ | | | | | | | | | | |
| *Florence* Museo della Casa Buonarrotti | | | | | | | | | ■ | | | | | | |
| *Florence* Museo di S. Marco o dell'Angelico | | | | | | | | | ■ | | | | | | |
| *Florence:* Museo Medeceo | | | | | | | | | ■ | | | | | | |
| *Florence:* Palazzo Vecchio | | | | | | | | | ■ | | | | | | |
| *Milan:* Galleria d'Arte Moderna | | | | | | | | | | | | ■ | ■ | | |
| *Milan:* Museo Archaeologico | | | | ■ | ■ | | | | | | | | | | |
| *Milan:* Museo d'Arte Anticha | | | | | | | | ■ | | | | | | | |
| *Milan:* Museo Nazionale della Scienza e della Tecnica Leonardo da Vinci | | | | | | | | | | | | | | | |
| *Milan:* Pinacoteca Ambrosiana | | | | | | | | | ■ | ■ | | | | | |
| *Milan:* Pinacoteca de Brera | | | | | | | | | ■ | ■ | | | | | |
| *Naples:* Museo Archaeologico Nazionale | | | ■ | ■ | ■ | | | | | | | | | | |
| *Naples:* Museo Nazionale | | | | | | | | | ■ | | | | | | |
| *Perugia:* Galleria Nazionale dell Umbria | | | | | | | | | ■ | | | | | | |
| *Pisa:* Museo Nazionale di S. Matteo | | | | | | | | ■ | ■ | | | | | | |
| *Rome:* Galleria Borghese | | | | | | | | | ■ | ■ | | | | | |
| *Rome:* Galleria Nazionale d'Arte Moderna | | | | | | | | | | | | ■ | ■ | | |
| *Rome:* Museo Capitolini | | | | | ■ | | | | | | | | | | |
| *Rome:* Museo Nazionale di Villa Giulia | | | | ■ | | | | | | | | | | | |
| *Rome:* Museo Nazionale Romano | | | | ■ | ■ | | | | | | | | | | |
| *Rome:* Vatican Museums: | | | | | | | | | | | | | | | |
|   Capelle Sale e Galleria Affrescate (Sistine etc) | | | | | | | | | ■ | | | | | | |
|   Museo Gregoriano Etrusco | | | | ■ | ■ | | | | | | | | | | |
|   Museo Gregoriano Profano | | | | ■ | ■ | | | | | | | | | | |
|   Museo Pio Clemente | | | | | ■ | | | | | | | | | | |
|   Museo Pio Cristiano | | | | | | ■ | | | | | | | | | |

## ITALY ctd.

| Museum | PAL | CTC | EGY | GRE | ROM | C/B | D/M | REN | ISL | 17 | 18 | 19 | 20 | ETH | IJC |
|---|---|---|---|---|---|---|---|---|---|---|---|---|---|---|---|
| Rome: Pinacoteca Vaticana | | | | | | | | | | X | X | | | | X |
| Tarquinia: Museo Nazionale Tarquiniense | | | | X | | | | | | | | | | | |
| Turin: Galleria Sabanda | | | | | | | | | | X | X | | | | |
| Turin: Museo Egizio | | | X | | | | | | | | | | | | |
| Venice: Biennale di Venezia (Bi-annual exhibition) | | | | | | | | | | | | | X | | |
| Venice: Galleria dell Accademia | | | | | | | | | | X | X | X | | | |
| Venice: Museo Archaeologico | | | | X | X | | | | | | | | | | |
| Venice: Palazzo Ducale | | | | | | | | | | X | X | | | | |
| Venice: Peggy Guggenheim Foundation | | | | | | | | | | | | | X | | |
| Volterra: Museo Etrusco | | | | X | | | | | | | | | | | |

## JAPAN

| Museum | PAL | CTC | EGY | GRE | ROM | C/B | D/M | REN | ISL | 17 | 18 | 19 | 20 | ETH | IJC |
|---|---|---|---|---|---|---|---|---|---|---|---|---|---|---|---|
| Hyogo: Hakutsuru Museum | | | | | | | | | | | | | | | X |
| Kyoto: National Museum | | | | | | | | | | | | | | | X |
| Tokyo: Bridgestone Museum of Art | | | | | | | | | | | | | X | | |
| Tokyo: Gotoh Museum of Art | | | | | | | | | | | | | | | X |
| Tokyo: National Museum of Eastern Fine Arts | | | | | | | | | | | | | | | X |
| Tokyo: National Museum of Modern Art | | | | | | | | | | | | | X | | |
| Tokyo: National Museum of Western Art | | | | | | | | | | X | X | X | X | | |

## NEPAL

| Museum | PAL | CTC | EGY | GRE | ROM | C/B | D/M | REN | ISL | 17 | 18 | 19 | 20 | ETH | IJC |
|---|---|---|---|---|---|---|---|---|---|---|---|---|---|---|---|
| Badgaon: Palace Museum | | | | | | | | | | | | | | | X |
| Kathmandu: National Museum | | | | | | | | | | | | | | | X |

## NETHERLANDS

| Museum | PAL | CTC | EGY | GRE | ROM | C/B | D/M | REN | ISL | 17 | 18 | 19 | 20 | ETH | IJC |
|---|---|---|---|---|---|---|---|---|---|---|---|---|---|---|---|
| Amsterdam: Rembrandt Huis Museum | | | | | | | | | | X | | | | | |
| Amsterdam: Rijksmuseum | | | | | | | | X | | X | X | X | | | |
| Amsterdam: Vincent Van Gogh National Museum | | | | | | | | | | | | | X | | |
| Amsterdam: Stedelijk Museum | | | | | | | | | | | | | X | | |
| Eindhoven: Municipal Van Abbemuseum | | | | | | | | | | | | | X | | |
| Haarlem: Frans Hals Museum | | | | | | | | | | X | | | | | |
| Hague: Gemeentemuseum | | | | X | X | X | | | | | | | | | |
| Hague: Mauritshuis Royal Picture Gallery | | | | | | | | X | | X | | | | | |
| Hague: Museum Bredius | | | | | | | | | | X | | | | | |
| Leiden: National Museum of Antiquities | X | X | X | X | X | | | | | | | | | | |
| Leiden: National Museum of Ethnology | | | | | | | | | | | | | | X | X |
| Leiden: Stadelijk Museum de Lakenhall | | | | | | | | X | | X | | | | | |
| Otterlo: Rijksmuseum Kroller Muller | | | | | | | | | | | | X | X | | |
| Rotterdam: Museum Boymans Van Beuningen | | | | | | | | X | | X | X | | | | |
| Rotterdam: Museum of Ethnology | | | X | | | | | | | | | | | X | X |

## NEW ZEALAND

| Museum | PAL | CTC | EGY | GRE | ROM | C/B | D/M | REN | ISL | 17 | 18 | 19 | 20 | ETH | IJC |
|---|---|---|---|---|---|---|---|---|---|---|---|---|---|---|---|
| Auckland: City Art Gallery | | | | | | | | | | X | X | X | X | | |
| Dunedin: Public Art Gallery | | | | | | | | | | | | X | X | | |
| Napier: Hawkes Bay Art Gallery and Museum | | | | | | | | | | | | | | | |
| Wangami: Serjeant Art Gallery | | | | | | | | | | X | X | X | | | |
| Wellington: National Art Gallery | | | | | | | | | | | X | X | | | |

## NORWAY

| Museum | PAL | CTC | EGY | GRE | ROM | C/B | D/M | REN | ISL | 17 | 18 | 19 | 20 | ETH | IJC |
|---|---|---|---|---|---|---|---|---|---|---|---|---|---|---|---|
| Oslo: Kommunes Kunstsamlinger | | | | | | | | | | | | X | X | | |
| Oslo: National Gallery | | | | | | | | | | X | | | | | |
| Oslo: University Museum of National Antiquities | | | | | | | | | | X | | | | | |

## POLAND

| Museum | PAL | CTC | EGY | GRE | ROM | C/B | D/M | REN | ISL | 17 | 18 | 19 | 20 | ETH | IJC |
|---|---|---|---|---|---|---|---|---|---|---|---|---|---|---|---|
| Cracow: Warwel State Collection | | | X | | | | | X | X | X | | | | | X |
| Poznau: National Museum | | | | | | | | | | | | | | | |
| Stettin: National Museum | | | | | | | | | | | | | | | |
| Warsaw: National Museum | | | X | X | X | | | X | X | X | X | X | | | |
| Wroclaw: National Museum | | | | | | | | | | | | | | | |

## SPAIN

| Museum | PAL | CTC | EGY | GRE | ROM | C/B | D/M | REN | ISL | 17 | 18 | 19 | 20 | ETH | IJC |
|---|---|---|---|---|---|---|---|---|---|---|---|---|---|---|---|
| Barcelona: Museo de Arte de Cataluna | | | | | | X | X | X | | | | | | | |
| Barcelona: Museo Picasso | | | | | | | | | | | | | X | | |
| Bilbao: Museo de Bellas Artes | | | | | | | X | X | X | X | | | | | |
| Burgos: Museo Arqueologico | | | | | | | | X | | | | | | | |
| Madrid: Monasterio de San Lorenzo de El Escorial | | | | | | | | X | X | X | | | | | |
| Madrid: Museo Arqueologico Nacional | X | X | | X | | X | X | | | | | | | | |
| Madrid: Museo Cerralbo | | | | | | | | X | X | X | | | | | |
| Madrid: Museo del Prado | | | | | | | | X | X | X | | | | | |
| Santander: Museo de Prehistoria y Arqueologia | X | X | | | | | | | | | | | | | |
| Toledo: Casa del Greco | | | | | | | | | | X | | | | | |
| Toledo: Museo del Greco | | | | | | | | | | X | | | | | |

## SYRIA

| Museum | PAL | CTC | EGY | GRE | ROM | C/B | D/M | REN | ISL | 17 | 18 | 19 | 20 | ETH | IJC |
|---|---|---|---|---|---|---|---|---|---|---|---|---|---|---|---|
| Damascus: National Museum | | X | X | X | X | X | X | | | | | | | | |

## TURKEY

| Museum | PAL | CTC | EGY | GRE | ROM | C/B | D/M | REN | ISL | 17 | 18 | 19 | 20 | ETH | IJC |
|---|---|---|---|---|---|---|---|---|---|---|---|---|---|---|---|
| Ankara: Museum of Anatolian Civilisations | X | X | | | | | | | | | | | | | |
| Bergama: Pergamon Museum | | | | X | | | | | | | | | | | |
| Istanbul: Archaeological Museum | | X | X | X | X | | | | | | | | | | |
| Istanbul: Santa Sophia Museum | | | | | | X | X | | | | | | | | |
| Istanbul: Topkapi Museum | | | | | | | | | X | | | | | | X |
| Konya: Konya Museum | | | | | | | | | X | | | | | | |
| Selsuk Izmir: Ephesus Collection Museum | | | | X | | | | | | | | | | | |

## U.K.

| Museum | PAL | CTC | EGY | GRE | ROM | C/B | D/M | REN | ISL | 17 | 18 | 19 | 20 | ETH | IJC |
|---|---|---|---|---|---|---|---|---|---|---|---|---|---|---|---|
| Bath: American Museum | | | | | | | | | | | | | | | |
| Bath: Holburne of Menstrie Museum | | | | | | | | | | | X | X | | | |
| Birmingham: Museum and Art Gallery | | | X | X | X | | | | X | X | X | X | | | |
| Brighton: Royal Pavilion Art Gallery and Museum | | | | | | | | | | | | X | X | | |
| Cambridge: Fitzwilliam Museum | | | X | X | X | X | X | X | X | X | X | X | X | | |
| County Durham: Bowes Museum | | | | | | | | | | | | | | | |

## U.K. ctd.

| Museum | PAL | CTC | EGY | GRE | ROM | C/B | D/M | REN | ISL | 17 | 18 | 19 | 20 | ETH | IJC |
|---|---|---|---|---|---|---|---|---|---|---|---|---|---|---|---|
| Durham: Gulbenkian Museum of Oriental Art and Archaeology | X | X | | X | | | | | | | | | | | X |
| Edinburgh: National Gallery of Scotland | | | | | | | | | | X | X | X | X | | |
| Edinburgh: Scottish National Gallery of Modern Art | | | | | | | | | | | | | X | | |
| Glasgow: Museums and Art Galleries | | | | | | | | X | | X | X | X | X | | |
| Leeds: City Art Gallery | | | | | | | | | | X | X | X | X | | |
| Liverpool: Walker Art Gallery | | | | | | | | X | | X | X | X | | | |
| London: British Museum | X | X | X | X | X | X | X | X | X | X | X | X | X | X | X |
| London: Courtauld Institute Galleries | | | | | | | | X | | X | X | X | | | |
| London: Dulwich College Picture Gallery | | | | | | | | X | | X | X | | | | |
| London: Horniman Museum | | | | | | | | | | | | | | X | X |
| London: Imperial War Museum | | | | | | | | | | | | | X | | |
| London: Iveagh Bequest Kenwood | | | | | | | | X | | X | X | | | | |
| London: National Gallery | | | | | | | | X | | X | X | X | | | |
| London: National Maritime Museum | | | | | | | | | | X | X | X | | | |
| London: National Portrait Gallery | | | | | | | | X | | X | X | X | | | |
| London: Royal Collection Buckingham Palace Queen's Gallery | | | | | | | | X | | X | X | | | | |
| London: Royal Collection Hampton Court Palace | | | | | | | | X | | X | X | | | | |
| London: Royal Collection Windsor Castle | | | | | | | | X | | X | X | | | | |
| London: Soane Museum | | | | | | X | X | X | | X | | | | | |
| London: Tate Gallery | | | | | | | | | | | | X | X | | |
| London: Victoria and Albert Museum and Bethnal Green Museum | | | | X | X | X | X | X | X | X | X | X | X | | |
| London: Wallace Collection | | | | | | | | X | | X | X | | | | |
| Manchester: City Art Gallery | | | | | | | | X | | | | X | X | | |
| Newcastle Upon Tyne: Laing Art Gallery and Museum | | | | | | | | | | | | X | X | | |
| Norwich: Castle Museum | | | | | | | | | | | | X | X | | |
| Oxford: Ashmolean Museum | | | | X | X | | | X | X | X | X | X | | | |
| Port Sunlight Merseyside: Lady Lever Art Gallery | | | | | | | | | | | | | | | |
| Sheffield: Graves Art Gallery | | | | | | | | | | X | X | X | X | | |
| York: City Art Gallery | | | | | | | | X | | X | X | X | | | |

## U.S.A.

| Museum | PAL | CTC | EGY | GRE | ROM | C/B | D/M | REN | ISL | 17 | 18 | 19 | 20 | ETH | IJC |
|---|---|---|---|---|---|---|---|---|---|---|---|---|---|---|---|
| Baltimore: Museum of Art | | | | | | | | | | | | | X | | |
| Baltimore: Walters Art Gallery | X | X | X | X | X | X | X | X | X | X | X | | | | X |
| Boston: Museum of Fine Arts | | | X | X | | X | | X | | X | | | | | X |
| Buffalo NY: Fine Arts Academy | | | | | | X | X | | | | | | | | X |
| Cambridge Mass: Peabody Museum Harvard Univeristy | | | | | | | | | | | | | | X | |
| Cambridge Mass: William Hayes Fogg Museum Harvard University | X | X | X | X | X | X | | X | X | X | X | X | | | X |
| Chicago: Art Institute | | | | | | | | X | | X | X | X | | | X |
| Chicago: Oriental Institute University of Chicago | X | X | X | X | | | | | | | | | | | |
| Cleveland: Museum of Art | | | | | | X | X | | X | X | X | X | | | X |
| Detroit: Institute of Arts | | | | | | | | X | | X | X | X | X | | |
| Malibu Cal.: J. Paul Getty Museum | | | | X | X | X | | X | | X | X | | | | |
| New Haven: Mellon Centre for British Art, Yale | | | | | | | | | | X | X | X | | | |
| New Orleans: Museum of Art | | | | | | X | X | | | X | | | | | |
| New York: Brooklyn Museum | X | X | X | X | X | | | X | | X | X | X | | | X |
| New York: Frick Collection | | | | | | | | X | | X | X | | | | |
| New York: Guggenheim Museum | | | | | | | | | | | | X | X | | |
| New York: Metropolitan Museum of Art | X | X | X | X | X | X | X | X | X | X | X | X | X | | X |
| New York: Museum of Modern Art | | | | | | | | | | | | | X | | |
| New York: Museum of the American Indian | | | | | | | | | | | | | | X | |
| New York: Whitney Museum of American Art | | | | | | | | | | | | | X | | |
| Philadelphia: Barnes Foundation Collection | | | | | | | | | | X | X | X | X | | |
| Philadelphia: Museum of Art | | | | | | X | X | | | X | X | X | | | |
| Philadelphia: Pennsylvania Academy of Fine Arts | | | | | | | | | | X | X | X | | | |
| San Diego Cal.: Fine Arts Gallery | | | | | | | | X | | X | X | X | | | |
| San Francisco Cal.: Asian Art Museum | | | | | | X | | | | | | | | | X |
| San Francisco Cal.: California Palace of Legion of Honor | | | | | | | | | | X | X | X | | | |
| San Francisco Cal.: Museum of Art | | | | | | | | | | | | | X | | |
| S. Louis: Art Museum | | | | | | | | | | | X | | | | |
| S. Marino Cal.: Huntington Art Gallery | | | | | | | | | | X | X | | | | |
| Washington D.C.: Freer Gallery of Art | | | | | | | X | | | | | | | | X |
| Washington D.C.: National Collection of Fine Arts | | | | | | | | | | | | X | X | | |
| Washington D.C.: National Gallery of Art | X | X | X | X | X | X | X | X | X | X | X | X | | | |
| Washington D.C.: National Portrait Gallery | | | | | | | | | | | X | X | | | |
| Williamsburg: Colonial Williamsburg Foundation | | | | | | | | | | X | X | | | | |
| Worcester Mass.: Worcester Art Museum | | | | X | X | X | X | X | | X | X | X | | | |

## U.S.S.R.

| Museum | PAL | CTC | EGY | GRE | ROM | C/B | D/M | REN | ISL | 17 | 18 | 19 | 20 | ETH | IJC |
|---|---|---|---|---|---|---|---|---|---|---|---|---|---|---|---|
| Leningrad: State Hermitage Museum | X | X | X | X | X | X | X | X | X | X | X | X | | | X |
| Leningrad: State Russian Museum | | | | | | | X | X | | X | X | X | | | |
| Leningrad: Summer Garden and Museum Palace of Peter the Great | | | | | | | | | | X | | | | | |
| Moscow: Andrei Rublyov Museum of Ancient Russian Art | | | | | | X | X | | | | | | | | |
| Moscow: Kremlin Museum | | | | | | | X | X | | X | X | X | | | |
| Moscow: Pushkin Museum of Fine Arts | X | X | X | X | X | | | X | | X | X | X | X | | |
| Moscow: Tretyakov Gallery | | | | | | X | X | X | | X | X | X | X | | |

# Further Reading List

## General Reference

There are a number of multi-volume publications which cover the history of art either as historical surveys, encyclopedia or dictionaries. The following should prove informative and are well illustrated:

*Art and Mankind Larousse Encyclopedia* (4 vols)
*Landmarks of World Art* (10 vols)
*The McGraw Hill Encyclopedia of Art* (15 vols)
*Methuen Art of the World* (25 + vols)
*The Pelican History of Art* (40 + vols)

Single volume general works include:

Bazin: *The Loom of Art*
Clark: *Civilization*
      *The Nude*
Copplestone (ed): *World Architecture*
Gombrich: *The Story of Art*
      *Art and Illusion*
Hauser: *Social History of Art*
Janson: *A History of Art*
      *Key Monuments of the History of Art*
Maison: *Themes and Variations*
Millon: *Key Monuments of the History of Architecture*
Myers: *Art and Civilization*
Pevsner: *An Outline of European Architecture*
Read: *The Art of Sculpture*

## Paleolithic and Primitive Art

Adam: *Primitive Art*
Bandi: *The Art of Stone Age: Forty Thousand Years of Rock Art*
Breuil: *Four Hundred Centuries of Cave Art*
Fraser: *Primitive Art*
Giedion: *The Eternal Present: The Beginnings of Art*
Hirn: *The Origins of Art*
Leroi- Gourhan: *The Art of Prehistoric Man in Western Europe*
Sandars: *Prehistoric Art in Europe*
Ucko and Rosenfeld: *Paleolithic Cave Art*

## Caves to Cities

Akurgal: *The Art of the Hittites*
Frankfurt: *The Art and Architecture of the Ancient Orient*
Kenyon: *The Architecture of the Holy Land*
Lloyd: *The Art of the Ancient Near East*
Megaw: *Art of the European Iron Age*
Moortgat: *The Art of Ancient Mesopotamia*
Mourgal: *The Hittites – The Art of Sumer*
Parrot: *Nineveh and Babylon Arts of Mankind*
Strommenger Hirmer: *The Art of Mesopotamia*
Woolley: *Mesopotamia and The Middle East*

## Egyptian Art

Harris: *Egyptian Art*
Lange and Hirmer: *Egypt: Architecture, Sculpture, Painting in Three Thousand Years*
Smith: *The Art and Architecture of Ancient Egypt*

## Greek Art

Boardman: *The Art and Architecture of Greece*
Cook: *Greek Art*
Higgins: *Minoan and Mycenean Art*
Lawrence: *Greek Architecture*
Lullies and Hirmer: *Greek Sculpture*
Richter: *A Handbook of Greek Art*

## Roman Art

Bianchi Bandinelli: *Rome: The Centre of Power*
      *The End of the Empire: Roman Art AD192–395*
Boethuis and Ward Perkins: *Etruscan and Roman Architecture*
Wheeler: *Roman Art and Architecture*

## Early Christian and Byzantine Art

Beckwith: *The Art of Constantinople*
Krautheimer: *Early Christian and Byzantine Architecture*
Rice: *The Art of Byzantium*

## Dark Ages

Conant: *Carolingian and Romanesque Architecture 800–1200*
D'Ancona and Aeschlinan: *The Art of Illumination*
Lasko: *Ars Sacra 800–1200*

## Islamic Art

Burckhardt: *Art of Islam*
Grube: *The World of Islam*
Planhol de: *The World of Islam*

## Japanese Art

Hillier: *The Japanese Print: A New Approach*
Kuno: *A Guide to Japanese Sculpture*
Cane: *Masters of the Japanese Print*
Paine and Soper: *The Art and Architecture of Japan*

## Chinese Art

Ashton and Grey: *Chinese Art*
Cahill: *Chinese Painting*
Cohn: *Chinese Painting*
Kodansha International (publ):
    *The Arts of China*, Vol. I (ed Mary Tregear): *Neolithic Cultures to the T'ang dynasty, Recent Discoveries;* Vol. II (ed A. C. Soper): *Buddhist Cave Temples, New Researches;* Vol. III: *Paintings in Chinese Museums, New Collections*
Sickman and Soper: *The Art and Architecture of China*

## Asia

Allchin: *The Birth of Indian Civilisation*
Rawson: *Art of South-East Asia*
Rawson: *Indian Art*
Rowland: *The Art and Architecture of India*

## Medieval Art

Conant: *Carolingian and Romanesque Architecture, 800–1200*
Dodwell: *Painting in Europe, 800–1200*
Evans: *Art in Medieval France*
Formaggio and Basso: *A Book of Miniatures*
Frankl: *Gothic Architecture*
Kidson: *The Medieval World*
Lasko: *Ars Sacra, 800–1200*
Martindale: *Gothic Art*
Mueller: *Sculpture in the Netherlands, Germany, France and Spain, 1400–1500*
Rickert: *Painting in Britain, the Middle Ages*
Stone: *Sculpture in Britain, the Middle Ages*
White: *Art and Architecture in Italy, 1250–1400*

## Renaissance Art

Benesch: *The Art of the Renaissance in Northern Europe*
Blunt: *Art and Architecture in France 1500–1800*
Brion: *German Painting*
Chastel: *Age of Humanism*
Freedberg: *Painting in Italy 1500–1600*
Gould: *An Introduction to Italian Renaissance Painting*
Hartt: *A History of Italian Renaissance Art*
Hay: *Age of the Renaissance*

Hughes and Lynton: *Renaissance Architecture*
Kubler and Soria: *Art and Architecture in Spain and Portugal and their American Dominions 1500–1800*
Muller: *Sculpture in the Netherlands, Germany, France and Spain 1400–1500*
Murray: *The High Renaissance*
Pope-Hennessy: *Italian Gothic Sculpture*
*Italian High Renaissance and Baroque Sculpture* (3 vols.)
*Italian Renaissance Sculpture*
Seymour: *Sculpture in Italy 1400–1500*
Shearman: *Mannerism*
Von der Osten, and Vey: *Painting and Sculpture in Germany and the Netherlands 1500–1600*
Whinney: *Early Flemish Painting*

## 17th and 18th Century

Blunt: *Art and Architecture in France, 1500–1700*
Downes: *English Baroque Architecture*
Gerson and Ter Kuile: *Art and Architecture in Belgium 1600–1800*
Hempel: *Baroque Art and Architecture in Central Europe*
Honour: *Neo-Classicism*
Kalnein and Levey: *Art and Architecture of the Eighteenth Century in France*
Kitson: *The Age of Baroque*
Levey: *From Rococo to Revolution*
Millar and Whinney: *English Art 1625–1714*
Nash: *The Age of Rembrandt and Vermeer*
Rosenburg, Slive and Ter Kuile: *Dutch Art and Architecture 1600–1800*
Summerson: *Architecture in Britain 1530–1830*
Waterhouse: *Italian Baroque Painting*
*Painting in Britain 1530–1830*
Whinney: *English Sculpture 1530–1830*
Wittkower: *Art and Architecture in Italy 1600–1750*

## American Art

Baigell: *A History of American Painting*
Craven: *Sculpture in America*
Dorra: *The American Muse*
Garrett, Norton, Gowans and Butler:
*The Arts in America: The Nineteenth Century*
Geldzahler: *New York Painting and Sculpture: 1940–1970*
Kubler: *Art and Architecture of Ancient America*
McCoubrey, Wright, Tatum, and Smith:
*The Arts in America: The Colonial Period.*
McLanathan: *The American Tradition in the Arts*
Mendelowitz: *A History of American Art*
Myers: *Mexican Painting in Our Time*
Novak: *American Painting of the Nineteenth Century: Realism, Idealism and the American Experience*
Rose: *American Art since 1900: A Critical History*

## 19th Century in Europe

Andrews: *The Nazarenes*
Bagin: *Romantic Art*
Briggs: *The Nineteenth Century*
Chasse: *The Nabis and their Period*
Hamilton: *Painting and Sculpture in Europe 1880–1940*
Hitchcock: *19th & 20th Century Architecture*
Jullien: *Dreamers of Decadence: Symbolist Painters of the 1890s*
Klingender: *Art and the Industrial Revolution* (ed Elton)
Maas: *Victorian Painters*
Nicoll: *The Pre-Raphaelites*
Nochlin: *Realism*

Novotny: *Painting and Sculpture in Europe, 1780–1880*
Reynolds: *Painters of the Victorian Scene*
Rewald: *The History of Impressionism*
*Post-Impressionism from Van Gogh to Gauguin*
Scharf: *Art and Photography*
Schmutzler: *Art Nouveau*
Wilenski: *English Painting*
*Modern French Painters*

## 20th Century

Ashtin: *Modern American Sculpture*
Ballow: *Modern Italian Painting*
Barr: *Cubism and Abstract Art*
*Fantastic Art, Dada and Surrealism*
Barrett: *Op Art*
Bowness: *Modern European Art*
Compton: *Pop Art*
Golding: *Cubism: A History and Analysis*
Goldwater: *Primitivism in Modern Painting*
Gray: *The Great Experiment: Russian art 1863–1922*
*Modern Russian Painting*
Giedion: *Mechanisation takes Command*
*Space Time and Architecture*
Haftmann: *Painting in the 20th Century*
Jaffe: *De Stijl, 1917–1931: The Dutch Contribution to Modern Art*
Jean: *The History of Surrealist Painting*
Kahnweiler: *The Rise of Cubism*
Licht: *Sculpture Nineteenth and Twentieth Century*
Martin: *Futurist Art and Theory 1909–1915*
Myers: *The German Expressionists: A Generation in Revolt*
Popper: *Kinetic Art*
Read: *Art Now: An Introduction To the Theory of Modern Painting and Sculpture*
Richter: *Dada Art and Anti-art*
Rose: *American Art since 1900*
Rosenblum: *Cubism and Twentieth-Century Art*
Rubin: *Dada and Surrealist*
Sandler: *Abstract Expressionism: The Triumph of American Painting*
Schmutzler: *Art Nouveau*
Seuphor: *A Dictionary of Abstract Painting*
Wingler: *The Bauhaus: Wiemar, Dessau, Berlin, Chicago*

## North American Indian Art

Dockstader: *Indian Art in America*
Haberland: *North America*
Lowie: *Indians of the Plains*
Siebert and Forman: *North American Indian Art*

## Pre-Columbian Art

Bushnell: *Ancient Arts of the Americas*
Castedo: *A History of Latin American Art and Architecture from pre-Columbian Times to the Present*
Disselhoff and Linne: *The Art of Ancient America*
Fernandez: *A Guide to Mexican Art from Its Beginnings to the Present*
Soustelle: *Arts of Ancient Mexico*

## African Art

Allison: *African Stone Sculpture*
Elisofon and Fagg: *The Sculpture of Africa*
Fagg: *African Tribal Images*
*Tribes and Forms in African Art*
Ferman and Dark: *Benin Art*
Leiris and Delange: *African Art*

## Oceanic Art

Buhler, Barrow and Mounford: *Art of the South Seas*
Dodd: *Polynesian Art*
Tischera: *Oceanic Art*

# Acknowledgements

ADAGP, Paris: *251, 259, 261, 262, 263, 264, 266, 267, 275, 277, 280, 282, 283;* Aerofilms Ltd: *130–1;* Airviews: *214–5;* Art Institute Chicago: *262–3;* Bayer Staatsbibliothek Munich: *116–7;* Bildarchiv Foto Marburg: *116–7, 126–7, 132–3;* Boston Museum of Fine Arts: *222–3;* British Museum: *288–9, 290–1, 304–5;* C. E. Brookeman: *222–3;* J. G. Bulloz: *122–3, 134–5;* Camera Press: *66–7;* J. Allan Cash: *68–9;* Christie's: *240–1;* P. Clayton: *18–9, 24–5, 30–1, 32–3, 34–5, 38–9, 40–1, 44–5, 48–9, 50–1, 52–3, 84–5, 100–1;* Colour Photo Hinz: *18–9, 20–1, 262–3;* Cooper-Bridgeman: *26–7, 34–5, 50–1, 54–5, 73–3, 78–9, 114–5, 140–1, 142–3, 146–7, 148–9, 150–1, 152–3, 154–5, 156–7, 158–9, 160–1, 162–3, 164–5, 166–7, 168–9, 170–1 172–3, 174–5, 180–1, 182–3, 186–7, 188–9, 190–1, 192–3, 194–5, 196–7, 198–9, 200–1, 202–3, 204–5, 208–9, 210–1, 212–3, 216–7, 220–1, 224–5, 226–7, 230–1, 232–3, 234–5, 236–7, 238–9, 240–1, 242, 244–5, 246–7, 248–9, 250–1, 252–3, 254–5, 260–1, 262–3, 264–5, 266–7, 268–9, 270–1, 274–5, 276–7, 278–9, 280–1, 286–7;* Trewin Copplestone Publishing: *26–7, 28–9, 30–1, 32–3, 34–5, 38–9, 42–3, 44–5, 46–7, 50–1, 52–3, 56–7, 60–1, 66–7, 68–9, 72–3, 74–5, 76–7, 88–9, 96–7, 114–5, 120–1, 130–1, 132–3, 144–5, 146–7, 148–9, 154–5, 156–7, 158–9, 162–3, 164–5, 166–7, 170–1, 172–3, 174–5, 182–3, 184–5, 188–9, 190–1, 192–3, 194–5, 196–7, 198–9, 204–5, 208–9, 210–1, 214–5, 220–1, 224–5, 226–7, 232–3, 234–5, 236–7, 238–9, 240–1, 242–3, 244–5, 246–7, 250–1, 254–5, 258–9, 264–5, 266–7, 270–1, 272–3, 274–5, 276–7, 278–9, 280–1, 282–3, 284–5, 290–1, 296–7, 300–1, 302–3, 304–5, 306–7;* M.H. De Young Memorial Museum, San Francisco: *288–9;* Farnham School of Art: *58–9, 62–3, 298–9, 300–1;* Virginia Fass: *62–3;* Fine Arts Museum, San Francisco: *288–9;* Werner Forman Archive: *70–1, 100–1, 102–3, 106–7, 112–3, 290–1 292–3;* Guggenheim: *266–7, 272–3;* Sonia Halliday: *36–7* (Photo by F. H. C. Birch), *38–9, 48–9, 84–5, 86–7, 88–9, 98–9* (Photo by P. Marsden), *104–5, 118–9, 120–1, 122–3, 126–7, 128–9, 130–1, 132–3;* Hamlyn Picture Group: *20–1, 32–3, 42–3, 68–9, 74–5, 78–9, 82–3, 90–1, 106–7, 132–3, 136–7, 176–7, 180–1, 254–5, 284–5;* Claus Hansmann: *66–7, 70–1, 76–7, 102–3, 110–1, 136–7;* Robert Harding Associates: *22–3, 32–3, 58–9, 70–1;* Lucien Herve: *284–5;* Hirmer Fotoarchiv: *46–7, 80–1, 88–9, 90–1, 134–5, 206–7;* Michael Holford Picture Library: *22–3, 26–7, 40–1, 42–3, 114–5, 166–7, 172–3, 188–9, 216–7;* Angelo Hornak Photo Library: *98–9, 100–1, 102–3, 124–5, 200–1, 206–7;* Victor Kennet: *92–3, 94–5;* A.F. Kersting: *124–5, 126–7, 176–7, 214–5, 228–9, 248–9;* Paolo Koch: *64–5, 66–7, 70–1, 72–3, 98–9, 104–5, 106–7;* Janet Le Caisne: *130–1, 132–3;* R. Lewcock: *104–5;* Mansell Collection: *48–9, 50–1, 82–3, 122–3, 138–9, 142–3, 148–9, 150–1, 156–7, 158–9, 164–5, 166–7, 172–3, 176–7, 182–3, 206–7, 212–3;* Metropolitan Museum, New York: *224–5, 226–7, 278–9;* Middle East Archive: *100–1, 102–3, 104–5;* Musée de l'Homme, Paris: *298–9;* Museum of Modern Art, New York: *268–9;* Musée des Thermes et d'Hotel de Cluny: *110–1;* Museum Philadelphia: *242–3;* Museum Stockholm: *112–3;* Bernard Myers: *52–3, 106–7;* National Monuments Record: *114–5;* National Gallery, London: *242–3;* National Museum of Ireland: *108–9;* Norwich Museums: *110–1;* Novosti Press Agency: *92–3, 94–5, 260–1;* Nuremburg Museums: *110–1;* Peter Oakeshott: *252–3;* Peabody Museum, Harvard University: *290–1;* Pennsylvania Acad Fine Arts: *222–3;* Hans Peterson, Copenhagen: *260–1;* Photo Collection Begouen: *20, 21;* Photographie Giraudon: *134–5, 174–5, 178–9, 184–5, 186–7, 188–9, 204–5, 206–7, 214–5, 232–3, 240–1, 262–3;* Photoresources: *108–9, 112–3;* Picturepoint Ltd.: *24–5, 36–7, 42–3, 52–3, 70–1, 76–7;* Paul Popper Ltd: *284–5;* Publications Filmées d'art et d'histoire, Paris: *298–9;* Rijksmuseum Amsterdam: *194–5;* Roger-Viollet, Paris: *20–1, 252–3;* Russian Information Service: *94–5;* Scala: *46–7, 80–1, 82–3, 84–5, 86–7, 88–9, 132–3, 138–9, 142–3, 144–5, 146–7, 150–1, 152–3, 154–5, 158–9, 160–1, 168–9, 170–1, 180–1, 182–3, 204–5, 258–9;* Ronald Sheridan: *24–5, 28–9, 54–5;* Edwin Smith: *124–5;* Snark International, Paris: *134–5;* South West Museum, Los Angeles: *288–9;* Sovfoto: *92–3;* SPADEM, Paris: *251, 260, 261, 262, 263, 267, 271, 273, 277;* Spectrum Colour Library: *66–7, 74–5, 94–5, 140–1, 218–9, 228–9, 256–7, 298–9, 304–5;* Staatsgalerie Stuttgart: *272–3;* Statens Historiska Museet: *108–9;* Sterling and Francine Clark Art Institute: *238–9;* Stickelman: *234–5;* Taylor Museum, Colorado Springs: *288–9;* UNESCO: *306–7;* Victoria and Albert Museum: *56–7, 58–9, 62–3, 82–3, 104–5, 136–7;* Wallace Collection, London: *198–9, 202–3;* Wiedenfeld and Nicholson: *184–5, 202–3;* Roger Wood Studio: *22–3;* Woodmansterne Publications Ltd.: *124–5;* Yale University: *222–3;* Zavho Press: *76–7;* Ziolo: *72–3* (Photo by Faillet), *74–5, 122–3.*

The publishers would also like to thank all the other artists, studios, museums, and companies who could not be traced in the course of preparing this book for publication. Picture research: Faith Perkins.